ART NOW
VOL 3

Edited by Hans Werner Holzwarth

ART NOW VOL 3

A cutting-edge selection of today's most exciting artists

Ein aktueller Überblick zu 133 internationalen Künstlern
Une sélection actuelle de 133 artistes de la scène internationale
Including illustrated appendix with price guide
Illustrierter Anhang mit Preisen und Auktionsergebnissen
Annexe illustrée avec les prix et résultats des ventes publiques

TASCHEN

HONG KONG KÖLN LONDON LOS ANGELES MADRID PARIS TOKYO

Contents — Inhalt — Sommaire

Preface

Three years have passed since the last volume of *ART NOW*, a long time considering how much exciting art is produced in studios worldwide every day. Artistic positions shift, new trends emerge: abstract painting has once again become an open field, many young artists work in the most varied media as if this were a matter of course and the use of materials drawn from popular culture and models taken from art history is at present extraordinarily innovative. These are frequently the themes that the older artists represented here have been addressing since the 1980s, which is reason enough to show both in this book.

Besides these developments, there are also totally different positions, and we hope that some of our entries will surprise or intrigue. The selection was, of course, a subjective process, in which the editor and the publisher participated along with the many people whom we've had discussions with during preparations. Which is exactly the point of this publication: it is not a list of the 133 "best" artists today, but instead highlights the works that have been at the centre of discussion over the last three years – either among insiders or the general public.

While we have continued the tried-and-tested formula, the contents are completely new: 133 of today's most exciting artists are each given four pages for a short introduction and, most importantly, images of their current work.

Since this volume marks a change in editorship, our first thanks go to Uta Grosenick and Burkhard Riemschneider, who made *ART NOW* what it is today.

A special thanks to our authors, Cecilia Alemani, Jens Asthoff, Andrew Bonacina, Suzanne Hudson, Christy Lange, Holger Lund, Astrid Mania, Rodrigo Moura, Simon Rees, Vivian Rehberg and Eva Scharrer, and to Kirsty Bell, who has helped to select this team.

Many thanks to all the members of staff in galleries and artists' studios, who quickly and willingly assisted us with images and information whenever we needed them. The information about auction results in the practical guide was generously provided by artnet.com.

However, the most important thanks go out to the artists involved, not only because some of them made personal contributions to this project but, above all, for their art, which is the heart of our book.

Hans Werner Holzwarth
Berlin, Autumn 2008

Vorwort

Seit dem letzten Band von *ART NOW* sind drei Jahre vergangen, eine lange Zeit dafür, was täglich an aufregender Kunst in den Ateliers entsteht. Künstlerische Positionen verschieben sich, Trends zeichnen sich ab: Die abstrakte Malerei ist wieder zu einem offenen Feld geworden, viele junge Künstler arbeiten ganz selbstverständlich in den unterschiedlichsten Medien und auch die Arbeit mit Fundstücken aus der Populärkultur und mit Vorbildern aus der Kunstgeschichte ist derzeit außerordentlich innovativ. Häufig sind das genau die Themen, mit denen sich die älteren der hier vertretenen Künstler seit den 1980er-Jahren beschäftigen. Grund genug beides zu zeigen.

Neben diesen Entwicklungen gibt es auch ganz andere Positionen, und wir hoffen, dass mancher Eintrag überrascht und neugierig macht. Die Auswahl war natürlich ein subjektiver Prozess, an dem Herausgeber und Verleger genauso beteiligt waren wie die vielen Menschen, mit denen wir im Vorfeld diskutiert haben. Und genau um diesen Punkt geht es in diesem Buch: Hier wird keine Liste der „besten" 133 Künstler geschaffen, sondern die Werke gezeigt, die über die letzten drei Jahre Diskussionsstoff gaben – in der Fachwelt oder auch beim Publikum.

Wir haben das bewährte Format beibehalten, der Inhalt ist wieder komplett neu: 133 der derzeit spannendsten Künstler werden auf je vier Seiten mit einer kurzen Einführung und vor allem mit Abbildungen ihrer aktuellen Arbeiten vorgestellt.

Mit diesem Band gab es einen Wechsel der Herausgeberschaft, unser erster Dank geht an Uta Grosenick und Burkhard Riemschneider, die *ART NOW* zu dem gemacht haben, was es ist.

Besonderen Dank unseren Autorinnen und Autoren Cecilia Alemani, Jens Asthoff, Andrew Bonacina, Suzanne Hudson, Christy Lange, Holger Lund, Astrid Mania, Rodrigo Moura, Simon Rees, Vivian Rehberg und Eva Scharrer sowie an Kirsty Bell, die bei der Wahl der Autoren beteiligt war.

Vielen Dank den vielen Mitarbeiterinnen und Mitarbeitern in den Galerien und Ateliers, die uns schnell und bereitwillig mit Bildmaterial und Informationen geholfen haben. Die Informationen über Auktionsergebnisse im Serviceteil wurden uns großzügigerweise von artnet.com zur Verfügung gestellt.

Der wichtigste Dank geht aber an alle Künstlerinnen und Künstler, nicht nur weil sich viele von ihnen in dieses Projekt persönlich mit eingebracht haben, sondern vor allem für ihre Kunst, das Herz unseres Buchs.

Hans Werner Holzwarth
Berlin, im Herbst 2008

Préface

Depuis la parution du dernier volume d'*ART NOW*, trois années se sont écoulées – période relativement longue au regard de l'art passionnant qui voit le jour dans les ateliers. Des positions artistiques changent, des tendances se dessinent : la peinture abstraite est redevenue un champ ouvert aux expérimentations, beaucoup d'artistes travaillent tout naturellement avec les médiums les plus divers et le travail avec les objets trouvés de la culture populaire ou les modèles de l'histoire de l'art est en ce moment particulièrement innovant. Ce sont d'ailleurs souvent les thèmes qui, depuis les années 1980, intéressent aussi les artistes un peu plus âgés représentés ici. Voilà des raisons suffisantes pour présenter les deux générations.

À côté de ces évolutions, on trouve aussi des positions tout à fait différentes. Nous espérons donc que plus d'une entrée surprendra et aiguisera la curiosité du lecteur. Comme on peut s'y attendre, la sélection des artistes a résulté d'une démarche subjective à laquelle l'éditeur et le directeur de publication ont participé tout autant que les nombreuses personnes avec qui nous avons préparé le projet en amont. Et c'est précisément ce dont il est question dans ce livre : nous n'y établissons pas une liste des 133 « meilleurs » artistes, mais présentons les œuvres qui ont alimenté le débat artistique des trois dernières années – dans le monde professionnel comme parmi le public.

Le format éprouvé a été conservé mais le contenu est entièrement inédit : 133 des artistes les plus passionnants du moment sont présentés chacun sur quatre pages par une brève introduction, mais surtout à travers des reproductions de leurs œuvres récentes.

Ce volume est marqué par un changement éditorial ; nos premiers remerciements vont donc à Uta Grosenick et Burkhard Riemschneider, qui ont fait d'*ART NOW* ce qu'il est aujourd'hui.

Nos remerciements particuliers vont ensuite aux auteurs – Cecilia Alemani, Jens Asthoff, Andrew Bonacina, Suzanne Hudson, Christy Lange, Holger Lund, Astrid Mania, Rodrigo Moura, Simon Rees, Vivian Rehberg et Eva Scharrer –, ainsi qu'à Kirsty Bell qui a participé à leur sélection.

Un grand merci également aux nombreux collaboratrices et collaborateurs des galeries et ateliers d'artistes qui nous ont soutenu en nous fournissant aimablement et rapidement des illustrations et des informations. Les données du guide pratique concernant les résultats des ventes publiques nous ont été gracieusement communiquées par artnet.com.

Nos remerciements vont enfin surtout à tous les artistes – pas seulement parce que beaucoup d'entre eux se sont investis personnellement dans ce projet, mais surtout pour leur art, qui est au cœur du présent ouvrage.

Hans Werner Holzwarth
Berlin, automne 2008

ARTISTS

Tomma Abts

1967 born in Kiel, Germany, lives and works in London, United Kingdom

For the past decade, Tomma Abts has been doing something that puts her in very rare company: painting modestly scaled, non-illustrational, abstract compositions. They are likewise notable for their interlocking linear elements, staccato repetitions and densely layered fields built up by a succession of thin strata and bisected by delicate webs of faintly protruding seams, as in *Weet* (2006). Luminous palettes are also a mainstay, even in works including the almost ineffably hushed *Ewo* (2006). Employing a standard size (48 x 38 cm) and working with a consistent process of oil and acrylics, Abts nonetheless – or perhaps precisely because of her process – succeeds in producing works of great internal complexity. She approaches each canvas without an a priori image or shape, eschewing sketches, research, and source material to instead work the material until a form emerges. Its appearance might be vaguely reminiscent of ornaments, tissues or even biomorphic structures, a fact seemingly corroborated by Abts' titles, plucked from dictionaries of names, except that the designations are as arbitrary and severed from referentiality as the paintings themselves. Illusions of shadows in *Eppe* (2006) and others suggest comparison with op art, while the same work's object-ness might also allow for a precedent such as Russian constructivism. Despite historical echoes, Abts' work exists in the time and process of its making. Hers is a distinctive approach to abstract painting that, presented in two solo exhibitions in Basel and London, led the jury to award the Turner Prize 2006 to Abts.

Die Bilder, die Tomma Abts seit zehn Jahren malt, machen sie zu einer Besonderheit in der heutigen Kunstszene: Ihre Kompositionen sind nicht abbildend, streng abstrakt und stets in kleinem Format gehalten. Sie zeigen ineinander greifende lineare Elemente, stakkatoartige Wiederholungen und dichte Überlagerungen, die sich aus vielfach aufgetragenen dünnen Malschichten entwickeln und, wie in *Weet* (2006), durch feine, leicht von unten heraufdrückende Nahtstellen in der Mitte aufgeschnitten sind. Hinzu kommen leuchtende Farbpaletten, sogar in Werken wie dem komplett gedämpften *Ewo* (2006). Obwohl Abts eine einheitliche Bildgröße (48 x 38 cm) benutzt und immer konsequent mit Öl und Acryl arbeitet – oder auch gerade deshalb –, gelingt es ihr, Gemälde von einer starken innerbildlichen Komplexität zu erzeugen. Sie beginnt ohne eine Vorstellung, ohne ein Gerüst für das entstehende Bild zu haben, ohne Skizze, Recherche und Quellenmaterial, und arbeitet stattdessen mit dem Material, bis sich die Form von selbst daraus entwickelt. Diese kann entfernt an grafische Ornamente, Gewebe oder biomorphe Strukturen erinnern; eine Wirkung, die dadurch verstärkt wird, dass sich die von Abts willkürlich aus einem Vornamenbuch gewählten Bildtitel nicht auf Geschehenes beziehen. Effekte von Licht und Schatten wie in *Eppe* (2006) deuten auf die Nähe zur Op Art, während dasselbe Bild aufgrund seiner Objekthaftigkeit einen Vergleich mit dem russischen Konstruktivismus zulässt. Trotz dieser kunsthistorischen Anklänge sind Abts' Gemälde jedoch der Ausdruck eines momentanen Schaffensprozesses. Diese Art abstrakt zu malen, war ausschlaggebend für die Jury, der Künstlerin nach zwei Einzelausstellungen in Basel und London den Turner Prize 2006 zu verleihen.

Au cours de la dernière décennie, Tomma Abts a développé une pratique devenue insolite aujourd'hui en peignant des compositions abstraites, non-illustratives, de petit format. Ses toiles se caractérisent également par des éléments linéaires entrecroisés, la répétition de motifs distincts, ou encore des zones dont la densité tient à une succession de minces strates que divisent de fins entrelacs de bordures à peine soulevées, comme dans *Ewo* (2006). Sa palette est toujours lumineuse, y compris dans des toiles tout en retenue comme *Eppe* (2006). Sur des toiles de taille standard (48 x 38 cm), et en dépit – ou en raison – d'une invariable technique à l'huile et à l'acrylique, Abts parvient à produire des œuvres d'une grande complexité interne. Elle aborde chaque toile sans image ni forme a priori, éludant les dessins préparatoires, les recherches et les sources pour travailler son matériau jusqu'à l'émergence d'une forme. L'apparence de celle-ci peut vaguement évoquer des ornements, des tissus, voire des structures organiques, ce que semblent corroborer les titres choisis, qui sont piochés dans des dictionnaires de noms propres – sauf que ces appellations sont aussi arbitraires et détachées de toute référentialité que les toiles elles-mêmes. Les illusions d'optique produites par le jeu des ombres, dans *Eppe* (2006) par exemple, appellent une comparaison avec l'Op Art, alors que l'absence de tout objet semble désigner le constructivisme russe comme source d'inspiration. Malgré des références à l'histoire de l'art, l'œuvre d'Abts existe avant tout dans le moment et dans le processus même de sa réalisation. Cette approche particulière de la peinture abstraite, présentée lors de deux expositions personnelles à Bâle et à Londres, lui a valu le prix Turner en 2006.

S. H.

SELECTED EXHIBITIONS →
2008 *Tomma Abts*, Hammer Museum, Los Angeles. *Tomma Abts*, New Museum, New York **2007** *Turner Prize: A Retrospective 1986 – 2007*, Tate Britain, London. *Von Abts bis Zmijewski*, Pinakothek der Moderne, Munich **2006** *Turner Prize 2006*, Tate Britain, London. *Tomma Abts*, Kunsthalle Kiel. *Of Mice and Men*, 4th Berlin Biennial for Contemporary Art, Berlin **2005** *Tomma Abts*, Kunsthalle Basel, Basle **2004** *54th Carnegie International*, Carnegie Museum of Art, Pittsburg. *Formalismus – Moderne Kunst, heute*, Kunstverein Hamburg

SELECTED PUBLICATIONS →
2008 *Tomma Abts*, New Museum, New York **2006** *Turner Prize 2006*, Tate Britain, London. *Of Mice and Men*, 4th Berlin Biennial for Contemporary Art, Berlin; Hatje Cantz, Ostfildern **2005** *Tomma Abts*, Kunsthalle Basel, Basle **2004** *Tomma Abts*, Galerie Daniel Buchholz, Cologne. *54th Carnegie International*, Carnegie Museum of Art, Pittsburg. *Formalismus – Moderne Kunst, heute*, Kunstverein Hamburg, Hamburg

14

1 **Keke**, 2006, acrylic, oil on canvas, 48 x 38 cm
2 **Ewo**, 2006, acrylic, oil on canvas, 48 x 38 cm

3 **Eppe**, 2006, acrylic, oil on canvas, 48 x 38 cm
4 **Weet**, 2006, acrylic, oil on canvas, 48 x 38 cm

„Mich interessiert an einem Gemälde, dass es nicht nur ein Bild sondern auch ein Objekt ist, und sich dadurch zwischen Illusion und realem Gegenstand bewegt."

« Ce qui m'intéresse dans une toile, sa qualité particulière, c'est qu'elle est à la fois un objet et une image, si bien qu'elle est tour à tour une illusion et la chose même. »

"I'm interested in that particular quality of a painting that it is an object but at the same time an image, so that the picture alternates between being an illusion and the real thing."

2

3

Franz Ackermann

1964 born in Neumarkt St. Veit, lives and works in Berlin and Karlsruhe, Germany

The expansiveness that distinguishes Franz Ackermann's work and its interaction with the exhibition space is the same that determines the artist's continual need to travel the world. Based in Berlin, Ackermann is a tireless globetrotter, and on these travels – from São Paulo to Hong Kong, from Los Angeles to Machu Picchu, from Libya to the confines of Europe – he gathers the feel for urban and natural spaces evinced throughout his oeuvre. Ackermann's psychogeography, a term derived from Guy Debord's situationist theory, is first laid out as watercolours in his "mental maps", in which architectural elements of the city appear in a sort of a quick psychedelic flow. These drawings that the artist produces during flights and in hotel rooms provide the base for large-format canvases that he paints in his studio, often creating site-specific paintings as part of large installations. In *No Direction Home* (2007), Ackermann presented a reflection on his rapport with São Paulo, a metropolis that he has visited since 1998 and refers to as "a master plan of anonymity". The installation comprised rotating paintings, second-hand furniture, and dozens of photographs shot in Tropical Islands, a German resort that glamorizes the stereotype of a tropical environment. The clichéd images conflicted with the chaotic representation of the large city rendered in the paintings, challenging the spectator's longing to still nurture a romantic view of the exotic. Always mediated by an extremely subjective vision, Ackermann's work offers a reflection on the many simultaneities in our contemporary world, its interrelations and superimpositions – in other words, its lack of centre.

Die Ausweitung der Malerei in den Raum, die Franz Ackermanns Werke kennzeichnet, und ihre Interaktion mit dem spezifischen Ausstellungsort entsprechen ganz dem Bedürfnis des Künstlers, ständig auf Reisen zu sein. Ackermann, der sein Atelier in Berlin hat, ist ein unermüdlicher Globetrotter, der von seinen Reisen – von São Paulo nach Hong Kong, von Los Angeles nach Machu Picchu, von Libyen bis an die letzten Grenzen von Europa – ein sein gesamtes Œuvre durchdringendes Faible für urbane und natürliche Räume mitbringt. Ackermanns Psychogeografie – der Ausdruck ist von Guy Debords situationistischer Theorie abgeleitet – entwickelt sich zunächst mit Aquarellfarben in Form so genannter *Mental Maps*, auf denen wie in einem schnellen psychedelischen Flow urbane Architekturansichten erscheinen. Diese Zeichnungen entstehen im Flugzeug oder im Hotelzimmer und dienen dem Künstler später im Atelier als Vorlage für seine großformatigen Gemälde, die er häufig für ortsspezifische Arbeiten als Teil von Rauminstallationen entwirft. In *No Direction Home* (2007) präsentierte Ackermann eine Reflexion über sein Verhältnis zur Metropole São Paulo, die für ihn „eine Art Masterplan der Anonymität" darstellt und die er seit 1998 immer wieder besucht hat. Die Installation umfasste rotierende Gemälde, Secondhand-Mobiliar und dutzende Fotografien aus dem Resort Tropical Islands in Brandenburg, das mit dem Ambiente von tropischen Inseln wirbt. Der scharfe Kontrast dieser klischeehaften Fotos zu den chaotischen Großstadtansichten der Gemälde reibt den Betrachter in seinem Verlangen nach exotisch-verträumter Idylle auf. Gegenstand von Ackermanns Arbeit, die immer eine extrem subjektive Sichtweise zeigt, ist die Reflexion über die vielen Gleichzeitigkeiten unserer heutigen Welt, ihre wechselseitigen Beziehungen und Überlagerungen – oder anders formuliert, den Verlust ihres Zentrums.

Le déploiement qui caractérise le travail de Franz Ackermann et son interaction avec l'espace d'exposition est ce qui le pousse à parcourir le monde sans relâche. Au cours de ses nombreux voyages – de São Paulo à Hong Kong, de Los Angeles au Machu Picchu, de la Libye aux confins de l'Europe – cet infatigable globe-trotter vivant à Berlin rassemble des impressions d'espaces urbains et naturels qui marquent son œuvre. Sa « psychogéographie » (pour emprunter un terme des théories situationnistes de Guy Debord) s'exprime sous forme d'aquarelles, ses *Mental Maps*, où des éléments d'architecture urbaine apparaissent dans un flux psychédélique. Ses dessins, réalisés lors de voyages en avion ou dans des chambres d'hôtel, fournissent la base de toiles grand format qu'il réalise dans son studio, pour une installation conçue spécialement pour un lieu d'exposition. Avec *No Direction Home* (2007), Ackermann propose une réflexion sur son rapport à São Paulo, une métropole où il se rend régulièrement depuis 1998 et qu'il décrit comme « un urbanisme de l'anonymat ». L'installation comprend des tableaux rotatifs, des meubles d'occasion et des dizaines de photos de Tropical Islands, un site de villégiature allemand qui pousse à l'extrême les stéréotypes de l'île tropicale. Les images-clichées entrent en conflit avec la représentation chaotique de la grande ville présentée dans les tableaux, et incitent le spectateur à reconsidérer son attachement à une vision romantique de l'exotisme. A travers son travail et le filtre très subjectif de son regard, Ackermann offre une réflexion sur les nombreuses contemporanéités de notre monde actuel, ses interrelations et superpositions – en d'autres termes, sur son absence de centre.

R. M.

SELECTED EXHIBITIONS →
2008 *Franz Ackermann*, Kunstmuseum St. Gallen. *Die Tropen*, Martin Gropius Bau, Berlin. *Vertrautes Terrain – Aktuelle Kunst in und über Deutschland*, ZKM, Karlsruhe **2007** *Reality Bites*, Opelvillen Rüsselsheim **2006** *Home, home again. 23 Ghosts*, Kestnergesellschaft, Hanover; Domus Artium 2002, Salamanca. *Faster! Bigger! Better!*, ZKM, Karlsruhe. *Berlin-Tokyo/Tokyo-Berlin*, Neue Nationalgalerie, Berlin. **2005** *Franz Ackermann*, Irish Museum of Modern Art, Dublin

SELECTED PUBLICATIONS →
2008 *Die Tropen*, Martin Gropius Bau, Berlin; Kerber Verlag, Bielefeld. *Vertrautes Terrain – Aktuelle Kunst in und über Deutschland*, ZKM, Karlsruhe **2006** *Franz Ackermann: Home, home again. 23 Ghosts*, Kestnergesellschaft, Hanover; Domus Artium 2002, Salamanca; Hatje Cantz, Ostfildern. *Eija-Liisa Ahtila, Franz Ackermann, Dan Graham, Parkett 68*, Zürich. *Faster! Bigger! Better!*, ZKM, Karlsruhe; Verlag der Buchhandlung Walther König, Cologne **2005** *Franz Ackermann*, Irish Museum of Modern Art, Dublin

1 **Home, Home Again/23 Gespenster**, 2006. Installation view, Kestnergesellschaft, Hanover

2 **Little Harbour**, 2007, pencil, gouache on paper on aludibond. Installation view, neugerriemschneider, Berlin

3 **Home, Home Again**, 2006, mixed media, dimensions variable. Installation view, Broad Art Foundation, Santa Monica, 2007

„Jene Fremdheit, die gekoppelt ist an Begriffe wie Abenteuer und Exotik, existiert nicht mehr."

« L'étrangeté, au sens d'aventure et d'exotisme, n'existe plus. »

"Foreignness, in the sense of adventure and exoticism, no longer exists."

2

Ai Weiwei

1957 born in Beijing, lives and works in Beijing, China

Ai Weiwei is best described as the creator of his environment, as this term encompasses both his architectural activities – which have included advising Herzog & De Meuron on designing the national stadium for the 2008 Olympic Games in Beijing – and his art projects. The conceptual artist's contribution to Documenta 2007 consisted of a huge sculptural structure and an equally large-scale social endeavour. *Template* (2007), an eight-winged construction inspired by Chinese temples, was built from the doors and windows of demolished historic Chinese houses, countering the customary attributions of tradition and innovation, familiarity and alienation, preservation and loss. For *Fairytale* (2007), Ai invited 1001 Chinese people to stay at Documenta. This sort of cultural clash is a central and recurrent theme in his work, but here the traditional Western view of China was turned on its head. The 1001 Chinese guests were accompanied to Kassel by the same number of Qing Dynasty chairs, which were reinvented as seating for footsore visitors and later as art objects for sale. Traditional everyday objects from China appear frequently in the artist's oeuvre, always significantly defamiliarized and displaced. A recent series of works revolves around the image of gigantic fallen chandeliers. *Descending Light* (2007) is like a helpless colossus that has collapsed under its own weight and excessive grandeur. With its reference to Vladimir Tatlin's unrealized *Monument to the Third International* (1920), Ai's *Working Progress (Fountain of Light)* (2007) brings to mind utopian undertakings – both of China and of every other place where the chandelier is shown.

Ai Weiwei beschreibt man am besten als Gestalter seiner Umwelt. Denn damit lassen sich seine architektonischen Aktivitäten – er war unter anderem beratend am Bau des Nationalstadions von Herzog & De Meuron für die Olympischen Spiele 2008 in Peking beteiligt – wie auch seine künstlerischen umfassen. So bestand der Beitrag des Konzeptkünstlers zur Documenta 2007 aus einer gewaltigen skulpturalen Struktur sowie aus einer ebenso gewaltigen sozialen Anstrengung. *Template* (2007), ein von chinesischen Tempeln inspirierter Bau aus acht Flügeln, wurde aus den Türen und Fenstern abgerissener historischer Häuser aus China errichtet, sodass die gängigen Zuschreibungen von Tradition und Neuerung, Vertrautem und Fremdem, Bewahren und Verlust ins Leere liefen. Für *Fairytale* (2007) lud Ai 1001 Chinesen zu einem Aufenthalt auf der Documenta ein. Damit nimmt er ein zentrales Thema seiner Arbeiten auf, den Zusammenprall von Kulturen, doch wird der übliche westliche Blick auf China hier umgekehrt. Zusammen mit den 1001 Chinesen wurde eine gleiche Anzahl Stühle aus der Quing-Dynastie zur Documenta verfrachtet, um dort eine Umdeutung als Sitzgelegenheit für müde Besucher und später als zu verkaufende Kunstobjekte zu erfahren. Traditionelle Objekte aus dem chinesischen Alltag erscheinen immer wieder stark verschoben und verfremdet im Werk des Künstlers. In jüngster Zeit ist eine Reihe von Arbeiten entstanden, die mit dem Bild gigantischer gestürzter Lüster spielen. *Descending Light* (2007) wirkt wie ein hilfloser Koloss, der unter seinem Gewicht und seiner Pracht zu Boden geht. *Working Progress (Fountain of Light)* (2007) nimmt Bezug auf Wladimir Tatlins nie realisiertes *Monument der Dritten Internationale* (1920) und verweist damit auf die utopischen Vorhaben sowohl Chinas als auch des jeweiligen Aufstellungsorts dieses Leuchters.

Pour aborder l'œuvre d'Ai Weiwei, le mieux est de décrire l'artiste conceptuel comme un créateur de son environnement. Cette approche tient compte en effet de ses activités architecturales – il a notamment participé à la construction du stade national de Herzog & De Meuron pour les Jeux Olympiques de Pékin en 2008 – comme de ses activités artistiques. Ainsi, sa contribution à la Documenta de 2007 a consisté en une gigantesque structure sculpturale accompagnée d'un tout aussi formidable engagement social. *Template* (2007), un bâtiment à huit ailes inspiré de temples chinois, a été construit avec les portes et les fenêtres d'anciennes maisons chinoises démolies, et les définitions habituelles – tradition et renouveau, familiarité et étrangeté, perte et conservation – devenaient dès lors caduques. Pour *Fairytale* (2007), Ai invitait 1001 Chinois à la Documenta. S'il revenait ainsi au thème central de son travail, à savoir le choc des cultures, le regard occidental habituellement porté sur la Chine y était inversé. Avec ces 1001 Chinois, un même nombre de chaises de la dynastie Qing furent transportées à la Documenta pour y subir une réinterprétation comme sièges pour les visiteurs fatigués et être vendues ensuite comme objets d'art. Dans l'œuvre de l'artiste, les objets traditionnels de la vie quotidienne chinoise apparaissent souvent de manière décalée et détournée. Récemment, Ai Weiwei a créé une série d'œuvres réalisées sur la base de gigantesques lustres effondrés. *Descending Light* (2007) ressemble à un colosse maladroit écrasé sous son propre poids et sa splendeur, *Working Progress (Fountain of Light)* (2007), une référence au *Monument à la IIIe Internationale* (1920) de Vladimir Tatline qui ne fut jamais réalisé, renvoie aux projets utopiques tant de la Chine que du lieu d'exposition respectif. A. M.

SELECTED EXHIBITIONS →
2008 *International 08*, Liverpool Biennial, Liverpool. *Ai Weiwei: Under Construction*, Campbelltown Arts Centre, Campbelltown. *Go China! Ai Weiwei*, Groninger Museum, Groningen **2007** *Documenta 12*, Kassel. *China Welcomes You...*, Kunsthaus Graz **2006** *Zones of Contact*, Biennale of Sydney 2006, Sydney. *Serge Spitzer und Ai Weiwei – Eroberung*, MMK, Frankfurt am Main **2005** *Mahjong – Chinesische Gegenwartskunst aus der Sammlung Sigg*, Kunstmuseum Bern

SELECTED PUBLICATIONS →
2008 *Ai Weiwei: Under Construction*, Campbelltown Arts Centre, Campbelltown. *Christian Jankowski, Cosima von Bonin, Ai Weiwei*, Parkett 81, Zürich. *MADE UP International 08 Guide*, Liverpool Biennial, Liverpool. **2007** *Documenta 12 Catalogue*, Taschen, Cologne **2006** *Zones of Contact*, Biennale of Sydney, Art Gallery of New South Wales, Sydney **2005** *Mahjong – Chinesische Gegenwartskunst aus der Sammlung Sigg*, Hatje Cantz, Ostfildern

1 **Fountain of Light**, 2007, steel, glass crystals, wooden base, 700 x 529 x 400 cm. Installation view, Tate Liverpool
2 **Template**, 2007 (after collapsing), wooden doors and windows from destroyed Ming and Qing Dynasty houses (1368–1911), wooden base, 422 x 1106 x 875 cm. Installation view, Documenta 12, Kassel
3 **Fairytale**, 2007, 1001 Qing Dynasty wooden chairs (1644–1911). Installation view, Ai Weiwei's studio
4 **Coloured Vases**, 2008, Neolithic vases, industrial paint, dimensions variable
5 **Descending Light**, 2007, glass crystals, stainless brass, electric lights, 396 x 457 x 681 cm

„Ich stelle nach Möglichkeit alle festen Vorstellungen in Frage und versuche gerade das umzustoßen, was als selbstverständlich vorausgesetzt wird."

« J'ai tendance à remettre en question tous les concepts figés et à bousculer certains faits que les gens considèrent toujours comme acquis. »

"I tend to question all fixed concepts and overthrow certain facts that people always take for granted."

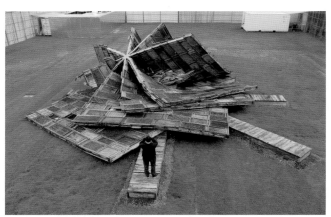

2

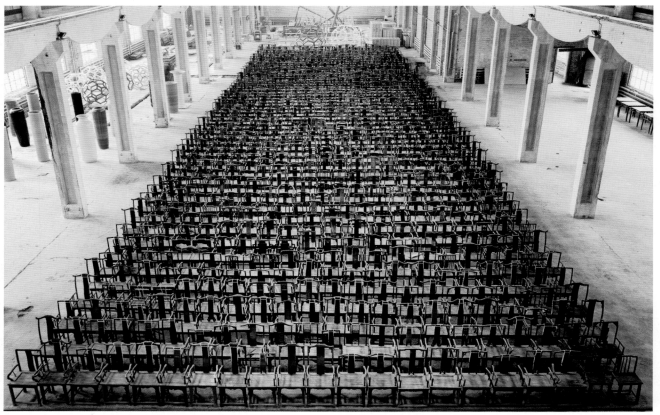

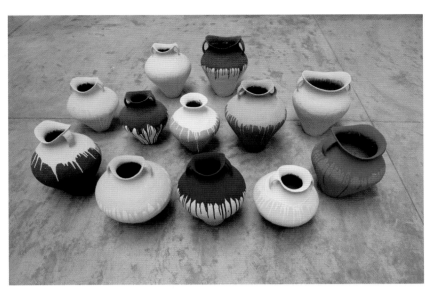

4

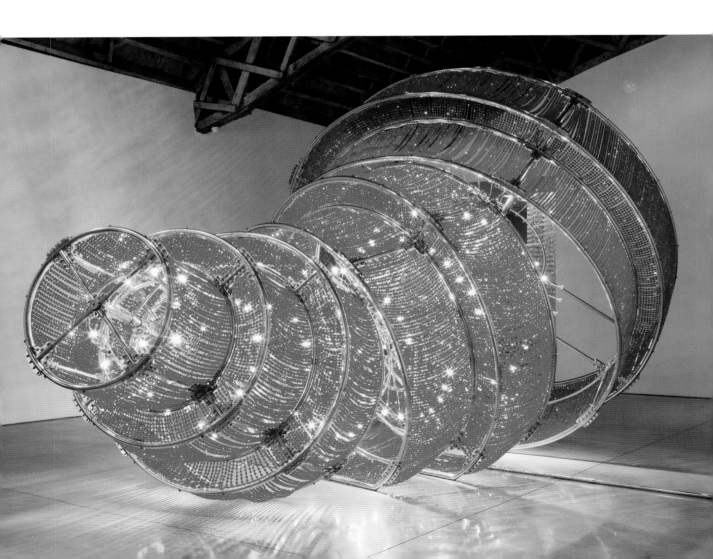

Doug Aitken

1968 born in Redondo Beach (CA), lives and works in Los Angeles (CA), USA

Broken Screen: Expanding the Image, Breaking the Narrative is not just the title of a 2006 book by Doug Aitken; it also sums up his artistic agenda. The screen is broken because Aitken seeks to expand the image using multiple projections, effectively breaking the conventions of cinematic narration. To this end, Aitken leaves the interior of the museum, and projects onto its facades. *sleepwalkers* (2007) is a parallel projection showing the actions of five people, all of whom depart from normality by performing ecstatic movements. In *migration* (2008), four projections show hotel and motel rooms being taken over, not by American people but by American animals. The films operate on a multi-narrative level, insofar as the parallel projections relate to one another and create interfaces and synchronicities. Aitken's artistic references are, on the one hand, the expanded cinema of the 1960s and its use of multiple projections in the attempt to go beyond the visual one-way street of the film theatre, and, on the other, an aesthetic derived from Hollywood productions as well as from music videos, of which he has made several, for artists such as Iggy Pop and Fatboy Slim. What comes as a surprise is the broad range of media in which Aitken realizes his artworks. Although his current focus is on outdoor multiple projections and photography, in *k-n-o-c-k-o-u-t* (2007) he constructed an interactive music table, and in *silent pavilion* (2008) an architectural structure with an exterior that reflects its surroundings and a sound-absorbing interior that can be used as a place of contemplation; here one can escape life's diffuse din – a topic to which Aitken responds in such diverse ways in many of his works.

Broken Screen: Expanding the Image, Breaking the Narrative – so lautet der Titel eines Buches von Doug Aitken (2006), der zugleich sein künstlerisches Programm zusammenfasst. Gebrochen ist die Projektionsfläche, weil Aitken mit Multi-Projektionen eine Erweiterung des Bildes anstrebt, was eine Auflösung der herkömmlichen Kinonarrativität bewirkt. Aitken verlässt dabei das Innere des Museums und projiziert auf die Fassaden. Bei *sleepwalkers* (2007) sind es parallel projizierte Handlungen von fünf Personen, die ihre Normalität verlassen, indem sie ekstatische Bewegungen ausführen. Bei *migration* (2008) zeigen vier Projektionen Räume von Hotels und Motels, in die nicht etwa amerikanische Menschen, sondern amerikanische Tiere eindringen. Die Filme arbeiten mit einer pluralen Narrativität, insofern sich die parallelen Projektionen aufeinander beziehen, Schnittpunkte und Synchronizitäten hergestellt werden. Aitkens künstlerische Bezugspunkte liegen einerseits beim Expanded Cinema der 1960er-Jahre und dessen Versuch, mit Multi-Projektionen die visuelle Einbahnstraße des Kinoraums zu überwinden. Andererseits bezieht er seine Ästhetik von Hollywood-Produktionen, aber auch von Musikvideos, von denen er selbst einige gedreht hat, etwa für Iggy Pop und Fatboy Slim. Überraschend ist die mediale Bandbreite, innerhalb derer sich Aitkens künstlerische Arbeiten manifestieren. Auch wenn Outdoor-Multi-Projektionen und Fotografie die aktuellen Schwerpunkte sind, so konstruierte er mit *k-n-o-c-k-o-u-t* (2007) einen interaktiven Musiktisch und mit *silent pavilion* (2008) eine Architektur, deren Äußeres die Umgebung reflektiert und deren Inneres als schallabsorbierter Kontemplationsort genutzt werden kann. In ihm kann man dem diffusen Rauschen des Lebens entkommen, auf das Aitken mit vielen seiner Arbeiten so facettenreich reagiert.

Broken Screen : Expanding the Image, Breaking the Narrative est le titre d'un livre de Doug Aitken (2006) qui résume en même temps son programme artistique. Ce qui est brisé, c'est la surface de projection – les projections multi-écrans d'Aitken visent en effet à un élargissement de l'image qui produit un éclatement de la narration cinématographique habituelle. En l'occurrence, Aitken quitte l'intérieur du musée pour projeter ses images sur les façades. *sleepwalkers* (2007) projette en parallèle les actions de cinq personnes qui quittent le champ de leur normalité en exécutant des mouvements extatiques. Dans *migration* (2008), quatre projections présentent des espaces d'hôtels et de motels investis non pas par des hommes américains, mais par des animaux américains. Ses films d'Aitken travaillent sur une narration multiple : les projections parallèles se réfèrent les unes aux autres et génèrent des coïncidences et des synchronicités. Les références artistiques relèvent pour une part du cinéma élargi des années 1960 et de sa tentative de dépasser le sens unique visuel de la salle de cinéma. De plus, Aitken emprunte son esthétique aux productions hollywoodiennes, mais aussi au clip vidéo – il en a lui-même tourné quelques-uns, notamment pour Iggy Pop et Fatboy Slim. Les œuvres d'Aitken couvrent une large palette de médiums. Même si les projections multi-écrans en extérieur et la photographie constituent aujourd'hui la part principale de son travail, pour *k-n-o-c-k-o-u-t* (2007), Aitken a aussi mis au point une table musicale interactive, et pour *silent pavilion* (2008) une architecture dont l'extérieur reflète l'environnement et l'intérieur peut servir de lieu de contemplation insonorisé. L'on y échappe au bruit diffus de la vie, à laquelle Aitken réagit si diversement dans chacune de ses œuvres. H. L.

SELECTED EXHIBITIONS →
2008 *Life on Mars – 55th Carnegie International*, Carnegie Museum of Art, Pittsburgh **2007** *sleepwalkers: Doug Aitken*, MoMA, New York. *Mapping the City*, Stedelijk Museum, Amsterdam **2006** *Doug Aitken*, Aspen Art Museum, Aspen. *Doug Aitken, The Parrish Art Museum*, Southampton. *Doug Aitken: Broken Screen*, Happenings, New York and Los Angeles. *Ecotopia: The Second ICP Triennial of Photography and Video*, ICP, New York **2005** *Doug Aitken*, Musée d'Art moderne de la Ville de Paris

SELECTED PUBLICATIONS →
2008 *Doug Aitken: 99 Cent Dreams*, Aspen Art Museum, Aspen **2007** *Doug Aitken: sleepwalkers*, MoMA, New York **2006** *Doug Aitken: Alpha*, JRP Ringier, Zürich. *Ecotopia: The Second ICP Triennial of Photography and Video*, ICP New York; Steidl, Göttingen **2005** *Doug Aitken: Broken Screen: Expanding the Image, Breaking the Narrative. 26 Conversations with Doug Aitken*, Distributed Art Publishers, New York

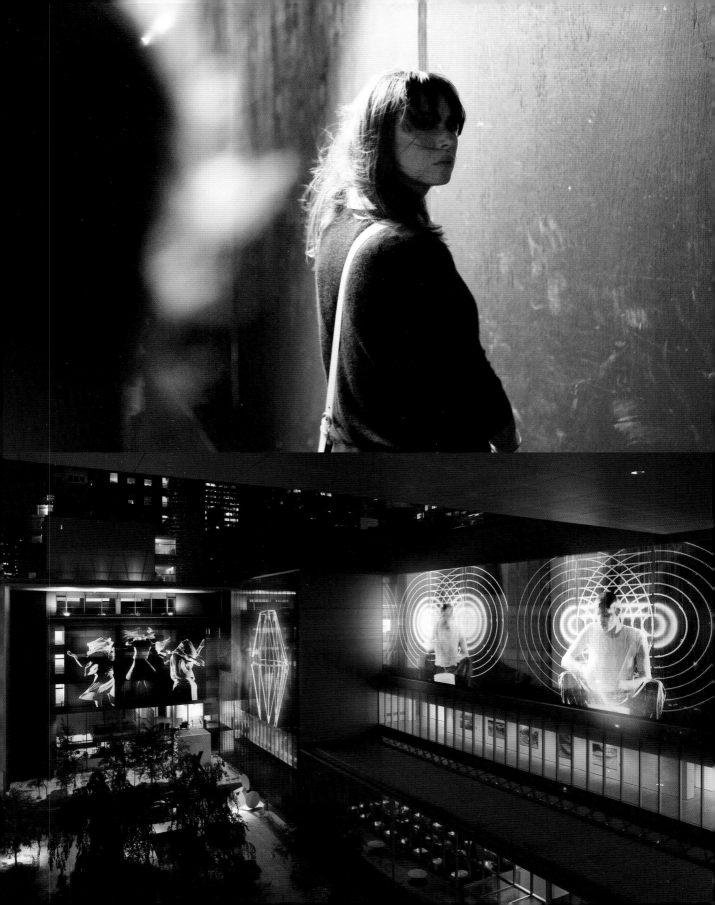

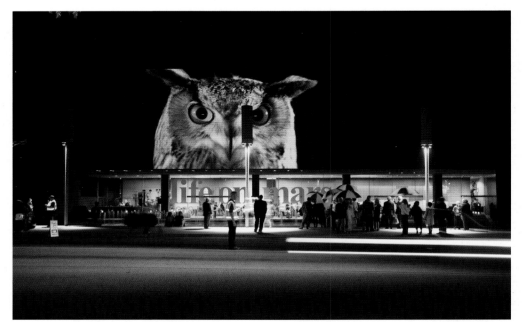

3

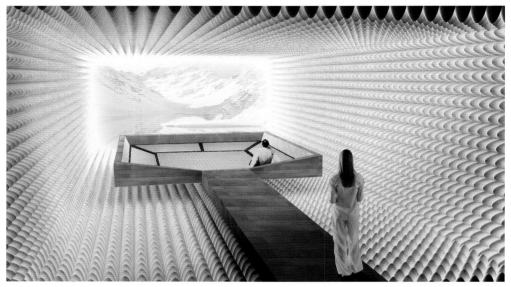

4

5

6

Haluk Akakçe

1970 born in Ankara, Turkey, lives and works in London, United Kingdom, and New York (NY), USA

A passion for drawing is a quality shared by many architects and artists. Haluk Akakçe trained as an architect but has been working as an artist for many years, using his drawing skills to create videos and graphic works that frequently oscillate between geometric and organic forms. While his geometric forms may reference the Russian constructivists, his organic ones are equally indebted to Henri Matisse's paper cut-outs and Japanese comics. Combining these forms results in a techno-organic hybrid. Akakçe's interest is not limited to drawing, however; his recent work has increasingly involved video, although here, too, his primary medium is drawing – he starts with drawings which are then digitally animated, like in *Shadow Machine* (2006). Grid-like structures, circles, rotating shapes, clockwork-like mechanisms from an abstract manga fantasy – these are just some of the elements that are set to music in his animated videos. Which brings us to another key point of reference for Akakçe's works: visual music. Visual music has had an important place in the canon of experimental film ever since Oskar Fischinger set abstract forms in motion to popular classical music in films from the 1930s onward. With his use of excerpts from Léo Delibes' ballet score *Coppelia*, Akakçe clearly draws on Fischinger's style, but goes a step further by creating forms that are more architectural in nature. He folds and unfolds graphic spaces in synchronization with the music in a way that is not far removed from the experiments in visual music currently being conducted by the likes of D-Fuse.

Die Leidenschaft für das Zeichnen ist etwas, das Architekt und Künstler gemeinsam haben können. Haluk Akakçe ist ausgebildeter Architekt und arbeitet seit Jahren als Künstler mit zeichnerischen Mitteln in Grafik und Videofilm. Typisch für ihn ist ein Spannungsfeld aus geometrischen und organischen Formen. Während seine geometrischen Formen sich auf die russischen Konstruktivisten beziehen können, haben die organischen Formen Henri Matisses *papiers découpés* ebenso viel zu verdanken wie japanischen Comics. In der Mischung der Formen entsteht dann ein techno-organisches Hybrid. Doch belässt es Akakçe nicht allein bei der Zeichnung, in den letzten Jahren gewann das Video immer stärker sein Interesse. Allerdings bleibt auch hierbei die Zeichnung Primärmedium, denn er beginnt mit Zeichnungen, die anschließend digital animiert werden, wie bei *Shadow Machine* (2006). Gitterhafte Strukturen, Kreise, rotierende Formen, uhrwerkartige Mechanismen einer abstrakt denkenden Manga-Fantasie – all das taucht in seinen animierten Videos auf, begleitet von Musik. Damit eröffnet sich ein weiterer, zentraler Bezugspunkt von Akakçes Arbeiten: Visual Music. Seit Oskar Fischinger im Film ab den 1930er-Jahren zu populärer klassischer Musik abstrakte Formen choreografisch in Gang setzte, gehört Visual Music fest in den Kanon des Experimentalfilms. Indem Akakçe Auszüge aus Léo Delibes Ballettmusik *Coppélia* nutzt, greift er deutlich auf Fischingers Stil zurück. Ohne dabei stehen zu bleiben, denn seine Formen sind wesentlich architektonischer gedacht. So entfaltet und faltet er im Zusammenspiel mit der Musik grafische Räume, die aktuellen Experimenten der Visual Music, wie etwa von D-Fuse, nicht fern stehen.

La passion pour le dessin est une chose que l'artiste et l'architecte peuvent avoir en commun. Architecte de formation, Haluk Akakçe travaille depuis des années en tant qu'artiste avec des moyens graphiques – en dessin comme en vidéo. Une caractéristique de son travail est le champ de tension entre formes géométriques et organiques. Alors que ses formes géométriques peuvent référer aux constructivistes russes, les formes organiques doivent autant aux papiers découpés de Matisse qu'aux mangas japonais. Du mélange des formes naît alors un hybride technico-organique. Mais Akakçe ne se limite pas au dessin : au cours des dernières années, la vidéo a de plus en plus fortement mobilisé son intérêt. Là encore, le dessin reste le médium de base : Akakçe commence son travail par des dessins qui sont ensuite animés par ordinateur, comme dans *Shadow Machine* (2006). Des structures en forme de grilles, des cercles, des formes tournoyantes, les mécanismes apparentés aux horlogeries d'une manga-imagination s'articulant en termes abstraits – toutes ces choses apparaissent dans ses vidéos animées avec accompagnement musical. Une autre référence centrale s'ouvre ainsi : la musique visuelle. Depuis qu' Oskar Fischinger anima chorégraphiquement, dès les années 1930, des formes abstraites sur de la musique classique populaire, la musique visuelle est une composante classique du film expérimental. En utilisant des extraits de *Coppélia*, le ballet-pantomime de Léo Delibes, Akaçe s'inspire clairement du style de Fischinger. Dans l'interaction avec la musique, il replie et déploie ainsi des espaces graphiques qui ne sont pas sans rappeler les expériences actuelles de la *visual music*, comme par exemple celles de D-Fuse.

H. L.

SELECTED EXHIBITIONS →
2008 *Sammlung als Aleph – Thyssen-Bornemisza Art Contemporary*, Kunsthaus Graz **2007** *The Incomplete*, Chelsea Art Museum, New York. *General Issue*, Centro Galego de Arte Contemporánea, Santiago de Compostela **2006** *Haluk Akakçe: Sky Is the Limit*, Creative Time New York in collaboration with Las Vegas Art Society, Las Vegas **2005** *Haluk Akakçe: Panorámica*, Museo Tamayo Arte Contemporáneo, Mexico. *Haluk Akakçe*, Rochester Contemporary Art Center, Rochester

SELECTED PUBLICATIONS →
2008 *Always There*, Galerie Max Hetzler, Berlin. *Sammlung als Aleph – Thyssen-Bornemisza Art Contemporary*, Kunsthaus Graz **2007** *General Issue*, Centro Galego de Arte Contemporánea, Santiago de Compostela. *The Incomplete*, Chelsea Art Museum, New York. *Haluk Akakçe: Sky Is the Limit*, Creative Time, New York. *Haluk Akakçe: I wish I was...*, Galerie Max Hetzler, Berlin. *Carbonic Anhydride*, Galerie Max Hetzler, Berlin

1 **Untitled (I wish I was a tower)**, 2006, acrylic, pencil, china ink on archival museum board, 97.5 x 78.5 cm

2 **The Garden**, 2007, film stills, single-channel DVD, colour, sound, 9 min 21 sec, loop

3 **Steal Me a Dream (Sleeping Beauty)**, 2006, painted wood relief, ca 191 x 263 x 10 cm

4 **Shadow Machine**, 2006, single-channel video, colour, sound, 6 min 16 sec, loop. Installation view, Galerie Max Hetzler, Berlin

„Zeichnen ist meine intimste Beschäftigung, Zeichnen ist wie Schreiben und es ist wie Beten."

« Les dessins sont ma plus intime activité ; dessiner, c'est comme écrire ; dessiner, c'est comme prier. »

"Drawings are my most intimate activity, drawing is like writing, and it is like praying."

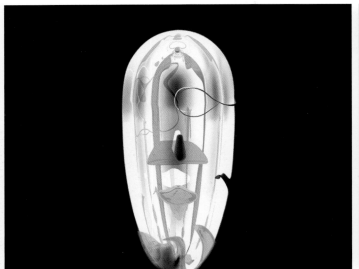

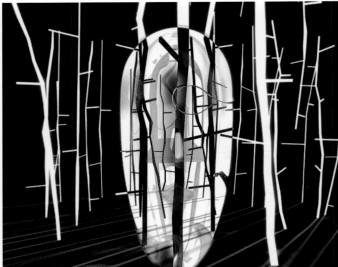

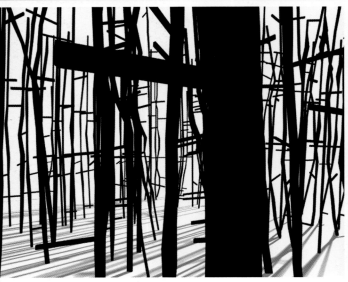

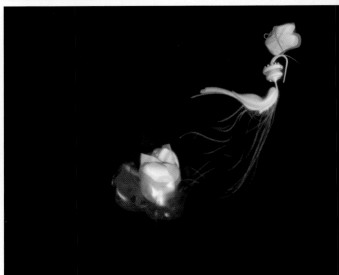

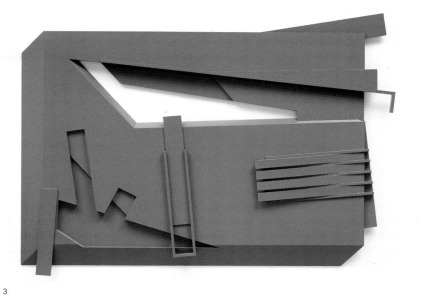

3

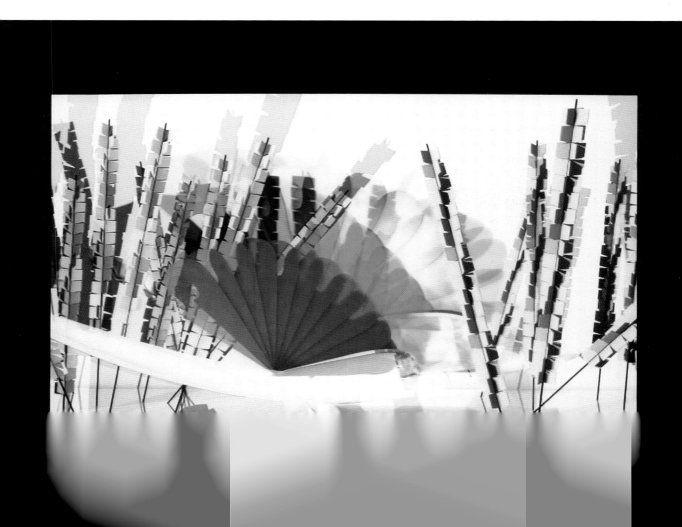

Allora & Calzadilla

Jennifer Allora, 1974 born in Philadelphia (PA), USA, and Guillermo Calzadilla, 1971 born in Havana, Cuba; live and work in San Juan, Puerto Rico

In their large-size sculpture *Sediments Sentiments (Figures of Speech)* (2007), the final part in a trilogy of installations, Jennifer Allora and Guillermo Calzadilla explore their interest in the interplay between sound, language and militarism in the context of a globalization that is armed to the teeth. The work is made from foam and white plaster, its large masses perforated by tunnel-like passageways, standing in for the ruins of some future havoc or a collapsed bunker. The sediments in the title refer both to the geological form of the sculpture and to the performances in its interior, where singers deliver fragments of speeches by major political players in an operatic style, with words from Saddam Hussein to George W. Bush and the Dalai Lama – an ironic presentation of historical events in a both direct and metaphorical reference to figures of speech. Collaborative artists Allora and Calzadilla have worked together since 1995 in Puerto Rico; in their work, they deal with language research while they find artistic approaches to explore different systems: from state architecture to natural phenomena, from biennial budgets to military policies, from genetic changes to political demonstrations. Their projects include film footage shot in Middle Eastern cities like Istanbul and Tehran, photographs, musical performances, sculptures and installations in which they appropriate works by other artists, such as Jenny Holzer and Dan Flavin. Allora and Calzadilla reveal a kind of ironical and poetical sensibility that is becoming more and more rare, and a needed disposition for all that is entropic and hybrid in today's reality.

In ihrer groß angelegten Skulptur *Sediments Sentiments (Figures of Speech)* (2007), dem letzten Teil einer Trilogie von Installationen, untersuchen Jennifer Allora und Guillermo Calzadilla die Verflechtungen zwischen Musik, Sprache und Militarismus im Kontext einer bis an die Zähne bewaffneten, globalisierten Welt. Bestehend aus Styropor und Weißgips, sind die ausladenden Formen endzeitlichen Ruinen oder einem zerstörten Bunker gleich, durchbrochen von tunnelartigen Öffnungen. Der Titel bezieht sich sowohl auf die geologische Gestalt der Skulptur als auch auf die Performance der Sänger, die aus dem Innern im Stil der Oper Fragmente aus politischen Reden berühmter Persönlichkeiten wie Saddam Hussein, George W. Bush oder dem Dalai Lama vortragen – eine ironische Verarbeitung historischer Ereignisse, die sich sowohl direkt als auch allegorisch mit „Redefiguren" beschäftigt. Die beiden Künstler Allora und Calzadilla arbeiten seit 1995 in Puerto Rico zusammen. In ihren Werken hinterfragen sie die Bedeutung von Sprache, indem sie mit künstlerischen Mitteln verschiedene Systeme untersuchen: von der Staatsarchitektur zum Naturphänomen, vom Zweijahreshaushalt zu militärpolitischen Maßnahmen, von genetischen Veränderungen zur politischen Demonstration. Sie arbeiten in unterschiedlichen Medien, so auch mit Filmdokumenten aus Städten des Nahen und Mittleren Ostens (wie Istanbul und Teheran), Fotografien, Musikperformances, Skulpturen und mit Installationen, bei denen sie sich die Werke anderer Künstler aneignen (z.B. von Jenny Holzer oder Dan Flavin). Allora und Calzadilla zeigen eine Art absurd-poetische Empfindsamkeit, die heute selten ist, und haben ein Gespür für das, was in unserer hybriden Wirklichkeit vom Aussterben bedroht ist.

Dans la sculpture grand format *Sediments Sentiments (Figures of Speech)* (2007), dernier volet d'une trilogie d'installations, Jennifer Allora et Guillermo Calzadilla étudient l'interaction entre son, langage et militarisme dans le contexte d'une globalisation armée jusqu'aux dents. L'œuvre consiste en de larges masses de mousse et de plâtre blanc, perforées de passages en forme de tunnels, symbolisant les ruines d'un chaos futur ou un bunker effondré. Les « sédiments » du titre se réfèrent à la fois à la forme géologique de la sculpture et à ce qui se déroule à l'intérieur : des chanteurs donnent une interprétation lyrique de fragments de discours de personnalités politiques majeures – de Saddam Hussein à George W. Bush et au Dalaï Lama – présentation ironique d'événements historiques en référence directe et métaphorique à des figures de rhétorique. Depuis le début de leur collaboration artistique à Puerto Rico en 1995, Allora et Calzadilla explorent dans leurs projets le fonctionnement du langage, tout en trouvant des approches artistiques pour étudier différents systèmes, de l'architecture d'état aux phénomènes naturels, des budgets biennaux aux interventions militaires, de la manipulation génétique aux manifestations politiques. Leurs projets intègrent des séquences filmiques tournées dans des villes du Moyen-Orient comme Istanbul et Téhéran, des photographies, des interventions musicales, des sculptures et des installations qui s'approprient des œuvres d'autres artistes, tels Jenny Holzer et Dan Flavin. Allora et Calzadilla dévoilent une sensibilité poétique et ironique devenue de plus en plus rare de nos jours, et révèlent une disposition nécessaire à l'entropique et l'hybride dans la réalité contemporaine.

R. M.

SELECTED EXHIBITIONS →
2008 *Allora & Calzadilla: Wake Up, Clamor, Sediments Sentiments (Figures of Speech)*, Kunstverein München and Haus der Kunst, Munich. *Allora & Calzadilla: Never Mind That Noise You Heard*, Stedelijk Museum, Amsterdam **2007** *Allora & Calzadilla*, Kunsthalle Zürich. *Allora & Calzadilla: Clamor*, Serpentine Gallery, London. *Allora & Calzadilla: Wake Up*, The Renaissance Society, Chicago. *Whitechapel Laboratory – Allora & Calzadilla*, Whitechapel Art Gallery, London **2006** *Allora & Calzadilla: Land Mark*, Palais de Tokyo, Paris

SELECTED PUBLICATIONS →
2008 *Allora & Calzadilla. Stop, Repair, Prepare: Variations on "Ode to Joy" for a Prepared Piano*, Verlag der Buchhandlung Walther König, Cologne **2007** *Dominique Gonzalez-Foerster, Mark Grotjahn, Jennifer Allora & Guillermo Calzadilla*, Parkett 80, Zürich **2006** *Allora and Calzadilla. Land Mark*, Palais de Tokyo, Paris **2005** *Allora & Calzadilla*, Americas Society, New York

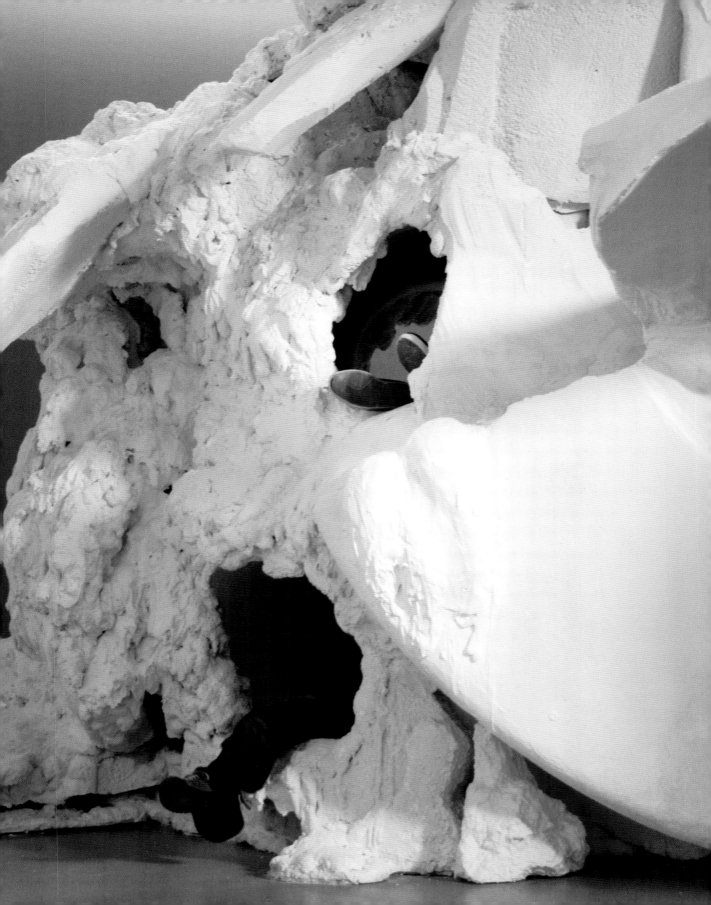

1 **Sediments, Sentiments (Figures of Speech)**, 2007, mixed media, live performance, sound, dimensions variable

2 **There's More Than One Way to Skin a Sheep**, 2007, single-channel video, sound, 6 min 40 sec

3 **Unrealizable Goals**, 2007, single-channel video, sound, 6 min 32 sec

4 **Stop, Repair, Prepare: Variations of Ode to Joy for a Prepared Piano**, 2008, prepared piano, live performance

5 **Clamor**, 2006, mixed media, live performance, sound, dimensions variable

„Skulptur hat eine sehr vielfältige Tradition, die wir geerbt haben, ohne es zu wollen, aber gleichzeitig nutzen, erforschen und manipulieren wir sie gerne und formulieren sie neu unter dem Einfluss der heutigen soziopolitischen Bedingungen. Man könnte sagen, dass die Formen eine Verantwortung tragen."

« La sculpture est une tradition hétérogène dont nous héritons sans le vouloir, mais à laquelle nous prenons aussi plaisir à exploiter, explorer, manipuler, réarticuler à la lumière des conditions sociopolitiques actuelles. C'est ce qu'on pourrait appeler une responsabilité des formes. »

"Sculpture is a heterogeneous tradition that we involuntarily inherit, but also take pleasure in drawing from, exploring, manipulating, re-articulating in light of contemporary socio-political conditions. This is what we might call a responsibility of forms."

2

3

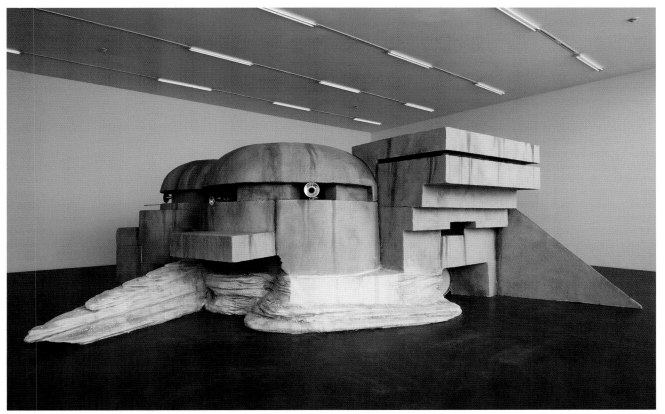

Darren Almond

1971 born in Wigan, lives and works in London, United Kingdom

Darren Almond's works are evocative explorations of temporal phenomena. Ranging from films devoted to specific periods of time, photographs taken with unusual exposure times and clock sculptures to installations about waiting, they examine different structures and perceptions of time. For the installation *Terminus* (2007), Almond took fourteen Socialist-era bus stops from Oświęcim (formerly Auschwitz), which were located near the memorial and museum at Auschwitz-Birkenau. They constitute a unique kind of waiting room; it is as if the historic experience of collectively waiting – either for freedom or death – had been condensed and preserved within them. Since 1998 Almond has been working on a photographic series entitled *Fifteen Minute Moons*, comprising landscape images shot during full moon nights with an exposure time of fifteen minutes. They have been captured in locations all over the world, with some of the most recent ones taken on the English coast in 2007. The artist's chosen method yields unusual colour and brightness values, making the images seem more like daylight shots. The nocturnal mood can still be felt, however, and lends the photographs a ghostly, otherworldly air. Devoid of people, the depicted landscapes are up to 400–600 million years old – they really are from another temporal world. Almond's interest in time structures has led him to create a number of film pieces dealing with routine working scenarios in extreme situations. The video *Bearing* (2007), for example, shows workers toiling in the dangerous, gruelling conditions of Indonesian sulphur mines. How does the extreme become routine? This is perhaps one of the key questions posed by Almond's diverse oeuvre.

Darren Almonds Arbeiten setzen sich auf unterschiedliche Weise mit Zeitphänomenen auseinander. Seien es Filme, die einer Zeitspanne gewidmet sind, Fotografien mit ungewöhnlicher Belichtungsdauer, Uhrenskulpturen oder Installationen mit Wartesituationen. Meist gehen sie verschiedenen Zeitstrukturen und Zeitwahrnehmungen nach. Für die Installation *Terminus* (2007) hat Almond 14 Bushaltestellen aus Oświęcim, ehemals Auschwitz, verwendet. Die Haltestellen stammen aus der Zeit des Sozialismus und befanden sich in der Nähe der Gedenkstätte und des Museums von Auschwitz-Birkenau. Sie eröffnen einen Warteraum der besonderen Art, als wäre in ihnen das historische, kollektive Warten auf Befreiung oder den Tod komprimiert erhalten geblieben. Seit 1998 beschäftigt sich Almond mit der Fotoserie *Fifteen Minute Moons*. Es handelt sich um Landschaftsbilder, bei denen die Belichtungszeit 15 Minuten bei Vollmond beträgt. Die Aufnahmen dafür erfolgten weltweit, einige der neuesten entstanden 2007 an der englischen Küste. Dabei wurden eigentümliche Farb- und Helligkeitswerte erzielt, welche die Bilder eher wie Tageslichtaufnahmen erscheinen lassen. In den Stimmungen jedoch sticht die Nacht durch, weshalb die Fotografien geisterhaft wirken, wie von einer anderen Welt. Die menschenleer aufgenommenen Landschaften sind bis zu 400–600 Millionen Jahre alt – sie stammen tatsächlich aus einer anderen Zeit-Welt. Almonds Interesse an Zeitstrukturen führt ihn immer wieder zu Arbeitsroutinen in Extremsituationen, die er filmisch erfasst. Zuletzt zeigte die Videoarbeit *Bearing* (2007) indonesische Schwefelminenarbeiter bei ihrer gefährlichen, extrem anstrengenden Arbeit. Wie kann das Extreme Routine werden? Vielleicht eine der wichtigsten Fragen, die Almond mit seinen verschiedenen Arbeiten stellt.

Les œuvres de Darren Almond abordent de différentes manières des phénomènes temporels – par des films portant sur une durée définie, des photographies résultant d'une exposition exceptionnellement longue, des sculptures à base d'horloges ou des installations comportant des situations d'attente – et suivent généralement plusieurs structures et perceptions temporelles. Pour l'installation *Terminus* (2007), Almond a utilisé quatorze abris-bus d'Oświęcim, anciennement Auschwitz. Les abris-bus datent de l'époque socialiste et se trouvaient près du mémorial et du musée d'Auschwitz-Birkenau. Ils instaurent une salle d'attente bien particulière, comme si l'attente historique et collective de la délivrance ou de la mort y était conservée de manière comprimée. Depuis 1998, Almond travaille sur la série photographique *Fifteen Minute Moons*, paysages photographiés les nuits de pleine lune avec une exposition de chaque fois quinze minutes. Les vues ont été prises dans le monde entier. Les plus récentes ont été réalisées en 2007 sur la côte anglaise. Les valeurs chromatiques et lumineuses très particulières résultant du procédé utilisé les font apparaître comme des vues diurnes plutôt que nocturnes, alors que les ambiances distillent des impressions de nuit qui confèrent aux images un aspect fantomatique, comme d'un autre monde. Les paysages déserts ont parfois entre 400 et 600 millions d'années et appartiennent donc réellement à un autre univers temporel. L'intérêt d'Almond pour les structures du temps le conduit régulièrement à des routines de travail en situation extrême qu'il capte cinématographiquement. Sa vidéo *Bearing* (2007) a récemment montré des ouvriers indonésiens travaillant dans des mines de soufre dans des conditions dangereuses et éreintantes. Comment l'extrême peut-il devenir routinier? Peut-être est-ce une des questions les plus importantes posées par les œuvres d'Almond.

H. L.

SELECTED EXHIBITIONS →
2008 *Darren Almond: Fire under Snow*, Parasol Unit, London. *The Cinema Effect: Illusion, Reality and the Moving Image*, Hirshhorn Museum and Sculpture Garden, Washington **2007** *Darren Almond: Day Return*, Castle Ujazdowski – Center for Contemporary Art, Warsaw **2006** *Darren Almond: Day Return*, Museum Folkwang Essen. *Darren Almond: If I Had You*, Domus Artium 2002, Salamanca **2005** *Darren Almond: Isolation*, K21 Kunstsammlung Nordrhein-Westfalen, Düsseldorf. *Turner Prize 2005*, Tate Britain, London

SELECTED PUBLICATIONS →
2008 *Darren Almond: Fire under Snow*, Parasol Unit, London. *Darren Almond: Moons of the Iapetus Ocean*, White Cube, London **2007** *Darren Almond: Day Return*, Folkwang Museum Essen; Steidl, Göttingen. *Darren Almond: Journey Time*, Steidl, Göttingen. *Darren Almond: Terminus*, Galerie Max Hetzler, Berlin; White Cube, London; Holzwarth Publications, Berlin **2006** *Carbonic Anhydride*, Galerie Max Hetzler, Berlin **2005** *Darren Almond: 50 moons at a time*, K21 Kunstsammlung Nordrhein-Westfalen, Düsseldorf

1 **Infinite Betweens: Life Between, Phase 3**, 2008, C-print, 220 x 176 cm
2 **Sakura Fullmoon**, 2006, C-print mounted on aluminium, 121.2 x 121.2 cm
3 **Terminus**, 2007, 14 bus shelters, aluminium, steel, wood, fibreglass, PVC, 1 salt cast train plate, bus shelters 265 x 600 x 335 cm (each), plaque 25.5 x 179.5 x 2.5 cm. Installation view, Galerie Max Hetzler Temporary, OsramHöfe, Berlin

4 **Tide**, 2008, 600 digital wall clocks, Perspex, electro-mechanics, steel, vinyl, computerised electronic control system and components, 31.2 x 18.2 x 14.2 cm (each)

„Besonders bin ich an Transportmitteln interessiert, sie sind ein Medium, durch das wir Kultur und Erinnerung verstehen können. Fließende und organisierte Systeme wie Zeit und Transport sind Instrumente, um Gedächtnis und Geschichte zu ordnen."

« Je suis très intéressé par le transport comme moyen permettant de comprendre notre culture et notre mémoire. Les systèmes de flux et d'organisation comme le temps et le transport sont des moyens ordonnateurs qui façonnent notre mémoire et notre histoire. »

"I am very interested in transport as a medium through which we can understand culture and memory. Systems of flow and organization, like time and transport, are ordering mediums that shape our memory and history."

2

Paweł Althamer

1967 born in Warsaw, lives and works in Warsaw, Poland

One of the most subtle works at the recent Skulptur Projekte Münster exhibition was Paveł Althamer's *Ścieżka* (2007) – a path through fields and meadows that began at a road junction near Lake Aa, led out of the city and ended abruptly in the middle of a field. It was a piece of Land Art in the classical sense: its existence as an artwork was determined solely by participation. If the path was used, it continued to exist and could even be extended; if not, it would disappear. Participation is a crucial aspect of Althamer's work, which frequently seeks to break down the boundaries between art and life. His project for the 4th Berlin Biennial was to try and stop the deportation of an illegal immigrant living in Berlin; entitled *Fairytale* (2006), it was a work in progress, the development of which could be followed in media reports and on the Biennial website. The only items on view in the exhibition were an abandoned pair of gym shoes in a former stable (one of the official venues) and, as a testament to the participative action, a signed petition to Berlin's interior minister. The human being in all its fragility is central to Althamer's work: *Fairytale* deals with the socio-political fragility of the immigrant, while the idea of physical transience is a recurrent theme in sculptural works, such as one where he portrays himself as an old man. For his exhibition *One of Many* (2007) in Milan, Althamer – with tongue firmly in cheek – created a giant double of his naked body in the form of a balloon and raised it over the city. Although the artist-giant seemed to be hovering above everything, looking down upon his viewers, this superiority was merely superficial, as a balloon can so easily burst.

Eine der subtilsten Arbeiten der letzten Skulptur Projekte Münster war Paweł Althamers *Ścieżka* (2007) – ein Trampelpfad, der an einer Wegkreuzung am Aaseeufer begann, über Wiesen und Felder aus der Stadt hinaus führte, bis er unvermittelt in einem Feld endete. Ein Stück Land Art im klassischen Sinn, war seine Permanenz als Kunstwerk allein durch Partizipation bestimmt: Wird der Pfad begangen, bleibt er bestehen und kann sogar weitergeführt werden; wenn nicht, verschwindet er. Partizipation ist ein entscheidender Aspekt in Althamers Werk. Es geht dabei immer wieder darum, die Grenzen zwischen Kunst und Leben aufzuheben. Sein Projekt *Fairytale* (2006) für die 4. Berlin Biennale bestand in dem Versuch, einen illegal in Berlin lebenden Einwanderer vor der Abschiebung zu bewahren. Das Projekt gestaltete sich als Work in Progress, dessen Verlauf anhand von Pressereaktionen und auf der Webseite der Biennale verfolgt werden konnte. In der Ausstellung selbst waren lediglich ein Paar zurückgelassene Turnschuhe in einem ehemaligen Pferdestall als Zeugnis der Teilhabe zu sehen: ein Petitionsbrief an den Berliner Innensenator mit Unterschriften. Das menschliche Wesen in seiner Fragilität steht im Zentrum von Althamers Arbeiten: Ist es bei *Fairytale* die politisch-soziale Fragilität der Immigration, so taucht in den skulpturalen Arbeiten wiederholt der Aspekt der körperlichen Vergänglichkeit auf, etwa wenn Althamer sich selbst als alten Mann porträtiert. In seiner Ausstellung *One of Many* in Mailand (2007) ließ er – nicht ohne ein humorvolles Augenzwinkern – ein riesenhaftes Double seines nackten Körpers als Ballon steigen. Der Künstler-Gigant schwebt zwar über dem Geschehen und blickt auf die Betrachter hinab, doch ist diese Überlegenheit nur Schein, denn die Ballonhülle kann nur zu leicht zerplatzen.

Ścieżka (2007), de Paveł Althamer, a été une des œuvres les plus subtiles de la dernière édition du Skulptur Projekte Münster. Il s'agissait d'un sentier pédestre partant d'une croisée de chemins proche des berges du lac de l'Aasee et menant hors de la ville à travers des champs et des prés pour se terminer inopinément au milieu d'un champ. Œuvre de Land Art au sens classique, sa permanence comme œuvre d'art était entièrement conditionnée par la participation : tant que des spectateurs empruntent le sentier, elle continue d'exister et peut même être prolongée, sinon, elle disparaît. La participation joue un rôle central dans l'œuvre d'Althamer, et elle vise toujours à effacer les limites entre l'art et la vie. Le projet *Fairytale* (2006) réalisé pour la 4ᵉ Biennale de Berlin a consisté en une tentative d'éviter l'expulsion d'un jeune sans-papiers vivant à Berlin. Ce projet a pris la forme d'un *work in progress* dont l'évolution pouvait être suivie à travers les multiples réactions de la presse et sur le site Internet de la biennale. L'exposition ne présentait quant à elle qu'une paire de chaussures de sport laissées dans une ancienne écurie et un témoignage de la participation : une pétition adressée au sénat de Berlin et des signatures. La fragilité de l'être humain est au centre des œuvres d'Althamer : s'il s'agit dans *Fairytale* de la fragilité socio-politique des immigrés, les œuvres sculpturales mettent régulièrement l'accent sur la fugacité du corps, par exemple quand Althamer se représente en vieillard. Lors de son exposition *One of Many* (Milan, 2007), l'artiste a fait monter dans le ciel – non sans humour – un immense ballon ayant la forme de son propre corps nu. Si l'artiste géant plane au-dessus de l'événement et regarde les spectateurs de haut, cette supériorité n'est qu'apparence, car le ballon peut éclater à tout moment.

E. S.

SELECTED EXHIBITIONS →
2008 *After Nature*, New Museum, New York **2007** *Paweł Althamer: One of Many*, Fondazione Nicola Trussardi, Milan. Skulptur Projekte Münster 07, Münster **2006** *Paweł Althamer*, Centre Georges Pompidou, Paris. *Of Mice and Men*, 4th Berlin Biennial for Contemporary Art, Berlin. *The Impossible Theatre*, Barbican Centre, London; Zacheta National Gallery of Art, Warsaw **2005** *Das unmögliche Theater*, Kunsthalle Wien, Vienna. *Paweł Althamer*, Zacheta National Gallery of Art, Warsaw

SELECTED PUBLICATIONS →
2008 *Paweł Althamer, Louise Bourgeois, Rachel Harrison, Parkett 82*, Zürich **2007** *Skulptur Projekte Münster 07*, Verlag der Buchhandlung Walther König, Cologne **2006** *Paweł Althamer – In the Centre Pompidou*, Editions du Centre Pompidou, Paris. *Of Mice and Men*, 4th Berlin Biennial for Contemporary Art, Berlin; Hatje Cantz, Ostfildern **2005** *Das unmögliche Theater / The Impossible Theater*, Kunsthalle Wien, Vienna, et al.; Verlag für moderne Kunst, Nuremberg

1 **Ścieżka (Path)**, 2007. Installation view, Skulptur Projekte Münster 07
2 **Untitled**, 2003, mixed media, dimensions variable.
Installation view, neugerriemschneider, Berlin

3 **Balloon**, 1999–2007, fabric, paint, helium, 210 x 671 x 366 cm.
Installation view, Fondazione Nicola Trussardi, Milan, 2007
4 **Matea**, 2006/08, aluminium, baseplate ø 340 cm, standing figure
175 x 75 x 46 cm, bust 55 x 40 x 25 cm, chair 85 x 65 x 60 cm

„Es ist ziemlich schwierig zu verstehen, dass der Körper ein Instrument der Seele ist. Ich fühle mich wie ein Kosmonaut im Anzug meines eigenen Körpers, ich bin eine gefangene Seele. Der Körper ist wie Kleidung, wie eine Anschrift. Meine körperliche Anschrift ist Paweł Althamer."

« C'est une grande réussite que de réaliser que le corps n'est qu'un véhicule de l'âme. Je me sens comme un cosmonaute revêtu de mon propre corps, je suis une âme prise au piège. Le corps joue le rôle d'un costume, d'une adresse. Mon adresse corporelle est Paweł Althamer. »

"It is a major achievement to realize that the body is only a vehicle for the soul. I feel like a cosmonaut in the suit of my own body, I am a trapped soul. The body plays a role of a dress, of an address. My bodily address is Paweł Althamer."

2

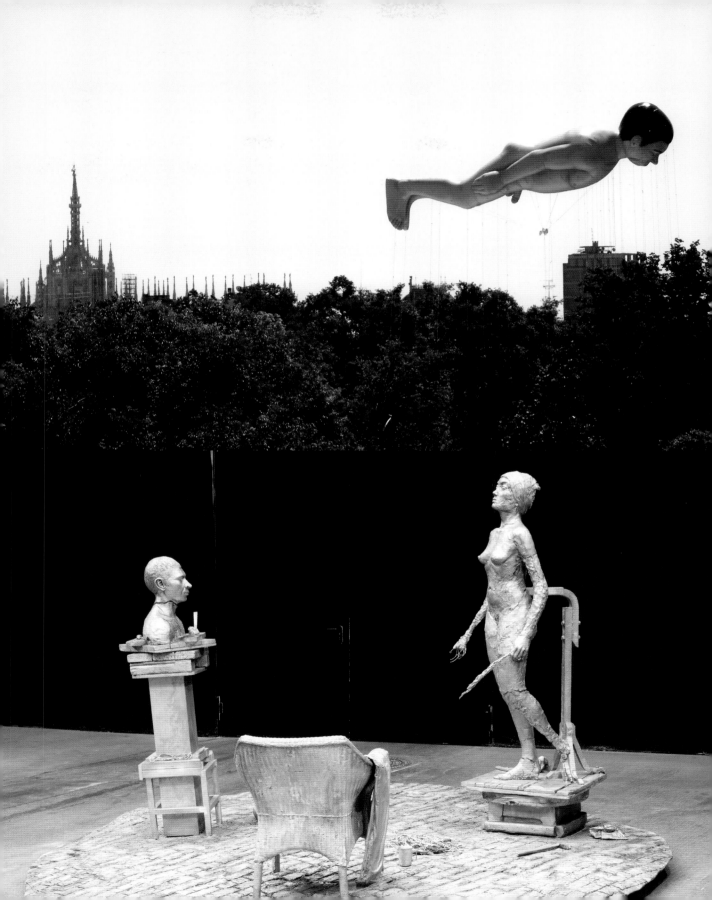

David Altmejd

1974 born in Montreal, Canada, lives and works in New York (NY), USA

David Altmejd is known for sculptures and installations that recall natural history dioramas and surreal cabinets of curiosities. For one of his most recent exhibitions, Altmejd constellated the gallery space with nine larger-than-life figures that resembled mythological creatures from outer space. Altmejd's titans – like most of his sculptures – are handmade and combine different materials such as mirrors, taxidermied animals or furs. Some of them, for example *The Quail* (2008), are covered with reflective surfaces, which turn them into more abstract sculptures. Others, like *The Center* (2008), are decorated with fake plants and organic materials that confer a sense of decay. Highly crafted but roughly finished, Altmejd's mutant colossi inhabit a world of hybrids, where the distance between animal and human is finally blurred. In several works on the werewolf, he adds a darker side to this world, as the werewolf is not only half human half animal but can also be seen as a metaphor for the struggle between good and evil. Decapitated werewolf heads also featured in *The Index* (2007), Altmejd's complex installation for the Canadian pavilion at the 52nd Venice Biennale, which transformed the exhibition space into the laboratory of a mad scientist guarded by *The Giant* (2007), a massive statue of a Goliath-like monster. Tropical plants, stuffed animals, plastic trees, human organs and bird-headed men shaped a nightmarish universe in continuous growth. Altmejd is often associated with a neo-gothic sensibility, although his work is also embedded with references to minimalism, updated by a visionary, at times grotesque sensuality.

David Altmejd ist für Skulpturen und Installationen bekannt, die wie naturhistorische Dioramen und surreale Gruselkabinette anmuten. Anlässlich einer aktuellen Ausstellung stellte Altmejd neun überlebensgroße Figuren in den Raum, die an mythische Wesen aus dem All denken ließen. Altmejds Titanen sind – wie die Mehrheit seiner Skulpturen – handgemacht und kombinieren verschiedene Materialien wie Spiegel, präparierte Tierkörper oder auch Tierfelle. Manche davon, etwa *The Quail* (2008), werden durch ihre verspiegelten Oberflächen eher abstrakte Skulpturen. Andere, wie *The Center* (2008), sind mit künstlichen Pflanzen und organischen Materialien dekoriert, was den Verfall mit ins Spiel bringt. Altmejds kunstvolle, aber grob vollendete Riesenmutanten bevölkern eine Welt voller Mischwesen, in denen die Grenzen zwischen Mensch und Tier verwischt sind. In mehreren Arbeiten über die Figur des Werwolfs fügt er diesem Reich noch eine düstere Komponente hinzu, da der Werwolf, halb Mensch und halb Tier, auch eine Metapher für den Kampf zwischen Gut und Böse ist. Abgehackte Werwolfköpfe waren denn auch im Zentrum von Altmejds vielschichtiger Installation *The Index* (2007) für den kanadischen Pavillon auf der 52. Biennale in Venedig, die den Ausstellungsraum, bewacht von der mächtigen Statue eines Monster-Goliaths, *The Giant* (2007), in das Labor eines irren Wissenschaftlers verwandelte. Tropische Pflanzen, ausgestopfte Tiere, Plastikbäume, menschliche Organe und Vogelkopf-Männer fügten sich zu einem alptraumhaften, wild wuchernden Universum. Altmejd wird häufig eine Tendenz zur Schauerromantik nachgesagt, dennoch enthält sein Œuvre auch Referenzen an den Minimalismus, den er durch eine visionäre, zuweilen groteske Sinnlichkeit aktualisiert hat.

David Altmejd est connu pour ses sculptures et installations qui rappellent les dioramas des musées d'histoire naturelle ou les cabinets de curiosités surréalistes. À l'occasion d'une exposition récente, il a constellé l'espace d'une galerie de neuf figures géantes s'apparentant à des créatures mythologiques extraterrestres. Les titans d'Altmejd, comme la plupart de ses sculptures, sont réalisés à la main à partir de matériaux aussi divers que des miroirs, des animaux empaillés ou de la fourrure. Certaines pièces, comme *The Quail* (2008), sont recouvertes de surfaces réfléchissantes qui les rapprochent de sculptures abstraites. D'autres, comme *The Center* (2008), sont décorées de plantes artificielles et de matériaux organiques qui les font paraître en état de décomposition. De fabrication complexe malgré leur finition grossière, les colosses mutants d'Altmejd habitent un monde d'êtres hybrides, où la distinction entre l'homme et l'animal est brouillée. Dans plusieurs travaux sur le loup-garou, cet univers révèle une face plus sombre : le loup-garou n'est pas seulement mi-homme, mi-animal, mais également une métaphore de la lutte entre le bien et le mal. Des têtes de loups-garous décapités figurent également dans *The Index* (2007), l'installation complexe d'Altmejd pour le pavillon canadien de la 52ᵉ Biennale de Venise ; l'espace d'exposition y devenait le laboratoire d'un savant fou, sous la surveillance de *The Giant* (2007), une immense statue d'un monstre aux allures de Goliath. Plantes tropicales, animaux empaillés, arbres en plastique, organes humains et hommes à tête d'oiseau créaient un univers en perpétuelle évolution. Si l'on attribue souvent à Altmejd une sensibilité néo-gothique, son œuvre est également truffée de références au minimalisme – mais un minimalisme associé à une sensualité visionnaire et parfois grotesque.

C. A.

SELECTED EXHIBITIONS →
2008 *David Altmejd*, Museum De Pont, Tilburg. *Freeway Balconies*, Deutsche Guggenheim, Berlin **2007** *David Altmejd*, Canadian Pavilion, 52nd Venice Biennial, Venice. *David Altmejd*, Illingworth Kerr Gallery, Alberta College of Art & Design, Calgary. *David Altmejd: Stages*, Fundació La Caixa, Barcelona. *David Altmejd. Métamorphose Metamorphosis*, Oakville Galleries, Ontario; Galerie de l'Uqam, Montreal **2006** *Six Feet Under*, Kunstmuseum Bern **2005** *Wunschwelten*, Schirn Kunsthalle, Frankfurt am Main

SELECTED PUBLICATIONS →
2008 *Collier Schorr: Freeway Balconies*, Deutsche Guggenheim, Berlin **2007** *David Altmejd: The Index*, The National Gallery of Canada, Ottawa. *David Altmejd*, Galerie de l'Uqam, Montreal **2006** *Six Feet Under*, Kunstmuseum Bern, Bern **2005** *Wunschwelten / Ideal Worlds*, Schirn Kunsthalle, Frankfurt am Main; Hatje Cantz, Ostfildern

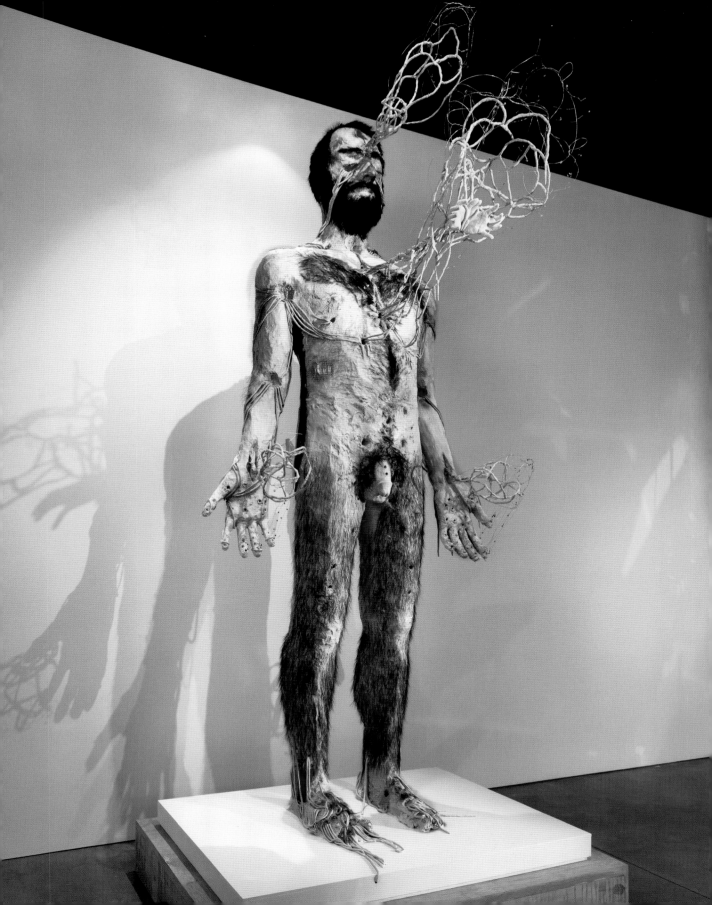

1 **The Spiderman**, 2008, wood, foam, epoxy clay, epoxy resin, horse hair, paint, metal wire, glass beads, plaster, glass, glitter, 389 x 183 x 173 cm

2 **The Center**, 2008, wood, foam, epoxy clay, resin, horsehair, metal wire, paint, mirror, glass beads, plaster, glue, feathers, glass eyes, 358 x 183 x 122 cm

3 **The Quail**, 2008, wood, mirror, glue, quail eggs, 354 x 104 x 64 cm

4 **The Index**, 2007 (detail), mixed media, 333 x 1297 x 923 cm. Installation view, Canadian Pavilion, 52. Biennale di Venezia, Venice

„Meine Arbeit soll hoffnungfroh und verführerisch sein. Die Geschöpfe in meinem Werk verwesen nicht, sie kristallisieren. So stehen die Geschichten, die meine Werke erzählen, dem Leben näher als dem Tod."

« Ce que je fais doit être positif et séduisant. Dans mon œuvre, les personnages ne pourrissent pas : ils cristallisent. Les histoires racontées ont pour horizon la vie, non la mort. »

"What I make has to be positive and seductive. Instead of rotting, the characters in my work are crystallizing. This makes the narratives of the pieces move towards life rather than death."

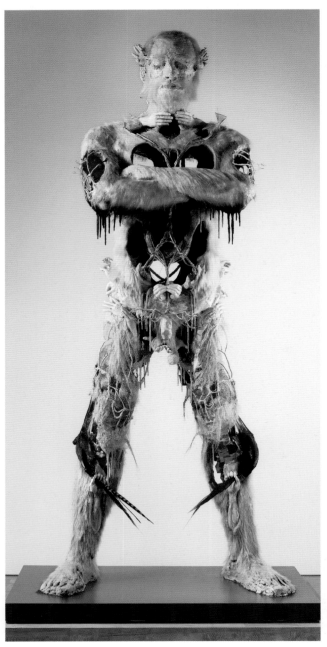

2

3

Hope Atherton

1974 born in Warrenton (VA), lives and works in New York (NY), USA

Frequently featured in magazine style spreads and esteemed for her sartorial panache, Hope Atherton emerged on the art scene at the dawn of the new century, paradoxically, with a quirky, brooding *fin-de-siècle* sensibility that belies her image as a golden-haired fashionista. Based on photographs taken during her travels, the painting series *Danced for Any Celebration* (2008), portrays a suave moustachioed figure decked out in floral robes, aviator sunglasses and a jaunty cap, standing guard with a sword held upright in one hand and a cigarette held aloft in the other. Looking at the three versions of this subject – one a loosely brushed study in blacks, silver-greys and whites, another solarized like a photo negative and the third nothing more than a pale wash of whites and sketched lines – is akin to watching a photograph develop in its watery chemical bath while possessing the magical capacity to seize each phantasmagoric instant of the struggle for reconciliation between fluidity and fixity in real time. Atherton's fascination for the light and dark sides of mortality, taxidermy animals, the occult and cabinets of curiosity – cultivated during her childhood on a small working farm – filters through the poignant *Doll Hospital* (2008), which features a wounded doll, her face obscured by shadow, perched on a pouf on a shelf, waiting to be repaired. In these, as in her earlier, less representational works, *Madonna in Dark Glass* (2006) and *Butcher* (2007), painted with an expressive and vibrant, almost cinematographic palette of hues and tones, Atherton ferries images from an anecdotal or documentary domain into an other-worldly realm all her own.

Hope Atherton, eine blendende Erscheinung, deren besonderer Kleidungsstil ihr schon einige Magazinstrecken bescherte, tauchte erstmals an der Schwelle zum 21. Jahrhundert in der Kunstszene auf, und das paradoxerweise mit einem seltsam düsteren Stilempfinden des *fin de siècle*, das so gar nicht zu dem Image der goldhaarigen Fashionista passte. Die auf Reisefotografien basierende Bildfolge *Danced for Any Celebration* (2008) zeigt eine weltmännische, schnurrbärtige Gestalt, ausstaffiert mit geblümten Gewändern, Fliegerbrille und verwegener Mütze, die mit erhobenem Schwert in der einen Hand und Zigarette in der anderen Wache steht. Beim Betrachten der drei Versionen des Sujets hintereinander – eine mit lockerem Pinselstrich angelegte Studie in Schattierungen von Schwarz, Silbergrau und Weiß, eine weitere in der Art eines solarisierten Fotoabzugs und eine dritte in Weißschattierungen mit skizzenhaften Linien – verdichtet sich das Bild wie eine Fotografie in einem Entwicklerbad, während gleichzeitig jedes Stadium die magische Fähigkeit besitzt, den fantasmagorischen Augenblick dieses Ringens um Aussöhnung zwischen Fließendem und Beständigem in Realzeit sichtbar zu machen. Athertons Faszination für die lichten und dunklen Seiten alles Sterblichen, präparierte Tiere, Okkultes und Kuriositätenkabinette – die auf ihre Kindheit auf einem kleinen Bauernhof zurückgeht –, durchdringt das ergreifende Bild *Doll Hospital* (2008): Eine verletzte Puppe, das Gesicht im Dunkeln, sitzt auf einem Kissen hoch oben im Regal und wartet auf den Puppendoktor. In diesen wie in früheren, weniger gegenständlichen Arbeiten, wie *Madonna in Dark Glass* (2006) und *Butcher* (2007) mit ihrer expressiven, vibrierenden, fast cinematografisch anmutenden Farbtonskala überträgt Atherton anekdotische und dokumentarische Bilder in ihre ganz eigene, andere Welt.

Figure récurrente des magazines de mode, admirée pour son panache vestimentaire, Hope Atherton s'est imposée dans le monde de l'art au début des années 2000, en affichant paradoxalement une sensibilité sombre et très fin-de-siècle qui semble désavouer son image de *fashionista* aux cheveux blonds. Réalisée d'après des photographies prises au cours de ses voyages, la série de toiles intitulée *Danced for Any Celebration* (2008) représente un personnage moustachu élégant, vêtu d'une robe à fleurs et portant des lunettes d'aviateur et un béret ; une épée à la main, une cigarette dans l'autre, il semble monter la garde. Observer successivement les trois versions du même sujet – l'une réalisée à grands coups de pinceau en noir, blanc et argent, une autre solarisée comme un négatif de photographie, une troisième qui se réduit à une esquisse sur fond blanc délavé –, c'est un peu comme regarder l'image photographique surgissant dans un bain chimique, mais en disposant de la faculté magique de saisir chacun de ces moments fantasmatiques, chaque instant de la lutte entre fluidité et fixité. La fascination d'Atherton pour les aspects sombres et lumineux de la mortalité, pour les animaux empaillés, pour l'occulte et les cabinets de curiosités – cultivée lors de son enfance dans une petite ferme – est perceptible dans le poignant *Doll Hospital* (2008), où une poupée blessée, perchée sur un pouf en haut d'une étagère, le visage plongé dans l'ombre, attend d'être réparée. Ici, comme dans des œuvres antérieures moins figuratives, *Madonna in Dark Glass* (2006) ou *Butcher* (2007), peintes dans une vibrante palette de tons et de coloris presque cinématographiques, Atherton puise des images dans l'anecdotique ou le documentaire pour les transmuer dans un monde imaginaire qui lui est propre. V. R.

SELECTED EXHIBITIONS →
2008 *Hope Atherton*, Bortolami, New York **2007** *Looking Up*, Galeria Màrio Sequeira, Braga. *Hope Atherton*, Patrick Painter Inc., Santa Monica **2006** *Hope Atherton*, Bortolami, New York **2005** *Hanging by a Thread*, The Moore Space, Miami. *Greater New York*, P.S.1 Contemporary Art Center, Long Island City and MoMA, New York **2004** *Hope Atherton*, Patrick Painter Inc., Santa Monica **2003** *Druid: Wood as a Superconductor*, Space 101, New York **2002** *Hope Atherton: Shrine*, Sperone Westwater, New York

SELECTED PUBLICATIONS →
2000 *American Bricolage*, Sperone Westwater, New York

50

1 **Danced for Any Celebration (White)**, 2008, oil on canvas, 128.9 x 114.3 cm
2 **Sunset**, 2008, acrylic, oil on linen, 147.3 x 162.6 cm
3 **Doll Hospital**, 2008, acrylic, oil on canvas, 213.4 x 152.4 cm
4 **Butcher**, 2007, acrylic on canvas, 221 x 165.1 cm
5 **Madonna in Dark Glass**, 2006, acrylic on canvas, 147.3 x 116.8 cm

„Gemälde stellen Momente des Übergangs zwischen bewussten gedanklichen Vorstellungen oder Erfahrungen dar. Meine Bilder sollen Traumlandschaften zeigen, wie undeutliche, fließende Erinnerungen."

« Les peintures illustrent des moments de transition entre des pensées conscientes et des expériences. Mes toiles doivent faire voir des paysages oniriques, comme une sorte de passé flou et flottant. »

"Paintings illustrate moments in transition between conscious thoughts or experiences. I want my paintings to depict dream landscapes, like a sort of floating imprecise past."

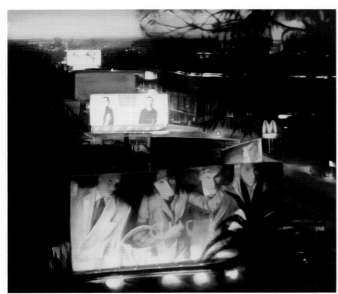

2

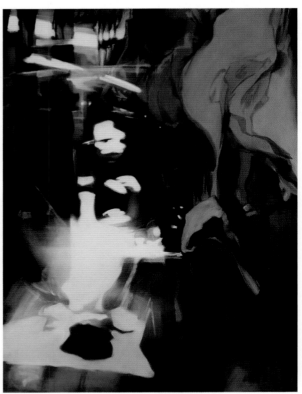

4

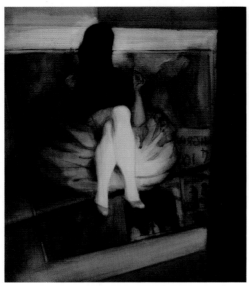

3

Banksy

While Banksy's identity remains a mystery, his irreverent interventions in the public sphere are anything but anonymous and have been vigorously embraced by the contemporary art world, media and general public alike. Following a trajectory previously carved out by artists such as Jean-Michel Basquiat and Keith Haring in the 1980s, Banksy brings the languages of traditional graffiti writing into the rarefied environs of art discourse and the auction house where his works have sold for staggering sums. Using a characteristic stencil technique which allows him to execute his graffiti works quickly and accurately, his subjects – from a pair of kissing policemen and armed rats to iconic moments taken from film and art history – are often paired with humorous slogans and pose wry critiques of capitalism, war and the establishment. In recent years Banksy has developed his graffiti works with large-scale sculptural interventions that play with images of urban decay and obsolescence as well as toying with traditional notions of public sculpture with comically altered versions of well-known works: Rodin's *The Thinker* with a traffic cone for a hat or a raunchy re-invention of the figure of "Justice" hitching her skirt to reveal a thong, garter stuffed with a dollar bill and PVC boots. While the guerrilla hanging of his own parody-ridden works in London's British Museum or New York's Metropolitan Museum of Art reflect on the antagonism between sanctioned institutions of art and the unlawful nature of his practice in the public sphere, these headline-grabbing interventions reveal the media itself, not the street or gallery, to be Banksy's primary context.

Bisher hat Banksy das Geheimnis um seine Person wahren können, doch seine respektlosen Interventionen im öffentlichen Raum bleiben beileibe nicht anonym und finden in der zeitgenössischen Kunst- und Medienwelt und vor allem in der Öffentlichkeit sehr lebhaftes Interesse. Banksy folgt den in den 1980ern von Künstlern wie Jean-Michel Basquiat und Keith Haring gelegten Spuren und bringt die Ausdrucksformen des traditionellen Graffiti-Writing in den exklusiven Bereich des Kunstbetriebs und der Auktionshäuser, wo seine Werke für Unsummen verkauft werden. Seine charakteristische Schablonentechnik ermöglicht ihm eine rasche, präzise Ausführung seiner Graffiti; seine Sujets – zwei sich küssende Polizisten, bewaffnete Ratten oder Höhepunkte aus der Film- und Kunstgeschichte – stellen, oft mit witzigen Sprüchen gepaart, eine sarkastische Kritik an Kapitalismus, Krieg und Establishment dar. In den letzten Jahren hat Banksy seine Graffitikunst in großen skulpturalen Aktionen weiterentwickelt und spielt mit Erscheinungsformen des Verfalls und der Überalterung der Städte oder macht sich über traditionelle Vorstellungen von öffentlicher Skulptur lustig, indem er bekannte Werke persifliert: Rodins *Denker* bekommt einen Verkehrskegel als Hut, und eine provokante Neuinterpretation der Justitia trägt Plastikboots, hebt ihren Rock und enthüllt ein Strumpfband mit einer Dollarnote darunter. Während seine Guerilla-Aktionen, bei denen er parodistische Werke ins British Museum in London und das Metropolitan Museum of Art in New York hängte, den Widerspruch zwischen sanktionierten Kunstinstitutionen und den eigenen illegalen Aktionen im öffentlichen Raum reflektieren, zeigen seine provozierenden, schlagzeilenträchtigen Interventionen, dass Banksy nicht nur auf der Straße oder in der Galerie, sondern mehr noch im medialen Kontext existiert.

Si l'identité de Banksy demeure un mystère, ses interventions impertinentes dans la sphère publique n'ont rien d'anonyme et reçoivent un accueil enthousiaste aussi bien de la part du monde de l'art contemporain que des médias ou du grand public. Suivant un parcours dessiné dans les années 1980 par des artistes comme Jean-Michel Basquiat et Keith Haring, Banksy importe le langage traditionnel du graffiti dans les hautes sphères du discours artistique et de la vente aux enchères, où le prix de ses œuvres atteint des sommes colossales. Usant d'une technique classique au pochoir, qui lui permet d'exécuter ses graffitis avec autant de rapidité que de précision, il enrichit souvent ses sujets – tels que policiers en train de s'embrasser, rats bardés d'armes à feu, scènes clés tirées du cinéma ou de l'histoire de l'art – de slogans critiquant avec un humour noir le capitalisme, la guerre ou l'ordre établi. Depuis quelques années, Banksy associe son travail sur le graffiti à des interventions sculpturales à grande échelle, dans lesquelles il met en scène le déclin et l'obsolescence des villes en jouant avec la conception traditionnelle de la sculpture publique – des œuvres célèbres sont ainsi détournées avec humour, tel *Le Penseur* de Rodin coiffé d'un cône de balisage orange, ou une allégorie de la Justice soulevant sa robe pour exhiber un string, une jarretière dont dépasse un billet d'un dollar et des bottes en caoutchouc. Si l'accrochage sauvage de ses œuvres parodiques, au British Museum de Londres ou au Metropolitan Museum of Art de New York, reflète l'antagonisme entre les institutions artistiques officielles et la nature illicite de sa propre pratique dans la sphère publique, de telles interventions – systématiquement relayées par la presse – révèlent que les médias, plus encore que la rue ou la galerie d'art, constituent désormais le cadre primordial de son œuvre.

A. B.

SELECTED EXHIBITIONS →
2008 *Call it what you like! Collection Rik Reinking*, Art Centre Silkeborg Bad. *Radical Advertising*, NRW-Forum, Düsseldorf **2007** *Warhol vs. Banksy*, Pollock Fine Art, London **2006** *In the darkest hour there may be light*, Serpentine Gallery, London. *Spank the Monkey*, BALTIC Centre for Contemporary Art, Gateshead. *Minimal Illusions – Arbeiten mit der Sammlung Rik Reinking*, Galerien der Stadt Esslingen

SELECTED PUBLICATIONS →
2007 Steve Wright: *Banksy's Bristol: Home Sweet Home*, Tangent Books, Bristol. Christian Hundertmark: *The Art of Rebellion 2. The World of Urban Art Activism*, Publikat, Mainaschaff **2006** Martin R. Bull: *Banksy Locations and Tours: A Collection of Graffiti Locations and Photographs in London*, Shell Shock Publishing, London. *In the darkest hour there may be light*, Serpentine Gallery; Other Criteria, London **2005** Banksy: *Wall and Piece*, Century, London

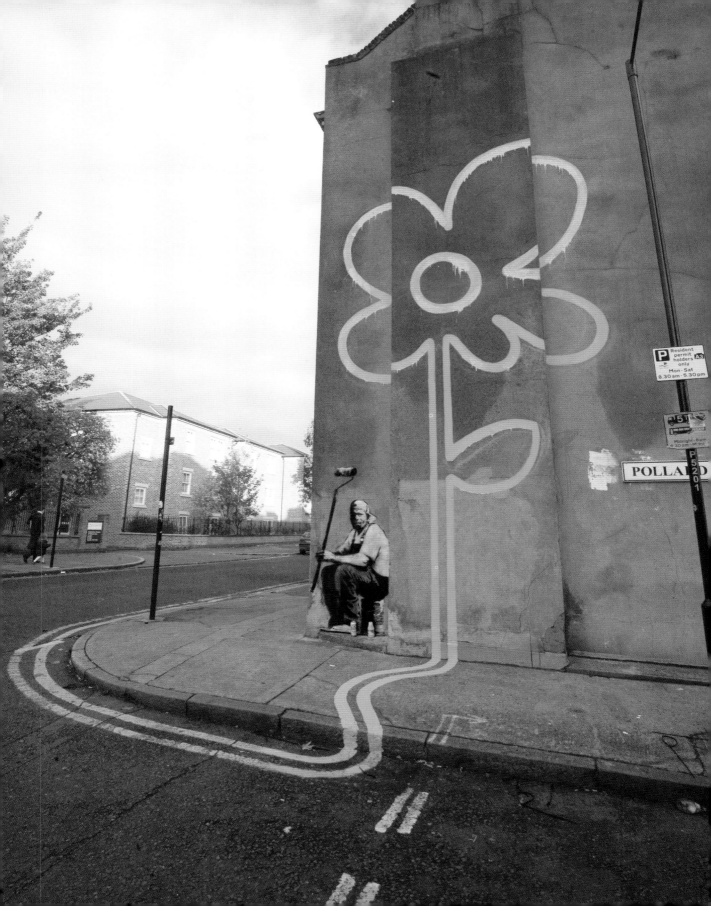

„Mir wird beim Gedanken an das Geld, das meine Arbeiten inzwischen erbringen, schon ein bisschen unbehaglich, aber das Problem lässt sich einfach lösen – nicht meckern sondern alles verschenken. Es ist nicht möglich, Kunst über Armut zu machen und dann all das Geld einzustecken, das wäre sogar mir zu ironisch. Ich mag es, wie der Kapitalismus sogar für seine Feinde noch ein Plätzchen findet."

« L'argent que mon œuvre rapporte en ce moment me met un peu mal à l'aise, mais c'est un problème qui se résout facilement – on arrête de geindre et on le distribue. Je ne pense pas qu'on puisse faire de l'art à propos de la pauvreté tout en empochant les billets, c'est pousser un peu loin l'ironie, même pour moi. J'adore la manière dont le capitalisme trouve une place, même pour ses ennemis. »

"The money that my work fetches these days makes me a bit uncomfortable, but that's an easy problem to solve – you just stop whingeing and give it all away. I don't think it's possible to make art about world poverty and then trouser all the cash, that's an irony too far, even for me. I love the way capitalism finds a place even for its enemies."

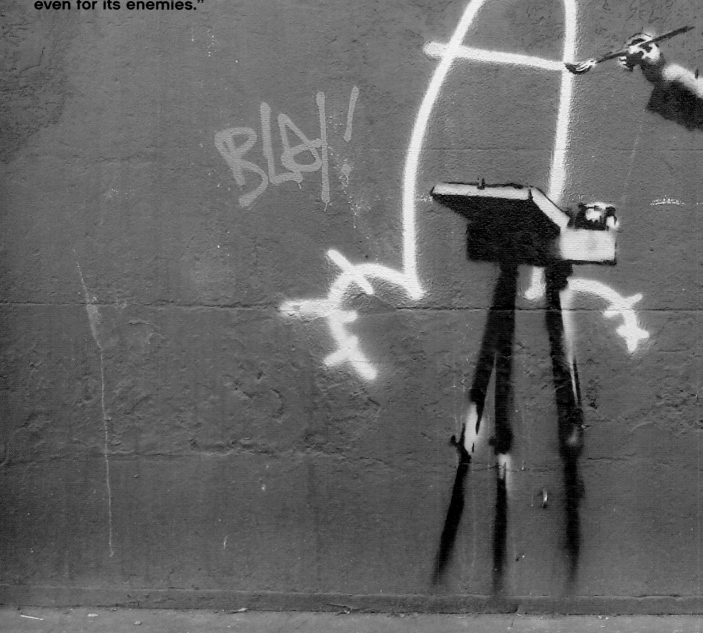

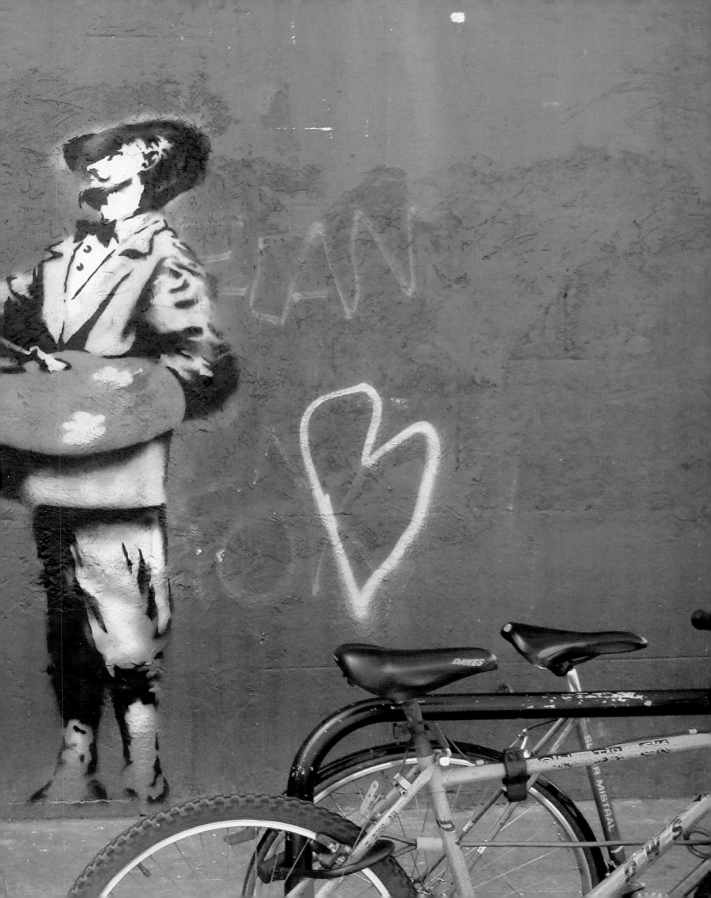

Matthew Barney

1967 born in San Francisco (CA), lives and works in New York (NY), USA

Matthew Barney didn't rest on his laurels after wrapping up the five films of his *Cremaster Cycle* (1994–2002) and an eponymous travelling exhibition. Instead, he came up with another intricately crafted, multi-sensory feature-length film. *Drawing Restraint 9* (2005) takes up the themes of resistance, physicality and mark-making that Barney has been exploring in his *Drawing Restraint* series of performances and works since 1998. The film stars Barney and pop musician Björk (who also composed the score) as "Occidental Guests" on a Japanese whaling ship whose cargo includes vast quantities of liquid petroleum jelly poured into a mould shaped like the artist's emblem: an oval field with a horizontal bar through it. As the vessel glides into colder waters and the petroleum jelly solidifies, the bar is removed, indicating the elimination of restraint, and the individuals, united during an elaborate Japanese tea ceremony, undergo a stunning physical and metaphorical sea change. Parallel to the *Drawing Restraint* series, Barney's provocative stage performance *Guardian of the Veil* (2007) – a collaboration with Jonathan Bepler that incorporates a live bull, a urinating contortionist, balaclava-wearing pall bearers and an automobile – draws on the *Cremaster Cycle* and meditates on the after-life. With astonishing formal originality and conceptual rigor, Barney's work at once tethers and liberates sexual energy and physical discipline, drawing inspiration from horror movies and video art as well as from the dance films of Busby Berkeley. This constant movement between restraint and release enables him to harness those elements as forces of sheer creative potential.

Anstatt sich auf seinen Lorbeeren auszuruhen, präsentierte Matthew Barney nach seinem fünfteiligen Filmzyklus *The Cremaster Cycle* (1994–2002) und einer gleichnamigen Wanderausstellung einen weiteren abendfüllenden, dicht gewebten, multisensorischen Film. *Drawing Restraint 9* (2005) greift die Themen von Widerstand, Körperlichkeit und Zeichen-Setzung auf, die Barney in den Performances und anderen Arbeiten seiner Serie *Drawing Restraint* seit 1998 untersucht hat. Der Film zeigt ihn mit der Popsängerin Björk (sie komponierte auch den Soundtrack) als „Gäste aus dem Okzident" auf einem japanischen Walfangschiff, das eine riesige Ladung flüssiger Vaseline an Deck hat, wobei die Containerform dem Emblem des Künstlers nachempfunden ist (ein von einem Querbalken gekreuztes Oval). Während das Schiff durch kältere Gewässer gleitet, geht die Vaseline in festen Aggregatzustand über; der horizontale Balken wird entfernt und alle Beschränkung ist aufgehoben: Die in einer kunstvollen japanischen Teezeremonie vereinten Gäste unterziehen sich einer wundersamen körperlichen und metaphorischen Verwandlung. Parallel zu der Serie *Drawing Restraint* entwickelte Barney Motive aus dem *Cremaster* Zyklus für seine gemeinsam mit Jonathan Bepler geschaffene, provozierende Bühnenperformance *Guardian of the Veil* (2007) weiter – eine Meditation über das Leben nach dem Tod, die einen lebenden Bullen, einen urinierenden Schlangenmenschen, Leichenträger mit Sturmhauben und ein Automobil kombiniert. Mit hoher formalstilistischer Originalität und konzeptueller Strenge erzeugt Barney ein Kraftfeld aus sexueller Energie und Körperdisziplin, inspiriert von Horrorfilmen, Videokunst und Busby Berkeleys Tanzfilmen. Durch den ständigen Fluss von An- und Entspannung werden diese Elemente als reines Kreativitätspotenzial genutzt.

Après avoir achevé les cinq films de son *Cremaster Cycle* (1994–2002) et l'exposition itinérante du même nom, Matthew Barney ne s'est pas reposé sur ses lauriers. Bien au contraire, il a imaginé un nouveau long métrage multisensoriel, d'une grande complexité. *Drawing Restraint 9* (2005) reprend les thèmes de la résistance, de la corporalité et de l'empreinte que Barney explore depuis 1998 dans la série de performances et d'œuvres regroupées sous le titre *Drawing Restraint*. Barney joue le rôle principal du film aux côtés de la musicienne pop Björk (qui en a composé la bande originale). Ils sont les « passagers occidentaux » d'un baleinier japonais dont la cargaison comporte de vastes quantités de vaseline liquide déposées dans un moule dont la forme reprend l'emblème de l'artiste : un ovale traversé d'une barre horizontale. Lorsque le vaisseau s'avance dans des eaux plus froides et que la vaseline se solidifie, la barre horizontale est retirée, symbolisant l'élimination de la contrainte. En parallèle à la série *Drawing Restraint*, la performance théâtrale intitulée *Guardian of the Veil* (2007) – une collaboration avec Jonathan Bepler comprenant entre autres un taureau vivant, un contortioniste incontinent, des porteurs de cerceuils encagoulés et une automobile – s'inspire du *Cremaster Cycle* et développe une méditation sur l'au-delà. Alliant rigueur conceptuelle et originalité formelle étonnante, le travail de Barney dompte et déchaîne tout à la fois les pulsions sexuelles et la discipline du corps, en s'inspirant de sources aussi diverses que les films d'horreur, l'art vidéo et les films de danse de Busby Berkeley. Le mouvement constant entre retenue et défoulement permet à l'artiste de maîtriser et d'exploiter ces éléments telles des forces de pure potentialité créatrice.

C. Es.

SELECTED EXHIBITIONS →
2008 *Matthew Barney: Drawing Restraint*, Kunsthalle Wien, Vienna **2007** *Matthew Barney*, Sammlung Goetz, Munich. *Matthew Barney – Kaiserringträger der Stadt Goslar 2007*, Mönchehaus-Museum, Goslar. *Matthew Barney*, Serpentine Gallery, London. *Mythos: Joseph Beuys, Matthew Barney, Douglas Gordon, Cy Twombly*, Kunsthaus Bregenz **2006** *Barney Beuys*, Deutsche Guggenheim, Berlin **2005** *Matthew Barney: Drawing Restraint*, 21st Century Museum of Contemporary Art, Kanazawa

SELECTED PUBLICATIONS →
2008 *Matthew Barney. Drawing Restraint Vol. 5*, Verlag der Buchhandlung Walther König, Cologne. *Matthew Barney*, Sammlung Goetz, Munich **2007** *Matthew Barney*, Mondadori, Milan. *Matthew Barney: Träger des Goslarer Kaiserrings 2007*, Mönchehaus-Museum, Goslar. *Mythos: Joseph Beuys, Matthew Barney, Douglas Gordon, Cy Twombly*, Kunsthaus Bregenz, Bregenz **2006** *Barney Beuys: All in the Present Must Be Transformed*. Deutsche Guggenheim, Berlin; Hatje Cantz, Ostfildern

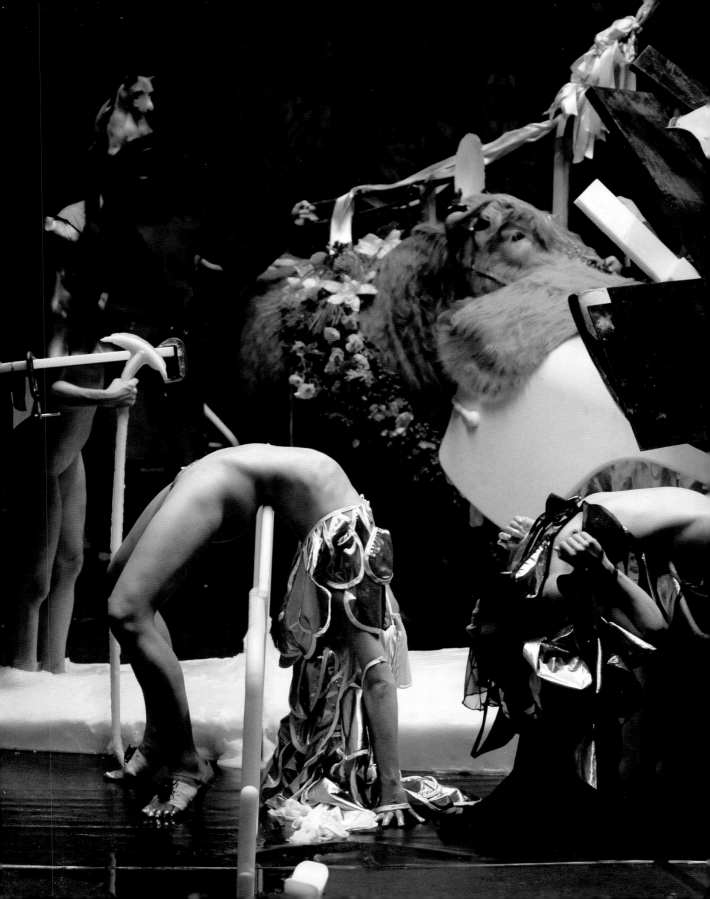

1 **Guardian of the Veil**, 2007, in collaboration with Jonathan Bepler
2–4 **Drawing Restraint 9**, 2005, production stills

„Ich glaube, bei vielen Entscheidungen in Bezug auf Dauer und Gewichtung geht es darum, einen Organismus darzustellen, der seinen eigenen Puls und sein eigenes Verhalten hat. Und das ist es, was mich immer wieder zum Medium Film zurückbringt."

« Je pense qu'un grand nombre de décisions prises sur le plan de la durée et de l'équilibre participent d'un effort de décrire un organisme ayant son propre pouls et son propre comportement. C'est ce qui me fait sans cesse revenir au procédé cinématographique. »

"I think a lot of the decisions that are made in regards to duration and balance are about trying to describe an organism that has its own pulse and that has its own behaviour. It's something that keeps me coming back to the filmmaking process."

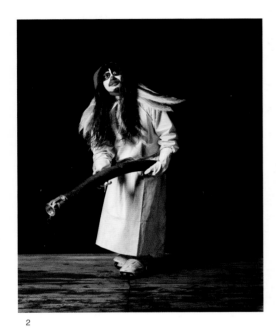

2

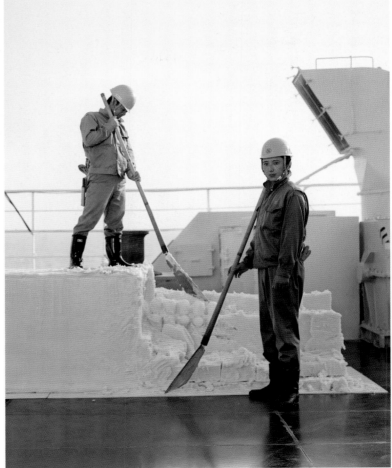

3

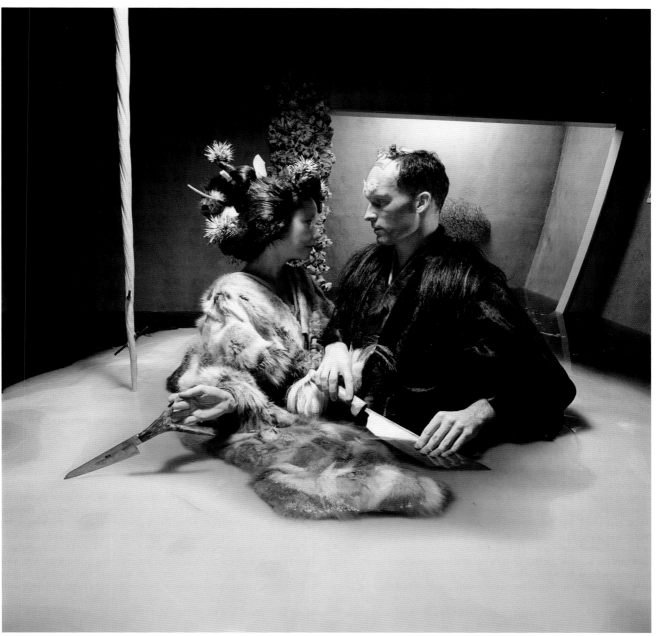

Tim Berresheim

1975 born in Heinsberg, lives and works in Cologne, Germany

Tim Berresheim's large-scale computer prints run counter to conventional viewing habits and genre-based thinking in a number of ways. A former student of Albert Oehlen's, he combines painting and photography, using digital means to brush both the wrong way, and happily overstepping boundaries of taste. Juggling media is part of his approach: it prevents any clear classification. Berresheim uses "new media", but by making them a playing field for issues of painting, photography and the conditions of image production, he is employing them in an artistically countercyclical manner. The visual range of his work is large, the combinations obscure and the style based on contrasts. Berresheim clearly refers to the traditions of abstract painting, his sweeping gestures occasionally recalling Hans Hartung. But his works can't be pinned down with what initially seem to be such obvious attributions. Tachist-style traces reveal themselves to be a loosely composed tangle of colourful strings, which is occasionally taken to the extreme of absurd abstract realism, for example when brushstrokes become an oversized bundle of strands of hair. In *Haar SW (Foto 1)* (2007) Berresheim transports this motif into the photographic realm. The surreal undertones are pushed even further in his figuration: Berresheim frequently uses collage to combine the incompatible in one image, in the best surrealist style, and his themes also draw on surrealism. The artificiality of the both sexless and hyper-sexualized mannequins in a staged setting ventures beyond the thematic scope of Dalí or Bellmer. In Berresheim's work, everything depends on the irritation being effective without being grasped.

Tim Berresheims großformatige Computerprints verlaufen in mehrfacher Hinsicht quer zu eingespielten Sehgewohnheiten und Gattungsvorstellungen. Der Albert-Oehlen-Schüler verquickt Malerei mit Fotografie, bürstet beides mit Mitteln des Computers gegen den Strich und überdehnt dabei gern gängige Geschmacksgrenzen. Schon der mediale Spagat ist Teil der Haltung, er verhindert eine klare Zuordnung. Berresheim nutzt die sogenannten Neuen Medien, doch indem er sie zum Spielfeld für Fragen der Malerei, der Fotografie und der Bedingungen von Bildproduktion macht, setzt er sie künstlerisch gleichsam antizyklisch ein. Die visuelle Spannweite ist groß, die Mischungen obskur, der Stil am Widerständigen orientiert. So klinkt sich Berresheim offensichtlich in die Traditionen der abstrakten Malerei ein, sein schwungvoller Gestus lässt zuweilen an Hans Hartung denken. Doch bleiben die Arbeiten nicht stehen bei diesen auf den ersten Blick so einleuchtenden Zuordnungen. Da entpuppen sich tachistische Pinselspuren bald als ein locker komponiertes Gewirr farbiger Schnüre, das mitunter zum absurden Abstrakto-Realismus zugespitzt wird, wenn etwa der Pinselschwung als überdimensionale Bündelung von Haarsträhnen daherkommt. In *Haar SW (Foto 1)* (2007) versetzt Berresheim das Motiv dann in den fotografischen Realraum. Das hat surreale Untertöne, die in der Figuration weiter ausgereizt werden: Berresheim nutzt häufig die Collage, um in bester surrealistischer Manier Unvereinbares zu einem Bild zusammenzuführen, wobei er sich durchaus auch motivisch auf den Surrealismus bezieht. Die Künstlichkeit der so geschlechtslosen wie übersexualisierten Schaufensterpuppen in bühnenhafter Inszenierung übersteigert die Motivik eines Dalí oder Bellmer. Bei Berresheim kommt alles darauf an, dass Irritation greift und doch nie wirklich greifbar wird.

Les impressions grand format que Tim Berresheim réalise sur ordinateur vont de diverses façons à contre-courant des habitudes visuelles et des genres établis. L'élève d'Albert Oehlen mélange peinture et photographie, prend les deux médiums à rebrousse-poil et malmène volontiers les frontières du goût. Ce grand écart relève déjà en soi d'une prise de position en empêchant tout classement univoque. Berresheim exploite en effet les possibilités des « nouveaux médias », mais dans la mesure où ceux-ci deviennent le terrain de jeu de questions picturales, photographiques et, plus généralement, liées à la production d'images, leur utilisation artistique est pour ainsi dire anticyclique. Le spectre visuel est vaste, les mélanges sont difficilement identifiables, le style s'appuie sur la résistance. Ainsi, Berresheim prend manifestement en marche le train de la tradition abstraite. Sa dynamique gestuelle rappelle parfois Hans Hartung, mais ses œuvres ne s'arrêtent pas à ces références apparemment si évidentes. Des traces de pinceau tachistes s'avèrent bientôt être la composition légère d'un fouillis de ficelles colorées que l'artiste pousse parfois jusqu'à un abstracto-réalisme absurde, par exemple quand le coup de pinceau se présente comme un faisceau surdimensionné de mèches de cheveux. Dans *Haar SW (Foto 1)* (2007), Berresheim transpose alors le motif dans l'espace réel de la photographie, produisant des connotations surréelles qu'il exacerbe ensuite dans la figuration, se servant souvent du collage pour réunir des éléments inconciliables dans la plus pure tradition surréaliste et n'hésitant pas à se référer au surréalisme pour ses motifs. L'artificialité de mannequins aussi asexués qu'hypersexualisés en leur mise en scène théâtrale exacerbe l'iconographie d'un Dalí ou d'un Bellmer. Chez Berresheim, tout concourt à ce que la perturbation soit aussi réelle qu'intangible.

J. A.

SELECTED EXHIBITIONS →
2008 *Vertrautes Terrain – Aktuelle Kunst in und über Deutschland*, ZKM, Karlsruhe. *INSIDE* (with Matthias Schaufler), Galerie Hammelehle und Ahrens, Cologne. *Regarding Düsseldorf 3*, arteversum, Düsseldorf **2008** *Leg Show* (with Albert Oehlen and Matthias Schaufler), Patrick Painter Inc., Santa Monica **2006** *Psycho*, Kunstverein Mönchengladbach **2005** *FYW: Tim Berresheim und Thomas Arnolds*, UBERBAU, Düsseldorf

SELECTED PUBLICATIONS →
2008 *Vertrautes Terrain – Aktuelle Kunst in und über Deutschland*, ZKM, Karlsruhe **2006** *Psycho*, Kunstverein Mönchengladbach, Mönchengladbach

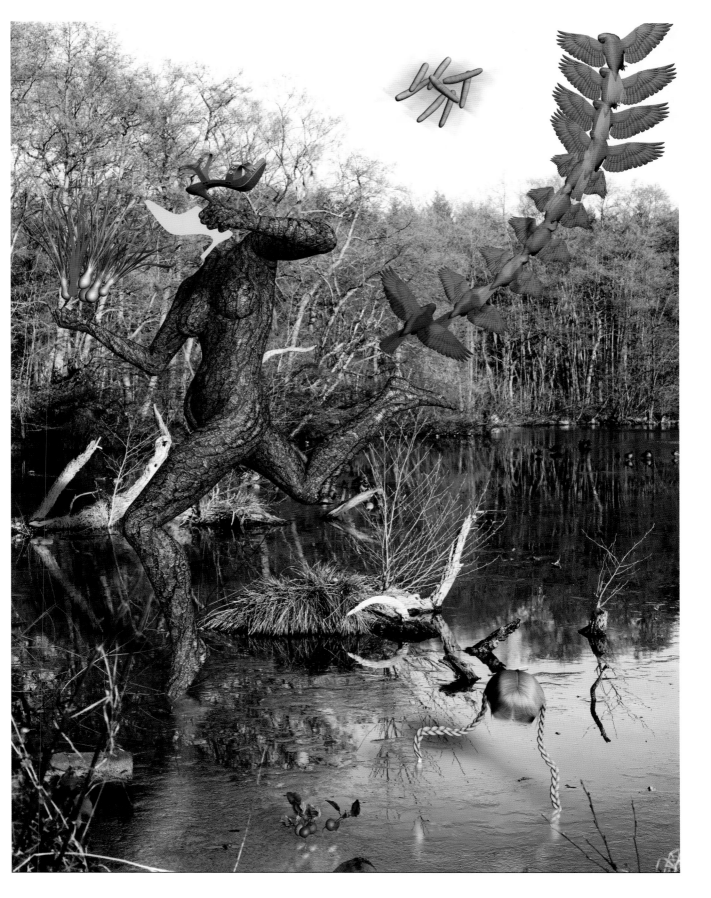

1 **RGB (Questionmark) Foto I**, 2008, photograph, 235 x 180 cm
2 **O.T.**, 2007, print on wood, 220 x 180 cm
3 **Haar SW (Foto) I**, 2007, photograph, 240 x 180 cm

4 **Hermetik I**, 2005, diptych, computer print on PVC, 2 plates, 200 x 180 cm (each)
5 **RGB (Questionmark) Foto II**, 2008, photograph, 235 x 310 cm

„Beim Arbeiten mit dem Computer besteht gegenüber den Möglichkeiten in der Malerei eine gigantische Chance, neue Bilder zu machen. Bilder entgegen der Sehgewohnheiten – um sich selber zu überraschen. Wenn man vor der Leinwand steht, überrascht man sich ja so schnell nicht mit einem Pinselstrich."

« Comparé aux possibilités de la peinture, le travail par ordinateur offre la chance inouïe de pouvoir réaliser des images inédites, des images qui contredisent les habitudes visuelles – afin de se surprendre soi-même. Devant la toile en effet, on ne se surprend pas si vite avec un trait de pinceau. »

"Unlike in painting, working with a computer offers a vast opportunity to create new pictures – pictures that confound viewing patterns – to surprise yourself with. When you stand in front of a canvas, you can't surprise yourself that fast with a brushstroke."

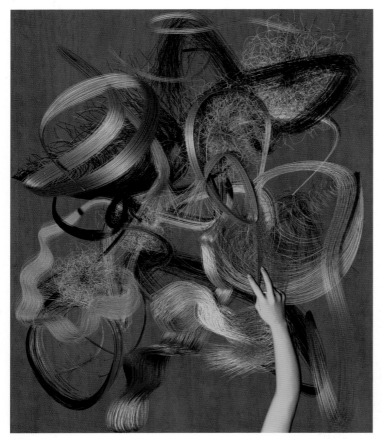

2

3

4

Cosima von Bonin

1962 born in Mombasa, Kenya, lives and works in Cologne, Germany

Cosima von Bonin is a "prominent representative of conceptual art who works with textiles, films, installations and social relations, among other media," according to wikipedia.de. This may sound rather vague and arbitrary, but in its very openness it hits the nail on the head. Von Bonin combines different genres, materials and social networks to produce striking imagery. Throughout her career she has used collaboration with other artists as a creative process, even going so far as to cede exhibitions to them (*Ingeborg Gabriel*, 1992) – but still, it must be noted, as her own work. Social coding is thus an integral part of her oeuvre. In recent works, the exploration of textile processes, sculpture and the aesthetics of architecture and design has become increasingly central to her practice. Her use of materials entails the displacement and association of diverse cultural codes: combining patterned fabrics by Laura Ashley or Hermès into a soft tableau, or turning plain grey or black cloth into plump sculptures of dogs. Hers is a patchwork minimalism that crosses modernist gestures with fashionable expressions to create its own ironic idiom. Lately this has included cartoon-like animal figures and reduced plots, as in *Deprionen, A Voyage to the Sea* (2006). The combination of formalism and pop is characterized by an expressive diversity of material. Von Bonin also incorporates her works into installations such as *Relax – It's Only a Ghost* (2006), last shown at Documenta 12, or *Roger and Out* (2007). Providing diverse outlooks and insights, her displays include obstacles or enclosures – hurdles that have to be overcome before the viewer can enjoy the experience.

Cosima von Bonin ist „eine prominente Vertreterin der Konzeptkunst und arbeitet u.a. mit Textilien, Filmen, Installationen und sozialen Beziehungen", weiß wikipedia.de. Das klingt vage zusammengewürfelt, trifft in dieser Offenheit aber durchaus zu. Denn indem von Bonin ganz unterschiedliche Gattungen, Materialien sowie soziale Netzwerke verknüpft, schafft sie eine markante Bildwelt. Von Beginn an nutzte von Bonin die Zusammenarbeit mit Künstlern als Verfahren und ging dabei sogar so weit, ihnen den Auftritt gleich komplett zu überlassen (*Ingeborg Gabriel*, 1992). Als eigene Arbeit, wohlgemerkt. Soziale Codierung wird so zum Werkbestandteil. In ihren neueren Arbeiten steht die Auseinandersetzung mit textilen Verfahren, Skulptur sowie Design- und Architekturästhetik im Zentrum. Ihr Umgang mit Material setzt dabei auf Verschiebung und Verknüpfung diverser kultureller Codes. Da werden etwa gemusterte Stoffe von Laura Ashley oder Hermès zum soften Tafelbild oder schlichtes Grau und Schwarz zu pummeligen Hundeskulpturen (2006) vernäht: Ein Patchwork-Minimalismus, der Attitüden der Moderne karikierend mit Modismen kreuzt und daraus ein eigenes ironisches Idiom gewinnt. Darin tauchen neuerdings verstärkt comichafte Tierfiguren und ein reduzierter Plot auf, etwa in *Deprionen, A Voyage to the Sea* (2006). Die Kombination von Formalismus und Pop ist gekennzeichnet von effektvoller Materialvielfalt, wobei von Bonin ihre Arbeiten in Displays einbindet, etwa bei der zuletzt auf der Documenta 12 gezeigten Installation *Relax – It's Only a Ghost* (2006) oder bei *Roger and Out* (2007). Die Displays vermitteln Aus- und Einsichten, nehmen die Form von Hindernissen und Gattern an und erzeugen somit Ausstellungsbedingungen, die sich der Betrachter erst erobern muss.

Cosima von Bonin, « représentante majeure de l'art conceptuel, travaille notamment avec des tissus, des films, des installations et des contextes sociaux », nous apprend wikipedia.de. Si cette description plutôt vague s'apparente à un pêle-mêle, elle n'en est pas moins pertinente par son ouverture. En combinant médiums, matériaux et réseaux sociaux hétéroclites, von Bonin construit des univers visuels marquants. Dès ses débuts, l'artiste a exploité la collaboration avec d'autres comme un procédé créatif, poussant même la démarche jusqu'à leur laisser toute la place (*Ingeborg Gabriel*, 1992) – comme un travail personnel, s'entend. Le codage social devient ainsi une composante de l'œuvre. Dans son travail récent, l'accent porte plutôt sur la confrontation avec des procédés textiles, des sculptures, l'esthétique du design et de l'architecture. Le maniement des matériaux mise sur le décalage et le mélange des codes culturels : des tissus de grands couturiers deviennent des tableaux mous, un simple tissu gris ou noir devient une sculpture canine potelée (2006), patchwork minimaliste qui croise caricaturalement les modes et les positions de la modernité pour en tirer un idiome personnel ironique. Récemment apparaissent de plus en plus souvent des figures animales proches de la BD et des intrigues embryonnaires comme dans *Deprionen, A Voyage to the Sea* (2006). La combinaison entre formalisme et pop est caractérisée par une efficiente diversité de matériaux, sachant que von Bonin confine ses œuvres dans des présentoirs, comme on l'a vu à la Documenta 12 avec l'installation *Relax – It's Only a Ghost* (2006) ou avec *Roger and Out* (2007). Les présentoirs créent des vues extérieures et intérieures, prennent la forme d'obstacles ou de clôtures et créent des conditions d'exposition que le spectateur doit d'abord s'approprier.

J. A.

SELECTED EXHIBITIONS →
2008 *Betwixt*, Magasin 3 Stockholm Konsthall, Stockholm. *Vertrautes Terrain – Aktuelle Kunst in und über Deutschland*, ZKM, Karlsruhe **2007** *Cosima von Bonin: Roger and Out*, MOCA, Los Angeles. Documenta 12, Kassel **2006** *Make Your Own Life: Artists in and out of Cologne*, ICA, Philadelphia; The Power Plant, Toronto; Henry Art Gallery, Seattle; MOCA, North Miami **2005** *It takes some time to open an oyster*, Centro Cultural Andratx **2004** *Cosima von Bonin*, Kölnischer Kunstverein, Cologne

SELECTED PUBLICATIONS →
2008 Christian Jankowski, *Cosima von Bonin, Ai Weiwei*, Parkett 81, Zürich. *Vertrautes Terrain – Aktuelle Kunst in und über Deutschland*, ZKM, Karlsruhe **2007** *Cosima von Bonin: Roger and Out*, MOCA, Los Angeles; Verlag der Buchhandlung Walther König, Cologne. *Documenta 12 Catalogue*, Taschen, Cologne **2006** *Make Your Own Life: Artists in and out of Cologne*, ICA, Philadelphia

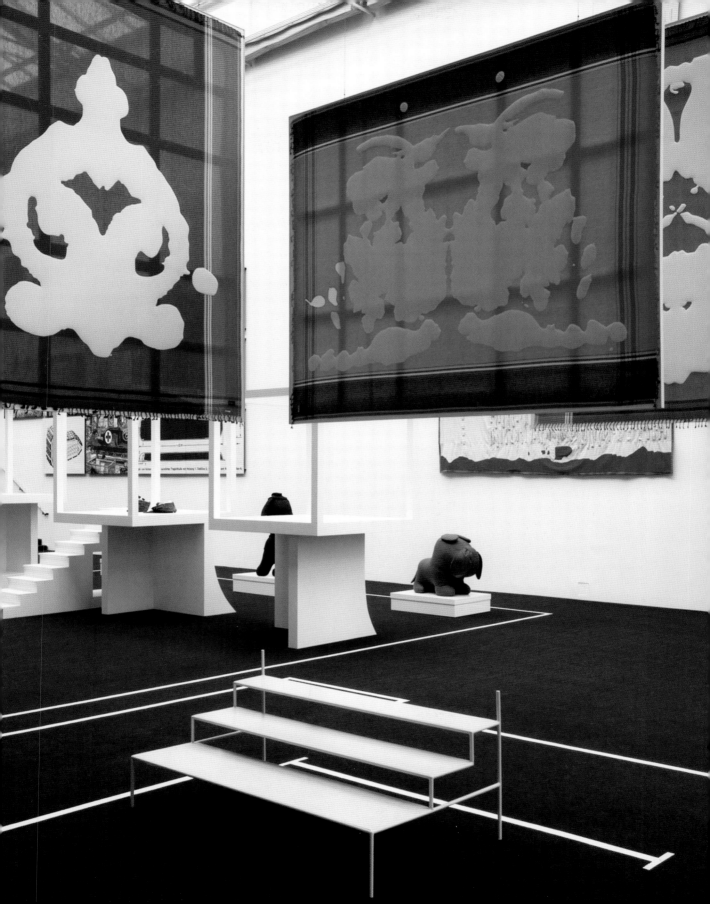

1 Installation view, Documenta 12, Kassel, 2007
2 **Deprionen, A Voyage to the Sea**, 2006, cotton, linen, 319 x 357 cm
3 **Reference Hell #2 (Mighty Mouse)**, 2007, powdercoated steel, soft toy,
 170 x 150 x 90 cm

4 **Decoy (Der Krake #3)**, 2007, mixed media, 65 x 235 x 330 cm
5 **England (Hut #1)**, 2007, lacquered wood panels, roofing cardboard,
 196 x 162 x 162 cm. Installation view, *Cosima von Bonin: Roger and Out*,
 MOCA, Los Angeles, 2007/08

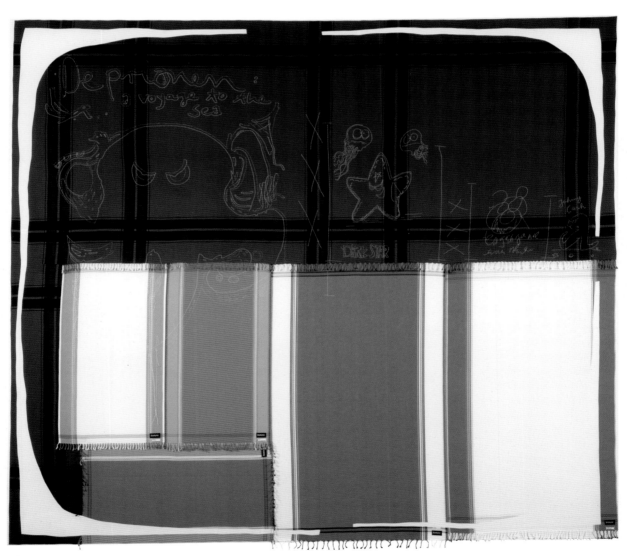

2

3

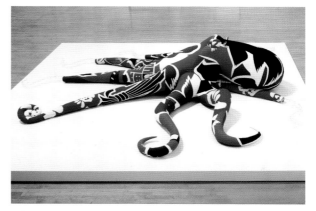

4

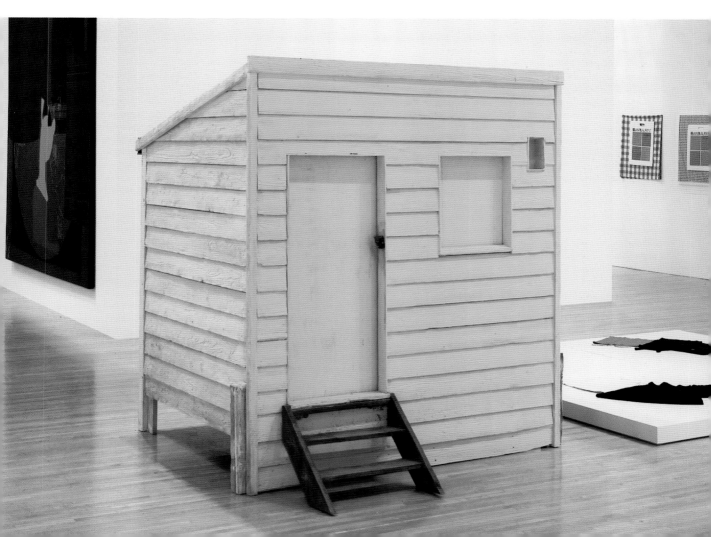

Monica Bonvicini

1965 born in Venice, Italy, lives and works in Berlin, Germany

Monica Bonvicini's artworks have a distinctly martial character. This applies not only to the materials used in her installations and text pieces – steel chains, metal bars, leather and broken glass – but also to aspects of her videos, such as a naked actress rubbing her crotch along a wall. In 2005, Bonvicini won the "Preis der Nationalgalerie für junge Kunst" with the installation *Never Again*, where leather mats on steel chains hung down from a metal scaffold installed in the exhibition space, unmistakeably evoking S&M practices. This is not the only work by Bonvicini characterized by a certain aggressiveness: in the text piece *no erection without castration* (2006), the words appear on safety glass that seems to have been riddled with bullets. Likewise the monumental *Not For You* (2006), which confronts the viewer with its prohibitive message. Aggressiveness, sexuality and the reclamation of space are key themes in Bonvicini's work, through which she seeks to create interfaces between the post-feminist discourse of power construction and architectural theories on the social functions of space. She repeatedly explores spaces – above all spaces that have been determined and designed by men – from a gendered perspective, pointing up their gender specificity and thus transforming them. In this respect, the martial aspect of her work is not an end in itself, but a sign of the force required to intervene in and change male-dominated spaces. *Built for Crime* (2007) is the title of another monumental text piece, installed in the central hall of a museum. The text is an apt summary of her fundamental artistic concerns: what crimes are being committed here, by whom and in whose name?

Martialisch geht es zu in den Werken von Monica Bonvicini. Das betrifft Materialien ihrer Installationen und Textkunstwerke – Stahlketten, Metallgitter, Leder und zerborstenes Glas –, aber auch Elemente ihrer Videos wie eine nackte Schauspielerin in sexuellem Kontakt mit einer Wand. 2005 gewann Bonvicini den „Preis der Nationalgalerie für junge Kunst" mit der Installation *Never Again*. Von einem Gerüst hingen Ledermatten an Stahlketten in den Ausstellungsraum hinab, unverkennbar Sado-Maso-Praktiken evozierend. Eine gewisse Agressivität kennzeichnet nicht nur diese Arbeit Bonvicinis. Bei dem Textkunstwerk *no erection without castration* (2006) steht die Schrift auf wie von Schüssen durchsiebtem Sicherheitsglas. Ähnlich verhält es sich bei dem monumentalen Textkunstwerk *Not For You* (2006), das den Betrachter erst einmal mit einem Ausschlussbann belegt: nicht für dich! Aggressivität, Sexualität, Raumreklamation – das sind bereits wesentliche Kennzeichen von Bonvicinis Arbeiten. Dabei versucht sie, Schnittstellen zu schaffen zwischen dem post-feministischen Diskurs zu Machtkonstruktionen und architekturtheoretischen Überlegungen zu sozialen Funktionen des Raums. Immer wieder gelingt es ihr, Raum, insbesondere vorgegebenen Raum, der von Männern entwickelt wurde, mit einer Genderperspektive zu wenden, seine Geschlechtsspezifität aufzuzeigen und zu transformieren. Insofern ist das Martialische nicht Selbstzweck, sondern Zeichen der Kräfte, die aufzuwenden sind, um in männlich dominierte Räume einzugreifen und diese zu verändern. *Built for Crime* (2007) lautet der Titel eines weiteren monumentalen Textkunstwerkes, installiert in der zentralen Halle eines Museums. Der Text liefert eine gute Zusammenfassung ihrer Ansätze: Wer begeht hier in wessen Namen welche Verbrechen?

Dans les œuvres de Monica Bonvicini, les choses se passent de façon martiale. Ceci vaut pour les matériaux de ses installations et de ses œuvres textuelles – chaînes en acier, grilles métalliques, cuir et verre éclaté – comme pour les éléments de ses vidéos lorsqu'une actrice nue entre en contact sexuel avec un mur. En 2005, Bonvicini recevait pour son installation *Never Again* le Prix de la Nationalgalerie de Berlin pour les jeunes artistes. Des tapis de cuir suspendus à des chaînes d'acier y pendaient dans un échafaudage, évoquant clairement des pratiques sado-masochistes. Cette œuvre n'est pas la seule à dénoter une certaine dose d'agressivité. Dans *no erection without castration* (2006), l'inscription couvre un verre de sécurité qui semble être percé d'impacts de balles. Il en va de même dans l'œuvre textuelle monumentale *Not For You* (2006), qui frappe d'exclusion le spectateur: pas pour toi! Agressivité, sexualité, revendication spatiale sont les caractéristiques essentielles des œuvres de Bonvicini. L'artiste tente d'y créer des interfaces entre le discours post-féministe sur les structures du pouvoir et les théories de l'architecture sur la fonction sociale de l'espace. Elle parvient régulièrement à détourner l'espace – plus particulièrement l'espace prédéterminé par les hommes – en le connotant d'une perspective sexuée, et à mettre en évidence et transformer sa polarisation sexuelle. Le caractère martial n'est donc pas une fin en soi, mais un signe des forces qui doivent être mises en œuvre pour pouvoir intervenir dans l'espace dominé par les hommes et le modifier. *Built for Crime* (2007) est le titre d'une autre œuvre monumentale installée dans un hall de musée. Le texte en résume bien l'approche de Bonvicini: qui commet ici quel crime et au nom de qui?

H. L.

SELECTED EXHIBITIONS →
2008 *Prospect 1*, New Orleans. *Publiek*, Sculpture International Rotterdam. *Female Trouble*, Pinakothek der Moderne, Munich. *The Museum as Medium*, MARCO, Vigo. *Art against Architecture*, National Gallery of Island, Reykjavik **2007** *Monica Bonvicini*, Bonniers Konsthall, Stockholm. *Monica Bonvicini*, Sculpture Center, New York **2006** *How to Live Together*, 27th São Paulo Biennial, São Paulo. *Jenseits des Kinos. Die Kunst der Projektion*, Hamburger Bahnhof, Berlin

SELECTED PUBLICATIONS →
2008 *Monica Bonvicini: Cut*, Verlag der Buchhandlung Walther König, Cologne **2007** *Plötzlich diese Übersicht. Was gute zeitgenössische Kunst ausmacht*, Claassen, Berlin **2006** *Jenseits des Kinos. Die Kunst der Projektion*, Hamburger Bahnhof, Berlin; Hatje Cantz, Ostfildern. *Under Construction – Perspektiven institutioneller Praxis / On Institutional Practice*, Verlag der Buchhandlung Walther König, Cologne **2005** *Monica Bonvicini, Richard Prince, Urs Fischer, Parkett 72*, Zürich

1/2 **Don't Miss a Sec**, 2003/08, two-way mirror structure, stainless-steel, toilet unit, concrete floor, aluminium, fluorescent lights, 250 x 140 x 190 cm
3 **no erection without castration**, 2006, enamel on broken safety glass, 122.9 x 166.1 x 1.3 cm

4 **Never Again**, 2005/08, leather, chains, rack, dimensions variable
5 **Not For You**, 2006, iron scaffolding, alucore dibond letters, aluminium frame, 40W bulbs, dimmer packs, lan box, cables, 230 x 1388 cm

„Ein Gebäude ist wie ein Container – etwas, das als Barriere fungiert und sich dir in den Weg stellt. Ehrlich gesagt wäre es schön, wenn es keine Gebäude gäbe. Wenn ich in der Nacht auf die Straße gehe und in die behaglich erleuchteten Wohnungen sehe, überkommt mich ein Ekelgefühl."

« Un immeuble est comme un container – quelque chose qui fonctionne comme une barrière et qui se met en travers de ta route. En fait, ce serait bien qu'il n'y ait pas du tout d'immeubles. Quand je marche dans la rue la nuit et que je vois les appartements avec leurs éclairages douillets à l'intérieur, je suis prise de dégoût. »

"A building is a container, something that acts as a barrier and stays in your way. Actually, it would be nice not to have any buildings. When I walk down the street at night and look into the apartments with the cosy lights on inside, a feeling of disgust hits me."

2

3

Cecily Brown

1969 born in London, United Kingdom, lives and works in New York (NY), USA

Cecily Brown's paintings slip almost imperceptibly between paint and depicted form, figuration and utter abstraction. The artist conjures bodily tempests that owe as much to Willem de Kooning (who, after all, lasciviously maintained that "flesh was the reason oil paint was invented") as to other strange bedfellows – Goya and Velázquez, Poussin and Cézanne, Francis Bacon and John Currin. Despite the startlingly precocious degree to which Brown has assimilated these historical and contemporary references, her distinctly irony-free approach is neither subtended by Oedipal fantasies nor subdued by an anxiety of influence. If anything, Brown has painted as she sees fit, transmuting paint into viscous bodily matter wherever she can: teeth and abject thighs, glimpses of lovers in various stages of copulation, orgies and climaxes exist alongside winged phalluses, supine nudes, pastoral landscapes, sylvan bacchanals and even a feverish celebration of a woman's new shoes, the aptly titled *New Louboutin Pumps* (2005). As this painting makes clear, the cheap thrills of the bad girl sex scenes for which she gained notoriety (following quickly on the heels of her 1997 exhibition of "bunny gang rape" paintings) have not gone away. But they are interspersed with other themes; beacons of mortality and intimations of the passage of time have crept in, and many recent paintings are altogether ambiguous in their subject. *The Picnic* (2006) nods to Manet's *Le Déjeuner sur l'herbe* (1862/63), but this triptych displays the meal's – and by extension modernism's – aftermath, platters and bowls askew. We might have come too late to the party, but there is still something to savour.

Cecily Browns Bilder changieren beinahe unmerklich zwischen Farbe und dargestellter Form, Figuration und völliger Abstraktion. Die Künstlerin zeigt uns körperliche Stürme, die Willem de Kooning (der doch lüstern behauptete, dass Fleisch der einzige Grund sei, warum die Ölfarbe erfunden wurde) ebenso viel verdanken wie anderen seltsamen Bettgenossen – Goya und Velázquez, Poussin und Cézanne, Francis Bacon und John Currin. Obwohl Brown sich verblüffend frühreif diese geschichtlichen und zeitgenössischen Bezüge aneignete, ist ihr bewusst ironiefreier Ansatz weder von ödipalen Fantasien begleitet noch von Einflussängsten gedämpft. Eindeutig malt Brown ganz wie es ihr gefällt und verwandelt Farbe in zähflüssige Körpermaterie, wo immer sie kann: Zähne und unterwürfige Schenkel, Blicke auf Liebende in verschiedenen Phasen des Geschlechtsverkehrs, Orgien und Orgasmen neben geflügelten Phalli, auf dem Rücken liegenden Nackten, pastoralen Landschaften, Waldbacchanalen und sogar einer fiebrigen Hommage an ein Paar neuer Frauenschuhe, die entsprechend *New Louboutin Pumps* (2005) betitelt ist. Wie dieses Bild zeigt, gehören die billigen Kicks der Böse-Mädchen-Sexszenen, mit denen sie (kurz nach der Ausstellung ihrer *bunny gang rape*-Bilder 1997) berühmt wurde, noch nicht der Vergangenheit an. Aber sie werden jetzt mit anderen Themen durchsetzt; Signale der Sterblichkeit und Andeutungen einer schnell vergehenden Zeit sind eingedrungen, und viele von Browns jüngsten Bildern sind in ihrem Gegenstand völlig uneindeutig. *The Picnic* (2006) verneigt sich vor Manets *Le Déjeuner sur l'herbe* (1862/63), aber dieses Triptychon zeigt im Durcheinander der Platten und Schüsseln die Nachwirkungen des Essens – und gleichzeitig des Modernismus. Aber obwohl wir zu spät zur Party gekommen sind, gibt es noch immer etwas zu genießen.

Les toiles de Cecily Brown oscillent imperceptiblement entre peinture et forme peinte, entre figuration et pure abstraction. L'artiste fait surgir des tempêtes charnelles qui doivent autant à Willem de Kooning (qui, après tout, affirmait lascivement que « la peinture à l'huile a été inventée pour peindre la chair ») qu'à d'autres compagnons inattendus – Goya et Velázquez, Poussin et Cézanne, Francis Bacon et John Currin. Malgré l'étonnante précocité qui a permis à Brown d'assimiler ces références historiques et contemporaines, son approche originale, résolument dénuée d'ironie, n'est nullement sous-tendue par des fantasmes œdipiens ni écrasée par l'angoisse d'une telle filiation. En réalité, Brown peint comme elle l'entend, transmue la peinture en une matière corporelle visqueuse à la moindre occasion : dents et cuisses abjectes, amants saisis dans différentes positions de copulation, orgies et orgasmes, coexistent avec des phallus ailés, des nus alanguis, des paysages de pastorale, des bacchanales sylvestres, ou même un vibrant hommage à des escarpins neufs dans *New Louboutin Pumps* (2005). Comme le prouve cette toile, le côté aguicheur de son travail avec ses scènes figurant des filles délurées qui a fait sa notoriété (depuis l'exposition en 1997 de toiles représentant filles provocantes et viols collectifs) n'a pas tout a fait disparu. Mais d'autres thèmes sont venus s'y ajouter : la mort et le passage du temps ont fait leur apparition dans son œuvre, et de nombreuses toiles récentes manifestent une ambiguïté thématique croissante. *The Picnic* (2006) est un clin d'œil au *Déjeuner sur l'herbe* de Manet (1862/63), mais ce triptyque s'attache à montrer ce qui reste après le déjeuner (assiettes et bols renversés), et par extension après le modernisme. Nous sommes peut-être arrivés une fois la fête terminée, mais on peut quand même encore en profiter.

S. H.

SELECTED EXHIBITIONS →
2008 *Garten Eden*, Städtische Galerie Bietigheim-Bissingen; Kunsthalle Emden **2007** *INSIGHT?*, Gagosian Gallery / Red October Chocolate Factory, Moscow. *True Romance*, Kunsthalle Wien, Vienna **2006** *Cecily Brown*, Museum of Fine Arts, Boston. *The Triumph of Painting 5*, Saatchi Gallery, London. *Full House*, Kunsthalle Mannheim **2005** *Cecily Brown*, Kunsthalle Mannheim. *Cecily Brown: Paintings*, Museum of Modern Art, Oxford.

SELECTED PUBLICATIONS →
2008 *Cecily Brown*, Rizzoli, New York **2007** *Extremes & In-Betweens*, Dorsky Gallery, New York. *INSIGHT?*, Gagosian Gallery, New York **2006** *Cecily Brown: Paintings 2003–2006*, Gagosian Gallery, New York. *Cecily Brown*, Des Moines Art Center, Des Moines; Museum of Fine Arts, Boston **2005** *Cecily Brown*, Museum of Modern Art, Oxford

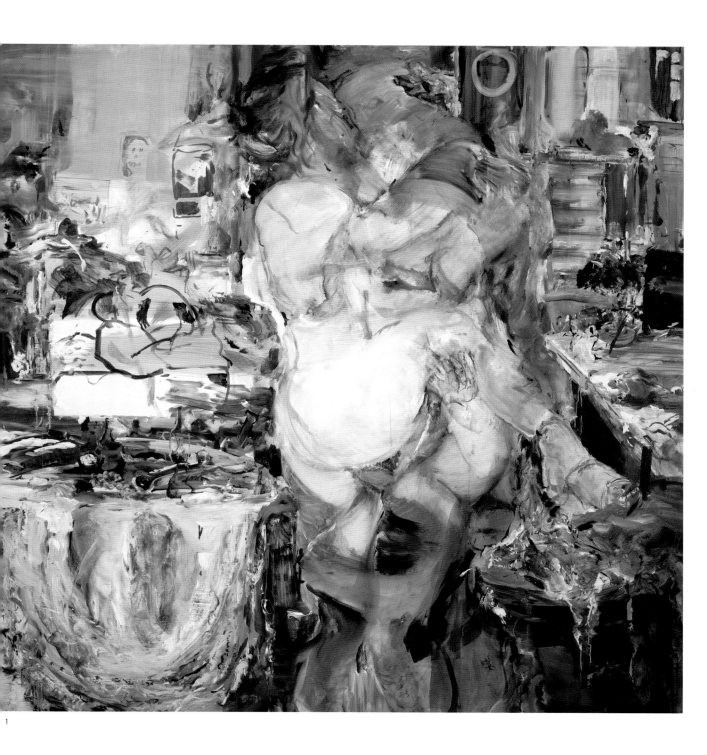

1

1　**New Louboutin Pumps**, 2005, oil on linen, 205.7 x 204.5 cm
2　**The Picnic**, 2006, oil on linen, 246.4 x 312.4 cm

3　**The Adoration of the Maid**, 2006, oil on linen, 198.1 x 198.1 cm

„Für mich ist die Kunst der Vergangenheit nichts Fernliegendes. Wenn man in ein Museum geht, ist sie heute da. Ich liebe die Freiheit, all diese Künstler nebeneinander in meinem Kopf zu haben: In einem Moment denkt man vielleicht an Jeff Koons und im nächsten dann an Giotto."

« Pour moi l'art du passé n'est pas si éloigné. Ce qui est exposé dans un musée est bien là, aujourd'hui. C'est une merveilleuse liberté que d'avoir tous ces artistes côte à côte dans la tête ; on est en train de penser à Jeff Koons, et une minute après on pense à Giotto. »

"I don't really think of the art of the past as distant. If you go into a museum, it's there today. One of the things I love is the freedom of having all these artists in your head side by side; you might find yourself thinking of Jeff Koons one minute and Giotto the next."

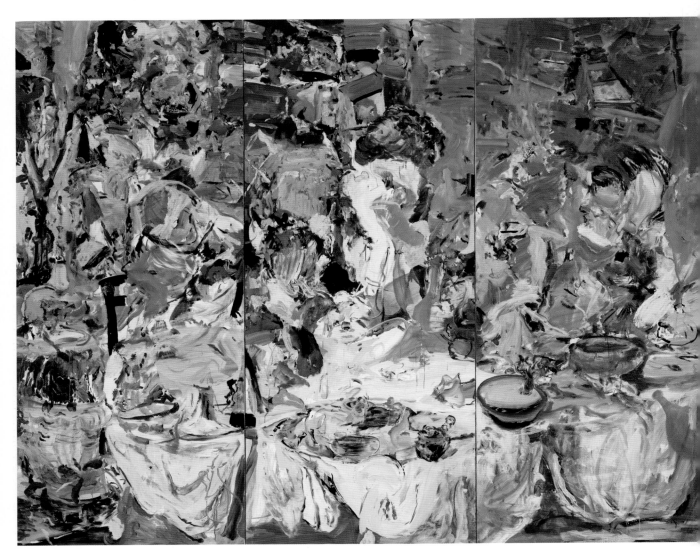

2

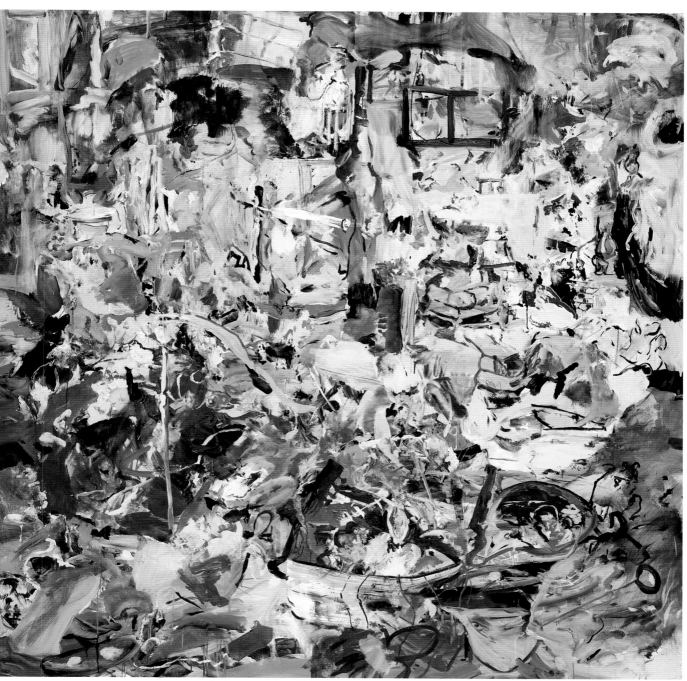

3

Glenn Brown

1966 born in Hexham, lives and works in London, United Kingdom

In Glenn Brown's paintings, the beautiful and the ugly, the familiar and the visionary are inextricably interwoven, creating associations that exude an almost magical fascination. Brown borrows motifs from the Old Masters such as Rembrandt, Fragonard or El Greco, but also from more recent painters like Auerbach and Dalí, as well as from science fiction illustrators. But Brown doesn't just quote, he comments and travesties: using anamorphosis, inversion and combination, he turns his source material into the stuff of dreams – and nightmares. Brown adds another twist to the postmodern game in that he borrows titles as well as source images from art history. *The Great Masturbator* (2006), for example, owes its title to a work by Dalí, although the image is based on Murillo's *Laughing Boy with a Feather-Adorned Headdress* (1655). The Spanish baroque painter's motif is steered sharply towards the burlesque by Brown: the laughing youth acquires a greenish complexion, streaky skin, blue eyeballs and black pupils, giving him a sickly gruesome look. But Brown paints his subject with such virtuosity that the beauty of the painting and the morbidity of its appearance challenge and surpass one another. His typically rich, impasto painting style is in fact elaborate *trompe l'oeil* – the clearly discernible and apparently virtuoso swirls of paint are actually created with fine brushstrokes that are barely visible under the smooth surface, recalling Dalí's expert command of Old Master painting techniques. The dramatic handling of colour and paint conveys extreme artificiality and carnal deterioration, deliberately bestowing, for example, the impression of bloated, rotting viscosity upon a bare skeleton. Brown's expertise aims at radical ambivalence, at disillusioning by means of illusion.

In Glenn Browns Malerei sind das Schöne und das Hässliche, das Bekannte und das Visionäre untrennbar verflochten, wobei ihre Verknüpfung eine fast magische Faszination erzeugt. Dafür greift Brown Motive alter Meister auf, etwa von Rembrandt, Fragonard oder El Greco, aber auch neuerer Maler wie Auerbach, Dalí sowie von Science-Fiction-Illustratoren. Doch Brown zitiert nicht nur, er kommentiert und travestiert, indem er Bildvorlagen durch Anamorphose, Inversion und Vermischung ins (Alp-)Traumhafte überführt. Brown treibt das postmoderne Spiel eine Ebene weiter, denn er greift allein auf Bildzitate zurück, sondern verschränkt diese mit Zitaten von Titeln. *The Great Masturbator* (2006) etwa entlehnt seinen Titel einem Werk von Dalí, auf dem Bild hingegen erkennt man Murillos *Lachenden Jungen mit federgeschmücktem Kopfputz* (1655). Das Genremotiv des spanischen Barockmalers lenkt Brown sehr drastisch ins Burleske: Grüner Teint, schlierige Haut, blaue Augäpfel und schwarze Pupillen geben dem lachenden Kerl einen krankhaft-grausigen Zug. Dabei malt Brown das Entstellende so virtuos, dass die Schönheit der Malerei und das Morbide der Erscheinung einander herausfordern und wechselseitig übertrumpfen. Seine typische, scheinbar satte und pastose Malweise ist dabei raffiniertes Trompe-l'oeil: die virtuosen, gut sichtbaren Pinselgesten entstehen tatsächlich aus feinen, unter der glatten Oberfläche kaum sichtbaren Pinselstrichen, die den glatten, altmeisterlichen Bildoberflächen Dalís nahe stehen. Der inszenatorische Umgang mit Farbe vermittelt größte Künstlichkeit und fleischlichen Verfall, der etwa ausgerechnet einem blanken Skelett den Eindruck körpersatt verrottender Viskosität verleiht: Browns Raffinement zielt auf radikale Ambivalenz, auf Desillusionierung durch die Illusion.

Dans la peinture de Glenn Brown, le beau et le laid, le connu et le visionnaire sont intimement imbriqués, et de leur mélange émane une fascination presque magique. Brown s'appuie pour cela sur les motifs de maîtres anciens comme Rembrandt, Fragonard ou El Greco, mais s'inspire aussi de peintres plus récents comme Auerbach, Dalí, ou encore d'illustrateurs de science-fiction. Toutefois, Brown ne se contente pas de citer, mais commente et travestit en transposant ses modèles dans la sphère du rêve ou du cauchemar par des procédés relevant de l'anamorphose, de l'inversion ou du mélange. Le jeu post-moderne passe sur un autre plan quand les citations visuelles sont mêlées à des citations de titres. *The Great Masturbator* (2006) tire son titre d'une œuvre de Dalí, alors que le tableau lui-même évoque le *Garçon riant coiffé d'un chapeau à plume* (1655) de Murillo. Le motif de genre du peintre espagnol y est drastiquement détourné vers le burlesque: teint glauque, peau glaireuse, prunelles bleues et pupilles noires confèrent au jeune homme riant un aspect maladif et monstrueux. Par même temps, Brown peint cette dénaturation avec une telle virtuosité que la beauté de la peinture et la morbidité de l'aspect rivalisent et ne cessent de se surclasser l'une l'autre. La facture fortement saturée et pâteuse est un trompe-l'œil raffiné: les traits de pinceau virtuoses et nettement visibles sont réalisés à partir de traits fins à peine visibles sous une surface lisse et proche de la facture des maîtres anciens qui caractérise également Dalí. La mise en scène de la couleur communique un sentiment de grande artificialité et de décomposition charnelle qui confère comme par hasard à un squelette décharné une apparence de viscosité charnelle putréfiée: le raffinement de Brown vise à une ambivalence radicale, au désillusionnement par l'illusion.

J. A.

SELECTED EXHIBITIONS →
2008 *Glenn Brown*, Kunsthistorisches Museum, Vienna. *Photopeintries*, FRAC Limousin, Limoges. **2007** *INSIGHT?*, Gagosian Gallery / Red October Chocolate Factory, Moscow. *Der Symbolismus und die Kunst der Gegenwart*, Von der Heydt Museum, Wuppertal **2006** *Zurück zur Figur*, Kunsthalle der Hypo-Kulturstiftung, Munich; Museum Franz Gertsch, Burgdorf. *Infinite Painting*, Villa Manin, Codroipo **2005** *Rückkehr ins All*, Hamburger Kunsthalle, Hamburg. *Ecstasy: In and about Altered States*, MOCA, Los Angeles

SELECTED PUBLICATIONS →
2008 *Painting Now*, Veenman Publishers, Rotterdam **2007** *Glenn Brown*, Gagosian Gallery, New York. *INSIGHT?*, Gagosian Gallery, New York **2006** *Glenn Brown*, Galerie Max Hetzler; Holzwarth Publications, Berlin. *Kai Althoff, Glenn Brown, Dana Schutz*, Parkett 75, Zürich. *Zurück zur Figur. Malerei der Gegenwart*, Kunsthalle der Hypo-Kulturstiftung; Prestel, Munich **2005** *Ecstasy: In and about Altered States*, MOCA, Los Angeles. *Rückkehr ins All*, Hamburger Kunsthalle, Hamburg; Hatje Cantz, Ostfildern

1 **The Great Masturbator**, 2006, oil on panel, 110 x 87.5 cm
2 **Youth, Beautiful Youth**, 2008, oil on panel, 153 x 121 cm

3 **Asylums of Mars**, 2006, oil on panel, 156 x 122.5 cm
4 **The Hinterland**, 2006, oil on panel, 148 x 122.5 cm

„Ich bin ein bisschen wie Dr. Frankenstein, denn ich baue meine Bilder mit Überresten oder toten Teilen von Arbeiten anderer Künstler."

« Je suis un peu comme le docteur Frankenstein, car je crée mes tableaux à partir des restes ou des parties mortes des œuvres d'autres artistes. »

"I'm rather like Dr. Frankenstein, constructing paintings out of the residue or dead parts of other artist's work."

2

3

André Butzer

1973 born in Stuttgart, lives and works in Berlin, Germany

André Butzer – who grew up in the 1980s in "American-occupied West Germany", as he calls it rather playfully in one of his interviews – describes his experience of seeing American soldiers having barbeques at army headquarters as he peered through the fence. Butzer's colourful, chaotic landscapes mirror this distanced but intense gaze upon the collision of these two cultures. In his paintings' imaginary worlds and in his cast of comically ghoulish characters, we glimpse a witty satire of the American Dream. The figures have Butzer's signature maniacal smiles, hollowed-out death mask eyes and puffy Mickey Mouse hands. Sometimes they stand beside a suburban house ominously marked with the letter N, which stands for "Nasaheim" – a conglomeration of NASA (the embodiment of American progress) and Anaheim (the location of Disneyland) – just one of the end-of-the-world science-fictional domains that the artist has invented. Lately, Butzer has also curated "Kommando exhibitions" (2004–), inspired by and named after his heroes – among them Henry Ford, Calvin Cohn and Friedrich Hölderlin – a motley crew comprised of misunderstood visionaries. Butzer's painterly inspirations are easier to discern: his gestural application and raw primitive renderings revive Jean Dubuffet's Art Brut. More recently, his paintings have incorporated jumbles of what look like cables or crossed wires, recalling the meandering lines of Joan Miró. These kaleidoscopically colourful canvases, chock-a-block with finger-painted scribbles and globs of pigment, can look like the work of a child with a box of multi-coloured crayons or Butzer's own apocalyptic view of the future his heroes have helped create.

André Butzer, der in den 1980ern im „amerikanisch besetzten Westdeutschland" aufwuchs, wie er einmal in einem Interview witzelte, beschrieb dann ein Barbecue von Soldaten auf einem US-amerikanischen Militärgelände, das er durch die Umzäunung beobachtet hatte. Butzers bunte, chaotische Bildlandschaften reflektieren seinen distanzierten, aber intensiven Blick auf das Zusammentreffen dieser beiden Kulturen. Seine imaginären Welten mit comicartig makabren Figuren sind satirische Anspielungen auf den Amerikanischen Traum. Die Figuren zeigen ein irres Lächeln, Butzers Markenzeichen, die ausgehöhlten Augen von Totenschädeln und die plumpen Hände von Mickey Mouse. Manchmal stehen sie neben einem mit einem ominösen N markierten Einfamilienhaus. Das N steht für „Nasaheim" – NASA (ein Wahrzeichen des amerikanischen Fortschritts) und Anaheim (der Standort von Disneyland) –, nur eine Unterkunft in den Science-Fiction-Welten, die sich der Künstler ausgedacht hat. Inspiriert von seinen Helden – wie Henry Ford, Calvin Cohn und Friedrich Hölderlin –, organisierte Butzer im Verlauf seiner Karriere „Kommando-Ausstellungen" (seit 2004), die er nach dieser bunt gescheckten Truppe missverstandener Visionäre benannte. Butzers malerische Inspirationen sind leichter zu erkennen: Sein malerischer Gestus und seine grob vereinfachte Malweise knüpfen an Jean Dubuffets Art Brut, während seine neueren Gemälde in Anlehnung an die mäandernden Linien Joan Mirós ein wildes Durcheinander mischen, das aus Kabeln und ineinander verknäulten Drähten bestehen könnte. Diese kaleidoskopartig bunten Bilder mit Kritzeleien und Farbklecksen können wie kindliche Buntstiftmalereien aussehen oder wie Butzers apokalyptische Visionen einer Zukunft, die von seinen Helden mitgestaltet wurde.

André Butzer, qui a grandi dans ce qu'il nomme avec humour « une Allemagne de l'Ouest occupée par les Américains », évoque un souvenir des années 1980 : à travers la palissade bordant le quartier général américain, il lui arrivait d'apercevoir des soldats réunis autour d'un barbecue. Les paysages colorés et chaotiques de Butzer reflètent ce regard, à la fois intense et distancié, sur la collision de ces deux cultures. Ses mondes imaginaires, peuplés d'une galerie de personnages morbides jusqu'au comique, font une subtile satire du rêve américain, comme ce couple grotesque devant un pavillon de banlieue sinistrement orné de la lettre N. Leurs traits sont déformés par un sourire halluciné et des yeux caverneux de masque mortuaire ; leurs mains sont démesurément gonflées comme celles de Mickey. Le N représente « Nasaheim », contraction de NASA (le progrès à l'américaine) et d'Anaheim (le site de Disneyland) : il s'agit d'un des lieux fictifs inventés par l'artiste, un lieu où semble se jouer la fin de notre monde. Tout au long de sa carrière, Butzer a organisé des « expositions Kommando » (2004–) inspirées par et baptisées d'après ses héros personnels – tels Henry Ford, Calvin Cohn ou Friedrich Hölderlin – évoquant un panthéon hétéroclite de visionnaires incompris. Ses sources d'inspiration picturale sont plus faciles à repérer, son application gestuelle et son interprétation primitiviste le situant dans la lignée de l'Art brut de Dubuffet. Plus récemment, il a incorporé dans sa peinture un agrégat de câbles et de barbelés qui rappellent les lignes d'un Joan Miró. Ces toiles, parées de couleurs kaléidoscopiques, barbouillées de traces de peinture ou de grumeaux de pigment et qui semblent parfois dues à un enfant à qui l'on aurait offert une boîte de crayons, figurent la vision apocalyptique de l'avenir que les héros de Butzer ont contribué à créer.

CH. L.

SELECTED EXHIBITIONS →
2008 *Son of... Guillaume Bruere, André Butzer...*, Musée des Beaux-Arts, Tourcoing. *Bad Painting – Good Art*, MUMOK, Vienna. *Kommando Tilmann Riemenschneider. Europa 2008*, Hospitalhof, Stuttgart **2007** *Kommando Calvin Cohn New York*, Salon 94, New York. *Kommando Friedrich Hölderlin Berlin*, Galerie Max Hetzler Temporary, Berlin **2006** *Imagination Becomes Reality*, Sammlung Goetz, Munich **2005** *La Peinture Allemande*, Carré d'Art, Nîmes **2004** *André Butzer*, Kunstverein Heilbronn

SELECTED PUBLICATIONS →
2008 *Kommando Tilmann Riemenschneider. Europa 2008*, Hospitalhof, Stuttgart. *Bad Painting – Good Art*, MUMOK, Vienna; DuMont, Cologne **2007** *André Butzer*, Galerie Guido W. Baudach Berlin. *Kommando Friedrich Hölderlin Berlin*, Galerie Max Hetzler, Berlin **2006** *Carbonic Anhydride*, Galerie Max Hetzler, Berlin **2005** *Haselnuß*, Galerie Guido W. Baudach, Berlin **2004** *André Butzer: Das Ende vom Friedens-Siemens Menschentraum*, Kunstverein Heilbronn; Snoeck Verlag, Cologne

1 **Portrait H.H.**, 2006, oil on canvas, 340 x 260 cm
2 **Untitled (8)**, 2007, oil on canvas, 200 x 160 cm

3 **Kommando Friedrich Hölderlin**, 2006, oil on canvas, 280 x 460 cm
4 **Gehirnzentrum von A.B.**, 2006, oil on canvas, 280 x 460 cm

„Ich mache einfach unbehelligt weiter, vermische alle Formen und Inhalte, vergesse alles ständig mit Absicht wieder, ich bin wie ein Fabrikant, der damit rechnet, dass seine Produkte dann von selber ernst drauf kommen."

« C'est tout simple, je continue sans me soucier de rien, je mélange toutes les formes et tous les contenus, j'oublie volontairement tout à chaque instant, je suis comme un fabricant qui s'attend à ce que ses produits se prennent au sérieux. »

"I simply carry on regardless, constantly mixing form and content and then intentionally forgetting them all again. I'm like a manufacturer who figures his products will hit on something serious by themselves."

2

Cai Guo-Qiang

1957 born in Quanzhou, China, lives and works in New York (NY), USA

Cai Guo-Qiang's practice spans from gunpowder drawings to ephemeral sculptures and monumental installations, all of which are rich with references to Chinese history, Taoist cosmology and current political events. Cai deals with the latter in a spectacular installation for *I Want to Believe*, his 2008 retrospective in New York: from the centre of the Guggenheim rotunda the artist – a learned set designer, by the way – suspended *Inopportune: Stage One* (2004), consisting of a series of nine cars hovering in mid air to represent in cinematic progression the effects of a car bomb. Since the 1980s, Cai has been working on drawings realized by igniting explosive powder on large sheets of paper. These works possess an aura that evokes both the vivid gestures of abstract expressionism and the quieter surfaces of Chinese traditional painting. Gunpowder is also at the centre of a series of environmental works, begun in 1989, which combine the tradition of Land Art with that of Chinese fireworks. For his explosion events, Cai stages pyrotechnical choreographies that sketch temporary drawings in the sky. These events are also meant to act as social, festive collective experiences that the artist – not without irony – believes could be perceived even from outer space. Cai participated in many international events, imposing himself as one of the strongest artists to emerge from China. At the Venice Biennale 1999 he was awarded the Golden Lion for *Venice's Rent Collection Courtyard* (1999), a series of unfired clay sculptures depicting icons of the Cultural Revolution. Cai also organized the opening ceremony for the 2008 Olympic Games in Beijing.

Cai Guo-Qiangs Werk umfasst Zeichnungen mit Schießpulver, vergängliche Skulpturen und monumentale Installationen, die alle reich an Anspielungen auf chinesische Geschichte, taoistische Kosmologie und aktuelle politische Ereignisse sind. Mit Letzteren beschäftigt Cai sich in einer spektakulären Installation für *I Want to Believe*, seine Retrospektive 2008 in New York: In das Innere der Rotunde des Guggenheim Museums hängte der Künstler – übrigens gelernter Setdesigner – *Inopportune: Stage One* (2004), das aus einer Reihe von neun in der Luft schwebenden Autos bestand, die in quasi filmischer Abfolge die Auswirkungen einer Autobombe darstellten. Seit den 1980er-Jahren arbeitet Cai an Zeichnungen, die durch das Entzünden von Schießpulver auf großen Papierbögen entstanden. Diese Arbeiten haben eine Aura, die sowohl die heftigen Gesten des Abstrakten Expressionismus als auch die ruhigeren Oberflächen der traditionellen chinesischen Malerei evozieren. Schießpulver steht auch im Mittelpunkt einer Reihe von Arbeiten (ab 1989), die die Tradition der Land Art mit der des chinesischen Feuerwerks verbinden. Für seine Explosionsevents inszeniert Cai pyrotechnische Choreografien, die flüchtige Zeichnungen an den Himmel werfen. Diese Events wollen auch soziale, festliche Gemeinschaftserfahrungen ermöglichen, von denen der Künstler – nicht ohne Ironie – glaubt, sie könnten sogar im Weltall wahrgenommen werden. Cai hat an vielen internationalen Veranstaltungen teilgenommen und etablierte sich dabei als einer der stärksten Künstler aus China. Bei der Biennale in Venedig 1999 bekam er den Goldenen Löwen für *Venice's Rent Collection Courtyard* (1999), einer Serie von ungebrannten Tonskulpturen, die Ikonen der Kulturrevolution darstellten. Cai organisierte auch die Eröffnungszeremonie der Olympischen Spiele 2008 in Peking.

Qu'il choisisse pour support le dessin à la poudre à canon, la sculpture éphémère ou l'installation monumentale, Cai Guo-Qiang se réfère constamment à l'histoire de la Chine, à la cosmologie taoïste et aux événements politiques contemporains. Ces derniers sont notamment abordés dans l'installation spectaculaire réalisée à l'occasion de la rétrospective *I Want to Believe* organisée en 2008 à New York : au centre de la rotonde du Guggenheim, l'artiste a suspendu dans les airs neuf véhicules figurant, comme dans un ralenti cinématographique, l'explosion d'une voiture piégée. Depuis les années 1980, Cai réalise des dessins en mettant le feu à de la poudre explosive sur de grandes feuilles de papier. Ces œuvres dégagent une aura évoquant aussi bien les gestes violents de l'expressionnisme abstrait que les surfaces paisibles de la peinture chinoise traditionnelle. La poudre à canon est également au cœur d'une série d'œuvres environnementales, entamée en 1989, qui associe la tradition du Land Art à celle des feux d'artifice chinois. Pour ses œuvres événementielles, Cai organise des chorégraphies pyrotechniques qui créent dans le ciel des dessins éphémères. Ces événements sont conçus comme des expériences sociales et festives que l'artiste – non sans ironie – entend rendre visibles y compris depuis l'espace. Cai a pris part à de nombreuses manifestations internationales et s'est imposé comme l'un des plus grands artistes chinois de sa génération. En 1999, à la Biennale de Venise, il a reçu le Lion d'Or pour sa *Venice's Rent Collection Courtyard* (1999), série de sculptures d'argile désamorcées figurant les icônes de la Révolution culturelle. Cai a également organisé la cérémonie d'ouverture des Jeux Olympiques de Pékin en 2008.

C. A.

SELECTED EXHIBITIONS →
2008 *Cai Guo-Qiang*, Hiroshima City Museum of Contemporary Art, Hiroshima. *Cai Guo-Qiang: I Want to Believe*, Solomon R. Guggenheim Museum, New York **2007** *Cai Guo-Qiang: Inopportune. Stage One*, Seattle Art Museum, Seattle **2006** *Cai Guo-Qiang: Head On*, Deutsche Guggenheim, Berlin. *Cai Guo-Qiang: Transparent Monument*, The Metropolitan Museum of Art, New York **2005** *Cai Guo-Qiang: Paradise*, Zacheta National Gallery of Art, Warsaw. *Cai Guo-Qiang: On Black Fireworks*, IVAM, Valencia

SELECTED PUBLICATIONS →
2008 *Cai Guo-Qiang: I Want to Believe*, Solomon R. Guggenheim Museum, New York **2006** *Cai Guo-Qiang: Head On*, Deutsche Guggenheim, Berlin; Hatje Cantz, Ostfildern. *Cai Guo-Qiang: Transparent Monument*, Charta, Milan. *Cai Guo-Qiang: Long Scroll*, National Gallery of Canada, Ottawa **2005** *Cai Guo-Qiang: On Black Fireworks*, IVAM, Valencia. *Where Heaven & Earth Meet: The Art of Xu Bing and Cai Guo-Qiang*, Timezone 8 Ltd, Beijing

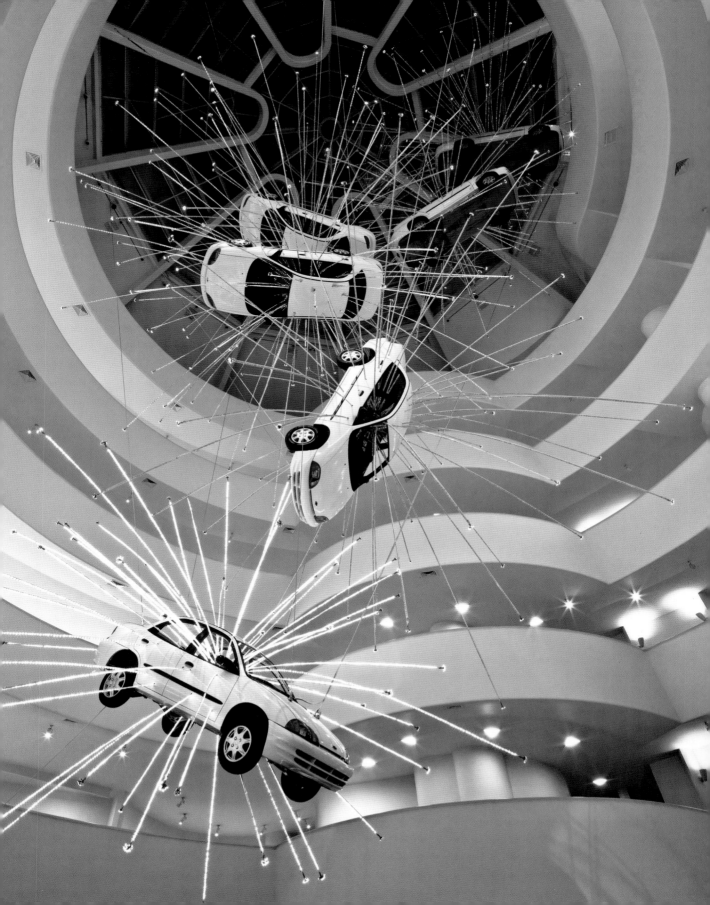

1 **Inopportune: Stage One**, 2004, 9 cars, sequenced multichannel light tubes, dimensions variable. Installation view, Solomon R. Guggenheim Museum, New York, 2008
2 **Light Passage – Autumn**, 2007, gunpowder on paper, 400 x 600 cm

3 **Head On**, 2006, 99 life-sized replicas of wolves (gauze, resin, painted hide), glass wall, dimensions variable. Installation view, Deutsche Guggenheim, Berlin
4 **Same Word, Same Seed, Same Root**, 2006, gunpowder on paper, LED screens, 1800 x 900 cm. Installation view, Min Tai Yuan Museum, Quanzhou

„Meine Installationen versuchen immer, den Zeitfluss darzustellen, ganz gleich, welche stilistische Freiheit ich mir erlaube. Jedenfalls haben meine Arbeiten im Kern diese Merkmale: die Einladung zur Teilnahme und das Fließen der Zeit."

« Mes installations s'efforcent toujours d'obtenir une fluidité temporelle, qui contraste avec la liberté de style que je m'autorise. Cependant mes œuvres se caractérisent essentiellement par leur nature participative et par le passage du temps. »

"My installations have consistently pursued a temporal fluidity, in contrast to the stylistic freedom I allow myself. However, my works in essence contain these characteristics: a participatory nature and a flow of time."

2

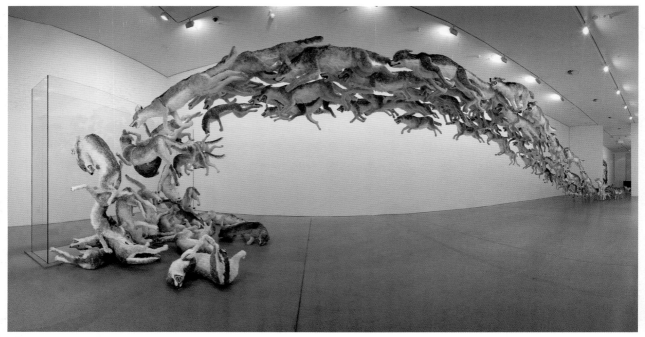

3

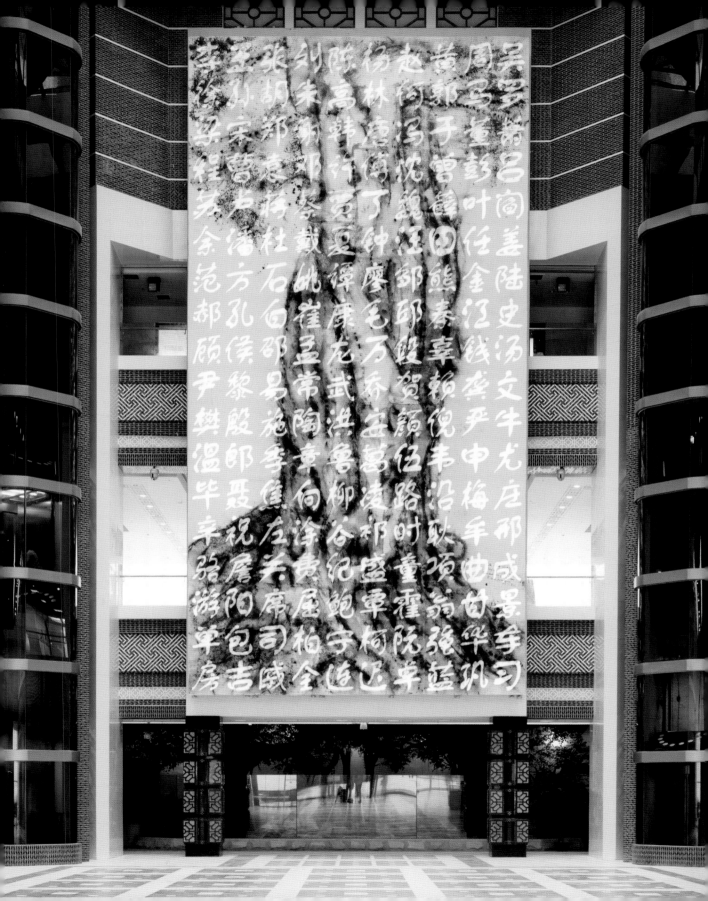

Maurizio Cattelan

1960 born in Padua, Italy, lives and works in New York (NY), USA

Some might say that Maurizio Cattelan's works resemble jokes, but they are more like political cartoons. Each of his pieces amounts to an iconic, provocative image with a darkly humorous twist: the Pope stricken by a meteorite, Hitler on his knees in prayer, a horse with its head buried in a wall. But the impact of his mischievous works doesn't dissipate after the punchline hits you; rather, the impression that remains after you've seen JFK lying barefoot in his coffin or a suicidal squirrel slumped over a miniature kitchen table is still haunting or befuddling long after the initial urge to laugh has worn off. Cattelan provokes public reaction mainly by satirizing authority – politicians, the Church, the police force, the art world. His disobedient gestures have drawn their fair share of controversy – most recently, his vision of a female crucifixion installed at a synagogue in Pulheim, Germany, in 2008 elicited public debate. Cattelan has no studio and no traces of his own hand appear in his work (though his face sometimes does, in the form of frequent caricatures of himself). He claims he spends most of his time on the phone. Working from a single idea, Cattelan employs fabricators to create taxidermied animals and extremely lifelike wax figures. He relishes playing the role of the mysterious producer behind the artwork – the burglar who sneaks in and out of the gallery unnoticed, the host who slinks away from his own party. Though he is frequently labelled a court jester, it's not Cattelan himself who is entertaining the masses – he is an escape artist, setting a spectacle in our midst and then fleeing the scene.

Manche betrachten Maurizio Cattelans Werke als reinen Schabernack, obwohl sie eigentlich politische Karikaturen sind. Jede seiner bildmächtigen, provozierenden Inszenierungen ist mit schwarzem Humor gewürzt: der durch einen Meteoriten zu Fall gebrachte Papst, der kniende Hitler im Gebet, das Pferd mit in die Wand gerammtem Kopf. Aber diese überspitzten Bilder leben nicht nur von ihrer Pointe; wenn der Lachreiz vergangen ist, haben sich die Ansichten des barfüßigen JFK in seinem Sarg oder eines am Küchentisch in den Selbstmord geschickten Eichhörnchens tief in die Erinnerung eingegraben. Öffentlichen Ärger ruft Catellan vor allem deshalb hervor, weil er die Systeme der Macht der Lächerlichkeit preisgibt – Politik, Kirche, Polizei, den Kunstbetrieb. Seinen unbotmäßigen Handlungen folgen stets reichlich kontroverse Debatten – erst dieses Jahr, 2008, hat er mit einer ans Kreuz geschlagenen Frauenfigur an der Synagoge Stommeln in Pulheim eine öffentliche Diskussion entfacht. Cattelan hat kein Atelier, und keines seiner Werke lässt Spuren seiner eigenen Hand erkennen (umso häufiger seine Gesichtszüge, da er sich oft selbst karikiert). Nach eigenen Angaben verbringt er die meiste Zeit am Telefon. Ausgehend von einer Idee beschäftigt Cattelan Leute, die ihm Tiere ausstopfen und ungemein lebensechte Wachsfiguren herstellen. Er gefällt sich in der Rolle des geheimnisvollen Machers hinter dem Kunstwerk – wie ein Dieb, der sich unbemerkt in die Galerien hinein und wieder hinaus schleicht, oder ein Gastgeber, der sich von der eigenen Party stiehlt. Obwohl Cattelan oft als Hofnarr betitelt wird, unterhält er das Volk nicht selbst – er ist ein Entfesselungskünstler, der ein Schauspiel inmitten der Menge inszeniert und anschließend den Schauplatz verlässt.

Si, pour certains, les œuvres de Maurizio Cattelan pourraient se résumer à des plaisanteries, il s'agit plutôt, en fait, de dessins satiriques. Chacune de ses pièces représente une image iconique provocatrice teintée d'humour noir : le Pape frappé par une météorite, Hitler enfant priant à genoux, un cheval dont la tête est encastrée dans un mur. Mais l'impact de ces œuvres facétieuses ne se dissipe pas immédiatement; au contraire, l'image de JFK pieds nus étendu dans son cercueil, ou celle d'un écureuil suicidaire, effondré sur une table de cuisine miniature, continue à hanter les esprits bien après que la première envie de rire ne se soit dissipée. C'est en faisant la satire de l'autorité sous toutes ses formes – hommes politiques, Église, forces de police, monde de l'art – que Cattelan provoque la réaction du public. Ses gestes frondeurs ont suscité bien des controverses – en 2008, son installation d'une crucifixion d'une femme dans une synagogue de Pulheim en Allemagne a provoqué la polémique. Cattelan n'a pas d'atelier et nulle trace de sa main n'apparaît dans son travail (même si on y aperçoit parfois son visage, sous la forme de caricature de lui-même). Il affirme passer le plus clair de son temps au téléphone. Cattelan génère des idées, des exécutants réalisent les animaux empaillés ou figurines de cire extrêmement ressemblantes. Il adore jouer le rôle du mystérieux producteur derrière l'œuvre d'art – le cambrioleur qui entre et sort de la galerie sans se faire voir, l'hôte quittant furtivement sa propre fête. Même si on lui colle souvent l'étiquette de bouffon de la cour, Catellan ne divertit pas lui-même les foules – c'est un artiste de l'échappée qui installe le spectacle parmi nous, puis fuit la scène.

CH. L.

SELECTED EXHIBITIONS →
2008 *Maurizio Cattelan*, Kunsthaus Bregenz. *Maurizio Cattelan*, Synagoge Stommeln, Pulheim. *Traces du Sacré*, Centre Georges Pompidou, Paris. *theanyspacewhatever*, Guggenheim Museum, New York **2007** *Maurizio Cattelan*, MMK, Frankfurt am Main. *Maurizio Cattelan*, Portikus, Frankfurt am Main **2006** *Of Mice and Men*, 4th Berlin Biennial for Contemporary Art, Berlin **2005** *Dionysiac*, Centre Georges Pompidou, Paris **2004** *Maurizio Cattelan*, Musée du Louvre, Paris

SELECTED PUBLICATIONS →
2008 *Maurizio Cattelan: Die/Die More/Die Better/Die Again*, Kunsthaus Bregenz; Three Star Books, Paris **2007** Maurizio Cattelan, Massimiliano Gioni, Ali Subotnick: *Charley 05*, Les Presses du Réel, Dijon **2006** Maurizio Cattelan, Massimiliano Gioni, Ali Subotnick: *Of Mice and Men*, 4th Berlin Biennial for Contemporary Art, Berlin; Hatje Cantz, Ostfildern. *Maurizio Cattelan*, Mondadori, Milan. *Maurizio Cattelan*, Trans-Atlantic Publications, Philadelphia **2005** *Dionysiac*, Centre Georges Pompidou, Paris

1 **Untitled**, 2007, stuffed horse, natural dimensions. Installation view, Museum für Moderne Kunst, Frankfurt am Main
2 **Untitled**, 2007, polyurethane, metal, clothes, paint. Installation view, Portikus, Frankfurt am Main

3 **Untitled**, 2007, silicon resin, real hair, steel, wood door, 216 x 130 x 70 cm. Installation view, Synagoge Stommeln, Pulheim, 2008

„Man versucht, die Grenzen ein wenig auszudehnen, und dann muss man erkennen, mit welcher Leichtigkeit die Kunstwelt alle Schläge verkraften kann. Aber das ist okay, das gehört zum Spiel."

« On essaie de repousser les frontières un peu plus loin, et puis on se rend compte avec quelle facilité le monde de l'art peut absorber tous les coups. Mais ce n'est pas grave, je suppose que ça fait partie du jeu. »

"You try to move the borders a little bit further, and then you realize how easily the art world can absorb any blow. But that's OK, I guess that's part of the game."

2

Mat Collishaw

1966 born in Nottingham, lives and works in London, United Kingdom

Mat Collishaw's works often explore the ambiguous relationship between reality and representation by using display strategies that make this disjunction apparent. His recent installation *Deliverance* (2008) is a spatialized inquiry into the captivating power of unsettling imagery and its potential effects or non-effects on today's media-saturated viewers. Ceiling-mounted projectors revolve, click and beam staged photographs of victims of an unnamed conflict onto walls coated with phosphorescent paint. Acute distress is momentarily palpable in the explosion of light that generates these figures under siege, while their absinthe-green phosphorescent traces linger just long enough to prolong and deaden the shock. Inspired by images of the 2004 Beslan school hostage tragedy, Collishaw echoes images such as Nick Ut's iconic 1972 war photograph of a naked Vietnamese girl fleeing a Napalm attack, thus collapsing the temporal and spatial distance between these all too universal calamities. He effectively questions media voracity and viewer passivity by delimiting a sulphurous representational zone in which the camera performs as a weapon of mass seduction, even when recording circumstances from which it can offer no refuge. Provocation, fascination and abjection have been key elements of Collishaw's photographic prints, light-boxes and installations since his infamous close-up of a *Bullet Hole* (1988). In his more recent *Infectious Flowers* series (2005), colour photographs of exquisite, sexually redolent orchids posed against dramatic skies are burdened with petals that seethe with pustulant skin diseases. Collishaw reminds us that sometimes beauty is not even skin deep.

Mat Collishaw Arbeiten bewegen sich in einer Ambivalenz zwischen Realität und Kunstwirklichkeit, die er durch seine Ausstellungsanordnung sichtbar macht. Seine aktuelle Installation *Deliverance* (2008) ist eine raumbezogene Erforschung der Magie irritierender Bilder und deren Wirkungspotenzial auf die mediengesättigten Zuschauer unserer Zeit. An der Decke montierte, rotierende Projektoren werfen inszenierte Fotografien von Opfern eines nicht genannten Konflikts auf die mit phosphoreszierender Farbe gestrichenen Wände. Dringende Not wird flüchtig erfahrbar in einer Lichtexplosion, die diese bedrohten Figuren nachzeichnet, während der Schock vor dem Abklingen noch durch absinthgrüne Phosphorenzen verlängert wird. Inspiriert von Bildern des Geiseldramas in Beslan 2004, zeigt Collishaw Fotos, die etwa Nick Uts allseits bekanntem Kriegsbild nachempfunden sind, in dem ein nacktes vietnamesisches Mädchen bei einem Napalm-Angriff 1972 um sein Leben läuft. Die zeitliche und räumliche Distanz zwischen diesen universellen Katastrophen ist hier aufgehoben. Um die unersättliche Gier der Medien nach Bildern und die Passivität der Zuschauer effektiv zu hinterfragen, grenzt der Künstler einen Ausstellungsbereich mit Schwefel ab, in dem die Kamera selbst dann, wenn sie ausweglose Umstände und Situationen aufzeichnet, als Instrument der Massenverführung dient. Provokation, Faszination und tiefste Erniedrigung sind seit seiner Großaufnahme eines Einschusslochs in einem Körper, *Bullet Hole* (1988), zentrale Elemente in Collishaws Fotoprints, Lichtkästen und Installationen. Die neuere Farbfotoserie *Infectious Flowers* (2005) zeigt vor einem dramatisch bewölkten Himmel kostbare, erotische Assoziationen weckende Orchideen, deren Blütenblätter sich als Abbildungen pustulöser Hautkrankheiten erweisen. Collishaw erinnert daran, dass Schönheit manchmal ganz an der Oberfläche bleibt.

L'œuvre de Mat Collishaw explore le rapport ambigu entre réalité et représentation en recourant à des stratégies d'exposition qui font apparaître cette disjonction. Une installation récente, *Deliverance* (2008), consiste ainsi en une étude spatialisée du pouvoir captivant que peut avoir une imagerie dérangeante et de ses effets possibles (ou de son absence d'effet) sur des spectateurs assommés d'images médiatiques. Des projecteurs fixés au plafond se mettent à tourner, à cliqueter, puis à projeter, sur des murs couverts d'une peinture phosphorescente, des photographies (mises en scène) de victimes de quelque conflit anonyme. Un désarroi aussi palpable que fugitif s'empare du spectateur chaque fois que, dans une explosion de lumière, apparaissent ces personnages brutalisés, dont la trace couleur absinthe dure juste assez longtemps pour en prolonger puis en étouffer l'impact. Inspiré par les images de la tragédie de Beslan – où des écoliers avaient été pris en otages en 2004 –, Collishaw revisite le cliché célèbre de Nick Ut (1972) montrant une fillette vietnamienne en train de fuir une attaque au napalm ; ce faisant, il abolit la distance spatiale et temporelle qui sépare ces deux désastres. Il interroge efficacement la voracité des médias et la passivité du spectateur, en délimitant une zone de représentation sulfureuse où l'objectif fonctionne comme arme de séduction massive. Provocation, fascination et abjection sont des éléments essentiels des photographies, boîtes lumineuses et installations de Collishaw depuis son célèbre gros plan d'une blessure par balle, *Bullet Hole* (1988). Une série plus récente, *Infectious Flowers* (2005), montre des orchidées aussi splendides que lascives, disposées devant des ciels spectaculaires, mais enlaidies par leurs pétales qui grouillent de pustules et autres maladies dermiques. Entre la laideur et la beauté, semble suggérer Collishaw, c'est à nous de distinguer. V. R.

SELECTED EXHIBITIONS →
2008 *Deliverance*, Spring Projects in collaboration with the Fashion in Film Festival 2008, London **2007** *Les Fleurs du Mal*, Museo Arcos, Benevento. *The Tempest – Mat Collishaw and Paul Fryer*, 52. Venice Biennale, Venice **2006** *Into Me/Out Of Me*, P.S.1 Contemporary Art Center, Long Island City; KW Institute for Contemporary Art, Berlin. *In the darkest hour there may be light*, Serpentine Gallery, London. *What makes you and I different*, Tramway Glasgow

SELECTED PUBLICATIONS →
2008 *Mat Collishaw*, White Cube; Other Criteria, London
2006 *In the darkest hour there may be light*, Serpentine Gallery; Other Criteria, London. *Into Me/Out Of Me*, P.S.1 Contemporary Art Center, Long Island City; KW Institute for Contemporary Art, Berlin; Hatje Cantz, Ostfildern

1 **Single Nights 1**, 2007, C-print on dibond, wooden frame, 183 x 140 cm
2 **Infectious Orchid 1**, 2005, C-print, 24.3 x 19.4 cm

3 **Infectious Amaryllis**, 2005, C-print, 24.3 x 19.4 cm
4–6 **Deliverance Installation**, 2008, 45 gobos, 3 projectors, luminescent paint

„Die dunkle Seite meiner Arbeit zielt hauptsächlich auf die inneren Mechanismen der Bildsymbolik und die Art, wie diese Mechanismen auf unseren Verstand einwirken."

« Le côté sombre de mon œuvre tient essentiellement aux mécanismes internes de l'imagerie visuelle, et à la manière dont ces mécanismes s'adressent à l'esprit. »

"The dark side of my work primarily concerns the internal mechanisms of visual imagery and how these mechanisms address the mind."

2

3

George Condo

1957 born in Concord (NH), lives and works in New York (NY), USA

Who would dare to paint Queen Elizabeth II of England as a cabbage patch doll? In September 2006, at the Wrong Gallery at Tate Modern, George Condo exhibited a tiny painting depicting the monarch as a strange crossover between a saggy vegetable and a ragged puppet dressed in a sumptuous fur cape. Part of a series of small canvases representing the Queen in a variety of poses and deformed expressions, this painting conveys many of Condo's favourite subjects and themes, in particular his obsession with portraiture as both a celebratory and defacing gesture. Queen Elizabeth, *Jesus* (2007) or *God* (2007) are not the only ones to be honoured with portraits, in his *Existential Portraits* (2005/06) Condo explores the psychological complexity of a group of figures and social archetypes, exposing both their outer appearance and their inner condition. In company of well known but "disenfranchised" – as Condo puts it – figures such as the Playboy Bunny and Batman, the main character, Jean Louis, is undergoing various transformations, thus questioning the stability of "the self". Since the early 1980s, Condo has been developing a highly personal language, in which popular illustrations, underground comics, and vernacular imaginary are combined with quotations from the tradition of Spanish court portraiture, Picasso's cubism, and de Chirico's suspended atmospheres. His fervid imagination has produced an endless gallery of broken heroes whose faces and bodies are distorted into comic grimaces or terrifying contortions. Often frozen into bizarre expressions that could either be of joy or despair, Condo's clownish, transfixed figures compose a grotesque fresco on the human condition.

Wer würde es schon wagen, Königin Elizabeth II. von England als pausbäckige Stoffpuppe zu malen? Im September 2006 zeigte George Condo in der Wrong Gallery der Tate Modern ein winziges Gemälde, das die Monarchin als Mischwesen aus welkem Gemüse und Lumpenpuppe im prächtigen Pelzcape karikierte. Als Teil einer kleinformatigen Serie mit der Queen in verschiedenen Posen und entstelltem Gesichtsausdruck vereint das Bild zahlreiche Lieblingssujets und Themen Condos, so auch seine Obsession für das Porträt als feierliches und zugleich entstellendes Genre. Aber seine Lust am Porträt beschränkt sich nicht allein auf Königin Elizabeth, *Jesus* (2007) oder auch *God* (2007). In den *Existential Portraits* (2005/06) untersucht Condo die komplexe Psychologie einer Gruppe von Figuren und gesellschaftlicher Archetypen, deren äußeres Erscheinungsbild und innere Verfassung er gleichermaßen bloßlegt. In Gesellschaft bekannter, aber – wie Condo sagt – „entprivilegierter" Figuren wie Playboy Bunny und Batman, wird die Hauptperson Jean Louis mehreren Wandlungen unterzogen und dabei die Stabilität seines „Selbst" hinterfragt. Seit Anfang der 1980er-Jahre hat Condo seine ganz eigene Sprache entwickelt, in der er bekannte Illustrationen, Underground-Comics und volkstümliche Bildsymbolik mit Anklängen an die traditionelle spanische Hofporträtmalerei, Picassos Kubismus und de Chiricos Traumwelten verknüpft. Seine blühende Fantasie hat eine endlos lange Reihe gebrochener Helden hervorgebracht, mit komisch verzerrten Gesichtszügen und entsetzlich verrenkten Körpern. Condos clowneske, erstarrte Figuren, deren oft seltsam eingefrorene Gesichtszüge sowohl Freude als auch Verzweiflung ausdrücken könnten, stellen ein groteskes Abbild des menschlichen Seins dar.

Qui oserait peindre la reine Elizabeth d'Angleterre en poupée de chiffon mâtinée de feuille de chou ? En septembre 2006, à la Wrong Gallery de la Tate Modern, George Condo a exposé une toile minuscule montrant la souveraine sous forme d'un curieux mélange de légume ramolli et de vieille poupée parée d'une somptueuse cape de fourrure. Cette peinture, qui fait partie d'une série de petites toiles figurant la reine dans diverses poses et sous des aspects plus ou moins difformes, comporte bien des sujets et thèmes chers à Condo, notamment son obsession du portrait comme geste à la fois glorifiant et défigurant. La reine Elizabeth, *Jesus* (2007) ou *God* (2007) ne sont pas les seuls à bénéficier d'un portrait : dans ses *Existential Portraits* (2005/06), Condo explore la complexité psychologique d'un groupe de personnages et d'archétypes sociaux, exposant aussi bien leur apparence extérieure que leur condition intérieure. Aux côtés de héros célèbres mais « défranchisés » – selon l'expression de Condo – comme le lapin de Playboy ou Batman, le personnage principal, Jean Louis, subit diverses transformations qui remettent en question la stabilité du moi. Depuis le début des années 1980, Condo affine un langage très personnel au sein duquel illustrations populaires, bandes dessinées underground et imaginaire vernaculaire sont associés à des références à la tradition du portrait de cour espagnol, au cubisme de Picasso, aux atmosphères suspendues d'un de Chirico. Son imagination passionnée a créé une galerie sans fin de héros fatigués, dont les corps et les visages sont tordus dans des grimaces hilarantes ou d'effrayantes contorsions. Saisis le plus souvent dans des expressions bizarres oscillant entre joie et désespoir, les personnages clownesques et figés de Condo composent une fresque grotesque de la condition humaine.

C. A.

SELECTED EXHIBITIONS →

2008 *God & Goods. Spirituality and Mass Confusion*, Villa Manin, Codroipo. *Go for it! Olbricht Collection (a sequel)*, Neues Museum Weserburg, Bremen **2007** *The Present*, Stedelijk Museum, Amsterdam. *Six Feet Under*, Kunstmuseum Bern **2006** *Zurück zur Figur*, Kunsthalle der Hypo-Kulturstiftung, Munich; Museum Franz Gertsch, Burgdorf. *Closer to Home – 48th Corcoran Biennial*, Corcoran Gallery of Art, Washington **2005** *George Condo. One Hundred Women*, Museum der Moderne Salzburg; Kunsthalle Bielefeld

SELECTED PUBLICATIONS →

2008 *God & Goods. Spirituality and Mass Confusion*, Villa Manin, Codroipo **2007** *George Condo*, Simon Lee, London **2006** *George Condo: Existential Portraits*, Holzwarth Publications, Berlin. *Over the Limit: Christopher Wool & George Condo*, Portalakis Collection, Athens. *Zurück zur Figur. Malerei der Gegenwart*, Kunsthalle der Hypo-Kulturstiftung; Prestel, Munich **2005** *George Condo: One Hundred Women*, Kunsthalle Bielefeld; Hatje Cantz, Ostfildern

1

98

1 **God**, 2007, oil on canvas, 233.7 x 198.1 cm
2 **Woman and Man**, 2008, oil on canvas, 215.9 x 190.5 cm
3 **The Bird Brain of Alcatraz**, 2008, oil on canvas, 190.5 x 215.9 cm
4 **The Orgy**, 2004, oil on canvas, 182.9 x 177.8 cm

5 **Jesus**, 2007, oil on canvas, 218.4 x 218.4 cm
6 **Dreams and Nightmares of the Queen**, 2006, oil on canvas, 50.8 x 40.6 cm
7 **Maja Desnuda**, 2005, oil on canvas, 76.2 x 101.6 cm

„Ich mag keine Cartoons. Aber man malt, was man nicht mag und versucht, es besser zu machen."

« Je déteste les dessins animés. Mais on peint ce que l'on n'aime pas, justement pour en faire quelque chose de bien. »

"I hate cartoons. But you paint what you don't like and try to make it right."

2

3

4

5

6

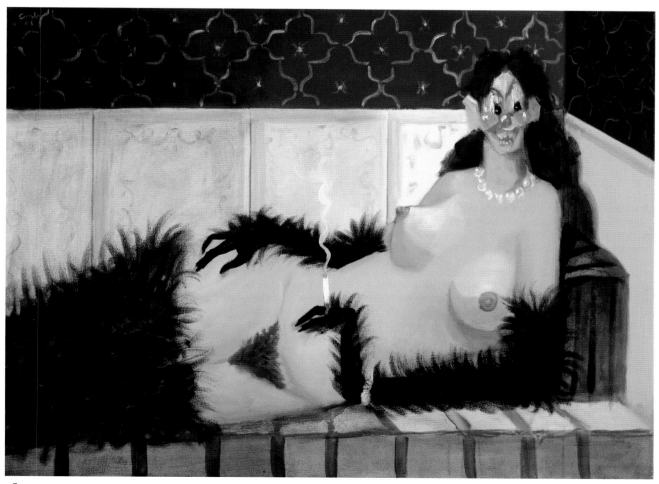

7

Martin Creed

1968 born in Wakefield, lives and works in London, United Kingdom, and Alicudi, Italy

In 2007, Martin Creed staged his most comprehensive exhibition to date under the title *Feelings*. The show at CSS Bard in Annandale-on-Hudson opened with one of his almost legendary *Half the Air in a Given Space* installations: *Work No. 628* (2007) filled the museum's atrium with an ocean of blue balloons, through which viewers were forced to pass in order to enter the galleries. In Creed's world, objects move, doors slam, lights are turned off and on, and sculptures are used as obstacles. Creed's vocabulary is often inspired by minimalism, but its obsession with repetition is taken to new extremes that can be joyful and suffocating, comic and excruciatingly dry. Recently, the artist has worked on a series of films, which he considers an expansion of his sculptural works. *Work No. 503: Sick Film* (2006) portrays young people walking around in a pristine white room and vomiting on the floor. The actions are carried out with an almost clinical detachment, and they are filmed with the cold precision of a scientific experiment. It is the structural repetition of gestures and sounds that fascinates the artist more than their repulsive subject matter. Creed's interest in the way bodies and people can be used to perform mechanical actions has resulted in a series of performances that combine a deadpan sensibility with an analytical approach. In 2006 at the Fondazione Trussardi in Milan he presented *Work No. 570* (2006), which he restaged at Tate Britain in 2008: a group of people run through the exhibition as fast as possible, as if they were escaping the scene of a crime.

Martin Creeds bis dato umfassendste Ausstellung fand im Jahr 2007 unter dem Titel *Feelings* in den Räumen von CSS Bard in Annandale-on-Hudson statt. Bei der Eröffnung füllte eine seiner schon fast legendären Installationen, *Half the Air in a Given Space: Work No. 628* (2007), den Lichthof mit einem Meer blauer Ballons, das von den Gästen auf dem Weg zu den Ausstellungsräumen durchquert werden musste. In Creeds Welt bewegen sich die Objekte, Türen fallen zu, Lichter gehen an und aus, Skulpturen werden zu Hindernissen. Creeds Vokabular ist oft minimalistisch beeinflusst, doch seine obsessive Freude an Wiederholungen steigert sich zu neuen Extremen, von lustig bis bedrückend, von komisch bis unerträglich trocken. Vor einiger Zeit realisierte der Künstler eine Videoprojektion, die er als eine Erweiterung seiner skulpturalen Arbeiten betrachtet. *Work No. 503: Sick Film* (2006) zeigt junge Leute, die in einem kahlen weißen Raum herumgehen und dabei auf den Boden kotzen. Die Aktionen werden mit einer geradezu klinischen Distanziertheit vollzogen und mit der kalten Präzision des wissenschaftlichen Experiments gefilmt. Für den Künstler ist die strukturelle Wiederholung von Gebärden und Lauten faszinierender als das abstoßende Sujet an sich. Creeds Interesse daran, wie Körper und Menschen für die Durchführung mechanischer Aktionen benutzt werden, mündete in einer Folge von Performances, die eine erstarrte Sensibilität mit einer analytischen Herangehensweise kombinieren. 2006 zeigte der Künstler in der Fondazione Trussardi in Mailand sein *Work No. 570* (2006), das er 2008 in der Tate Britain erneut inszenierte: Eine Menschengruppe rennt so schnell wie möglich durch die Ausstellung wie auf der Flucht vor einem Verbrechen.

Sous le titre *Feelings*, Martin Creed a organisé en 2007, au CSS Bard d'Annandale-on-Hudson, sa plus grande exposition à ce jour. Elle s'ouvrait sur *Work No. 628* (2007), l'une des installations quasi légendaires de la série *Half the Air in a Given Space* : un océan de ballons bleus remplissait l'espace de l'atrium que le visiteur doit traverser pour atteindre les galeries. Dans l'univers de Creed, les objets se déplacent, les portes claquent, les lumières s'allument et s'éteignent, les sculptures font obstacles. Le vocabulaire de l'artiste est souvent inspiré par le minimalisme, mais l'obsession de la répétition est ici poussée à l'extrême, dans un mélange de joie et d'étouffement, de verve comique et de froideur douloureuse. Creed a récemment travaillé à une série de films qu'il envisage comme une extension de son œuvre sculpturale. *Work No. 503: Sick Film* (2006) montre des jeunes gens en train de déambuler dans une pièce blanche immaculée et de vomir par terre. Leurs gestes, accomplis avec un détachement presque clinique, sont filmés avec la rigueur glacée d'une expérience scientifique. Plus que le sujet lui-même, aussi répugnant soit-il, c'est la répétition structurelle des gestes et des sons qui semble fasciner l'artiste. L'intérêt de Creed pour la manière dont on peut utiliser les corps et les individus pour leur faire accomplir des actes mécaniques se retrouve dans une série de performances associant impassibilité totale et approche analytique. En 2006, à la Fondazione Trussardi de Milan, il a présenté son *Work No. 570* (2006), repris en 2008 à la Tate Britain, où des gens courent à toute vitesse à travers l'espace d'exposition, comme fuyant la scène d'un crime.

C. A.

SELECTED EXHIBITIONS →
2008 *Martin Creed*, Tate Britain, London. *History in the Making*, Mori Art Museum, Tokyo **2007** *Martin Creed: The Lights Going On and Off*, Boston Center for the Arts, Boston. *Out of Time – A Contemporary View*, MoMA, New York **2006** *Martin Creed: I Like Things*, Fondazione Nicola Trussardi, Palazzo Reale, Milan. *Martin Creed*, The Wrong Gallery, Tate Modern, London. *Word Sculpture*, Tate Modern, London. *Of Mice and Men*, 4th Berlin Biennial for Contemporary Art, Berlin

SELECTED PUBLICATIONS →
2008 *Martin Creed: Complete Works*, Steidl, Göttingen **2006** *Into Me / Out Of Me*, P.S.1 Contemporary Art Center, Long Island City; KW Institute for Contemporary Art, Berlin; Hatje Cantz, Ostfildern. *Nichts / Nothing*, Schirn Kunsthalle, Frankfurt am Main; Hatje Cantz, Ostfildern. *Of Mice and Men*, 4th Berlin Biennial for Contemporary Art, Berlin; Hatje Cantz, Ostfildern

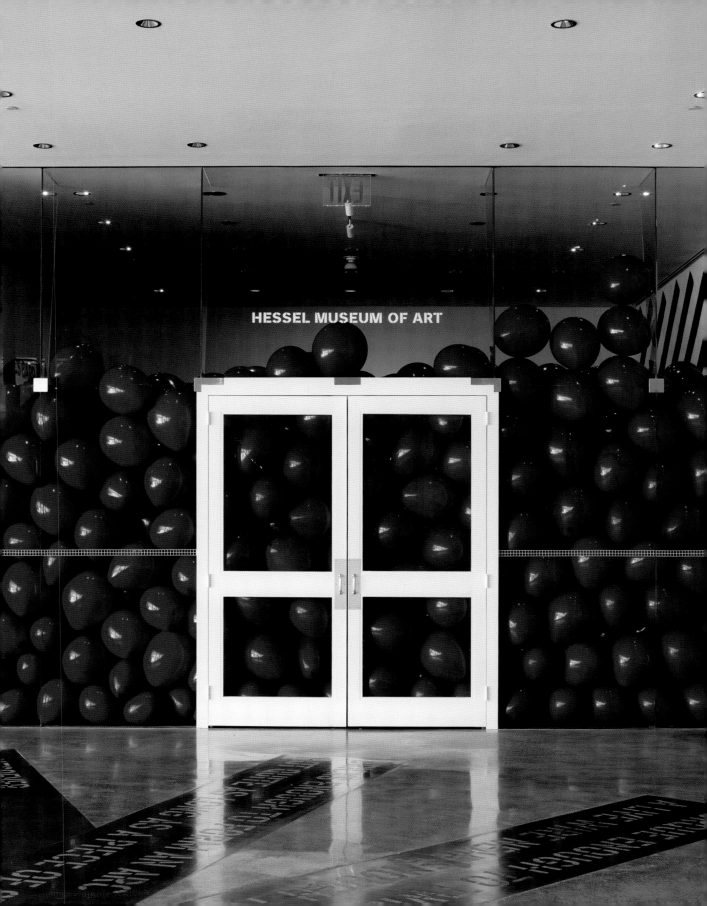

1 **Work No. 628: Half the Air in a Given Space**, 2006, blue balloons, ø 40.6 cm (each), dimensions variable. Installation view, Bard College, Annandale-on-Hudson, 2007

2 **Work No. 610: Sick Film**, 2006, 35mm film transferred to DVD, colour, sound, 21 min

3 **Work No. 503**, 2006, single-channel video installation, 35mm film transferred to DVD, colour, sound, 1 min 6 sec, loop

4 **Work No. 850**, 2008, people running as fast as they can. Installation view, Tate Britain, London

5 **Work No. 891**, 2008, ink on paper, 17.8 x 17.8 cm

6 **Work No. 876**, 2008, tower of card board boxes in ascending order from smallest to largest, 107.5 x 60.5 x 47 cm

„Ich denke, die besten Arbeiten enstehen, wenn man die Kontrolle verliert, wenn man locker und offen ist ... aber das lässt sich schwer herbeiführen."

« Je pense qu'on fait les meilleures œuvres quand on lâche prise, quand on est détaché et ouvert... mais il est difficile de faire en sorte que cela arrive. »

"I think the best work usually happens when you lose control, when you're loose and open… but it's difficult to make it happen."

2

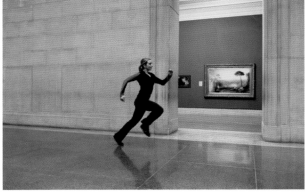

4

3

5

John Currin

1962 born in Boulder (CO), lives and works in New York (NY), USA

For an exhibition in 2007 in New York, John Currin exhibited *Kissers* (2006), a small canvas depicting two lovers absorbed in a lustful kiss next to *Malmo* (2006), a larger painting that shows the same couple during passionate sexual intercourse. Around 2006, the artist began a series of erotic pictures, taking inspiration from porn magazines and restricted websites. While the subject of these paintings might be debased to the point of straightforward scurrility, Currin's style remains that of a refined virtuoso. A more classical subject is painted in *Patch and Pearl* (2006), where two young women stand on the edge of a balcony, both pregnant but with their bellies awkwardly misplaced. This kind of anatomical distortion is typical of Currin's practice: since the early 1990s, he has been making provocative works that often portray naked bodies, domestic scenes and objectified women. His style has been deeply influenced by Old Master techniques, in particular that of underpainting, which allows the artist to capture the reverberations of light and colour with unusual intensity, especially in flesh and skin tones. When applied to mundane subjects, Currin's masterful technique produces a vibrant tension. These technical refinements are often combined with his interest in revisiting the old masters' styles – we frequently meet contemporary versions of Cranach's Eve and Botticelli's Venus in his paintings – and even single masterworks: oscillating between pornography and classical fine art, *After Courbet* (2008) shows a woman wearing a flouncing white garment, her legs wide open and her genitalia in the foreground, directly quoting Gustave Courbet's groundbreaking work *The Origin of the World* (1866).

2007 zeigte John Currin in New York seine *Kissers* (2006), ein kleines Gemälde mit zwei sich hingebungsvoll küssenden Liebenden, und daneben *Malmo* (2006), ein größeres Bild, auf dem dasselbe Paar im leidenschaftlichen Koitus zu sehen ist. Angeregt durch Pornohefte und verbotene Webseiten, begann der Künstler 2006 eine erotische Bilderfolge. Obwohl das Sujet dieser Bilder bis zum rein Skurrilen entstellt sein kann, bleibt Currins Stil stets unübersehbar virtuos. In *Patch and Pearl* (2006) zeigt das eher klassische Sujet zwei junge, schwangere Frauen mit hässlich deplatzierten Bäuchen auf einem Balkon. Diese Art der anatomischen Entstellung ist typisch für Currins Arbeitsweise: Seit Anfang der 1990er-Jahre provozieren seine Arbeiten oft durch die Darstellung nackter Körper, häuslicher Szenen und auf Objekte reduzierter Frauen. Unter dem Einfluss altmeisterlicher Techniken wie der Untermalung gelingt es dem Künstler, Licht- und Farbreflexe vor allem von menschlicher Haut und Fleisch mit ungewöhnlicher Intensität wiederzugeben. In Bezug auf alltägliche Themen erzeugt Currins meisterliche Technik eine vibrierende Spannung. Neben diesen technischen Feinheiten offenbart er häufig auch Interesse an den verschiedenen Malstilen der alten Meister – in seinen Bildern begegnen wir zeitgenössischen Versionen der Eva von Cranach und der Venus Botticellis – und besonders an ihren weltberühmten Werken: An der Kippe zwischen Pornografie und klassischer Malkunst zeigt *After Courbet* (2008) eine in ein weißes Gewand drapierte Frau, die zwischen weit auseinander gespreizten Beinen ihr Geschlecht enthüllt, im direkten Verweis auf Gustave Courbets bahnbrechendes Gemälde *Der Ursprung der Welt* (1866).

À l'occasion d'une exposition à New York, en 2007, John Currin a présenté *Kissers* (2006), petite toile figurant deux amants absorbés par un baiser sensuel, juste à côté de *Malmo* (2006), une toile plus grande où est représenté le même couple, cette fois dans une scène de coït passionné. Vers 2006, l'artiste a entamé une série de peintures érotiques inspirées par les magazines et les sites pornographiques. Si le sujet de ces toiles peut paraître vulgaire jusqu'à l'obscénité, le style de Currin demeure celui d'un virtuose raffiné. C'est un thème plus classique que présente *Patch and Pearl* (2006), où deux jeunes femmes enceintes se tiennent au bord d'un balcon, sauf que leur ventre n'est pas placé au bon endroit. Ce genre de distorsion anatomique caractérise souvent la pratique de Currin : depuis le début des années 1990, il réalise des œuvres provocantes mettant en scène des corps nus, des scènes domestiques, des femmes-objets. Son style est profondément influencé par la redécouverte de techniques anciennes, notamment l'imprimature qui permet de saisir les réverbérations de lumière et de couleur avec une intensité inhabituelle, surtout pour les teintes de chair ou de peau. Appliqué à des sujets triviaux, ce procédé savant crée une tension et une vibration sans égales. Ces raffinements techniques sont souvent associés à son intérêt pour la relecture des grands maîtres – on rencontre souvent chez lui, par exemple, des versions contemporaines de l'Ève de Cranach ou de la Vénus de Botticelli –, ou même de tel chef-d'œuvre particulier : à mi-chemin entre les beaux-arts et la pornographie, *After Courbet* (2008) montre une femme vêtue de blanc, jambes ouvertes, sexe offert aux regards, évoquant clairement *L'Origine du monde* de Courbet (1866).

C. A.

SELECTED EXHIBITIONS →
2008 *Bad Painting – Good Art*, MUMOK, Vienna **2007** *INSIGHT?*, Gagosian Gallery / Red October Chocolate Factory, Moscow. *What Is Painting? – Contemporary Art from the Collection*, MoMA, New York. *Jake & Dinos Chapman and John Currin*, Magasin 3 Stockholm Konsthall, Stockholm **2006** *In the darkest hour there may be light*, Serpentine Gallery, London. *Zurück zur Figur*, Kunsthalle der Hypo-Kulturstiftung, Munich; Museum Franz Gertsch, Burgdorf **2005** *Big Bang*, Centre Georges Pompidou, Paris

SELECTED PUBLICATIONS →
2008 *Bad Painting – Good Art*, MUMOK, Vienna; DuMont, Cologne **2007** *INSIGHT?*, Gagosian Gallery / Red October Chocolate Factory, Moscow **2006** *John Currin: The Complete Works*, Gagosian Gallery, New York; Rizzoli, New York. *In the darkest hour there may be light*, Serpentine Gallery; Other Criteria, London. *Zurück zur Figur. Malerei der Gegenwart*, Kunsthalle der Hypo-Kulturstiftung; Prestel, Munich

1

1 **Patch and Pearl**, 2006, oil on canvas, 203.5 x 127 cm
2 **Kissers**, 2006, oil on canvas, 58.4 x 63.5 cm
3 **Rotterdam**, 2006, oil on canvas, 71.1 x 91.4 cm
4 **Tolbrook**, 2006, oil on canvas, 203.2 x 106.7 cm

„Bei Pornografie denkt man sofort an Fotografie, und es ist entscheidend, dass die Kamera nichts ist, was zwischen dich und die Darstellung tritt. Eine Frage für mich war, ob ich etwas so eindeutig Verdorbenes und Unschönes vielleicht durch die Malerei schön machen könnte."

« La pornographie est si étroitement liée à la photographie et dépend tellement de l'idée que l'appareil ne vienne pas s'interposer entre le spectateur et le sujet. Une chose qui me motive, c'est de voir si je pourrais arriver à faire que cette chose manifestement avilie et laide puisse devenir belle en peinture. »

"Pornography is so associated with photography, and so dependent on the idea that the camera doesn't intercede between you and the subject. One motive of mine is to see if I could make this clearly debased and unbeautiful thing become beautiful in painting."

2

3

Aaron Curry

1972 born in San Antonio (TX), lives and works in Los Angeles (CA), USA

Aaron Curry's *Pixelator (Mink and Veil)* (2008) and *Pierced Line (Brown Goblinoid)* (2008) superficially appear to do what conventional sculptures are supposed to do: at a considerable height of around two metres, both works are freestanding sculptures that can be viewed from all sides, and are mounted on plinths. They clearly address classical themes of art, recalling human or animal-like forms and evoking the formal language of the early 20th century. They are reminiscent of works of classical modernism, particularly as further developed by American surrealism. At the same time, however, Curry is utterly contemporary: he breaks the rules of traditional sculpture as often as he obeys them. His sculptures are made of plywood, their three-dimensional quality derives from individual sheets being slotted into one another rather than from the employment of sculptural technique. In addition, his works are peppered with allusions to popular culture. *Pixelator (Mink and Veil)* is almost completely covered in a black-and-white chessboard pattern inspired by a fantasy story by H. P. Lovecraft in which a meteor hits earth and wipes out all colour, and consequently all life, in the surrounding area. This colouring can also be related to artistic traditions such as that of constructivist sculpture or black-and-white photography. In this way, Curry's work, which also includes paintings and collages, intertwines art-historical references with concrete allusions to everyday life in America – graffiti, science fiction, film posters or even the décor of fast food restaurants.

Aaron Currys *Pixelator (Mink and Veil)* (2008) oder auch *Pierced Line (Brown Goblinoid)* (2008) gebärden sich vordergründig so, wie sich eine konventionelle Plastik verhalten sollte – beide Werke stehen mit ihrer beachtlichen Größe von rund zwei Metern frei im Raum, sind von allen Seiten gleichermaßen zu betrachten und wurden auf Sockeln platziert. Sie sind eindeutig klassischen Themen der Kunst verhaftet, denn sie erinnern an menschliche oder auch tierhafte Gestalten und beschwören die Formensprache des frühen 20. Jahrhunderts herauf. Sie lassen an Werke der klassischen Moderne, besonders an deren Weiterentwicklung im amerikanischen Surrealismus denken. Doch zugleich ist Curry höchst zeitgenössisch, denn in dem Maße, in dem er die Regeln traditioneller Skulptur befolgt, bricht er diese auch. Seine Plastiken bestehen aus Sperrholz, und auch ihre Dreidimensionalität verdankt sich nicht einer bildhauerischen Technik, sondern entsteht durch das Ineinanderstecken einzelner flächiger Elemente. Hinzu kommen häufig Anspielungen auf Ausdrucksformen der Populärkultur. So wurde die Farbgebung von *Pixelator (Mink and Veil)* – das Werk ist fast vollständig mit einem schwarz-weißen Schachbrettmuster überzogen – von einer fantastischen Erzählung H.P. Lovecrafts inspiriert, in der ein Meteoriteneinschlag in seiner Umgebung jegliche Farbigkeit und damit alles Leben auslöscht. Das Kolorit verweist auch auf künstlerische Traditionen wie die konstruktivistische Plastik und die Schwarz-Weiß-Fotografie. Currys Werk, das neben Skulptur gleichermaßen Gemälde und Collagen umfasst, verschränkt so stets kunsthistorische Verweise mit konkreten Anspielungen auf die amerikanische Alltagswelt, auf Graffiti, Science-Fiction, Filmposter oder auch das Dekor von Fastfood-Restaurants.

De prime abord, *Pixelator (Mink and Veil)* (2008) ou *Pierced Line (Brown Goblinoid)* (2008) d'Aaron Curry se comportent tout à fait selon les règles de la sculpture au sens classique : d'une taille respectable d'environ deux mètres, toutes deux se dressent librement dans l'espace, peuvent être contemplées de tous les côtés et ont été installées sur des socles. Elles traitent manifestement de sujets artistiques traditionnels, car elles rappellent des figures humaines ou animales et elles évoquent par ailleurs le vocabulaire formel du début du XXᵉ siècle. Elles rappellent les œuvres de la modernité classique, plus particulièrement son développement au sein du surréalisme américain. Curry n'en est pas moins hautement contemporain en ce qu'il suit les règles traditionnelles de la sculpture tout autant qu'il les rompt. Ses sculptures sont constituées de contreplaqué et leur tridimensionnalité ne procède pas non plus d'une technique de taille, mais de l'encastrement de différents éléments plans. À cela viennent souvent s'ajouter des allusions à des formes d'expression de la culture populaire. Le chromatisme de *Pixelator (Mink and Veil)* – œuvre presque entièrement recouverte d'un motif en damier noir et blanc – a été inspiré par la nouvelle fantastique de H. P. Lovecraft dans laquelle la chute d'une météorite éteint toute couleur et donc toute vie environnante. Le coloris renvoie également à des traditions artistiques comme la sculpture constructiviste et la photographie en noir et blanc. L'œuvre de Curry qui, outre la sculpture, contient également des peintures et des collages, imbrique ainsi des renvois constants à l'histoire de l'art et des allusions concrètes à la vie quotidienne américaine, au graffiti, à la science-fiction, à l'affiche de cinéma ou encore aux décors des fast-foods.

A. M.

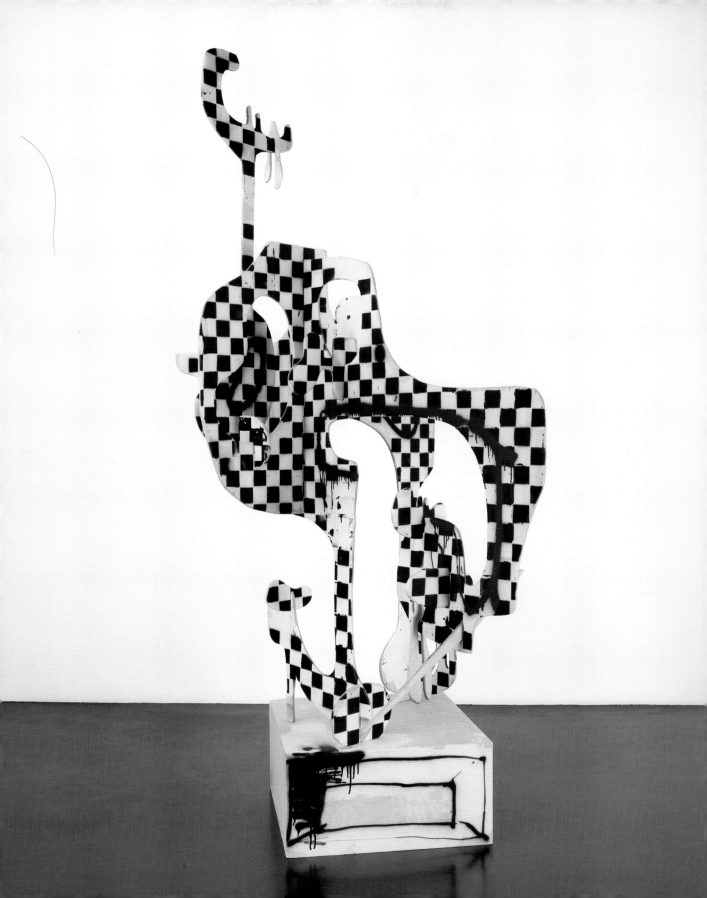

1 **Pixelator (Mink and Veil)**, 2008, wood, paint, sculpture
 213 x 147 x 102 cm, pedestal 32 x 60 x 60 cm
2 **Form Dwellers (In Vulgar Space)**, 2008, collage, triptyche,
 27.9 x 33.7 cm (each)
3 Installation view, Galerie Daniel Buchholz, Köln, 2008

4 **Devil's Horseman/Frameless (White)**, 2008, wood, paint,
 263 x 84 x 117 cm
5 **Pierced Line (Brown Goblinoid)**, 2008, wood, rope, paint,
 213 x 152 x 33 cm

„Mein Verständnis für Kunst hat sich zuerst aus Büchern entwickelt, was meine Neigung zum Kubismus erklären könnte. Ich versuche immer, Räumlichkeit zu schaffen indem ich zweidimensionale Formen ausschneide. Wie bei einem Pop-up-Buch, nur dass die Seiten gleichzeitig offen und geschlossen sind."

« Ma compréhension de l'art m'est d'abord venue par des illustrations de livres, ce qui pourrait expliquer mes affinités avec le cubisme. Je cherche toujours à créer de l'espace en sculptant des formes en deux dimensions. Comme un livre animé, sauf que les pages sont à la fois ouvertes et fermées. »

"My understanding of art first came from images in books, which could explain my affinity towards cubism. I'm always trying to create space by carving out forms in two dimensions. Like a pop-up book, only the pages are both open and closed at the same time."

2

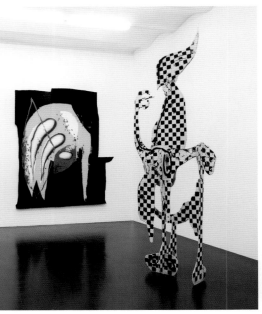 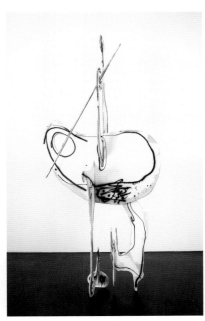

3 4

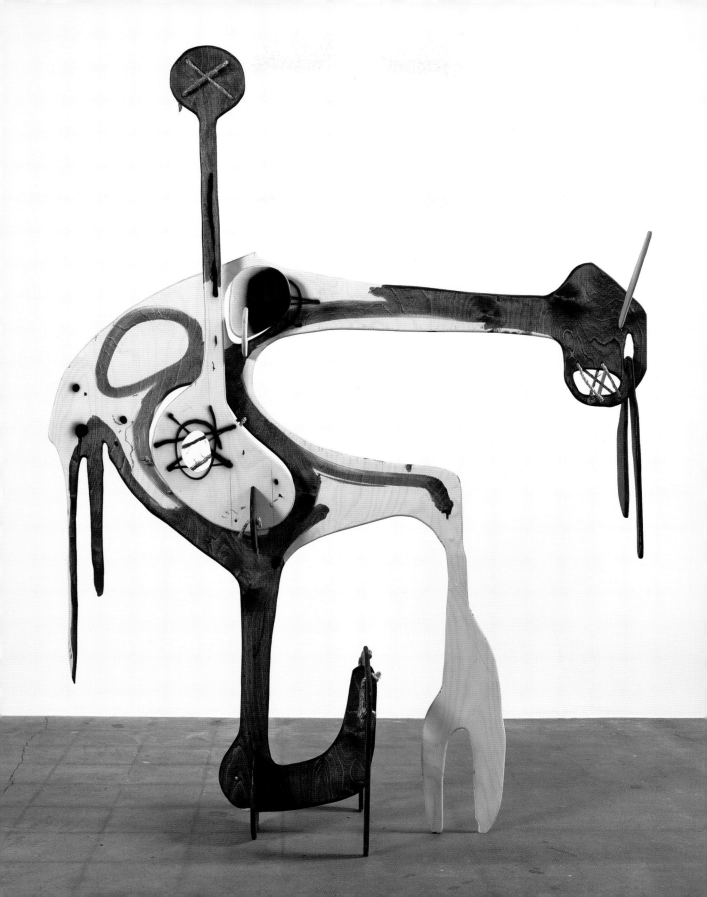

Enrico David

1966 born in Ancona, Italy, lives and works in London, United Kingdom

"I am drawn towards the theatrical," Enrico David has observed, "which isn't to say theatre *per se* — more the moment when culture becomes histrionic" — an inclination embodied in his paintings, sculptures and installations where provocative gestures of revelation and disruption are deliriously acted out. David's work stages an immaculately crafted psychodrama interweaving personal histories, memories, desires and creative dilemmas with reminiscences of 20th century aesthetic movements, colliding art deco with folk art or modernism's clean "masculine" lines with "feminine" craft techniques. For David, the creative act is the exposure of an inner world, which often manifests itself in the form of sexually provocative and confessional images. *Shitty Tantrum* (2007) is a shamelessly autobiographical series of 23 gouaches, inspired by André Gide's seminal novel about homosexuality, *L'Immoraliste*. In each of the delicately painted vignettes, scenes from David's life play out: arguments with his boyfriend, family feuds and anxieties about his self-appearance. In his recent installation *Ultra Paste* (2007), David takes us further into his past and into the stylish confines of his childhood bedroom, based on the one designed for him by his father in the early 1970s, as well as on a 1935 collage by artist and photographer Dora Maar. The viewer's gaze into the moody green room falls on a cut-out figure rubbing itself against an artists' mannequin — a moment of adolescent awakening that appears both vividly real and dreamlike, conjuring a space for the enactment of David's inner fantasies and a stage-like setting for the projection of our own.

„Das Theatralische zieht mich an", sagt Enrico David, „nicht so sehr das Theater an sich, sondern eher der Moment, in dem Kultur theatralisch wird." Diese Vorliebe ist seinen Bildern, Skulpturen und Installationen anzusehen, in denen provokante Gesten der Enthüllung und der Zerrüttung wie im Wahn ausgelebt werden. Davids Arbeit inszeniert ein bis ins Detail ausgeführtes Psychodrama: private Geschichten, Erinnerungen, Sehnsüchte und kreative Sackgassen verwebt er mit Reminiszenzen an die ästhetischen Bewegungen des 20. Jahrhunderts, Jugendstil trifft auf Folk Art und die sterilen „männlichen" Linien des Modernismus prallen auf „weibliche" Handarbeitstechniken. *Shitty Tantrum* (2007) ist eine schamlos autobiografische Serie von 23 Gouachen, die von *L'Immoraliste*, André Gides einflussreichem Roman über Homosexualität, inspiriert wurde. In jeder der mit zartem Strich gezeichneten Vignetten spielen sich Szenen aus Davids Leben ab: Auseinandersetzungen mit seinem Freund, Familienstreitigkeiten und Ängste um das eigene Aussehen. In seiner jüngsten Installation *Ultra Paste* (2007) führt uns David noch weiter in seine Vergangenheit und in das modische Gefängnis seines eigenen Kinderschlafzimmers — ein Bastard aus dem von seinem Vater in den frühen 1970ern für ihn entworfenen Zimmer und einer Collage der Künstlerin und Fotografin Dora Maar aus dem Jahr 1935. Der Blick des Betrachters fällt in einem stimmungsvollen grünen Raum auf eine ausgeschnittene Figur, die sich an einer Gliederpuppe reibt: ein Moment des jugendlichen Erwachens, der so lebendig wirklich wie traumhaft erscheint und einen Raum für die Aufführung von Davids persönlichen Fantasien entstehen lässt — und eine bühnenartige Kulisse für die Projektion unserer eigenen.

« Ce qui est théâtral m'attire », observe Enrico David, « il ne s'agit pas du théâtre en tant que tel mais plutôt du moment particulier où la culture se transforme en représentation théâtrale ». Cette inclinaison se retrouve dans ses peintures, sculptures et installations, où des gestes provocateurs de révélation et de disruption sont dramatisés de façon délirante. Son œuvre met en scène un psychodrame soigneusement construit, qui entrelace histoires personnelles, souvenirs, désirs et dilemmes artistiques, et où s'entrechoquent des réminiscences de mouvements esthétiques du XXᵉ siècle, de l'Art déco au « folk art », des lignes pures et « masculines » du modernisme aux techniques artisanales dites « féminines ». Pour David, créer consiste à exposer un univers intérieur qui se manifeste à travers des images sexuelles provocatrices ou confessionnelles. *Shitty Tantrum* (2007) est une série autobiographique sans fard de 23 gouaches inspirée par *L'Immoraliste*, le roman d'André Gide sur l'homosexualité. Dans chacune des vignettes sont représentées des scènes de la vie de David : disputes avec son compagnon, querelles familiales, inquiétudes liées à son apparence. Dans l'installation *Ultra Paste* (2007), David nous entraîne plus loin encore dans son passé : dans sa chambre d'enfant. L'installation s'inspire de la chambre que le père de David avait créée pour lui au début des années 1970, mais aussi d'un collage de 1935 de Dora Maar. Le regard du spectateur sur cette pièce d'un vert maussade s'arrête sur une figure découpée qui se frotte contre un mannequin d'artiste — un épisode d'éveil adolescent, à la fois onirique et réaliste, qui propose un espace consacré à la réalisation des fantasmes de David et un décor de théâtre où projeter les nôtres.

A. B.

SELECTED EXHIBITIONS →
2009 *Enrico David*, Museum für Gegenwartskunst, Basle **2008** *Marc Camille Chaimowicz "...In The Cherished Company of Others..."*, De Appel, Amsterdam **2007** *Enrico David*, ICA, London. *Enrico David: Chicken Man Gong*, Stedelijk Museum, Amsterdam **2005** *British Art Show 6*, Hayward Gallery, London. *Enrico David*, Tate Britain, London **2004** *Flesh at War with Enigma: David, Davis, Göthe, Hernandez, Janas, Szapocznikow*, Kunsthalle Basel, Basle **2003** *Enrico David*, Project Arts Centre, Dublin. *50th Venice Biennial*, Venice

SELECTED PUBLICATIONS →
2005 *British Art Show 6*, Hayward Gallery, London **2004** *Flesh at War with Enigma: David, Davis, Göthe, Hernandez, Janas, Szapocznikow*, Kunsthalle Basel, Basle

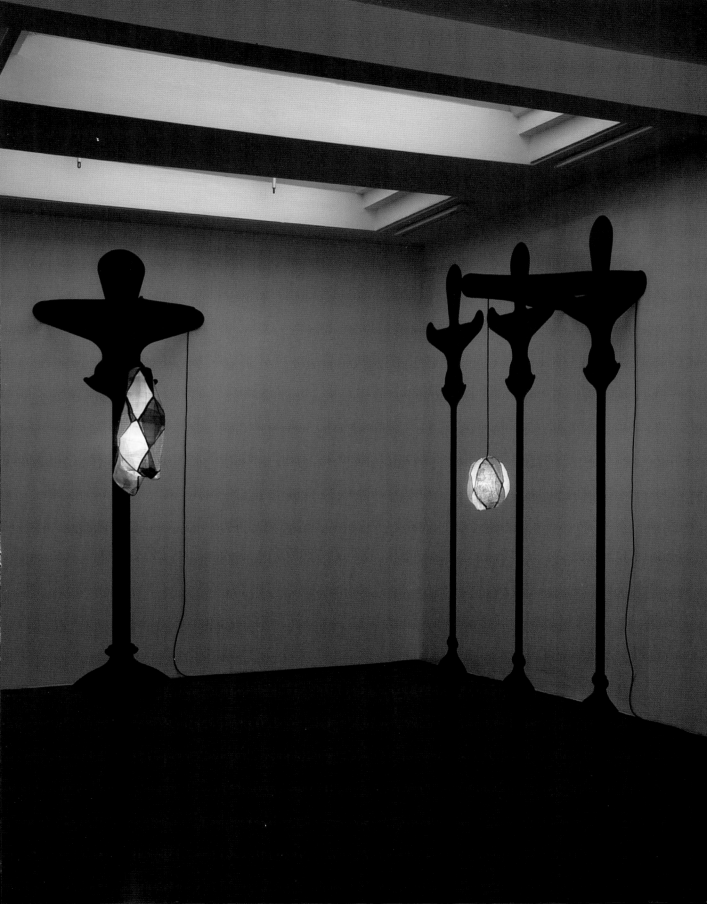

1 **Bulbous Marauder**, 2008. Installation view,
 Galerie Daniel Buchholz, Cologne
2 **Bulbous Marauder**, 2008, gouache on paper, 116 x 83 cm
3 **Bulbous Marauder**, 2008, gouache on paper, 116 x 83 cm

4 **Model for a Non-Fictional Narrative**, 2007, 7 panels (birch plywood),
 14 wood studs, paint, pencil, coloured plastic gelatines, 245 x 492 x 6 cm
5 **Shitty Tantrum: On the Eve of Our Kabuki Play, I Console My Brother
 for Running out of Ideas**, 2007, gouache on paper, 48 x 48 cm (framed)
6 **Bubble Protest**, 2005, acrylic, pencil, ink, paper, wood, 280 x 450 cm

„Ich bediene mich gern bei traditionellen Handwerkstechniken, Mustern und Formen, nehme das dazugehörige Regelwerk und das praktische Potenzial und versuche, damit meine oft chaotische emotionale Reaktion auf die Realität zu organisieren und zu strukturieren."

« J'emprunte souvent aux techniques artisanales et aux formes traditionnelles et me sers de leurs règles et de leur potentiel fonctionnel pour tenter d'organiser et structurer la nature souvent chaotique de ma réaction émotionnelle face à la réalité. »

"I often borrow from traditional craft techniques and design styles, using their pre-given rules and functional potential in an attempt to organize and give structure to the often chaotic nature of my emotional response to reality."

2

3

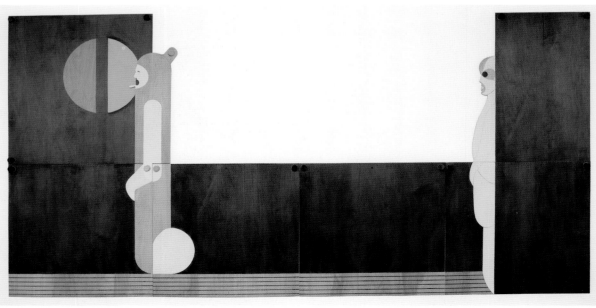

4

5

Tacita Dean

1965 born in Canterbury, United Kingdom, lives and works in Berlin, Germany

In her films, photographs, drawings and collections of found objects Tacita Dean reveals a deep-rooted fascination with the act of observation, particularly of subjects which may quickly disappear or become invisible. Her 16mm films lend space and light a palpable materiality and counter the frenetic speed of modern life with a gaze characterized by static camera positions and long takes that create a certain stillness in the moving images. Whether of events, people or places, her films might for the most part be classified as portraits, revealing the innate qualities of her various subjects. Dean's recent *Darmstädter Werkblock* (2007) is filmed in the suite of rooms devoted to and installed by Joseph Beuys in Darmstadt's Hessisches Landesmuseum. Rather than focusing on the works themselves, Dean trains her camera on the rooms' dilapidated jute walls carpet which are soon to be replaced, emphasising the entropic nature of Beuys' work and creating an enigmatic portrait of the artist. Many of Dean's films and drawings explore elusive natural phenomena, from solar eclipses to the green flash of light that accompanies the setting of the sun. Often they appear together with architectural elements, symbols for outmoded or bankrupt beliefs. *Palast* (2004) for example – an elegiac portrait of the now destroyed Palast der Republik in Berlin, an iconic building of the GDR era – shows reflections of light on the mirror-like surface of the building. As much as Dean's films are recordings of the visual beauty of these spectacular moments, their focus on the passing of time casts each of Dean's films as an elegiac and reflexive musing on the obsolescence of the medium of film itself.

In ihren Filmen, Fotografien, Zeichnungen und Sammlungen gefundener Objekte beschäftigt sich Tacita Dean gerne mit dem Akt der Beobachtung, vor allem jener Sujets, die bald verschwinden oder unsichtbar werden können. Ihre 16-mm-Filme verleihen Licht und Raum eine fühlbare Materialität. Dem rasenden Tempo des modernen Lebens begegnen sie durch statische Kamerapositionen und lange Einstellungen, die ein Element der Stille in die bewegten Bilder bringen. Ganz gleich, ob sie Situationen, Menschen oder Orte zeigen, lassen sich die Filme zumeist als Porträts bezeichnen, da sie die verborgenen Eigenschaften ihrer jeweiligen Sujets enthüllen. In ihrer neuen Arbeit *Darmstädter Werkblock* (2007) filmt Dean in den nach Beuys benannten und von ihm installierten Räumen des Hessischen Landesmuseums in Darmstadt. Anstatt auf die Werke selbst richtet die Künstlerin ihre Kamera auf die marode Jutebespannung an den Wänden, die bald ersetzt werden soll, wobei unter Hervorhebung des entropischen Charakters von Beuys' Arbeit ein enigmatisches Künstlerporträt entsteht. Dean untersucht in ihren Filmen und Zeichnungen oft schwer fassbare Naturerscheinungen, wie Sonnenfinsternisse oder das grüne aufblitzende Licht, das einen Sonnenuntergang begleitet. Häufig tauchen sie in Verbindung mit Architektur auf, die veraltete oder gescheiterte Ideologie symbolisiert. *Palast* (2004) z.B. – ein melancholisches Porträt des nunmehr abgerissenen Palasts der Republik in Berlin, eines Symbols der DDR-Zeit – zeigt Lichtreflexe auf der spiegelglatten Oberfläche des Gebäudes. Wenn Dean in ihren Filmen einerseits die visuelle Schönheit solch besonderer Momente festhält, sind ihre Arbeiten, die das Verstreichen der Zeit fokussieren, andererseits ein wehmütiges Reflektieren über das Veralten des Mediums Film an sich.

Dans ses films, ses photographies, ses images et ses collections d'objets trouvés, Tacita Dean révèle une profonde fascination pour l'acte d'observer – notamment des sujets dont la disparition peut les faire se perdre ou les rendre invisibles. Ses films en 16 mm donnent à l'espace et à la lumière une matérialité palpable, opposant à la frénésie de la vie moderne un regard que caractérisent un cadre fixe et de longues prises dotant ces images mouvantes d'un certain statisme. Qu'ils portent sur des événements, des gens ou des lieux, ses films apparaissent pour la plupart comme des portraits révélant les qualités intrinsèques de leurs divers sujets. Le récent *Darmstädter Werkblock* (2007) est filmé dans les pièces consacrées à Joseph Beuys et installées par ce dernier au Hessisches Landesmuseum de Darmstadt. Au lieu de filmer les œuvres elles-mêmes, Dean a braqué sa caméra sur la vieille tapisserie de jute qui, en attente de remplacement, recouvre les murs de la pièce – soulignant ainsi la nature entropique de l'œuvre de Beuys et offrant de l'artiste un portrait énigmatique. De nombreux films et dessins de Dean explorent des phénomènes naturels éphémères, de l'éclipse solaire au rayon vert qui parfois accompagne le coucher ou le lever du soleil. Ces phénomènes sont souvent présentés en relation avec des éléments d'architecture, symboles de croyances désuètes ou déçues. *Palast* (2004), par exemple – portrait mélancolique d'une icône de l'ancienne RDA, le Palast der Republik de Berlin aujourd'hui détruit –, saisit des reflets de lumière sur la surface en miroir du bâtiment. Si les films de Dean enregistrent la beauté visuelle de ces moments spectaculaires, leur fascination obsessionnelle pour le passage du temps fait de chacun d'eux une méditation élégiaque sur l'obsolescence de la pellicule cinématographique comme support artistique.

A. B.

SELECTED EXHIBITIONS →
2008 *Tacita Dean*, Dia: Beacon, New York. *Real*, Städel Museum, Frankfurt am Main **2007** *Tacita Dean: The Hugo Boss Prize 2006*, Solomon R. Guggenheim Museum, New York. *Tacita Dean: Film Works*, Miami Art Central, Miami **2006** *Tacita Dean: Human Treasure*, Center for Contemporary Art, Kitakyushu. *Tacita Dean*, The National Gallery, Oslo. *Tacita Dean & Francis Alÿs*, Schaulager, Münchenstein / Basle **2005** *Tacita Dean*, Tate St. Ives. *Tacita Dean: The Russian Ending, 2001*, Berlinische Galerie, Berlin

SELECTED PUBLICATIONS →
2008 *Tacita Dean: Film Works*, Miami Art Central, Miami; Charta, Milan **2006** *Tacita Dean*, Phaidon Press, London. *Tacita Dean: Analogue. Drawings 1991–2006*, Schaulager, Münchenstein / Basle; Steidl, Göttingen **2005** *Tacita Dean: An Aside*, Hayward Gallery, London; Steidl, Göttingen. *Tacita Dean: Die Regimentstochter*, Steidl, Göttingen

1 **Merce Cunningham Performs** *Stillness (in Three Movements)* **to John Cage's Composition 4'33" with Trevor Carlson, New York City, 28 April 2007 (Six Performances, Six Films)**, 2008, production still, 16mm colour film, optical sound

2 **Merce Cunningham Performs** *Stillness (in Three Movements)* **to John Cage's Composition 4'33" with Trevor Carlson, New York City, 28 April 2007 (Six Performances, Six Films)**, 2008, 16mm colour film, optical sound. Installation view, Dia:Beacon, New York

3 **Crowhurst II**, 2007, gouache on fibre-based photograph, mounted on paper, 300 x 380 cm

4 **Darmstädter Werkblock**, 2007, production still, 16mm colour film, optical sound, 18 min, continuous loop

5 **Darmstädter Werkblock**, 2007, 16mm colour film, optical sound, 18 min, continuous loop. Installation view, Frith Street Gallery, London

„Es wird gesagt, dass es in meinen Filmen oft um Erinnerung geht, aber Erinnerung ist etwas sehr Subjektives."

« On dit que la mémoire constitue souvent le sujet de mes films – mais la mémoire est une chose bien subjective. »

"People say that my films are often about memory, but memory is such a subjective thing."

3

Thomas Demand

1964 born in Munich, lives and works in Berlin, Germany

Thomas Demand uses photography to gamble with reality – while maintaining a healthy distance to both. His images, mainly interiors and still lifes, are based on elaborate mock-ups made of coloured paper. The preparations for his spectacular work *Grotte* (2006) are said to have taken two whole years. Demand does not regard himself as a photographer, given that he uses the medium as a mode of translation, i.e., in the staged reproduction of the models. Nor does he see himself as a model builder, as the models are merely points of reference for the images; they are not exhibited and are destroyed after being photographed. Yet the link between them engenders a simulation of the real that shakes the confidence of the gaze: "The photograph gives you the information you need to see exactly what it is," says Demand, "and then it falls apart before your very eyes." He underscores this fragile relationship to reality by alluding to publicly available images, reconstructing well-known photographs of crime scenes or accidents that have been disseminated by the media and become lodged in our visual consciousness. The models, usually on a scale of 1:1, deflate and condense such source images by removing detail and focusing on objects. Humans are present only as traces, and this becomes all the more acute when Demand's works contain topical references: *Klause* (2006), for example, reconstructs the scene of a suspected child-abuse incident that dominated the German media for weeks as the "Pascal Case". *Embassy* (2007) shows images of the ransacked Embassy of Niger in Rome, where papers were stolen that served the CIA to justify the Iraq war. Demand's photographs activate our media-encoded memory images – and simultaneously create a distance to them.

Thomas Demand setzt in der Fotografie die Wirklichkeit aufs Spiel – und geht dafür zu beidem auf Distanz. Seine Fotos, überwiegend Interieurs und Stillleben, basieren auf aufwendig hergestellten farbigen Papierattrappen. Allein die Vorbereitung für das spektakuläre *Grotte* (2006) soll zwei Jahre in Anspruch genommen haben. Er selbst sieht sich nicht eigentlich als Fotograf, da er das Medium übertragend, also zur inszenierenden Wiedergabe der Modelle nutzt. Er versteht sich aber auch nicht als Modellbauer, denn die Modelle sind nur Referenzobjekt fürs Bild, werden nicht ausgestellt, sondern nach fotografischer Umsetzung zerstört. Doch in der Verknüpfung entsteht eine Simulation des Wirklichen, die den Blick aus der Wahrnehmungsgewissheit reißt: „Das Foto gibt dir die Information, die du brauchst, um genau das zu sehen, was es ist", sagt Demand, „und dann zerfällt es vor deinen Augen." Dieses brüchige Realitätsverhältnis verschärft er durch Bezug auf öffentliches Bildmaterial. Seine Modelle rekonstruieren aus Presse und TV bekannte Tatort- oder Unfallfotos, die sich im medial gespeisten Bildbewusstsein eingenistet haben. Die Nachbauten, meist im Maßstab 1:1, entleeren und verdichten solche Vorlagen durch Reduktion von Details und Konzentration auf die Dinge. Menschen sind nur als Spuren präsent, und das wird umso brisanter, wenn die Werke aktuelle Verweise haben: *Klause* (2006) etwa rekonstruiert den Ort eines mutmaßlichen Kindesmissbrauchs, ein Vorfall, der als „Pascal"-Prozess wochenlang durch die Medien ging. *Embassy* (2007) zeigt Bilder der verwüsteten Botschaft Nigerias in Rom. Dort wurden Papiere gestohlen, die der CIA zur Legitimation des Irakkriegs dienten. Demands Fotos aktivieren medial codierte Erinnerungsbilder der Betrachter – und schaffen zugleich Distanz dazu.

Dans son travail photographique, Thomas Demand met le réel à l'épreuve – et se distancie pour cela des deux domaines. Ses photographies, le plus souvent des intérieurs ou des natures mortes, partent de complexes simulations réalisées en papiers de couleurs. La préparation de la spectaculaire *Grotte* (2006) aurait demandé deux années de travail. L'artiste ne se considère ni comme photographe, car il n'utilise le médium qu'indirectement pour une représentation scénographiée des maquettes, ni comme maquettiste, car ses maquettes ne sont que des objets de référence réalisés en vue de leur mise en images : elles sont détruites une fois photographiées. La combinaison des deux médiums produit pourtant une simulation du réel qui ébranle les certitudes de la perception visuelle : «La photo te donne l'information dont tu as besoin pour voir exactement ce qu'elle est, avant de se décomposer sous tes yeux», dit Demand. Cette friabilité du rapport au réel est encore renforcée par la référence à une source iconique connue. Les maquettes reconstituent des scènes de crimes ou d'accidents de la route publiées par la presse et la télévision, et donc inscrites dans une conscience iconique nourrie par les médias. Les reconstitutions, généralement grandeur nature, vident et concentrent ces modèles par la simplification des détails et la concentration sur les choses. La présence humaine est réduite à l'état de trace, ce qui devient encore plus crucial en cas de renvoi à l'actualité : *Klause* (2006) reconstitue la scène d'un crime pédophile présumé qui a mobilisé l'attention des médias pendant des semaines, *Embassy* (2007) montre des images de l'ambassade du Nigeria dévastée à Rome, où furent volés des papiers qui permirent à la CIA de justifier la guerre d'Irak. Les photographies de Demand activent des images mémorielles du spectateur codées par les médias – tout en l'en distanciant. J. A.

SELECTED EXHIBITIONS →
2008 *Thomas Demand: Camera*, Hamburger Kunsthalle, Hamburg. *Thomas Demand*, Photo Espana 2008, Fundación Telefónica, Madrid **2007** *Thomas Demand: L'Esprit d'Escalier*, Irish Museum of Modern Art, Dublin. *Thomas Demand: Processo grottesco*, Fondazione Prada, Venice **2006** *Faster! Bigger! Better!*, ZKM, Karlsruhe. *Thomas Demand*, Serpentine Gallery, London. *Thomas Demand & Max Beckmann*, MMK, Frankfurt am Main **2005** *Thomas Demand*, MoMA, New York

SELECTED PUBLICATIONS →
2007 *Thomas Demand: Processo grottesco*, Fondazione Prada, Venice; Progetto Prada Arte, Milano. *Thomas Demand: L'Esprit d'Escalier*, Irish Museum of Modern Art, Dublin; Verlag der Buchhandlung Walther König, Cologne **2006** *Faster! Bigger! Better!*, ZKM, Karlsruhe; Verlag der Buchhandlung König, Cologne. *Thomas Demand*, Serpentine Gallery, London, Schirmer/Mosel, Munich **2005** *Thomas Demand*, MoMA, New York

1 **Klause 5**, 2006, C-print, Diasec, 197 x 137 cm
2 **Camera**, 2007, high-definition video, stereo, 1 min 40 sec, loop

3 **Embassy IV**, 2007, C-print, Diasec, 198 x 198 cm
4 **Shed**, 2006, C-print, Diasec, 200 x 177 cm

„Meine Bilder betreffen weder den banalen Ort noch den Streit über den Tathergang, sondern das, was als Mythos hängenbleibt und sich verselbständigt."

« Mes images ne concernent ni le lieu banal, ni l'argumentation sur la réalité des faits, mais ce qui y reste accroché et prend son autonomie pour devenir mythe. »

"My pictures reference neither the banal location nor the argument about the sequence of events, but instead those things which are left over in the form of myths and which take on a life of their own."

2

3

Rineke Dijkstra

1959 born in Sittard, lives and works in Amsterdam, The Netherlands

Rineke Dijkstra's photographic series prove that the relationship between a photographer and her subject does not have to be a glancing exchange between strangers, in which one is armed with a camera and the other without any defence. Dijkstra's portraits bear witness to the development of young men and women experiencing rites of passage such as adolescence or childbirth, but to ensure that she doesn't merely steal single images of these moments, Dijkstra stays in contact with her subjects and chronicles their growth over time. Every two years, for instance, she has photographed Almerisa, a young Bosnian girl she met in an asylum seekers' centre in the Netherlands in 1994. Almerisa appears first as a slouching teenager with black painted fingernails, then a defiant young woman and, most recently, as a softened young mother holding her baby. By photographing her subjects in minimal surroundings and providing few clues about their environments or upbringings, Dijkstra directs her viewers toward subtler clues. We can just barely glimpse her subjects' imminent adulthood in their elongated limbs or oversize feet, the way they hold their heads, apply their makeup or the way their hair falls over their shoulders. Dijkstra says her interest in photography arose as an extension of her passive observation of people she found interesting or special: "I was interested in photographing people at moments when they had dropped all pretence of a pose." By forging enduring relationships out of these brief encounters, Dijkstra's act of photographing is less like distant or detached observation and more akin to the sensitivity and intimacy of friendship or motherhood.

Wie Rineke Dijkstra in ihren fotografischen Porträtserien beweist, muss die Beziehung zwischen der Fotografin und ihrem Sujet nicht wie ein Blickwechsel zwischen Fremden aussehen – die eine Seite mit einer Kamera bewaffnet, die andere dem wehrlos ausgesetzt. Dijkstras Porträtfotografien dokumentieren Veränderungen von jungen Männern und Frauen in einer Übergangsphase, etwa in der Pubertät oder nach einer Entbindung. Doch anstatt sich Einzelbilder dieser Momente anzueignen, hält Dijkstra den Kontakt weiter aufrecht, um spätere Entwicklungen immer wieder festzuhalten. So fotografierte sie im Zweijahres-Turnus ein junges bosnisches Mädchen namens Almerisa, das sie 1994 in einem niederländischen Asylbewerberheim kennengelernt hatte. Erst erscheint Almerisa als durchhängender Teenager mit schwarz lackierten Fingernägeln, dann als herausfordernde junge Frau und zuletzt besänftigt als Mutter mit ihrem Baby. Durch das minimalistische Dekor, das kaum einen Hinweis auf Umfeld oder Herkunft liefert, lenkt Dijkstra den Blick des Betrachters auf subtilere Details. Die Schwelle zum Erwachsensein angedeutet in den überlangen Gliedmaßen oder den großen Füßen, in der Kopfhaltung, im Make-up, in der Art, wie die Haare über die Schulter fallen. Dijkstras fotografisches Interesse entwickelte sich, wie sie sagt, ursprünglich aus rein passiver Beobachtung von Menschen, die sie interessant oder bemerkenswert fand: „Mein Anliegen war, die Leute in dem Moment zu fotografieren, wo sie ihre Posen abwerfen." Dadurch, dass sie diese Kurzbegegnungen zu dauerhaften Beziehungen weiterzuentwickeln vermag, ist Dijkstras fotografischer Akt weniger eine distanzierte oder unparteiische Betrachtung, als vielmehr dem Feingefühl und der Intimität von Freundschaft oder Mütterlichkeit verwandt.

Les séries photographiques de Rineke Dijkstra démontrent que la relation entre un photographe et son sujet ne se réduit pas nécessairement à un échange de regards entre étrangers, où l'un est armé d'un appareil et l'autre laissé sans défense. Les portraits de Dijkstra témoignent du développement de jeunes hommes et de jeunes femmes qui vivent des rites de passages comme l'adolescence ou la naissance d'un enfant. Pour s'assurer qu'elle ne se contente pas de ravir à ces moments des images isolées, Dijkstra reste en contact avec ses sujets et rend compte de leur évolution dans le temps. Un an sur deux, par exemple, elle revient photographier Almerisa, une jeune Bosniaque rencontrée en 1994 aux Pays-Bas dans un centre d'hébergement pour demandeurs d'asile. Almerisa apparaît d'abord comme une adolescente avachie aux ongles vernis de noir, puis comme une jeune femme rebelle et plus récemment en jeune mère adoucie tenant son bébé dans ses bras. En photographiant ses sujets dans des décors minimalistes et en ne donnant que de rares indications sur leur milieu d'origine, Dijkstra suggère au spectateur des indices plus subtils. Nous entrapercevons la maturité à venir de ses sujets à leurs membres étirés, leurs pieds surdimensionnés, la façon dont ils tiennent leur tête, se maquillent ou se coiffent. Dijkstra explique que son intérêt pour la photographie est apparu comme une extension de son observation passive des gens qu'elle trouvait intéressants ou spéciaux : « Ce qui m'intéressait, c'était de photographier les gens à des moments où ils abandonnent toute prétention de pose. » En créant des relations durables à partir de ces brèves rencontres, le *modus operandi* photographique de Dijkstra renvoie moins à une observation distanciée qu'à la sensibilité et l'intimité qui fondent une amitié ou un rapport maternel.

CH. L.

SELECTED EXHIBITIONS →
2008 *Puberty*, Haugar Vestfold Kunstmuseum, Tonsberg. *Presumed Innocence: Photographic Perspectives of Children*, DeCordova Museum, Lincoln **2007** *Schmerz*, Hamburger Bahnhof, Berlin **2006** *Faster! Bigger! Better!*, ZKM, Karlsruhe. **2003** *Rineke Dijkstra, The Buzzclub*, Liverpool; Mysteryworld, Zaandam; Kunstverein für die Rheinlande und Westfalen, Düsseldorf **2001** *Israel Portraits*, The Herzliya Museum of Art, Herzliya. *Focus: Rineke Dijkstra*, The Art Institute of Chicago. *Rineke Dijkstra: Portraits*, ICA, Boston

SELECTED PUBLICATIONS →
2007 *Schmerz*, Hamburger Bahnhof, Berlin; DuMont, Cologne **2006** *Faster! Bigger! Better!*, ZKM, Karlsruhe; Verlag der Buchhandlung Walther König, Cologne **2004** *Rineke Dijkstra: Portraits*, Schirmer/Mosel, Munich **2002** *Rineke Dijkstra: Beach Portraits*, LaSalle Bank, Chicago **2001** *Israel Portraits: Rineke Dijkstra*, The Herzliya Museum of Art, Herzliya; Sommer Contemporary Art, Tel Aviv. *Rineke Dijkstra: Portaits*, ICA, Boston; Hatje Cantz, Ostfildern

1 **Almerisa, Zoetermeer, The Netherlands, June 19**, 2008, C-print, 94 x 75 cm

2 **Vondelpark, Amsterdam, June 10**, 2005, C-print, 112.5 x 140 cm

3 **Almerisa, Asylumcenter Leiden, The Netherlands, March 14**, 1994, C-print, 94 x 75 cm

4 **Almerisa, Wormer, The Netherlands, June 23**, 1996, C-print, 94 x 75 cm

5 **Almerisa, Leidschendam, The Netherlands, December 9**, 2000, C-print, 94 x 75 cm

6 **Almerisa, Leidschendam, The Netherlands, June 25**, 2003, C-print, 94 x 75 cm

„Für mich ist es wichtig, eine Beziehung zum Modell aufzubauen. Es muss da ein Wechselspiel geben. Ich denke, es geht darum, einander auf einer emotionalen Ebene zu erkennen. Ich gebe nicht gern viele Anweisungen."

« Il est important pour moi de pouvoir me relier au sujet. Il faut qu'il y ait une interaction. Je pense qu'il s'agit essentiellement de reconnaissance à un niveau émotionnel. Je n'aime pas donner beaucoup de directives. »

"For me it is important that I can relate to my subject. There needs to be an interaction. I think it's all about recognition on an emotional level. I don't like to direct too much."

2

Nathalie Djurberg

1978 born in Lysekil, Sweden, lives and works in Berlin, Germany

Nathalie Djurberg's video animations picture a world populated by vicious girls, tortured men, mutilated bodies and grotesque animals. Adopting the old-fashioned technique of stop-motion, Djurberg portrays small handmade clay figures and marionettes that move in dreamlike sets. She explores bestial human instincts and primordial desires, which appear even more perverse as they contrast with the child-like simplicity of the medium of animation. Deviant sexuality, sadistic violence, monstrous incest and brutal death are weaved together in a theatre of cruelty that combines juvenile innocence with adult guilt. Female figures abound and are often accompanied by animals, as in *Tiger Licking Girl's Butt* (2004), in which, as the title implies, a tiger compulsively licks a girl's behind. Along with the modelling clay animations she began in 1999, Djurberg has also been making charcoal animations, like *My Name Is Mud* (2003), the story of a personified blob of mud that swallows animals and houses. Djurberg's short narratives play around themes such as male-female relationships, parental love and domestic abuse, mixing childhood memories with fairytale archetypes and a generous share of dark humour. All her works, which usually lack dialogue, are accompanied by vibrant musical scores composed by Hans Berg: at times joyful or dramatic, the electronic soundtracks give a baroque grandiosity to the scenarios of Djurberg's videos. Recently, Djurberg has also started experimenting with sculpture: for her exhibition *Turn into Me* (2008), she created several sculptural environments: a forest, a giant potato, a female body – pavilion-like structures which viewers can enter to watch the videos, as though immersed in the terrifying setting of a contemporary fable.

Nathalie Djurbergs Animationsfilme zeigen eine von bösartigen Frauen, gequälten Männern, verstümmelten Körpern und grotesken Tieren bevölkerte Welt. Mit der altmodischen Stop-Motion-Technik porträtiert Djurberg kleine, handgefertigte Plastilinfiguren und Marionetten vor traumartigen Kulissen. Sie interessiert sich für menschliche Bestialität und Urbegierden, wobei die Perversion durch die Harmlosigkeit des Kindertrickfilms betont wird. Sexuelle Abartigkeit, sadistische Gewalt, inzestuöse Monstrosität und tödliche Brutalität verbinden sich zu einem Theater des Grauens, in einem Spiel mit unschuldigen Kindern und schuldigen Erwachsenen. Die überwiegend weiblichen Figuren treten oft zusammen mit Tieren auf, wie in *Tiger Licking Girl's Butt* (2004), wo ein Tiger gierig am Hinterteil eines kleinen Mädchens leckt. Außer ihren 1999 begonnenen Trickfilmen mit Plastilin machte Djurberg auch animierte Kohlezeichnungen: *My Name Is Mud* (2003) handelt von einem belebten Stück Mist, das Tiere und Häuser verschlingt. Djurbergs kurze narrative Filme thematisieren Mann-Frau-Beziehungen, Elternliebe und häusliche Gewalt, wobei sie Kindheitserinnerungen und Archetypen der Märchenwelt mit einem kräftigen Schuss makabrem Humor verknüpfen. Die Filme haben keinen Dialog, sondern werden von Hans Bergs kraftvoller Musik untermalt. Die teils heiteren, teils dramatischen elektronischen Soundtracks verdichten Djurbergs Videofilme zu einer grandios barocken Fülle. Neuerdings experimentiert Djurberg auch mit Skulptur: Für ihre Ausstellung *Turn into Me* (2008) schuf sie skulpturale Environments – einen Wald, eine Riesenkartoffel, einen Frauenkörper –, pavillonartige Strukturen, die der Zuschauer betritt, um in der beklemmenden Kulisse einer zeitgenössischen Fabel die Videos zu betrachten.

Les animations vidéo de Nathalie Djurberg dépeignent un monde peuplé de filles sadiques, d'hommes torturés, de corps mutilés et d'animaux grotesques. Adoptant la vieille technique de l'animation image par image, Djurberg manipule des figurines d'argile réalisées à la main et des marionnettes qui évoluent dans des décors oniriques. Elle explore les instincts bestiaux et les désirs primaux de l'homme, qui apparaissent d'autant plus pervers qu'ils contrastent chez elle avec la simplicité enfantine de son médium. Sexualité déviante, violence sadique, incestes monstrueux et morts brutales s'entremêlent dans un théâtre de la cruauté associant innocence juvénile et culpabilité adulte. Les personnages féminins, très nombreux, sont souvent accompagnés d'animaux comme dans *Tiger Licking Girl's Butt* (2004), où l'on voit un tigre lécher avec ferveur les fesses d'une jeune fille. Outre ses animations employant des figurines d'argile, entamées en 1999, Djurberg réalise des dessins animés au fusain, tel *My Name Is Mud* (2003), qui raconte l'histoire d'un petit tas de boue qui engloutit des animaux et des maisons. Les courts récits de Djurberg mettent en scène les rapports homme-femme, l'amour parental et les violences conjugales, mêlant des souvenirs d'enfance aux archétypes du conte de fées, avec une bonne dose d'humour noir. Ses œuvres, presque toujours dépourvues de dialogue, s'appuient toujours sur une ardente partition musicale de Hans Berg – joyeuse ou dramatique, cette musique donne une ampleur baroque à ses scénarios. Depuis peu, Djurberg pratique également la sculpture : pour son exposition *Turn into Me* (2008), elle a créé différents environnements sculpturaux – une forêt, une pomme de terre géante, un corps de femme –, structures gigantesques que le visiteur est invité à pénétrer pour regarder les vidéos, comme immergé dans le décor terrifiant d'une fable contemporaine.

C. A.

SELECTED EXHIBITIONS →
2008 *Nathalie Djurberg: Turn into Me*, Fondazione Prada, Milan. *Nathalie Djurberg*, Sammlung Goetz, Munich **2007** *Nathalie Djurberg: Denn es ist schön zu leben*, Kunsthalle Wien, Vienna. *Nathalie Djurberg*, Kunsthalle Winterthur. *Traum und Trauma*, MUMOK, Vienna **2006** *Into Me/Out Of Me*, P.S.1 Contemporary Art Center, Long Island City; KW Institute for Contemporary Art, Berlin. *Of Mice and Men*, 4th Berlin Biennial for Contemporary Art, Berlin **2005** *Tirana Biennale*, Tirana

SELECTED PUBLICATIONS →
2007 *Nathalie Djurberg: Denn es ist schön zu leben*, Kunsthalle Wien, Vienna; Verlag für moderne Kunst, Nuremberg. *Traum und Trauma*, MUMOK, Vienna; Hatje Cantz, Ostfildern. *Into Me/Out Of Me*, P.S.1 Contemporary Art Center, Long Island City; KW Institute for Contemporary Art, Berlin; Hatje Cantz, Ostfildern **2006** *Of Mice and Men*, 4th Berlin Biennial for Contemporary Art, Berlin; Hatje Cantz, Ostfildern

1 **New Movements in Fashion**, 2006, clay animation, video, music by Hans Berg, 9 min 24 sec
2 **It's the Mother**, 2008, clay animation, video, music by Hans Berg, 6 min

3 **The Natural Selection**, 2006, clay animation, video, music by Hans Berg, 11 min 42 sec
4 **Turn into Me**, 2008, clay animation, video, music by Hans Berg, 7 min 10 sec

„Ich spiele alle Rollen in meinen Filmen, ich bringe meine weiblichen und männlichen Anteile ein. Als ich mit den Trickfilmen anfing, identifizierte ich mich mit dem Opfer, aber dann erkannte ich, dass ich genauso als Peiniger auftrat. Ich bin Opfer und Täter."

« Dans mes films, je joue tous les rôles ; j'y suis à la fois homme et femme. Quand j'ai commencé l'animation, je me voyais toujours comme la victime, avant de comprendre que j'étais aussi le tortionnaire. Je suis la victime et le bourreau. »

"I play all the parts in my films, so I am both male and female in them. When I started animating, I always saw myself as the victim, but then I realized that I was just as much the torturer. I am the victim and the perpetrator."

2

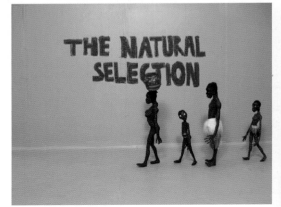

3

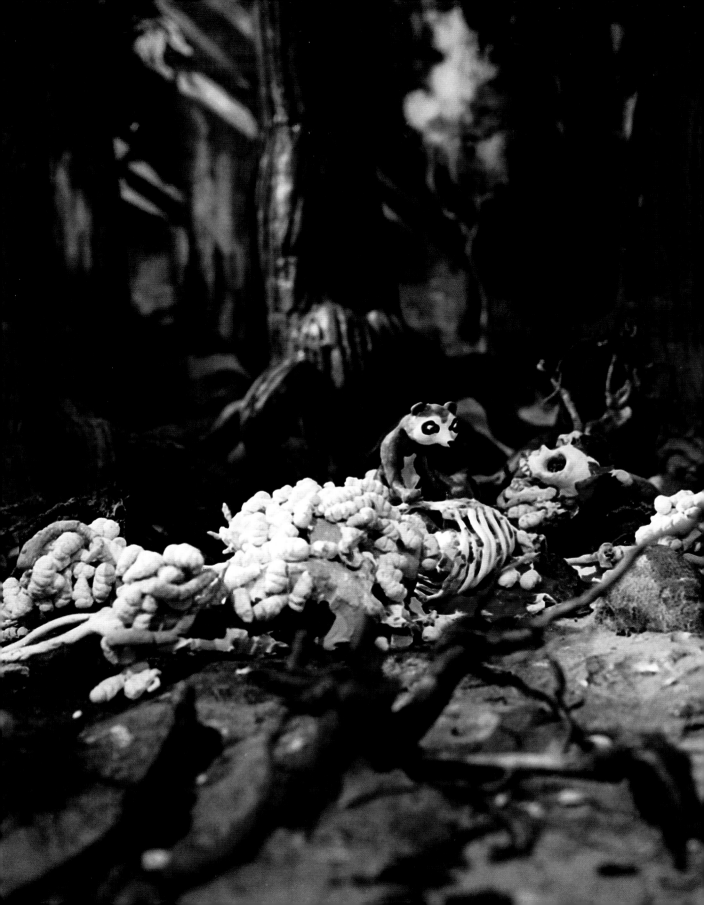

Peter Doig

1959 born in Edinburgh, United Kingdom, lives and works in Port of Spain, Trinidad and Tobago

Peter Doig is a phenomenon. His paintings break price records, are lauded by critics, influence other artists and, to this day, remain seductive for imitators. Doig spearheaded a renaissance of figurative painting that began in the mid-1990s and has continued almost uninterrupted since then. As a result, it is not easy to view his paintings without the distortions of hype and mythmaking. That it is nevertheless worth the effort was demonstrated most recently by Doig's retrospective exhibition at Tate Britain (2008), which proved that terms such as "magical realism" or "Gauguin exoticism" do not suffice to describe his work. One of Doig's qualities is that he has not fallen victim to a stylistic standstill. Over the course of time he has considerably altered his approach to the figure and to landscape, and has even modified painting itself while testing the boundaries of figuration. "I don't like repetition in progress. I want to avoid that way of working," he says. This is particularly evident in motifs which Doig has employed on a number of occasions and repeatedly transformed: for example in *Red Boat (Imaginary Boys)*, 2004, and *Figures in Red Boat* (2005–07), or in *Man Dressed as Bat* (2004 and 2007). The archaic *Untitled (Jungle Painting)*, 2007, obviously an echo of the no less sombre *Untitled (Paramin)*, 2004, also shows that such differentiations are not merely about variations or sketches. What is expressed here is a power of invention, sometimes tentative, sometimes erratic, whose "contents" are derived from painting. Doig thus succeeds, above all in his more recent paintings, in opening up figuration for broader contexts: "Painting should evolve into a type of abstraction; it should slowly dissipate into something else through time, through working, seeing things through."

Peter Doig ist ein Phänomen. Seine Bilder stellen Preisrekorde auf, werden von Kritikern gefeiert, waren für Künstler richtungweisend und sind bis heute verführerisch für Epigonen. Doig wurde zur Gallionsfigur der Wiederentdeckung einer figurativen Malerei, die Mitte der 1990er-Jahre in Gang kam und seither beinah ungebrochen ist, sodass es einige Mühe kostet, die Bilder unverstellt von Hype und Mythenbildung zu sehen. Dass so etwas durchaus lohnt, erwies sich zuletzt bei Doigs Retrospektive in der Tate Britain (2008), die zeigte, dass das Werk in Schlagworten von "Magischer Realismus" bis "Gauguin-Exotik" nicht aufgeht. Zu Doigs Qualität gehört, dass er keinem stilistischen Stillstand verfällt. Seinen Zugang zu Figur und Landschaft hat er im Laufe der Jahre stark verändert und im Ausloten der Grenzen von Figuration auch die Malerei selbst immer wieder neu justiert. "Ich mag keine Wiederholungen und versuche, solche Arbeitsweisen zu vermeiden", sagt er. Besonders deutlich wird das an Motiven, die Doig mehrfach aufgegriffen und dabei immer wieder verändert hat: etwa in *Red Boat (Imaginary Boys)* (2004) und *Figures in Red Boat* (2005–07) oder bei *Man Dressed as Bat* (2004 und 2007). Auch das archaische *Untitled (Jungle Painting)* (2007), offenbar ein Echo des nicht weniger düsteren *Untitled (Paramin)* (2004), zeigt: Bei solchen Differenzierungen geht es nicht bloß um Varianten oder Skizzen. Hier drückt sich eine mal tastend, mal sprunghaft vollzogene Erfindungskraft aus, die ihre "Inhalte" vom Malerischen her bestimmt. So gelingt es Doig vor allem in neueren Bildern, die Figuration auch für weitere Kontexte zu öffnen: "Malerei sollte sich zu einer Art von Abstraktion entwickeln", sagte er einmal, "und sich langsam in etwas anderes verwandeln – durch Zeit, durch Arbeit, indem man Dinge durchschaut."

Peter Doig est un phénomène. Ses tableaux battent des records en termes de prix, sont célébrés par la critique, influencent d'autres artistes et tentent les épigones. Doig est une des figures de proue d'une redécouverte de la peinture figurative qui s'est amorcée au milieu des années 1990 et s'est développée presque sans discontinuer, de telle manière qu'il est aujourd'hui difficile de regarder ses tableaux en laissant de côté la frénésie et le mythe. Le fait que son œuvre mérite un tel regard s'est à nouveau vérifié lors de la rétrospective présentée en 2008 à la Tate Britain et qui a montré qu'il ne pouvait être réduit à des clichés comme « réalisme magique » ou « exotisme à la Gauguin ». Une de ses qualités est qu'il ne s'enferme dans aucune forme de stagnation stylistique. Son approche de la figure et du paysage a fortement évolué au fil des ans, et Doig n'a cessé de renouveler aussi sa peinture en sondant les limites de la figuration. « Je n'aime pas les répétitions. Je préfère éviter cette manière de travailler », explique-t-il. Ceci ressort clairement des motifs que Doig a repris plusieurs fois de façon toujours différente, par exemple dans *Red Boat (Imaginary Boys)* (2004) et *Figures in Red Boat* (2005–07) ou *Man Dressed as Bat* (2004 et 2007). L'archaïque *Untitled (Jungle Painting)* de 2007, qui fait manifestement écho au non moins sombre *Untitled (Paramin)* de 2004, montre que ces distinctions ne sont pas seulement des variantes ou des études. Une puissance d'invention y procède tantôt par tâtonnements, tantôt par bonds, mais détermine surtout ses « contenus » à partir du fait pictural. Dans ses tableaux récents, Doig parvient ainsi à ouvrir la figuration à d'autres contextes : « La peinture devrait évoluer vers une sorte d'abstraction », a-t-il pu dire, « et se transformer lentement en quelque chose d'autre – par le temps, le travail, en perçant les choses à jour. »

J. A.

SELECTED EXHIBITIONS →
2008 *Peter Doig*, Tate Britain, London; Musée d'Art moderne de la Ville de Paris; Schirn Kunsthalle, Frankfurt am Main **2007** *Von Abts bis Zmijewski*, Pinakothek der Moderne, Munich. *The Secret Public*, ICA, London **2006** *Peter Doig: Go West Young Man*, Museum der bildenden Künste, Leipzig. *Peter Doig*, Ballroom Marfa. *Eye on Europe*, MoMA, New York **2005** *Peter Doig: Studiofilmclub*, Museum Ludwig, Cologne **2004** *Peter Doig: Metropolitain*, Kestnergesellschaft, Hanover

SELECTED PUBLICATIONS →
2008 *Peter Doig*, Tate Publishing, London; DuMont, Cologne **2006** *Peter Doig: Works on Paper*, Rizzoli, New York **2007** *Peter Doig*, Phaidon Press, London **2005** *Peter Doig: Studiofilmclub*, Museum Ludwig, Cologne; Kunsthalle Zürich, Zürich **2004** *Peter Doig: Metropolitain*, Pinakothek der Moderne, Munich; Kestnergesellschaft, Hanover; Verlag der Buchhandlung Walther König, Cologne

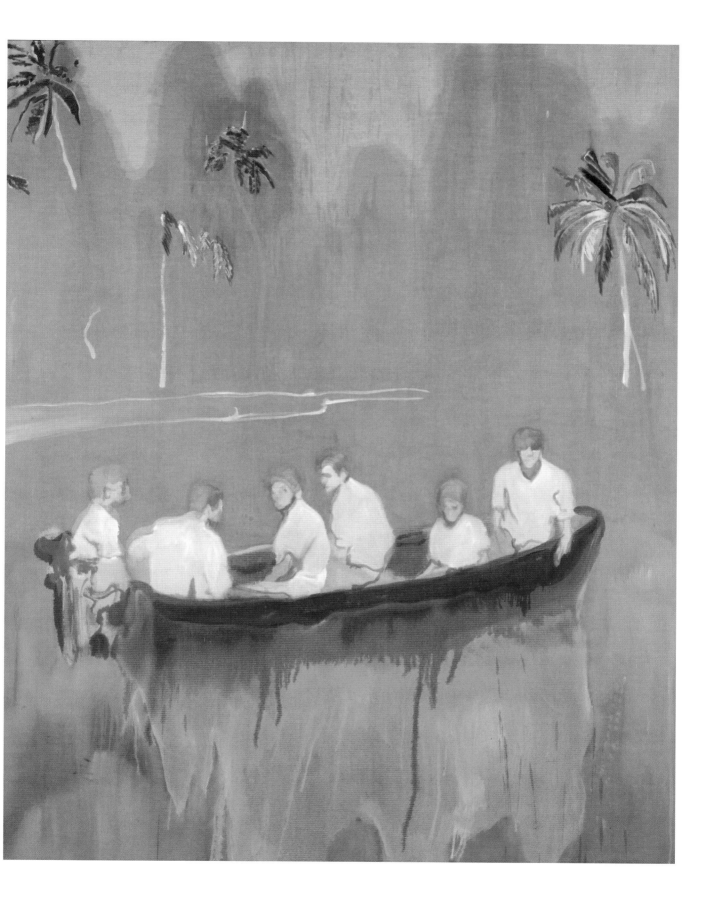

1 **Figures in Red Boat**, 2005–07, oil on linen, 250 x 200 cm
2 **Man Dressed as Bat**, 2007, oil on linen, 300 x 350 cm

3 **Untitled (Jungle Painting)**, 2007, oil on linen, 275 x 200 cm

„Häufig versuche ich, eine Art von ‚Sprachlosigkeit' zu schaffen. Ich versuche etwas zu machen, das fragwürdig bleibt, etwas, das sich schwer oder unmöglich in Worte fassen lässt."

« Souvent j'essaie de provoquer une "stupeur". J'essaie de créer le doute, de créer quelque chose de difficile voir d'impossible à définir. »

"Often I am trying to create a 'numbness'. I am trying to create something that is questionable, something that is difficult, if not impossible, to put into words."

2

Marlene Dumas

1953 born in Cape Town, South Africa, lives and works in Amsterdam, The Netherlands

Known for her oil, watercolour and ink portraits and renderings of the human figure, Marlene Dumas has made the personal political for the past twenty-five years, effectively throwing a grenade into an art-historical field where sexuality – and sexual politics as they intersect with race – too often remains untroubled. So perhaps it comes as little surprise that, in the aftermath of September 11 and in the midst of the atrocities perpetrated at Abu Ghraib, she would return to representations of death, a leitmotif in her work, alongside violence, religion and motherhood. *Measuring Your Own Grave* (2003), also the title of her recent retrospective, evinces a woman, arms spread like wings or maybe a cross, peering down into a monochrome void. Other works like *Dead Marilyn* (2008) shift from the anticipatory to the already gone. Based on a post-mortem shot of Marilyn Monroe, it makes use of photographic source material, as do most of Dumas' past images, some of which originate in the artist's own personal Polaroids, while others appropriate pornographic sources or frames from media archives. But lest the transcription from photograph to painting seem too direct, Dumas' close cropping decontextualizes its subjects, cleaving them from broader narrative and the signposts of background detail; their frontality might suggest an unsavory mugshot. Often as grisly in content as they are gorgeous in execution, the violence Dumas' wrestles into expressionistic pictorial form in fact remains at the level of implication, the better to psychologically unquiet and otherwise – ethically and ideologically – provoke.

Die für ihre Porträts und Darstellungen der menschlichen Gestalt in Öl, Aquarell und Tusche bekannte Künstlerin Marlene Dumas hat seit 25 Jahren das Persönliche zum Politischen erhoben. In einer Kunstgeschichte, in der Sexualität – und Sexualpolitik, die sich mit Rassenfragen überschneidet – allzu oft unbeachtet bleibt, schlug ihre Arbeit wie eine Bombe ein. So gesehen überrascht es nicht, dass sie nach dem 11. September und inmitten des Folterskandals von Abu Ghraib erneut an die Todesdarstellungen knüpft, die neben Gewalt, Religion und Mutterschaft ein Leitmotiv ihres Kunstschaffens sind. Das Bild *Measuring Your Own Grave* (2003), nach dem die aktuelle Retrospektive benannt wurde, zeigt eine Frau mit ausgebreiteten Armen, die an Flügel oder ein Kreuz erinnern, den Blick in eine monochrome Leere gerichtet. Andere Arbeiten wie *Dead Marilyn* (2008) werden vom Antizipatorischen weg zum bereits Geschehenen verlagert. Das auf einer Aufnahme der toten Marilyn Monroe basierende Bild benutzt eine fotografische Quelle – wie die meisten von Dumas Arbeiten, die teils auf eigene Polaroidaufnahmen, teils auf pornografische Quellen oder Material aus Medienarchiven zurückgehen. Um zu vermeiden, dass die Übertragung von der Fotografie zur Malerei zu unmittelbar erscheint, reißt Dumas durch Beschneiden der Fotos die Sujets aus ihrem ursprünglichen Kontext und trennt sie von ihren narrativen Zusammenhängen und Hintergrundinformationen; ihre direkte Frontalität könnte auf ein hässliches Fahndungsfoto verweisen. Oft inhaltlich abschreckend, sind die Werke doch schön ausgeführt. Die in Dumas' expressionistischen Bildern verdichtete Gewalt bleibt auf der Bedeutungsebene erhalten, um dadurch die Psyche stärker zu beunruhigen und sowohl ethisch wie auch ideologisch zu provozieren.

Connue pour ses représentations du corps humain et ses portraits à l'huile, à l'aquarelle ou à l'encre, Marlene Dumas, fait du personnel un sujet politique en dynamitant efficacement depuis un quart de siècle une histoire de l'art où la sexualité – tout comme la politique sexuelle dans son rapport à la politique raciale – est trop rarement mise à mal. On ne saurait donc s'étonner de ce que, au lendemain du 11 Septembre et des atrocités commises à Abu Ghraib, elle revienne à des représentations de la mort – motif récurrent de son œuvre au même titre que la violence, la religion et la maternité. *Measuring Your Own Grave* (2003), dont le titre est également celui d'une rétrospective récente, montre une femme aux bras ouverts comme deux ailes ou en croix, qui observe à ses pieds un néant monochrome. Ailleurs – comme dans *Dead Marilyn* (2008), d'après une photographie *post mortem* de Marylin –, la disparition remplace l'anticipation. Par le passé, Dumas a souvent utilisé pour ses peintures des sources photographiques : polaroids personnels, photos de presse, images pornographiques. Pour que ce passage de la photographie à la peinture ne soit pas trop direct, elle décontextualise ses sujets par un recadrage serré qui les prive de leur environnement narratif et les dépouille de tout détail d'arrière-plan. Leur caractère frontal peut alors évoquer un sinistre cliché d'anthropométrie judiciaire. Contenu macabre, exécution somptueuse : la violence de Dumas, exprimée sous une forme quasi expressionniste, demeure toujours implicite – comme pour mieux nous déstabiliser psychologiquement et mieux nous interroger sur le plan éthique, et idéologique.　　　　　　　S. H.

SELECTED EXHIBITIONS →
2008 *Marlene Dumas: Measuring Your Own Grave*, MOCA, Los Angeles; MoMA, New York. *Order. Desire. Light*, Irish Museum of Modern Art, Dublin. *The Painting of Modern Life*, Castello di Rivoli, Turin **2007** *Marlene Dumas: Broken White*, Museum of Contemporary Art, Tokyo **2006** *The 80's: A Topology*. Museo Serralves, Porto. *The Present*, Stedelijk Museum, Amsterdam **2005** *Marlene Dumas: Female*, Taidehalli Helsinki; Staatliche Kunsthalle Baden-Baden. *Eros*, Fondation Beyeler, Riehen/Basle

SELECTED PUBLICATIONS →
2008 *Marlene Dumas*, Phaidon Press, London. *Marlene Dumas: Measuring Your Own Grave*, MOCA, Los Angeles **2007** *Marlene Dumas: Broken White*, Museum of Contemporary Art, Tokyo **2006** *Marlene Dumas*, Mondadori, Milan. *Marlene Dumas: Broken White*, Museum of Contemporary Art, Tokyo **2005** *Marlene Dumas: Female*, Taidehalli Helsinki; Staatliche Kunsthalle Baden-Baden; Snoeck Verlag, Cologne

„Meine besten Arbeiten sind erotische Zurschaustellungen mentaler
Verwirrungen (mit eingestreuten belanglosen Informationen)."

« Mes meilleures œuvres sont l'expression érotique d'une confusion mentale
(où viennent s'ajouter des informations dépourvues de toute pertinence). »

"My best works are erotic displays of mental confusions (with intrusions of irrelevant information)."

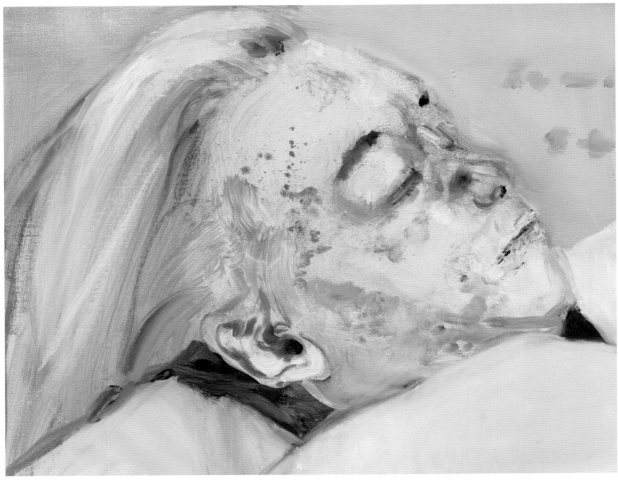

2

3

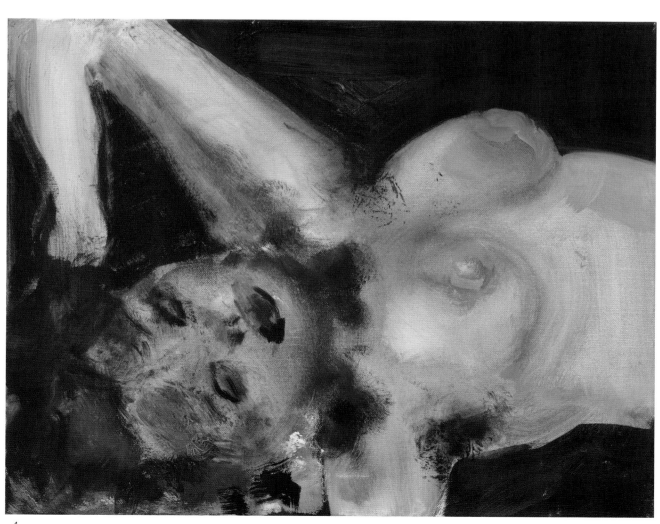

Marcel Dzama

1974 born in Winnipeg, Canada, lives and works in Brooklyn (NY), USA

Marcel Dzama's works depict a fairytale world in which people, animals, anthropomorphic plants and hybrid creatures interact, but where familiar dimensions and natural laws no longer apply. Dzama chooses to explore the threatening side of fairytales in his drawings, collages, films and sculptures, as they rarely promise a happy ending. In his recent dioramas he alludes to diverse cultural references: on the one hand to the forms of display found in natural history museums, on the other to religious shrines, which he became interested in during a stay in Mexico. At the same time, references to dada and surrealism abound, for example to Joseph Cornell. A work shown in his New York exhibition *Even the Ghost of the Past* (2008) reveals what might have preceded Marcel Duchamp's *Etant donnés* (1946–66): through a hole in a door a fox can be spied that seems to have knocked the couple out – in Duchamp's work, only the naked woman would be visible. Staged groups of figures such as *Welcome to the Land of the Bat* (2008) portray nightmarish scenes, for example when a sleeping bear is harried by a swarm of bats that could have flown straight out of Goya's *The Sleep of Reason*. In *On the Banks of the Red River* (2008), Dzama translates the catalogue cover of one of his own previous exhibitions into a surreal hunt and visitation scene consisting of almost 300 ceramic figures, including aristocratic hunters, bats and oversize heads. In contrast to his earlier works, today Dzama also includes commentary on contemporary US politics, as in *The Underground* (2008), a diorama that uses puppet-like sculptures to evoke images of the Iraq war.

Marcel Dzamas Arbeiten zeigen eine märchenhafte Welt, in der Menschen, Tiere, beseelte Pflanzen und hybride Kreaturen interagieren, wobei vertraute Größenverhältnisse und Naturgesetze keine Geltung mehr haben. Es ist eher die bedrohliche Seite von Märchen, die Dzama in seinen Zeichnungen, Collagen, Filmen und Skulpturen aufnimmt, denn sie verheißen selten ein gutes Ende. In neueren Arbeiten spielt er mit der Form des Dioramas auf verschiedene kulturelle Bezüge an: zum einen auf die Präsentationsform naturhistorischer Museen, zum anderen auf religiöse Schreine, wie er sie bei einem Mexiko-Aufenthalt kennengelernt hat. Zugleich enthalten sie immer wieder Bezüge zu Dada und Surrealismus, etwa zu Joseph Cornell. In seiner Ausstellung *Even the Ghost of the Past* (2008) in New York enthüllt eine Arbeit, was Marcel Duchamps *Etant donnés* (1946–66) zeitlich vorausgegangen sein könnte: Durch ein Loch in einer Tür lässt sich ein Fuchs erspähen, der vielleicht das Liebespaar – bei Duchamp wäre dann nur die nackte Frau zu sehen – in den Ruhezustand versetzt hat. Inszenierte Figurengruppen wie *Welcome to the Land of the Bat* (2008) schildern alptraumartige Szenen, wenn etwa ein schlafender Bär von einer Schar Fledermäuse bedrängt wird, die aus Goyas *Der Schlaf der Vernunft gebiert Ungeheuer* stammen könnten. In *On the Banks of the Red River* (2008) überträgt Dzama sein eigenes Cover für den Katalog einer früheren Ausstellung in eine aus fast 300 Keramikfiguren bestehende surreale Jagd- und Heimsuchungsszene mit aristokratischen Jägern, Fledermäusen und überdimensionalen Köpfen. Anders als in früheren Werken finden sich bei Dzama heute auch Kommentare zur aktuellen US-Politik. So in *The Underground* (2008), einem Schaukasten, der mit puppenartigen Skulpturen Bilder aus dem Irakkrieg heraufbeschwört.

Les œuvres de Marcel Dzama montrent un monde féerique où interagissent des hommes, des animaux, des plantes animées et des créatures hybrides, et où les rapports de proportions et les lois de la nature habituels n'ont plus cours. C'est plutôt la face inquiétante des contes que Dzama fait entrer dans ses dessins, collages, films, sculptures, qui présagent rarement un dénouement heureux. Récemment, Dzama exploite les possibilités du diorama pour évoquer différentes références culturelles : d'un côté, la forme de présentation des musées d'histoire naturelle, de l'autre, les châsses religieuses découvertes lors d'un séjour au Mexique. En même temps, on y trouve régulièrement des références au dadaïsme et au surréalisme, notamment à Joseph Cornell. Dans son exposition *Even the Ghost of the Past* (New York, 2008), une des œuvres dévoilait aux spectateurs l'évènement qui aurait pu précéder *Étant donnés* (1946–66) de Marcel Duchamp : par un trou de serrure ménagé dans une porte, on aperçoit un renard qui a peut-être mis le couple d'amants à la retraite – chez Duchamp, seule la femme nue apparaîtrait à cet endroit. Les groupes de figures comme *Welcome to the Land of the Bat* (2008) décrivent des scènes cauchemardesques, par exemple quand un ours ensommeillé est assailli par une nuée de chauves-souris qui pourraient être sorties du *Sommeil de la raison* de Goya. Dans *On the Banks of the Red River* (2008), Dzama transforme la couverture de catalogue d'une précédente exposition en scène de chasse et d'affliction surréaliste composée de plus de 300 figures en terre cuite – avec chasseurs aristocrates, chauves-souris, têtes surdimensionnées. Contrairement aux œuvres plus anciennes, on trouve aussi aujourd'hui chez Dzama des commentaires sur l'actualité politique américaine : *The Underground* (2008) est une vitrine dans laquelle les sculptures apparentées à des poupées évoquent des scènes de la guerre d'Irak. A. M.

SELECTED EXHIBITIONS →
2007 *Marcel Dzama*, Oficina para Proyectos de Arte (OPA), Guadalajara. *Comix*, Kunsthallen Brandts, Odense **2006** *Marcel Dzama*, Ikon Gallery, Birmingham. *Marcel Dzama*, Centre for Contemporary Art, Glasgow. *Into Me/Out Of Me*, P.S.1 Contemporary Art Center, Long Island City; KW Institute for Contemporary Art, Berlin. *Day for Night*, Whitney Biennial 2006, Whitney Museum, New York **2005** *Marcel Dzama*, Le Magasin, Grenoble. *XII. Rohkunstbau: Child's Play*, Wasserschloss Groß Leuthen. *IBCA 2005*, IBCA Biennale Prague

SELECTED PUBLICATIONS →
2008 *Marcel Dzama: Even the Ghost of the Past*, David Zwirner, New York; Steidl, Göttingen. *Marcel Dzama: The Berlin Years*, Perseus Distribution, Jackson **2006** *Marcel Dzama: Tree with Roots*, Ikon Gallery, Birmingham. *Marcel Dzama: The Course of Human History Personified*, David Zwirner, New York. *Whitney Biennial: Day for Night*, Whitney Museum of American Art, New York **2005** *Marcel Dzama: Paintings & Drawings*, Verlag der Buchhandlung Walther König, Cologne

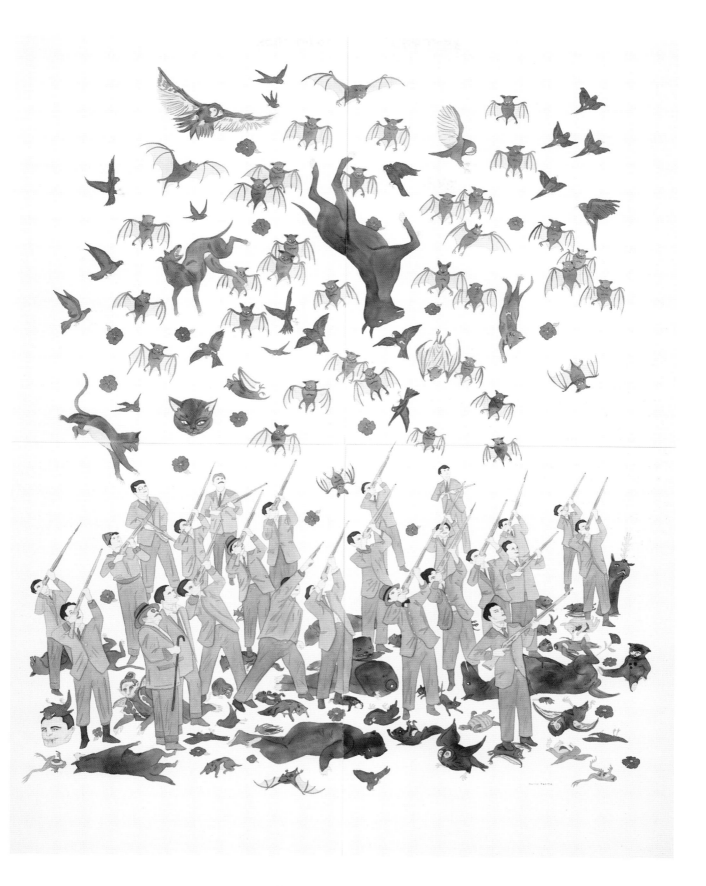

1 **The Banks of the Red River / A Veritable Army of Underdogs**, 2008, ink, watercolour, graphite on paper, 4 parts, 34.9 x 27 cm (each)
2 **Even the Ghost of the Past**, 2008, diorama, brick, door, wood, taxidermic fox, glazed ceramic sculptures, acrylic on blackboard, dimensions variable
3 **Welcome to the Land of the Bat**, 2008, diorama, wood, glazed ceramic sculptures, metal, fabric, outer dimensions 84 x 71 x 102 cm, window 58 x 71 cm, display height 202 cm

4 **On the Banks of the Red River**, 2008, diorama, wood, glazed ceramic sculptures, metal, fabric, outer dimensions 643 x 246 x 218 cm, window 179 x 635 cm, display height 285 cm
5 **The Underground**, 2008, diorama, wood, glazed ceramic sculptures, fibreglass, resin, sand, metal, fabric, outer dimensions 132 x 74 x 211 cm, window 165 x 119 cm, display height 236 cm

„Wenn es um Zeichnungen und Collagen geht bin ich eher Perfektionist. In der Malerei bin ich etwas lockerer. Aber aus irgendeinem Grund habe ich in der Skulptur das Gefühl, dass alles erlaubt ist. Da ist mehr Freiheit, und ich lasse mir ganz andere Dinge durchgehen."

« Je suis un peu un perfectionniste quand il s'agit de dessins et de collages. Je suis plus décontracté en peinture. Mais avec la sculpture, je ne sais pas pourquoi, je sens que tout est possible. J'ai plus de liberté, je sens que je peux donner davantage. »

"I'm a little bit of a perfectionist when it comes to drawings and collages. I'm kind of looser in paintings. But with sculpture for some reason I feel that anything goes. There's more freedom, I feel that I can get away with more."

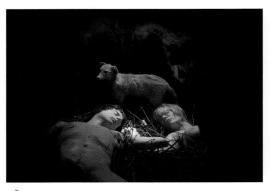

2

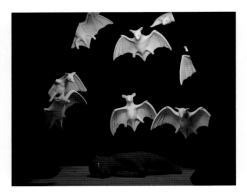

3

4

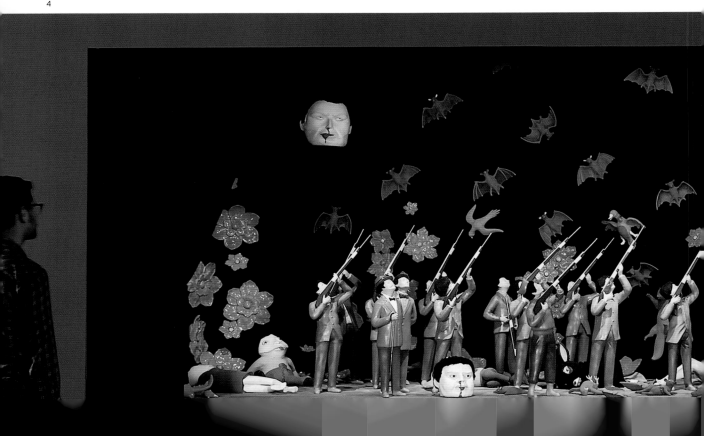

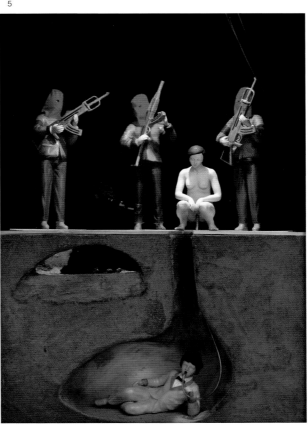

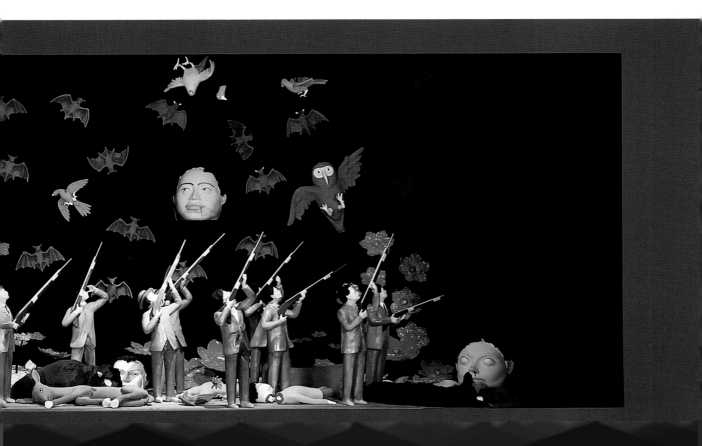

Martin Eder

1968, born in Augsburg, lives and works in Berlin, Germany

Martin Eder's *Stille wohnt in blauen Räumen* (2007) is a fastidiously painted close-up of a cranky cat set against a chalky blue background. The feline's flat snout and long hair betray an aristocratic lineage, and though we catch it un-groomed, it barely acknowledges our presence with a half-open, unimpressed eye. The portrait is a *tour de force* that captures the insouciant essence of cat-ness. Eder includes cats, kittens and other animals in surreal painted scenes, enriched with references to Hans Makart or James Ensor that usually contain women in various states of undress. Their former soft-porn sweetness, however, has become more cutting and somewhat reminiscent of Francis Picabia's nudes from the 1940s. A brunette seated with her legs slightly spread on a lush velvet bed, her chin and breasts jutting in defiance, occupies half the canvas *La Paix du Cul* (2006). Two guileless oversize Siamese kittens in a natural landscape fill the other. The contrast between blatant sexuality and fluffy innocence seems less consequential than Eder's wry manipulation of space and scale, and his command of an impressively sensuous painterly technique. In contrast, his large-scale colour photographs *Les Nus* (2006–08), take a more classical approach to composition. These are dramatically dark portraits of women, many pierced and tattooed, some bruised. A young woman in profile, wearing nothing but polka-dot red knee socks and a skirt stands next to a rumpled bed and looks down at a cell-phone (*Les Nus # 0180*, 2008). As unaware or uninterested in the viewer's gaze as the aforementioned cat, she is absorbed by Eder's lens, like the animal was in paint.

Martin Eders *Stille wohnt in blauen Räumen* (2007) ist ein anspruchsvoll gemaltes Close-up einer mürrischen Katze vor einem blauen Hintergrund. Die flache Schnauze und das lange Haar der Katze verraten ihre aristokratische Herkunft, und obwohl sie nicht zurechtgemacht ist, betrachtet sie uns gelangweilt durch ein halb geöffnetes Auge von oben herab. Das Porträt ist eine *tour de force*, die die sorglose Unmittelbarkeit des kätzischen Wesens festhält. Eder setzt Katzen, kleine Kätzchen und andere Tiere in surreal gemalte Szenerien, reich an Bezügen auf Hans Makart oder James Ensor, am liebsten mit Frauen in verschiedenen Graden der Nacktheit garniert. Anstatt der früheren Softpornolieblichkeit herrscht jetzt ein rauerer Ton, der etwas an Francis Picabias Akte aus den 1940ern erinnert. Eine Brünette, die mit leicht gespreizten Schenkeln in einem opulenten, samtenen Bett sitzt und Kinn und Brüste trotzig vorstreckt, nimmt die Hälfte der Leinwand von *La Paix du Cul* (2006) ein. Zwei unschuldige übergroße Siamkätzchen in einer naturalistischen Landschaft füllen die andere. Der Kontrast zwischen unverhohlener Sexualität und flauschiger Unschuld scheint weniger wichtig als Eders ironische Manipulation von Raum und Maßstab und seine Beherrschung einer bestechend sinnlichen Maltechnik. Im Gegensatz dazu finden seine großformatigen Farbfotografien *Les Nus* (2006–08) einen klassischeren Zugang zur Komposition in dramatisch verdunkelten Porträts von Frauen – viele gepierct und tätowiert, einige mit Hämatomen. Eine junge Frau im Profil, die nichts trägt als gepunktete rote Kniestrümpfe und einen Rock, steht neben einem zerwühlten Bett und blickt auf ein Handy herab (*Les Nus # 0180*, 2008). Wie die oben beschriebene Katze schenkt sie dem Blick des Betrachters weder Aufmerksamkeit noch Interesse, sie wird von Eders Linse absorbiert wie das Tier von der Farbe.

Stille wohnt in blauen Räumen (2007) de Martin Eder est le portrait peint en gros plan d'un chat d'aspect revêche sur fond bleu crayeux. Le museau plat et les longs poils du félin trahissent un pedigree aristocratique, et bien que mal-peigné, il ne nous lance qu'un regard indifférent à travers ses paupières mi-closes. Le portrait est un *tour de force* qui capture l'essence insoucieuse de « l'être-chat ». Eder peuple ses scènes surréelles de chats, de chatons ou d'autres animaux, en y introduisant des références à Hans Makart ou James Ensor sous la forme de figures de femmes dénudées. Mais le côté « porno-soft » gentillet qui les caractérisait au départ devient plus acerbe et rappelle les nus des années 1940 de Francis Picabia. Une brune assise, les jambes écartées sur un lit de velours, son menton et ses seins redressés, défiante, occupe une moitié de la toile *La Paix du Cul* (2006). Deux chatons siamois ingénus et surdimensionnés dans un paysage champêtre remplissent l'autre moitié. Le contraste entre sexualité sulfureuse et innocence ébouriffée porte moins à conséquence que la subtile manipulation par Eder de l'espace et de l'échelle des dimensions à l'intérieur de la toile, ou l'impressionnante maîtrise technique et la qualité sensuelle de sa peinture. Par contraste, ses photographies couleur et grand format intitulées *Les Nus* (2006–08) font preuve d'une approche plus classique de la composition. Il s'agit de portraits exagérément sombres de femmes, dont beaucoup sont piercées, tatouées ou couvertes de bleus. Une jeune femme, de profil, habillée de chaussettes à pois rouge et d'une jupe, se tient debout près d'un lit défait, son regard plongeant vers un téléphone portable (*Les Nus # 0180*, 2008). Indifférente à notre regard, elle est absorbée par l'objectif d'Eder, tout comme le chat l'était par son pinceau.

V. R.

SELECTED EXHIBITIONS →
2008 *Sebastian Gögel, Martin Eder, Thorsten Brinkmann, Enrique Marty*, Gemeentemuseum, Den Haag. *Martin Eder. Fotografie: Die Armen*, Kunsthalle Mannheim **2007** *Die Kunst zu sammeln*, Museum Kunst Palast, Düsseldorf **2006** *Netherlands v. Germany – Painting*, Gemeentemuseum, Den Haag. *Full House – Gesichter einer Sammlung*, Kunsthalle Mannheim **2005** *After Cézanne*, MOCA, Los Angeles. *Prague Biennale 2*, Prague. *25 Jahre Sammlung Deutsche Bank*, Deutsche Guggenheim, Berlin

SELECTED PUBLICATIONS →
2008 *Martin Eder: Die Armen*, Kunsthalle Mannheim; Prestel, Munich **2007** *Martin Eder: Silbern weint ein Krankes*, EIGEN + ART, Leipzig/Berlin; DuMont, Cologne **2006** *Schilderkunst Nederland – Deutschland Malerei*, Gemeentemuseum, Den Haag. *All the best. The Deutsche Bank Collection and Zaha Hadid*, Singapore Art Museum. *New German Painting. Remix*, Prestel, Munich **2004** *Martin Eder: Die Kalte Kraft*, Kunstverein Lingen Kunsthalle, Lingen; Hatje Cantz, Ostfildern

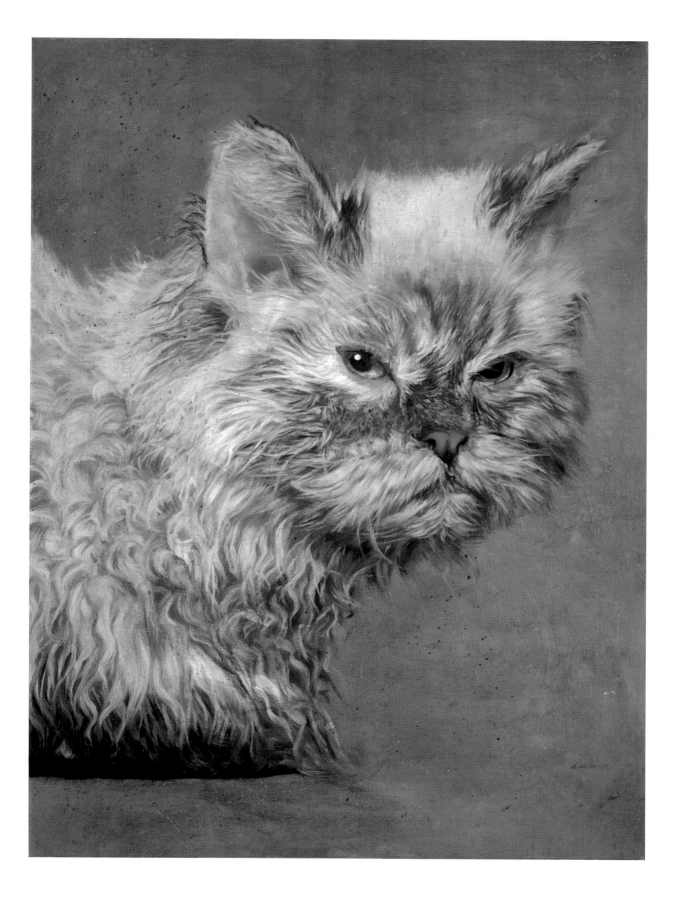

1 **Stille wohnt in blauen Räumen**, 2007, oil on canvas, 110 x 80 cm
2 **Les Nus #9075**, 2008, C-print, 240 x 160 cm
3 **Les Nus #0114**, 2008, C-print, 240 x 160 cm
4 **In den Nachmittag geflüstert**, 2007, oil on canvas, 200 x 150 cm

„Ich beschäftige mich nicht mit Kitsch. Ich beschäftige mich mit Fantasie und Projektionsflächen. Außerdem hat es viel mit dem Spiel Täter-Opfer zu tun."

« Je ne travaille pas sur le kitsch. Je m'intéresse à l'imaginaire et aux surfaces de projection. Et cela a aussi beaucoup à voir avec le jeu bourreau/victime. »

"I don't concern myself with kitsch. I concern myself with imagination and projection surfaces. Apart from that, it's got a lot to do with the game of perpetrator and victim."

2

3

Olafur Eliasson

1967 born in Copenhagen, Denmark, lives and works in Berlin, Germany

Research is an integral part of Olafur Eliasson's art, his practice is informed by a laboratory spirit. Based in his Berlin studio since the mid-1990s, he has built a network of collaborators working there: architects, scientists and technicians who play a major role in the creation of his projects. It takes many a blueprint and model before one of Eliasson's large-scale dramatic works can be realized to challenge the viewer's perception of how to deal, in phenomenological terms, with space, vision, light, colour and, at the same time, with his expectations of art in an everyday experience. *The New York City Waterfalls* (2008) bring a new dimension to art in public space: four giant artificial waterfalls were installed at different places in Manhattan's East River, where they introduced a man-made "natural" component into the complex and socially dense context of the hyper-coded vista of the New York skyline. Nature in a man-made world is a central topic of Eliasson's art: for a gallery exhibition in Berlin, he hauled six metric tons of 15,000 year-old glacier ice from Iceland and created a refrigeration system to keep it frozen in the neutral atmosphere of the showroom throughout the duration of the exhibition (2006). Whether it be in architectural projects such as his temporary pavilion at Serpentine Gallery in London (2007), or in his works with light projections of abstract forms, whose afterimages blend on the viewer's retina into a new and individual image (*the inside of outside*, 2008): Eliasson's oeuvre elicits both individual and collective reactions and extracts truth and power from the contradictions between the two.

Forschung ist ein integraler Bestandteil von Olafur Eliassons Kunst, seine Arbeitsweise folgt dem Prinzip eines Labors. Seit er sich Mitte der 1990er-Jahre in einem Studio in Berlin niederließ, hat er sich ein Netzwerk aus Mitarbeitern aufgebaut: Architekten, Wissenschaftler und Techniker, die eine wichtige Rolle bei der Realisierung seiner Projekte spielen. Es braucht viele Entwürfe und Modelle, bis eine von Eliassons groß angelegten Arbeiten verwirklicht werden kann – Arbeiten, die die Wahrnehmung der Betrachter herausfordern, ihren phänomenologischen Umgang mit Raum, Sehen, Licht und Farbe und gleichzeitig ihre Erwartung an Kunst itn der alltäglichen Erfahrung verändern. *The New York City Waterfalls* (2008) fügt der Kunst im öffentlichen Raum eine neue Dimension hinzu: Vier riesige, künstliche Wasserfälle wurden an verschiedenen Orten im East River in Manhattan errichtet und fügen dort ein „natürliches" Element aus menschlicher Hand in den komplexen und sozial dichten Kontext der hypercodierten New Yorker Skyline ein. Natur in einer menschengemachten Welt ist ein zentrales Thema von Eliassons Kunst: Für eine Ausstellung in einer Berliner Galerie ließ er sechs Tonnen von 15.000 Jahre altem Gletschereis aus Island holen und konstruierte ein Kühlsystem, um das Eis während der gesamten Dauer der Ausstellung im neutralen Galerieraum gefroren zu halten (2006). Ob in einem Architekturprojekt wie seinem temporären Pavillon für die Londoner Serpentine Gallery (2007) oder bei seinen Arbeiten mit abstrakten Lichtprojektionen, deren Nachbilder sich auf der Netzhaut des Betrachters zu ganz neuen individuellen Eindrücken vermischen (*the inside of outside*, 2008): Eliassons Werk provoziert sowohl individuelle als auch kollektive Reaktionen und gewinnt Wahrheit und Macht aus den Widersprüchen zwischen beiden.

La recherche fait partie intégrante du travail d'Olafur Eliasson et l'esprit de laboratoire nourrit sa démarche artistique. Depuis qu'il s'est installé dans son studio berlinois au milieu des années 1990, il y a créé un réseau de collaborateurs (architectes, scientifiques, techniciens), qui jouent un rôle crucial dans la réalisation de ses projets. Nombre de plans, prototypes et maquettes précèdent la réalisation de ses spectaculaires œuvres monumentales qui – en termes de phénoménologie – défient la perception sensorielle de l'espace, de la vision, de la lumière, de la couleur ainsi que les attentes du spectateur en matière d'expérience d'art au quotidien. *The New York City Waterfalls* (2008) redéfinissent l'art dans l'espace public. Quatre cascades artificielles géantes, érigées à divers endroits le long d'East River à Manhattan, introduisent un élément « naturel » façonné par la main de l'homme, dans le contexte complexe et socialement dense de la vue hypercodée de la *skyline* new-yorkaise. La nature dans un monde modelé par l'homme est au cœur de l'art d'Eliasson. Pour une exposition dans une galerie berlinoise, il a fait venir six tonnes de glace vieille de 15 000 ans provenant d'un glacier islandais et créé un système de réfrigération pour assurer sa conservation pendant toute la durée de l'exposition. Qu'il s'agisse de projets architecturaux, tel son pavillon temporaire pour la Serpentine Gallery à Londres (2007), ou de ses projections lumineuses de formes abstraites, dont les images projetées sur la rétine du spectateur produisent de nouvelles formes individuelles (*the inside of outside*, 2008) : l'œuvre d'Eliasson provoque des réactions individuelles et collectives parfois contradictoires dont elle tire sa force et sa vérité.

R. M.

SELECTED EXHIBITIONS →
2008 *Olafur Eliasson: The Nature of Things*, Fundació Caixa, Girona and Fundació Joan Miró, Barcelona. *Olafur Eliasson: Your mobile expectations – BMW H2R project*, Pinakothek der Moderne, Munich **2007** *Olafur Eliasson: Take Your Time*, SFMOMA, San Francisco; MoMA, New York and P.S.1 Contemporary Art Center, Long Island City **2006** *Olafur Eliasson: The collectivity project*, The National Museum of Art, Architecture and Design, Oslo **2005** *Olafur Eliasson: Notion motion*, Museum Boijmans van Beuningen, Rotterdam

SELECTED PUBLICATIONS →
2008 *Studio Olafur Eliasson: An Encyclopedia*, Taschen, Cologne. *Olafur Eliasson: The Nature of Things*, Fundacio Joan Miro, Barcelona. Hans Ulrich Obrist: *Olafur Eliasson*, Verlag der Buchhandlung Walther König, Cologne **2007** *Olafur Eliasson: Take Your Time*, SFMOMA, San Francisco; Thames & Hudson, London. *Olafur Eliasson, David Adjaye: Your Black Horizon*, Thyssen-Bornemisza Art Contemporary, Vienna; Verlag der Buchhandlung Walther König, Cologne **2006** *Olafur Eliasson: Remagine*, Kunstmuseum Bonn, Bonn

1 **the inside of outside**, 2008, 24 source-four spotlights, dimmers, filter foil, control unit, spherical stainless steel wall fixture, 3 wooden benches, metronome (54 beats/min), 5 min projection sequences, spherical stainless steel wall fixture: ø 4 cm, 3 benches: 46,5 x 300 x 42 cm (each), overall installation size variable
2 **Timetable**, 2007, elm wood, stainless steel, 84 x 387 x 110 cm

3 **Temporal Pavilion Lamps**, 2007, set of 4 lamps, dimensions variable, 2 lamps ø 150 cm, height up to 450 cm, 2 lamps ø 120 cm, stainless steel, height adjustable tripod, fluorescent lamp, energy saving lamp, dimmer cable
4/5 **Serpentine Gallery Pavilion**, 2007, in collaboration with Kjetil Thorsens. Installation view, Serpentine Gallery, Kensington Gardens, London

„Körperliche Erfahrung macht einen viel tieferen Eindruck als eine rein intellektuelle Begegnung. Ich kann Ihnen erklären, wie es sich anfühlt, wenn Ihnen kalt ist, aber ich kann Sie auch durch meine Kunst frieren lassen. Mein Ziel ist es, Menschen für hochkomplexe Fragen zu sensibilisieren."

« L'expérience physique produit une impression beaucoup plus profonde que la rencontre purement intellectuelle. Je peux vous expliquer ce que l'on ressent quand on a froid, mais je peux aussi vous faire éprouver le froid par le truchement de mon art. Mon but est de sensibiliser les gens à des questions hautement complexes. »

"Physical experience makes a much deeper impression than a purely intellectual encounter. I can explain to you what it's like to feel cold, but I can also have you feel the cold yourself through my art. My goal is to sensitize people to highly complex questions."

2

3

Elmgreen & Dragset

Michael Elmgreen, 1961 born in Copenhagen, Denmark, and Ingar Dragset, 1969 born in Trondheim, Norway; live and work in Berlin, Germany

Elmgreen & Dragset's practice confronts the definition of sculpture by investing the forms of minimalism and modernism with new social and political content. From their *Powerless Structures* (1997–), a series of works in which the artists test the boundaries of institutional spaces, to the very recent *Memorial for the Homosexual Victims of the Nazi Regime* (2008) they have been using art to challenge architectural and institutional assumptions with a peculiar taste for paradox. In their memorial, for example, they subvert the tradition of modernist monuments by showing a short video of a gay couple kissing, inside an abstract cement block. For *The Welfare Show* (2005), the artists turned the exhibition into a nightmarish investigation of the western welfare state and its power structures: empty halls and desolate rooms evoking hospitals and airports with abandoned babies, sinisterly empty turning baggage claim carousels and lonely security guards watching each other – the whole installation a bleak portrait of our society. A similarly critical approach towards convention is traceable in *Drama Queens* (2007), a play Elmgreen & Dragset premiered at Skulptur Projekte Münster 07. Instead of real actors, life-size reproductions of seven sculptural masterpieces from the 20th century such as Giacometti's *Walking Man* (1947), Barbara Hepworth's *Elegy III* (1966) and Jeff Koons' *Rabbit* (1986) move on stage, operated by remote control and dubbed by professional actors. In hilarious dialogues and sarcastic comments, the sculptures make fun of each other, breaking some of art's most solid taboos while writing an irreverent and absolutely personal history of art.

Elmgreen & Dragset stellen in ihren Arbeiten unseren Begriff von Skulptur in Frage, wobei sie minimalistische und modernistische Formen mit neuen sozialen und politischen Inhalten füllen. Von der Serie *Powerless Structures* (1997–), in der die Grenzen institutioneller Räume ausgelotet werden, bis hin zu dem neuen *Denkmal für die im Nationalsozialismus verfolgten Homosexuellen* (2008) in Berlin hinterfragen die Künstler architektonische und institutionelle Prämissen mit einem ausgeprägten Sinn für Widersprüche. In ihrem Mahnmal unterwandern sie z.B. die Tradition modernistischer Denkmäler durch ein kurzes Video, das ein sich küssendes homosexuelles Paar in einem abstrakten Zementblock zeigt. Für *The Welfare Show* (2005) inszenierten die Künstler eine beklemmende Analyse westlicher Wohlfahrtsstaaten und deren Machtstrukturen: leere Hallen und verlassene Räume, die an Krankenhäuser oder Abflughallen mit ausgesetzten Babys denken ließen. Gepäckbänder umkreisten einander in unheimlicher Leere und einsame Sicherheitsleute bewachten sich gegenseitig – die ganze Installation ein düsteres Porträt unserer Gesellschaft. Auch in *Drama Queens* (2007), einer Bühnenschau, die im Rahmen der Skulptur Projekte Münster 07 Premiere feierte, setzten sich die Künstler ähnlich kritisch mit den konventionellen Strukturen auseinander. Statt echter Schauspieler wurden sieben lebensgroße Nachbildungen skulpturaler Meisterwerke des 20. Jahrhunderts per Fernbedienung auf der Bühne bewegt und von Schauspielern synchronisiert – darunter Giacomettis *Gehender* (1947), Barbara Hepworths *Elegy III* (1966) und Jeff Koons' *Rabbit* (1986). In vergnüglichen Dialogen und sarkastischen Kommentaren verulbern sich die Skulpturen gegenseitig und brechen mit heiligen Tabus, um eine eigene, respektlose Version der Kunstgeschichte zu schreiben.

La pratique d'Elmgreen & Dragset défie la définition de la sculpture en donnant aux formes du minimalisme et du modernisme un nouveau contenu social et politique. Depuis les *Powerless Structures*, une série d'œuvres commencée en 1997 dans laquelle les artistes testent les limites des espaces institutionnels, jusqu'au tout récent *Mémorial pour les homosexuels victimes du Régime nazi* (2008), ils utilisent l'art pour défier les présupposés architecturaux et institutionnels, avec un goût prononcé pour le paradoxe. Ainsi, dans leur mémorial, ils subvertissent la tradition des monuments modernistes en montrant une courte vidéo d'un couple gay en train de s'embrasser à l'intérieur d'un bloc de ciment abstrait. Pour *The Welfare Show* (2005), les artistes ont donné à l'exposition la forme d'une enquête cauchemardesque sur l'État-providence occidental et ses structures de pouvoir : salles vides, pièces désolées évoquant des hôpitaux et des aéroports avec des bébés abandonnés, tapis à bagages tournant à vide dans une ambiance sinistre et personnels de sécurité isolés, se dévisageant les uns les autres – cette installation compose un sombre portrait de notre société. On retrouve une telle approche critique à l'égard des conventions dans *Drama Queens* (2007), une pièce créée par Elmgreen & Dragset pour l'exposition Skulptur Projekte Münster 07. Au lieu d'acteurs en chair et en os, des reproductions grandeur nature de chefs d'œuvres de la sculpture du XXᵉ siècle comme *L'homme qui marche* de Giacometti (1947), *Elegy III* de Barbara Hepworth (1966) et le *Rabbit* de Jeff Koons (1986) évoluent sur une scène, télécommandés et doublés par des acteurs professionnels. À travers des dialogues hilarants et des commentaires sarcastiques, les sculptures se moquent les unes des autres, brisant certains des plus solides tabous artistiques en écrivant une histoire de l'art aussi irrévérencieuse que résolument personnelle. C. A.

SELECTED EXHIBITIONS →
2008 *Elmgreen & Dragset: Home Is the Place You Left*, Trondheim Kunstmuseum, Trondheim. *Reality Check*, Statens Museum for Kunst, Copenhagen **2007** *Elmgreen & Dragset: This Is the First Day of My Life*, Malmö Konsthall, Malmö. *Skulptur Projekte Münster 07*, Münster. *Protections/steirischer herbst 06*, Kunsthaus Graz **2005** *Elmgreen & Dragset: The Welfare Show*, Bergen Kunsthall, Bergen; The Power Plant, Toronto; BAWAG Foundation, Vienna; Serpentine Gallery, London.

SELECTED PUBLICATIONS →
2008 *Elmgreen & Dragset: Home Is the Place You Left*, Trondheim Kunstmuseum, Trondheim; Verlag der Buchhandlung Walther König, Cologne. *Elmgreen & Dragset: This Is the First Day of My Life*, Hatje Cantz, Ostfildern. *Reality Check*, Statens Museum for Kunst, Copenhagen **2007** *Skulptur Projekte Münster 07*, Verlag der Buchhandlung Walther König, Cologne **2006** *Elmgreen & Dragset: Prada Marfa*, Verlag der Buchhandlung Walther König, Cologne

1 **Drama Queens**, 2007, play with 7 remote controlled lifesize sculptures, text by Tim Etchells, performance. Installation view, Skulptur Projekte Münster 07
2 **Untitled**, 2008, naked guy sitting in a chair listening to music and reading the book *Home Is the Place You Left*, performance. Installation view, Trondheim Art Museum, Trondheim
3 **Rosa**, 2006, gilded brass, steel, fiber glass with epoxy, garments, shoes, 153 x 46 x 44 cm

4 **Singled Out**, 2007, 7 fireplaces, mirrors, candles, cristal chandelier, clock, fireplace 130 x 30 x 115 cm, mirror 56 x 78 cm. Installation view, Malmö Konsthall, Malmö
5/6 **Prada Marfa**, 2005, adobe bricks, plaster, paint, glass pane, aluminium frame, MDF, carpet, Prada shoes and handbags, 760 x 470 x 480 cm. Permanent installation, Chihuahua Desert, Texas

„Wir versuchen uns an das zu erinnern, was wir einst vergessen wollten." « Nous essayons de nous rappeler ce qu'autrefois nous voulions oublier. »

"We try to remember what we once wanted to forget."

2

3

Tracey Emin

1963 born in London, lives and works in London, United Kingdom

When Tracey Emin, who has attained celebrity status over the past two decades – as much for her intimate, frequently sexually explicit installations, paintings, drawings and embroidered artworks as for her notorious "joie de vivre" – was nominated to represent Great Britain at the Venice Biennale 2007 and elected to the Royal Academy of Arts in the same year, it seemed on the surface that *Mad Tracey from Margate* (1997) had come a very long way indeed. Analogies with Eliza Doolittle, that ruffian transformed into a society lady in George Cukor's 1964 film *My Fair Lady* easily sprang to mind. Emin's mixed-media exhibition in the British Pavilion, entitled *Borrowed Light*, which combined new and earlier works, may have marked a legitimizing milestone in the former Young British Artist's career, but it remained quintessential Emin nonetheless: deeply personal and confessional in spirit, balanced between classical and experimental in facture. A sweetly sentimental songbird on a leafy branch, fashioned out of turquoise neon and hung next to the pavilion's entrance (*Our Angels*, 2007), found itself, on paper inside, riding astride a penis like a rocket. Text-based neons (*I Know, I Know, I Know*, 2002/07), figurative drawings, mono-prints, and paintings (*Sometimes I Feel So Fucking Lost*, 2005), flanked a touching watercolour series on lined note-paper Emin made around her debilitating abortion during the 1990s (*After My Abortion*, 1990–96). Wearing her heart on her sleeve, and not one to mince words, Emin introduces her viewers to an amusement park range of experience and emotion that leaves nobody indifferent.

Dass Tracey Emin in den letzten zwei Jahrzehnten zu einem Star der Kunstwelt aufgestiegen ist, verdankt sie gleichermaßen ihren oft intimen, explizit sexuellen Installationen, Gemälden, Zeichnungen und kunstvollen Stickereien wie ihrer berüchtigten *joie de vivre*. Nachdem sie 2007 auf der Biennale in Venedig als offizielle Vertreterin Großbritanniens erschienen und im selben Jahr in die Royal Academy of Arts gewählt worden war, schien *Mad Tracey from Margate* (1997) es tatsächlich sehr weit gebracht zu haben. Schnell kam man auf Vergleiche mit der ungebildeten Eliza Doolittle, die sich in George Cukors Musicalverfilmung *My Fair Lady* (1964) von der einfachen Blumenverkäuferin in eine Dame der feinen Gesellschaft verwandelt. Wenn die Ausstellung im britischen Pavillon, in der Emin unter dem Titel *Borrowed Light* frühere und neuere Arbeiten in verschiedenen Materialien zeigte, in der Karriere der ehemaligen Young-British-Art-Künstlerin auch offizielle Anerkennung bedeutete, war sie doch ganz von Emin selbst durchdrungen: ein zutiefst persönliches geistiges Bekenntnis, in der Ausführung mit klassischen und experimentellen Elementen balancierend. Die türkisgrüne Neonlichtgestalt eines anrührenden Singvogels auf einem Blätterzweig am Eingang (*Our Angels*, 2007) tauchte im Inneren auf Papier, rittlings auf einer penisartig anmutenden Rakete sitzend, wieder auf. Textbasierte Neonkunst (*I Know, I Know, I Know*, 2002/07), figurative Zeichnungen, Monoprints und Gemälde (*Sometimes I Feel So Fucking Lost*, 2005) flankierten eine bewegende Aquarellserie auf liniertem Papier, die Emin in den 1990ern nach einer schwierigen Abtreibung schuf (*After My Abortion*, 1990–96). Mit schonungsloser Offenheit führte sie ihr Publikum in eine Achterbahn der Erfahrungen und Gefühle, die niemanden gleichgültig lassen konnte.

Quand Tracey Emin, devenue en vingt ans une véritable célébrité – aussi bien en raison de ses installations, peintures, dessins ou broderies à forte connotation sexuelle que pour son illustre exubérance –, a été choisie pour représenter la Grande-Bretagne à la Biennale de Venise en 2007, puis promue académicienne à la Royal Academy of Arts la même année, on a pu se dire que la *Mad Tracey from Margate* (1997) avait fait du chemin. L'analogie avec Eliza Doolittle, la petite marchande de violettes métamorphosée en grande dame dans *My Fair Lady* (1964) de George Cukor faisait sens. L'exposition d'Emin au pavillon britannique, intitulée *Borrowed Light*, mêlait des œuvres nouvelles et anciennes, et différents médiums. Moment de légitimation ultime pour cette artiste emblématique des Young British Artists, elle n'en demeurait pas moins fidèle à son style faisant preuve d'un esprit personnel et intime intense et d'une facture oscillant entre le classique et l'expérimental. L'oiseau de néon turquoise, délicieusement sentimental, perché sur une branche à l'entrée du pavillon (*Our Angels*, 2007) apparaissait de nouveau, à l'intérieur et sur papier cette fois, chevauchant un pénis aux allures de fusée. Lettres épelant des textes en néon (*I Know, I Know, I Know*, 2002–07), dessins figuratifs, pochoirs et peintures (*Sometimes I Feel So Fucking Lost*, 2005) figuraient aux côtés d'une émouvante série d'aquarelles sur papier quadrillé, peintes par Emin après un avortement dans les années 1990 (*After My Abortion*, 1990–96). Écorchée vive, d'une franchise redoutable, Emin met les émotions et sentiments de ses visiteurs à l'épreuve, expérience dont on ne sort pas indemne. V. R.

SELECTED EXHIBITIONS →
2008 *Tracey Emin 20 Years*, Scottish National Gallery of Modern Art, Edinburgh. *Love*, Bristol City Museum & Art Gallery, Bristol; Laing Art Gallery, Newcastle upon Tyne; National Gallery, London. *True Romance*, Kunsthalle Wien, Vienna; Villa Stuck, Munich; Kunsthalle zu Kiel **2007** *A Tribute to Tracey Emin*, Goss Michael Foundation, Dallas. *Tracey Emin*, British Pavilion, 52nd Venice Biennale, Venice **2006** *International 06*, Liverpool Biennial, Liverpool **2005** *Tracey Emin*, Magasin – Centre national d'art contemporain, Grenoble

SELECTED PUBLICATIONS →
2008 *Tracey Emin 20 Years*, Scottish National Gallery of Modern Art, Edinburgh. *Tracey Emin: You Left Me Breathing*, Gagosian Gallery, Beverly Hills **2007** *Tracey Emin: Borrowed Light. Venice Biennale 2007*, British Council, London **2006** *Tracey Emin*, Tate Publishing, London. *Tracey Emin*, Rizzoli, New York **2005** *Tracey Emin: Strangeland*, Sceptre, London. *Tracey Emin: When I Think about Sex...*, White Cube, London

1 Installation view, Gagosian Gallery, New York, 2007
2 **I Could Have Really Loved You**, 2007, neon, 144 x 140 cm

3 **Sleeping with You**, 2005, reclaimed painted timber, white neon. Installation view, Lehmann Maupin, New York
4 Installation view, British Pavilion, 52. Biennale di Venezia, Venice, 2007

„Als Künstlerin habe ich das Anliegen, das ganze Spektrum von gefühlvoll bis nüchtern abzudecken, und manchmal heißt das, dass ich mir das Leben ziemlich schwer mache."

« L'important pour moi, en tant qu'artiste, c'est de traiter absolument de tout, du plus prosaïque au plus sentimental – et ça, ça peut demander beaucoup de boulot. »

"For me, as an artist, what's important is to cover everything from the emotional to the literal, and sometimes that means I give myself a very hard time."

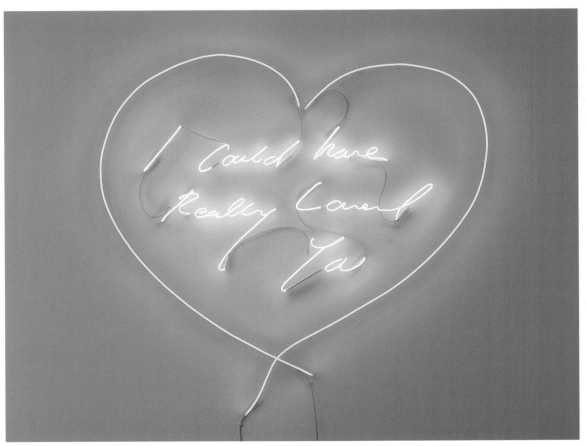

2

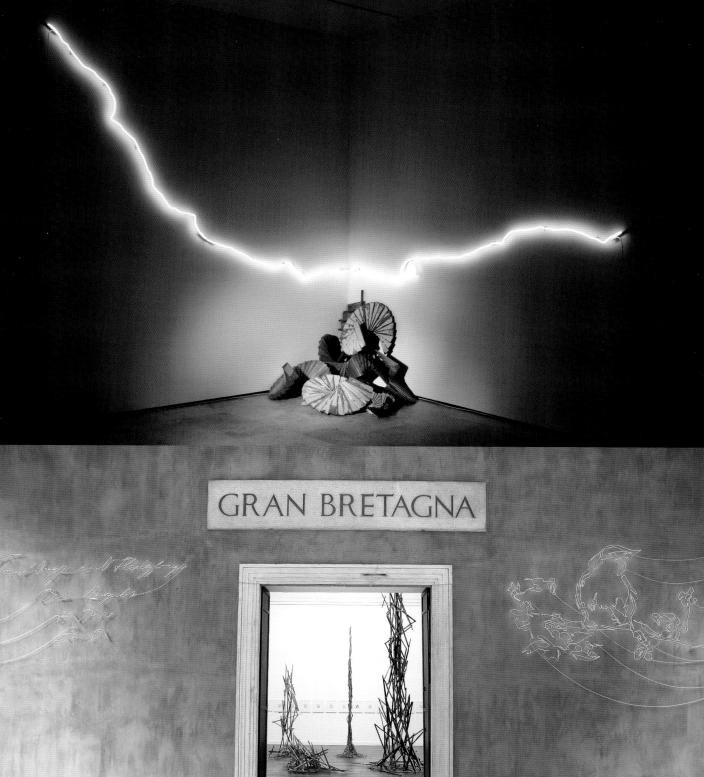

GRAN BRETAGNA

Urs Fischer

1973, born in Zürich, lives and works in Zürich, Switzerland, and New York (NY), USA

Known for his almost obsessive use and transformation of the humble chair (*How to Tell a Joke*, 2007; *Addict*, 2006; *Chair for a Ghost*, 2003), Urs Fischer creates playful and poignant sculptures and installations that can change the shape of a room, both literally and figuratively. Spectacular gestures accompany simpler ones; some are additive, some subtractive. Fischer has breached walls in galleries and art fairs, opening up unexpected vistas, has cast an open grave in aluminium (*Untitled (Hole)*, 2007), plunging its craggy relief into the floor below, and reduced an art gallery to an earthen crater (*You*, 2007). He occupied the former prison and boarding school of Cockatoo Island, off the coast of Sydney, Australia, with skeleton sculptures and the pale branches of crooked horizontal lines that wander through the space of the outer courtyard, like fat strings shot from a slowly spinning cannon and frozen in mid-air. Other works include life-size candles shaped like nude women that melt over the duration of an exhibition (*What If the Phone Rings?*, 2003), masses of coral tear drops raining down from the ceiling of the Palazzo Grassi in Venice (*Vintage Violence*, 2004/05), a chalet built out of bread left to the birds (*Bread House*, 2004/05) and a massive tree made of framed drawings and lights (*Jet Set Lady*, 2005). Though Fischer studied photography, he prefers to work in a wide range of media, including painting and drawing. Across materials and processes, Fischer's visual and visceral work subverts the habitual approaches we take to spaces and the uses we make of objects, reminding us of their contingency and transience, as well as our own.

Der durch die beinahe obsessive Verwendung und Verwandlung von einfachen Stühlen (*How to Tell a Joke*, 2007; *Addict*, 2006; *Chair for a Ghost*, 2003) bekannt gewordene Urs Fischer erschafft spielerische und eindrucksvolle Skulpturen und Installationen, die die Form eines Raumes sowohl im wörtlichen als auch im übertragenen Sinn verändern können. Spektakuläre Gesten treffen auf einfache Formen, einige fügen etwas hinzu, andere nehmen etwas weg. Fischer hat Wände in Galerien und auf Kunstmessen durchbrochen und so unerwartete Durchblicke ermöglicht, hat ein offenes Grab mit Aluminium ausgegossen und dessen schroffes Relief in den Boden versenkt (*Untitled (Hole)*, 2007) und hat eine Kunstgalerie auf einen Krater aus Erde reduziert (*You*, 2007). Er besetzte das ehemalige Gefängnis und Internat Cockatoo Island vor der Küste Australiens mit Skelettskulpturen und den bleichen Zweigen gebogener horizontaler Linien, die durch den Raum des Innenhofs wanderten wie fette Linien, die aus einer sich langsam drehenden Kanone geschossen in der Luft gefrieren. Andere Arbeiten sind zum Beispiel lebensgroße Kerzen in Form von nackten Frauen, die während der Dauer einer Ausstellung herunterbrennen (*What If the Phone Rings?*, 2003), Unmengen von korallenen Tränen, die von der Decke des Palazzo Grassi in Venedig hängen (*Vintage Violence*, 2004/05), eine Hütte aus Brot, die den Vögeln überlassen wird (*Bread House*, 2004/05) und ein riesiger Baum aus gerahmten Zeichnungen und Lichtern (*Jet Set Lady*, 2005). Obwohl Fischer gelernter Fotograf ist, arbeitet er lieber in verschiedenen Medien, darunter auch Malerei und Zeichnung. Ganz gleich in welchem Material und mit welcher Strategie, Fischers visuelles und emotionales Werk untergräbt unseren vertrauten Umgang mit Räumen und Gegenständen und erinnert uns an ihre Zufälligkeit und Vergänglichkeit – und ebenso an unsere eigene.

Connu pour son obsession à utiliser et transformer des chaises ordinaires (*How to Tell a Joke*, 2007 ; *Addict*, 2006 ; *Chair for a Ghost*, 2003), Urs Fischer crée des sculptures amusantes et poignantes, des installations modifiant la forme d'une pièce, au propre comme au figuré. Des gestes spectaculaires s'accompagnent des plus anodins, certains ajoutent, d'autres retranchent. Fischer a ouvert des murs dans des galeries ou des foires et dévoilé ainsi des perspectives inattendues ; il a réalisé le moule en aluminium d'une fosse (*Untitled (Hole)*, 2007), laissant apparaître le relief terreux à l'étage inférieur ; il a fait d'une galerie un gigantesque cratère (*You*, 2007). Fischer a rempli l'ancienne prison et pensionnat de Cockatoo Island, au large de Sydney (Australie) de sculptures de squelettes et de branches sinueuses et blanchâtres qui jaillissaient dans l'espace de la cour extérieure comme s'il s'agissait de gros rubans projetés par un canon mobile et figés en plein vol. Parmi ses autres œuvres, on compte des bougies représentant des femmes nues grandeur nature qui se consument le temps de l'exposition (*What If the Phone Rings?*, 2003) ; une pluie de gouttes de corail tombant du plafond du Palazzo Grassi à Venise (*Vintage Violence*, 2004/05) ; un chalet en pain livré à l'appétit des oiseaux (*Bread House*, 2004/05) ; ou encore un arbre immense fait de lumières et de dessins encadrés (*Jet Set Lady*, 2005). Bien que photographe de formation, il travaille aussi avec la peinture et le dessin. Circulant entre des matériaux et des procédés hétérogènes, l'œuvre de Fischer subvertit nos approches habituelles de l'espace et nos utilisations quotidiennes des objets, pointant leur caractère éphémère et contingent si semblable au nôtre.

V. R.

SELECTED EXHIBITIONS →
2008 *Archeology of Mind*, Malmö Konstmuseum, Malmö **2007** *Urs Fischer*, Switzerland Pavilion, 52nd Venice Biennale, Venice. *Unmonumental: The Object in the 21st Century*, New Museum, New York **2006** *Urs Fischer: Oh. Sad. I see*, The Modern Institute, Glasgow. *Urs Fischer*, Museum Boijmans van Beuningen, Rotterdam. *Day for Night*, Whitney Biennial 2006, Whitney Museum, New York **2005** *Urs Fischer*, Camden Arts Centre, London. *Urs Fischer*, Hamburger Bahnhof, Berlin **2004** *Urs Fischer: Kir Royal*, Kunsthaus Zürich

SELECTED PUBLICATIONS →
2007 *Album: On/around the works of Urs Fischer, Yves Netzhammer, Ugo Rondinone, and Christine Streuli*, Swiss Federal Office of Culture, Bern; JRP Ringier, Zürich. *Urs Fischer: Paris 1919*, JRP Ringier, Zürich **2006** *Strange I've Seen That Face Before*, DuMont, Cologne. *Whitney Biennial: Day for Night*, Whitney Museum of American Art, New York **2005** *Monica Bonvicini, Richard Prince, Urs Fischer, Parkett 72*, Zürich **2004** *Urs Fischer: Kir Royal*, Kunsthaus Zürich; JRP Ringier, Zürich

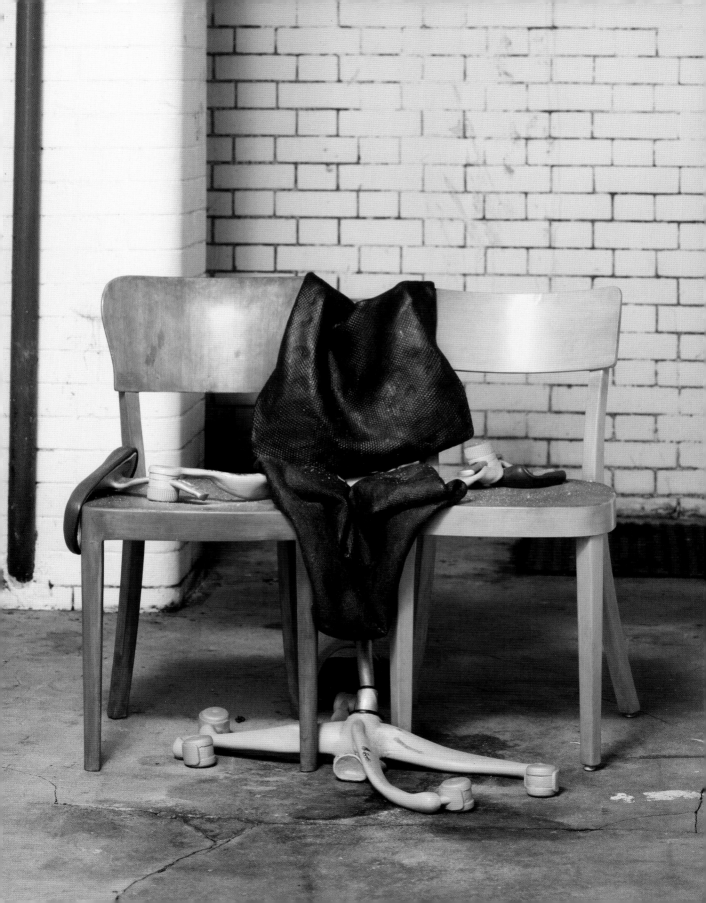

1 **How to Tell a Joke**, 2007, polyurethane cast resin, acrystal, pigments, 95 x 100 x 100 cm
2 **Ohne Titel (Brothaus)**, 2004/05, bread, wood, silicon, screws, polyurethane foam, 500 x 400 x 500 cm. Installation view, Museum Boijmans van Beuningen, Rotterdam, 2006

3 **Ohne Titel (Loch)**, 2007, cast aluminium, 540 x 340 x 270 cm. Installation view, Sadie Coles HQ, London
4 **Jet Set Lady**, 2000–05, iron, 2000 framed drawings (colour prints), 24 fluorescent tubes, 900 x 700 x 700 cm. Installation view, Fondazione Nicola Trussardi, Instituto dei Ciechi, Milan, 2005

„Jedes Werk beginnt mit einer raschen Zeichnung, aber sobald ich mit dem Material arbeite, geht etwas schief. Zum Beispiel bleibt das Ding nicht stehen, und mein Ärger darüber führt dann zu etwas anderem. Meine Arbeit sieht am Ende nie so aus, wie sie geplant war."

« Chaque œuvre commence par un rapide croquis, mais dès que je commence à travailler avec les matériaux, ça tourne mal. Par exemple, le truc ne tient pas debout et mon agacement me mène ensuite vers autre chose. Le résultat ne ressemble jamais à ce que j'avais l'intention de faire au départ. »

"Each work begins with a quick sketch, but as soon as I start to work with materials, something goes wrong. For example, the thing won't stand up and my irritation about that then leads to something else. My work never ends up looking the way I had intended."

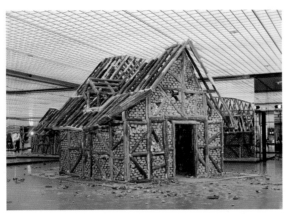

2

3

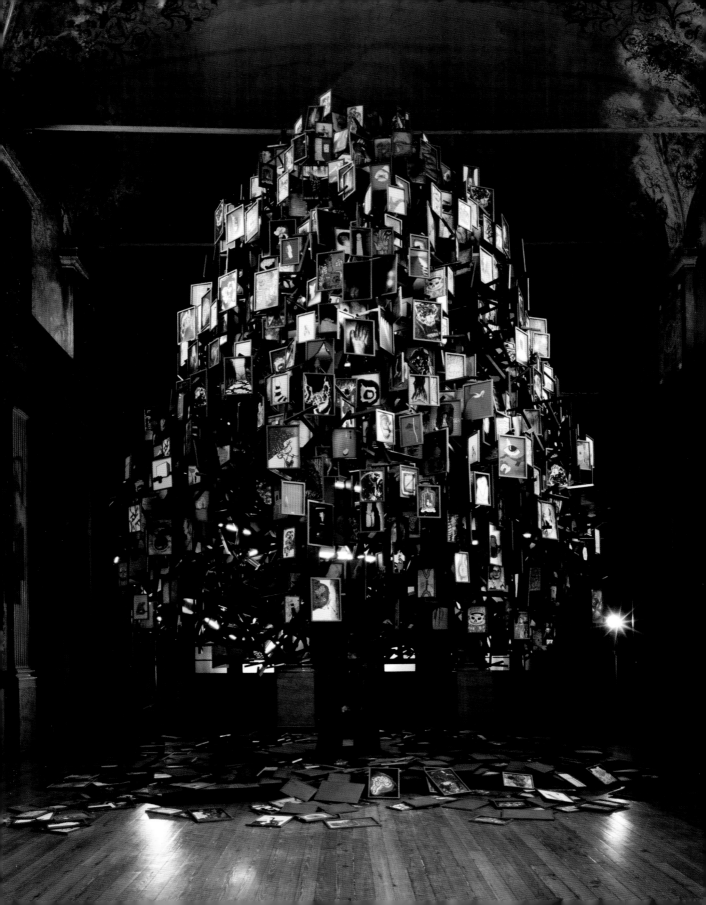

Günther Förg

1952 born in Füssen, Germany, lives and works in Colombier, Switzerland

The pursuit of reduction characterizes numerous artistic avant-gardes of the 20th century. Above all in non-representational art it has been a way of getting closer to the essence of the image. The painter, photographer and sculptor Günther Förg frequently adopts this approach in his works, whether in the representational realm – for example when he photographs Bauhaus architecture – or in the realm of the abstract, when he explores visual structures in his paintings. Förg began his career with painting and has since returned to it: in recent years he has mainly focused on creating series of canvases. In the 1990s he worked on large-scale paintings featuring grid-like or striped structures. His most recent paintings often involve groups of short brushstrokes in single colours placed directly next to one another, whereby the coloration varies across the surface of the canvas. Occasional traces of his familiar grid or stripe structures can also be detected. In this way, his recent paintings are less architectural in appearance; instead they are more like landscapes, as if fleeting moods of colour and light had been captured within them. Even when Förg's paintings are abstract this association with landscape still holds, above all in terms of their art-historical references, such as to Monet and Mondrian. Monet was the first artist to paint series of landscapes dedicated to various expressions of light and colour, while Mondrian's early works continued this serial approach and abstracted landscapes into grid-like structures. Förg takes this working method and further reduces it in order to get to the core of the painterly process: a valid ordering of colours and forms on the canvas.

Das Streben nach Reduktion kennzeichnet mehrere künstlerische Avantgarden des 20. Jahrhunderts. Gerade innerhalb der ungegenständlichen Kunst versuchte man so, zur bildnerischen Essenz zu gelangen. Der Maler, Fotograf und Bildhauer Günther Förg bezieht sich in seinen Arbeiten immer wieder auf diesen Ansatz. Sei es im Bereich des Gegenständlichen, wenn er sich fotografisch etwa der Architektur des Bauhaus annimmt, sei es im Bereich des Ungegenständlichen, wenn er sich malend mit visuellen Strukturen beschäftigt. Förg hat seine Laufbahn mit Malerei begonnen, inzwischen ist er dort wieder angekommen, denn in den letzten Jahren fertigte er vor allem Gemäldeserien. Seit den 1990er-Jahren malte er großformatige Gemälde mit Gitter- oder Streifenstrukturen. Die neueren Gemälde hingegen zeigen immer wieder Ballungen kurzer, direkt nebeneinander gesetzter Pinselstriche in gleicher Farbe. Diese Ballungen wechseln über die Bildfläche hinweg ihre Farbigkeit. Teilweise sind auch noch Reste der vormals häufig anzutreffenden Gitter- oder Streifenstrukturen vorhanden. Dadurch wirken die neueren Bilder weniger architektonisch, dafür eher landschaftlich, so als würden flüchtige Farb- und Lichtstimmungen einer Landschaft eingefangen. Auch wenn Förgs Bilder abstrakt ausfallen, so ist diese landschaftliche Assoziation nicht unzutreffend, zumal was die kunsthistorischen Bezüge betrifft, Monet und Mondrian. Monet stellte als erster Bildserien von Landschaften her, die unterschiedlichen Farb- und Lichtstimmungen gewidmet waren. Mondrians frühe Werke setzten diesen seriellen Ansatz fort und abstrahierten Landschaften zu Rasterstrukturen. Förg greift diese Arbeitsweise auf und reduziert sie erneut, um dem Kern des malerischen Prozesses auf die Spur zu kommen: einer gültigen Anordnung von Farben und Formen auf der Leinwand.

La tendance à la réduction caractérise plusieurs avant-gardes du XXᵉ siècle. Dans l'art non figuratif en particulier, les artistes tentaient de parvenir à la quintessence du fait plastique. Les œuvres du peintre, photographe et sculpteur Günther Förg se réfèrent constamment à cette démarche – que ce soit dans le domaine figuratif quand il aborde, par exemple, l'architecture du Bauhaus par le truchement de la photographie ou dans le domaine non figuratif quand sa peinture s'intéresse aux structures visuelles. Après avoir débuté comme peintre, Förg revient aujourd'hui à la peinture. Ces dernières années, il a surtout réalisé des séries de tableaux. Depuis les années 1990, il peint des grands formats montrant des structures croisées ou en bandes. Les dernières peintures présentent toutefois toujours des concentrations de traits de pinceau courts, juxtaposés, de même couleur. Le chromatisme de ces concentrations évolue au fil de la surface peinte. On y retrouve parfois aussi les restes des structures croisées ou en bandes qui précédemment dominaient. Si les peintures récentes sont donc moins architectoniques, elles dénotent un caractère plus paysager, comme si l'artiste y captait de fugaces ambiances de couleur et de lumière. Cette référence au paysage conserve sa validité même quand les tableaux sont abstraits – du moins en tant que références à l'histoire de l'art, en particulier à Monet et Mondrian. Monet fut le premier à créer des séries de paysages soumis à différents effets de couleur et de lumière. Les œuvres anciennes de Mondrian ont développé cette première sérialité et abstrait des structures tramées à partir de paysages. Förg reprend ce mode de travail et pousse à nouveau la réduction afin de découvrir le noyau du processus pictural : l'organisation légitime de couleurs et de formes sur une toile.

H. L.

SELECTED EXHIBITIONS →
2008 *Günther Förg: Back and Forth*, Essl Museum, Klosterneuburg. *Tàpies, Hartung, Uecker, Förg*, Kunstmuseum St. Gallen. *abstrakt / abstract*, Museum Moderner Kunst Kärnten, Klagenfurt **2007** *Günther Förg/Bernhard Frize*, Museum für Gegenwartskunst, Basle **2006** *Günther Förg: Fotografie*, Kunsthalle Bremen. *Biella Prize for Engraving 2006*, Museo del Territorio Biellese, Biella. *The 80's: A Topology*, Museo Serralves, Porto **2005** *Günther Förg*, IKOB, Eupen. *(my private) Heroes*, MARTa, Herford

SELECTED PUBLICATIONS →
2008 *Günther Förg: Back and Forth*, Essl Museum, Klosterneuburg; Snoeck Verlag, Cologne. Günther Förg, Günter Herburger: *Die Trilogie der Tatzen*, Snoeck Verlag, Cologne **2007** *Günther Förg. Zwischenräume*, Langen Foundation, Neuss. *Günther Förg. Felder – Ränder*, Galleria Salvatore e Carolina Ala, Milan; Snoeck Verlag, Cologne **2006** *Günther Förg: Fotografie*, Kunsthalle Bremen; Snoeck Verlag, Cologne. *Günther Förg: Gazetta dello sport*, Snoeck Verlag, Cologne

1

1 **Untitled**, 2008, acrylic, oil on canvas, 180 x 150 cm
2 **Untitled**, 2007, acrylic, oil on canvas, 150 x 140 cm

3 **Untitled**, 2008, acrylic, oil on canvas, 180 x 150 cm

„Für mich ist abstrakte Kunst heute das, was man sieht, und nicht mehr."

« Pour moi, l'art abstrait est aujourd'hui ce qu'on voit, rien de plus. »

"For me, abstract art today is that what you see, and nothing more."

2

Walton Ford

1960 born in Larchmont (NY), lives and works in Great Barrington (MA), USA

Walton Ford's works are technically brilliant and visually spectacular. His detailed, life-size depictions of animals in watercolour and gouache are fascinatingly reminiscent of natural history drawings from past centuries. Indeed Ford himself has named the ornithologist John J. Audubon, creator of the legendary *Birds of America* series (1827–38) as one of his inspirations. Ford's interest in this visual language is not motivated by simple admiration, however; his aim is to subvert its humanizing approach to animals by creating complex allegories imbued with absurd humour à la John Tenniel. His images are full of surprises and fractures; the depicted scenes often appear brutal or comical – and thus utterly disconcerting. In *Falling Bough* (2002), a large flock of pigeons perch on a branch that hangs in the air somewhere between freefall and surreal suspension. In its detail, the ostensibly naturalistic rendering of the feathered colony is as chaotic as a Brueghelian apocalypse. Ford draws attention to his often very specific and allegorical narrative threads in handwritten commentaries – Dürer plays a role in *Loss of the Lisbon Rhinoceros* (2008), for example, and Hemingway is involved in *Lost Trophy* (2005). A series of paintings that includes *Jack on his Deathbed* (2005) form a cartoon homage to Richard Burton, a spectacular 19th-century adventurer and naturalist who shared his home with forty apes and even compiled a Simian dictionary. Here, the animals represent the colonial master: as civilized apes, they look down upon the viewer with an air of superiority or even contempt. In this comedy of exchanged roles, Ford's actors are protagonists of an unnatural nature, and the satirical alienation is always aimed at human characteristics.

Walton Fords Arbeiten sind technisch virtuos und visuell spektakulär. Die detaillierten, lebensgroßen Tierdarstellungen in Aquarell und Gouache faszinieren durch die Ästhetik naturhistorischer Zeichnungen der letzten Jahrhunderte. Ford selbst nennt den Ornithologen John J. Audubon, Verfasser des legendären *Birds of America* (1827–38), als Vorbild. Doch Ford nutzt diese Bildsprache nicht aus realistischem Interesse, sondern um ihre vermenschlichende Auffassung des Tiers in komplexen Allegorien gegen den Strich zu bürsten – stets mit einem Schuss absurden Humors à la John Tenniel. Die Bilder stecken voller Überraschungen und Brüche, oft wirken Szenen brutal, auch komisch – und darin insgesamt befremdend. In *Falling Bough* (2002) etwa sieht man das Gewimmel eines Taubenschwarms auf einem Ast, der zwischen freiem Fall und surrealem Schweben in der Luft hängt. Die vermeintlich naturalistisch dargestellte Vogelkolonie wirkt im Detail so chaotisch wie ein Brueghelscher Weltuntergang. Ford bringt Hinweise auf die oft sehr speziellen allegorischen Erzählstränge durch handschriftliche Bildkommentare ein – in *Loss of the Lisbon Rhinoceros* (2008) spielt etwa Dürer, in *Lost Trophy* (2005) Hemingway eine Rolle. Eine Reihe von Bildern, zu denen *Jack on his Deathbed* (2005) gehört, sind eine karikierende Hommage an Richard Burton, spektakulärer Abenteurer und Naturforscher des 19. Jahrhunderts, der mit vierzig Affen im eigenen Haus zusammenlebte und ein Wörterbuch der Affensprache verfasst hat. Die Tiere repräsentieren hier den Kolonialherrn, als zivilisierte Affen blicken sie erhaben oder leicht verächtlich auf den Betrachter herab. In der Komik der vertauschten Rollen sind Fords Darsteller Protagonisten einer unnatürlichen Natur, und die satirische Verfremdung zielt immer auf Züge des Humanen.

Les œuvres de Walton Ford sont techniquement virtuoses et visuellement spectaculaires. Réalisées à l'aquarelle et à la gouache, ses représentations animalières détaillées, peintes en grandeur nature, fascinent par leur esthétique proche du dessin d'histoire naturelle des derniers siècles. Ford cite lui-même comme modèle l'ornithologue John J. Audubon, auteur du légendaire *Birds of America* (1827–38). Cela dit, ce langage iconique ne sert pas un propos réaliste, mais Ford prend son anthropomorphisme implicite à rebrousse-poil par des allégories complexes – toujours avec une pointe d'humour absurde à la John Tenniel. Les images sont pleines de surprises et de ruptures, les scènes souvent d'un effet brutal, parfois comique et donc globalement étrange. *Falling Bough* (2002) montre une nuée de pigeons agglomérés autour d'une branche suspendue entre chute libre et indétermination surréaliste ; représentée sur un mode prétendument réaliste, dans le détail, la colonie d'oiseaux est aussi chaotique qu'une Apocalypse de Bruegel. Avec ses inscriptions, Ford renvoie à des fils narratifs allégoriques souvent très particuliers – Dürer est présent dans *Loss of the Lisbon Rhinoceros* (2008), dans *Lost Trophy* (2005), il s'agit d'Hemingway. Une série de tableaux parmi lesquels on trouve *Jack on his Deathbed* (2005), constitue un hommage caricatural à Richard Burton, spectaculaire aventurier et explorateur du XIXᵉ siècle qui vécut dans sa maison avec une quarantaine de singes et fut l'auteur d'un dictionnaire de la langue des singes. Les animaux incarnent ici le seigneur colonial ; singes civilisés, ils jettent sur le spectateur un regard supérieur ou légèrement méprisant. Par le comique de l'inversion des rôles, les personnages de Ford sont les protagonistes d'une nature artificielle, alors que le détournement satirique vise toujours des traits de l'humain.

J. A.

SELECTED EXHIBITIONS →
2008 *Walton Ford*, Paul Kasmin Gallery, New York **2006** *Tigers of Wrath: Watercolors by Walton Ford*, Brooklyn Museum, New York; Norton Museum of Art, West Palm Beach; San Antonio Museum of Art, San Antonio. *Going Ape: Confronting Animals in Contemporary Art*, DeCordova Museum and Sculpture Park, Lincoln **2005** *Walton Ford*, New Britain Museum of American Art, New Britain. *Social Realisms*, Park School, Brooklandville **2004** *Political Nature*, Whitney Museum of American Art, New York

SELECTED PUBLICATIONS →
2007 *Walton Ford: Pancha Tantra*, Taschen, Cologne **2002** *Walton Ford: Tigers of Wrath, Horses of Instruction*, Harry N. Abrams, New York

A Monster from Guiny,
get of a man and she-baboone...
London 1838

Chimpanzee Pan troglodytes

1 **A Monster from Guiny**, 2007, watercolour, gouache, pencil, ink on paper, 151.8 x 104.1 cm
2 **Tur**, 2007, watercolour, gouache, pencil, ink on paper, 3 panels, 1st and 3rd panel 248.9 x 97.8 cm (framed), 2nd panel 248.9 x 158.8 cm (framed)
3 Installation view, Paul Kasmin Gallery, New York, 2008

4 **Scipio and the Bear**, 2007, watercolour, gouache, pencil, ink on paper, 151.1 x 303.5 cm
5 **Loss of the Lisbon Rhinoceros**, 2008, watercolour, gouache, pencil, ink on paper, 1st panel 249.6 x 108.6 cm, 2nd panel 249.6 x 159.4 cm, 3rd panel 249.6 x 108.6 cm

„Die wirklich große Sache, die ich in meiner Arbeit immer verfolge, ist diese Spannung zwischen Anziehung und Abstoßung. Zu Beginn scheint alles wunderschön, bis man plötzlich merkt, dass gleich eine schreckliche Gewalttat passieren wird, oder sogar schon begonnen hat."

« La chose la plus importante que je cherche toujours dans mon travail a quelque chose à voir avec l'attraction-répulsion : dans un premier temps, les choses sont belles, puis l'on remarque une horrible violence latente, qui pourrait surgir à tout instant. »

"The big, big thing I'm always looking for in my work is a sort of attraction-repulsion thing, where the stuff is beautiful to begin with until you notice that some sort of horrible violence is about to happen or is in the middle of happening."

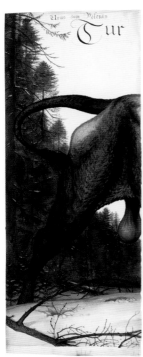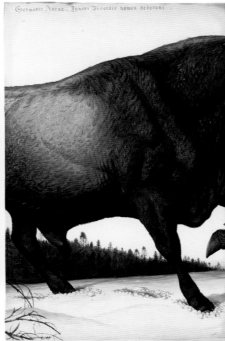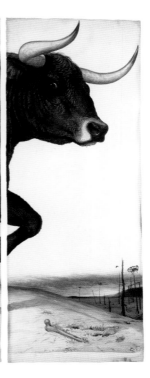

2

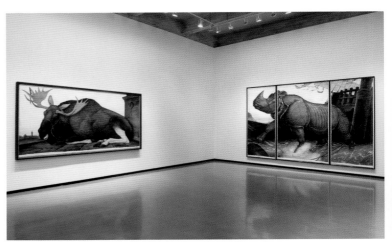

3

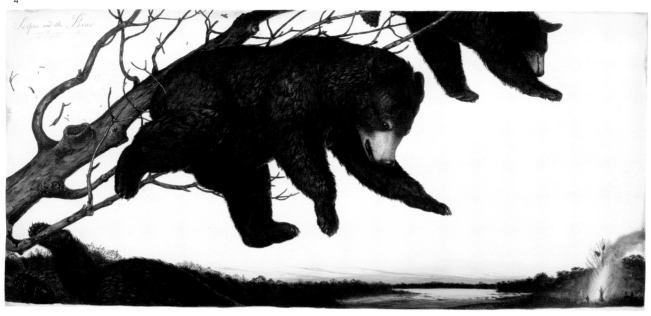

Tom Friedman

1965 born in St. Louis (MO), lives and works in Northampton (MA), USA

Those who believe that art is simply handicraft taken to the extreme might find confirmation upon first glance at the artist Tom Friedman's sculptures and installations. Friedman creates sculptures and drawings with obsessive attention to detail and handiwork, and then combines them to make installations. His materials can be picked up at any supermarket: paper, wire, cardboard, foam, foil and marker pens. Friedman is influenced by 1960s conceptual art and minimalism. The Fluxus movement is worthy of special mention here, as it inspired humorous, reflexive works such as *1000 Hours of Staring* (1992–97), an empty sheet of paper that – as the title suggests – the artist stared at for 1000 hours. In his latest collages and sculptures, shown in his exhibition *Monsters and Stuff* (2008), Friedman has stayed true to his choice of materials and painstakingly elaborate production process, but the gulf between the banality of the material and the spectacular forms that emerge from it has widened, for example in the sculpture *Green Demon* (2008). The field of reference is also considerably broader here, with Frankenstein and voodoo associations slotting in easily next to African sculpture, Miró and Picasso. However, the question remains as to whether the harmless material removes the horror aspect or whether the artist has drawn hidden horror out of the material. And thus the question of art as handicraft comes full circle. As soon as handicraft is supported by a conceptual approach and – in the true spirit of the surrealist idea of the miraculous – mundane everyday material is transformed to something astounding, then you have art.

Wer zu der Ansicht neigt, dass Kunst nur exzessives Basteln sei, könnte auf den ersten Blick von den Arbeiten des Bildhauers und Installationskünstlers Tom Friedman bestätigt werden. In geradezu obsessiver Klein- und Handarbeit erstellt Friedman Skulpturen und Grafiken, die er dann zu Installationen zusammenfasst. Das Material, das er verwendet, ist allenthalben in Supermärkten zu bekommen: Papier, Draht, Pappe, Schaumstoff, Folie und Stifte. Friedmans Schulung basiert auf der Konzeptkunst und Minimal Art der 1960er-Jahre. Insbesondere die Fluxus-Bewegung ist zu erwähnen, deren humorvolle, kunstreflexive Werke ihn zu Arbeiten wie *1000 Hours of Staring* (1992–97) angeregt haben, einem leeren Blatt Papier, das der Künstler 1000 Stunden lang angestarrt hat. Bei seinen neueren Collagen und Skulpturen, wie sie die Ausstellung *Monsters and Stuff* (2008) zeigt, ist Friedman der Materialwahl wie auch dem aufwändigen und kleinteiligen Produktionsprozess treu geblieben. Allerdings vergrößert er die Spanne zwischen der Nichtigkeit des Materials und dem Spektakulären des daraus Geformten. Ein Beispiel dafür liefert die Skulptur *Green Demon* (2008). Hier ist das Bezugsfeld dann auch wesentlich breiter, neben afrikanischer Plastik, Miró und Picasso stellen sich auch unschwer Frankenstein- und Voodoo-Assoziationen ein. Fraglich bleibt jedoch, ob das harmlose Material den Schrecken auflöst oder ob der Künstler den verborgenen Schrecken aus dem Material geholt hat. Und da schließt sich der Kreis zur Frage von Kunst als Basteln. Sobald das Basteln einem konzeptuellen Ansatz unterworfen wird und das banale Alltagsmaterial, ganz im Geiste der surrealistischen Idee des Wunderbaren, zu etwas Verblüffendem transformiert wird, entsteht Kunst.

Ceux qui tendent à penser que l'art n'est rien d'autre qu'une débauche de bricolage pourraient bien se sentir confortés de prime abord par les œuvres du sculpteur et installationniste Tom Friedman. Par un travail manuel minutieux jusqu'à l'obsession, Friedman crée des sculptures et des dessins qu'il regroupe ensuite en installations. Le matériau utilisé peut être trouvé dans le premier supermarché venu : papier, carton, fil de fer, mousse synthétique, film plastique et crayons. La formation de Friedman remonte à l'art conceptuel et au minimalisme des années 1960. Dans ce contexte, il convient de citer plus particulièrement le mouvement Fluxus, dont les œuvres pleines d'humour et la réflexion sur l'art ont notamment inspiré *1000 Hours of Staring* (1992–97), une feuille de papier blanc que l'artiste a regardée pendant 1000 heures. Dans ses collages et sculptures récents, comme les présente l'exposition *Monsters and Stuff* (2008), Friedman est resté fidèle au choix des matériaux et à un mode de production infiniment minutieux, tout en augmentant encore l'écart entre la futilité du matériau et l'aspect spectaculaire de ce qu'il en fait, comme l'illustre très bien *Green Demon* (2008). Ici, le champ référentiel est lui aussi nettement plus vaste : à côté de la sculpture africaine, de Picasso et de Miró, s'instaurent également aisément des associations avec Frankenstein et le vaudou. Reste la question de savoir si l'épouvante est résorbée par la banalité du matériau ou si l'artiste a fait surgir l'épouvante cachée dans le matériau. C'est ici que nous revenons à la question initiale de l'art comme bricolage : l'art apparaît dès que le bricolage est soumis à une approche conceptuelle et qu'un matériau quotidien est transformé en quelque chose de surprenant – en l'occurrence dans l'esprit du merveilleux surréaliste.

H. L.

SELECTED EXHIBITIONS →
2008 *About Us*, Boulder Museum of Contemporary Art, Boulder. *Styrofoam*, RISD Museum, Providence **2007** *Mapping the Self*, Museum of Contemporary Art, Chicago. *INSIGHT?*, Gagosian Gallery/Red October Chocolate Factory, Moscow. *Into Me/Out Of Me*, P.S.1 Contemporary Art Center, Long Island City; KW Institute for Contemporary Art, Berlin. *The Shapes of Space*, Solomon R. Guggenheim Museum, New York **2006** *Tom Friedman: Pure Invention*, Mildred Lane Kemper Art Museum, St. Louis.

SELECTED PUBLICATIONS →
2008 *Tom Friedman*, Yale University Press, New Haven. *Tom Friedman*, Gagosian Gallery, New York **2007** *INSIGHT?*, Gagosian Gallery/Red October Chocolate Factory, Moscow. *Pop Art Is*, Gagosian Gallery, London. *Into Me/Out Of Me*, P.S.1 Contemporary Art Center, Long Island City; KW Institute for Contemporary Art, Berlin; Hatje Cantz, Ostfildern **2006** *Tom Friedman*, Gagosian Gallery, New York **2005** *Ecstasy: In and about Altered States*, MOCA, Los Angeles

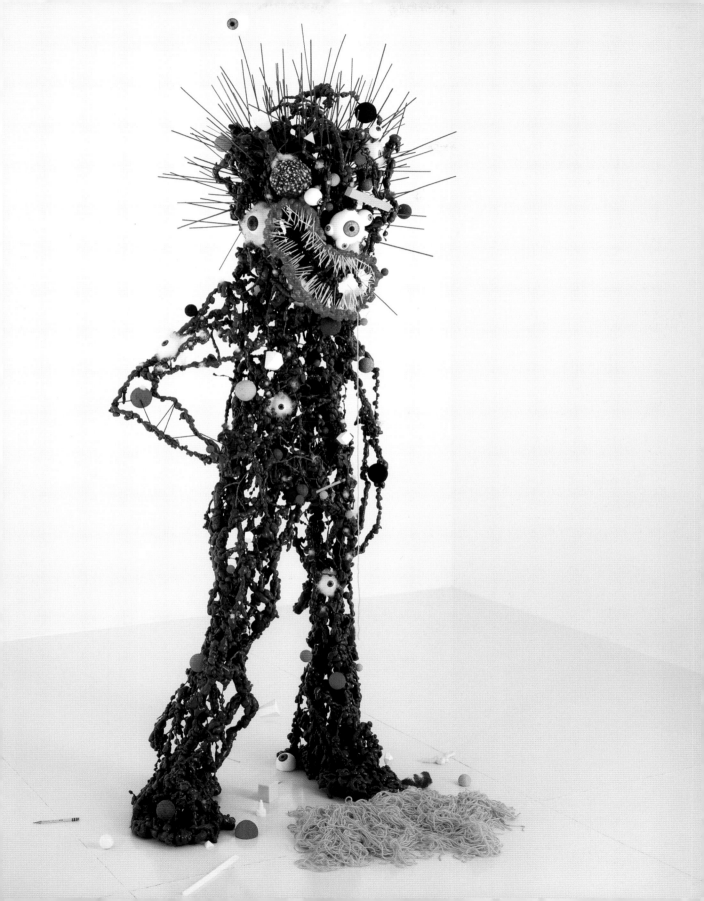

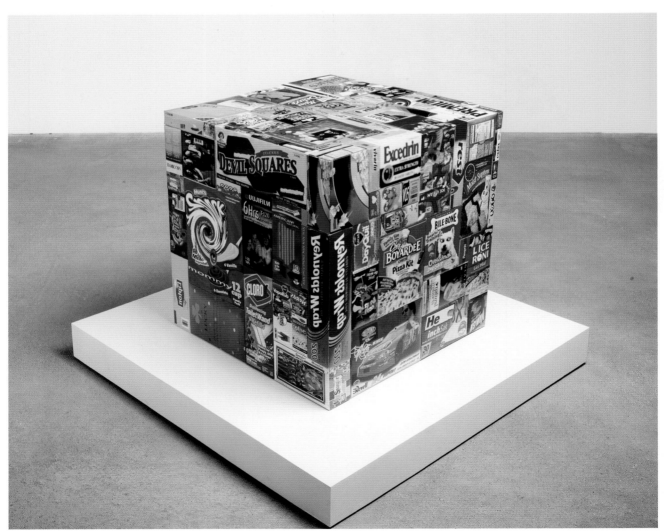

174

1　**Green Demon**, 2008, expanding insulation foam, mixed media, 231 x 109 x 91 cm

2　**Care Package (Manipulated)**, 2008, inkjet photos, 57 x 56 x 56 cm
3　**Monster Collage**, 2007, collage with artist's hair, 345.4 x 304.8 cm

„Mich interessiert, dass ich gar nicht in der Lage bin, alles zu verarbeiten womit ich konfrontiert werde, eine Idee vom Ganzen zu bekommen … Was mein Werk zusammenhält ist, dass ich etwas nehme, das mir sonnenklar erscheint, das ich zu kennen glaube, nur um festzustellen, dass, je näher ich komme und je genauer ich es untersuche, alles umso unklarer wird."

« Ce qui m'intéresse avant tout, c'est l'incapacité de transformer tout ce à quoi je suis confronté et l'idée de globalité… le dénominateur commun de mon travail, c'est de prendre une chose qui était pour moi claire comme de l'eau de roche, une chose que je croyais connaître, et de découvrir que plus je m'en rapproche en l'examinant méticuleusement, moins cette chose est claire. »

"What interests me is my inability to process everything that I am confronted with and the idea of the whole… what unifies what I do is taking something that is crystal clear to me, something that I seem to know, and finding that the closer I get and the more carefully I inspect it, the less clear it becomes."

2

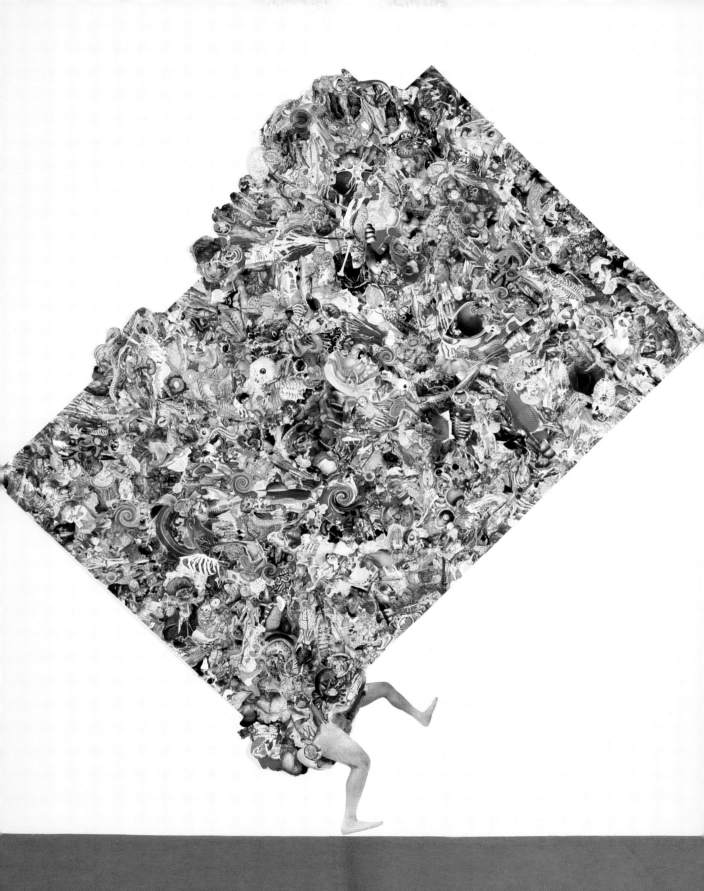

Ellen Gallagher

1965 born in Providence (RI), lives and works in New York (NY), USA

With different techniques from painting to 16mm films, Ellen Gallagher opens up windows onto a universe in which narratives of black history and identity are at once pulled apart and re-imagined. Gallagher's work is affected through its subtle straddling of the aesthetic, social and political, in the collision of historical realism with science fiction fantasy, or the austere structures of minimalism with mass-media representation. In her ongoing series *Watery Ecstatic* (2001–), Gallagher submerges her exploration of racial stereotypes in an underwater realm of aquatic plant and animal life. She focuses on the "middle passage" in which millions of slaves lost their lives on the journey from Africa to America by creating her version of a "black Atlantis", the mythical Drexciya populated by slaves who jumped from the ships during the passage and who now emerge like ghosts in this world of translucent watercolours. Gallagher is particularly interested in the way in which images of black culture have been mediated. In *IGBT* (2008) she has mounted two stereotyped black male silhouettes on a gilded PCB thus creating a sort of modern icon. The PCB and the insulated gate bipolar transistor (IGBT) to which the title alludes are elements of an electronized and computerized time, whereas the silhouettes are characterized by their clothes as belonging to the 19th century. By interweaving these different elements, Gallagher opens up a wide field of associations such as the metaphor of the "black gold" on which the modern US society is, at least partly, built. A memory that is still engraved in the society's structure, even if contemporary gold takes a different – an electronical – form.

Mit verschiedenen Techniken vom Gemälde bis zum 16mm-Film öffnet Ellen Gallagher Fenster auf eine Welt, in der Erzählungen von schwarzer Geschichte und Identität gleichzeitig auseinandergenommen und neu geschildert werden. Gallaghers Arbeit vereint in sehr subtiler Weise Ästhetik, Soziales und Politik, geschichtsbewusster Realismus prallt auf Science-Fiction-Fantasien oder strenge, minimalistische Strukturen auf Bilder aus den Massenmedien. In der laufenden Serie *Watery Ecstatic* (2001–) verlegt Gallagher ihre Untersuchung von Rassenvorurteilen in ein Unterwasserreich mit Pflanzen und Tieren. Sie konzentriert sich auf die „Middle Passage", die Überfahrt zwischen Afrika und Amerika, auf der Millionen von Sklaven ihr Leben verloren haben, und sie erschafft ihre Version eines „schwarzen Atlantis", dem mythischen Drexciya, das von Sklaven bewohnt wird, die während der Fahrt von den Schiffen gesprungen sind und nun wie Geister in dieser Welt durchsichtiger Wasserfarben schweben. Gallagher interessiert besonders, wie die Bilder der schwarzen Kultur vermittelt werden. Für *IGBT* (2008) hat sie zwei männliche Silhouetten auf einer vergoldeten Platine befestigt und so eine Art moderne Ikone geschaffen. Die Platine und der Insulated Gate Bipolar Transistor (IGBT), auf den der Titel anspielt, sind Teile einer elektronisierten und computerisierten Zeit, während die Scherenschnitte durch ihre Kleidung dem 19. Jahrhundert zuzuordnen sind. Indem sie diese verschiedenen Elemente verbindet, macht Gallagher eine Vielzahl von Assoziationen möglich, wie etwa die Metapher des „schwarzen Goldes", auf dem die Gesellschaft der USA zumindest teilweise erschaffen wurde. Eine Erinnerung, die noch immer in die Struktur dieser Gesellschaft eingeschrieben ist, auch wenn das moderne Gold eine andere – elektronische – Form annimmt.

En utilisant différentes techniques, de la peinture au film 16 mm, Ellen Gallagher nous ouvre des portes donnant sur un univers qui démonte le récit historique et identitaire noir pour mieux le ré-imaginer. Se plaçant de manière subtile à la croisée de l'esthétique, du social et du politique, son travail est influencé par l'opposition entre réalisme historique et science-fiction, entre austères structures du minimalisme et représentation médiatique. Dans la série *Watery Ecstatic*, initiée en 2001, l'artiste immerge son étude des stéréotypes raciaux dans un royaume de flore et faune sous-marines. Elle cible le « Passage du milieu » où des millions d'esclaves périrent pendant leur transfert d'Afrique en Amérique, et crée sa version de « l'Atlantide noire », la mythique Drexciya peuplée par les esclaves qui se sont jetés à la mer durant le voyage et qui émergent à présent, fantomatiques, dans ce monde d'aquarelles diaphanes. Gallagher s'intéresse particulièrement à la transmission des images de la culture noire. Dans *IGBT* (2008), elle a collé deux silhouettes stéréotypées d'hommes noirs sur l'image d'une plaquette de circuit intégré, créant ainsi une sorte d'icône moderne. Si la plaquette et le transistor bipolaire à grille isolée du titre (IGBT en anglais) participent d'une ère électronique et informatique, les vêtements des personnages les ancrent dans le XIXe siècle. En entrelaçant ces différents éléments, Gallagher ouvre un vaste champ d'associations, telle la métaphore de « l'or noir », fondement – partiel – de la société américaine moderne. Un souvenir toujours gravé dans sa structure, même si aujourd'hui, l'or prend une forme différente – électronique.

A. B.

SELECTED EXHIBITIONS →
2008 *Eclipse – Art in a Dark Age*, Moderna Museet, Stockholm
2007 *Ellen Gallagher*, Tate Liverpool; Dublin City Gallery, The Hugh Lane, Dublin. *Comic Abstraction*, MoMA, New York **2006** *Heart of Darkness*, Walker Art Center, Minneapolis. *Black Alphabet*, Zacheta National Gallery, Warsaw. *Having New Eyes*, Aspen Art Museum, Aspen. *Skin Is a Language*, Whitney Museum of American Art, New York **2005** *Ellen Gallagher: Murmur and DeLuxe*, MOCA, North Miami. *Ellen Gallagher: DeLuxe*, Whitney Museum of American Art, New York

SELECTED PUBLICATIONS →
2007 *Ellen Gallagher: Coral Cities*, Tate Publishing, London
2006 *Ellen Gallagher: Heart of Darkness*, Walker Art Center, Minneapolis. *Alien Nation*, ICA, London et al.; Hatje Cantz, Ostfildern **2005** *Ellen Gallagher. Exelento*, Gagosian Gallery, New York. *Paul McCarthy, Ellen Gallagher, Anri Sala, Parkett 73*, Zürich

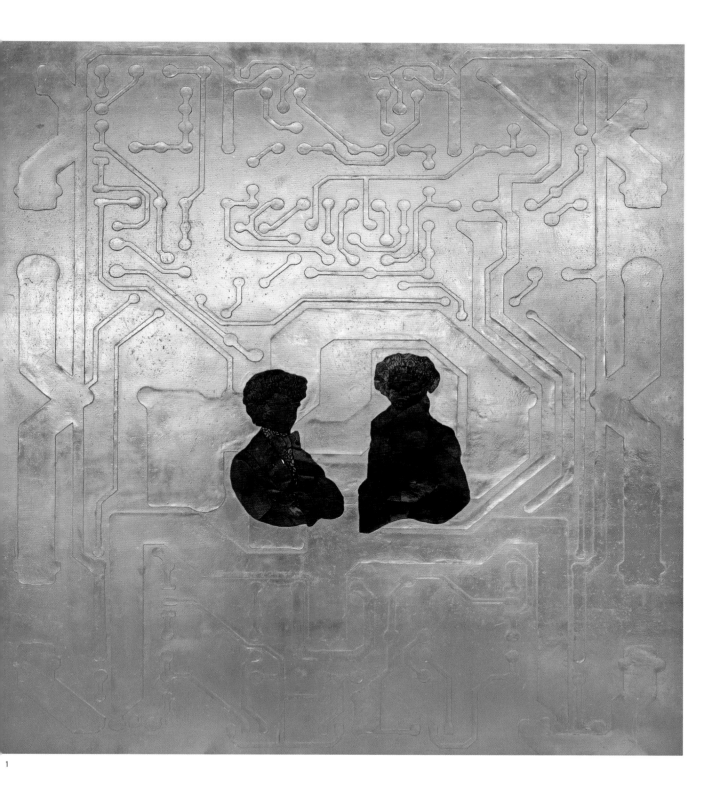

1 **IGBT**, 2008, gesso, gold leaf, ink, varnish, cut paper on canvas, 201.9 x 188 cm
2 **Dirty O's**, 2006, pencil, ink, watercolour, plasticine, cut paper on paper, 60.5 x 80.5 cm

3 **Bird in Hand**, 2006, oil, ink, cut paper, polymer medium, salt, gold leaf on canvas, 238 x 307 cm
4 **An Experiment of Unusual Opportunity**, 2008, ink, graphite, oil, varnish, cut paper on canvas, 202 x 188 cm

„In vielen meiner Arbeiten gibt es diese Idee des Gigantischen, aber in miniaturisierter Form. Bezogen auf den Gegenstand kann dies eine sehr kleine Beobachtung sein, etwa eine bestimmte Geste oder eine bestimmte Geschichte."

« Le gigantesque est présent dans mon travail mais sous forme miniature. Le sujet peut être quelque chose d'effroyable réduit à une observation microscopique : un geste ou un récit spécifiques. »

"In much of my work there is this idea of the gigantic, but in a miniaturized form. In terms of the subject matter, it can be something sort of awful that's then reduced to a very minute observation, maybe a specific gesture or specific narrative."

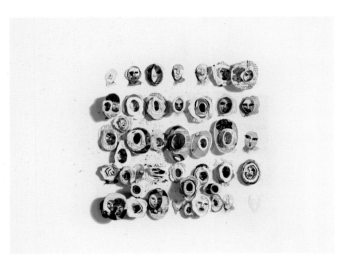

2

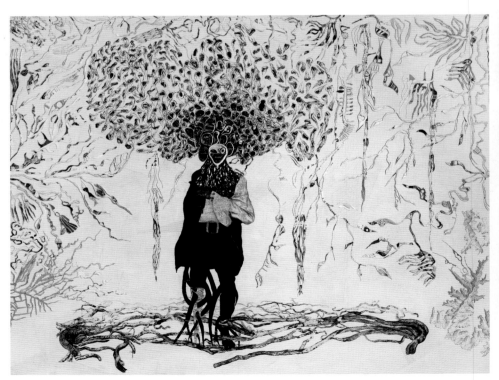

3

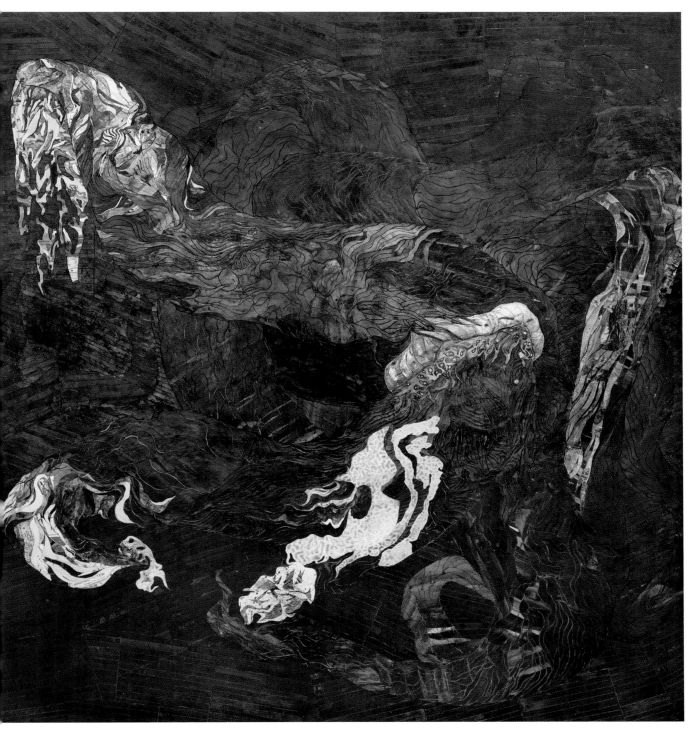

Isa Genzken

1948 born in Bad Oldesloe, lives and works in Berlin, Germany

Since the mid-1970s, Isa Genzken has examined the medium of sculpture, working at its limits and pushing it to the point of near collapse. From her very first works Genzken has subverted the austere forms of minimalist sculpture with exaggerated gestures and mass-media imagery, a confrontation staged in her installation for the 2007 Venice Biennale in which the smooth mirrored surfaces that enveloped the entrance soon gave way to a spawling assemblage of components gleaned from the detritus of consumer society. Titled *Oil*, Genzken's installation painted a withering portrait of a fractured world governed by greed. From her concrete sculptures of the late 1980s and totemic stele sculptures from the late 1990s to the monumental collage book *I Love New York, Crazy City* (2006), references to architecture are frequent in Genzken's work. Her sculptures often resemble dystopic architectural models, a form exploited in her recent sculptural propositions for New York's "Ground Zero" site. From a hospital and a church to a car park and the provocatively named *Osama Fashion Store (Ground Zero)* (2008), the terror and destruction of the act that ripped open this dense plot of urban real estate is wholly subsumed into Genzken's defiant accumulations of gaudy objects and materials. They provide at once visions of radical social possibility and deny the desire to build over and forget a traumatic past. Genzken's work is both a re-envisioning of the history of sculpture and a distorting mirror in which to observe the terrors of contemporary society.

Seit Mitte der 1970er-Jahre hat sich Isa Genzken der Erweiterung des Skulpturbegriffs gewidmet und ihn bis an seine Grenzen ausgelotet. Bereits in ihren ersten Werken hatte sie die strengen Formen der minimalistischen Skulptur durch einen raumgreifenden Gestus und die Bildwelt der Massenmedien aufgebrochen. Diese Konfrontation offenbarte auch ihre Inszenierung auf der Biennale in Venedig 2007, in der die glatten, spiegelnden Flächen im Eingangsbereich des Inneren sehr schnell zu einer Assemblage von Fragmenten unserer Wegwerfgesellschaft wurden. Die Installation war *Oil* betitelt und zeichnete das eindringliche Porträt einer gebrochenen, von Gier beherrschten Welt. Von Genzkens Betonskulpturen, die sie Ende der 1980er schuf, über die Totemstelen der ausgehenden 1990er Jahre bis hin zu ihrem monumentalen Collagenbuch *I Love New York, Crazy City* (2006), setzte die Künstlerin in ihren Arbeiten vielfach Bezüge zur Architektur. Oft legen ihre Skulpturen die Assoziation zu dystopischen Architekturmodellen nahe, eine Form, die sie jüngst in ihre skulpturalen Entwürfe für den „Ground Zero"-Bauplatz in New York einbrachte. Ein Krankenhaus, eine Kirche, ein Parkplatz und der provozierende Titel *Osama Fashion Store (Ground Zero)* (2008) – die Zerstörungskraft jenes Terrorakts, der in dieses dicht bebaute Stadtviertel ein klaffendes Loch gerissen hat, wird von Genzken in herausfordernden Ansammlungen greller Objekte und Materialien zusammengefasst. Diese augenfälligen Visionen einer radikalen Sozialutopie verweigern sich dem Drang, die Baulücke zu schließen und damit die traumatische Vergangenheit dem Vergessen zu überantworten. Genzkens Arbeit ist eine Neuinterpretation der Skulpturgeschichte und zugleich eine Art Zerrspiegel, der den Blick auf die Schrecken der modernen Gesellschaft lenkt.

Isa Genzken explore la sculpture depuis le milieu des années 1970, repoussant les limites de son médium jusqu'à son point d'effondrement. Depuis ses toutes premières œuvres, Genzken subvertit les formes austères de la sculpture minimaliste par le recours à des gestes exagérés et à des images tirées des mass médias. Cette confrontation était mise en scène notamment dans son installation réalisée pour la Biennale de Venise de 2007, où succédait, sans solution de continuité, aux surfaces lisses et réfléchissantes enveloppant l'entrée de l'installation, un grouillant assemblage d'éléments récupérés dans des détritus issus de la consommation courante. L'installation, intitulée *Oil*, dépeignait le portrait terrible d'un monde fracturé et guidé par la convoitise. De ses sculptures en béton (datant de la fin des années 1980) à ses sculptures totémiques (de la fin des années 1990), en passant par un livre de collages monumental intitulé *I Love New York, Crazy City* (2006), Genzken multiplie les références à l'architecture. Ses sculptures ressemblent parfois à des maquettes dystopiques, comme dans ses récentes propositions sculpturales pour le site de Ground Zero à New York : un hôpital, une église, un parking et même une boutique de vêtements hardiment baptisée *Osama Fashion Store (Ground Zero)* (2008). Chaque fois, la violence et la barbarie de l'acte qui a éventré cette zone urbaine très dense sont entièrement absorbées dans des accumulations de matériaux et d'objets clinquants, qui, tout en suggérant des lendemains où tout serait possible, réfutent notre désir d'oublier et d'enfouir un passé traumatisant. L'œuvre de Genzken est à la fois une réécriture imaginaire de l'histoire de la sculpture et un miroir déformant où se reflètent les terreurs de la société contemporaine.

A. B.

SELECTED EXHIBITIONS →
2008 *Isa Genzken*, Malmö Konsthall, Malmö. *Vertrautes Terrain – Aktuelle Kunst in und über Deutschland*, ZKM, Karlsruhe. *Peripheral Vision and Collective Body*, Museion, Bolzano **2007** *Isa Genzken: Wir sind hier in Dresden*, Staatliche Kunstsammlungen Dresden. *Isa Genzken*, German Pavilion, 52nd Venice Biennale, Venice **2006** *The 80's: A Topology*. Museo Serralves, Porto. *Isa Genzken*, Secession, Vienna. *Isa Genzken*, Camden Arts Centre, London. *Isa Genzken*, Kunsthalle zu Kiel

SELECTED PUBLICATIONS →
2008 *Isa Genzken: Ground Zero*, Hauser & Wirth, London; Steidl, Göttingen **2007** *Isa Genzken: OIL*, Venice Biennale, DuMont, Cologne **2006** *Isa Genzken*, *I Love New York, Crazy City*, JRP Ringier, Zürich. *Isa Genzken*, Phaidon Press, London. *Isa Genzken*, Secession, Vienna. *Ballerina in a Whirlpool*, *Werke aus der Hauser & Wirth Collection*, Staatliche Kunsthalle Baden-Baden; Snoeck, Cologne **2005** *PressPlay: Contemporary Artists in Conversation*, Phaidon Press, London

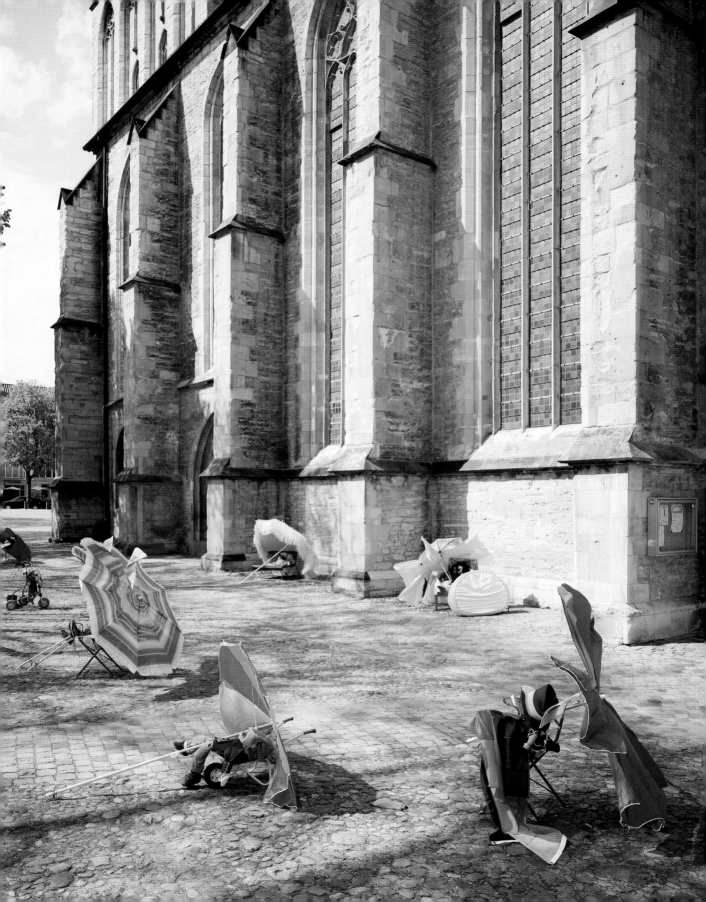

1 **Untitled**, 2007, mixed media, 12 assemblages, dimensions variable.
 Installation view, Skulptur Projekte Münster 07
2 **Leonardos Katze**, 2006, mixed media, 180 x 180 x 145 cm
3 **Papst**, 2006, mixed media, 191 x 299 x 187 cm

4 **Untitled**, 2006, wheelchair, mirror foil, clip, 109 x 70 x 87 cm
5/6 **Oil**, 2007, mixed media, dimensions variable. Installation view,
 German Pavilion, 52. Biennale di Venezia, Venice

„Ich habe kein Interesse an Readymades. Die Bedeutung liegt im Kombinieren der Dinge. In einer Zeit wie dieser, in der alles herunterkommt, ist es wichtig, billige Materialien zu benutzen."

« Le ready-made ne m'intéresse pas. C'est par l'assemblage qu'est produit le sens. À une époque comme la nôtre, où tout semble se détériorer, il est essentiel d'utiliser des matériaux ordinaires. »

"I'm not interested in readymades. The meaning is in the combination of things. In a time such as the present one, a time when things go to seed, it is important to use cheap materials."

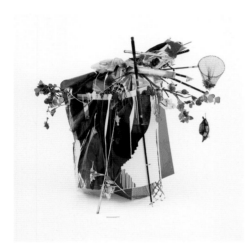

2

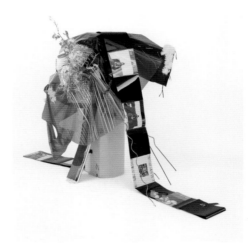

3

4

5

Luis Gispert

1972 born in Jersey City (NJ), lives and works in Brooklyn (NY), USA

In his large-scale photographs, interactive sound sculptures and installations, Luis Gispert filters what is frequently described as "urban youth culture" through screens as diverse as science fiction films, music videos and baroque art. An artist who has wryly admitted to learning English from watching television, Gispert made use of this training in the quixotic *Smother* (2006/07), a 24-minute video set in the 1980s Miami of the artist's childhood, with references to the film *Scarface*. Co-written with Orly Genger, the narrative centers on Waylon, an eleven-year old bed-wetter, and Nora, his pill-popping, castration-obsessed mother; they live in a "narco-nouveau-riche" house – in the artist's inimitable words – of art deco flourishes and candy-coloured pastels, furnished by Waylon's absent, drug dealing father. In the film's course, the family's German shepherd gets deep fried by Nora's suitor (a butcher), and other misadventures ensue, the sum total of which suggest a boy's odyssey through a fallen world riddled by intractable signs of class. It is also the subject of related photos (a particularly arresting one frames Waylon floating, like a partially submerged Ophelia, in a pool of his own urine, clutching stereo equipment to his chest), as well as a sculptural installation extending the film's settings into space via heart shaped speakers and a neon-framed mirror. Like his earlier projects that enlist a personal if not strictly autobiographical iconography – e.g., his photographs of Latina cheerleaders or his images that make use of friends' or relatives' dwellings – Gispert's new work plumbs social identities, revealing cultural codes that are no less odd for being ubiquitous.

Luis Gisperts großformatige Fotografien, interaktive Klangskulpturen und Installationen filtern die so genannte urbane Jugendkultur durch verschiedene Genres wie Science-Fiction-Filme, Musikvideos und barocke Kunst. Gispert, der erzählt, dass er Englisch vor dem Fernseher gelernt hat, nutzte dieses Training für seinen 24-minütigen Videofilm *Smother* (2006/07), der in den 1980ern in Miami spielt, wo Gispert aufwuchs, und darüber hinaus Referenzen an den Film *Scarface* enthält. Das mit Orly Genger erarbeitete Drehbuch handelt von dem elfjährigen Bettnässer Waylon und von Nora, seiner drogensüchtigen, kastrationswütigen Mutter. In den Worten des Künstlers wohnen sie in einem „narco-neureichen" Haus, das Waylons nie anwesender Vater, ein Drogenhändler, in schwülstigem Art-Deco mit bonbonfarbenen Pastellbildern ausgestattet hat. Im Verlauf der Handlung wird der Deutsche Schäferhund der Familie von Noras Freier (einem Metzger) in schwimmendem Fett ausgebraten. Weitere Katastrophen folgen in der Odyssee eines Jungen durch eine vom sozialen Zerfall gezeichnete Welt. Das Sujet ist auch Thema der begleitenden Fotografien (eine besonders interessante Aufnahme zeigt Waylon, seine Stereoanlage fest an sich gedrückt, wie Ophelia halb untergetaucht in einer Pfütze seines eigenen Urins) und einer skulpturalen Installation, die den Schauplatz der Handlung durch herzförmige Lautsprecher und einen neongerahmten Spiegel in den realen Raum hinein erweitert. Wie in früheren Projekten, die persönliche, wenn nicht strikt autobiografische Bilder enthielten – so auch eigene Fotos lateinamerikanischer Cheerleader oder Abbildungen der Wohnungen von Freunden oder Verwandten –, lotet Gispert in seiner neuen Arbeit gesellschaftliche Identitäten aus und enthüllt dabei kulturelle Codes, die nicht weniger seltsam werden, nur weil sie allgegenwärtig sind.

Dans ses photographies grand format, ses sculptures sonores interactives ou ses installations, Luis Gispert explore la « culture de la jeunesse urbaine » par le biais de « filtres » aussi divers que les films de science-fiction, les clips vidéo ou l'art baroque. Gispert, qui admet avec humour qu'il a appris l'anglais en regardant la télévision, a mis cette formation à profit avec *Smother* (2006/07), une vidéo picaresque de 24 minutes dont l'action se déroule – comme l'enfance de l'artiste – dans un Miami des années 1980 émaillé de références au film *Scarface*. Co-écrite avec Orly Genger, l'histoire tourne autour de Waylon, garçonnet de 11 ans qui fait encore pipi au lit, et de Nora, mère castratrice et dévoreuse de cachets. Ils habitent, selon la formule de l'artiste, une maison de « narco-nouveau-riche » ornée de bibelots Art déco aux couleurs pastels et acidulées, décorée par un père absent et narcotrafiquant. Le film se présente comme une succession de péripéties (un prétendant de Nora, boucher de son état, finira ainsi par cuire à la casserole le berger allemand de la famille) retraçant l'épopée d'un jeune garçon dans un monde encombré de symboles d'appartenance sociale. L'histoire se décline aussi sous la forme de photographies – l'une d'elles montre un Waylon aux allures d'Ophélie flottant dans une mare de sa propre urine, son matériel hi-fi serré sur la poitrine – ou encore d'une installation sculpturale qui prolonge dans l'espace les décors du film (enceintes audio en forme de cœur, miroir au cadre en néon). À l'instar de ses œuvres plus anciennes, qui convoquent une iconographie personnelle sinon strictement autobiographique – photographies de *pom-pom girls* portoricaines ou d'intérieurs habités par ses proches –, l'œuvre récente de Gispert sonde les identités sociales, révélant des codes culturels aussi excentriques que courants.

S. H.

SELECTED EXHIBITIONS →
2007 *Rock'n'Roll Fantasy*, White Box, New York. *The State*, Hermitage Museum, St. Petersburg. *Zwischen zwei Toden / Between Two Deaths*, ZKM, Karlsruhe. *Art in America, Now*, MOCA Shanghai. *MOCA's Tenth Anniversary Collection*, MOCA, North Miami. *Not for Sale*, P.S.1 Contemporary Art Center, Long Island City **2006** *USA Today*, Royal Academy of Arts, London. *Die Jugend von heute*, Schirn Kunsthalle, Frankfurt am Main **2005** *Will Boys Be Boys?*, Museum of Contemporary Art, Denver

SELECTED PUBLICATIONS →
2008 *Lacanian Ink 31 – Sacrosanct Depression*, The Wooster Press, New York **2004** *Luis Gispert: Loud Image*, Hood Museum of Art, Hanover

1/2 Installation views, *Luis Gispert: The World Is Yours*, Mary Boone Gallery, New York, 2008

3 **Photograph from** *Smother* **(Air Hockey)**, 2006/07, C-print, 101.6 x 152.4 cm

4 **Photograph from** *Smother* **(Little Brownie)**, 2006/07, C-print, 101.6 x 188 cm

5 **Untitled (Escalades)**, 2007, C-print, 106.7 x 152.4 cm

6 **Untitled (Gerilla)**, 2007, C-print, 106.7 x 162.6 cm

„Was mich an der Popkultur am meisten anspricht ist, dass sie uns daran erinnert, wie absolut wichtig Veränderung ist."

« Ce qui m'attire le plus dans la culture pop, c'est sa façon de suggérer que le changement est absolument essentiel. »

"The part of pop culture that most appeals to me is the part that suggests that change is absolutely essential."

3

4

Robert Gober

1954 born in Wallingford (CT), lives and works in New York (NY), USA

Prolonged scrutiny of even the most quotidian objects can render them strange or mysterious. A similar transformation is enacted in Robert Gober's sculptures, drawings and installations, where alternative narratives and associations are drawn out of painstaking recreations and juxtapositions of everyday objects. In elusive sculptures such as *Melted Rifle* (2006), in which a limp Winchester rifle is draped over a milk crate filled with gleaming green apples, surrealist games of chance encounter and narrative association are played out. The rifle appears again in a piece from an untitled series of wall-mounted compositions (2007/08), in this case stuck through a stool on which two breasts are growing. But even where the objects appear to be real on first sight, up close they divulge the secrets of their careful fabrication from common materials, lending an uncanny air to Gober's works. His early series of sink sculptures already followed that principle, conjuring references to Duchamp's ready-made pissoir, but fabricated from plaster and other materials. The latent human presence that resides in these inanimate representations took on more recognizable figurative form in Gober's work from the 1990s onwards: dismembered limbs began to populate his ever more complex installations, growing out of walls or human torsos, interspersing references to childhood and religion with architectural metaphors for both imprisonment and escape. Gober's work interrogates the shadowy space between surface and subtext; his is an ever-growing lexicon of objects taken from everyday life that questions what we readily take for granted.

Lange Beschäftigung selbst mit den alltäglichsten Gegenständen kann diese in etwas Fremdes und Rätselhaftes verwandeln. Eine ähnliche Verwandlung findet in Robert Gobers Skulpturen, Zeichnungen und Installationen statt, wo neue, überraschende Geschichten und Assoziationen durch die sorgfältige Neuschöpfung und Gegenüberstellung von alltäglichen Gegenständen entstehen. In einer schwer fassbaren Skulptur wie *Melted Rifle* (2006) – ein schlaffes Winchester-Gewehr, das über einer mit glänzenden grünen Äpfeln gefüllten Plastikkiste hängt – finden zufällige Begegnungen im surrealistischen Sinne statt und werden narrative Assoziationen durchgespielt. Das Gewehr taucht auch bei einer Arbeit aus einer titellosen Serie von an der Wand hängenden Kompositionen auf, wo es durch einen Stuhl gesteckt ist, auf dem zwei Brüste wachsen. Aber auch da, wo Gegenstände auf den ersten Blick echt zu sein scheinen, enthüllen sie, genau besehen, die Geheimnisse einer sorgfältigen Produktion aus ungewöhnlichen Materialien – und genau das macht Gobers Arbeiten etwas unheimlich. Seine frühe Serie von Waschbecken funktionierte schon nach diesem Prinzip, rief Erinnerungen an Duchamps Pissoir und das Readymade wach, bestand tatsächlich aber aus Gips und anderen Materialien. Die versteckte Gegenwart des Menschlichen in diesen leblosen Darstellungen wurde in Gobers Werk seit den 1990ern erkennbar figurativ: Losgelöste Gliedmaßen begannen seine immer komplexeren Installationen zu bevölkern, wuchsen aus den Wänden oder aus menschlichen Torsos, durchsetzten Bezüge zu Kindheit und Religion mit architektonischen Metaphern für Gefangenschaft und Freiheit. Gobers Arbeiten befragen den grauen Bereich zwischen Oberfläche und Subtext; sie sind ein stetig wachsendes Inventar von Objekten unseres alltäglichen Lebens, das in Frage stellt, was wir bereitwillig für selbstverständlich halten.

L'examen approfondi d'un objet, même le plus ordinaire, peut le rendre étrange et mystérieux. Une transformation de ce type est mise en œuvre dans les sculptures, les dessins et les installations de Robert Gober, où des associations et des récits nouveaux surgissent de la re-création méticuleuse d'objets familiers et de leur juxtaposition. Des sculptures au sens élusif telles que *Melted Rifle* (2006) – une carabine Winchester molle posée sur un cageot rempli de pommes d'un vert éclatant – convoquent des jeux surréalistes de rencontres fortuites et d'associations d'idées. Le fusil apparaît à nouveau dans une série sans titre de pièces murales (2007/08): il est ici passé à travers un tabouret sur lequel pousse une paire de seins. Même lorsque les objets semblent a priori réels, un second examen révèle leurs secrets de fabrication, à partir de matériaux ordinaires, ce qui leur donne un air troublant. Les premières séries de sculptures d'éviers suivaient déjà ce principe: ils faisaient référence à l'urinoir ready-made de Duchamp mais étaient faits de plâtre et d'autres matériaux. La présence humaine latente qui habite ces représentations inanimées prit une forme plus figurative à partir des années 1990: des membres séparés de leurs corps commencèrent à peupler ses installations à la complexité grandissante. Ils jaillissent des murs ou de torses humains et mêlent métaphores architecturales de l'emprisonnement et de l'évasion avec des références à l'enfance et à la religion. L'œuvre de Gober interroge l'interstice entre surface et sous-texte; sous-texte qui, dans son cas, est un vocabulaire sans cesse grossissant d'objets arrachés à la vie quotidienne et mettant en question ce que nous considérons comme allant de soi.

A. B.

SELECTED EXHIBITIONS →
2008 *The Shape of Time*, Walker Art Center, Minneapolis. *Wunderkammer: A Century of Curiosities*, MoMA, New York **2007** *Robert Gober*, Schaulager, Münchenstein/Basle. *More than the World – Works from the Astrup Fearnley Collection*, Astrup Fearnley Museet for Moderne Kunst, Oslo. *Out of Time – A Contemporary View*, MoMA, New York. **2006** *Quartet – Barney, Gober, Levine, Schütte*, Walker Art Center, Minneapolis. *Day for Night*, Whitney Biennial 2006, Whitney Museum, New York

SELECTED PUBLICATIONS →
2007 *Robert Gober: Sculptures 1979–2007*, Schaulager, Münchenstein/Basle; Steidl, Göttingen **2006** *Robert Gober: The Meat Wagon*, The Menil Foundation, Houston **2005** *A Robert Gober Lexicon*, Matthew Marks Gallery, New York; Steidl, Göttingen **2004** *Robert Gober*, Phaidon Press, London

1 **Untitled**, 2007/08, beeswax, pigment, cotton, leather, aluminium pull tabs, human hair, cast gypsum polymer, paint, 70 x 43 x 45 cm
2 **Untitled**, 2006/07, plaster, pewter, watercolour, oil paint, ceramic, acrylic paints, twigs, grass, 89 x 86 x 57 cm

3 **Melted Rifle**, 2006, plaster, paint, cast plastic, beeswax, walnut, lead, 69 x 58 x 40 cm

„Was ich zu sagen habe, ist in meinen Werken und nicht in meinen Worten." « Ce que j'ai à dire est dans l'œuvre, pas dans les mots. »

"My communication is the work and not the word."

2

Douglas Gordon

1966 born in Glasgow, United Kingdom, lives and works in New York (NY), USA

In 2007 Douglas Gordon produced the performative-photographic work *Psycho Hitchhiker (Coming or Going)* for a retrospective in Wolfsburg; it is a self-ironic reference to his famous work *24 Hour Psycho* (1993). Gordon stood next to a street in Wolfsburg holding up a sign with the word "Psycho" written on it. This gesture reveals an ambiguity that is symptomatic of his work across the media of film, text, photography and installation. In addition to temporality, his works always deal with duality: light/dark, good/bad, reality/image. The exhibition *Douglas Gordon's The Vanity of Allegory* (2005) exemplified the relationship between self-presentation and mortality by examining the veiled self-portrait as a topos in art history, a literary device and a filmic strategy. Gordon explores the theme of reflection and copy in a variety of ways in his works: in *Plato's Cave* (2006) he confronted viewers in Edinburgh with their own shadow in a deconstruction of Plato's cave allegory. In the series *Self-Portrait of You and Me*, he availed himself of pop iconography and mounted partially destroyed photographs of Bond girls on mirrors (2006). In the second part of this series, the stars were presented in the already iconic form of Warholian silkscreen prints (2007). The viewers then see themselves in the holes of these star portraits, so that their image blends with that of the star, taking the place of the object of desire and projections. Through his collaboration with the band Chicks on Speed (*Art Rules*, 2006–), which takes the form of a record and various stage performances, Gordon himself has become a pop star, as it were, and has thus gone behind the mirror.

Für seine Retrospektive in Wolfsburg schuf Douglas Gordon die performativ-fotografische Arbeit *Psycho Hitchhiker (Coming or Going)* (2007), mit der er sich selbstironisch auf seine berühmte Arbeit *24 Hour Psycho* (1993) bezieht. Gordon stellte sich an eine Straße in Wolfsburg und hielt ein Schild mit der Aufschrift „Psycho" empor. In dieser Geste offenbart sich eine Ambiguität, die symptomatisch für Gordons Arbeit in den Medien Film, Text, Fotografie und Installation ist. In ihnen geht es, neben Zeitlichkeit, immer auch um Dualität: Hell/Dunkel, Gut/Böse, Realität/Abbild. Das Verhältnis von Selbstpräsentation und Sterblichkeit exemplifizierte Gordon in der Ausstellung *Douglas Gordon's The Vanity of Allegory* (2005) anhand einer Untersuchung des verschleierten Selbstporträts als kunsthistorischem Topos, literarischem Kunstgriff und filmischer Strategie. Spiegelung und Abbild sind Themen, die Gordon in seinen Arbeiten auf unterschiedliche Weise untersucht: In *Plato's Cave* (2006) in Edinburgh konfrontierte er den Betrachter in einer Dekonstruktion von Platons Höhlengleichnis mit seinem eigenen Schatten. In der Serie *Self-Portrait of You and Me* greift Gordon auf Popikonografie zurück und montiert teilweise zerstörte Fotografien von Bond Girls auf Spiegel (2006). In einem zweiten Teil der Serie erscheinen die Stars in der bereits schon ikonischen Form von Warholschen Siebdrucken (2007). In den Löchern der Starporträts erblickt der Betrachter dann sich selbst, sein Abbild vermischt sich so mit demjenigen des Stars, schiebt sich an den Platz des Objekts der Bewunderung und Projektionen. In der Zusammenarbeit mit Chicks on Speed (*Art Rules*, 2006–), die sich in einer Schallplatte und verschiedenen Bühnenauftritten äußert, ist Gordon gleichsam selbst zum Popstar geworden und begibt sich damit hinter den Spiegel.

Pour sa rétrospective à Wolfsburg, Douglas Gordon devait créer son œuvre performative-photographique *Psycho Hitchhiker (Coming or Going)* (2007), avec laquelle il se référait à sa célèbre œuvre *24 Hour Psycho* (1993) – non sans porter sur lui-même un regard ironique. Gordon se plaça au bord d'une rue de Wolfsburg en brandissant un écriteau marqué « Psycho ». Cette posture révèle une ambiguïté symptomatique du travail que Gordon réalise dans les médiums du cinéma, du texte, de la photographie et de l'installation. À côté de la qualité temporelle, ceux-ci traitent toujours et notamment de dualité : clair/obscur, bien/mal, réalité/représentation. Dans son exposition *Douglas Gordon's The Vanity of Allegory* (2005), Gordon a illustré le rapport entre représentation de soi et mortalité à l'appui d'une étude de l'autoportrait voilé, lieu commun de l'histoire de l'art, tour de main littéraire et stratégie cinématographique. Le reflet et l'image sont des thèmes que ses œuvres abordent de manière très diverse : dans *Plato's Cave* (2006) qu'on a pu voir à Édimbourg, Gordon confrontait le spectateur à sa propre ombre par le truchement d'une déconstruction du mythe de la caverne de Platon. Dans la série *Self-Portrait of You and Me*, il revient à l'iconographie pop en montant sur des miroirs des photographies partiellement détruites de James Bond Girls. Dans une seconde partie de la série, les stars apparaissent sous la forme déjà iconique des sérigraphies de Warhol (2007). Dans les épargnes des portraits de stars, le spectateur se voit ensuite lui-même ; son image se mêle ainsi à celle de la star et prend la place de l'objet d'admiration et de projection. Par le biais de sa collaboration avec Chicks on Speed (*Art Rules*, 2006–), qui a débouché sur un disque et différentes apparitions sur scène, Gordon est en quelque sorte devenu lui-même une pop star et passe ainsi de l'autre côté du miroir.

E. S.

SELECTED EXHIBITIONS →
2008 *Douglas Gordon*, Collection Lambert, Avignon **2007** *Douglas Gordon*, SFMOMA, San Francisco. *Douglas Gordon: Between Darkness and Light*, Kunstmuseum Wolfsburg **2006** *Douglas Gordon: Superhumanatural*, National Gallery of Scotland, Edinburgh. *Douglas Gordon: Timeline*, MoMa, New York **2005** *Douglas Gordon's The Vanity of Allegory*, Deutsche Guggenheim, Berlin

SELECTED PUBLICATIONS →
2007 *Douglas Gordon: Self-Portrait of You and Me, after the Factory*, Gagosian Gallery, New York. *Douglas Gordon: Between Darkness and Light*, Kunstmuseum Wolfsburg, Wolfsburg; Hatje Cantz, Ostfildern. *Douglas Gordon: Superhumanatural*, National Galleries of Scotland, Edinburgh **2006** Douglas Gordon, Philippe Parreno: *Zinédine Zidane*, DVD, 90 min., Walther Koenig Books Ltd., London. *Douglas Gordon: Timeline*, MoMA, New York **2005** *Douglas Gordon's The Vanity of Allegory*, Deutsche Guggenheim, Berlin

1 **Bloom**, 2006, C-print, dimensions variable
2 **Plato's Cave**, 2006, room, fire, dimensions variable

3 **Psycho Hitchhiker (Coming or Going)**, 2007, lambda-print, 46 x 59,6 cm
4 **Self-Portrait of You and Me (Elvis)**, 2007, smoke, mirror, 139.1 x 99.1 x 7.6 cm

„Wir brauchen Stars, um uns selbst in ihnen zu spiegeln."

« Nous avons besoin de stars pour pouvoir nous refléter en elles. »

"We need stars so as to mirror ourselves in them."

3

Mark Grotjahn

1968 born in Pasadena (CA), lives and works in Los Angeles (CA), USA

In January 2007, Mark Grotjahn surprised the New York art scene with an exhibition of eleven dark-blue canvases that only unfold their composition when carefully contemplated. Part of the artist's ongoing series of "butterfly paintings" since 2001, these monochromatic abstractions are geometric compositions of thick strips of colour expanding centrifugally – although slightly out of symmetry – from two vanishing points. This structure recurs in both monochromatic and joyfully colourful paintings, in which the artist applies the paint in dense layers, allowing for an illusion of depth. The series *Blue Painting Light to Dark* (2006) consists of dark blue canvases in which various tonalities of blue radiate on the canvas creating a kaleidoscopic composition which references modernist abstraction and colourfield painting as well as Beat Generation aesthetics. At times, at the centre of the canvas, one can barely perceive a refraction of a very different colour, which actually belongs to a preliminary primer featuring cartoonish faces or expressionistic explosions of colour that Grotjahn conceals underneath the final coats of paint. Almost completely invisible in the final work, these traces of the hidden life of the painting do seem to agitate the pictorial surface, suggesting the ominous presence of a secret world. Although he is best known for his abstract paintings, Grotjahn has also been exhibiting figurative works, such as the recent *Untitled (Angry Flower Guga the Architect 727)* (2008), in which the artist finally reveals the grotesque caricature style that he has often hidden behind his more sombre pictures.

Im Januar 2007 überraschte Mark Grotjahn die New Yorker Kunstszene mit einer Ausstellung von elf dunkelblauen Leinwänden, die ihre Komposition erst nach gründlicher Betrachtung enthüllten. Als Teil einer seit 2001 fortlaufenden Serie von „Butterfly Paintings" sind diese monochromen Abstraktionen geometrische Kompositionen von dicken Farbstreifen, die sich – wenn auch leicht asymmetrisch – von zwei Fluchtpunkten aus zentrifugal ausdehnen. Diese Struktur wiederholt sich sowohl in monochromen als auch in farbenfröhlichen Bildern, bei denen der Künstler die Farbe in dichten Schichten aufträgt, um eine Illusion von Tiefe zu erzeugen. Die Serie *Blue Painting Light to Dark* (2006) besteht aus dunkelblauen Leinwänden, auf denen verschiedene Blautöne Strahlen aussenden und eine kaleidoskopartige Form entstehen lassen, die an modernistische Abstraktion und Farbfeldmalerei ebenso erinnert wie an die Ästhetik der Beat Generation. Manchmal kann man im Mittelpunkt der Leinwand ganz schwach die Lichtbrechung einer anderen Farbe erkennen, die tatsächlich zur vorigen Grundierung gehört, bei der Grotjahn cartoonartige Gesichter oder expressionistische Farbexplosionen malt, bevor er sie unter den endgültigen Farbschichten verbirgt. Beinahe völlig unsichtbar im fertigen Werk, scheinen diese Spuren eines verborgenen Lebens unter dem Bild die gemalte Oberfläche aufzurühren, die ahnungsvolle Existenz einer geheimen Welt andeutend. Obwohl seine abstrakten Gemälde am bekanntesten sind, hat Grotjahn auch figurative Arbeiten ausgestellt, wie jüngst *Untitled (Angry Flower Guga the Architect 727)* (2008), mit dem der Künstler endlich den grotesken karikaturhaften Stil offenbart, den er oft unter seinen düstereren Bildern verbirgt.

En janvier 2007, Mark Grotjahn surprit le monde de l'art new-yorkais avec une exposition de onze toiles bleu foncé dont la composition ne se révélait qu'après un examen attentif. Ces abstractions monochromes, qui font partie de sa série des «butterfly paintings» en cours depuis 2001, sont des compositions géométriques où de larges bandes de couleur s'élargissent à partir de deux points de fuite, de façon centrifuge mais pas tout à fait symétrique. Cette même structure réapparaît dans des toiles, certaines monochromes, d'autres joyeusement multicolores, dans lesquelles l'artiste applique la peinture en couches denses, créant ainsi une illusion de profondeur. La série *Blue Painting Light to Dark* (2006) se compose d'œuvres bleu foncé où différentes teintes de bleu rayonnent sur la toile, rappelant les compositions kaléidoscopiques de l'abstraction moderniste et du colourfield painting, ainsi que l'esthétique de la *beat generation*. Parfois, au centre de la toile, on peut voir, à peine, la réfraction d'une toute autre couleur : celle-ci appartient à une couche de préparation où figurent des visages caricaturaux ou bien des explosions expressionnistes de couleur que Grotjahn dissimule ensuite sous les dernières couches de peinture. Bien qu'elles soient presque invisibles une fois la toile terminée, ces traces d'une vie cachée de l'œuvre semblent en agiter la surface picturale, suggérant la présence inquiétante d'un univers secret. Même si Grotjahn est surtout connu pour ses peintures abstraites, il a aussi exposé des travaux figuratifs, comme le récent *Untitled (Angry Flower Guga the Architect 727)* (2008), dans lequel il divulgue enfin le style grotesque et caricatural qu'il a si souvent caché dans ses peintures plus sombres.

C. A.

SELECTED EXHIBITIONS →
2008 *Oranges and Sardines: Conversations on Abstract Painting with Mark Grotjahn, Wade Guyton, Mary Heilmann, Amy Sillman, Charline von Heyl, and Christopher Wool*, Hammer Museum, Los Angeles **2007** *Mark Grotjahn*, Kunstmuseum Thun. *Like Color in Pictures*, Aspen Art Museum, Aspen **2006** *Mark Grotjahn*, Whitney Museum of American Art, New York. *Painting in Tongues*, MOCA, Los Angeles **2005** *Mark Grotjahn: Drawings*, Hammer Museum, Los Angeles

SELECTED PUBLICATIONS →
2008 Dominique Gonzalez-Foerster, *Mark Grotjahn, Allora & Calzadilla*, Parkett 80, Zürich **2007** *Mark Grotjahn*, Kunstmuseum Thun, Thun. *Like Color in Pictures*, Aspen Art Press, Aspen **2006** *Whitney Biennial: Day For Night*, Whitney Museum of American Art, New York **2005** *Mark Grotjahn: Drawings*, Blum & Poe, Los Angeles; Anton Kern, New York

1 **Untitled (Angry Flower Guga the Architect 727)**, 2008, oil, enamel paint on linen, 152.4 x 121.9 cm
2 **Untitled (Angry Flower Female Big Nose Baby Moose #3)**, 2006, sock, oil on cardboard, mounted on canvas, 183 x 137 x 15.2 cm

3 **Untitled (Creamsicle 681)**, 2007, colour pencil on paper, 163.8 x 121.3 cm
4 **Untitled (Blue Butterfly Dark to Light IV #654)**, 2006, oil on linen, 182.9 x 137.2 cm

„Ich habe eine Vorstellung davon, was für eine Art von Gesicht es werden wird, wenn ich ein ‚Face Painting' male, aber ich weiß nicht genau, was für eine Farbe oder wie viele Augen es haben wird, wohingegen die ‚Butterflies' recht streng geplant sind."

« Lorsque je fais un "face painting", j'ai une idée du type de visage qui va émerger, mais je ne sais pas exactement quelle couleur il aura, ni combien d'yeux, alors qu'avec les "butterfly paintings" tout est plus ou moins planifié d'avance. »

"I have an idea as to what sort of face is going to happen when I do a 'face painting', but I don't exactly know what color it will take, or how many eyes it's going to have, whereas the 'butterflies' are fairly planned out."

2

3

Subodh Gupta

1964 born in Khagaul, lives and works in New Delhi, India

Subodh Gupta subjects his artworks – mainly installations, sculptures or paintings – to a strategic process of multiple encoding. While his source materials are emblematic objects of everyday life in India, they may be interpreted differently in other geographical contexts and are also given new meaning when filtered through the system of Western aesthetics. *Spill* (2007), for example, has lots of small stainless steel pots and bowls spilling out of a large, shiny bucket. It is in fact a larger-than-life milk pail and the other objects are cooking or eating utensils; as such they form part of India's gastronomic culture with its sacred and ritual connotations, but they could also be regarded as representative of Indian culture as a whole. In the form of an artwork they become a sculpture with strong references to pop art and the readymade. For Gupta, however, it is not about the gesture of elevating utilitarian objects to the level of artworks, but about the multiple meanings such objects have. In the installation *Silk Road* (2007), for instance, countless pots and pans have been piled up into shiny silvery towers, which together evoke a futuristic urban landscape, while in Gupta's recent paintings, entitled *Still Steal Steel* (2007–) or left untitled, utensils are depicted in a virtuoso, hyperrealist style of painting reminiscent of American photorealism. By combining themes from his Indian homeland with stylistic references to recent US art history and by harnessing the tension that arises when country and city, tradition and change, specifically local and standardized global interests collide, Gupta's work convincingly reflects the complex nature of contemporary Indian society.

Subodh Gupta unterwirft seine Arbeiten – meist Installationen, Skulpturen oder Gemälde – einer Strategie der Mehrfachcodierung: Sein Ausgangsmaterial sind emblematische Objekte aus der Alltagswelt Indiens, die allerdings in wechselnden geografischen Kontexten jeweils andere Lesarten erfahren können, und die zudem durch das System der westlichen Ästhetik gefiltert und umgedeutet werden. *Spill* (2007) etwa besteht aus einem glänzenden Eimer, aus dem kleinere Edelstahlgefäße und -schalen quellen. Es handelt sich um einen Milcheimer und Essge-schirr; beides entstammt der indischen Esskultur mit ihren sakralen und rituellen Konnotationen, könnte aber andernorts stereotypisch für die indische Kultur einstehen, und wird in Form eines Kunstwerks zu einer Skulptur, die starke Bezüge zur Pop Art oder auch zum Readymade aufweist. Doch geht es bei Gupta nicht um die Geste, mit der Gebrauchsgegenstände in den Rang eines Kunstwerks erhoben werden, sondern um deren vielfältige Bedeutungen. So finden sich in der Installation *Silk Road* (2007) unzählige Töpfe und Schalen zu silbrig glänzenden Türmen aufgestapelt, die in ihrer Gesamtheit eine futuristische Stadtlandschaft evozieren. Auf Guptas neueren, unbetitelten oder *Still Steal Steel* genannten Gemälden (2007–) wird Geschirr zum Vorwand für eine virtuose hyperrealistische Malerei, die an die amerikanischen Fotorealisten denken lässt. Indem Gupta Motive aus seiner indischen Heimat mit vorwiegend stilistischen Referenzen an die neuere US-amerikanische Kunst-geschichte verquickt, gelingt es ihm in seinen Arbeiten, im Aufeinandertreffen von Land und Stadt, Tradition und Umbruch, Lokal-Spezifischem und Global-Standardisiertem die Komplexität der zeitgenössischen indischen Gesellschaft zu reflektieren.

Subodh Gupta soumet ses œuvres – le plus souvent des installations, des sculptures ou des peintures – à une stratégie du codage multiple : son matériau de base est constitué d'objets emblématiques de la vie quotidienne indienne qui peuvent néanmoins subir des lectures diverses en fonction des contextes géographiques et qui sont de surcroît filtrés et réinterprétés par le système esthétique occidental. *Spill* (2007) consiste en un seau rutilant d'où débordent toutes sortes de récipients en inox de moindre taille. Il s'agit d'un seau à lait et d'éléments de vaisselle qui font partie de la culture de table indienne avec ses connotations sacrées et rituelles. Dans d'autres zones, ces objets peuvent toutefois apparaître comme les représentants stéréotypés de la culture indienne ; en tant qu'œuvre d'art, ils deviennent une sculpture avec de fortes références au Pop Art ou au ready-made. Cela dit, le propos de Gupta n'est pas d'incarner une position artistique par laquelle des objets utilitaires sont élevés au rang d'œuvre d'art, mais de mettre en évidence leur polysémie. Dans l'installation *Silk Road* (2007) sont empilés d'in-nombrables pots et coupes qui forment des tours brillantes et argentées dont l'ensemble évoque un paysage urbain futuriste. Dans les œuvres récentes laissées sans titre ou intitulées *Still Steal Steel* (2007–), la vaisselle devient le prétexte d'une peinture hyperréaliste virtuose qui rap-pelle le photoréalisme américain. En associant des motifs de sa patrie indienne et des aspects stylistiques se référant essentiellement à l'histoire de l'art américain récent, Gupta parvient à traduire la complexité de la société indienne d'aujourd'hui, avec le télescopage de la ville et de la campagne, de la tradition et du changement, de la spécificité régionale et d'une standardisation globalisée. A. M.

SELECTED EXHIBITIONS →
2008 *Chalo! India: A New Era of Indian*, Art Mori Art Museum, Tokyo. *God & Goods. Spirituality and Mass Confusion*, Villa Manin, Codroipo. *Freedom – Sixty Years after Indian Independence*, CIMA, Calcutta **2007** *Subodh Gupta: Silk Route*, BALTIC Centre for Contemporary Art, Gateshead. *Hungry God: Indian Contemporary Art*, Busan Museum of Modern Art, Busan; Art Gallery of Ontario, Toronto. *Edge of Desire*, National Gallery of Modern Art, Bombay **2006** *Dirty Yoga*, Taipei Biennial 2006, Taipei

SELECTED PUBLICATIONS →
2008 *God & Goods. Spirituality and Mass Confusion*, Villa Manin, Codroipo **2007** *Hungry God: Indian Contemporary Art*, Busan Museum of Modern Art, Busan **2005** *Edge of Desire: Recent Art in India*, Philip Wilson Publishers, London

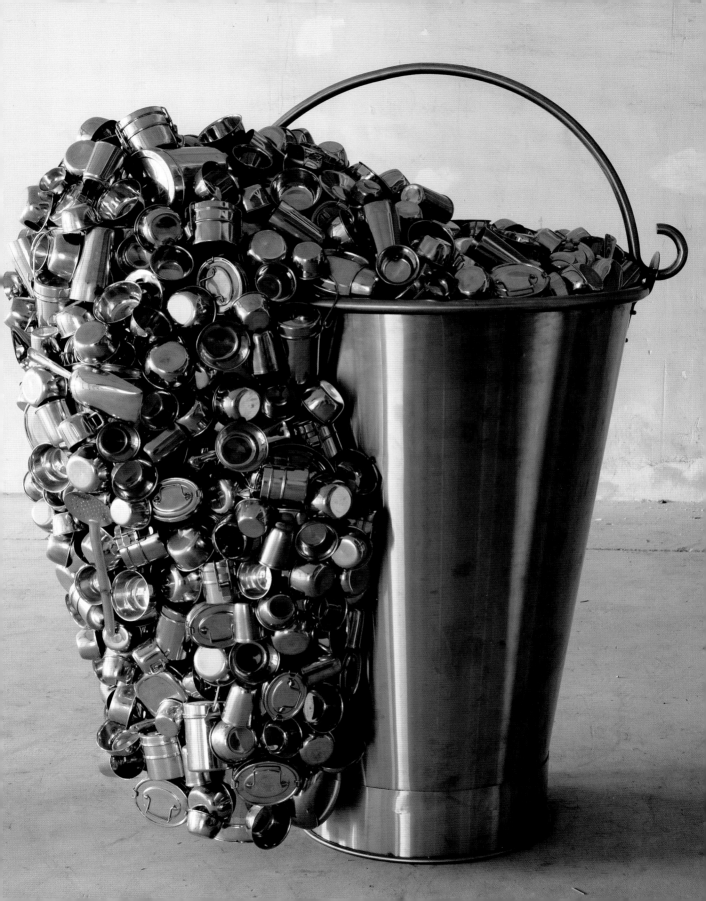

1 **Spill**, 2007, stainless steel, stainless steel utensils, 170 x 145 x 95 cm
2 **Curry**, 2005, stainless steel, stainless steel utensils, 5 cabinets, 360 x 279 cm (each). Installation view, Nerman Museum of Contemporary Art, Kansas, 2008

3 **Gandhi's Three Monkeys**, 2007/08, antique utensils, bronze, steel, 1st head 184 x 140 x 256 cm, 2nd head 200 x 131 x 155 cm, 3rd head 175 x 125 x 150 cm. Installation view, Jack Shainman Gallery, New York, 2008

„Ich stehle Idole. Ich stehle aus dem Drama im Leben der Hindus. Und aus der Küche – diese Töpfe sind wie gestohlene Götter, die aus dem Land geschmuggelt wurden."

« Je suis le voleur d'idoles. Je me sers dans le drame de la vie hindoue. Et dans la cuisine – ces bols sont comme des dieux volés, sortis du pays en contrebande. »

"I am the idol thief. I steal from the drama of Hindu life. And from the kitchen – these pots, they are like stolen gods, smuggled out of the country."

2

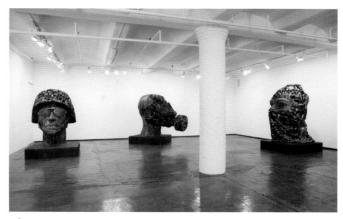

3

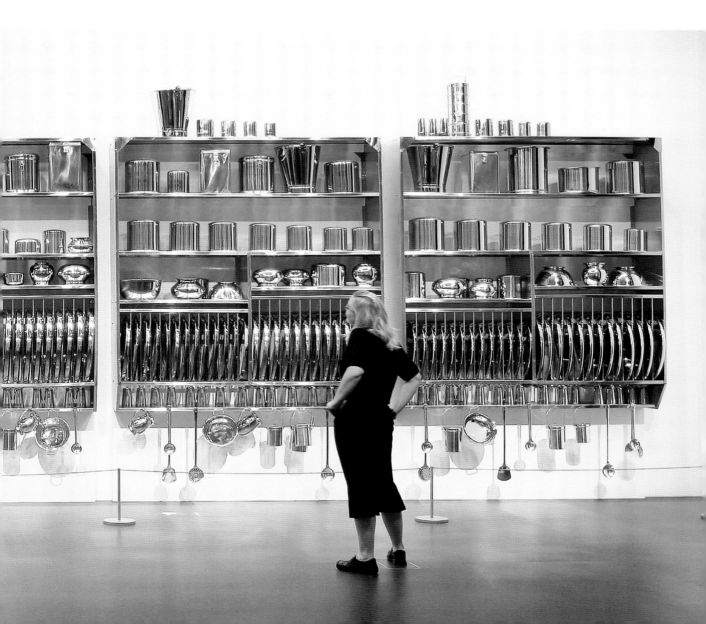

Andreas Gursky

1955 born in Leipzig, lives and works in Düsseldorf, Germany

Andreas Gursky is known for his large-scale panoramic overviews of mass events, architecture, landscapes as well as commercial and leisure sites, capturing the human conditions in modern life. He extends the documentary approach of his teachers Bernd and Hilla Becher by making slight digital changes to the photographs, thus reinforcing their perceptual illogic, produced by the oscillation between the almost ornamental structure of the whole and a surfeit of detail. No wonder he has encountered ideal subjects in the North Korean Mass Games, where colourful pictures are performed by thousands of people (*Pyongyang*, 2007) and on the *Kuwait Stock Exchange* (2007), where hundreds of brokers move across the floor in white garments. By contrast, there is no human presence in *Kamiokande* (2007), Gursky's photograph of a subterranean detector of neutrinos, elementary particles of matter that have almost no mass and zip around at a speed nearly as fast as light: two tiny boats floating on a dark pool of water are dwarfed by the curved, shimmering interior of the cylindrical detector, which is lined with parallel rows of huge gold spheres creating an image like Böcklin's *Toteninsel* boats in a huge disco. Sometimes Gursky's perspective engenders an indeterminacy that veers sharply from the real toward abstraction, like in *Bahrain I* (2007) where a racetrack meanders through the desert like a serpent. The stands and a settlement in the background appear in sharply focused realism but the tarmac is folded and knotted in ribbons until it appears like an M.C. Escher perspective absurdity viewed through a funhouse mirror.

Andreas Gursky ist bekannt für großformatige Panoramabilder von Massenevents, Architektur, Landschaften sowie Szenen aus Beruf und Freizeit, in denen er die modernen Lebensbedingungen erfasst. Er erweitert den dokumentarischen Ansatz seiner Lehrer Bernd und Hilla Becher, indem er die Fotografien leichten digitalen Veränderungen unterzieht. Dadurch verstärkt er die Verunsicherung der Wahrnehmung, die durch das Oszillieren der Motive zwischen dem nahezu ornamentalen Gesamtaufbau und einer Überfülle an Details ausgelöst wird. Kein Wunder, dass er in den nordkoreanischen Massenaufführungen, die Abertausende von Menschen zu farbenprächtigen Bildern vereinen (*Pyongyang*, 2007), und mit dem *Kuwait Stock Exchange* (2007), in dem sich hunderte von Brokern in weißen Gewändern über den Floor bewegen, ideale Sujets gefunden hat. Dem stellt Gursky das fast menschenleere *Kamiokande* (2007) gegenüber, seine Fotografie eines unterirdischen Detektors für Neutrinos, nahezu masselose, quasi mit Lichtgeschwindigkeit herumwirbelnde Elementarteilchen: Zwei kleine Boote treiben auf der dunklen Wasserfläche und erscheinen noch winziger unter den gekrümmten Innenwänden des zylindrischen Detektors, dessen parallel zueinander angeordnete goldene Lichtkugeln die Szenerie wie Böcklins *Toteninsel* in einer riesigen Disko wirken lassen. Gurskys verunsichernde Perspektive kann ein Umschwenken vom Realen zur Abstraktion bewirken, so in *Bahrain I* (2007), wo sich eine Rennstrecke durch die Sandwüste schlängelt. Die Tribüne und eine Siedlung in der Ferne erscheinen in gestochen scharfem Realismus, während die schwarze Strecke selbst sich faltet und Schleifen wirft, bis sie aussieht wie eine von einem Zerrspiegel zurückgeworfene absurde Perspektiv-Konstruktion von M.C. Escher.

Andreas Gursky est célèbre pour ses immenses vues panoramiques d'évènements de masse, de bâtiments, paysages, sites commerciaux ou de loisirs, dans lesquelles il saisit la condition humaine à l'ère moderne. Il prolonge l'approche documentaire de ses maîtres Bernd et Hilla Becher en apportant de légères modifications numériques à ses images, dont il renforce ainsi l'illogisme de la perception produit par l'aller-retour entre la structure quasi ornementale de l'ensemble et la profusion de détails. On ne s'étonnera pas qu'il ait trouvé un sujet idéal dans les rassemblements de masse en Corée du Nord, lors desquels des milliers d'individus dessinent une image colorée (*Pyongyang* 2007) ou avec les courtiers en bourse habillé de blanc dans *Kuwait Stock Exchange* (2007). À l'inverse, on ne décèle nulle présence humaine dans *Kamiokande* (2007), photographie d'un observatoire souterrain de neutrinos – ces particules élémentaires, de masse infinitésimale, qui se déplacent presque à la vitesse de la lumière. Deux petits bateaux, flottant sur un bassin d'eau sombre, paraissent minuscules à côté de l'intérieur incurvé et étincelant du détecteur cylindrique que bordent des rangées parallèles d'énormes sphères dorées : c'est un peu comme si les navires de *l'Île des Morts* de Böcklin se retrouvaient dans une immense discothèque. La perspective indéterminée de Gursky le mène parfois du réel à l'abstraction, comme dans *Bahrain I* (2007), où les méandres d'un circuit automobile serpentent dans le désert. La tribune et la cité à l'arrière-plan apparaissent avec un réalisme acéré alors que le circuit se déploie tel un ruban jusqu'à ressembler à une perspective absurde de M.C. Escher vue à travers un miroir déformant.

C. Es.

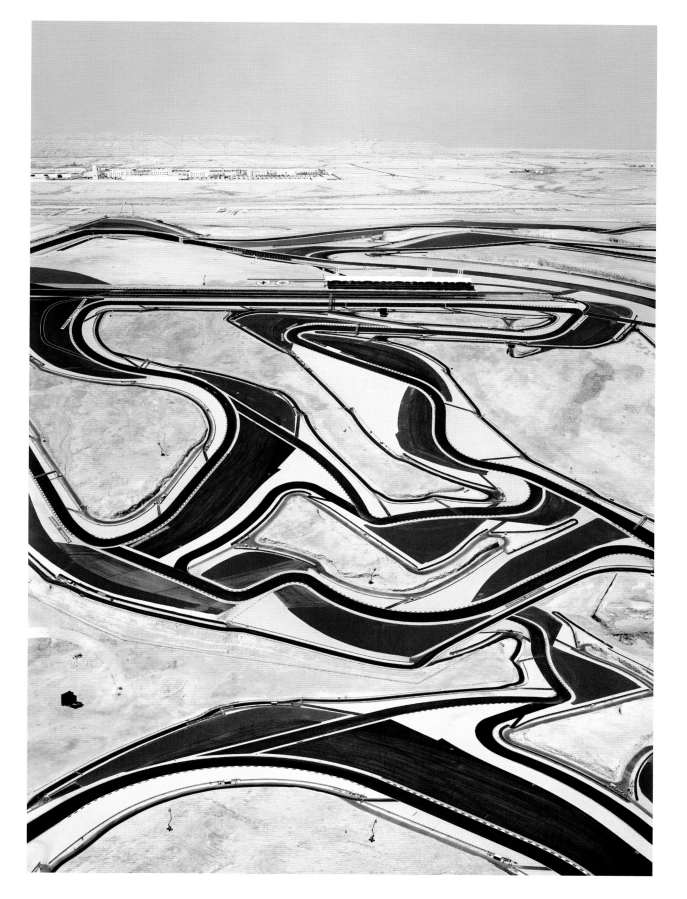

1 **Bahrain I**, 2005, C-print, 302.2 x 219.6 x 6.2 cm
2 **Kamiokande**, 2007, C-print, 228.2 x 367.2 x 6.2 cm

3 **Kuwait Stock Exchange**, 2007, C-print, 295.1 x 222 x 6.2 cm

„Im Prinzip bin ich sehr nahe am Geschehen und bin doch mit den Bildern nicht mehr in der realen Welt."

« En principe, je suis tout près de l'évènement tout en n'étant plus dans le monde réel avec mes images. »

"In principle, I'm very close to the event and at the same time my pictures are no longer in the real world."

2

3

Wade Guyton

1972 born in Hammond (IN), lives and works in New York (NY), USA

Although many of Wade Guyton's works appear — at more than first glance, even — to be humble castaways from modernism's heyday, closer inspection reveals the extent to which they are resolutely indebted to the present. His recent series of what he calls "ostensibly black monochromes" (since 2007) are no exception. Indeed, for the past few years, Guyton has turned away from sculpture and adopted painting, producing works on pre-primed linen intended for use with oil paints, which he makes with the help of a computer and an Epson UltraChrome large-format inkjet printer. The artist conjures a motif, here a Photoshop-drawn black rectangle, and prints it on the linen that has been folded to fit into the machine, resulting in paintings with a central vertical seam abutted by two ebony slabs. Despite the uniformity of Guyton's process, the results vary owing to such exigencies as too much or too little ink or the printer running askew. Thus, while their delicate tracery (lines drawn by the cartridge) invoke Agnes Martin and their zips cannot but summon Barnett Newman, these untitled paintings nonetheless also admit Guyton's status as an appropriationist who plays on the fact that abstraction always already exists in and as reproduction. As with his earlier printer drawings — made through a similar process, though then he printed Xs, diagonals and horizontal passages on small pages torn from architecture books and art monographs and catalogues — Guyton's paintings simultaneously void and flag their referents to question modernist shibboleths of originality and heroic authorship, as well as the image culture in which aesthetic products circulate.

Wenn auf den ersten Blick viele Arbeiten von Wade Guyton — selbst aus der Nähe — wie Überbleibsel aus den heroischen Zeiten des Modernismus erscheinen, bringt eine eingehendere Untersuchung schnell zu Tage, wie konsequent sie in der Gegenwart verhaftet sind. Seine aktuelle Serie „scheinbar schwarzer Monochrome" (seit 2007), wie der Künstler sie nennt, bildet da keine Ausnahme. Tatsächlich hat Guyton in den letzten Jahren eine Wende von der Skulptur zum Malerischen hin vollzogen, um auf vorgrundierten Leinwänden für Ölgemälde mittels Computer und dem Großformat-Tintenstrahldrucker UltraChrome von Epson Bilder zu erzeugen. Der Künstler entwirft ein Motiv, in diesem Fall ein mit Photoshop erzeugtes schwarzes Rechteck, und druckt es auf die zuvor auf Maschinengröße geknickte Leinwand, was dann Bilder mit einer von zwei tiefschwarzen Flächen begrenzten vertikalen Mittelnaht ergibt. Obwohl Guyton immer nach dem gleichen Prinzip vorgeht, unterscheiden sich die Produkte, je nachdem, ob zu viel oder zu wenig Tinte in der Patrone ist oder sonst etwas schief läuft. Während man bei dem (druckbedingten) filigranen Raster Agnes Martin assoziiert, und bei den vertikalen Streifen unweigerlich Barnett Newmans „Zips", beweisen diese unbetitelten Gemälde doch eher Guytons Status als Aneignungskünstler, der sich die Tatsache zunutze macht, dass durch Reproduzieren die Reproduktion an sich schon immer als Abstraktion existiert. Wie in seinen früheren Druckzeichnungen — die auf einem ähnlichen Verfahren basierten, nur dass er Xe sowie diagonale und horizontale Flächen auf kleine Ausrisse aus Architekturbänden, Kunstmonografien und Katalogen druckte — stellt Guyton mit seinen Bildern die modernistische Bedeutsamkeit von Echtheit und heroischer Autorschaft gleichzeitig ins Zentrum und in Frage, gemeinsam mit der Bildkultur, in der ästhetische Produkte heute zirkulieren.

Même si nombre des œuvres de Wade Guyton semblent n'être — même au-delà du premier coup d'œil — que d'humbles naufragées de l'âge d'or du modernisme, un examen plus approfondi révèle à quel point elles sont tributaires du présent. Sa récente série qu'il nomme « monochromes ostensiblement noirs » (depuis 2007) ne fait pas exception. Ces dernières années, Wade Guyton a abandonné la sculpture pour se tourner vers la peinture, produisant, sur toile de lin préparée pour la peinture à l'huile, des œuvres qu'il réalise à l'aide d'un ordinateur et d'une imprimante à jet d'encre grand format Epson UltraChrome. L'artiste fait apparaître un motif, ici un rectangle noir dessiné à l'aide de Photoshop, et l'imprime sur la toile qui a été pliée pour entrer dans l'imprimante, générant des peintures avec une couture centrale verticale séparant deux panneaux de couleur ébène. Malgré l'uniformité du procédé de Guyton, les résultats varient en fonction du niveau d'encre ou du bon fonctionnement de l'imprimante. Ainsi, alors que le réseau délicat des lignes dessinées par la cartouche évoque Agnès Martin et que leurs « zips » rappellent Barnett Newman, ces peintures sans titres n'en donnent pas moins à Guyton le statut d'appropriationniste. Il joue avec le fait que l'abstraction existe dans la reproduction, et en tant que reproduction. À la manière de ses précédents dessins à l'imprimante — réalisés selon un même procédé, bien qu'à l'époque, il imprimait des X, des diagonales et des horizontales sur des pages arrachées à des livres d'art et d'architecture — les peintures de Guyton annulent et signalent leurs référents pour questionner les principes d'originalité et de paternité héroïque du modernisme, ainsi que la culture de l'image dans laquelle la production esthétique existe.

S. H.

SELECTED EXHIBITIONS →
2008 *Wade Guyton*, Portikus, Frankfurt am Main. *Oranges and Sardines: Conversations on Abstract Painting with Mark Grotjahn, Wade Guyton, Mary Heilmann, Amy Sillman, Charline von Heyl and Christopher Wool*, Hammer Museum, Los Angeles **2007** *9. Biennale de Lyon 2007*, Lyon. *Imagination Becomes Reality*, ZKM, Karlsruhe **2006** *Wade Guyton, Seth Price, Joshua Smith, Kelley Walker*, Kunsthalle Zürich **2005** *Wade Guyton: Color, Power & Style*, Kunstverein Hamburg

SELECTED PUBLICATIONS →
2008 *Robert Frank, Wade Guyton, Christopher Wool*, Parkett 83, Zürich **2007** *Guyton, Price, Smith, Walker*, Kunsthalle Zürich; JRP Ringier, Zürich. *Wade Guyton: Color, Power & Style*, Kunstverein Hamburg, Hamburg; Verlag der Buchhandlung Walther König, Cologne. *Lyon Biennial*, Les Biennales de Lyon, Lyon; JRP Ringier, Zürich **2005** *Wade Guyton & Kelley Walker: The Failever Of Judgement*, Midway Museum of Contemporary Art, Minneapolis; JRP Ringier, Zürich

1 **Untitled**, 2008, inkjet on linen, 213.4 x 175.3 cm
2 **Untitled (19)**, 2008, inkjet on book page, 21.6 x 21.6 cm
3 **U Sculpture (v. 7)**, 2007, mirrored stainless steel, 135.9 x 61 x 58.4 cm
4 **Untitled (15)**, 2008, inkjet on book page, 21.6 x 21.6 cm
5 **Untitled**, 2008, inkjet on canvas, 213.4 x 175.3 cm

„Jeder kann ein interessantes Bild auswählen, weil Bilder anscheinend schon mit Bedeutung aufgeladen sind. Es ist vielleicht schwieriger, etwas zu finden, das mehr Potenzial hat und noch nicht so vorbelastet ist."

« N'importe qui peut choisir une image intéressante parce que les images semblent déjà déborder de signification. Il est peut-être plus difficile, alors, de trouver quelque chose qui a plus de potentiel et n'est pas chargé d'un tel fardeau. »

"Well, anyone can choose an interesting image because images already seem to be loaded full of meaning. So maybe it's more difficult to try to find something that has more potential and isn't burdened with so much baggage."

3

2

4

Daniel Guzmán

1964 born in Mexico City, lives and works in Mexico City, Mexico

"I am a rock and roll artist at heart," says Daniel Guzmán. Indeed the artist's works pay overt homage to rock bands like Deep Purple and Kiss, incorporating song lyrics, album covers and adolescent idolatry into sculptures, drawings and installations. But his artworks are also about much more. His series of black-and-white drawings *La búsqueda del ombligo* (The Search of the Navel, 2005–07), for instance, comprises diptychs mounted on wood that bring together Mexican iconography from past and present. The series directly references ancient Aztec symbols, pyramids and masks, as well as a 1945 series of drawings by the Mexican muralist José Clemente Orozco. In his own drawings, created in the textured, gestural style of a teenager compulsively sketching into the margins of his notebook, Guzmán has created his own delirious, hybrid cosmos of heroes and anti-heroes. Other works by Guzmán draw their inspiration from sources as diverse as political cartoons, Mexican comic books and William S. Burroughs' *Naked Lunch*, still they all echo their chosen icons with fanatical devotion. Recent sculptures like *Brutal Youth* and *The Principle Pleasure* (both 2008) incorporate personal items such as clothing and record albums with found furniture and detached doors engraved with texts and it is as if we were peering into the empty bedroom refuge of a moody, disillusioned teenager. While Guzmán's works may cloak an underlying violence in their severed heads or distorted, tortured figures, it is a violence touched by pop, filtered through the iconography of origin myths of cartoon supermen, guitar heroes and pre-Columbian gods.

„Im Herzen bin ich ein Rock'n'Roll-Künstler", sagt Daniel Guzmán. Und tatsächlich erweisen seine Werke Rockbands wie Deep Purple und Kiss ihre Reverenz, bedienen sich der Songtexte, der Plattencover und der Vergötterung durch Teenager für Skulpturen, Zeichnungen und Installationen. Aber in seiner Kunst geht es auch um viel mehr. So besteht seine Serie von Schwarzweiß-Zeichnungen, *La búsqueda del ombligo* (Die Suche nach dem Nabel, 2005–07), aus Diptychen, die auf Holz aufgetragen mexikanische Bildersprache der Vergangenheit und Gegenwart zusammenbringen. Die Serie spielt unmittelbar auf Symbole, Pyramiden und Masken der Azteken an, und auf eine Reihe von Zeichnungen, die der mexikanische Wandmaler José Clemente Orozco 1945 machte. Guzmán hat in seinen eigenen Zeichnungen, die im detailreichen, gestischen Stil eines Teenagers ausgeführt sind, der zwanghaft die Ränder seines Schulbuchs mit Skizzen füllt, seine eigene rauschhafte Mischwelt aus Helden und Antihelden geschaffen. Andere Arbeiten Guzmáns nehmen ihre Inspiration aus so verschiedenen Quellen wie politischen Karikaturen, mexikanischen Comics und *Naked Lunch* von William S. Burroughs, und dabei geben sie alle ihre ausgewählten Vorbilder mit fanatischer Inbrunst wieder. Neue Skulpturen wie *Brutal Youth* und *The Principle Pleasure* (beide 2008) beziehen persönliche Gegenstände wie Kleidung und die Schallplattensammlung ein, zusammen mit gefundenen Möbelstücken und einzelnen Türen, die mit Texten beschrieben sind – das Ganze wirkt wie ein Blick in das leere Schlafzimmer eines launischen, desillusionierten Teenagers. Auch wenn Guzmáns Arbeiten die unterschwellige Gewalt in abgetrennten Köpfen und verzerrten, gequälten Figuren darstellen, ist diese Gewalt stets durch Pop gefiltert, die Ikonografie der Entstehungsmythen von Comic-Supermännern, Gitarrenhelden und präkolumbischen Göttern.

« Dans le fond, je suis un artiste rock and roll », dit Daniel Guzmán. L'artiste rend ouvertement hommage à des groupes de rock comme Deep Purple ou Kiss, intégrant paroles de chansons, pochettes d'albums et traces d'idolâtrie adolescente dans ses dessins, sculptures ou installations. Mais ses œuvres vont bien au-delà de ces seules références. Sa série de dessins en noir et blanc *La búsqueda del ombligo* (La quête du nombril, 2005–07), par exemple, est composée de diptyques en panneaux de bois mêlant l'iconographie mexicaine passée et présente. La série fait directement référence à d'anciens symboles, pyramides ou masques aztèques, ainsi qu'à une série de dessins de 1945 du peintre muraliste mexicain José Clemente Orozco. Dans ses dessins, réalisés dans le style d'un adolescent griffonnant de façon compulsive dans la marge de ses cahiers, Guzmán a créé son propre univers hybride et délirant de héros et d'anti-héros. Si d'autres œuvres de Guzmán puisent leur inspiration à des sources aussi diverses que les dessins satiriques, les bandes dessinées mexicaines ou *Le Festin nu* de William S. Burroughs, elles vouent toutes une dévotion fanatique à leurs icônes. En mêlant des effets personnels tels que vêtements et disques à du mobilier de récupération et des portes recouvertes de textes, des sculptures récentes comme *Brutal Youth* (2008) et *The Principle Pleasure* (2008) nous laissent entrevoir la chambre-refuge vide d'un adolescent neurasthénique. Si l'on sent une violence sous-jacente dans les œuvres de Guzmán, avec leurs têtes coupées ou leurs figures torturées, il s'agit d'une violence touchée par le Pop Art, passée au filtre de l'iconographie des mythes originaux des surhommes de bandes dessinées, des héros de la guitare et des dieux précolombiens. CH. L.

SELECTED EXHIBITIONS →
2008 *Double Album: Daniel Guzmán and Steven Shearer*, New Museum, New York; MUCA, Mexico City. *Life on Mars: The 55th Carnegie International*, Carnegie Museum of Art, Pittsburgh. *When Things Cast No Shadow*, 5th Berlin Biennial for Contemporary Art, Berlin **2007** *¡Viva la Muerte!*, Kunsthalle Wien, Vienna; Centro Atlántico de Arte Moderno, La Palma de Gran Canaria. *Viva Mexico!*, Zacheta National Gallery of Art, Warsaw. *Escultura Social: A New Generation of Art from Mexico City*, MCA, Chicago **2006** *T1 Torino Triennale*, Turin

SELECTED PUBLICATIONS →
2008 *Double Album. Daniel Guzmán with Steven Shearer*, New Museum, New York. *Life on Mars: The 55th Carnegie International*, Carnegie Museum of Art, Pittsburgh. *When Things Cast No Shadow*, 5th Berlin Biennial for Contemporary Art, Berlin; JRP Ringier, Zürich **2007** *¡Viva la muerte!*, Kunsthalle Wien, Vienna. *Daniel Guzman: Lost & Found*, kurimanzutto, Mexico. *Escultura Social: New Generation of Art from Mexico City*, MCA, Chicago

1

1 **Tristessa (from the series *La búsqueda del ombligo*)**, 2007, ink, paper on wood panel, 210 x 180 x 3.5 cm
2 **P.P.P. Monk (from the series *The World Doesn't Want Me Any More and Doesn't Know It*)**, 2007, acrylic on wood, 50 x 40 x 2.5 cm
3 **The Principle Pleasure (from the series *Everything Is Temporary*)**, 2008, found furniture, found door with engraved phrase, 8 plastic bananas, 2 record covers, 5 socks, 2 coloured Plexiglas pyramids, 2 coloured Plexiglas engraved pyramids, 215 x 110 x 78 cm
4 **Negro (from the series *La búsqueda del ombligo*)**, 2006/07, ink, paper on wood panel, 210 x 180 x 3.5 cm

„Ich bin in der Innenstadt von Mexico City aufgewachsen, in einem alten Arbeiterviertel. Als Kind sah ich mexikanische Comics, Zeitungen, Sportmagazine. Ich habe nicht als Kunststudent die Populärkultur entdeckt, ich war schon immer mittendrin."

« J'ai grandi dans le centre de Mexico, dans un très vieux quartier populaire. En grandissant, j'ai vu des bandes dessinées, des journaux, des revues de sports mexicains. Je n'ai pas fréquenté d'école d'art où j'aurais découvert la culture populaire ; je baignais déjà dedans. »

"I grew up in downtown Mexico City, in a very old, working-class neighbourhood. When I was growing up, I saw comics, Mexican comics, newspapers, sports magazines. I didn't go to art school and discover popular culture; it was already all around me."

2

Rachel Harrison

1966 born in New York (NY), lives and works in New York (NY), USA

Rachel Harrison's Technicolor-surfaced sculptures are amorphous in contour and wryly ambiguous in meaning, often crossing threads of celebrity pulp, mythology, current events and politics. Deploying the language and history of sculpture – its materials, structures and conditions of display – while contaminating notions of its autonomous purity, Harrison renders her assemblages simultaneously artwork and impromptu pedestal for a quixotic exhibition of ready-made objects (air fresheners, canned food, fake food, Barbie dolls, wigs and mannequins), of house plants and taxidermied animals. Her recent New York exhibition, tauntingly called *If I Did It* (2007) after O.J. Simpson's ill-advised hypothetical tell-all of the same name, pressed Harrison's juxtaposition-based logic to its furthest conclusions yet. Indeed, it even warranted her supplying a booklet of photocopies and printouts for reference – a secret decoder ring for the works on view were it not for the fact that Harrison refuses interpretive fixity. Instead, her assembly of nine mixed-media sculptures titled after famous men (amongst them Alexander the Great, Johnny Depp, Fats Domino, Rainer Werner Fassbinder, Claude Lévi-Strauss, Amerigo Vespucci and Tiger Woods) and a series of portrait photographs inspired by Charles Darwin's expedition journal, *Voyage of the Beagle* (2007), obliquely mirror their subjects and offer a critique of the cultural conditions in which they came to fame or power. This decidedly un-heroic memorializing is the crux of Harrison's feminism. It also furthers her earlier play with the status of the monument, denuding those to whom it pays tribute.

Rachel Harrisons bunt bemalte Skulpturen sind amorphe, mit ironischer Mehrdeutigkeit aufgeladene Gebilde, die oft auf Promi-Kitsch, mythologische Themen, aktuelle und politische Ereignisse referieren. Indem Harrison die Sprache und Geschichte der Skulptur aufruft – ihrer Materialien, Strukturen und Ausstellungsbedingungen – und gleichzeitig die Wahrnehmung von Skulptur als eigenständiger Kunstform zerstört, lässt sie ihre Arrangements als Kunstwerke wie auch als Sockelimprovisation für die donquichottische Präsentation von Readymades (Luftbefeuchter, Konserven, Lebensmittelattrappen, Barbiepuppen, Perücken und Schaufensterpuppen), Zimmerpflanzen und ausgestopften Tieren erscheinen. In ihrer letzten Ausstellung in New York, deren Titel *If I Did It* (2007) auf das gleichnamige Buch mit O.J. Simpsons problematisch-hypothetischem Mordgeständnis anspielte, trieb Harrison diese Logik des Nebeneinanders verschiedenster Dinge auf die Spitze. So gab sie sogar ein Broschüre mit dazugehörigen Fotokopien und Laserdrucken heraus – wie eine Art Geheimcode zu den Exponaten, wenn Harrison sich auf eine Interpretation festlegen ließe. Eher spiegelten ihre neun Skulpturen aus verschiedenen Materialien, die sie mit den Namen berühmter Männer versah (wie Alexander der Große, Johnny Depp, Fats Domino, Rainer Werner Fassbinder, Claude Lévi-Strauss, Amerigo Vespucci, Tiger Woods), in Verbindung mit einer von den Reisenotizen aus Charles Darwins Reisetagebuch *Voyage of the Beagle* (2007) inspirierten fotografischen Porträtserie indirekt ihre Sujets und hinterfragten dadurch den kulturellen Kontext, der ihnen zu Ruhm und Macht verhalf. Diese dezidiert entheroisierende Erinnerungsarbeit bildet die Krux in Harrisons Feminismus. Und sie ist eine Weiterentwicklung ihres früheren Spiels mit dem Status des Denkmals, dessen Ehrenträger sie in voller Blöße zeigt.

Les sculptures en technicolor de Rachel Harrison, aux formes organiques, aux significations équivoques et pleines d'humour, mêlent magazines people, mythologie, actualité et politique. Se référant au langage et à l'histoire de la sculpture – à travers les matériaux, les structures et les conditions d'exposition – tout en altérant l'idée de sa pureté indépendante, Harrison fait de ses assemblages tout à la fois une œuvre d'art et un support improvisé pour une exposition donquichottesque de ready-made (désodorisants d'atmosphère, boîtes de conserve, aliments factices, poupées Barbie, perruques et mannequins), de plantes d'intérieur ou d'animaux empaillés. Sa récente exposition new-yorkaise, ironiquement intitulée d'après le livre de pseudo-confessions de O.J. Simpson, *If I Did It* (Si je l'avais fait) (2007), a poussé la logique de juxtaposition d'Harrison dans ses derniers retranchements. Elle a même fourni une brochure photocopiée et des imprimés – apparemment un décodeur secret pour les pièces exposées, si Harrison ne refusait pas toute fixité interprétative. Au lieu de cela, son assemblage de neuf sculptures de technique mixte, intitulée d'après le nom d'homme célèbre (Alexandre le Grand, Johnny Depp, Fats Domino, Rainer Werner Fassbinder, Claude Lévi-Strauss, Amerigo Vespucci ou Tiger Woods), et sa série de portraits photo inspirés du journal d'expédition de Charles Darwin, *Voyage of the Beagle* (2007), reflètent indirectement leurs sujets et proposent une critique des conditions culturelles dans lesquelles ils sont devenus célèbres ou arrivés au pouvoir. Cette immortalisation résolument non-héroïque est au centre du féminisme d'Harrison. Elle fait également avancer le jeu qu'elle menait précédemment avec le statut du monument, en dénudant ceux à qui il rend hommage. S. H.

SELECTED EXHIBITIONS →
2008 *Lay of the Land*, Le Consortium, Dijon. *The Hamsterwheel*, Malmö Konsthall, Malmö. *Whitney Biennial 2008*, Whitney Museum of American Art, New York **2007** *Rachel Harrison*, Kunsthalle Nürnberg, Nuremberg. *Rachel Harrison*, Migros Museum für Gegenwartskunst, Zürich **2006** The Uncertainty of Objects and Ideas, Hirshhorn Museum and Sculpture Garden, Washington. *Of Mice and Men*, 4th Berlin Biennial for Contemporary Art, Berlin. *DARK*, Museum Boijmans van Beuningen, Rotterdam

SELECTED PUBLICATIONS →
2008 *Rachel Harrison: If I Did It*, Kunsthalle Nürnberg, Nuremberg; JRP Ringier, Zürich. *Pawel Althamer, Louise Bourgeois, Rachel Harrison*, Parkett 82, Zürich. *Whitney Biennial 2008*, Whitney Museum of American Art, New York; Yale University Press, New Haven **2006** *Of Mice and Men*, 4th Berlin Biennial for Contemporary Art, Berlin; Hatje Cantz, Ostfildern **2004** *Rachel Harrison: Currents 30*, Milwaukee Art Museum, Milwaukee

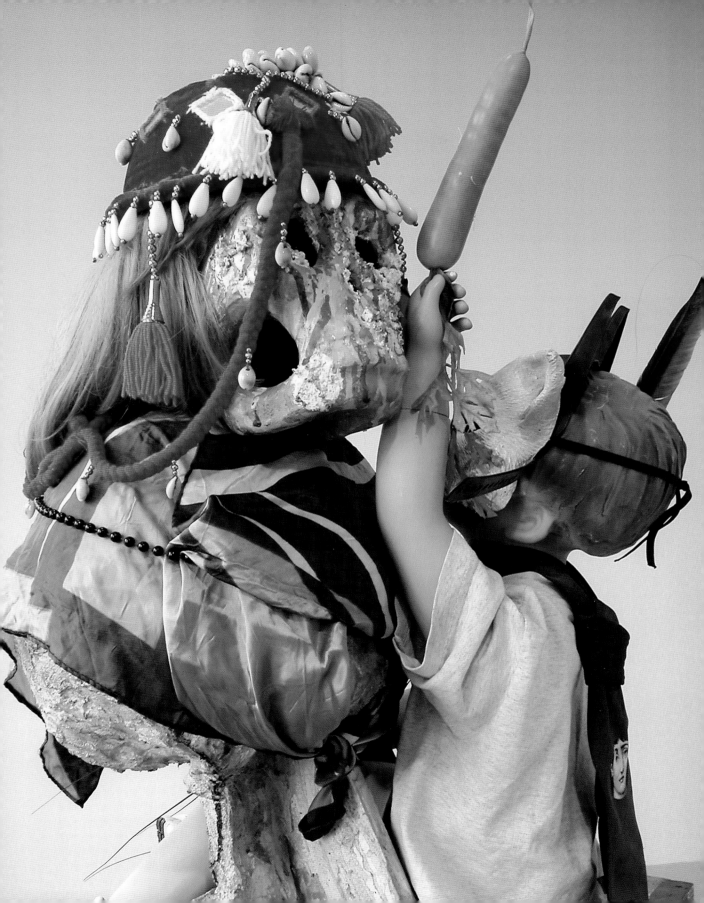

1 **I'm with Stupid**, 2007 (detail), wood, polystyrene, cement, Parex, acrylic, child mannequin, papier-mâché skull, green wig, festive hat, Spongebob Squarepants sneakers, Pokemon t-shirt, wheels, canned fruits and vegetables, artificial carrot, artificial feathers, artificial grass, Batman and Cat mask, necktie, scarf, plastic beads, 165 x 79 x 61 cm

2 **Rainer Werner Fassbinder**, 2007, mannequin, latex Dick Cheney mask, cornstarch bio-degradable peanuts, Flo-pak regular and heavy duty peanuts, eyeglasses, athletic wear, 170 x 228 x 84 cm. Installation view, Greene Naftali, New York

3 **Alexander the Great**, 2007, wood, chicken wire, polystyrene, cement, Parex, acrylic, mannequin, Jeff Gordon waste basket, plastic Abraham

Lincoln mask, sunglasses, fabric, necklace, 2 unidentified items, 221 x 231 x 102 cm

4 **Tiger Woods**, 2006, wood, chicken wire, polystyrene, cement, Parex, acrylic, spray paint, video monitor, DVD player, NYC marathon video, artificial apple, sewing pins, lottery tickets, Arnold Palmer Arizona Lite Half & Half green tea lemonade can, 201 x 122 x 109 cm

5 **Al Gore**, 2007, wood, chicken wire, polystyrene, cement, Parex, acrylic, Honeywell T87 thermostat, 216 x 86 x 43 cm

6 **Sphinx**, 2002, wood, polystyrene, cement, Parex, acrylic, sheetrock, wheels, C-print, 244 x 122 x 165 cm

„Wenn du die Hunde hörst, bleib nicht stehen." « Si vous entendez les chiens, ne vous arrêtez pas. »

"If you hear the dogs, keep going."

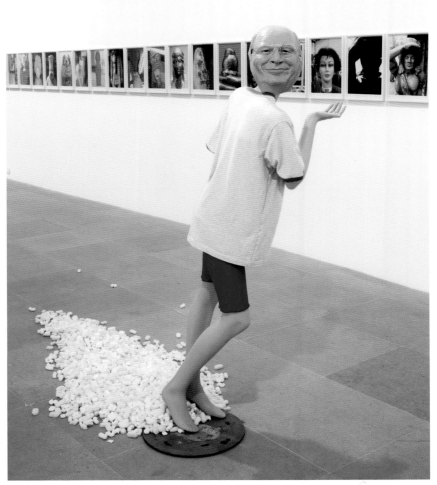

2

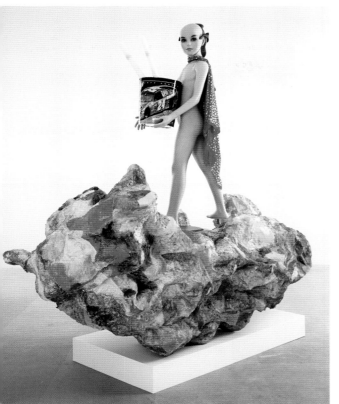

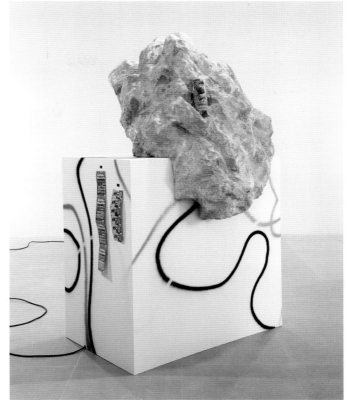

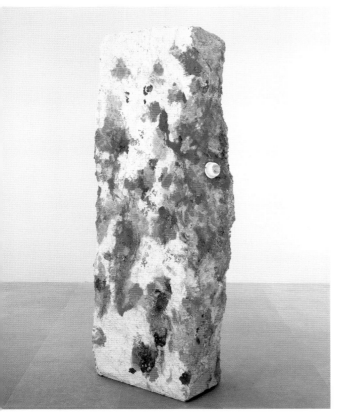

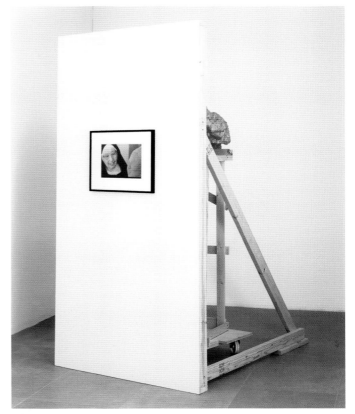

Mona Hatoum

1952 born in Beirut, Lebanon, lives and works in London, United Kingdom, and Berlin, Germany

An oversize kitchen grater as a *Daybed* (2008) whose sharp surface would strip the goose pimples from your flesh; a folding cheese grater as a metal room divider with nastily jagged openings (*Paravent*, 2008) – Mona Hatoum subjects commonplace objects to a transformation that lends them an unsettling or threatening air. The same applies to her series of "cut-outs", small fold-and-cut works reminiscent of children's handcrafts. In *Untitled* (*Cut-Out 7*, 2008) for example, the repeating ornament turns out to be soldiers aiming at one another. War, exile and living conditions in crisis areas are recurrent themes in Hatoum's oeuvre, which may not be wholly unconnected to her own biography. She never addresses these topics in a simplistically concrete way, however; they always appear in a subliminal and menacing way. In *Nature morte aux grenades* (2006/07) there is an uncanny tension between the seductive material aesthetic of the coloured glass objects and the implicit danger they harbour: similar to organic shapes such as lemons or pomegranates, here the glass has been blown into the form of hand grenades. The installation *Hanging Garden* (2008) consists not only of sandbags – recalling barricades used in military conflicts – but also of grass, which grows over the course of the exhibition. As such it alludes to the discussion that has been ongoing since the 1960s about the permanence and variability of artworks and artistic actions. A sculpture like *Cube* (2008) can also be linked with the debate surrounding art-historical references: although the geometrical grid structure recalls works of minimal art, closer scrutiny reveals that the rods of the cage are fitted with the hooks of barbed wire.

Eine überdimensionale Küchenreibe als Ruhebett (*Daybed*, 2008), dessen scharfkantige Oberfläche die Gänsehaut vom Fleisch nimmt, eine aufklappbare Käsereibe als metallischer Raumteiler mit ungemütlich gezackten Öffnungen (*Paravent*, 2008) – Mona Hatoum unterwirft alltägliche Gegenstände einer Wandlung, der ihnen etwas Beunruhigendes oder Bedrohliches verleiht. So auch in der Serie der „Cut-Outs", kleiner Faltschnitte, die an Kinderbasteleien erinnern. In *Untitled* (*Cut-Out 7*, 2008) etwa entpuppt sich der ornamentale Rapport als Muster aus Soldaten, die aufeinander zielen. Krieg, Zustände in Krisengebieten und Exil sind Themen, die immer wieder in Hatoums Arbeiten auftauchen – sicherlich nicht ganz ohne Bezug zu ihrer eigenen Biografie. Allerdings behandelt Hatoum diese Themen nie vordergründig-konkret, sie erscheinen stets unterschwellig und bedrohlich. So entsteht in *Nature morte aux grenades* (2006/07) eine eigentümliche Spannung zwischen der verführerischen Materialästhetik der bunten Glasobjekte und der impliziten Gefahr, die sie bergen: Es handelt sich um Handgranaten, die nach organischen Vorbildern wie Zitronen oder Granatäpfeln geblasen wurden. Die Installation *Hanging Garden* (2008) besteht aus Sandsäcken, die an Verschanzungen bei kriegerischen Konflikten gemahnen, doch auch aus Gras, das während der Ausstellungszeit wuchs. So nimmt *Hanging Garden* Bezug auf die seit den 1960er-Jahren geführte Diskussion um Fragen der Beständigkeit und Veränderlichkeit eines Kunstwerks oder einer künstlerischen Aktion. Eine Skulptur wie *Cube* (2008) steht ebenfalls in diesem Spannungsfeld der Auseinandersetzung mit kunsthistorischen Bezügen: Die geometrische Gitterstruktur erinnert an Werke der Minimal Art, doch bei näherem Hinsehen zeigt sich, dass die Stäbe mit den Widerhaken von Stacheldraht versehen sind.

Une râpe de cuisine surdimensionnée en guise de lit (*Daybed*, 2008) dont la surface déchiquetée vous donne la chair de poule, une râpe dépliable en guise de cloison métallique aux fâcheuses ouvertures dentelées (*Paravent*, 2008) – Mona Hatoum soumet des objets quotidiens à une transformation qui leur confère un caractère inquiétant ou menaçant. Il en va de même pour la série des « cut-outs », petits découpages qui rappellent des travaux d'enfants. Dans *Untitled* (*Cut-Out 7*) (2008), le découpage ornemental s'avère être un motif de soldats se visant les uns les autres. La guerre, les conditions des zones de crise et l'exil sont des thèmes récurrents dans l'œuvre de Hatoum – ce qui n'est pas sans lien avec sa propre biographie. Il est vrai qu'Hatoum n'aborde pas ces thèmes de manière concrète et directe, ils apparaissent toujours sous la forme d'une menace sous-jacente. Ainsi, dans *Nature morte aux grenades* (2006/07), la menace naît de la tension entre l'esthétique matérielle attrayante des objets en verre teinté et le danger implicite qu'ils recèlent : il s'agit de grenades en verre soufflé présentant les formes de modèles naturels comme des citrons ou des grenades. L'installation *Hanging Garden* (2008) est constituée d'herbe qui poussait durant l'exposition et de sacs de sable qui évoquent un retranchement militaire. *Hanging Garden* se réfère ainsi au débat qui, depuis les années 1960, tourne autour de la pérennité et de la fugacité de l'œuvre d'art ou de l'action artistique. Une sculpture comme *Cube* (2008) s'inscrit également dans le champ de tension de la confrontation avec des questions d'histoire de l'art : sa structure géométrique tramée rappelle les œuvres du Minimal Art, mais en y regardant de plus près, on s'aperçoit que les tiges sont garnies de pointes de fil de fer barbelé. A. M.

SELECTED EXHIBITIONS →
2008 *Mona Hatoum: Present Tense*, Parasol Unit, London. *Mona Hatoum: Undercurrents*, XIII Biennale Donna, Palazzo Massari, Ferrara. *Genesis – Die Kunst der Schöpfung*, Zentrum Paul Klee, Bern **2007** *Neue Heimat*, Berlinische Galerie, Berlin. *Capricci: Possibilités d'autres mondes*, Casino Luxembourg – Forum d'art contemporain, Luxembourg **2005** *Mona Hatoum: Over My Dead Body*, Museum of Contemporary Art, Sydney **2004** *Mona Hatoum*, Hamburger Kunsthalle, Hamburg; Magasin 3 Stockholm Konsthall, Stockholm

SELECTED PUBLICATIONS →
2008 *Mona Hatoum: Undercurrents*, XIII Biennale Donna, Palazzo Massari, Ferrara. *Mona Hatoum: Unhomely*, Galerie Max Hetzler; Holzwarth Publications, Berlin **2006** *Mona Hatoum*, White Cube, London. *Carbonic Anhydride*, Galerie Max Hetzler, Berlin **2005** *Mona Hatoum*, The Reed Institute, Portland **2004** *Mona Hatoum*, Hamburger Kunsthalle, Hamburg; Hatje Cantz, Ostfildern

1 **Nature morte aux grenades**, 2006/07 (detail), crystal, mild steel, rubber, 95 x 208 x 70 cm
2 **Round and Round**, 2007, bronze, 61 x 33 x 33 cm

3 **Daybed**, 2008, black finished steel, 32 x 219 x 98 cm
4 **Home**, 1999, wood, stainless steel, electric cable, light bulbs, dimmer device, amplifier, 2 speakers, dimensions variable, table 77 x 198 x 74 cm

„Ich halte meine Arbeiten gern offen, so dass sie auf verschiedenen Ebenen interpretiert werden können. Mit Kunst kann man nicht konkrete Fragen erörtern, Kunst ist kein Jourrnalismus."

« J'aime que mon travail conserve une indétermination qui permette de l'interpréter à différents niveaux. L'art ne peut être comparé au journalisme ; il ne peut débattre de sujets concrets. »

"I like keeping my work so open that it can be interpreted on different levels. Art can't be compared with journalism; it can't discuss concrete issues."

2

Eberhard Havekost

1967, born in Dresden, lives and works in Dresden and Berlin, Germany

Using the devices of photographic representation, Eberhard Havekost investigates the processes by which images are constructed and interrelated. Taking as his starting point photographs shot or found, he employs digital technologies to enhance or alter the source image and inkjet printing as steps on the road to the final canvas. Havekost tinkers with his images, but the original always lurks in his mind's eye. He once said: "Because I always see the precise photographic basis while I paint, I sense how the image forever oscillates between two levels of meaning." In his recent series grouped under the title *Zensur* (Censorship), he has started redacting whole regions of his pictures with unrelenting grey or black rectangles (*Keller 1, B07*, 2007), as if working against these inevitable pictorial recollections. Yet, Havekost is not just concerned with how information is or is not conveyed; the placement of these censoring patches enables him to explore how painterly space functions in general. Works incorporating architectural elements, like *L.A. Grau* (2005) or *Superstar* (2005) demonstrate how Havekost's circuitous approach leads to a curiously straightforward-looking result. Too muted in tone and gesture to be considered in the historical vein of socialist realism or photo-realist painting, yet undeniably based on photographs, his swaths of drab colour hug the picture plane with hyper-awareness, yet the effect is never fully abstract. Disturbing portraits of masked figures (*Geist* and *Universal Soldier*, 2006) seem almost uncannily displaced from these vacant interiors, land and cityscapes (*Dunkle Modellwelt*, 2007), lending them a menacing quality after the fact.

Indem er das Medium Fotografie einbezieht, untersucht Eberhard Havekost in seinen Gemälden die Prozesse, die der Konstruktion von Bildern und deren wechselseitigen Beziehungen zugrunde liegen. Ausgehend von eigenen Aufnahmen oder auch gefundenen Fotografien korrigiert und verändert er diese am Computer und bedient sich außerdem des Inkjet-Prints, beides Schritte auf dem Weg bis zum vollendeten Gemälde. Havekost arbeitet die Bilder um, aber er behält das Original im Blick: „Da ich die fotografische Vorlage beim Malen immer genau vor mir sehe, nehme ich das Bild als Übergang zwischen zwei Bedeutungsebenen wahr." In seiner neueren Serie *Zensur* hat er ganze Bereiche seiner Bilder mit unerbittlichen grauen oder schwarzen Rechtecken überarbeitet (*Keller 1, B07*, 2007), als wollte er zwanghaften bildlichen Erinnerungen etwas entgegensetzen. Havekost will hier nicht nur wissen, wie Information übertragen wird oder eben nicht. Durch die Platzierung dieser zensierenden Balken erhält er vielmehr Einblick in den malerischen Bildraum überhaupt. Arbeiten mit architektonischen Elementen, wie *L.A. Grau* (2005) oder *Superstar* (2005), demonstrieren, wie Havekosts Umweg über ein anderes Medium zu erstaunlich unkompliziert wirkenden Ergebnissen findet. Zu verhalten in Ton und Gestus, um im historischen Kontext der Malerei des sozialistischen Realismus oder des Fotorealismus gesehen zu werden, und doch auf Fotografien basierend, liegt der Farbauftrag sehr gezielt dicht auf der Bildoberfläche, aber der Effekt ist nie völlig abstrakt. Beunruhigende Porträts von Vermummten (*Geist* und *Universal Soldier*, 2006) wirken fast unheimlich entrückt in diesen leeren Innenräumen, Landschaften und Stadtbildern (*Dunkle Modellwelt*, 2007), denen sie eine bedrohliche Atmosphäre verleihen.

Eberhard Havekost utilise les stratégies de la représentation photographique afin d'explorer en peinture la manière dont les images se construisent et se font écho. À partir de photographies trouvées ou qu'il réalise lui-même, il utilise la technologie numérique pour renforcer ou modifier l'image source et l'impression au jet d'encre comme autant d'étapes vers la toile finale. Havekost altère certes ses images, mais sans jamais perdre de vue l'original : « Comme j'ai toujours une base photographique précise sous les yeux quand je peins, je vois l'image osciller sans cesse entre deux niveaux de sens. » Dans une série récente baptisée *Zensur*, des rectangles gris ou noirs occultent impitoyablement des parties entières de ses toiles (*Keller 1, B07*, 2007), comme si son travail s'effectuait contre ces inévitables souvenirs picturaux. Mais la manière dont l'information se transmet (ou non) n'est pas ici sa seule préoccupation ; la répartition de ces aplats venant « censurer » le motif sur la toile lui permet de révéler le fonctionnement général de la surface peinte. Des œuvres comportant des éléments d'architecture, comme *L.A. Grau* (2005) ou *Superstar* (2005), montrent bien comment Havekost parvient par ce détour à un résultat étonnamment direct. D'une tonalité et d'une expressivité trop retenues pour s'inscrire dans la veine du réalisme social ou de la peinture hyperréaliste, mais indéniablement inspirées par la photographie, ses toiles sont comme enserrées par des bandes grisâtres qui font de la censure une forme de lucidité suraiguë, sans que le résultat soit jamais purement abstrait. Des portraits inquiétants de personnages masqués (*Geist* et *Universal Soldier*, 2006) ne semblent pas trouver leur place dans ces intérieurs vides, ces paysages naturels ou urbains désertés (*Dunkle Modellwelt*, 2007) et ils finissent par en devenir menaçants.

V. R.

SELECTED EXHIBITIONS →
2008 *Living Landscapes: A Journey through German Art*, NAMOC – National Art Museum of China, Beijing. *Comme des bêtes: ours, chat, cochon & Cie*, Musée cantonal des Beaux-Arts, Lausanne **2007** *Eberhard Havekost – Paintings from the Rubell Family Collection*, Tampa Museum of Art, Tampa. *Imagination Becomes Reality*, ZKM, Karlsruhe **2006** *Havekost, Kahrs, Plessen, Sasnal*, Museu Serralves, Porto **2005** *Eberhard Havekost: Harmonie*, Kunstmuseum Wolfsburg; Stedelijk Museum, Amsterdam

SELECTED PUBLICATIONS →
2007 *Eberhard Havekost. Benutzeroberfläche / User Interface*, Schirmer/Mosel, Munich. *Havekost: Background*, White Cube; Walther Koenig Books Ltd., London **2006** *Eberhard Havekost 1996–2006*, Rubell Family Collection, Miami. *Imagination Becomes Reality: Part II*, Sammlung Goetz, Munich. *Landschafts-Paraphrasen: Dring, Drühl, Havekost, Jensen*, Museum Baden, Solingen; Salon Verlag, Cologne **2005** *Eberhard Havekost: Harmonie*, Kunstmuseum Wolfsburg; Hatje Cantz, Ostfildern

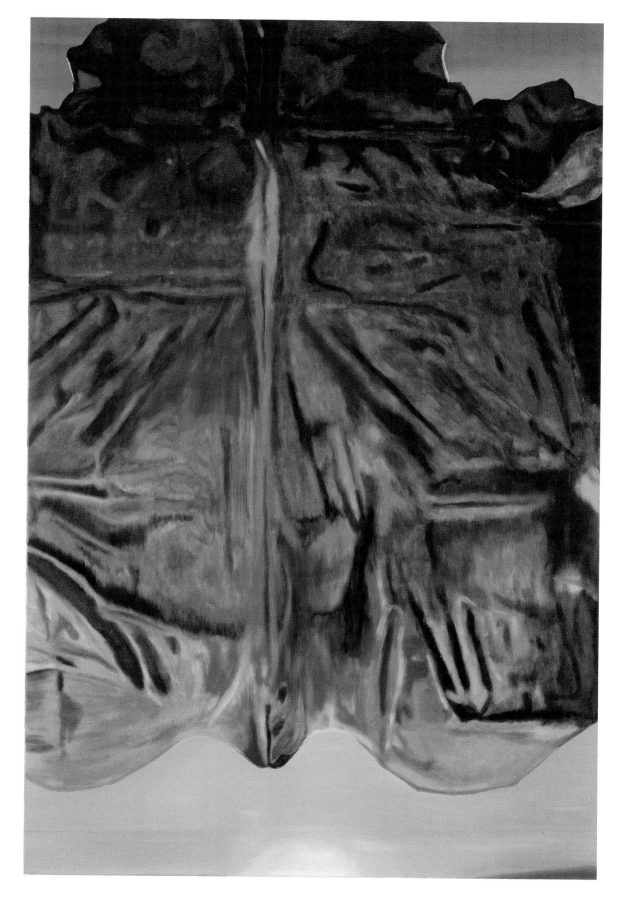

1 **Idee 1, B08**, 2008, oil on canvas, 170 x 110 cm
2 **Unendlichkeit 1/2, B08**, 2008, oil on canvas, 120 x 80 cm
3 **Unendlichkeit 2/2, B08**, 2008, oil on canvas, 120 x 80 cm

4 **Überzüchtung, B07**, 2007, oil on canvas, 140 x 78 cm
5 **Erscheinung, B07**, 2007, oil on canvas, 170 x 250 cm

„So etwas wie Ganzheit existiert weder in der Realität noch in der Fotografie. Die Fotografie ist ein Medium, das die Realität reduziert, und sie ist ein ‚Gastmedium' für das Bild, wie die Malerei. So gesehen gibt es für mich keinen Unterschied zwischen Fotografie und Malerei."

« L' "intégrité" n'existe ni dans la réalité, ni dans la photographie. La photographie est un support qui restreint le réel, c'est un "support hôte" de l'image, au même titre que la peinture. En ce sens, je ne vois aucune différence entre photographie et peinture. »

"There is no such thing as 'entirety' either in reality or in photography. Photography is a medium that restricts reality and it is a 'guest medium' for the image, as is painting. In this respect, I see no difference between photography and painting."

2

3

4

5

Richard Hawkins

1960 born in Mexia (TX), lives and works in Los Angeles (CA), USA

In the course of his career, Richard Hawkins' mutable style has taken surprising shifts from collage to painting to sculpture. This multiform body of work, however, is linked together by recurrent motifs and subjects such as the conflict between the idolization and iconoclasm of the male figure in art, and an acute awareness of the art-historical traditions that he engages with and rebels against. In the collage series *Urbis Paganus* (2005) Hawkins explores the issues of gender and sexuality under pagan rule, using images from classical art history books. He almost seems to be creating satirical versions of his own early work from the 1990s – collages of male idols made from pages of magazines featuring models, rock stars or porn actors. These gradually became images of brutally severed heads of androgynous boys, floating in dreamy fields of pastel colours. In 1999, Hawkins began to make figurative paintings in the satirical vein of German expressionists, featuring sexually ambiguous figures with sunburns and unflattering physiques. The paintings are social studies of forays into sex tourism, but also border on a Hockney-esque portrayal of a particular gay lifestyle. The recurrent subject of sexuality is also present in his altered dollhouses: *Bordello on Rue St. Lazare* (2007) seems to spring up directly from a horror film, haunted, dilapidated, becoming an ironic symbol of sexual debauchery whereas the black box-like *House of the Mad Professor* (2008) more subtly evokes an 18th century scenery of libertinage: peeping through the windows like a voyeur, the spectator gets sight of a suite of richly furnished rooms containing well known works of art bathed in red light.

Im Verlauf seiner Karriere hat Richard Hawkins' wandlungsfähiger Stil eine bemerkenswerte Entwicklung von der Collage über die Malerei zur Skulptur genommen. Diese formale Vielfalt seines Werks wird aber durch wiederkehrende Motive und Sujets zusammengehalten, etwa dem Konflikt zwischen glorifiziertem und misshandeltem männlichem Körper in der Kunst oder in einem geschärften Bewusstsein für kunstgeschichtliche Traditionen, die der Künstler sowohl beansprucht als auch umstürzt. In der Collagenserie *Urbis Paganus* (2005) erforscht Hawkins Fragen der Geschlechtszugehörigkeit und Sexualität in heidnischen Zeiten anhand von Bildern aus klassischen Kunstbänden. Fast scheint es, als würde er seine eigenen Arbeiten der 1990er-Jahre satirisch verfremden – Collagen mit aus Zeitschriften herausgerissenen Seiten, die männliche Idole, Models, Rock- oder Pornostars zeigen. Diese wurden mit der Zeit zu Bildern von abgehackten, durch traumhafte Pastell-Farbfelder gleitenden Köpfen mit androgynen Zügen. 1999 begann Hawkins mit gegenständlichen Bildern in einer satirischen Variante der deutschen Expressionisten – Gemälde von geschlechtlich nicht eindeutig definierbaren Wesen, mit Sonnenbrand und wenig attraktiven Körpern. Die Gemälde sind Sozialstudien von Abstechern in den Sextourismus, erinnern aber auch an die Hockney'schen Darstellungen eines homosexuellen Lifestyles. Das erotische Sujet ist auch in Hawkins' Geisterpuppenhäusern präsent: *Bordello on Rue St. Lazare* (2007), baufällig und unheimlich wie in einem Horrorfilm, wird zum ironschen Symbol sexueller Ausschweifungen, während *House of the Mad Professor* (2008) eher subtil die Freizügigkeit des 18. Jahrhunderts andeutet: Der Betrachter schaut wie ein Voyeur durch ein Fenster und entdeckt eine prächtige Suite mit berühmten Kunstwerken, in rötliches Licht getaucht.

Au fil de sa carrière, le style de Richard Hawkins a connu des évolutions étonnantes, du collage à la peinture et à la sculpture. Son œuvre protéiforme est toutefois lié par des motifs et des sujets récurrents tel le conflit entre l'idolâtrie et l'iconoclasme de la figure masculine dans l'art, et une conscience aiguë des traditions artistiques aux côtés desquelles il s'engage tout en les critiquant. Dans la série de collages *Urbis Paganus* (2005), Hawkins explore les questions du genre et de la sexualité à l'aune de rituels païens, utilisant des images tirées d'ouvrages classiques d'histoire de l'art. Il semble presque créer des versions satiriques de ses premières œuvres des années 1990 – collages d'idoles masculines réalisés à partir de pages de magazines représentant des vedettes, des stars du rock ou des acteurs porno. Peu à peu, ceux-ci ont cédé la place aux têtes brutalement coupées de garçons androgynes flottant dans la douceur d'un environnement de couleurs pastel. En 1999, Hawkins s'est mis à la peinture figurative, dans la veine satirique des expressionnistes allemands, peignant des personnages sexuellement ambigus avec des coups de soleil et aux physiques peu flatteurs. Ces études sociales du tourisme sexuel rappellent également les portraits à la manière de Hockney du style de vie gay. La sexualité, sujet récurrent, est aussi présente dans ses maisons de poupées transformées : *Bordello on Rue St. Lazare* (2007) semble tout droit sorti d'un film d'horreur, hanté, délabré, symbole ironique de la débauche sexuelle, tandis que *House of the Mad Professor* (2008), semblable à une boîte noire, évoque de manière plus subtile une scène de libertinage du XVIIIe siècle : regardant furtivement par les fenêtres, le spectateur-voyeur voit une suite de pièces richement meublées, décorées d'œuvres d'art célèbres baignant dans une lumière rouge.

CH. L.

SELECTED EXHIBITIONS →
2008 *Gewoon Anders! (Just Different)*, Cobra Museum, Amstelveen. *5000 Jahre Moderne Kunst*, Galerien der Stadt Esslingen **2007** *Richard Hawkins: Of Two Minds, Simultaneously*, De Appel, Amsterdam. *Strange Events Permit Themselves the Luxury of Occurring*, Camden Arts Centre, London. *If Everybody Had an Ocean*, CAPC, Bordeaux. *Oh Girl, It's a Boy!*, Kunstverein München, Munich **2006** *Red Eye: Los Angeles Artists from the Rubell Family Collection*, Rubell Family Collection, Miami

SELECTED PUBLICATIONS →
2008 *Richard Hawkins: Of Two Minds, Simultaneously*, De Appel, Amsterdam. *Gewoon Anders! (Just Different)*, Cobra Museum, Amstelveen **2007** *Red Eye: Los Angeles Artists from the Rubell Family Collection*, The Rubell Family Collection, Miami **2006** *Another History*, Milliken Gallery publication, Stockholm

1 **Bordello on Rue St. Lazare**, 2007, altered dollhouse, table, dimensions variable
2 **Untitled (Blanket Flags #1)**, 2004, collage, 55.5 x 71 cm
3 **Untitled (Blanket Flags #2)**, 2004, collage, 55.5 x 71 cm

4 **Untitled (Blanket Flags #3)**, 2004, collage, 55.5 x 71 cm
5 **Shinjuku Boy (#2)**, 2008, collage, 45.5 x 60.5 cm
6 **House of the Mad Professor**, 2008, wood, collage, plastic, electric components, 106 x 94 x 94 cm

„Ich halte mich durch Affirmation kritikfähig. Ganz gleich, ob mich die Assimilationsdynamik von zeitgenössischen oder historischen Minderheiten-Kulturen fasziniert, die Entstehung und der aktuelle Zustand der ungegenständlichen Malerei oder die seltsamen Ausformungen auf den Rückseiten klassischer Skulpturen, ich finde es immer wichtig, mir eine kritische Haltung dazu vorzustellen und dann die Lösung zu finden."

« J'entretiens un rapport avec la critique par affirmation. Que je sois intrigué par les dynamiques d'assimilation des cultures minoritaires historiques ou contemporaines, par les origines et l'état actuel de la peinture non figurative ou par l'aspect anormal des faces arrières de la sculpture classique, je trouve important d'imaginer une position critique et d'envisager sa solution. »

"I maintain a relationship to criticality through affirmation. Whether I'm intrigued by the assimilation dynamics of contemporary or historical minority cultures, the origins and current state of non-representational painting or the anomalous aspect of the backsides of classical sculpture, I find it important to fantasize a critical position and imagine its solution."

2

3

4

5

Jonathan Hernández

1972 born in Mexico City, lives and works in Mexico City, Mexico

When J.-J. Grandville published the print *Une promenade dans le ciel* in 1847, he had no way of knowing that the surrealists would carry forth his associative, non-narrative method of depiction in their art and films. And while Aby Warburg was working on his associative image atlas *Mnemosyne* (1924–29), he couldn't have predicted the archival trend in art at the turn of the 21st century. Both are now fundamental components of the work of Jonathan Hernández: chains of association in the juxtapositions of people in *Vulnerabilia (Simetrías y multiplicaciones)* (2006–08) and the circular forms of *Estado vacioso I* (2008); archival image conglomerations in *Mosaico* (2008). Hernández begins by selecting images from magazines and newspapers. He removes them from their original contexts, so that nothing detracts from their thematic presence. Then comes the arrangement of the images, performed with Hernández's sharp eye for formal-compositional references, so that a subtle network of diagonal, vertical and horizontal lines tauten and traverse the amassed images. But Hernández does not only produce collages: one of his latest works is the wall relief *Intención/Intuición* (2007). What's visible: an almost empty gallery space. In one place only, a fist forms out of the wall, as if someone were behind it and the wall soft. While it is dotted with surreal references, this work transcends surrealist horror. It points – *ex positivo* – on the one hand towards the emptiness of the space and the art business. On the other hand, it signals an outside, a place where you might find what you are looking for in vain in the empty gallery – art. This is institutional critique that carries its own punch.

Als J.-J. Grandville 1847 die Grafik *Une promenade dans le ciel* veröffentlichte, bei der die Motive nicht narrativ, sondern assoziativ miteinander verkettet sind, ahnte er nicht, dass die Surrealisten diese Darstellungsweise für ihre Kunst und ihre Filme fortführen würden. Und als Aby Warburg an seinem assoziativen Bildatlas *Mnemosyne* (1924–29) arbeitete, wusste er nichts von den Archivkunstbestrebungen zum Wechsel des Jahrtausends. Beides nun, assoziative Bildverkettung, wie mit den Menschenreihungen bei *Vulnerabilia (Simetrías y multiplicaciones)* (2006–08) und den Rundformen bei *Estado vacioso I* (2008), sowie archivische Bildkonglomerate, wie bei *Mosáico* (2008), sind wesentliche Bestandteile des Werks von Jonathan Hernández. Die Feinarbeit beginnt schon bei der Auswahl der Bilder aus Zeitungen und Zeitschriften. Ihre Ursprungskontexte werden gelöscht, so dass nichts von ihrer motivischen Präsenz ablenkt. Das Arrangieren der Bilder erfolgt dann mit dem für Hernández typischen Blick für formal-kompositionelle Bezüge, so dass ein subtiles Netz aus Diagonalen, Vertikalen und Horizontalen die Bildansammlungen verspannt und durchzieht. Doch Hernández stellt nicht nur Collagen her, eine seiner jüngsten Arbeiten ist das Wandrelief *Intención/Intuición* (2007). Zu sehen ist: ein fast leerer Galerieraum. Lediglich an einer Stelle wölbt sich eine Faust aus der Wand, als wäre eine Person dahinter und die Wand weich. Wiederum mit surrealistischer Referenz gespickt, geht diese Arbeit jedoch über surrealistischen Horror hinaus. Sie pointiert – *ex positivo* – einerseits die Leere des Raumes und des Kunstbetriebs. Andererseits kündet sie von einem Außerhalb, in dem möglicherweise das zu finden ist, was man in der leeren Galerie vergeblich sucht: Kunst. Das ist Institutionskritik, die trifft – wie die Faust aufs Auge.

En 1847, au moment où il publiait sa gravure *Une Promenade dans le ciel*, dans laquelle les motifs étaient liés de manière associative et non narrative, J.-J. Grandville ne se doutait pas que les surréalistes allaient développer ce mode de représentation dans leur art et dans leurs films. Et à l'époque où il travaillait à son atlas photographique *Mnemosyne* (1924–29), Aby Warburg ignorait tout des recherches archivistiques de l'art au tournant du millénaire. Ces deux aspects – la démarche associative, avec les rangées d'hommes de *Vulnerabilia (Simetrías y multiplicaciones)* (2006–08) ou les formes rondes d'*Estado vacioso I* (2008) et les archivages d'images de *Mosáico* (2008) – sont des éléments essentiels de l'œuvre de Jonathan Hernández. Le travail minutieux commence déjà avec le choix des images tirées de journaux et de revues. Les contextes d'origine sont effacés de manière à ce que rien ne vienne distraire l'attention de la présence du motif. L'arrangement des images est alors soumis au regard particulier d'Hernández, qui crée des rapports formels et compositionnels dont la trame subtile de diagonales, de verticales et d'horizontales parcourt ces compilations et les met sous tension. Mais Hernández ne se contente pas de réaliser des collages : une de ses dernières œuvres est le relief mural *Intención/Intuición* (2007). On y voit la salle presque vide d'une galerie d'art. À un seul endroit, un poing sort du mur comme si une personne était placée à l'arrière et que le mur était mou. Bien qu'empreinte d'une note surréelle, cette œuvre va au-delà de l'horreur surréaliste. Elle renvoie – *ex positivo* – à l'inanité de l'espace et du marché de l'art tout en évoquant un extérieur où pourrait éventuellement être trouvé ce que l'on cherche en vain dans la galerie vide : l'art. On peut y voir une critique pertinente des institutions en forme de coup de poing.

H. L.

SELECTED EXHIBITIONS →
2008 *Jonathan Hernandez: Licht und Schatten (por fin)*. MC Kunst, Los Angeles. *The Implications of Image*, Museo Universitario de Ciencias y Arte, MUCA, Mexico City. *Collage: The Unmonumental Picture*, New Museum, New York **2007** *Jonathan Hernandez: Tiempo perdido, ganado y empatado*, Fundación RAC, Madrid. *Private Passions, Public Visions*, MARCO, Vigo. *Unmonumental: The Object in the 21st Century*, New Museum, New York. 2nd Moscow Biennale of Contemporary Art, Moscow **2006** 9. Bienal de La Habana, Havana

SELECTED PUBLICATIONS →
2008 *Assembling Contemporary Art*, Black Dog Publishing, London **2007** *Collage: The Unmonumental Picture*, New Museum, New York; Merrell Publishers, London. *Unmonumental: The Object in the 21st Century*, New Museum, New York; Phaidon Press, London **2006** *Vitamin Ph: New Perspectives in Photography*, Phaidon Press, London

1 **Wish You Were Here**, 2007, letters in acrylic, mirror, styrene, MDF,
 250 x 180 cm
2 **Estado vacioso I**, 2007, 48 newspaper cuttings, each with a circular
 incision, 106 x 89.9 cm

3 **Intención/Intuición**, 2007, hydrocal, drywall compound, empty space,
 dimensions variable
4 **Mural**, 2006, 47 posters mounted on 45 acid-free cardboard, panels with
 intervened traces from a Siqueiros mural sketch, 400 x 700 cm

„Ich denke die Realität, oder die Realitäten, bestehen bereits zu einem guten
Teil aus Fiktion … Die Collagen sind ein Katalysator für alltägliche Ereignisse,
die wie Stammbäume von Apokalypsen dargestellt werden – die Art von
Apokalypsen, die wir jeden Tag hervorbringen."

« Je considère que la ou les réalités contiennent déjà une forte part de
fiction… Les collages sont des catalyseurs d'événements quotidiens pré-
sentés comme arbre généalogique de l'apocalypse – le genre d'apocalypse
que nous créons chaque jour. »

"I consider reality or realities to have a strong content of fiction to begin with… The collages are a catalyst of daily events displayed like the genealogical trees of the Apocalypses – the kind of Apocalypses we create every day."

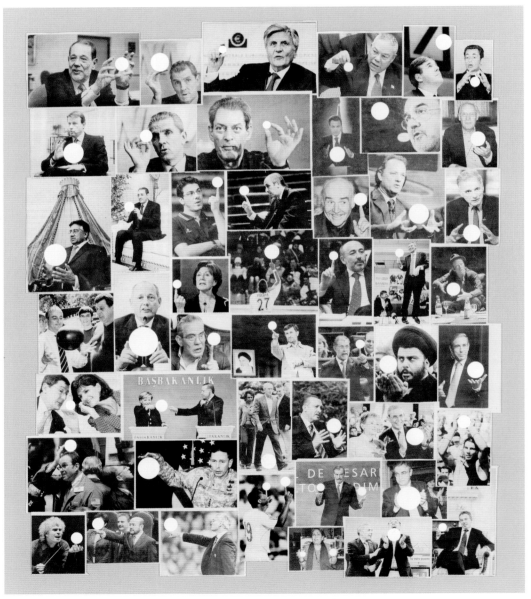

2

3

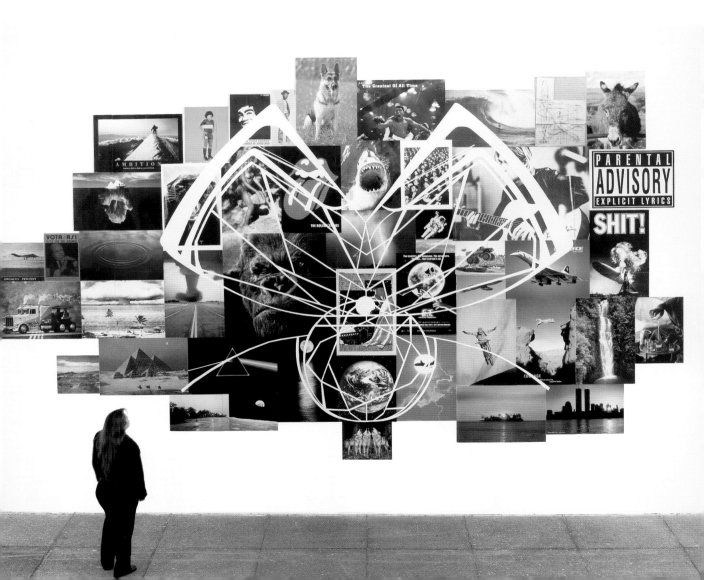

Arturo Herrera

1959 born in Caracas, Venezuela, lives and works in Berlin, Germany

Arturo Herrera is interested in advancing to transitional areas: were his multi-faceted oeuvre to be reduced to a simple formula, it might be that it always contains both sides of an idea. His current works, made from dark grey felt, take the guise of non-representational forms that evoke something organic or vegetable. But while Herrera's felt works are quite literally material, they speak to both the visual and the tactile, and thus stand on the threshold of the sculptural. His paintings and collages also oscillate between representation and abstraction. The extensive series of collages entitled *Boy and Dwarf* (2006) is based on two characters from a painting book – a boy who plays the accordion and a dwarf – and on twenty abstract drawings by the artist. Herrera had "back views" made of the figures, modifying the resulting four prototypes every fifth time, before overlaying them with the twenty drawings. These basic images were then projected onto surfaces that had already been worked on – painted or collaged – and their silhouettes were cut out, sometimes with elements left blank, doubled or upturned. Seventy-five works were created in this way. Their titles indicate their place in the series as well as the figures they are based on – B for boy, D for dwarf, B for back and F for front. The process of transformation leaves the source images barely discernible in the interplay of fine colourful lines, grainy painterly fields and patterned materials. In this way, Herrera plays two traditional poles of art off against each other – he loads abstraction with a concrete legibility, which he simultaneously works hard to dismantle.

Wenn man das vielfältige Œuvre von Arturo Herrera auf eine Formel reduzieren wollte, dann vielleicht darauf, dass es bei ihm um das Vordringen in Zwischenbereiche geht, um Werke, die ein „sowohl – als auch" in sich tragen. Seine aktuellen Arbeiten aus tiefgrauem Filz haben die Gestalt ungegenständlicher Formen, die Organisches oder Pflanzliches evozieren. Doch sind Herreras Filzarbeiten im wahrsten Sinne des Wortes stofflich, sprechen nicht allein den Seh-, sondern auch den Tastsinn an und stehen damit auf der Schwelle zum Skulpturalen. Seine Gemälde und Collagen wiederum oszillieren zwischen Gegenständlichkeit und Abstraktion. Die umfangreiche Collagenserie *Boy and Dwarf* aus dem Jahre 2006 fußt auf zwei Figuren aus einem Malbuch, einem Akkordeon spielenden Jungen und einem Zwerg, und auf 20 abstrakten Zeichnungen des Künstlers. Herrera ließ Rückenansichten von beiden Figuren anfertigen und variierte die vier Muster je fünf Mal, dann überlagerte er sie mit den 20 Zeichnungen. Diese Grundbilder wurden auf ihrerseits schon bearbeitete – bemalte oder collagierte – Flächen projiziert und ausgeschnitten, manchmal mit ausgesparten, verdoppelten oder umgedrehten Elementen. Aus diesem Prozess entstanden 75 Arbeiten, deren Titel ihren Platz in der Serie sowie die Figurenansichten bezeichnen – B für boy, D für dwarf, B für back und F für front. Durch den Transformationsprozess ist das bildhafte Ausgangsmaterial meist kaum noch auszumachen im Zusammenspiel feiner farbiger Linien, gemaserter malerischer Felder und gemusterten Materials. So spielt Herrera hier zwei traditionelle Pole der Kunst gegeneinander aus – er lädt die Abstraktion mit einer konkreten Lesbarkeit auf, die er jedoch zugleich mit allen Mitteln wieder auflöst.

Si l'on voulait réduire le travail très diversifié d'Arturo Herrera à une formule, on pourrait dire que son propos est d'entrer dans les domaines interstitiels avec des œuvres qui portent en elles un aspect « ceci-et-son-contraire ». Ses œuvres actuelles réalisées en feutre gris foncé se présentent comme des formes non-figuratives qui évoquent l'organique ou le végétal. Mais les œuvres en feutre d'Herrera sont tangibles au sens littéral : elles ne s'adressent pas seulement au sens visuel mais aussi au toucher et se situent donc au seuil du sculptural. Ses peintures et ses collages oscillent quant à eux entre figuration et abstraction. La série de collages *Boy and Dwarf*, réalisée en 2006, repose sur deux figures d'un album de coloriages – un jeune accordéoniste et un nain – et vingt dessins abstraits de l'artiste. Herrera a fait réaliser des vues postérieures des deux figures et a varié cinq fois chacun des quatre motifs avant d'y superposer les vingt dessins. Ces images de base ont été projetées à leur tour sur des surfaces déjà traitées – peintes ou recouvertes de collages –, puis découpées, parfois avec des parties épargnées, redoublées ou renversées. Soixante-quinze œuvres ont vu le jour selon ce procédé, dont les titres désignent la place dans la série et les figures représentées – B pour boy, D pour dwarf, B pour back, F pour front. Après avoir subi cette transformation, le matériau visuel de départ est généralement devenu méconnaissable du fait de l'interaction entre fines lignes colorées, parties picturales veinées et matériaux à motifs. Herrera joue ainsi sur deux polarités traditionnelles – il charge l'abstraction d'une lisibilité concrète tout en dissolvant cette lisibilité par tous les moyens.

A. M.

SELECTED EXHIBITIONS →
2008 *Adaptation*, Smart Museum of Art, Chicago **2007** *Arturo Herrera*, Ikon Gallery, Birmingham. *Arturo Herrera*, Aldrich Museum of Contemporary Art, Ridgefield. *Comic Abstraction*, MoMA, New York **2006** *Anstoß Berlin*, Haus am Waldsee, Berlin. *Transforming Chronologies: An Atlas of Drawings (Part Two)*, MoMA, New York **2005** *Arturo Herrera*, Centro Galego de Arte Contemporánea, Santiago de Compostela. *Extreme Abstraction*, Albright-Knox Art Gallery, Buffalo

SELECTED PUBLICATIONS →
2007 *Arturo Herrera: Boy and Dwarf*, Galerie Max Hetzler, Berlin; Sikkema Jenkins, New York; Holzwarth Publications, Berlin. *Arturo Herrera*, Ikon Gallery, Birmingham. Rosa Olivares, *100 Latin American Artists*, Exit Publicaciones, Olivares y Asociados, Madrid **2006** *Transforming Chronologies*, MoMA, New York. *Carbonic Anhydride*, Galerie Max Hetzler, Berlin **2005** *Arturo Herrera: Keep in Touch*, Centro Galego de Arte Contemporánea, Santiago de Compostela. *Arturo Herrera: You Go First*, DAP, New York

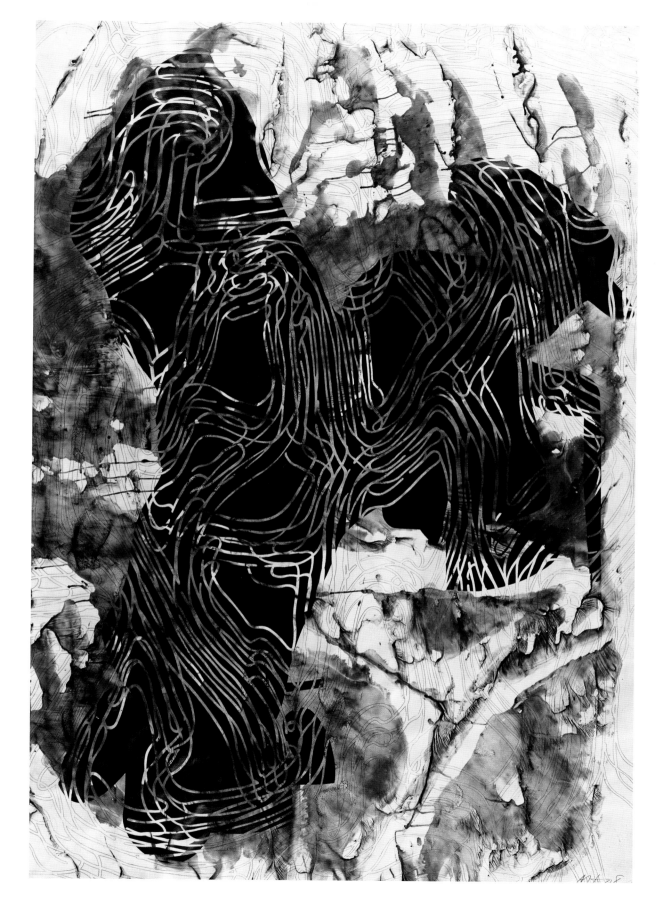

1 **Waiting for Siegfried #2**, 2008, graphite, acrylic on paper, 224.5 x 150 cm
2 **Catch**, 2008, felt, 161 x 153 cm

3 **# 57 BF2**, 2006, cut-out collage, mixed media on paper, 250 x 123 cm
4 **# 69 DB1**, 2006, cut-out collage, mixed media on paper, 250 x 123 cm

„All unsere visuellen Interaktionen werden durch Fragmentierung und Sehnsucht, durch Erinnerungen und Vorstellungen gefiltert."

« Toutes nos interactions visuelles sont relayées par la fragmentation et le désir, la mémoire et l'association. »

"All of our visual interactions are mediated by fragmentation and desire, memory and association."

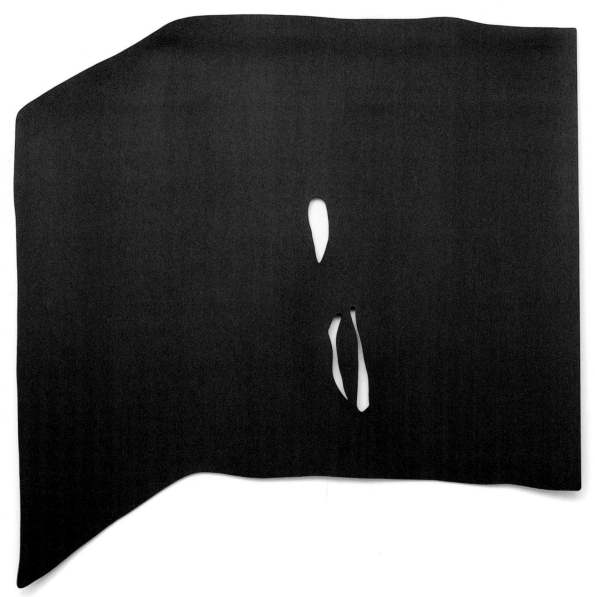

2

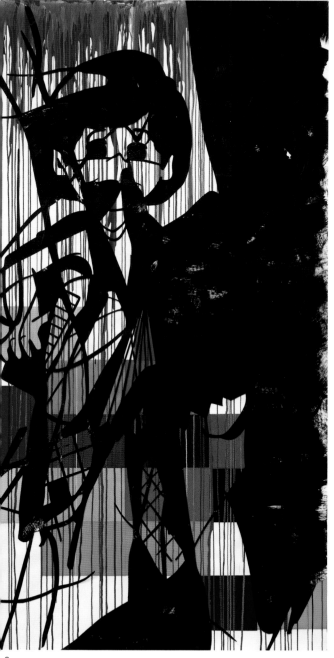

3

4

Charline von Heyl

1960 born in Mainz, Germany, lives and works in New York (NY), USA

Painting, reworking, seizing the right point, emphasizing the imponderable: Charline von Heyl forges paintings through process, thereby overcoming the greatest challenge, that of repetition. Her exhibitions are often emphatically uneven, and this itself is a direct consequence of her artistic approach. Von Heyl works through the broad spectrum of gestural-abstract formal languages in order to open up each painting to surprising new possibilities. Her works combine different idioms, attitudes and speeds, bringing diverse representational forms together within the same space. Von Heyl smuggles representational subtexts into her inclination toward opulence and extensive allover painting. *Yellow Rose* (2007), for example, can be seen as an abstract painting, but strangely alarming, zig-zagging lines and skull-like faces seem to threaten the blossom. And one look at the title makes *Woman* (2005) a violated shape, all patched and stitched up. While the former stylistically might recall Basquiat, the other de Kooning, von Heyl never stops at mere allusion, but instead takes stylistic formulae in unexpected directions. The crucial thing is what remains undecidable. *Tathata* (2007), for example, visually embodies the openness of its title (a Buddhist term for the "true state of things"), *Foul* (2005) sumptuously celebrates the unfinished state. The New York critic Jerry Saltz once described von Heyl's work somewhat smugly: "Much of her art takes me to a wonderful snake pit where styles I thought were outmoded turn dangerous again." But more and more it looks like the true danger of these paintings lies in their content.

Malen, umarbeiten, den richtigen Punkt erwischen, Unwägbarkeit zuspitzen. Charline von Heyl erfindet das Bild nah am Prozess und dabei gelingt wiederholt das Schwerste: sich nicht zu reproduzieren. Ihre Ausstellungen sind oft entschieden unausgewogen und gerade darin zeigt sich die Konsequenz der künstlerischen Haltung. Von Heyl arbeitet sich durchs weite Spektrum gestisch-abstrakter Formensprachen, um das jeweils nächste Bild für überraschend neue Möglichkeiten zu öffnen. Ihre Malerei verknüpft ganz unterschiedliche Idiome, Attitüden und Geschwindigkeiten, bringt verschiedene Repräsentationsformen nebeneinander zu stehen. In die Tendenz zu Üppigkeit und flächigem Allover schleust von Heyl auch gegenständliche Subtexte ein: *Yellow Rose* (2007) etwa kann man als abstraktes Gemälde betrachten, aber seltsam unheimliche Zickzack-Linien und schädelartige Gesichtsformen scheinen die Blüte zu bedrohen. Und wenn man den Titel gelesen hat, wird aus *Woman* (2005) eine verletzte Form, die verbunden und zusammengenäht wurde. Lässt der Stil des einen Bildes vielleicht an Basquiat und des anderen an de Kooning denken, bleibt von Heyl jedoch nie bei Anspielungen stehen, sondern wendet Stilformeln ins Unerwartete: Entscheidend ist, was unentscheidbar bleibt. *Tathata* (2007) etwa verkörpert bildhaft und im Titel (ein buddhistischer Terminus für die Form fundamentaler Wirklichkeit) solche Offenheit, *Foul* (2005) zelebriert auf großartige Weise das Unfertige. Der New Yorker Kritiker Jerry Saltz bezeichnete von Heyls Werk einmal ein wenig süffisant als „herrliche Schlangengrube, in der Stile, die man längst für ausrangiert gehalten hatte, plötzlich wieder Biss bekommen." Aber immer deutlicher wird, dass der wahre Biss dieser Gemälde in ihrem Gegenstand liegt.

Peindre, transformer, capter le juste équilibre, exacerber l'impondérable. Charline von Heyl invente le tableau au plus près du processus et réussit de manière récurrente le plus difficile : éviter la redite. Ses expositions sont souvent résolument mal équilibrées et c'est précisément ce qui fait la cohérence de sa démarche artistique. Elle se fraye un chemin à travers le vaste éventail du vocabulaire gestuel-abstrait pour ouvrir chaque tableau à des possibilités étonnamment nouvelles. Sa peinture relie des idiomes, des attitudes et des vitesses totalement différents et fait coexister des modes de représentation divergents. Dans sa tendance à l'exubérance et à l'*all-over*, elle intègre également des sous-textes figuratifs : *Yellow Rose* (2007) peut être lu de manière abstraite ou figurative, mais les étranges zigzags et figures en forme de crâne semblent menacer la floraison. Après lecture du titre, le tableau *Woman* (2007) devient une forme blessée. Si le style du premier tableau peut rappeler Basquiat et le second de Kooning, von Heyl ne se cantonne jamais à l'allusion, mais retourne inopinément les formules stylistiques : l'aspect décisif est ce qui reste indécis. *Tathata* (2007) incarne ce genre d'ouverture de manière imagée et par son titre (un terme bouddhiste désignant un état suprême de vérité). *Foul* (2005) est une célébration grandiose de l'inachevé. Non sans suffisance, le critique new-yorkais Jerry Saltz a décrit l'œuvre de von Heyl comme « une magnifique fosse aux serpents dans laquelle les styles qu'on croyait depuis longtemps dépassés retrouvent tout à coup du mordant. » Il devient cependant de plus en plus évident que le danger de ces peintures provient de leur contenu.

J. A.

SELECTED EXHIBITIONS →
2008 *Charline von Heyl*, Westlondonprojects, London. *Oranges and Sardines: Conversations on Abstract Painting with Mark Grotjahn, Wade Guyton, Mary Heilmann, Amy Sillman, Charline von Heyl, and Christopher Wool*, Hammer Museum, Los Angeles **2006** *Make Your Own Life: Artists in and out of Cologne*, ICA, Philadelphia; The Power Plant, Toronto; Henry Art Gallery, Seattle; MOCA, North Miami **2005** *Concentrations 48: Charline von Heyl*, Dallas Museum of Art, Dallas **2004** *Charline von Heyl*, Secession, Vienna

SELECTED PUBLICATIONS →
2008 Jörg Heiser, *All of a Sudden: Things that Matter in Contemporary Art*, Sternberg Press, Berlin. Kim Seung-duk, Franck Gautherot, *The Alliance*, doArt Co., Seoul **2006** *Make Your Own Life: Artists in and out of Cologne*, ICA, Philadelphia **2005** Richer, Francesca and Matthew Rosenzweig, *No. 1: First Works by 362 Artists*, DAP, New York. *CAP Collection*, CAP Art Limited, Dublin **2004** *Charline von Heyl*, Secession, Vienna

1

1 **Yellow Rose**, 2007, oil on canvas, 208 x 198 cm
2 **Tathata**, 2007, oil on canvas, 208 x 198 cm

3 **Foul**, 2005, acrylic, oil on canvas, 228.6 x 215.9 cm
4 **Woman**, 2005, charcoal, acrylic, oil on canvas, 208.3 x 198.1 cm

„Jedes Gemälde schafft auf seine ganz individuelle Weise einen völlig abstrakten Raum der Stille im Kopf, eine Ruhe, die Bewegung einschließt, die Gegenwart einer Abwesenheit und etwas, an dem die Augen zu nagen haben."

« Chacune des peintures crée de manière totalement différente un espace radicalement abstrait de silence dans la tête, avec une quiétude pleine de mouvement, avec la présence d'une absence, avec de quoi ronger pour les yeux. »

"Each one of the paintings in a completely different way creates a radically abstract space of silence in the head, with a stillness that contains movement, with the presence of an absence, with something for the eyes to chew on."

2

3

Thomas Hirschhorn

1957 born in Bern, Switzerland, lives and works in Paris, France

Cardboard, polystyrene, adhesive tape, dolls, baby seals, sunsets and Ferraris, all soaked in red – objects and images that evoke horror films, news reports or blunt advertising. "Brutales Paradies" (brutal paradise): Thomas Hirschhorn included these words in his expansive installation *Das Auge* at the Vienna Secession (2008) – a textual reference that reveals the artist's interest in contradictions, especially those in the systems of art and politics. Having been influenced by the "social sculptures" of Joseph Beuys and the burgeoning installative collages of Anna Oppermann, Hirschhorn has in recent years been developing installation-based artworks which – in the form of kiosks, altars or monuments – often find their way out of the art institutions and onto the streets. One such piece is his *Ingeborg Bachmann Altar* shown in the context of the exhibition project "U2 Alexanderplatz" by Berlin's Neue Gesellschaft für Bildende Kunst (2006). What looks like a spontaneous piece of popular memorial culture is simultaneously a gesture of opposition to slick, market-friendly art. "I deliberately make them bad," Hirschhorn once said of his installations. Yet his do-it-yourself aesthetic should not be confused with lack of ability: it is a calculated gesture – artistic and political at once. The photographs, writing, books and commonplace items he incorporates into his installations constitute systems of reference to art and politics. A recurring theme is the treatment of people in art, philosophy and politics, whereby Hirschhorn seeks to point up contradictions. In the overwhelming abundance of his installative praxis it is always the small indicators that break open meanings and reveal contradictions: a "brutal paradise" – as the human condition?

Pappe, Styropor, Klebeband, Puppen und Robbenbabys, Sonnenuntergänge und Ferraris, alles in Rot getränkt – Objekte und Bilder wie aus Horrorfilmen, Nachrichten und Werbung. „Brutales Paradies": Thomas Hirschhorn schrieb diese Worte als Teil seiner hallenfüllenden Installation *Das Auge* in der Wiener Secession (2008). Ein Texthinweis, der auf das Interesse des Künstlers an Widersprüchen schließen lässt, vor allem an Widersprüchen im System der Kunst und der Politik. Geschult an den sozialen Plastiken von Joseph Beuys und den wuchernden installativen Collagen von Anna Oppermann, entwickelte Hirschhorn in den letzten Jahren installative Kunstwerke, die oftmals in Form von Kiosken, Altären oder Monumenten den Weg aus den Kunstinstitutionen auf die Straße suchten. So verhält es sich auch bei dem *Ingeborg Bachmann Altar* im Rahmen des Ausstellungsprojektes „U2 Alexanderplatz" der Neuen Gesellschaft für Bildende Kunst (2006). Was wie spontane, populäre Memorialkultur aussieht, ist zugleich eine Widerstandsgeste gegen glatte, marktkonforme Kunst. „Ich mache sie extra schlecht", äußerte sich Thomas Hirschhorn zu seinen Installationen. Doch seine Do-it-yourself-Ästhetik ist nicht mit Unfähigkeit zu verwechseln, sondern kalkulierte künstlerische und politische Geste in einem. Denn die eingefügten Fotografien, Schriftzüge, Bücher und Alltagsgegenstände errichten Verweissysteme auf Kunst und Politik. Immer wieder geht es dabei um den Umgang mit dem Menschen, in der Kunst, der Philosophie und der Politik. Hirschhorn versucht dabei, Widersprüche zu thematisieren. In der überbordenden Fülle seiner installativen Praxis sind es dann auch stets die kleinen Hinweise, welche Bedeutungen aufbrechen lassen und Widersprüche hervorkehren: ein „brutales Paradies" – als conditio humana?

Carton, polystyrène, ruban adhésif, poupées et bébés phoques, couchers de soleil et Ferraris, le tout trempé de rouge – des objets et des images comme sortis de films d'horreur, des nouvelles et de la publicité. Thomas Hirschhorn a écrit les mots « Brutales Paradies » (paradis brutal) comme partie de sa vaste installation *Das Auge* exposée à la Secession à Vienne (2008), référence textuelle dont on déduit l'intérêt de l'artiste pour les contradictions, particulièrement celles des systèmes de l'art et de la politique. Formé à la sculpture sociale de Joseph Beuys et aux débauches de collages installatifs d'Anna Oppermann, Hirschhorn a développé ces dernières années des œuvres proches de l'installation qui cherchent un chemin vers la rue, souvent sous forme de kiosques, d'autels ou de monuments, hors des institutions artistiques. Ceci vaut notamment pour son *Ingeborg Bachmann Altar* réalisé dans le cadre du projet d'exposition « U2 Alexanderplatz » de la Neue Gesellschaft für Bildende Kunst à Berlin (2006). Ce qui se présente comme une culture mémorielle spontanée, populaire, est aussi un acte de résistance contre un art léché répondant aux besoins du marché. « Je m'arrange pour mal les faire », déclare Hirschhorn à propos de ses installations. Mais son esthétique « bricolée » ne doit pas être prise pour un manque de savoir-faire, elle est à la fois position artistique et politique. Car les photographies présentes dans ses œuvres, les écritures, les livres et les objets quotidiens élaborent des systèmes de références à l'art et à la politique. Il y est sans cesse question des relations humaines dans l'art, la philosophie et la politique. Hirschhorn tente ainsi de mettre en évidence des contradictions. Dans la surabondance de sa pratique installative, ce sont dès lors toujours les petits renvois qui marquent le sens et qui soulignent les contradictions. La condition humaine : un « brutal paradis » ?

H. L.

SELECTED EXHIBITIONS →
2008 *Thomas Hirschhorn: Das Auge*, Secession, Vienna. *Thomas Hirschhorn: Stand-alone*, Museo Tamayo, Mexico **2007** *Thomas Hirschhorn: Jumbo Spoons and Big Cake*, Musée d'art contemporain de Montréal. Volksgarten **2006** *Thomas Hirschhorn, Le Creux de l'enfer*, Thiers. *Thomas Hirschhorn: The Procession*, Kestnergesellschaft, Hanover. *Thomas Hirschhorn: Utopia, Utopia = One World, One War, One Army, One Dress*, CCA Wattis Institute for Contemporary Arts, San Francisco

SELECTED PUBLICATIONS →
2008 *Thomas Hirschhorn*, Secession, Vienna **2007** *J'ai parlé avec...*, Les Presses du Réel, Dijon. *Heart of Darkness*, Walker Art Center, Minneapolis. *Volksgarten. Die Politik der Zugehörigkeit*, Kunsthaus Graz; Verlag der Buchhandlung Walther König, Cologne **2006** *Thomas Hirschhorn: Concretion*, Le Creux de l'enfer, Thiers. *Hirschhorn: The Procession*, Kestnergesellschaft, Hanover **2004** *Thomas Hirschhorn*, Phaidon Press, London

1 Installation view, *Thomas Hirschhorn: Das Auge*, Secession, Vienna, 2008
2 **Substitution 2 (The Unforgettable)**, 2007, mixed media installation, 325 x 562 x 940 cm
3 **Nietzsche Car**, 2008. Installation view, Antiga Lota no Passeio Ribeirinho, Portimão

4 **Ingeborg Bachmann Altar**, 1998. Installation view, U2 Alexanderplatz, Berlin, 2006
5 **Superficial Engagement**, 2006. Installation view, Gladstone Gallery, New York
6 **Stand-alone**, 2007. Installation view, Museo Tamayo Arte Contemporaneo, Mexico City

„Ich benutze Kunst als Werkzeug – als Werkzeug, um die Welt kennenzu-lernen, als Werkzeug, um mich mit der Realität zu konfrontieren, und als Werkzeug, um mich mit der Zeit, in der wir leben, auseinanderzusetzen."

« J'utilise l'art comme un outil, un outil pour connaître le monde, un outil pour affronter la réalité et un outil pour travailler sur l'époque où nous vivons. »

"I use art as a tool – a tool through which I can get to know the world, a tool through which I can confront myself with reality and a tool through which I can get to grips with the times in which we live."

2

3

4

Damien Hirst

1965 born in Bristol, lives and works in Devon, United Kingdom

Death – a fact of life that is systematically repressed despite its crushing relevance to us all – is one of the great themes of art, and one that Damien Hirst returns to repeatedly. It underlies not only his sculptures of animals in vitrines, such as *Saint Sebastian* (2007), but also his spectacular diamond-covered skull *For the Love of God* (2007) and his recent series of *Biopsy Paintings* (2007), which depict different types of cancer. These find their counterpart in a series featuring the birth of the artist's son by Caesarean section: *Birth Paintings* (2007). Exploring the span of life and death – the intersections of religion, science and art – often through Christian iconography, constitutes one side of Hirst's work. However, he devotes just as much passion and energy to playing the art market. Besides being an artist and producer, he is also curator and collector of art. In this last role he also exhibited works from his collection under the ironic title *In the darkest hour there may be light* (2007). The circularity of art embodied within a single person is also found in Hirst's diamond skull. With what initially appears to be consummate decadence, he covered the platinum cast of a real human skull with 8601 flawless diamonds. It was bought for around 100 million dollars by a group of investors, among them – to the subsequent amazement of the public – Hirst himself. His public image thus remains divided: for some people he is the guy who deals in dead animals; others think he explores existential issues in extraordinary ways; others again consider him a manipulator of the art market, or even its emblem. Perhaps there are more facets to those diamonds than we first thought?

Der Tod, meist verdrängt und dennoch von zwingender Relevanz für jeden, ist eines jener großen Themen der Kunst, denen sich auch Damien Hirst immer wieder zuwendet. Dies gilt für seine Tier-Skulpturen in Vitrinen, wie *Saint Sebastian* (2007), seinen spektakulären Diamantenschädel *For the Love of God* (2007), aber auch seine neuere Gemäldeserie der *Biopsy Paintings* (2007). Diese zeigt verschiedene Formen von Krebserkrankungen. Ihr gegenüber steht die Serie der *Birth Paintings* (2007), auf der die Geburt des Sohns des Künstlers durch Kaiserschnitt das Thema ist. Die Spanne von Leben und Tod an den Schnittpunkten von Religion, Wissenschaft und Kunst auszuloten, oft unter Nutzung christlicher Ikonografie, prägt eine Seite der Arbeiten von Hirst. Mit genauso großer Leidenschaft wie diesen Themen widmet er sich auch dem Spiel mit dem Kunstmarkt. Denn Hirst ist nicht nur Künstler und Produzent, sondern auch Kurator und Kunstsammler. Als solcher stellte er seine selbst gesammelte Kunst unter dem ironischen Titel *In the darkest hour there may be light* (2007) aus. Die Zirkularität von Kunst in einer Person betrifft dann auch Hirsts Diamantenschädel. Was zunächst wie perfekte Dekadenz wirkt – den Platinabguss eines echten Totenschädels mit 8601 lupenreinen Diamanten zu bedecken –, wurde für ca. 100 Millionen Dollar an eine Investorengruppe verkauft. Der wiederum gehört, zur nachträglichen Verblüffung der Öffentlichkeit, Hirst selbst an. Und so bleibt Hirsts Wahrnehmung in der Öffentlichkeit gespalten: für die einen ein Händler mit toten Tieren, für die anderen jemand, der auf außergewöhnliche Weise existenziellen Fragen nachgeht, und für manche ein Voltendreher des Kunstmarktes, wenn nicht gar dessen Emblem. Vielleicht stecken in den Reflexionen der Diamanten doch mehr Reflexionen als gedacht?

La mort, le plus souvent refoulée, mais néanmoins une réalité cruciale pour chacun, est un des grands thèmes de l'art auquel Damien Hirst revient lui aussi de manière récurrente. Ceci vaut pour ses sculptures animales exposées dans des aquariums (*Saint Sebastian*, 2007), son spectaculaire crâne couvert de diamants *For the Love of God* (2007), mais aussi pour sa nouvelle série de peintures, les *Biopsy Paintings* (2007), qui montre différentes formes de cancers. À cette série s'oppose celle des *Birth Paintings* (2007) illustrant la naissance de son fils par césarienne. Sonder la frange de temps entre la naissance et la mort à la croisée de la religion, des sciences et de l'art, souvent en faisant appel à l'iconographie chrétienne, est une facette de l'œuvre de Hirst. Mais l'artiste se consacre tout aussi passionnément au jeu avec le marché de l'art. Car Hirst n'est pas seulement artiste et producteur, mais aussi commissaire d'exposition et collectionneur. Le commissaire exposa l'art qu'il a lui-même collectionné et le présenta sous le titre ironique *In the darkest hour there may be light* (2007). La boucle artistique à l'intérieur d'une seule et même personne englobe dès lors aussi le crâne diamanté de Hirst. Ce qui fait d'abord l'effet d'une parfaite décadence – couvrir de 8601 diamants parfaitement purs le moulage en platine d'un crâne du XVIIIᵉ siècle – a été vendu pour quelque 100 millions de dollars à un groupe d'investisseurs dont Hirst – à la surprise ultérieure du public – fait lui-même partie. La réception publique de l'artiste reste de ce fait partagée : marchand d'animaux morts pour les uns, artiste qui se pose des questions existentielles d'une manière inhabituelle pour les autres, ou encore voltigeur du marché de l'art, voire son emblème. Malgré tout, les réflexions des diamants révèlent peut-être plus de facettes qu'on ne le pense ?

H. L.

SELECTED EXHIBITIONS →
2008 *Damien Hirst: Beautiful inside My Head Forever*, Sotheby's Auction, London. *Focus: Damien Hirst*, Kemper Museum of Contemporary Art, Kansas City **2007** *Damien Hirst*, Lever House, New York. *Damien Hirst: Beyond Belief*, White Cube, London. *Damien Hirst/David Bailey: The Stations of the Cross*, Sammlung Essl, Klosterneuburg **2006** *Damien Hirst: New Religion*, Rogaland Museum of Fine Arts, Stavanger **2005** *Damien Hirst*, Astrup Fearnly Museet for Moderne Kunst, Oslo

SELECTED PUBLICATIONS →
2008 *Damien Hirst: Beyond Belief*, White Cube; Other Criteria, London **2007** *Damien Hirst: For the Love of God. The Making of the Diamond Skull*, White Cube, London. *Damien Hirst: Superstition*, Gagosian Gallery, Los Angeles; Other Criteria, London **2006** *Damien Hirst: Corpus, Drawings 1981–2006*, Gagosian Gallery, Other Criteria, London. *Hirst, Damien: The Death of God. Towards a Better Understanding of a Life Without God Aboard the Ship of Fools*, Galeria Hilario Galguera, Mexico City; Other Criteria, London

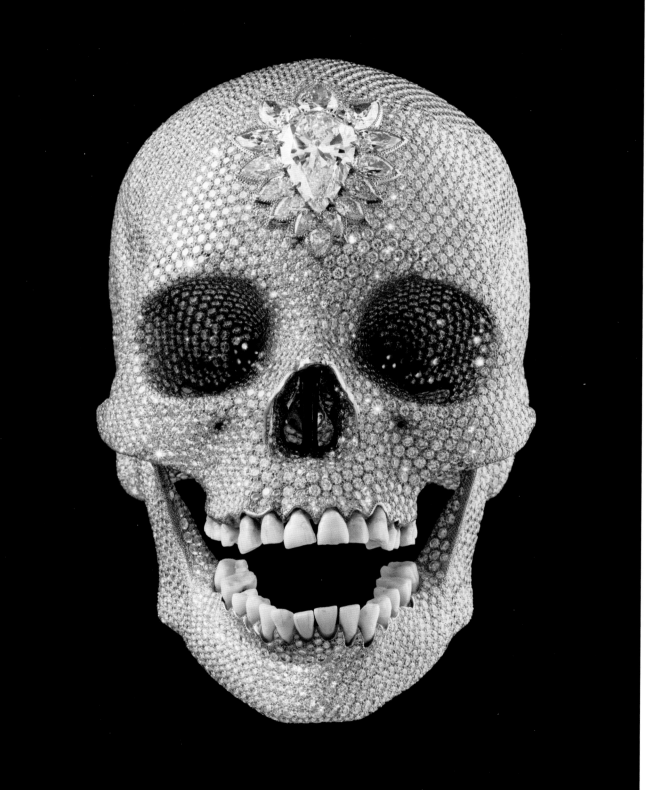

1 **For the Love of God**, 2007, platinum, diamonds, human teeth,
17 x 13 x 19 cm
2 **Baby Born by Caesarean Section (Cyrus)**, 2007, oil on canvas, 81.3 x 61 cm

3 **Saint Sebastian, Exquisite Pain**, 2007 (detail), glass, steel, bullock, arrows,
crossbow bolts, formaldehyde solution, 322 x 156 x 156 cm

„Über die Kunst kommt man der Unsterblichkeit so nahe wie nur möglich, aber sie ist ein dürftiger Ersatz – du arbeitest für Menschen, die noch nicht geboren sind – und die Leute wollen die Sachen, weil sie genial sind. Am Ende landet sowieso alles in Museen; die Reichen müssen es dem Volk zurückgeben. Sie haben keine Wahl, ein Leichentuch hat keine Taschen."

« L'art est la meilleure façon d'approcher l'immortalité, bien que ce soit un piètre substitut – on travaille pour des gens qui ne sont pas encore nés – et les gens veulent de l'art parce qu'il est génial. De toutes façons il finit dans les musées, les riches doivent le rendre au peuple. Ils n'ont pas le choix, un linceul n'a pas de poches. »

"Art is the closest you can get to immortality, though it's a poor substitute – you're working for people not yet born – and people want it because it is brilliant. It ends up in museums anyway; the rich have to give it back to the people, it's their only option. There are no pockets in a shroud."

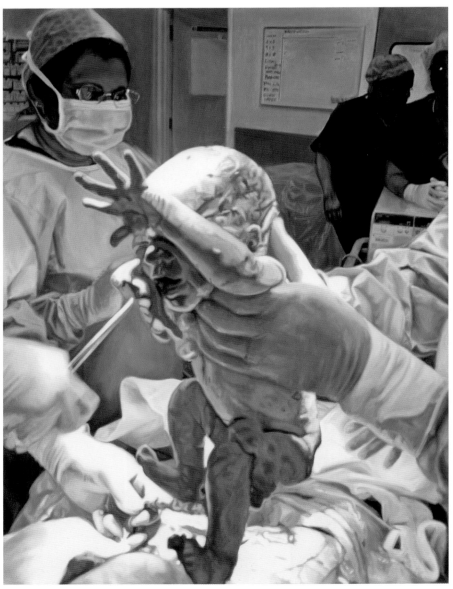

2

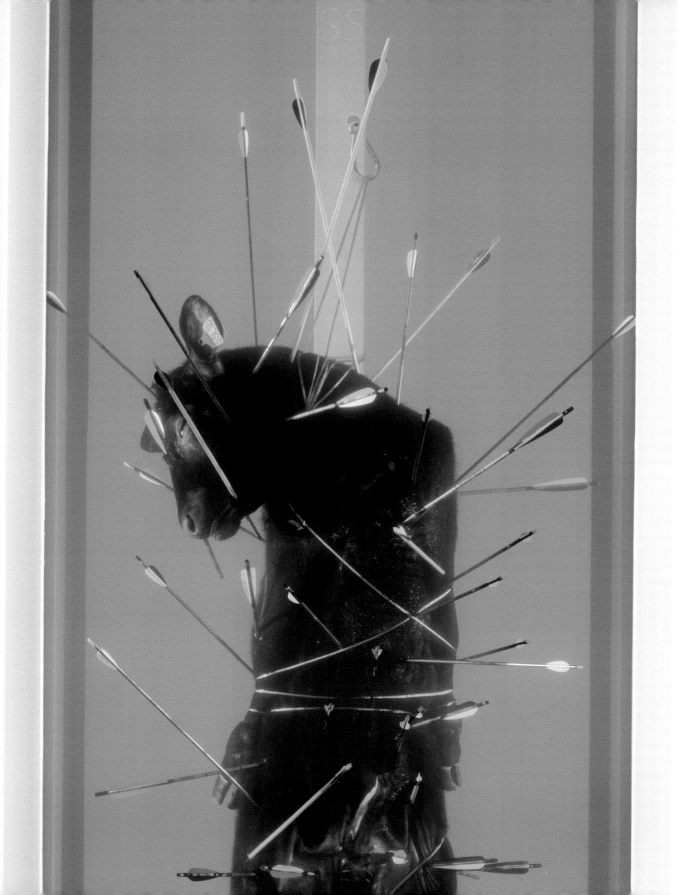

Andreas Hofer

1963 born in Munich, lives and works in Berlin, Germany

For *Phantom Gallery*, which took place concurrently in Zurich and Los Angeles in 2008, Andreas Hofer exhibited empty space. In L.A. it was an empty store on Sunset Strip, on whose yellowing walls negative traces of shelves and posters maintained a ghostly presence. In Zurich he reconstructed the same space, complete with traces and carpet, within a gallery. The locations were connected by video conference. Hofer's latest choice of medium may come as a surprise, given his otherwise rich language of images and symbols. But his work across a variety of media often deals with spirits and demons, shadows of the past and ambiguity. Hofer usually signs his paintings "Andy Hope 1930" – a date that, for him, marks the zero point of modernity, particularly as far as German history is concerned. In his magicaly ambivalent pictorial worlds he quotes German romanticism, Nazi symbols and art, surrealism, Christian iconography and occultism, but also comic-strip superheroes and fetish items of American culture, for example in the series *V People* (2008). Hofer's exhibitions are characterized by a transformative appropriation of space. In *Trans Time* (2006) he transformed the exhibition space with an installation based on Mount Rushmore, but with the monumental presidential heads replaced by those of Hollywood stars. In the interior of this pop-culturized national monument, Hofer presented an installation of his own works staged with mystical lighting, as if it were a shrine – also a form of playing with (his own) ghosts.

Mit *Phantom Gallery*, die 2008 parallel in Zürich und in L.A. stattfand, stellte Andreas Hofer leere Räume aus. In L.A. war es ein leer stehender Laden am Sunset Strip, an dessen vergilbten Wänden Negativspuren von Einrichtung und Bildern als Phantome existierten. In Zürich baute er die Räume samt Spuren und Teppich als Raum im Raum in die Galerie ein. Beide Orte waren durch eine Videokonferenz verbunden. Das Ausstellen leerer Räume mag überraschen in der sonst an Bildern und Symbolen reichen Sprache Hofers. Doch geht es in seinen Arbeiten, die verschiedene Medien umfassen, viel um Geister und Dämonen, um Schatten der Vergangenheit, um Ambiguität. Hofer signiert seine Bilder meist mit „Andy Hope 1930" – ein Datum, das für ihn einen Nullpunkt der Moderne markiert, gerade im Hinblick auf die deutsche Geschichte. In seinen magisch ambivalenten Bildwelten zitiert er unter anderem die deutsche Romantik, Symbole und Kunst des Nationalsozialismus, den Surrealismus, christliche Ikonografie und Okkultismus, doch auch Comic-Superhelden und Fetische der amerikanischen Kultur, etwa in der Serie *V People* (2008). Hofers Ausstellungspraxis ist geprägt von der transformierenden Aneignung von Räumen. In *Trans Time* (2006) verwandelte er die Ausstellungsräume durch eine Installation, die an die Präsidentenporträts des Mount Rushmore erinnert. Allerdings erscheinen monumentale Porträtköpfe von Hollywooddiven anstelle der Präsidenten. Hofer nutzte dann das Innere des popkulturalisierten Nationalmonuments für eine mit geheimnisvoller Beleuchtung inszenierte Präsentation seiner Arbeiten, die so zum Memorialinhalt avancierten – auch eine Form des Spiels mit den (eigenen) Geistern.

Pour son exposition *Phantom Gallery* qui s'est tenue simultanément à Zurich et à Los Angeles, Andreas Hofer exposait des espaces vides. À Los Angeles, il s'agissait d'une boutique vide de Sunset Strip dont les murs jaunis présentaient les traces négatives et fantomatiques du mobilier et des images qui y avaient existé. Dans la galerie zurichoise, Hofer avait recréé les espaces – avec traces et tapis – comme espace dans l'espace. Les deux lieux étaient reliés par vidéoconférence. Dans le contexte du langage artistique de Hofer, qui abonde habituellement en images et en symboles, l'exposition d'espaces vides peut surprendre. Mais les œuvres qu'il réalise avec différents médiums traitent souvent d'esprits et de démons, des ombres du passé, d'ambiguïté. Hofer signe généralement ses tableaux « Andy Hope 1930 », date qui marque selon lui le moment zéro de la modernité, particulièrement dans l'histoire allemande. Dans ses univers visuels magiques et ambivalents, il cite notamment le romantisme allemand, les symboles et l'art nazis, le surréalisme, l'iconographie chrétienne et l'occultisme, mais aussi les superhéros des bandes dessinées et les fétiches de la culture américaine, comme dans la série *V People* (2008). La pratique d'exposition de Hofer est marquée par l'appropriation transformatrice des espaces. Dans *Trans Time* (2006), il transformait les salles d'exposition par une installation rappelant les portraits présidentiels du mont Rushmore, mais dont les têtes avaient été remplacées par les portraits monumentaux de divas hollywoodiennes. De plus, Hofer utilisait l'espace intérieur du monument national de la culture pop pour une présentation – mise en scène avec des éclairages mystérieux – de ses propres œuvres, dont le contenu devenait ainsi lui-même un mémorial – une autre forme du jeu avec les esprits (de l'artiste).

E. S.

SELECTED EXHIBITIONS →
2008 *Vertrautes Terrain – Aktuelle Kunst in und über Deutschland*, ZKM, Karlsruhe. *Back to Black – Schwarz in der aktuellen Malerei*, Kestnergesellschaft, Hanover. *Daydreams & Dark Sides*, Künstlerhaus Bethanien, Berlin **2007** *NIVEAUALARM*, Kunstraum Innsbruck. *Made in Germany*, Kestnergesellschaft, Hanover. *There is never a stop and never a finish*, Hamburger Bahnhof, Berlin **2005** *Andreas Hofer: Welt ohne Ende*, Lenbachhaus München, Munich; MARTa Herford, Herford

SELECTED PUBLICATIONS →
2007 *Andreas Hofer: Only Gods Could Survive*, Metro Pictures, New York. *Kommando Friedrich Hölderlin Berlin*, Galerie Max Hetzler, Berlin **2006** *Andreas Hofer: This Island Earth*, Steidl Hauser & Wirth, Göttingen **2005** *Andreas Hofer: Welt ohne Ende*, Lenbachhaus München, Munich; MARTa Herford, Herford; Verlag der Buchhandlung Walther König, Cologne. *Andreas Hofer: Peiner Block*, Galerie Guido W. Baudach; Verlag Heckler & Koch, Berlin. *Neverworld Technik*, Verlag Heckler & Koch, Berlin.

1 **Being Immortal. MXYZPTLK**, 2008, acrylic on canvas, 70 x 50 cm
2 **City of Sokrates**, 2008, acrylic on canvas, 230 x 314 cm
3 **Tomorrow People**, 2004, acrylic lacquer on wood, 280 x 450 cm

4 Installation view, *Andreas Hofer: This Island Earth*,
 Hauser & Wirth, London, 2006
5 Installation view, *Andreas Hofer: Trans Time*,
 Galerie Guido W. Baudach, Berlin, 2006

„Mir geht es grundsätzlich darum, nicht nur einfach zu sampeln,
sondern ich will einen neuen Zusammenhang erzeugen."

« Ce qui m'importe avant tout, ce n'est pas simplement de sampler ;
je veux instaurer un nouveau rapport entre les choses. »

"Basically, I'm not interested in just sampling, but in creating a new context."

2

3

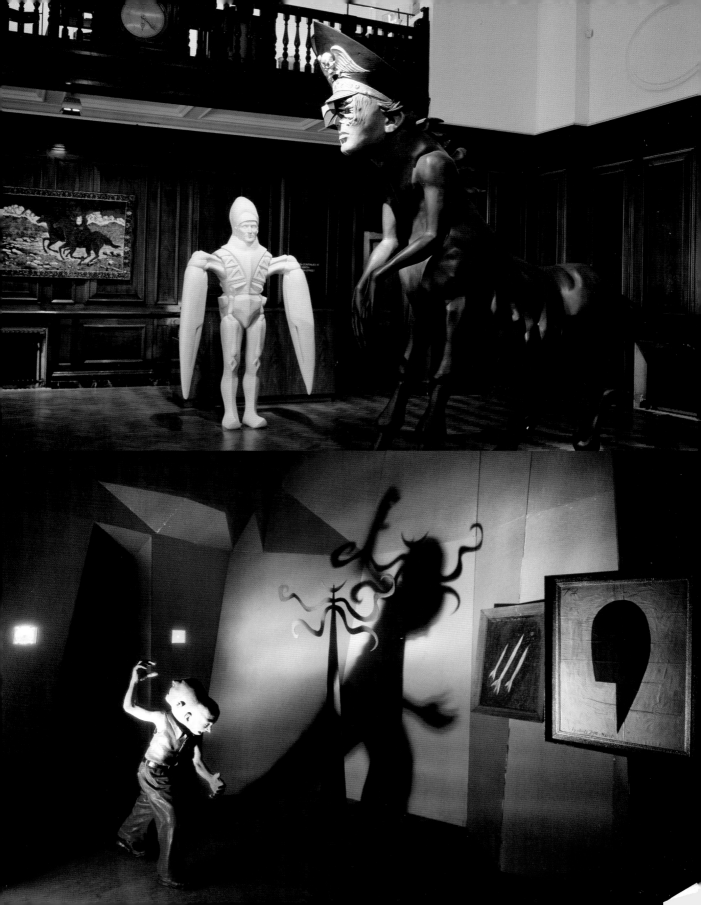

Thomas Houseago

1972 born in Leeds, United Kingdom, lives and works in Los Angeles (CA), USA

Archaic and contemporary, monumental yet fragile, commanding respect but also broken – Thomas Houseago's sculptures of human figures, heads and individual body parts unite qualities that at first seem completely incompatible. His larger than life *Striding Giant* (2008), for example, looms over the viewer with balled fist and sunken head tipped forward. The figure looks as if it could be part of a theatre backdrop – if you walk around it, its two-dimensionality is revealed, along with the way in which it was built. The giant figure is made of disparate elements that are all forms of construction material. The wooden head is shaped like an oval and bears an abstract relief that recalls cubist experiments with form. The body consists of a cut-out piece of plasterboard, on the front of which anatomic details have been roughly sketched. One arm is attached in an oddly awkward position and the feet are weighted with plaster, as if the artist wanted to slow the giant's steps in nightmarish fashion. But the nightmare, the uncanny, is only one facet of these predominantly white sculptures; there is also something comical about these bodies with their strange limbs and bent shapes. Houseago's sculptures are characterized by their engagement with art history. The art-historical influences in his oeuvre are numerous, but both thematically and formally his works are already almost a fusion of the various strands of modernism, which segmented the conventional image, integrated everyday materials into art and borrowed from art forms as disparate as Greek classicism or non-Western cult images.

Archaisch und zeitgenössisch, monumental und doch fragil, respekteinflößend und gebrochen zugleich – Thomas Houseagos Skulpturen von vorwiegend menschlichen Figuren, Köpfen und einzelnen Körperteilen vereinen Eigenschaften in sich, die zunächst vollkommen unvereinbar scheinen. Sein überlebensgroßer *Striding Giant* (2008) etwa schreitet dem Betrachter schwerfällig entgegen, eine Faust geballt, der Kopf gesenkt, nach vorn gebeugt. Es ist eine Gestalt, die etwas Kulissenhaftes hat, denn geht man um sie herum, offenbart sich ihre Flächigkeit, stellt sich ihre Konstruktion zur Schau. Die Figur ist aus disparaten Elementen, sämtlich Baumaterialien, zusammengesetzt: Der hölzerne Kopf beruht auf einem Oval, auf das ein Relief aus abstrakten Formen gesetzt ist, das an kubistische Formenexperimente denken lässt. Der Körper besteht aus einer ausgeschnittenen Gipsplatte, auf deren Vorderseite mit wenigen Strichen anatomische Details angedeutet sind, ein Arm ist seltsam ungelenk angesetzt, die Füße sind mit Gips beschwert, als wollte der Künstler dem Riesen seine Schritte alptraumhaft verlangsamen. Doch ist der Alptraum, das Unheimliche nur eine Facette von Houseagos meist weißen Skulpturen, oft haftet den Körpern mit den seltsamen Gliedmaßen und der verbogenen Körperhaltung auch etwas Komisches an. Houseagos Skulpturen sind dabei geprägt von seiner Auseinandersetzung mit der Kunstgeschichte: Die kunsthistorischen Einflüsse auf sein Œuvre sind vielfältig, doch geraten seine Werke thematisch wie formal fast schon zu einer Fusion der verschiedenen Ausprägungen der Moderne, die das konventionelle Bild zergliederte, Alltagsmaterialien in die Kunst integrierte und bei so disparaten Kunstformen wie der griechischen Klassik oder außereuropäischen Kultbildern Anleihen machte.

Archaïques et contemporaines, monumentales et pourtant fragiles, inspirant le respect et en même temps brisées – les sculptures de Thomas Houseago, essentiellement des figures humaines, des têtes et des parties corporelles, réunissent en elles des propriétés qui semblent a priori s'exclure. Son *Striding Giant* (2008) plus grand que nature marche lourdement à la rencontre du spectateur, poing serré, tête baissée, penché en avant. Cette figure tient du décor de théâtre : quand on la contourne, elle révèle sa superficialité et expose sa conformation. Elle est composée de matériaux disparates appartenant au domaine du bâtiment : la tête de bois est un ovale sur lequel l'artiste a monté des formes abstraites rappelant les expériences cubistes, le corps est fait d'une plaque de plâtre découpée sur laquelle quelques traits indiquent des parties anatomiques, l'attache d'un bras est singulièrement maladroite, les pieds sont lestés de plâtre comme si l'artiste voulait ralentir les pas du géant à la manière d'un cauchemar. Mais le cauchemar et l'étrange ne sont qu'une facette des sculptures le plus souvent blanches de Houseago : avec leurs membres étranges et leurs attitudes tordues, les corps ont aussi quelque chose de comique. En même temps, les œuvres de Houseago sont marquées par un travail sur l'histoire de l'art : les influences de l'histoire de l'art sur son propre travail sont de diverses natures, mais du point de vue thématique autant que formel, ses œuvres se présentent presque comme une fusion des différents développements de la modernité, qui a démembré le tableau traditionnel, fait entré dans l'art des matériaux ordinaires et puisé à des sources aussi disparates que le classicisme grec et les figures cultuelles extra-européennes.

A. M.

SELECTED EXHIBITIONS →
2008 *Thomas Houseago*, Xavier Huffkens, Brussels. *Thomas Houseago*, David Kordansky Gallery, Los Angeles. *Thomas Houseago*, Herald St, London. *Academia: Qui es-tu?*, Chapelle de l'Ecole Nationale Supérieure des Beaux-Arts, Paris **2007** *Thomas Houseago: A Million Miles Away*, The Modern Institute, Glasgow. *Strange things permit themselves the luxury of occurring*, Camden Arts Center, London **2006** *Red Eye: Los Angeles Artists from the Rubell Family Collection*, Rubell Family Collection, Miami

SELECTED PUBLICATIONS →
2008 *Sonsbeek 2008: Grandeur*, Sonsbeek International Foundation, Arnhem **2007** *Red Eye: Los Angeles Artists from the Rubell Family Collection*, Rubell Family Collection, Miami **2005** *Both Ends Burning*, David Kordansky Gallery, Los Angeles

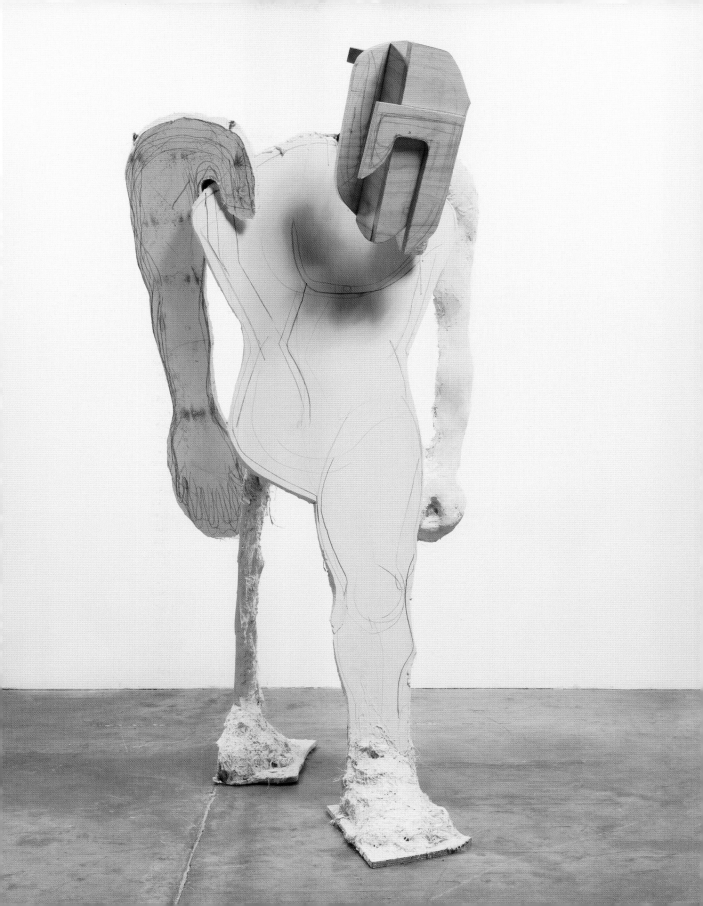

1 **Striding Giant**, 2008, Tuf-Cal, hemp, iron, graphite, 241 x 127 x 173 cm
2 **Snake**, 2007, Tuf-Cal, hemp, iron, graphite, 168 x 127 x 122 cm
3 **Untitled Striding Figure, 1**, 2007, bronze, 315 x 244 x 122 cm
4 **Untitled**, 2008, bronze, 249 x 175 x 200 cm

„Ich glaube, dass man Skulptur jedes Mal, wenn man damit beginnt, neu zum Leben erwecken muss."

« Je pense que chaque fois qu'on approche la sculpture, il faut entièrement la réinspirer. »

"I think that every time someone approaches sculpture, you have to completely re-breathe it."

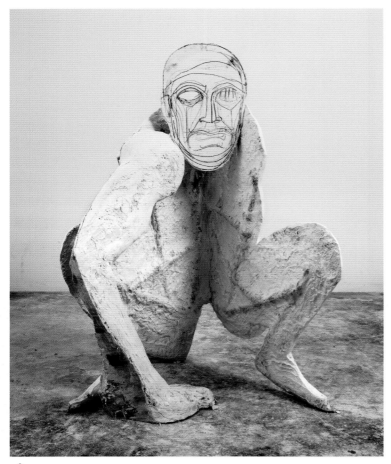

2

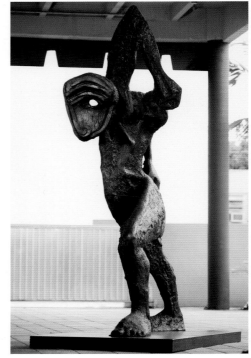

3

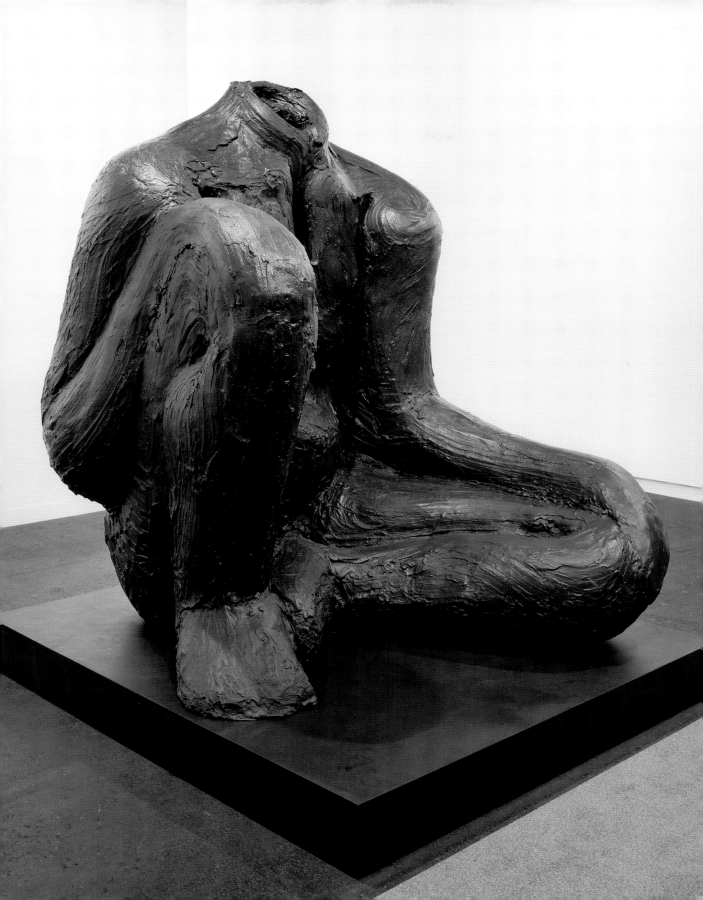

Huang Yong Ping

1954 born in Xiamen, China, lives and works in Paris, France

Since his seminal *The History of Chinese Painting and the History of Modern Western Art Washed in the Washing Machine for Two Minutes* (1987) – for which it took him a mere two minutes to launder an English-language textbook on 20th-century Western art and a classic Chinese art history book into a soggy pulp –, Huang Yong Ping has emerged as one of the most complex artists from China. Co-founder of the collaborative group Xiamen Dada in 1986, which contributed to revive the Chinese art world and make it more widely known internationally, Huang settled in France in 1989 and has been advancing his reflection on the dialogue between the two cultures. He reminds us that taoism is a Chinese philosophy, but also a significant discovery for the Western avant-garde that made John Cage introduce chance operations into his compositions. Huang feels indebted to Cage's work, and he specially shares the same non-chronological, non-hierarchical outlook on the arts, for example with his recent projects rooted in architectural icons that include the Roman Coliseum and the Pentagon, which he rebuilds in ceramics and plants, as seedbed maquettes (*Colosseum*, 2007). One of his most controversial works is *Bat Project* (2001–05), for which Huang partially reconstructed the fuselage of an U.S. surveillance aircraft that had collided with a Chinese military plane in 2001. The crash resulted in a diplomatic incident that ended with the shipping of the dismantled spy plane back to the U.S. onboard a cargo liner. The inaugural presentation of *Bat Project* in China caused controversy, ending in censorship, as it points to the hazy and ill-defined relations between East and West.

Seit seiner einflussreichen Arbeit *The History of Chinese Painting and the History of Modern Western Art Washed in the Washing Machine for Two Minutes* (1987) – bei der er nur zwei Minuten brauchte, um ein englischsprachiges Buch über die westliche Kunst des 20. Jahrhunderts und eine Geschichte der klassischen chinesischen Malerei zu einer breiigen Masse zu waschen – hat sich Huang Yong Ping als einer der komplexesten Künstler Chinas etabliert. 1986 war er Mitbegründer der Künstlergruppe Xiamen Dada, die dazu beitrug, die chinesische Kunstwelt wiederzubeleben und sie international bekannt zu machen, 1989 zog Huang nach Frankreich und hat seine Arbeit über den Dialog der beiden Kulturen stets weiter vertieft. Er verweist darauf, dass der Taoismus nicht nur chinesische Philosophie ist, sondern ebenso eine bedeutsame Entdeckung für die westliche Avantgarde, die John Cage Zufallsoperationen in seine Kompositionen einführen ließ. Huang fühlt sich Cages Arbeit verpflichtet, und er teilt besonders dessen nicht-chronologischen, nicht-hierarchischen Blick auf die Kunst. So beispielsweise in seinen jüngsten Projekten, die sich auf Ikonen der Architektur wie das Kolosseum in Rom und das Pentagon beziehen, die er mit Keramik und Pflanzen als Saatbeet-Modelle nachbaut. Eine seiner umstrittensten Arbeiten ist *Bat Project* (2001–05), für die Huang den Rumpf eines amerikanischen Aufklärungsflugzeugs, das 2001 mit einem chinesischen Militärflugzeug zusammengestoßen war, teilweise nachbaute. Der Crash hatte eine diplomatische Auseinandersetzung zur Folge, später wurde das zerlegte Spionageflugzeug auf einem Frachter zurück in die USA verschifft. Die erstmalige Ausstellung von *Bat Project* in China führte zu einer Kontroverse, die zum Verbot führte, da das Werk zu viel über die vagen und unsicheren Beziehungen zwischen Ost und West aussagte.

Depuis son œuvre majeure, *The History of Chinese Painting and the History of Modern Western Art Washed in the Washing Machine for Two Minutes* (1987), pour laquelle il ne lui fallut pas plus de deux minutes pour passer à la machine un manuel anglais d'histoire de l'art occidental au XXᵉ siècle et un de l'histoire de l'art chinois classique, et les rendre à l'état de substance pâteuse détrempée, Huang Yong Ping est apparu comme l'un des artistes chinois parmi les plus complexes. Cofondateur, en 1986, du collectif d'artistes Xiamen Dada, qui a contribué au renouveau de la scène artistique chinoise et à une meilleure reconnaissance internationale, Huang s'est installé en France en 1989 et a poussé sa réflexion concernant le dialogue entre les deux cultures. Il nous rappelle que le taoïsme est une philosophie chinoise, mais également une découverte marquante pour l'avant-garde occidentale qui a permis à John Cage d'introduire le hasard dans ses compositions. Huang se dit redevable de Cage, et partage avec lui la même conception non chronologique et non hiérarchique des arts, comme le montre ses récents projets faisant référence à des icônes architecturales, tel que le Colisée à Rome ou le Pentagone, qu'il reproduit en céramique et en plantes tels des maquettes en semis (*Colosseum*, 2007). L'une de ses œuvres les plus controversées est *Bat Project* (2001–05), pour laquelle Huang a reconstruit en partie le fuselage d'un avion de surveillance américain entré en collision avec un avion militaire chinois en 2001. L'accident avait provoqué un incident diplomatique qui s'était soldé par le renvoi par cargo de ligne, aux Etats-Unis, de l'avion-espion en pièces détachées. La présentation inaugurale de *Bat Project* en Chine avait suscité la polémique, et le projet, qui pointait du doigt les relations nébuleuses existant entre l'Orient et l'Occident, avait fini par être censuré.

R. M.

SELECTED EXHIBITIONS →
2008 *Huang Yong Ping: Frolic*, Barbican Art Gallery, London. *Huang Yong Ping: Ping Pong*, Astrup Fearnley Museet for Moderne Kunst, Oslo **2006** *Huang Yong Ping: Pantheon*, Centre international d'art et du paysage, Île de Vassivière. *The Unhomely*, 2nd International Biennial of Contemporary Art of Seville **2005** *House of Oracles: A Huang Yong Ping Retrospective*, Walker Art Center, Minneapolis; Mass MOCA, North Adams. *Mahjong: Chinesische Gegenwartskunst aus der Sammlung Sigg*, Kunstmuseum Bern

SELECTED PUBLICATIONS →
2008 *Huang Yong Ping: Ping Pong*, Astrup Fearnley Museet for Moderne Kunst, Oslo. *Huang Yong Ping: Pantheon*, Sylvana, London. *Huang Yong Ping*, Mondadori, Milan **2007** *Breakout: Chinese Art outside China*, Charta, Milan **2005** *House of Oracles: A Huang Yong Ping Retrospective*, Walker Art Center, Minneapolis. *Mahjong: Chinesische Gegenwartskunst aus der Sammlung Sigg*, Kunstmuseum Bern; Hatje Cantz, Ostfildern

1 **Colosseum**, 2007 (detail), ceramic, soil, plants, 226 x 556 x 758 cm
2 **Colosseum**, 2007, ceramic, soil, plants, 226 x 556 x 758 cm. Installation
 view, Gladstone Gallery, New York
3 **Pentagon**, 2007, ceramic, soil, plants, 50 x 550 x 550 cm. Installation view,
 Gladstone Gallery, New York

4/5 **Bat Project IV**, 2004/05, airplane cockpit, bamboo scaffolding, plastic
 construction fence, taxidermic bats, documents, photographs. Installation
 view, The Walker Art Center, Minneapolis, 2006

„Kunstwerke haben eine zeitlose Dimension und sind darin das absolute
Gegenteil von Politik."

« Les œuvres d'art ont une dimension intemporelle, ce qui est le contraire de
la politique. »

"Artworks have a timeless dimension, which is quite the opposite of politics."

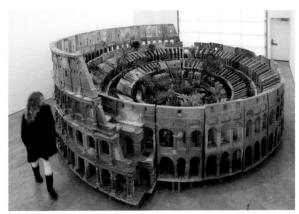

2

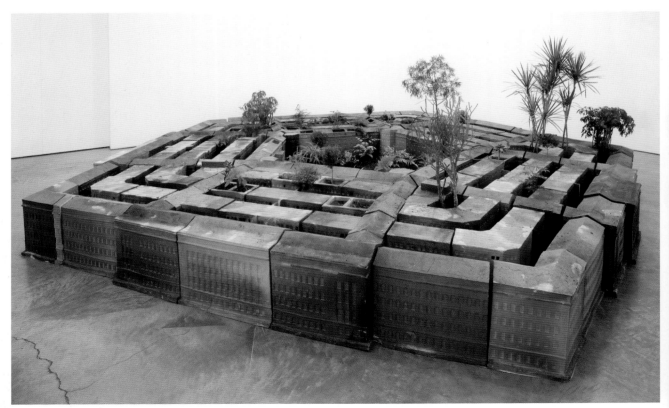

3

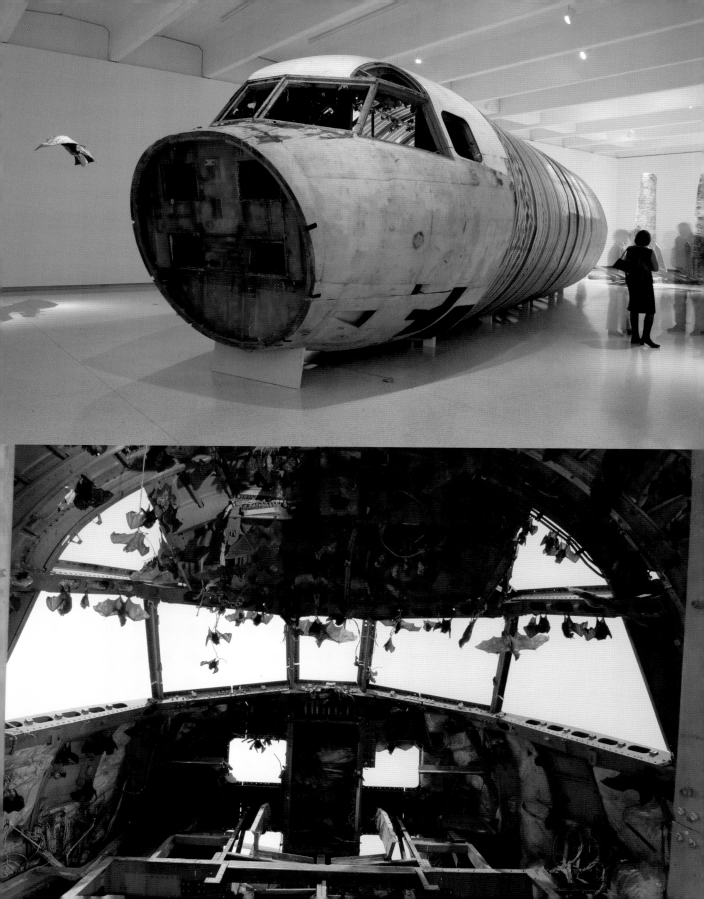

Pierre Huyghe

1962 born in Paris, lives and works in Paris, France, and New York (NY), USA

Pierre Huyghe described his 2006 retrospective *Celebration Park*, in Paris and London venues, as "an exhibition of exhibitions, and an exhibition about another exhibition to come." Huyghe has been experimenting with exhibition formats since his art school days. Using the exhibition as a multi-faceted medium, he pushes and stretches display paradigms and temporalities, rendering our overview of his artistic production fluid, permeable and malleable rather than static and linear. In *Celebration Park*, early works, like the floor-plan of *Death Star Interior* (1997) or *Silence Score* (1997), a rendition for flute of John Cage's "silent piece", were replaced by repudiating white neon disclaimers that stretched across the walls (*I Do Not Own Tate Modern or the Death Star*, 2006; *I Do Not Own 4'33"*, 2006), functioning like traces or memories of these past works. Huyghe's retrospective glance into his own body of work mixed fact and fiction to dramatic effect, much like his film *A Journey That Wasn't* (2005), which documents an Antarctic voyage to an uncharted island to seek out an albino penguin, combining footage from the trip with that of an ice-bound musical he staged in New York's Central Park. A master at coupling real and imaginary journeys through spaces and times, Huyghe continues to probe our capacity to travel along with him in his recent forays into theatre-based works (*A Forest of Lines*, 2008, which he installed with 1000 trees, swirling fog and a single singer in the Sydney Opera House). He works on temporal protocols with regard to a context, creating situations that question the possibilities inherent in the reality we trust to inhabit.

Pierre Huyghe beschrieb seine Retrospektive *Celebration Park*, 2006 in Paris und London gezeigt, als „eine Ausstellung von Ausstellungen, und eine Ausstellung über eine zukünftige Ausstellung". Huyghe experimentiert seit seinem Kunststudium mit Ausstellungsformen. Indem er die Ausstellung als ein facettenreiches Medium nutzt, verändert er die Paradigmen und die Zeitlichkeit der Präsentation und macht unsere Wahrnehmung seiner Arbeit eher fließend, durchlässig und formbar als statisch und linear. In *Celebration Park* wurden Frühwerke wie der Grundriss *Death Star Interior* (1997) oder *Silence Score* (1997), eine Realisierung von John Cages „silent piece" mit Querflöte, durch Erklärungen in weißen Neonbuchstaben ersetzt, die ganze Wände einnahmen (*I Do Not Own Tate Modern or the Death Star*, 2006; *I Do Not Own 4'33"*, 2006) und wie Spuren oder Erinnerungen an diese früheren Arbeiten funktionierten. Huyghes retrospektiver Blick auf seine eigene Arbeit verbindet Tatsachen und Fiktion zu dramatischer Wirkung, wie in seinem Film *A Journey That Wasn't* (2005), der eine Reise in die Antarktis zu einer unbekannten Insel dokumentiert, auf der ein Albinopinguin aufgespürt werden soll, und das Material von dieser Reise mit Aufnahmen eines gleichnamigen Musicals kombinierte, das er im New Yorker Central Park aufführte. Ein Meister darin, wirkliche und imaginäre Reisen durch Raum und Zeit zu kombinieren, fährt Huyghe bei seinen jüngsten Vorstößen in Richtung Theater darin fort, unsere Fähigkeit, ihm zu folgen, auf die Probe zu stellen (für *A Forest of Lines*, 2008, installierte er mit 1000 Bäumen, wirbelndem Nebel und einem einzigen Sänger in der Oper von Sidney). Er arbeitet an Zeitprotokollen für den jeweiligen Zusammenhang und schafft Situationen, die die Möglichkeiten innerhalb der Wirklichkeit, in der wir uns zu bewegen glauben, in Frage stellen.

Pierre Huyghe voit sa rétrospective 2006, *Celebration Park*, présentée à Paris et à Londres, comme une « exposition d'expositions, une exposition sur une autre exposition à venir. » Depuis ses études, Huyghe expérimente la présentation en exposition. Utilisant celle-ci comme un médium protéiforme, il en repousse et en étire les paradigmes et les temporalités, rendant sa production artistique fluide, perméable et malléable plutôt que statique et linéaire. Dans *Celebration Park*, les premières œuvres, comme le plan de *Death Star Interior* (1997) ou *Silence Score* (1997) – une interprétation pour flûte de la « pièce silencieuse » de John Cage – ont été remplacées par des phrases au néon blanc déployées sur les murs (*I Do Not Own Tate Modern or the Death Star*, 2006 ; *I Do Not Own 4'33"*, 2006) telles des traces ou des souvenirs de ces œuvres passées. Le regard rétrospectif d'Huyghe sur son propre travail mêlait faits et fiction pour un effet dramatique, à la manière de son film *A Journey That Wasn't* (2005), qui relate un voyage vers une île inconnue en Antarctique, à la recherche d'un pingouin albinos, et qui combine séquences du voyage à celles d'un spectacle musical sur glace auquel il avait participé à Central Park à New York. Maître dans l'art d'associer voyages réels et imaginaires à travers les lieux et les temps, Huyghe continue de nous mettre à l'épreuve dans ses œuvres récentes inspirées du théâtre. Pour *A Forest of Lines* (2008) il a installé mille arbres, un brouillard tourbillonnant et un chanteur soliste dans l'opéra de Sydney. Il travaille sur les codes temporels en regard d'un contexte donné, créant des situations qui interrogent les possibilités inhérentes à la réalité qui nous entoure.

V. R.

SELECTED EXHIBITIONS →
2008 *Traces du sacré*, Centre Georges Pompidou, Paris. *Revolutions – Forms That Turn*, 16th Biennale of Sydney **2007** *Pierre Huyghe, A Time Score*, MUSAC, León. *Pierre Huyghe: Show as Exhibition*, Reykyavik Art Museum, Reykyavik **2006** *Day for Night*, Whitney Biennial 2006, Whitney Museum, New York. *Pierre Huyghe: Celebration Park*, Tate Modern, London; Musée d'Art moderne de la Ville de Paris **2005** *Pierre Huyghe*, Moderna Museet, Stockholm. *Pierre Huyghe: Streamside Day*, Irish Museum of Modern Art, Dublin

SELECTED PUBLICATIONS →
2008 *Pierre Huyghe: Float*, Skira, Milan *Revolutions – Forms That Turn*, Biennale of Sydney, Sydney **2006** *Pierre Huyghe: Celebration Park*, Tate Modern, London; Musée d'Art moderne de la Ville de Paris, Paris. *Whitney Biennial 2006: Day for Night*, Whitney Museum of American Art, New York **2005** *Pierre Huyghe: Streamside Day*, Irish Museum of Modern Art, Dublin

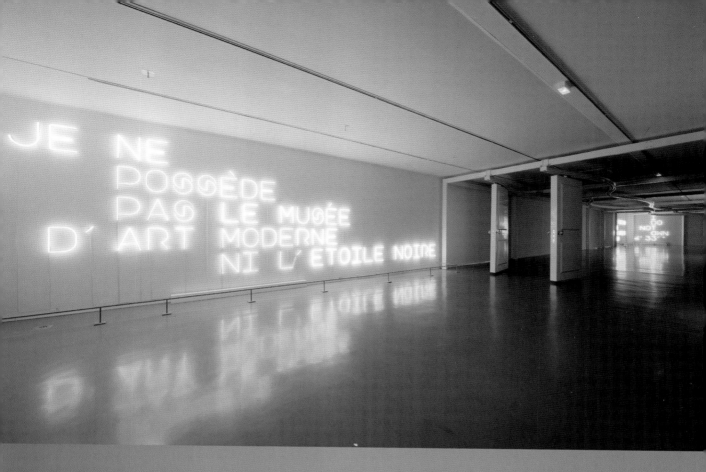

1 **Disclaimer**, neons, letters 50 cm height, proportional width, design by M/M, **Gates**, wood, 360 x 180 x 600 cm. Installation view, *Pierre Huyghe: Celebration Park*, ARC – Musée d'Art moderne de la Ville de Paris, 2006
2 **I Do Not Own Snow White**, neons, letters 50 cm height, proportional width, design by M/M. Installation view, *Pierre Huyghe: Celebration Park*, ARC – Musée d'Art moderne de la Ville de Paris, 2006

3 **A Forest of Lines**, event, Sydney Opera House, 2008
4/5 **A Journey That Wasn't**, 2005, double negative, super-16mm film and high-definition video transfered to high-definition video, colour, sound, 21 min 41 sec. Event, Wollman Ice Rink, Central Park, Public Art Fund, New York

„Mir ist wichtig, dass eine Ausstellung nicht das Ende eines Prozesses ist, sondern ein Ausgangspunkt für neue Wege."

« Ce qui m'intéresse, c'est que l'exposition soit non pas la fin du processus mais un point de départ pour aller ailleurs. »

"I'm interested that the exhibition is not the end of the process but a starting point to go somewhere else."

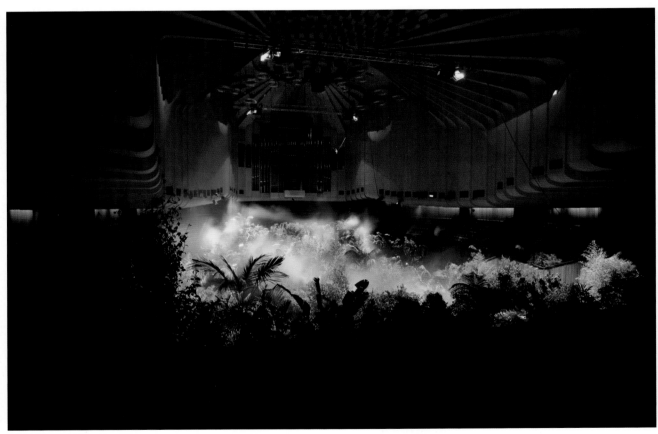

3

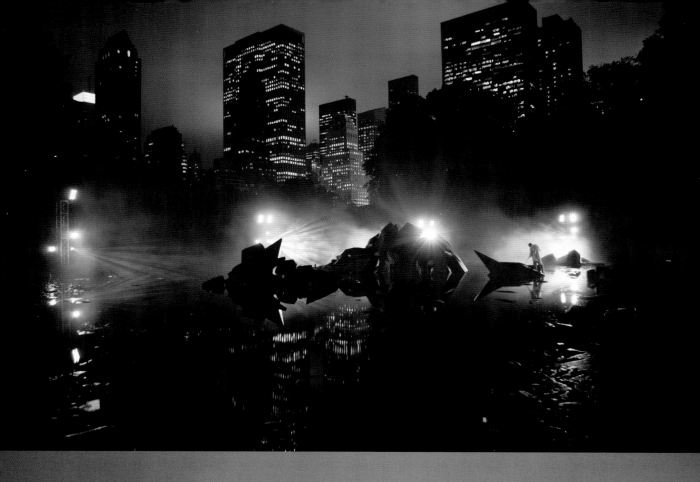
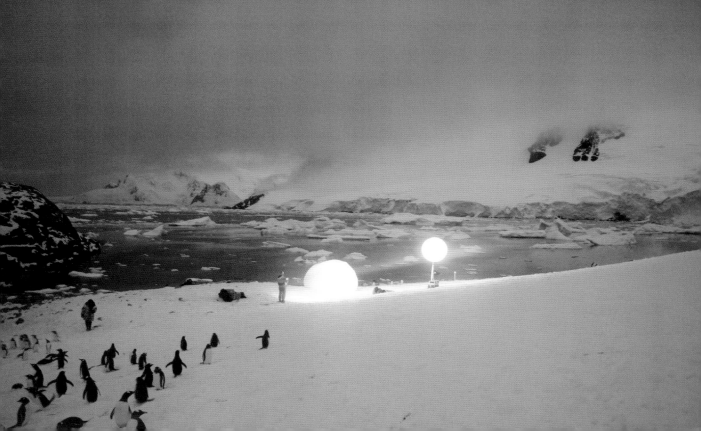

Emily Jacir

1970 born in Riyadh, Saudi Arabia, lives and works in Ramallah, Palestine, and New York (NY), USA

At the 2007 Venice Biennial, Emily Jacir presented *Material for a Film* (2005–), which deals with the violent death of Wael Zuaiter, a Palestinian intellectual living in Rome who was killed in 1972 by Israeli Mossad agents. Struck by twelve bullets outside his home for his alleged role in the attacks at the Munich Olympics, he was the first victim in a series of assassinations of Palestinian civilians living in Europe. Jacir took an unrealized film project about Zuaiter as the starting point for her research – this is the film referred to in the title. Using various available images and recordings, as well as conversations with Zuaiter's partner and friends, Jacir's work is a piece-by-piece reconstruction of the complexity of an individual fate representative of many others. Her survey operates with the usual means of presenting archival and documentary material, the more so as the title suggests that it is research for a film project. The purely documentary function of the material is repeatedly interrupted, however, for example when Jacir shows photographs of all pages of the copy of *One Thousand and One Nights* that was grazed by a highly symbolic 13th bullet when Zuaiter was assassinated. It was a book he had hoped to be the first to translate from Arabic into Italian. The smouldering conflict between Israel and Palestine is a central theme of Jacir's works, which she addresses using various artistic means. The photographic series *Entry Denied* (2003–06), for example, shows places and houses that laconically represent the state of being displaced – the impossibility of normality and a return to their own homeland for many Palestinians.

Auf der Biennale Venedig 2007 präsentierte Emily Jacir *Material for a Film* (2005–): Die Arbeit setzt sich mit dem gewaltsamen Tod von Wael Zuaiter auseinander, einem palästinensischen Intellektuellen, der 1972 in Folge der Münchner Olympiaanschläge als angeblicher Attentäter vom israelischen Geheimdienst Mossad mit 12 Kugeln vor seiner Haustür in Rom getötet wurde – das erste Opfer in einer Serie von Anschlägen auf palästinensische Zivilisten in Europa. Jacir nahm ein nicht realisiertes Filmprojekt über Zuaiter als Ausgangspunkt für ihre Recherchen – hierauf bezieht sich auch der Titel der Arbeit. Ihre Bestandsaufnahme rekonstruiert anhand von verschiedenem Bild- und Tonmaterial sowie Gesprächen mit Freunden und der Lebensgefährtin Zuaiters fragmentarisch die Komplexität eines Schicksals stellvertretend für viele. Die Arbeit spielt mit den üblichen Präsentationsformen für Archiv- und Dokumentationsmaterial, zumal ihr Titel suggeriert, dass es sich um Recherchen für ein Filmprojekt handelt. Die rein dokumentarische Funktion der Materialien wird jedoch immer wieder gebrochen, etwa wenn Jacir Fotos aller Seiten des Exemplars von *Tausend und eine Nacht* zeigt, das beim Anschlag auf Zuaiter von einer symbolträchtigen 13. Kugel berührt wurde – ein Buch übrigens, das Zuaiter als erster vom Arabischen ins Italienische zu übersetzen hoffte. Der seit Jahrzehnten schwelende Konflikt zwischen Israel und Palästina ist immer wieder zentrales Thema in Jacirs Arbeiten, das sie mit unterschiedlichen künstlerischen Mitteln angeht. Die Fotoserie *Entry Denied* (2003–06) etwa zeigt Orte und Häuser, die lakonisch für den Zustand der Deplatzierung stehen – die Unmöglichkeit für viele Palästinenser, in die eigene Heimat und in die Normalität zurückzukehren.

Lors de la Biennale de Venise de 2007, Emily Jacir présentait *Material for a Film* (2005–), une œuvre qui abordait la mort violente de Wael Zuaiter, un intellectuel palestinien et auteur présumé de l'attentat des Jeux Olympiques de Munich qui fut tué de douze balles par le Mossad, le service secret israélien, en 1972 devant la porte de sa maison à Rome – devenant ainsi la première victime d'une série d'attentats commis contre des civils palestiniens en Europe. Comme point de départ pour ses recherches, Jacir avait pris un projet de film non réalisé sur Zuaiter, projet auquel se réfère le titre de l'œuvre. À l'appui de différents matériaux filmiques et sonores, mais aussi d'entretiens avec des amis de Zuaiter comme avec sa compagne, le constat dressé par Jacir reconstitue fragmentairement un destin complexe, représentatif de celui vécu par beaucoup d'autres. Avec un titre qui suggère qu'il s'agit de recherches autour d'un projet de film, l'œuvre joue des formes de présentation habituellement utilisées pour les documents et les matériaux d'archives. Mais la fonction purement documentaire des matériaux est sans cesse rompue, notamment quand Jacir présente des photos de toutes les pages de l'exemplaire des *Mille et Une Nuits* touché par une 13ᵉ balle lourdement symbolique lors de l'assassinat de Zuaiter, qui espérait être le premier à traduire cet ouvrage d'arabe en italien. Le conflit latent qui couve depuis des décennies entre Israël et la Palestine est un thème central et récurrent du travail de Jacir, qui l'aborde par le truchement de différents moyens artistiques. Ainsi, la série de photographies *Entry Denied* (2003–06) montre des lieux et des maisons qui représentent laconiquement la condition des déplacés – l'impossibilité pour de nombreux Palestiniens de revenir dans leur propre patrie et à une vie normale.

E. S.

SELECTED EXHIBITIONS →
2008 *Scènes du Sud II – Méditerranée Orientale*, Carré d'art de Nîmes **2007** *Emily Jacir*, Kunstmuseum St. Gallen; Galerien der Stadt Esslingen. *Think with the Senses – Feel with the Mind*, 52nd Venice Biennale, Venice **2006** *Zones of Contact*, 15th Biennale of Sydney. *Without Boundary: Seventeen Ways of Looking*, MoMA, New York. *Dark Places*, Santa Monica Museum of Art, Santa Monica

SELECTED PUBLICATIONS →
2008 *Emily Jacir*, Kunstmuseum St. Gallen; Galerien der Stadt Esslingen; Verlag für moderne Kunst, Nuremberg. *The Hugo Boss Prize 2008*, Guggenheim Museum, New York **2006** *Zones of Contact*, Biennale of Sydney, Sydney. *Without Boundary: Seventeen Ways of Looking*, MoMA, New York

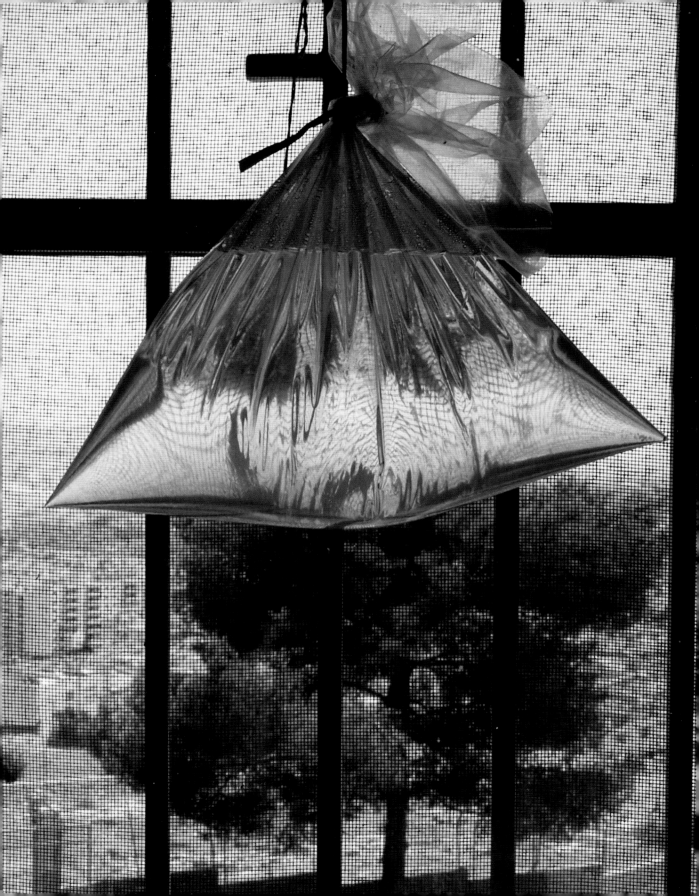

1 **Entry Denied: Outside the Malja**, 2003, C-print, 76 x 56.5 cm
2 **Entry Denied (a concert in Jerusalem)**, 2003, betacam video, 105 min. Documentation of a Marwan Abado concert which never happened

3 **Material for a Film** 2005–. Installation view, Italian Pavilion, 52. Biennale di Venezia, Venice
4 **Entry Denied: Nablus Eid**, 2006, C-print, 56.5 x 76 cm
5 **Entry Denied: Zuaiter House, Nablus**, 2006, C-print, 56.5 x 76 cm

„Es geht um Widerstand, Bewegung, Alltag, hinterlassene Spuren, Poesie, Schönheit, Untersuchungen, Eingriffe, unterdrückte Geschichtsschreibung und Nachforschungen. Es geht darum, Umsiedlungen, Ausweisungen und das Vergessen der Geschichte zu bekämpfen. Es geht darum, dass wir uns zu eigenen Bedingungen definieren."

« Il s'agit de résistance, de mouvement, de quotidien, de traces, de poésie, de beauté, d'investigations, d'interventions, de récits historiques réprimés et de recherches. Il s'agit de lutter contre les déplacements, les expulsions et l'oubli de l'histoire. Il s'agit de nous définir nous-mêmes selon nos propres critères. »

"It is about resistance, movement, everyday life, traces, poetry, beauty, investigations, interventions, repressed historical narratives and research. It's about fighting against displacement, expulsion and historical erasure. It's about defining ourselves on our own terms."

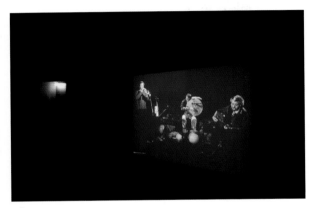

2

22/10/2006
Nablus
Naila and I are eating dinner. I am staring at the book-shelf next to the table wondering whose books they are and ask. She tells me they are hers and then laughs, "Who reads these days?"
I focus on the books again skimming titles until I stop on "The Divine Comedy" in English. I ask her about it. It was Wael's.
She says she remembers because he loved the book so much and was obsessed with it in the 50's when he was around the age of 20 or 21. When she visited Rome in 1964 she carried many of his books back to Nablus. He had wanted to sell them all because he needed money, but she loved Wael and wanted to hold them.

23/10/2006
Eid
F-16's circle above us all morning.
I woke up at 4 am because of the huge gun battle outside as the Israelis entered Nablus.

3

Mike Kelley

1954 born in Detroit (MI), lives and works in Los Angeles (CA), USA

Mike Kelley's installation *Kandors* (2007) is based on the comic series *Superman*. Kandor, Superman's hometown, was once shrunk to miniature scale by one of his adversaries and is now kept in a bottle by the superhero. Kelley has created resin models of the town based on its various depictions in the comic books; these are surrounded by videos of glass vials and bottles whose contents fester and bubble. In this way, he creates the impression of a futuristic laboratory. Kelley's exhibition *Educational Complex Onwards: 1995–2008* (2008) also takes architecture as its starting point. In 1995, Kelley exhibited a model representing every school he had ever attended. The exhibition develops a narrative around this model where the artist's works constitute the chapters, right up to his most recent creations. In this way, Kelley's engagement with the autobiographical is interwoven with other themes that characterize his performances, paintings and installations: he investigates the different ways in which mass culture and legends are created. They manifest supra-individual longings and fears, as for example in the legend of Lot's wife being turned to a pillar of salt, which he explores in his *Petting Zoo* (2007), which contains videos and a salt figure for the animals. Kelley incorporates into his artworks the explanations given by philosophy, psychology and science for popular forms of expression. He is particularly interested in how human perception and memory functions. So, for example, the different forms in which the city of Kandor appears symbolize the possible mental associations with which the brain calls up, saves, overlays or suppresses images, facts or experiences.

Mike Kelleys Installation *Kandors* (2007) basiert auf der Comicserie *Superman*, in der Kandor, Supermans Heimatstadt, einst von einem Widersacher auf Kleinstformat geschrumpft wurde und nun von ihm in einer Flasche aufbewahrt wird. Ausgehend von ihren unterschiedlichen Darstellungen im Comic hat Kelley Modelle der Stadt in Kunstharz erschaffen, umgeben von Videos mit Ampullen und Destillen, in denen es gärt und brodelt. Dadurch erzeugt er den Eindruck einer futuristischen Laborsituation. Kelleys Ausstellung *Educational Complex Onwards: 1995–2008* (2008) hat ebenfalls Architektur zum Ausgangspunkt: 1995 stellte Kelley zum ersten Mal ein Modell mit allen Schulen aus, die er besucht hatte. Um dieses Modell herum entwickelt die Ausstellung eine Geschichte, bei der die Arbeiten des Künstlers die Kapitel bilden, bis hin zu seinen neuesten Produktionen. Kelleys Beschäftigung mit dem Begriff des Autobiografischen verschränkt sich hierbei mit anderen Themen, die seine Performances, Gemälde und Installationen prägen: Er untersucht die verschiedenen Ausformungen von Massenkultur und Legenden. In ihnen manifestieren sich überindividuelle Sehnsüchte und Ängste, wie etwa in der Legende von Lots zur Salzsäule erstarrten Frau, die Kelley in seinem *Petting Zoo* (2007) untersucht, einem Streichelzoo mit Videos und einer Figur aus Salz für die Tiere. Kelley lässt seine Auseinandersetzung mit den Erklärungen, die Philosophie, Psychologie und Wissenschaft für populäre Ausdrucksformen geben, in seine Arbeiten einfließen. Sein besonderes Interesse gilt dabei der Funktionsweise von menschlicher Erkenntnis und Erinnerung. So symbolisieren etwa die verschiedenen Formen, in denen die Stadt Kandor erscheint, die möglichen Vorstellungen, mit denen das Gedächtnis Bilder, Fakten oder Erlebnisse aufruft, abspeichert, überlagert oder aber verdrängt.

L'installation de Mike Kelley *Kandors* (2007) est inspirée de la bande dessinée *Superman* : un ennemi de Kandor a réduit autrefois à une taille infime la ville natale de Superman qui la conserve à présent dans une bouteille. Partant des différentes représentations de Kandor dans la bande dessinée, Kelley en a créé des maquettes en résine synthétique entourées de vidéos où toutes sortes de liquides bouillonnent et fermentent dans des ampoules et des alambics, si bien que l'ensemble s'apparente à un laboratoire futuriste. L'exposition *Educational Complex Onwards : 1995–2008* (2008) a elle aussi pour point de départ l'architecture : en 1995, Kelley exposait pour la première fois une maquette montrant toutes les écoles qu'il avait fréquentées. Autour de cette maquette, l'exposition développe une histoire dont les chapitres sont ses œuvres, et ce jusqu'aux plus récentes. Dans le travail autobiographique de Kelley s'intercalent d'autres thèmes qui régissent ses performances, peintures et installations : Kelley étudie les différents avatars de la culture de masse et des légendes, dans lesquelles se manifestent des aspirations et des angoisses collectives. C'est par exemple le cas de la légende de Loth et de sa femme qui fut changée en statue de sel, légende que Kelley aborde dans *Petting Zoo* (2007), un zoo pour enfants comportant des vidéos et une statue de sel en guise d'animaux. Kelley fait entrer dans ses œuvres les explications que la philosophie, la psychologie et la science donnent des modes d'expression populaires. Il s'intéresse plus particulièrement aux modes de fonctionnement de la connaissance et de la mémoire humaines. C'est ainsi que les différentes formes sous lesquelles se présente la ville de Kandor symbolisent les configurations possibles sur la base desquelles la mémoire évoque, stratifie ou simplement refoule les images, les faits ou les expériences.

A. M.

SELECTED EXHIBITIONS →
2008 *Mike Kelley: Educational Complex Onwards: 1995–2008*, Wiels, Brussels **2007** *Sympathy for the Devil: Art and Rock and Roll since 1967*, Museum of Contemporary Art, Chicago. Skulptur Projekte Münster 07, Münster **2006** *Mike Kelley: Profondeurs Vertes*, Musée du Louvre, Paris. *The 80's: A Topology*, Museo Serralves, Porto. *Magritte and Contemporary Art: The Treachery of Images*, MOCA, Los Angeles. *Without Boundary: Seventeen Ways of Looking*, MoMA, New York **2005** *Translation*, Palais de Tokyo, Paris

SELECTED PUBLICATIONS →
2007 *Mike Kelley: Day Is Done*, Gagosian Gallery, New York; Yale University Press, New Haven. *Mike Kelley: Hermaphrodite Drawings (2005–2006)*, Gagosian Gallery, London. *Pop Art Is*, Gagosian Gallery, London **2005** *Mike Kelley: Interviews, Conversations, and Chit-Chat (1986–2004)*, Les presses du réel, Dijon; JRP Ringier, Zürich. *Mike Kelley: Memory Ware, Wood Grain, Carpet*, Galleria Emi Fontana, Milan

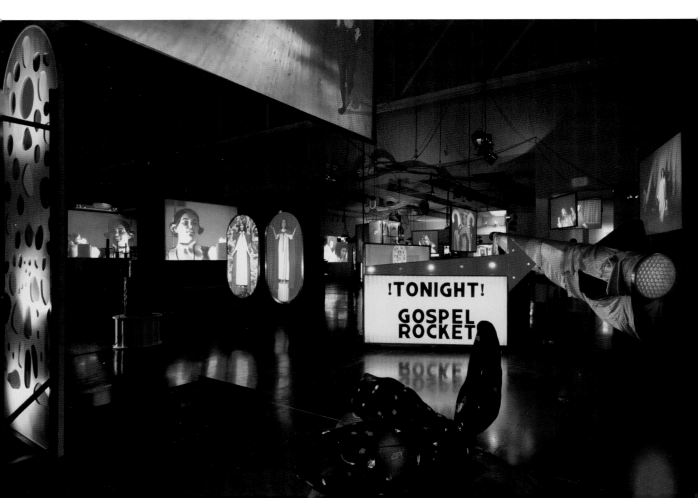

1 **Extracurricular Activity Projective Reconstruction #21 (Chicken Dance)**,
 2005, piezo print on rag paper (b/w) and C-print (colour),
 76.2 x 70.1 cm (each)

2 Installation view, *Mike Kelley: Day Is Done*, Gagosian Gallery,
 New York, 2005

3 Installation view, *Mike Kelley: Kandors*, Jablonka Galerie, Berlin, 2007

„Ich finde meine Arbeiten schön. Sie sind schön, weil sie Begriffe und Gren-
zen zwischen den Begriffen durcheinander bringen, und so werden die
Grenzen zwischen Kategorien durchlässig. Dadurch wirkt es für mich erhaben,
oder aber humorvoll."

« Je pense que ce que je fais est beau. Je pense que c'est beau parce que
les termes et les frontières entre les termes sont confus et que les frontières
entre les catégories commencent à devenir glissantes. Cela produit ce que
je considère comme un effet sublime, ou bien cela produit de l'humour. »

"I think what I make is beautiful. I think it's beautiful because terms, and divisions between terms, are confused and divisions between categories start to slip. That produces what I think of as a sublime effect, or it produces humour."

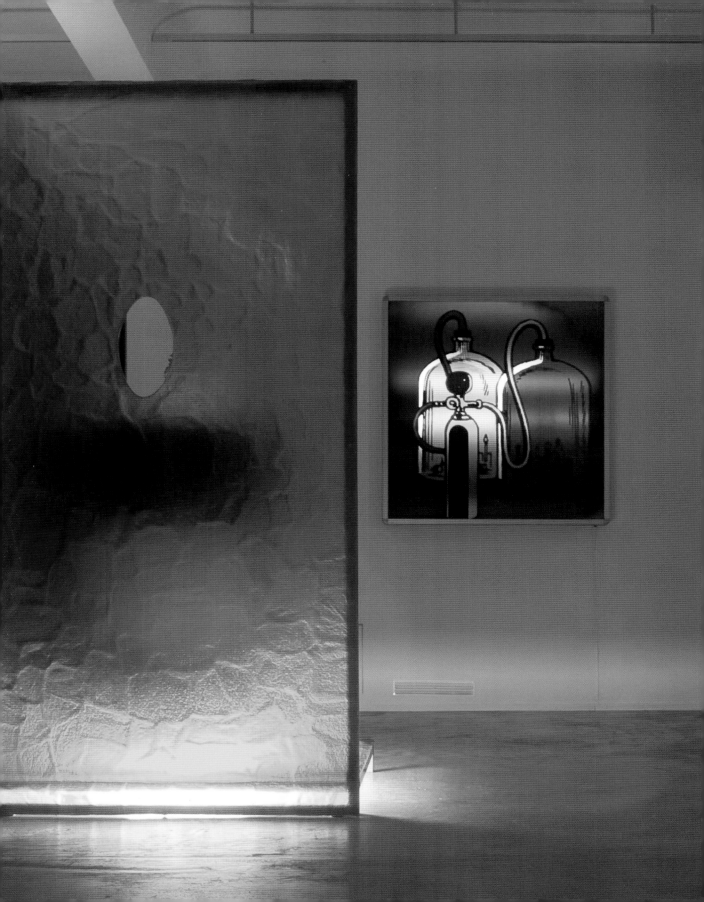

Terence Koh

1969 born in Beijing, China, lives and works in New York (NY), USA

In his monochromatic black or white objects, his environments and sound pieces, his handmade books, photographs and performances, Terence Koh references – and often comprises – gnomic rituals and cultish practices. His work additionally pays homage to the particularity of sexual subcultures and pillages the history of art. Lately, Koh's appropriations have taken his own past practice as their source. He restaged his infamous *The Whole Family* (2003) at Peres Projects in Los Angeles five years after the original show in the same location. *The Whole Family* (2008) thus reprised his otherworldly installation wholesale: the first floor of the gallery appeared empty save for a white desk lamp and a white styrofoam cup rimming the edge of a 3-inch hole in the floor. In the basement gallery below, a dense blanket of snowy powder covered and clung to viewers as well as to a motley assortment of objects, also white (e.g., figurines mounted upside down on shelves, a silk flag, a diminutive ladder), which were cast from bronze, aluminium and steel in a telling nod to the artist's meteoric ascent since his debut. Self-promotional from the start, Koh was formerly known as "asianpunkboy" thanks to his eponymous, still-extant website. He has since anointed himself the "Naomi Campbell of the art world". But while his public proclamations trumpet the artist's decadent narcissism, past works – some of which are perishable with constituents including lube, saliva, sperm and chocolate – might also suggest a poetics of loss more fragile than presumptive. Reversely, one could cite Koh's hubristic installation *God* (2007) and argue for his incipient self-deification.

Für seine monochromen schwarzen oder weißen Objekte, Environments und Klangstücke, seine handgemachten Bücher, Fotografien und Performances benutzt Terence Koh gnomische Rituale und kultische Praktiken als Bezugspunkt und Material. Seine Arbeiten sind außerdem eine Hommage an die Besonderheiten sexueller Subkulturen und plündern die Kunstgeschichte. In letzter Zeit hat Koh auch sein eigenes Werk als Fundus entdeckt. Er inszenierte sein berüchtigtes *The Whole Family* (2003) bei Peres Projects in Los Angeles fünf Jahre nach der Erstausstellung an derselben Stelle neu. *The Whole Family* (2008) gab also diese außergewöhnliche Installation komplett wieder: Das Erdgeschoss der Galerie schien leer bis auf eine weiße Schreibtischlampe und einen weißen Becher aus Styropor, der die Kante eines acht Zentimeter breiten Lochs im Boden umfasste. Im Keller darunter verschwanden die Besucher unter einer dichten Schicht schneeigen Puders, der an ihnen ebenso wie an einem Sammelsurium von weißen Gegenständen haften blieb (z.B. an von Regalbrettern kopfüber herabhängenden Figürchen, einer seidenen Flagge, einer winzigen Leiter), die diesmal in Bronze, Aluminium und Stahl gegossen waren, als Referenz auf den kometenhaften Aufstieg des Künstlers seit seinem Debut. Von Anfang an warb der Künstler, der dank seiner gleichnamigen noch immer existierenden Homepage als „asianpunkboy" bekannt war, geschickt für sich selbst und bezeichnete sich als „Naomi Campbell der Kunstwelt". Aber während Kohs öffentliche Proklamationen einen dekadenten Narzissmus verkünden, suggerieren seine früheren Arbeiten – von denen einige aus vergänglichem Material wie Vaseline, Speichel, Sperma und Schokolade bestehen –, vielleicht eher eine zerbrechliche als eine überhebliche Poetik des Verlusts. Umgekehrt könnte man Kohs anmaßende Installation *God* (2007) zitieren und den Beginn seiner Selbstvergöttlichung feststellen.

Dans ses objets monochromes noirs ou blancs, ses œuvres environnementales, ses pièces sonores, ses livres faits main, ses photos et ses performances, Terence Koh inclut et se réfère souvent à des rituels gnomiques et des pratiques cultuelles. Il rend en outre hommage aux minorités sexuelles et s'approprie l'histoire des arts. Il pousse ce phénomène d'appropriation jusqu'à réutiliser sa propre pratique passée. C'est ainsi qu'il a remis en scène son célèbre *The Whole Family* (2003) à Peres Projects (Los Angeles), cinq ans après la première installation dans ce même lieu. En 2008, *The Whole Family* reprenait l'ensemble de l'installation antérieure : la galerie semblait vide, à l'exception d'une lampe de bureau blanche et d'un gobelet en polystyrène blanc entourant un trou de 8 centimètres dans le sol. Un épais tapis de poudre blanche recouvrait le sous-sol de la galerie et s'accrochait aux visiteurs ainsi qu'à un assortiment hétéroclite d'objets blancs (parmi lesquels des figurines suspendues à l'envers à des étagères, un drapeau en soie, une échelle miniature) moulés dans du bronze, de l'aluminium ou de l'acier ; un clin d'œil à l'ascension fulgurante de l'artiste. Assurant seul son auto-promotion, Koh se fait connaître sous le nom de « asianpunkboy », grâce à son site éponyme toujours en activité. Il s'est depuis sacré « Naomi Campbell du monde de l'art ». Alors que ses déclarations publiques revendiquent un narcissisme décadent, des œuvres passées – périssables en raison des matériaux utilisés comme le lubrifiant, la salive, le sperme ou le chocolat – pourraient suggérer une poétique de la perte plus fragile qu'elles ne le laisseraient croire. À l'inverse, sa prétentieuse installation *God* (2007) suggère les prémices d'une auto-déification.

S. H.

SELECTED EXHIBITIONS →
2008 *Terence Koh: Love for Eternity*, MUSAC, León. *Terence Koh: Captain Buddha*, Schirn Kunsthalle, Frankfurt am Main. *Expenditure*, Busan Biennale 2008, Busan Museum of Modern Art, Busan. *Eurasia – Geographic Cross-Overs in Art*, Museo di Arte Moderna e Contemporanea die Trento e Rovereto, Trento **2007** *Fractured Figure – Works from the Dakis Joannou Collection*, Deste Foundation, Athens **2006** *Terence Koh*, Kunsthalle Zürich; Whitney Museum of American Art, New York **2005** *Terence Koh*, Secession, Vienna

SELECTED PUBLICATIONS →
2008 *Terence Koh*, MUSAC, León; Hatje Cantz, Ostfildern. *Terence Koh: Captain Buddha*, Schirn Kunsthalle, Frankfurt am Main; Verlag der Buchhandlung Walther König, Cologne **2006** *Terence Koh*, Kunsthalle Zürich, Zürich; Whitney Museum of American Art, New York; Yale University Press, New Haven **2005** *Terence Koh*, Secession, Vienna

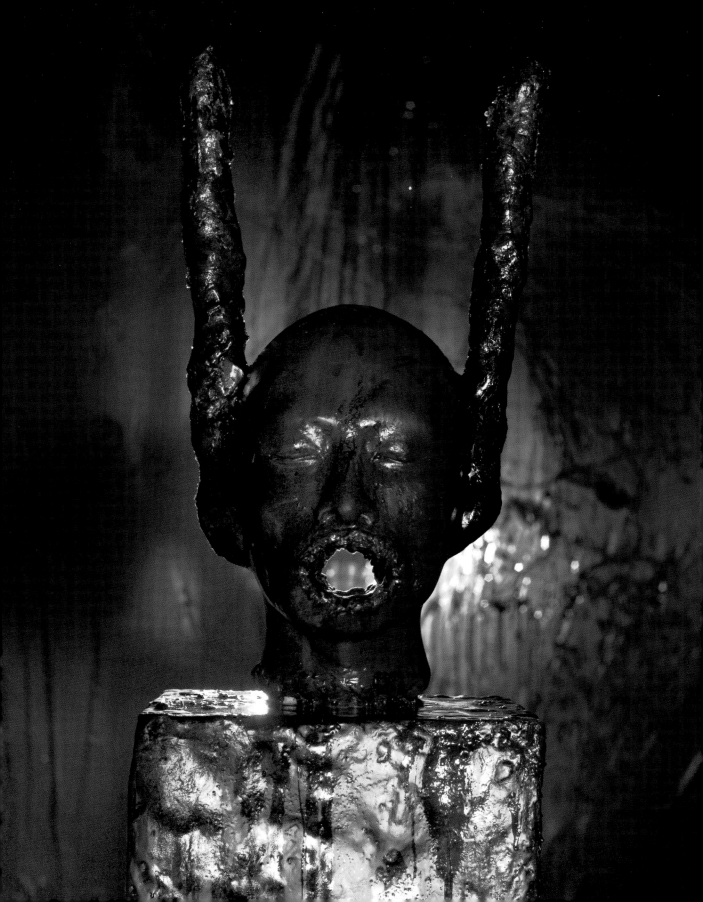

1 **God**, 2007, plaster, wood, wax, paint, Eros lube, artist's saliva, cum of the artist and others, 186 x 26 x 26 cm
2 **The World Is the Speed of Fire, Cry Tears But They Still Turn to Silver**, 2007, acrylic, charred enamel, plaster, Hermes perfume, the sweat of big and little men, 232 x 80 x 86 cm

3 **Judas Was Sad**, 2007, found skeleton, wood, paint, varnish, wax, artist's blood, secret message whispered to Judas, 135 x 70 x 65 cm
4 **Untitled 1 (Hole, Plant, Light Cup)**, 2008, bronze cup, steel string, aluminium lamp, bronze plant, bronze ladder, automative paint, dimensions variable, hole 8 cm. Installation view, Peres Project, Los Angeles

„Ich sehe in mir die klassische Sinnlichkeit eines alchimistischen Bildhauers. In meinen Werken geht es um reine Emotion, Liebe und Chemikalien."

« Je me considère comme quelqu'un qui est dans la sensualité classique du sculpteur alchimiste. Mon œuvre tourne autour de l'émotion pure, de l'amour et des produits chimiques. »

"I conceive of myself in the classical sensuality of the alchemist sculptor. My work is about pure emotion, love and chemicals."

2

3

Jeff Koons

1955 born in York (PA), lives and works in New York (NY), USA

The Museum of Contemporary Art in Chicago was the first one to dedicate a major solo show to Jeff Koons in 1988. Twenty years later, the museum hosted the most comprehensive American retrospective of Koons, arguably the artist who best incarnates our times with their mixture of vulgarity and elegance, the overproduced commodities and the delusions of grandeur. The exhibition gathered works from the beginning of his career in the late 1970s up to now. From his sarcophagi for vacuum cleaners to his porno paintings, from shiny sculptures to multilayered canvases, Koons has been composing a maddening encyclopedia of induced needs, where the inorganic may have more sex appeal than the human body. *Celebration*, one of his most renowned series, was begun in 1994 and includes sculptures and paintings that relate to celebratory moments in popular culture. The stainless steel sculptures combine the lightness of the shapes they take inspiration from – balloons, ornaments, children's toys – with a sense of monumentality achieved through a sophisticated polishing technique, which Koons has refined to truly obsessive ends. Among the recent additions to this series is *Cracked Egg* (1994–2006), a stainless steel egg with a fractured top, and *Hanging Heart (Red/Gold)* (1994–2006), which has become one of the most expensive artworks in the history of art. Lately, Koons has been working on large-scale paintings for the series *Hulk Elvis*. Playing with some of America's most famous heroes (*Triple Hulk Elvis*, 2007) and combining them with other symbols of American pop culture – as in *Liberty Bell* (2007) – Koons continues exploring the secret mechanisms that regulate our desires.

Das Museum of Contemporary Art in Chicago war das erste, das Jeff Koons 1988 eine große Einzelausstellung widmete. Zwanzig Jahre später veranstaltete das Museum die umfassendste amerikanische Retrospektive für Koons – vielleicht der Künstler, der unsere Zeit mit ihrer Mischung aus Vulgarität und Eleganz, ihren überproduzierten Waren und ihrem Größenwahn am besten verkörpert. Die Ausstellung versammelte Arbeiten vom Beginn seiner Karriere in den späten 1970ern bis heute. Von seinen Sarkophagen für Staubsauger über seine Pornobilder, von glänzenden Skulpturen zu vielschichtigen Leinwänden hat Koons eine verwirrende Enzyklopädie künstlich hervorgerufener Bedürfnisse geschaffen, wo anorganische Dinge mehr Sexappeal haben können als der menschliche Körper. *Celebration*, eine seiner bekanntesten Serien, wurde 1994 begonnen und umfasst Skulpturen und Gemälde, die sich mit den festlichen Momenten der populären Kultur befassen. Die Edelstahl-Skulpturen verbinden die Leichtigkeit der Formen, von der sie sich inspirieren lassen – Ballons, Ornamente, Kinderspielzeug – mit einem Sinn für Monumentalität, der durch die anspruchsvolle Kunst des Polierens erreicht wird, welche Koons bis zu einem obsessiven Grad verfeinert hat. Zu den jüngsten Stücken dieser Serie gehören *Cracked Egg* (1994–2006), ein aufgeklopftes Ei aus Edelstahl, und *Hanging Heart (Red/Gold)* (1994–2006), das zu einem der teuersten Werke in der Geschichte der Kunst geworden ist. Zuletzt hat Koons an großformatigen Gemälden für die Serie *Hulk Elvis* gearbeitet. Indem er mit den berühmtesten Helden Amerikas spielt (*Triple Hulk Elvis*, 2007) und sie mit anderen Symbolen der amerikanischen Popkultur kombiniert – wie in *Liberty Bell* (2007) –, fährt Koons fort, die geheimen Mechanismen zu erforschen, die unsere Begierden steuern.

Le Museum of Contemporary Art de Chicago a été le premier, en 1988, à consacrer une exposition personnelle majeure à Jeff Koons. Vingt ans plus tard, le musée accueillait la rétrospective américaine la plus complète de Koons ; sans doute l'artiste qui incarne le mieux notre époque, avec son mélange de vulgarité et d'élégance, de profusion de matières premières et de folie des grandeurs. L'exposition rassemblait des œuvres du début de sa carrière, entamée à la fin des années 1970, jusqu'à l'époque actuelle. De ses sarcophages pour aspirateurs à ses peintures porno, en passant par les sculptures brillantes et les toiles à plusieurs couches, Koons compose une exaspérante encyclopédie des besoins induits, où l'inorganique peut avoir plus de sex-appeal que le corps humain. *Celebration*, une de ses séries les plus remarquées amorcée en 1994, se compose de peintures et de sculptures qui sont en lien avec des moments de célébration dans la culture populaire. Les sculptures en inox associent monumentalité et légèreté des formes dont elles s'inspirent – ballons, décorations, jouets d'enfants –, grâce à une technique de polissage sophistiquée que Koons a affiné jusqu'à l'obsession. On trouve, parmi les récentes adjonctions à cette série, *Cracked Egg* (1994–2006), un œuf en acier inoxydable dont le haut est brisé et *Hanging Heart (Red/Gold)* (1994–2006) qui est devenue l'une des œuvres les plus chères de l'histoire de l'art. Koons travaille maintenant à des peintures grand format pour la série *Hulk Elvis*. Jouant avec les héros américains parmi les plus célèbres (*Triple Hulk Elvis*, 2007) et les associant à d'autres symboles de la culture pop américaine – comme dans *Liberty Bell* (2007) – Koons continue d'explorer les mécanismes secrets qui régulent nos désirs.

C. A.

SELECTED EXHIBITIONS →
2008 *Jeff Koons*, Château de Versailles. *Jeff Koons: Kult des Künstlers*, Neue Nationalgalerie, Berlin. *Jeff Koons on the Roof*, The Metropolitan Museum of Art, New York. *Jeff Koons*, Museum of Contemporary Art, Chicago **2007** *Jeff Koons: Balloon Flower (Red)*, 7 World Trade Center, New York. *INSIGHT?*, Gagosian Gallery/Red October Chocolate Factory, Moscow. *Traum und Trauma*, MUMOK, Vienna **2006** *Jeff Koons: Diamond (Pink/Gold)*, Victoria and Albert Museum, London **2005** *Jeff Koons*, Lever House, New York

SELECTED PUBLICATIONS →
2008 *Jeff Koons*, Taschen, Cologne. *Jeff Koons*, Museum of Contemporary Art, Chicago **2007** *Re-Object: Marcel Duchamp, Damien Hirst, Jeff Koons, Gerhard Merz*, Kunsthaus Bregenz, Bregenz. *Traum und Trauma*, MUMOK, Vienna; Hatje Cantz, Ostfildern **2006** *Where Are We Going: Selections from the François Pinault Collection*, Skira, Milan **2005** *Blumenmythos: Van Gogh bis Jeff Koons*. Fondation Beyeler, Riehen/Basle; Edition Minerva, Wolfratshausen

1 **Landscape (Tree) II**, 2007, oil on canvas, 274.3 x 213.4 cm
2 **Moustache**, 2003, polychromed aluminium, wrought iron, coated steel chain, 260 x 53 x 192 cm

3 **Cracked Egg (Blue)**, 1994–2006, high chromium stainless steel with transparent colour coating, ca 198 x 158 x 305 cm
4 **Triple Hulk Elvis III**, 2005, oil on canvas, 274.3 x 371.2 cm
5 **Liberty Bell**, 2007, oil on canvas, 259.1 x 350.5 cm

„Ich glaube nicht, dass man Kunst einfach herstellen kann. Um zur Kunst zu kommen, musst du dir selbst vertrauen, die eigenen Themen verfolgen und dich absolut darauf konzentrieren. Das führt dich in einen metaphysischen Bereich."

« Je ne cois pas qu'on puisse créer de l'art. Mais je cois que ce qui mène à l'art, c'est d'avoir confiance en soi, de suivre et de se concentrer sur ce qui t'intéresse. Cela te fera parvenir à un état très métaphysique. »

"I don't believe that you can create art. But I believe what will lead you to art is to trust in yourself, follow your interests and focus on your interests. That will take you to a very metaphysical state."

2

3

Dr. Lakra

1972 born Jeronimo Lopez Ramirez, lives and works in Mexico City and Oaxaca, Mexico

Eagles, skull and cross bones, crosses, spider webs, black widows, demons, bats, snakes, stars, roses, mermaids, wrestlers, chains, barbed wire, proper names, naked pin-up girls and Virgin Marys: subculture tattoo and its imagery are central to the work of Dr. Lakra, a Mexican tattoo artist by trade who since the late 1990s has been showing his drawings – on paper, wood, found objects, walls and of course on skin – in the international art circuit. His most celebrated images are drawings finely inked over yellowed vintage Mexican magazine covers and pages (preferably over the limbs of buxom pin-up girls), but he also layers his intricate patterns over family portraits, advertisements, anatomy illustrations and old Japanese prints. He mingled both worlds when he set up a tattoo parlour in an art fair booth at which he tattooed visitors, while in the other corner the gallery sold his "real" artworks. In a somewhat nostalgic manner, Dr. Lakra practices at the intersection of high-brow and low culture, introducing in the art realm the sensibility and symbolism inherent in tattoo work with a pinch of its violence, which relates to a rich graphic tradition of transgression and underground, from William Blake to Robert Crumb. His work could also be interpreted as a play on art's desire for permanence, since a tattoo usually won't survive its bearer. But more recently, the artist has considerably broadened his scope, working in a variety of media, creating autonomous drawings and graffiti art, and constructing collage portraits out of hair and dried insects that he puts into old wooden frames like pieces of remembrance from the ephemeral past.

Adler, Schädel mit gekreuzten Knochen, Kreuze, Spinnweben, Schwarze Witwen, Dämonen, Fledermäuse, Schlangen, Sterne, Rosen, Meer-jungfrauen, Ringkämpfer, Ketten, Stacheldraht, Eigennamen, Pin-up-Girls und die Jungfrau Maria: Tätowierungen aus der Subkultur und ihre Bild-sprache stehen im Zentrum der Arbeit von Dr. Lakra, einem mexikanischen Tattookünstler von Beruf, der seit den 1990ern seine Zeichnungen – auf Papier, Holz, Fundstücken, Wänden und natürlich auf Häuten – in der internationalen Kunstszene ausstellt. Seine berühmtesten Bilder sind mit feiner Tusche ausgeführte Zeichnungen auf vergilbten alten mexikanischen Magazinseiten und Titelblättern (vorzugsweise auf den Körperteilen von drallen Pin-up-Girls), aber er zeichnet seine feinen Muster auch auf Familienporträts, Anzeigen, anatomische Darstellungen und alte japani-sche Drucke. Er brachte beide Welten zusammen, als er ein Tattoo-Studio auf einer Kunstmesse aufstellte, wo er die Besucher tätowierte, während er in der anderen Ecke der Galerie seine „echten" Kunstwerke verkaufte. Mit einer Prise Nostalgie arbeitet Dr. Lakra am Schnittpunkt von Hoch- und Trivialkultur und führt in den Bereich der Kunst die Gefühlswelt und die Symbolik des Tattoos ein, inklusive eines gewalttätigen Untertons, der sich auf eine reiche Tradition von Tabubrüchen und Underground in der Grafik von William Blake bis Robert Crumb bezieht. Seine Arbeit kann auch als ein Spiel mit dem Verlangen der Kunst nach Unvergänglichkeit gelesen werden, da ein Tattoo normalerweise seinen Träger nicht überlebt. Dabei hat Dr. Lakra in letzter Zeit sein Spektrum deutlich erweitert und in einer Vielzahl von Medien gearbeitet, Zeichnungen und Graffitikunst geschaffen sowie Collagenporträts aus Haaren und getrockneten Insekten, die er auf alte Holzrahmen setzt, als wären sie Erinne-rungsstücke aus einer kaum fassbaren Vergangenheit.

Aigles, têtes de mort et tibias entrecroisés, croix, toiles d'araignée, veuves noires, démons, chauve-souris, serpents, étoiles, roses, sirènes, lutteurs, chaînes, fils barbelés, prénoms, pin-up nues et la Vierge Marie : la subculture *tattoo* et son imagerie sont au centre de l'œuvre du mexicain Dr. Lakra, artiste tatoueur qui, depuis la fin des années 1990, expose et appose ses dessins sur papier, bois, divers objets de récupé-ration, murs et bien sûr la peau. Ses images les plus connues sont des dessins finement tracés à l'encre sur des pages ou des couvertures de vieux magazines mexicains (de préférence sur les membres de pulpeuses pin-up), mais il applique aussi ses entrelacs subtils sur des portraits de famille, des publicités, des planches d'anatomie ou encore de vieilles estampes japonaises. Il a croisé les deux mondes en instal-lant, dans un coin du stand d'une foire d'art, un salon de tatouage où il tatouait les visiteurs pendant que, dans l'autre coin, la galerie s'occupait de vendre ses « vraies » œuvres. De façon un peu nostalgique, Dr. Lakra agit à la croisée des cultures intellectuelles et populaires, introduisant au royaume de l'art la sensibilité et le symbolisme du tatouage, une touche de violence en plus, et fait appel à une tradition graphique trans-gressive et underground, de William Blake à Robert Crumb. On pourrait voir aussi dans son travail un jeu sur le désir de permanence de l'art, puisqu'un tatouage ne survivra pas à celui qui le porte. Mais l'artiste a récemment élargi son champ d'action, travaillant avec des techniques diverses, réalisant des dessins autonomes et des graffitis, construisant des portraits en collage à partir de cheveux et d'insectes séchés qu'il met dans des vieux cadres en bois, tels des souvenirs d'un passé éphémère.

R. M.

SELECTED EXHIBITIONS →
2008 *Martian Museum of Terrestrial Art*, Barbican Art Gallery, London **2007** *Goth: Reality of the Departed World*, Yokohama Museum of Art, Yokohama. *Feral Kingdom*, The Centre for Contemporary Arts CCA, Glasgow. *General Issue*, Centro Galego de Arte Contemporánea, Santiago de Compostela **2006** *Spank the Monkey*, BALTIC Centre for Contemporary Art, Gateshead **2005** *Los Dos Amigos. Dr. Lakra & Abraham Cruzvillegas*, Museo de Arte Contemporáneo de Oaxaca

SELECTED PUBLICATIONS →
2008 *Martian Museum of Terrestrial Art*, Barbican Art Gallery, London **2007** *Escultura Social: A New Generation of Art from Mexico City*, The Alameda National Center, San Antonio; Yale University Press, New Haven **2006** *Los Dos Amigos. Dr. Lakra & Abraham Cruzvillegas*, Museo de Arte Contemporáneo de Oaxaca; Turner, Nashville. *Spank the Monkey*, BALTIC Centre for Contemporary Art, Gateshead; Die Gestalten Verlag, Berlin

1 **Untitled (Shunga VI)**, 2007, pigment on Japanese woodblock print, 24.5 x 16.9 cm
2 **Untitled (Alma)**, 2007, gouache, acrylic, watercolour on Japanese Paper, 194 x 187.5 cm

3 **Untitled (Bruce Lee y caras femeninas)**, 2006, gouache, acrylic, watercolour on Japanese Paper, 195 x 188.5 cm

„Die Gesellschaft versucht immer, den Teil unseres Menschseins zu begraben, um den es in Pornos und Tattoos geht."

« La société essaie sans relâche d'enterrer la part de la condition humaine qui est explorée dans le porno et le tatouage. »

"Society is always trying to bury the part of the human condition that is explored in porn and tattoo."

Ulrich Lamsfuß

1971 born in Bonn, lives and works in Berlin, Germany

Ulrich Lamsfuß belongs to a generation of young painters described by the magazine *Der Spiegel* as "the young villains". The reference is to a generation of artists who hover stylistically between post-impressionism and post-expressionism, with the odd excursion into the field of photorealism. What links them even more, however, are their incursions into the reality of the media and its transformation into a painted reality. In doing this the "villain" will stop at nothing: according to the rules of postmodernism, all materials are of equal value, appropriable and transformable. Lamsfuß' motifs are consequently drawn from various sources: magazines, films and frequently from the world of art, where the "young villains'" method is not all that unusual – after all, it was developed by the "old villain" Andy Warhol. It is in this spirit of reproductive image creation that Lamsfuß produces his own repetitions. "Who says you can only paint a work once?" he asks cheekily, and can thus exhibit the same paintings simultaneously in exhibitions in New York and Los Angeles (*Pet Sounds*, 2005). Or he can claim that by means of this multiple painting he is producing something like a video film in slow motion. But impudence alone does not account for the quality of his works. When Lamsfuß does photorealistic paintings of advertising photographs for Escada fashion collections (2006/07), he addresses issues of reproduction (photography) and singularity (painting). But his impudent approach is always visible: for example in *Die ganze Familie Federvieh (Kochen – Die neue große Schule)* (2006) where he paints roast chickens, sorted according to size, which have been positioned – not unlike the models of the Escada collection – in the best possible way for a group shot, resulting in a family portrait of an ironic kind.

Ulrich Lamsfuß gehört einer Generation junger Maler an, die im *Spiegel* als „die jungen Bösewichte" bezeichnet wurden. Gemeint ist eine Künstlergeneration, die stilistisch zwischen Post-Impressionismus und Post-Expressionismus mit Ausflügen ins Fotorealistische arbeitet. Verbindender ist jedoch das motivische Ausgreifen in die mediale Realität sowie deren Wandlung in eine gemalte. Hierbei schreckt der „Bösewicht" vor nichts zurück. Gemäß den Spielregeln der Postmoderne ist jegliches Bildmaterial gleichwertig, vereinnahmbar und wandelbar. Und so entstammen Lamsfuß' Motive unterschiedlichen Quellen: Zeitschriften, Filmen und immer wieder der Welt der Kunst. In dieser ist das Vorgehen der „jungen Bösewichte" nicht ganz unbekannt, denn ein „alter Bösewicht", Andy Warhol, hat es bereits entwickelt. In seinem Geiste der reproduktiven Bildfabrikation fertigt Lamsfuß auch die eigenen Wiederholungen. „Wer sagt denn, dass man jedes Bild nur einmal malen darf?", fragt er keck. Und kann so zeitgleich eine Ausstellung in New York und Los Angeles mit denselben Bildern bestücken (*Pet Sounds*, 2005). Oder von sich behaupten, durch die Mehrfachmalerei so etwas wie einen Videofilm in Slow-Motion herzustellen. Doch Keckheit allein macht nicht die Qualität seiner Arbeiten aus. Wenn er Werbefotografien der Escada-Kollektionen (2006/07) fotorealistisch malt, so thematisiert er Fragen von Reproduzierbarkeit (Fotografie) und Singularität (Malerei). Doch die Keckheit dringt immer wieder durch. Etwa wenn er bei *Die ganze Familie Federvieh (Kochen – Die neue große Schule)* (2006) nach Größe wohl sortierte Geflügelbraten malt, die, nicht unähnlich den Models der Escada-Kollektion, fürs Gruppenporträt in beste Stellung gebracht worden sind, um ein Familienbild ironischer Art zu bieten.

Ulrich Lamsfuß fait partie d'une jeune génération de peintres qui ont été qualifiés de « jeunes garnements » dans *Der Spiegel* et dont le travail se situe stylistiquement entre post-impressionnisme et post-expressionnisme avec des incursions dans le photoréalisme. Mais ce qui les lie encore plus fortement, c'est le fait que leurs motifs abordent la réalité médiatique et sa transformation en réalité picturale. Pour cela, le « garnement » ne recule devant rien. Conformément aux règles du jeu post-moderne, tous les matériaux visuels se valent, sont exploitables et transformables. Lamsfuß puise donc ses motifs aux sources les plus diverses : revues, cinéma et régulièrement aussi au monde de l'art, où la démarche des « jeunes garnements » n'est pas tout à fait inconnue : un « vieux garnement », Andy Warhol, l'avait déjà développée. C'est dans l'esprit de sa production sérielle d'images que Lamsfuß réalise ses propres répétitions. « Qui dit qu'on ne puisse peindre un tableau qu'une seule fois ? », demande-t-il effrontément. Ce qui lui permet de présenter simultanément deux expositions des mêmes œuvres à New York et à Los Angeles (*Pet Sounds*, 2005) ou d'affirmer que sa peinture multiple réalise quelque chose comme une vidéo au ralenti. Mais l'effronterie ne fait pas seule la qualité de ses œuvres. Quand il peint des photos de mode de la collection Escada (2006/07) sur un mode photoréaliste, il aborde aussi des questions de reproductibilité (photographie) et de singularité (peinture). Cela dit, l'effronterie refait toujours surface. Par exemple avec *Die ganze Familie Federvieh (Kochen – Die neue große Schule)* (2006), lorsque Lamsfuß peint des poulets rôtis soigneusement rangés par taille et qui, à la manière des top models de la collection Escada, ont été placés dans la meilleure position possible pour offrir un portrait de famille ironique.

H. L.

SELECTED EXHIBITIONS →
2008 *Ad Absurdum*, MARTa, Herford. *Ulrich Lamsfuß: Pet Sounds*, Lombard Freid Projects, New York; Daniel Hug Gallery, Los Angeles
2007 *Ulrich Lamsfuß: Gläserne Bienen*, Galerie Daniel Templon, Paris
2005 *Rückkehr ins All*, Hamburger Kunsthalle, Hamburg

SELECTED PUBLICATIONS →
2007 *Jetzt*, Beck & Eggeling, Düsseldorf **2006** *Carbonic Anhydride*, Galerie Max Hetzler, Berlin **2005** *Rückkehr ins All*, Hamburger Kunsthalle, Hamburg

„Ich sehe meine Kunst ein bisschen wie einen langsamen Video-Clip."

« Je considère mon art un peu comme un lent clip vidéo. »

"I think of my art as somewhat of a slow video clip."

3

4

Won Ju Lim

1968 born in Kwangju, Korea, lives and works in Los Angeles (CA), USA

With her installation *Ruined Traces* (2007), Won Ju Lim transports the viewer into a wondrous winter garden, in which miniature landscapes covered by Plexiglas vitrines stand on high pedestals amidst real and artificial foliage plants. The landscapes are sliced in half like scientific preparations, thus revealing their material and method of construction. Video projections overlay the sculptural elements with images of lush vegetation or the Californian landscape. The interplay of light and space, together with artificial and natural materials, creates a landscape that, while recalling architectural and landscape models, also bears distinct traces of the fantastic. In her series *Broken Landscapes* (2007), Lim experimented with a new method: the works consist of found landscape paintings, which have been cut into pieces and then put back together, their individual parts attached with pins to a foam base so that they create a relief-like surface. But she is not concerned with accurate natural representations or engaging with art-historical genres, but rather with the fragmentation and fragility of perception and memory. *A Piece of Sun Valley* (2007) and *A Piece of Echo Park* (2007) are both models of mountainous landscapes presented under yellow Plexiglas, to which the artist adds an additional disturbing element: the alpine scenes are at odds with the titles, which refer to areas of Los Angeles. The works have a second view: from behind, colourful rubbery gels pour down the plaster frame. Lim's choice of material is always significant and never just the means to an end, but she employs materials in such a way that they are often pushed to their physical limits.

Mit ihrer Rauminstallation *Ruined Traces* (2007) versetzt Won Ju Lim die Betrachter in einen wunderlichen Wintergarten: Zwischen echten und artifiziellen Grünpflanzen stehen auf hohen Sockeln unter Plexiglasgehäusen Miniaturlandschaften, die wie aufgeschnittene Präparate ihre Konstruktion und ihr Material zur Schau stellen. Videoprojektionen überlagern die skulpturalen Elemente mit üppigen Vegetationen oder kalifornischer Landschaft. Das Zusammenspiel von Licht, Raum sowie künstlichen und natürlichen Materialien erzeugt eine Landschaft, die zwar an Architektur- und Landschaftsmodelle erinnert, jedoch deutliche Züge des Fantastischen trägt. In ihrer Serie *Broken Landscapes* (2007) erprobt Lim eine für sie neue Vorgehensweise: Die Arbeiten bestehen aus vorgefundenen Landschaftsmalereien, die zerschnitten und als Einzelteile mit Nadeln auf einen Untergrund gespießt werden, so dass sich eine reliefartige Oberfläche ergibt. Doch geht es ihr nicht um präzise Naturdarstellung oder die Auseinandersetzung mit einem kunsthistorischen Genre, sondern um den Verweis auf die Fragmentierung und Brüchigkeit von Wahrnehmung und Erinnerung. In Werken wie *A Piece of Sun Valley* (2007) oder *A Piece of Echo Park* (2007), ebenfalls Modelle bergiger Landschaften, präsentiert unter gelbem Plexiglas, führt die Künstlerin als zusätzlich irritierendes Moment einen Kontrast zwischen der alpin wirkenden Szenerie und den Titeln ein, die sich auf Stadtviertel in Los Angeles beziehen. Die Arbeiten haben zwei Ansichten, an ihrer Rückseite fließen zähe, farbige Gele über das Gipsgerippe. Das Material, das Lim für ihre Arbeiten wählt, ist nie einfach nur Mittel zum Zweck, sein Charakter bleibt stets bedeutsam und wird als solcher vorgeführt, wobei das Material oftmals bis an die Grenzen seiner physikalischen Eigenschaften genutzt wird.

Avec sa vaste installation *Ruined Traces* (2007), Won Ju Lim transporte le spectateur dans un étrange jardin d'hiver : au milieu de plantes vertes naturelles ou artificielles, des vitrines en plexiglas sont posées sur de hauts socles, dans lesquelles des paysages miniatures exhibent leur conformation et leur matériau comme des préparations laborantines vues en coupe. Des projections vidéo se superposent aux éléments sculpturaux des flores foisonnantes ou des paysages californiens. L'interaction entre la lumière, l'espace et les matériaux artificiels et naturels crée un paysage qui rappelle sans doute les maquettes d'architecture ou de paysages, mais qui présente manifestement des traits fantastiques. Dans sa série *Broken Landscapes* (2007), Lim s'essaie à une nouvelle manière de procéder : les œuvres sont constituées de découpages ou de parties de peintures paysagères existantes épinglées sur une base, de manière à produire des surfaces en relief. Cela dit, le propos de Lim n'est pas de donner une reconstitution précise de la nature ou de travailler sur un genre artistique passé, mais de renvoyer à la discontinuité et à la fragilité de la perception et de la mémoire. Dans des œuvres comme *A Piece of Sun Valley* (2007) ou *A Piece of Echo Park* (2007) – également des maquettes de paysages montagneux présentées ici sous plexiglas jaune –, l'artiste introduit une perturbation supplémentaire avec le contraste entre un décor alpestre et des titres évoquant des quartiers de Los Angeles. Les œuvres proposent deux vues : sur la face arrière, des gels colorés visqueux coulent le long de la structure en plâtre. Le matériau que Lim choisit pour ses œuvres n'est jamais un simple moyen justifiant une fin, son caractère reste toujours porteur de sens et est présenté comme tel, les matériaux étant souvent exploités jusqu'aux limites de leurs propriétés physiques.

A. M.

SELECTED EXHIBITIONS →
2008 *Won Ju Lim: 24 Seconds of Silence*, Ullens Center for Contemporary Art, Beijing. *All-inclusive. A Tourist World*, Schirn Kunsthalle, Frankfurt am Main **2007** *Won Ju Lim: Refraction/ Reflection*, Korean Cultural Center, Los Angeles **2006** *Idylle: Traum und Trugschluss*, National Gallery Prague; Domus Artium 2002, Salamanca; Phoenix Kulturstiftung/Sammlung Falckenberg, Hamburg. *Won Ju Lim: In Many Things to Come*, Honolulu Academy of Arts, Honolulu

SELECTED PUBLICATIONS →
2008 *All-inclusive. A Tourist World*, Schirn Kunsthalle, Frankfurt am Main; Snoeck Verlag, Cologne **2007** *Idylle: Traum und Trugschluss*, Phoenix Kulturstiftung/Sammlung Falckenberg, Hamburg; Hatje Cantz, Ostfildern **2006** *Carbonic Anhydride*, Galerie Max Hetzler, Berlin. *Lichtkunst aus Kunstlicht. Licht als Medium der Kunst im 20. und 21. Jahrhundert*, ZKM, Karlsruhe; Hatje Cantz, Ostfildern.

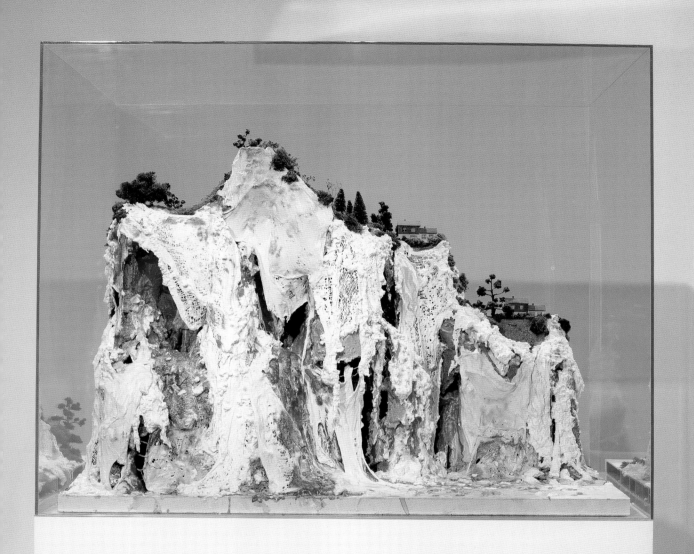

1 **A Piece of Sun Valley**, 2007, mixed media, Plexiglas, 97 x 114 x 97 cm
2 **Untitled (Pepto Bismol)**, 2007, mixed media, 34 x 97 x 91 cm
3 **Broken Landscape #2**, 2007, paint on canvas, silk pins, foam,
53 x 66 x 13 cm

4 **Ruined Traces**, 2007, mixed media sculpture, Plexiglas, artificial plants, live plants, video projections, dimensions variable

„Ich möchte, dass meine Arbeit sich auf viele Dinge gleichzeitig bezieht. Ich möchte auch, dass meine Arbeit von einer Referenz zur nächsten gleitet."

« Dans mon travail, ce qui m'intéresse est de me référer simultanément à des choses multiples, mais aussi de glisser d'une référence à une autre. »

"I am interested in my work referring to multiple things simultaneously. I am also interested in my work slipping from one reference to another."

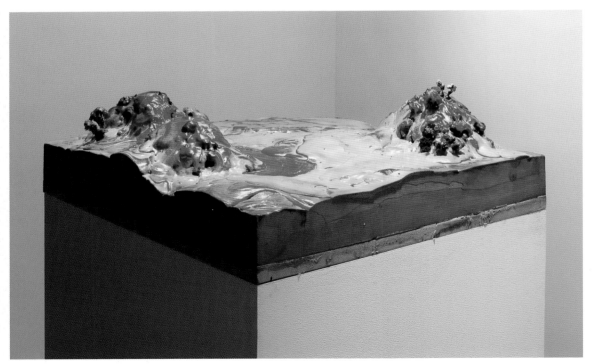

2

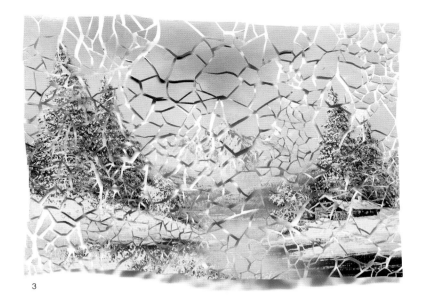

3

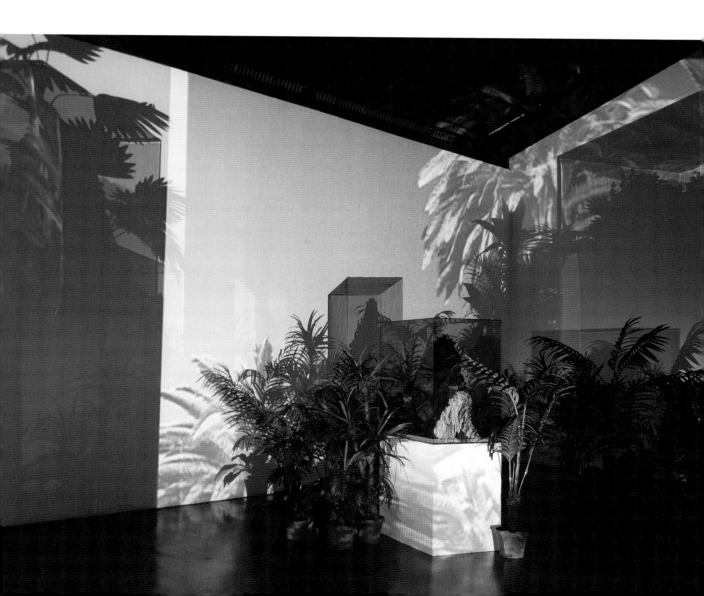

Vera Lutter

1960 born in Kaiserslautern, Germany, lives and works in New York (NY), USA

As the shutters of digital cameras click away with ever-increasing frequency, the flood of irrelevant images grows. This makes it all the more significant when someone decides to go against the digital trend and apply the basic principle of photography with a *camera obscura*. Vera Lutter has chosen to use this technique to produce large-format unique works. Sometimes she even uses whole rooms as her camera shell, darkening them until only a small chink of light remains. An inverted image of the external world then appears on the opposite wall and is captured by Lutter on photographic paper in the form of a unique negative. This process generates negatives of the world, where even things that normally need illumination gain their own luminosity. Lately, Lutter has increasingly been employing this technique in her architectural photography, so that buildings appear to emit light and thus have an ethereal, almost weightless quality. Stone and steel become light – Lutter's working method in a nutshell. Lutter's work often deals with urban landscapes, most recently in Venice (*Venice Portfolios*, 2007). Perhaps this city, whose water-bound state lends it an ethereal quality and at the same time threatens its very existence, is particularly suited to Lutter's concerns. Venice's mystical morbidity, its beauty and its endangered character, are revealed in her photographs, which dematerialize the architecture, free it from gravity and simultaneously rematerialize it as an impression of light. The fact that this process also accentuates the structure of the depicted architecture, as in her images of industrial buildings, locates her work within Düsseldorf's Becher School, but she leaves this legacy far behind with her precious images of weightlessness.

Je häufiger der Auslöser von Digitalkameras gedrückt wird, desto größer wird die Flut an irrelevanten Bildern. Umso bedeutsamer, wenn sich dann jemand entscheidet, gegen den digitalfotografischen Trend ein Urprinzip der Fotografie, die *camera obscura*, die Lochkamera, zu nutzen. Vera Lutter hat sich dieser Technik verschrieben, um großformatige Unikate herzustellen. Dabei wählt sie zuweilen ganze Räume als Kamerahülle. Sie werden abgedunkelt und nur ein kleines Lichtloch bleibt offen. Auf der gegenüberliegenden Seite erscheint dann ein umgekehrtes Bild der Außenwelt. Dieses wird von Lutter aufgefangen auf Fotopapier in der Form eines singulären Negativs. Was so entsteht, sind Negative der Welt, bei denen normalerweise beleuchtete Dinge selbst Leuchtkraft gewinnen. Lutter nutzt diese Technik in letzter Zeit wieder verstärkt für Architekturfotografien, so dass die Gebäude lichtabstrahlend wirken und dadurch zugleich ätherisch-leicht. Aus Stein und Stahl wird Licht – so lässt sich Lutters Vorgehensweise zusammenfassen. Immer wieder beschäftigt sie sich mit urbanen Landschaften, zuletzt war sie dazu in Venedig (*Venice Portfolios*, 2007). Vielleicht ist diese Stadt, deren Wasser ihr einerseits eine ätherische Qualität verleiht und andererseits ihre Existenz bedroht, besonders geeignet für Lutter. Denn die mystische Morbidität von Venedig, die Schönheit und Bedrohtheit dieser Stadt, findet ihre Offenlegung in den Fotografien, welche die Architektur dematerialisieren, ihr die Schwerkraft nehmen und sie doch zugleich rematerialisieren, und zwar als Lichterscheinung. Dass dabei, wie auch bei Lutters Fotografien von Industriebauten, die Struktur der Architektur hervorgehoben wird, verortet ihre Arbeiten in der Düsseldorfer Becher-Schule, die sie mit ihren Preziosen der Schwerelosigkeit allerdings wiederum hinter sich lässt.

Plus on appuie sur les déclencheurs des appareils numériques, plus le flot d'images non signifiantes augmente. Il est donc d'autant plus significatif que quelqu'un décide d'utiliser un procédé remontant aux origines de la photographie et allant à contre-courant de la tendance numérique : la *camera obscura*, l'appareil à chambre noire. Vera Lutter s'est vouée à cette technique pour réaliser des grands formats uniques. Parfois, elle choisit pour cela des pièces entières qui lui servent d'appareil photo. Ces pièces sont obscurcies, seule une ouverture minuscule est ménagée, sur le mur opposé apparaît l'image inversée du monde extérieur. Cette image, Lutter la fixe sur papier photographique. Ce que produit ce procédé, ce sont des négatifs du monde dans lesquels les objets habituellement éclairés deviennent eux-mêmes luminescents. Récemment, Lutter s'est à nouveau servi plus fortement de cette technique pour des photographies d'architecture ; les immeubles semblent irradier tout en étant d'une légèreté éthérée. La pierre et l'acier deviennent lumière – ainsi pourrait-on résumer la démarche de Lutter. Travaillant régulièrement sur le paysage urbain, Lutter a séjourné récemment à Venise (*Venice Portfolios*, 2007), une ville peut-être plus propice à son travail que d'autres du fait de la qualité éthérée que lui confère l'omniprésence de l'eau – qui en même temps la met en péril. La morbidité mystique, la beauté et la fragilité de Venise sont mises à nu dans des photographies qui dématérialisent l'architecture, lui ôtent sa pesanteur tout en la rematérialisant sous forme de manifestation lumineuse. Comme dans ses photographies de sites industriels, son travail souligne la structure de l'architecture, ce qui rapproche Lutter de l'école des Becher, qu'elle dépasse en revanche par ses bijoux d'apesanteur. H. L.

SELECTED EXHIBITIONS →
2008 *Venedig. Von Canaletto und Turner bis Monet*, Fondation Beyeler, Riehen/Basle **2007** *Rückblende*, Neue Galerie Graz am Landesmuseum Joanneum, Graz. *Welt – Bilder 2*, Helmhaus, Zürich. *Alchemy*, Abbot Hall Art Gallery, Kendal; Lakeside Arts Centre, Nottingham **2006** *Ann Hamilton, Vera Lutter and Abelardo Morell: Taken with Time*, The Print Center, Philadelphia **2005** *Vera Lutter: Nabisco Factory Beacon*, Dia:Beacon, Riggio Galleries, Beacon. *Vera Lutter*, The Modern Art Museum of Fort Worth

SELECTED PUBLICATIONS →
2007 *Vera Lutter*, Gagosian Gallery, New York. *Welt – Bilder 2*, Helmhaus Zürich; Verlag für moderne Kunst, Nuremberg **2006** *Carbonic Anhydride*, Galerie Max Hetzler, Berlin. *Vitamin Ph: New Perspectives in Photography*, Phaidon Press, London **2004** *Vera Lutter: Battersea*, Gagosian Gallery, London. *Vera Lutter: Inside in*, Kunsthaus Graz; Verlag der Buchhandlung Walther König, Cologne

1 **Times Square, V: July 31, 2007**, silver gelatin print, 255.9 cm x 142.2 cm
2 **Rheinbraun, XVI: September 4, 2006**, silver gelatin print, 249.9 cm x 426.7 cm
3 **Palazzo Papadopoli, Venice, XVIII: March 13, 2006**, silver gelatin print, 231.1 cm x 284.5 cm

4 **San Giorgio, Venice XVIII, January 26, 2008**, silver gelatin print, 259.4 cm x 284.5 cm
5 **Corte Barozzi, Venice, XXXIII: December 11, 2005**, silver gelatin print, 174 cm x 106.7 cm

„Ich weiß vorher nie, was passiert. Ich lasse in meiner Arbeit vieles einfach geschehen. Ich installiere meine Apparatur zur Beobachtung, die Kamera, dann harre ich während des Beobachtungsvorgangs aus und nehme auf, egal was passiert. Es geht vor allem um diesen Zeitraum, nicht um die Darstellung an sich."

« Je ne sais jamais ce qui va se passer. Ma manière de travailler est très détachée. J'installe un outil d'observation, l'appareil photo, puis je vais jusqu'au bout du processus d'observation et enregistre tout ce qui arrive. L'œuvre porte essentiellement sur la fuite du temps, pas sur des idées de représentation. »

"I never know what is going to happen. My way of working is very hands-off. I install the apparatus of observation, the camera, and then endure the process of observation and record whatever happens. The work is essentially about the passage of time, not about ideas of representation."

2

3

4

Marepe

1970 born as Marcos Reis Peixoto in Santo Antônio de Jesus, lives and works in Santo Antônio de Jesus, Brazil

To Marepe, displacement is an important matter. In *Veja Meu Bem* (2007), made to last only two days at Tate Modern's Turbine Hall, the artist recreated the ambiance of a Brazilian funfair, installing a fully functional carnival roundabout and adding to it a cascade of sugar-coated apples made available to the public as a signifier of abundance and desire. The installation was inspired by what he calls "beautiful and precarious Brazil" and was ultimately a way to bring a piece of his country and its contradictions to London – a displacement comparable to an earlier project, where the artist had brought a store wall from his native town to the São Paulo Biennial. With the transport of everyday objects into the art world, the artist honours the Duchampian gesture of the readymade, but he also extrapolates it, loading up concrete objects with new layers of meaning. Unlike most contemporary Brazilian artists who have elected Rio de Janeiro or São Paulo as their residence, Marepe lives in his native town at the southern outskirts of Salvador, a fact which deeply impacts his oeuvre. The Brazilian Northeastern way of life, its precarious material conditions and creative craftsmanship are his constant sources: a peddler's stall, low-income households, metal basins or the trunk of a cashew tree appear in his work in a changing context. As he straddles the different universes, Marepe creates a voice of alterity within the art world and his poetically shaped comments on colonialism, identity, social class, memory, family and the conflict between modern and traditional lifestyles have no pamphletary, regionalistic or naïve tones whatsoever.

Dislokation ist ein wichtiges Konzept in Marepes Kunst. In *Veja Meu Bem* (2007), das für nur zwei Tage in der Turbinenhalle der Tate Modern stand, stellte er ein brasilianisches Vergnügungsfest nach, indem er ein voll funktionsfähiges Karnevalskarussell aufbaute und ihm eine Fülle von kandierten Äpfeln – ein Zeichen für Überfluss und Verlangen – hinzufügte, die das Publikum mitnehmen konnte. Die Installation war von dem inspiriert, was Marepe das „wunderschöne und prekäre Brasilien" nennt, und war für ihn letzten Endes eine Gelegenheit, Brasilien und ein Stück seiner Widersprüche nach London zu bringen – ein Ortswechsel, der einem früheren Projekt vergleichbar ist, bei dem der Künstler die Wand eines Geschäfts seiner Geburtsstadt auf die Biennale in São Paulo brachte. Mit dem Versetzen von alltäglichen Gegenständen in die Welt der Kunst folgt Marepe Duchamp und seiner Geste des Readymades, aber er extrapoliert sie auch, indem er konkrete Gegenstände mit neuen Bedeutungen anreichert. Anders als die meisten zeitgenössischen brasilianischen Künstler, die in Rio de Janeiro oder São Paulo wohnen, lebt Marepe in seinem Geburtsort in den südlichen Vororten von Salvador, was sein Werk deutlich prägt. Das Leben im Nordosten Brasiliens, seine schwierigen Lebensbedingungen und die kreative Handwerkskunst dort sind seine Quellen: die Bude eines Händlers, die Haushalte der Armen, Blechbecken oder der Stamm eines Cashewbaums tauchen in seinem Werk in wechselnden Zusammenhängen auf. Indem er verschiedene Welten verbindet, gibt Marepe der Alterität innerhalb der Kunstwelt eine Stimme, und seine poetischen Kommentare zu Kolonialismus, Identität, sozialer Klasse, Erinnerung, Familie und dem Konflikt zwischen modernen und traditionellen Lebensstilen haben keinerlei pamphletartigen, regionalistischen oder naiven Ton an sich.

Pour Marepe, le déplacement est un sujet important. Avec *Veja Meu Bem* (2007), conçu pour ne durer que deux jours à l'intérieur du Turbine Hall de la Tate Modern à Londres, l'artiste recréait l'ambiance d'une fête foraine brésilienne, en y installant un manège forain opérationnel et en y ajoutant une cascade de pommes d'amour offertes au public, symbole d'abondance et de désir. L'installation, inspirée par ce qu'il nomme le « Brésil magnifique mais précaire », était un moyen de transporter à Londres une part de son pays et de ses contradictions – un déplacement comparable à un projet antérieur, où l'artiste avait exposé le mur d'une boutique de sa ville natale à la Biennale de São Paulo. Avec le transfert d'objets quotidiens dans le monde de l'art, l'artiste honore le geste Duchampien du ready-made, et le prolonge en chargeant des objets concrets d'un sens nouveau. Contrairement à la plupart des artistes contemporains brésiliens qui ont choisi de vivre à Rio de Janeiro ou à São Paulo, Marepe vit dans sa ville natale à la lisière sud du Salvador, ce qui a un impact significatif sur son œuvre. Le mode de vie dans le Nordeste brésilien, les conditions matérielles précaires et l'artisanat sont autant de sources d'inspiration : un éventaire de colporteur, des ménages pauvres, des cuvettes en métal ou un tronc d'anacardier apparaissent dans son œuvre dans un contexte transformé. En enjambant les différents univers, Marepe fait entendre une voix nouvelle dans le monde de l'art. Ses commentaires poétiques sur le colonialisme, l'identité, les classes sociales, la mémoire, la famille ou le conflit entre modes de vie moderne et traditionnel n'ont aucune tonalité pamphlétaire, régionaliste ou naïve.

R. M.

SELECTED EXHIBITIONS →
2007 *Marepe*, Museu de Arte Moderna de São Paulo. *Marepe: Veja Meu Bem*, Tate Modern, London **2006** *Alien Nation*, ICA, London; Manchester Art Gallery, Manchester; Sainsbury Centre for Visual Arts, Norwich. *How to live together*, 27th Bienal de São Paulo, Pavilhão Ciccillo Matarazzo, São Paulo. *Zones of Contact*, Biennale of Sydney 2006, Sydney **2005** *Marepe: Vermelho – Amarelo – Azul – Verde*, Centre Georges Pompidou, Paris. *Marepe*, Museu de Arte da Pampulha, Belo Horizonte

SELECTED PUBLICATIONS →
2007 *Marepe*, Galerie Max Hetzler, Berlin; Galerie Luisa Strina São Paulo; Holzwarth Publications, Berlin. *100 Latin American Artists*, Exit Publicaciones, Olivares y Asociados, Madrid **2006** *Alien Nation*, ICA, London et al., Hatje Cantz, Ostfildern. *Carbonic Anhydride*, Galerie Max Hetzler, Berlin. *Zones of Contact*, Biennale of Sydney, Art Gallery of New South Wales, Sydney **2005** *Marepe*, Museu de Arte da Pampulha, Belo Horizonte

1 **Veja Meu Bem (Look, My Dear)**, 2007, carousel, lamps, toffee apples, acetate, cloth, dimensions variable. Installation view, *UBS Openings: The Long Weekend*, Tate Modern, London
2 **Periquitos**, 2005/07, mixed media, 41 x 53.5 x 30 cm
3 **Quatro Cadeiras Conversando (Four Chairs Talking)**, 2007, wood, steel wool, metal, ca 140 x 240 x 200 cm, dimensions variable
4 **Andador (Chair)**, 2005, metal, fabric, rubber, 323 x 259 x 288 cm

„In meiner Arbeit geht es um das, was mich umgibt, was ich sehe und fühle, den Alltag, den Wunsch nach einer gerechteren Welt, in der es weniger Gewalt gibt."

« Mon travail porte sur ce qui m'entoure, sur ce que je vois, sur le quotidien, le désir d'un monde plus juste et moins violent. »

"My work deals with what surrounds me, what I see, feel, the everyday, desires for a more equal world that is less violent."

2

3

Paul McCarthy

1945 born in Salt Lake City (UT), lives and works in Altadena (CA), USA

Paul McCarthy, a contemporary master of the grotesque, began his artistic career in the 1960s with physical performances that could involve using his penis as a paintbrush. In the 1980s he began developing stage sets and incorporating video into his works. His sculptural cast includes politicians, pigs and Santa Clauses (to name just a few), who do their best to show the dark side of life in classically Freudian style. Sometimes all it takes is a nine-metre-tall inflatable ketchup bottle – when it goes by the name of *Daddies Ketchup* (2001) and evokes some nasty associations. Deliriously infantile and over the top, the work of this influential artist is often grotesque and always full of irreverent humour. McCarthy himself was influenced by Warhol and often employs the pop artist's blow-up method, although he attacks the incunabula of consumer society in a more playful manner. *Caribbean Pirates* (2001–05), his largest project to date, alludes to both the Disneyland ride and the Johnny Depp film. Realized in collaboration with Damon McCarthy, it comprises 20 video projections, a 70-foot frigate sculpture installation, a houseboat (used as a set), and numerous props from the original filming. Chaotic video sequences are collaged together to show the pirates' raucous debauchery and blood lust; not much remains of Disney's merry pirates. In his latest works McCarthy again shifts the ground beneath the viewer's feet – quite literally so in *Spinning Room* and *Mad House* (2008), which cast viewers into a disorientating world of rotation and reflection. McCarthy adjusts the parameters of how we perceive the world, setting up a Nightmare Factory opposite the Dream Factory of Hollywood.

Paul McCarthy, heute ein Meister des Grotesken, begann seine künstlerische Karriere in den 1960er-Jahren mit körperbetonten Performances, bei denen er auch mal seinen Penis als Pinsel einsetzte. Ab den 1980er-Jahren begann er, Bühnenaufbauten zu entwickeln und mit Video zu arbeiten. Sein Skulpturenpersonal enthält unter anderem Politiker, Schweine und Nikoläuse, die ihr Bestes geben, um freudianisch korrekt die dunkle Seite des Lebens zu zeigen. Manchmal reicht jedoch schon eine neun Meter hoch aufgeblasene Ketchup-Flasche, wenn sie *Daddies Ketchup* (2001) heißt und üble Assoziationen weckt. Delirierend infantil, großspurig im XXL-Format, grotesk und voll bösen Humors – so zeigt sich das Werk dieses einflussstarken Künstlers. Selbst beeinflusst von Warhol, greift er oft dessen Blow-up-Verfahren auf, wendet sich jedoch viel spielerischer als jener gegen Inkunabeln der Konsumgesellschaft. *Caribbean Pirates* (2001–05), zusammen mit seinem Sohn Damon realisiert, ist das bislang aufwändigste Projekt und bezieht sich auf den Disney-Themenpark sowie den Film mit Johnny Depp. Das Werk besteht aus 20 Video-Projektionen, einer Installation mit einer über 20 Meter langen Fregatte, einem Hausboot, das als Filmset benutzt wurde, und viele Requisiten der originalen Dreharbeiten. Chaotische Video-Sequenzen werden ineinander collagiert, sie zeigen die lärmenden Ausschweifungen und die Blutlust der Piraten – hier bleibt von Disneys fröhlichen Freibeutern nicht viel übrig. Auch bei seinen jüngsten Arbeiten geht es McCarthy darum, dem Betrachter den Boden unter den Füßen wegzuziehen. Das geschieht durchaus wörtlich bei *Spinning Room* und *Mad House* (2008), die den Betrachter in eine desorientierende Welt aus Rotationen und Spiegeln versetzen. McCarthy dreht an den Parametern unserer Weltwahrnehmung und setzt gegen Hollywoods Dream Factory eine Nightmare Factory in Gang.

Paul McCarthy, qui est aujourd'hui un maître du grotesque, a débuté sa carrière artistique dans les années 1960 avec des performances centrées autour du corps dans lesquelles il lui est arrivé d'utiliser son pénis comme un pinceau. À partir des années 1980, il commence à mettre au point des décors de scènes et à travailler avec la vidéo. Sa troupe de personnages-sculptures est notamment composée de politiciens, de porcs et de pères Noëls qui font tout pour mettre en évidence la face sombre de la vie selon le canon freudien. Une bouteille de ketchup gonflable de neuf mètres de haut intitulée *Daddies Ketchup* (2001) peut suffire à évoquer de fâcheuses associations. Empreinte de délire infantile, d'excès au format XXL, de grotesque et d'humour aigre – telle est l'œuvre de cet artiste influent. Lui-même influencé par Warhol, McCarthy utilise souvent le *blow up*, mais s'attaque de façon beaucoup plus ludique aux incunables de la société de consommation. *Caribbean Pirates* (2001–05), le projet le plus ambitieux réalisé à ce jour avec son fils Damon, se réfère au parc à thème de Disney et au film joué par Johnny Depp. L'œuvre est constituée de vingt projections vidéos et d'une installation avec une frégate de vingt mètres de long, un bateau-maison utilisé comme lieu de tournage et beaucoup d'accessoires utilisés lors du tournage original. Des séquences vidéos chaotiques ont été superposées, montrant les débauches tapageuses des pirates assoiffés de sang – mais des flibustiers joyeux de Disney il n'y a plus de traces. Dans ses toutes dernières œuvres, le propos de McCarthy est de faucher l'herbe sous le pied du spectateur, ce qui se produit presque littéralement avec *Spinning Room* et *Mad House* (2008), qui emportent le spectateur dans un monde déroutant de rotations et de miroirs. McCarthy manipule les paramètres de notre perception du monde et met en route une Nightmare Factory contre la Dream Factory de Hollywood. H. L.

SELECTED EXHIBITIONS →
2008 *Paul McCarthy: Central Symetrical Rotation Movement – Three Installations, Two Films,* Whitney Museum of American Art, New York. *Kult des Künstlers: Ich kann mir nicht jeden Tag ein Ohr abschneiden,* Hamburger Bahnhof, Berlin. *Here Is Every. Four Decades of Contemporary Art,* MoMA, New York **2007** *Paul McCarthy: Tokyo Santa 1996/2004,* The Essl Collection, Klosterneuburg **2006** *Into Me/ Out Of Me,* P.S.1 Contemporary Art Center, Long Island City; KW Institute for Contemporary Art, Berlin

SELECTED PUBLICATIONS →
2008 *Paul McCarthy: Central Symmetrical Rotation Movement – Three Installations, Two Films,* Whitney Museum of American Art, New York. *Southern Exposure. Works from the Collection of the Museum of Contemporary Art San Diego,* MCA, Sydney. *Stations. 100 Meisterwerke zeitgenössischer Kunst,* DuMont, Cologne **2006** *Into Me/Out Of Me,* P.S.1 Contemporary Art Center, Long Island City; KW Institute for Contemporary Art, Berlin; Hatje Cantz, Ostfildern

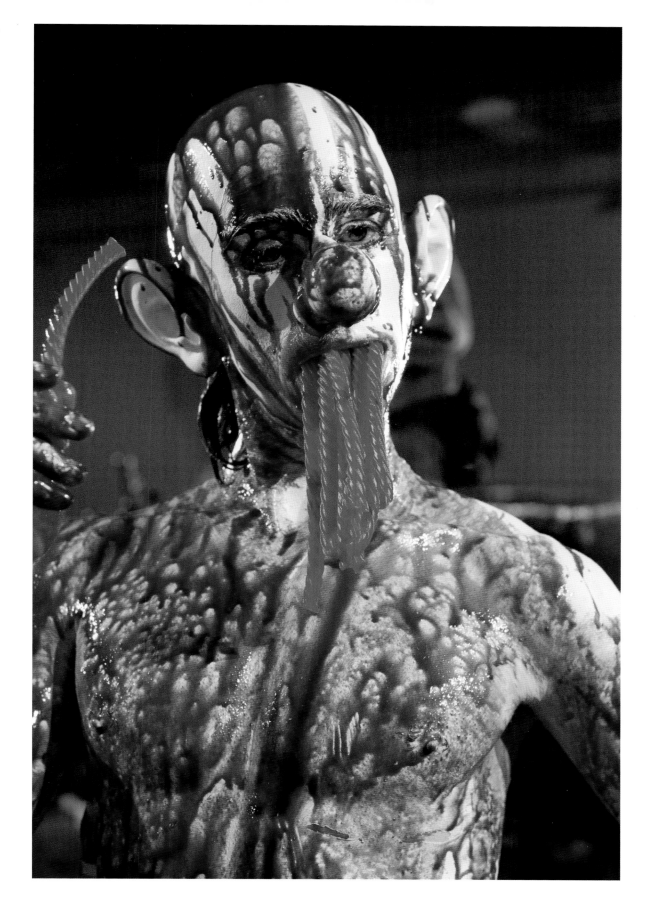

1/4/5 **Caribbean Pirates**, 2001–05, in collaboration with Damon McCarthy, performance, video, installation, photographs
2 **Brancusi Tree (Gold)**, 2007, self inflatable Mylar fabric, 1 integrated fan, 190 x 95 cm

3 **Train, Pig Island**, 2007, foam, mixed media. Installation view, S.M.A.K. Stedelijk Museum voor Actuele Kunst, Gent

„Ich verwende Humor, um eine Reflexion über das Schreckliche zu ermöglichen."

« J'utilise l'humour pour permettre une réflexion sur l'horreur. »

"I use humour to facilitate a reflection on the horrendous."

2

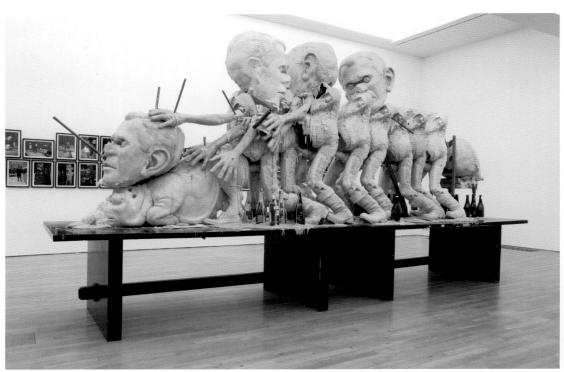

3

Josephine Meckseper

1964 born in Lilienthal, Germany, lives and works in New York (NY), USA

For her recent exhibition in New York, Josephine Meckseper turned the gallery space into a strange department store in which commodities were surrounded by political slogans and references to the US presidential elections. A giant, black-and-white mural of the American flag was wrapped around the walls, focusing the viewers' attention on the centre of the room where stood *Ten High* (2008), a shiny platform onto which various objects were aligned, including silver mannequins, a bottle of whiskey, a bible and other classic American icons. Meckseper's arrangements of objects – which the artist began in 2000 – mimic the display techniques of department store windows, high-end boutiques and vernacular shops. While connecting to the work of artists such as Jeff Koons and Haim Steinbach, Meckseper's vitrines and shelves incorporate more explicit references to the objectification of women and take a more direct political stand. In *Blow Up (Tamara, Michelli, Laura)* (2006) three models strike poses reminiscent of a Helmut Newton photo, but their old-fashioned 1950s underwear gives them an altogether more human aura. The series *Quelle International* (2008) refers to German middle-class fashion from the 1970s and features large-scale reproductions of pages from the almost legendary mail-order catalogue "Quelle". Juxtaposing fashion items with images of political protest, the artist suggests hidden links between consumerist society, the politics of power and the mechanics of desire. Meckseper often refers to the language of advertising and propaganda: in her recent video *0% Down* (2008), the artist appropriates footage from car commercials and turns them into a brutal commentary against the Western way of life.

Für ihre jüngste Ausstellung in New York verwandelte Josephine Meckseper den Raum einer Galerie in ein eigenartiges Kaufhaus, in dem die Waren von politischen Slogans und Bezügen zum US-amerikanischen Wahlkampf umgeben waren. Die Wände waren mit dem gigantischen, schwarz-weißen Wandgemälde einer amerikanischen Flagge bedeckt, die die Aufmerksamkeit des Betrachters auf die Mitte des Raumes lenkte, wo *Ten High* (2008) stand, eine glänzende Bühne auf der verschiedene Gegenstände wie silberne Schaufensterpuppen, eine Whiskeyflasche, eine Bibel und andere klassische amerikanische Ikonen angeordnet waren. Mecksepers Arrangements von Gegenständen – mit denen die Künstlerin im Jahr 2000 begonnen hat – stellen die Präsentationsformen der Schaufenster von Geschäften, Kaufhäusern und Nobelboutiquen nach. Auch wenn sie sich auf die Arbeiten von Künstlern wie Jeff Koons und Haim Steinbach bezieht, nehmen Mecksepers Vitrinen und Regale deutlicher Stellung zur Frau als Objekt und zu politischen Fragen. In *Blow Up (Tamara, Michelli, Laura)* (2006) werfen sich drei Models in Posen, die an Helmut Newton denken lassen, aber die altmodische 1950er-Jahre-Unterwäsche, die sie tragen, lässt sie viel menschlicher erscheinen. Die Serie *Quelle International* (2008) nimmt auf die Mode der Mittelschicht im Deutschland der 1970er-Jahre Bezug und zeigt großformatige Reproduktionen von Seiten aus dem beinahe legendären Quelle-Bestellkatalog. Indem sie Modeartikeln Bilder des politischen Widerstands gegenüberstellt, deutet die Künstlerin versteckte Bezüge zwischen Konsumgesellschaft, Machtpolitik und den Mechanismen des Verlangens an. Meckseper bezieht sich dabei oft auf die Sprache der Werbung und Propaganda: In ihrem jüngsten Video *0% Down* (2008) verwendet sie Material aus Autowerbefilmen und verwandelt diese in eine gnadenlose Kritik am westlichen Lebensstil.

La récente exposition new-yorkaise de Josephine Meckseper transformait la galerie en grand magasin bizarre, cernant les articles de slogans politiques et de références aux élections présidentielles américaines. Les murs de l'espace étaient couverts d'une immense peinture murale en noir et blanc du drapeau américain, forçant l'attention du spectateur sur le centre de la pièce où brillait *Ten High* (2008), une estrade sur laquelle s'alignaient divers objets, dont des mannequins argentés, une bouteille de whiskey, une Bible et d'autres icônes classiques de l'Amérique. Les installations d'objets, sur lesquelles Meckseper a commencé à travailler en 2000, parodient les devantures de grands magasins, de boutiques de luxe et de petits commerces typiques. Si leur lien avec des artistes comme Jeff Koons et Haim Steinbach est évident, ses vitrines et rayons développent des références plus explicites à la réification des femmes et sont marqués d'une prise de position politique plus radicale. Dans *Blow Up (Tamara, Michelli, Laura)* (2006), la pose des trois mannequins rappelle Helmut Newton, mais les sous-vêtements démodés des années 1950 leur donnent une apparence plus humaine. La série *Quelle International* (2008) fait allusion à la mode allemande bourgeoise des années 1970 en reproduisant à grande échelle des pages du mythique catalogue de vente par correspondance de la maison « Quelle ». En juxtaposant articles de mode et images de contestation politique, l'artiste suggère des liens cachés entre la société consumériste, la politique du pouvoir et les rouages du désir. Meckseper utilise souvent le langage de la publicité et de la propagande : sa récente vidéo *0% Down* (2008) s'empare de séquences publicitaires pour automobiles et les transforme en critique brutale du style de vie occidental. C. A.

SELECTED EXHIBITIONS →
2008 *Josephine Meckseper and Mikhael Subotzky: New Photography 2008*, MoMA, New York. *Josephine Meckseper*, Gesellschaft Für Aktuelle Kunst, Bremen. *That Was Then... This is Now*, P.S.1 Contemporary Art Center, Long Island City **2007** *Josephine Meckseper*, Kunstmuseum Stuttgart. *New York States of Mind*, Haus der Kulturen der Welt, Berlin; Queens Museum of Art, New York **2006** *Day for Night*, Whitney Biennial 2006: Whitney Museum, New York

SELECTED PUBLICATIONS →
2007 *Josephine Meckseper*, Kunstmuseum Stuttgart; Hatje Cantz, Ostfildern. *Brave New Worlds*, Walker Art Center, Minneapolis **2006** *Josephine Meckseper: The Catalogue No. 2*, Lukas & Sternberg, New York. *Whitney Biennial: Day For Night*, Whitney Museum of American Art, New York. *USA Today: New America Art from the Saatchi Gallery*, Royal Academy of Arts, London

„Die wichtigste Grundlage meiner Arbeit ist Kapitalismuskritik." « La critique du capitalisme est à la base de mon travail. »

"The basic foundation of my work is a critique of capitalism."

2

3

Jonathan Meese

1971 born in Tokyo, Japan, lives and works in Berlin and Hamburg, Germany

In his performances and paintings, Jonathan Meese declares the dictatorship of art, presenting himself as its humble and willing servant. But perhaps he is also its medium, its mouthpiece, because he transmits the messages of art to his texts and paintings. In his latest series of works he creates the insignia of art's power with great feeling for the symbolism of numbers. At the core is a heraldic eagle, *TOTALADLER, Baby-CHEF der Kunst (das Ei des Columbussy)* (2007), surrounded by four guardian figures, bronze sculptures based on assembled everyday materials, twelve self-portraits and a thirteenth painting in which a chimera makes cryptic proclamations. In the self-portraits, Meese cavorts around like a demon, sometimes wearing devil's horns or the emblematic three-striped jacket, at others displaying enormous sexual organs that turn into paintbrushes. The titles are characterized by wild linguistic extravagance, and the paintings are still lush with invocations of symbols, but compared to older paintings they are somewhat subdued, the range of colours reduced to red, black and the white of the background. Meese appears here as a jack-in-the-box of art, claiming its right to be untamed and autonomous and celebrating it with his hieratic habitus. His works have always been heavily laced with allusions to literature and philosophy, a preoccupation that Meese has developed into close links between theatre and art through collaborations with Frank Castorf. The stage sets Meese designed for Castorf's production of Pitigrilli's *Kokain* at the Volksbühne Berlin were in turn incorporated into his own exhibitions, while the cast also performed in the gallery.

Jonathan Meese deklariert in seinen Performances und Bildwerken theatralisch die Diktatur der Kunst, als deren williger und demütiger Diener er sich gibt. Vielleicht ist er aber auch ihr Medium, ihr Sprachrohr, denn er überträgt die Botschaften der Kunst in seine Texte und auf seine Gemälde. In seiner jüngsten Werkgruppe erschafft er mit viel Sinn für Zahlensymbolik die Abzeichen ihrer Macht. Im Zentrum steht ein Wappentier, *TOTALADLER, Baby-CHEF der Kunst (das Ei des Columbussy)* (2007), umgeben von vier Wächterfiguren, Bronzeskulpturen, deren Formen aus unterschiedlichen Alltagsmaterialien zusammengesetzt sind, zwölf Selbstporträts, und einem dreizehnten Gemälde, auf dem eine Chimäre ihre verrätselten Botschaften kundtut. Auf den Selbstporträts tummelt sich Meese als diabolische Gestalt, teilweise mit Teufelshörnern versehen, mit der emblematischen dreistreifigen Jacke oder mit gewaltigen Geschlechtsteilen, die sich in Pinsel verwandeln. Die Titel sind immer noch sprachlicher Wildwuchs, in ihrer Symbolbeschwörung sind die Gemälde immer noch saftig, doch malerisch sind sie im Vergleich zu älteren Werken eher zurückhaltend, die Farbigkeit auf Rot, Schwarz und das Weiß des Bildgrunds reduziert. Meese erscheint hier als der Spring-teufel der Kunst, der ihre Ungezähmtheit, ihre Autonomie einfordert und mit seinem hieratischen Habitus zelebriert. Schon immer waren seine Arbeiten getränkt mit Anspielungen auf Literatur und Philosophie, eine Auseinandersetzung, die Meese in seiner Zusammenarbeit mit Frank Castorf auf eine enge Verzahnung von Theater- und Kunstbetrieb erweitert hat. Die Bühnenbilder für Castorfs Inszenierung von Pitigrillis *Kokain* an der Volksbühne in Berlin wurden wiederum in Meeses Ausstellungen integriert, während die Theatertruppe ihrerseits auch in Galerieräumen spielte.

Dans ses performances et dans ses œuvres picturales, Jonathan Meese affirme théâtralement la dictature de l'art, dont il se présente comme l'humble et dévoué serviteur. Mais peut-être en est-il aussi le médium et le porte-voix, car il en transpose les messages dans ses textes et ses peintures. Dans ses toutes dernières œuvres réalisées avec un sens très poussé de la symbolique des nombres, il a créé les insignes de son pouvoir. Au centre se trouve le *TOTALADLER, Baby-CHEF der Kunst (das Ei des Columbussy)* (2007), animal héraldique entouré de quatre gardiens, sculptures en bronze dont les formes sont composées de différents matériaux quotidiens, de douze autoportraits et d'une treizième peinture dans laquelle une chimère proclame ses énigmatiques messages. Dans les autoportraits, Meese apparaît en figure diabolique, parfois cornue, avec l'emblématique veste aux trois bandes ou avec un sexe démesuré qui peut servir de pinceau. Si les titres relèvent encore d'une extravagance linguistique et si les peintures restent juteuses par leurs invocations symboliques, du point de vue proprement pictural, elles sont plutôt mesurées comparées aux œuvres plus anciennes : le chromatisme est réduit à des tons rouges, noirs et au blanc du fond. Meese y apparaît comme le diablotin sortant de sa boîte pour revendiquer l'insoumission et l'autonomie de l'art, et pour le célébrer par le hiératisme de la pose. Les œuvres de Meese ont toujours abondé en allusions littéraires et philosophiques qu'il a étendues à une étroite imbrication entre les univers du théâtre et de l'art après sa collaboration avec Frank Carstorf. Les décors réalisés pour *Kokain*, le roman de Pitigrilli mis en scène à la Volksbühne de Berlin par Carstorf, ont été intégrés à leur tour dans les expositions de Meese, tandis que la troupe de théâtre a joué dans plusieurs galeries d'art.

A. M.

SELECTED EXHIBITIONS →
2008 *Jonathan Meese: Marlene Dietrich in Dr. No's Ludovico Clinic (Dr. Baby's Erzland)*, Watermill Foundation, New York. *Jonathan Meese: Ufo go Home – Fasching der Kunst*, Fundació La Caixa, Barcelona **2007** *Jonathan Meese: Fräulein Atlantis*, Essl Museum, Klosterneuburg. *Jonathan Meese: Jonathan Rockford (Don't Call Me Back, Please)*, De Appel, Amsterdam **2006** *Jonathan Meese: Mama Johnny*, Deichtorhallen, Hamburg; Le Magasin, Grenoble. *Sherwood Forest*, with Jörg Immendorff, Frans Hals Museum, Haarlem

SELECTED PUBLICATIONS →
2008 *Jonathan Meese: Ufo go Home – Fasching der Kunst*, Fundació La Caixa, Barcelona. *Jonathan Meese: 23. Januar 1970*, Contemporary Fine Arts, Berlin **2007** *Jonathan Meese: Grundling Meese Erzstaat*, Stiftung Schloss Neuhardenberg; Verlag der Buchhandlung Walther König, Cologne **2006** *Jonathan Meese: Mama Johnny. Retrospektive*, Deichtorhallen Hamburg; Le Magasin, Grenoble; Verlag der Buchhandlung Walther König, Cologne

1 **Dictatorbaby Mary Poppin's Cats, Dogs and Eggpies (The Revolutionbaby de Large Is Back)**, 2008, performance. Installation view, Bortolami, New York

2 **Chips-Teufel sucht den Stern der Kunst, wie ein einarmiger Bandit an Luziferz' Münze lutscht**, 2007, bronze, 116 x 58 x 73 cm

3 **Mutter Natyrn säugt bald Rudolph das Rentier, also sich selbst, viel Spaß**, 2007, bronze, 104 x 52 x 48 cm

4 **Das Großmütterchen im Kettenhemd (das Erzreich ist ihr Schnuller, wie Kapitän Fritz)**, 2007, bronze, 102 x 42 x 46 cm

5 **Spass an de Freud (Geburtstagsrevolution)**, 2008, oil on canvas, 360.2 x 600.6 cm

6 **Der Parteitag des Erzes (Dein Kind), wie die Süße**, 2006, oil on canvas, 3 parts, 365 x 601 cm

7 **Dr. Baby Doll ist voll**, 2006, oil on canvas, 3 parts, 365 x 600.5 cm

„Die Diktatur der Kunst ist die einzige antinostalgische Weltanschauung der Zukunft. Kunst ist keine Religion, aber jede Religion ist Kunst. Die Machtergreifung der ‚Sache Kunst' ist die einzige Alternative. Sorry."

« La dictature de l'art est la seule vision antinostalgique du monde qui ait de l'avenir. L'art n'est pas une religion, mais toute religion est art. Il n'y a pas d'autre alternative que la prise de pouvoir du fait artistique. Désolé. »

"The dictatorship of art is the only possible anti-nostalgic world view for the future. Art is not religion, but every religion is art. The usurpation of power by 'that thing called art' is the only solution. Sorry."

2

3

4

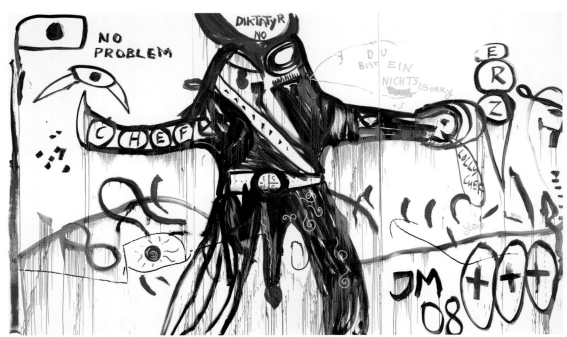

5

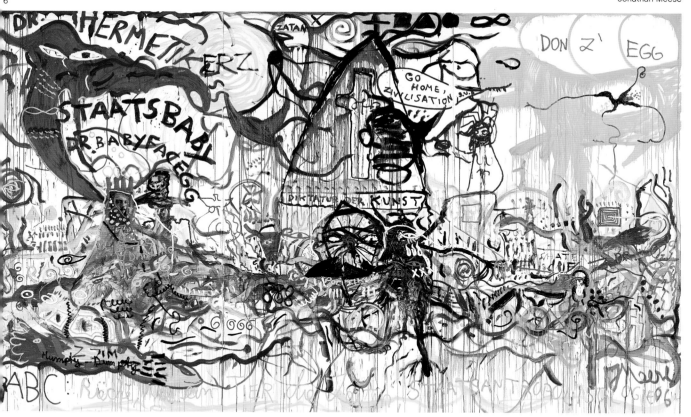

Beatriz Milhazes

1960 born in Rio de Janeiro, lives and works in Rio de Janeiro, Brazil

In her paintings and collages, Beatriz Milhazes has always revelled in the carnivalesque colour spectrum of her native Rio de Janeiro and in the decorative patterns of folk handicraft. Her works have consistently taken the form of vibrant, tropically hued canvases with an excessive and exuberant sampling of artisanal forms, baroque motifs and pop-cultural icons. An unabashed use of ornamental elements like flower petals and rosebuds, peace signs, strands of pearls, butterflies, lace doilies characterized her earliest paintings in the 1980s, since then, Milhazes' compositions have gradually become more explosive, with vivid bursts of concentric circles and exploding floral blooms, as well as an ever more psychedelic colour palette. Works like *Beleza Pura* (2006) have stretched into the scale of landscapes, with meandering organic tendrils and flourishes and overlapping circles drifting like balloons across the canvas. The overall effect is similar to the dizzying afterimage of dots that you see after staring directly at the sun. In contrast to this, Milhazes' collages are based on a loose structure of stripes or grids made of flattened candy wrappers, chocolate labels or shopping bags from stores around the world. She delights in the graphic design of these simple "throw-away" labels, making no distinction between the products of contemporary commercial marketing and of modernist abstraction. In the act of collecting fabric swatches, flattening out wrinkled labels and transferring plastic decals onto her pictures, Milhazes incorporates mass-produced products – while the works remain essentially handmade.

Mit ihren Gemälden und Collagen schwelgt Beatriz Milhazes schon immer im karnevalesken Farbenspektrum ihrer Heimatstadt Rio de Janeiro und in den dekorativen Mustern der Volkskunst. Ihre Arbeiten sind stets hoch lebendige Leinwände in tropischen Farben mit einer überbordenden Auswahl an künstlerischen Formen, barocken Motiven und Ikonen der Popkultur. Ihre unerschrockene Verwendung von ornamentalen Elementen wie Blütenblättern und Rosenknospen, Peace-Zeichen, Perlenketten, Schmetterlingen und Spitzendeckchen kennzeichneten schon ihre frühesten Bilder in den 1980ern. Seither sind Milhazes' Kompositionen schrittweise explosiver geworden, durch lebhafte Ausbrüche konzentrischer Kreise und explodierender Blumenblüten, wie auch durch eine immer psychedelischere Farbpalette. Arbeiten wie *Beleza Pura* (2006) haben sich auf die Größe von Landschaften ausgedehnt, mit mäandernden organischen Ranken und Schnörkeln und überlappenden Kreisen, die wie Ballons über die Leinwand gleiten. Der Gesamteindruck ist mit den schwankenden Punkten zu vergleichen, die man als Nachbild sieht, wenn man direkt in die Sonne geschaut hat. Im Gegensatz dazu basieren ihre Collagen auf losen Strukturen von Streifen oder Gittern, die aus geglätteten Keksverpackungen, Schokoladenetiketten oder Einkaufstüten aus aller Welt bestehen. Milhazes hat ihre Freude am Design dieser einfachen „Wegwerf"-Label, zwischen den Produkten des zeitgenössischen kommerziellen Marketings und denen der modernen Abstraktion unterscheidet sie nicht. Indem sie Stoffmuster sammelt, zerknitterte Etiketten glättet und Plastikfolien auf ihre Bilder setzt, baut sie massenproduzierte Produkte ein – und trotzdem bleibt ihre Arbeit komplett handgemacht.

Dans ses peintures et collages, Beatriz Milhazes joue constamment avec les couleurs du carnaval de sa ville natale, Rio de Janeiro, et avec les motifs décoratifs de l'artisanat populaire. Ses œuvres prennent invariablement la forme de toiles aux couleurs tropicales, vibrantes, avec un assemblage excessif et exubérant de formes artisanales, de thèmes baroques et d'icônes de la culture pop. Ses premiers travaux des années 1980 se caractérisaient par une utilisation sans bornes d'éléments ornementaux comme des pétales de fleurs et des boutons de roses, des symboles de paix, des rangs de perles, des papillons, des napperons de dentelle. Depuis, les compositions de Milhazes sont devenues plus explosives, avec des déploiements saisissants de cercles concentriques et de floraisons exubérantes, ainsi qu'une palette de couleurs de plus en plus psychédélique. Des œuvres telles que *Beleza Pura* (2006) prennent la dimension de paysages, avec de sinueuses vrilles, des fioritures organiques et des cercles entrecroisés, dérivant sur la toile à la manière de ballons. L'effet d'ensemble rappelle les étourdissantes taches lumineuses que l'on voit après avoir regardé le soleil à l'œil nu. D'autres tableaux récents sont composés à partir d'une structure lâche de rayures et de grilles faite de papiers de bonbons aplatis, d'étiquettes de chocolats ou de sacs à l'effigie des boutiques du monde entier. Milhazes se délecte du graphisme de ces identités visuelles simples et jetables, sans faire de distinction entre les produits du marketing commercial contemporain et ceux de l'abstraction moderniste. En collectant des échantillons de tissus, en aplatissant des étiquettes fripées et en transférant des décalcomanies sur ses tableaux, Milhazes incorpore des objets produits en masse à des œuvres faites à la main. CH. L.

SELECTED EXHIBITIONS →
2008 *Beatriz Milhazes: Pintura, Colagem*, Estação Pinacoteca, São Paulo. *Die Tropen*, Martin Gropius Bau, Berlin. *Prospect.1 New Orleans Biennial*, New Orleans **2007** *Um Século de Arte Brasileira*, Coleção Gilberto Chateaubriand, Museu de Arte Moderna da Bahia, Salvador **2006** *Hyper Design*, 6th Shanghai Biennale, Shanghai **2005** *Beatriz Milhazes: Lagoa*, Museu de Arte da Pampulha, Belo Horizonte

SELECTED PUBLICATIONS →
2008 *Die Tropen*, Martin Gropius Bau, Berlin; Kerber Verlag, Bielefeld **2006** *Beatriz Milhazes: Color and 'Volupté'*, Barléu Edições, Rio de Janeiro. *Hyper Design*, 6th Shanghai Biennale, Shanghai Fine Arts Publishers, Shanghai **2005** *Beatriz Milhazes*, Domain de Kerguéhennec, Centre d'Art Contemporain, Bignan. *The Cut-and-paste Tumulto of Collage (Populence)*, Blaffer Gallery, The Art Museum of the University of Houston. *Works on Paper*, Galerie Max Hetzler, Berlin

1 **Junior Mints**, 2006, collage on paper, 141 x 94 cm
2 **Beleza Pura**, 2006, acrylic on canvas, 200 x 402 cm

„Ich suche nach geometrischen Strukturen, aber mit der Freiheit der Form und Symbolik aus verschiedenen Welten."

« J'expérimente les structures géométriques, mais avec une liberté de la forme et une imagerie venue de différents univers. »

"I am seeking geometrical structures, but with freedom of form and imagery taken from different worlds."

2

Sarah Morris

1967 born in London, lives and works in London, United Kingdom, and New York (NY), USA

Sarah Morris' primary media are painting and film, which she uses in very different ways: while her paintings are geometric and abstract, her films are representational. They are mainly portraits of cities, or, more recently, of people. The common denominator of both media is an interest in urban structures, be they architectural or social. Morris sees her films as complementary to her painting; consequently, both films and painting series often share the same title, such as *Robert Towne* (2006). The film is about the scriptwriter and director Towne, starting from a panoramic view of his city, Los Angeles, then zooming in into an intimate portrait. After a series of smaller works with the same title, Morris realized *Robert Towne* in 2007 as a vast painting on the ceiling of the ground floor in Lever House, New York, taking the aesthetics of one city and grafting it onto the architecture of another. Cities are structured horizontally by networks of streets, and vertically by the facades of buildings. Morris addresses both: the street system of Beijing in the series *Rings* (2006/07), for example. Her most recent film, *1972* (2008), deals with the Olympic Games of that year in Munich. Her interview partner is Georg Sieber, a psychologist who worked with the security services at that event. Sieber developed a threat scenario that was subsequently delivered by reality, almost down to the last detail. Using montage, Morris supplements the interview with images of police checks, archive photographs of the Olympics and views of the site. The resulting image of the social structure of the city combines elements of terror, state control and architecture.

Sarah Morris arbeitet vor allem in den Medien Malerei und Film, die sie jedoch auf sehr unterschiedliche Weise nutzt: die Gemälde fallen geometrisch-abstrakt aus, die Filme hingegen sind gegenständlich. Meist liefern sie Porträts von Städten oder, seit kürzerem, auch von Personen. Der gemeinsame Nenner in beiden Medien ist das Interesse an urbanen Strukturen, seien sie architektonischer oder sozialer Art. Ihre Filme begreift sie dabei als Komplement der Malerei. Folgerichtig tragen Filme und Bildserien oft denselben Titel, wie bei *Robert Towne* (2006). Im Film geht es um den Drehbuchautor und Regisseur Towne; er beginnt mit einer Panorama-Ansicht der Stadt, in der Towne lebt, Los Angeles, zoomt dann näher und wird zu einem sehr intimen Porträt. Nach einer Serie von kleineren Arbeiten mit demselben Titel realisiert Morris *Robert Towne* dann 2007 als riesiges Deckengemälde im Erdgeschoss des Lever Hause in New York – und übertrug so die Ästhetik einer Stadt auf die Architektur einer anderen. Städte sind horizontal geprägt von Straßennetzen und vertikal geprägt von Fassaden. Beidem widmet sich Morris stets von neuem, bei der Serie *Rings* (2006/07) etwa dem Straßensystem von Peking. Ihr jüngster Film, *1972* (2008), beschäftigt sich mit den Olympischen Spielen desselben Jahres in München. Ihr Interviewpartner ist Georg Sieber, Psychologe des Ordnungsdienstes bei der damaligen Olympiade. Er entwarf ein Bedrohungsszenario, das von der Realität fast punktgenau eingelöst worden ist. Per Montage reichert Morris das Interview mit Bildern von Polizeikontrollen, Archivfotografien der Spiele sowie Ansichten des Olympiaparks an. So entsteht ein Bild der sozialen Struktur der Stadt, das Momente des Terrors, des Kontrollstaates und der Architektur miteinander verknüpft.

Sarah Morris travaille surtout avec les médiums de la peinture et du cinéma, qu'elle utilise toutefois de manière très différente : si ses peintures sont abstraites et géométriques, ses films sont figuratifs. Ils présentent généralement des portraits de villes, mais dernièrement aussi des portraits de personnes. Le dénominateur commun de son utilisation des deux médiums réside dans l'intérêt pour les structures urbaines, qu'elles soient de nature architectonique ou sociale. Elle considère ses films comme complémentaires de la peinture. En conséquence de quoi, ses films et séries peintes portent souvent le même titre, comme *Robert Towne* (2006). Le film parle du scénariste et réalisateur Towne, et débute par une scène panoramique de sa ville de résidence : Los Angeles, pour se poursuivre en un plan rapproché, et dresser de lui un portrait intime. Après une série de petits travaux du même nom, Morris réalise en 2007 *Robert Towne*, une grande fresque au plafond du rez-de-chaussée de la maison Lever à New York et transpose ainsi l'esthétique d'une ville sur l'architecture d'une autre. Les villes sont marquées horizontalement par des réseaux de rues et verticalement par des façades. Morris revient toujours à ces deux aspects : dans la série *Rings* (2006/07), il s'agit du système de rues de Pékin. Son dernier film, *1972* (2008), parle des Jeux Olympiques de Munich de la même année. La personne interviewée est Georg Sieber, psychologue du service d'ordre des Jeux de 1972. Il avait élaboré un scénario que la réalité devait illustrer presque point par point. Le montage réalisé par Morris enrichit l'interview d'images de contrôles policiers, de photos d'archives et de vues du parc olympique. Il en résulte une image de la structure sociale de la ville qui relie entre eux des moments de terreur, d'État policier et d'architecture.

H. L.

SELECTED EXHIBITIONS →
2008 *Sarah Morris: Black Beetle*, Fondation Beyeler, Riehen/Basle. *Sarah Morris: 1972*, Lenbachhaus, Munich. *Art Is for the Spirit: Works from the UBS Art Collection*, Mori Art Museum, Tokyo **2007** *The Shapes of Space*, Solomon R. Guggenheim Museum, New York **2006** *Sarah Morris: Robert Towne*, Public Art Fund Project, Lever House Building, New York. *Sarah Morris: Artist in Focus*, 35th International Film Festival Rotterdam, Museum Boijmans van Beuningen, Rotterdam

SELECTED PUBLICATIONS →
2008 *Sarah Morris: 1972*, Verlag der Buchhandlung Walther König, Cologne. *Always There*, Galerie Max Hetzler, Berlin. *General Issue*, CGAC – Centro Galego de Arte Contemporánea, Santiago de Compostela **2006** *Carbonic Anhydride*, Galerie Max Hetzler, Berlin. *Without Boundary: Seventeen Ways of Looking*, MoMA, New York

1 **1952 (Rings)**, 2006, household gloss paint on canvas, 214 x 214 cm
2 **Robert Towne**, 2006, 35mm film, 34 min 25 sec

3 **1972**, 2008, 35mm film, 38 min 12 sec
4 **Weasel (Origami)**, 2007, household gloss paint on canvas, 289 x 289 cm

„Der rasche Wechsel zwischen verschiedenen Bereichen wie Politik, Architektur und Design ist für mich ein typisches Merkmal meiner Generation. Ich sehe auf die Wirklichkeit und beginne mit ihr zu spielen, schnell und riskant."

« À mon sens, ce qui caractérise ma génération est le passage rapide d'un domaine à l'autre – par exemple la politique, l'architecture ou le design. Je regarde la réalité et joue avec elle de manière rapide et légère. »

"Moving swiftly between different arenas like politics, architecture or commercial design is what I would consider defintive of my generation. I am looking at reality and playing fast and loose with it."

2

3

Ron Mueck

1958 born in Melbourne, Australia, lives and works in London, United Kingdom

As Aristotle noted in his *Poetics*, people take pleasure from the most faithful representations of things, which is why they persist with such replications. In the 1960s, Duane Hanson created sculptures that at first glance could easily be taken for actual people – they seemed so real. This distinctive, almost exaggerated realism led to the works being described as hyperrealist. Like Hanson, Ron Mueck works with fibreglass, polyester and latex, although his repertoire now includes the more flexible silicon. He then adds colour and features such as hair and clothing. Mueck acquired his skills in hyperrealism while working in special effects for film productions, and also with Jim Henson's team of puppet makers. Both of these aspects – special effects and puppet-like figures – still feature in his artworks, which either evince the shocking size of giants or a strange dwarfishness. This also applies to recent works such as *Wild Man* (2005), *Two Women* (2005) or *A Girl* (2006). What makes Mueck's sculptural figures unique is their scale, which deviates far from the norm. His exploration of monumental sculpture is particularly interesting: traditionally, the substantial enlargement of human scale has been reserved for the depiction of gods, heroes or rulers – size was a means of confirming the subject's status. Mueck's enormous figures, on the other hand, look fearful (*Wild Man*) or seem far removed from the point where they will be judged as deity, hero or ruler; often they are newborn babies (*A Girl*). In this way, Mueck subverts the heroic pathos of the monumental sculpture, revealing its mechanisms and at the same time posing the question as to how *size matters*.

Schon Aristoteles notierte in seiner *Poetik*, dass Menschen sich an möglichst getreuen Nachbildungen von Dingen erfreuen, weshalb sie solche auch immer wieder in Angriff nehmen. In den 1960er-Jahren schuf Duane Hanson Plastiken, die man auf den ersten Blick für tatsächliche Menschen halten konnte – so real wirkten sie. Aufgrund ihres ausgeprägten, geradezu übersteigert erscheinenden Realismus werden die Arbeiten als hyperrealistisch bezeichnet. Ron Mueck arbeitet wie Hanson vor allem mit Fiberglas, Polyester und Latex, seit Kurzem jedoch auch mit dem flexibleren Silikon. Hinzu kommen jeweils Farbe und Ausstattungsdetails wie Haare und Kleidung. Seine Fertigkeit im Hyperrealismus gewann Mueck bei der Arbeit für Special Effects im Film und bei Jim Hensons Team von Puppenbauern. Beides, Special Effects und Puppen, steckt noch in seinen Kunstwerken, die entweder die erschreckende Größe von Riesen oder eine merkwürdige Zwergenhaftigkeit aufweisen. Das gilt auch für seine neueren Arbeiten wie *Wild Man* (2005), *Two Women* (2005) und *A Girl* (2006). Die von der üblichen Norm abweichende Dimensionierung machen Muecks Menschenplastiken einzigartig. Interessant ist dabei vor allem seine Auseinandersetzung mit der Monumentalskulptur. Diese nutzt die erhebliche Vergrößerung der menschlichen Dimensionen meist für die Darstellung von Göttern, Helden und Herrschern. Nicht zuletzt durch die Größe wird dabei der Status der Dargestellten bestätigt. Muecks riesenhafte Figuren hingegen schauen angstvoll drein (*Wild Man*) oder stehen in ihrer Entwicklung noch lange vor der Bewertung, ob Gott, Held oder Herrscher – es sind immer wieder auch Neugeborene (*A Girl*). Solcherart unterläuft Mueck den heroischen Pathos der Monumentalskulptur, legt ihren Mechanismus offen, verbunden mit der Frage, inwiefern *size matters*.

Dans sa *Poétique*, Aristote notait déjà que les hommes se réjouissent à la vue de représentations fidèles des choses et ne cessent donc d'en produire. Dans les années 1960, Duane Hanson créait des sculptures que l'on pouvait prendre pour des personnes réelles tant elles étaient réalistes. Du fait de leur réalisme marqué, voire exacerbé, ces œuvres sont qualifiées d'hyperréalistes. Tout comme Hanson, Ron Mueck travaille surtout avec la fibre de verre, le polyester et le latex, et plus récemment avec de la silicone, matériau plus souple. À cela s'ajoutent la couleur et les accessoires tels cheveux et vêtements. Sa maestria dans l'hyperréalisme, Mueck l'a acquise en travaillant pour les effets spéciaux au cinéma et comme membre de l'équipe de fabricants de marionnettes de Jim Henson. Ces deux domaines transparaissent encore dans ses œuvres, qui présentent soit l'effrayante grandeur des géants, soit un étrange nanisme. La même chose vaut pour ses œuvres récentes comme *Wild Man* (2005), *Two Women* (2005) ou *A Girl* (2006). S'écartant de la norme habituelle, les dimensions de ses œuvres font le caractère unique de sa sculpture humaine. Dans ce contexte, un aspect intéressant est surtout sa confrontation avec la sculpture monumentale, qui utilise généralement le fort agrandissement de la taille humaine pour représenter les dieux, les héros et les princes. Si les dimensions de ces œuvres contribuent à confirmer le statut des personnages représentés, les immenses figures de Mueck ont pour leur part des regards apeurés (*Wild Man*), ou bien leur évolution les situe très en deçà de la question de savoir s'il faut les considérer comme des dieux, des héros ou des princes – il s'agit aussi régulièrement de nouveau-nés (*A Girl*). Mueck court-circuite ainsi le pathos héroïque de la sculpture monumentale, met à nu ses mécanismes – avec la question de savoir dans quelle mesure *size matters*.

H. L.

SELECTED EXHIBITIONS →
2008 *Ron Mueck*, Kanazawa 21st Century Museum of Contemporary Art, Kanazawa. *Real Life: Guy Ben-Ner, Ron Mueck*, National Gallery of Canada, Ottawa **2007** *Ron Mueck*, The Andy Warhol Museum, Pittsburg. *Ron Mueck: A Girl*, CAC Málaga **2005** *Ron Mueck*, Fondation Cartier, Paris; Brooklyn Museum of Art, Brooklyn; Gallery of Canada, Ottawa; The Modern Art Museum of Fort Worth et al. *Melancholie – Genie und Wahnsinn in der Kunst*, Neue Nationalgalerie, Berlin

SELECTED PUBLICATIONS →
2008 *Ron Mueck*, Kanazawa 21st Century Museum of Contemporary Art, Kanazawa; Foil, Tokyo. *Real Life: Guy Ben-Ner, Ron Mueck*, National Gallery of Canada, Ottawa; ABC Art Books Canada, Montreal **2007** *Ron Mueck: A Girl*, CAC Málaga, Málaga **2006** *Ron Mueck. Catalogue raisonné*, Hatje Cantz, Ostfildern. *Ron Mueck*, Thames & Hudson, London **2005** *Ron Mueck*, Fondation Cartier, Paris; Brooklyn Museum of Art, Brooklyn; Gallery of Canada, Ottawa; The Modern Art Museum of Fort Worth et al.; Paris – Actes Sud, Paris

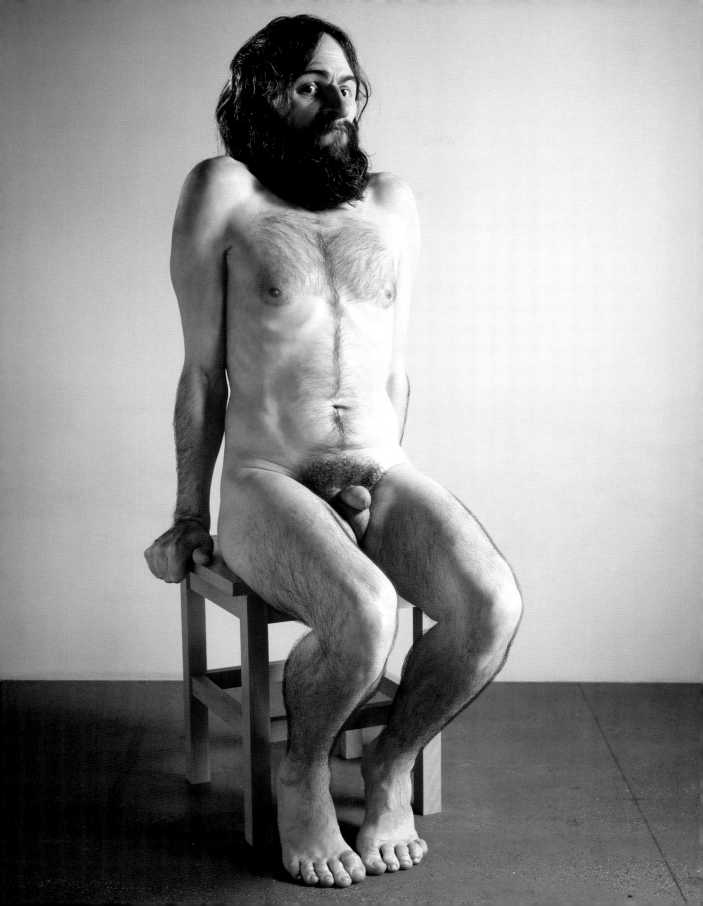

1 **Wild Man**, 2005, mixed media, 285 x 162 x 108 cm
2 **A Girl**, 2006/07, mixed media, 110 x 502 x 135 cm

3 **Two Women**, 2005, mixed media, 85 x 48 x 38 cm

„Ich habe nie lebensgroße Figuren gemacht, weil es mir nie interessant schien. Man trifft jeden Tag lebensgroße Menschen."

« Je n'ai jamais réalisé de figures grandeur nature parce que cela ne m'a jamais semblé intéressant. Des gens grandeur nature, nous en croisons à longueur de journée. »

"I never made life-size figures because it never seemed to be interesting. We meet life-size people every day."

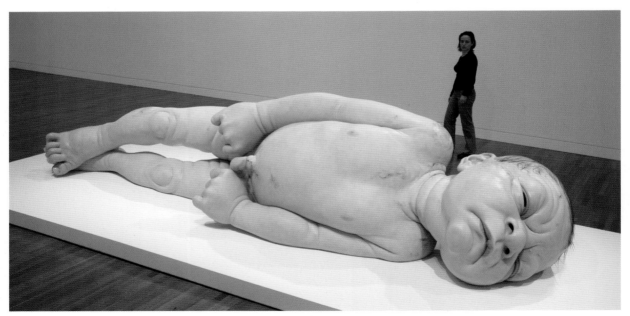

2

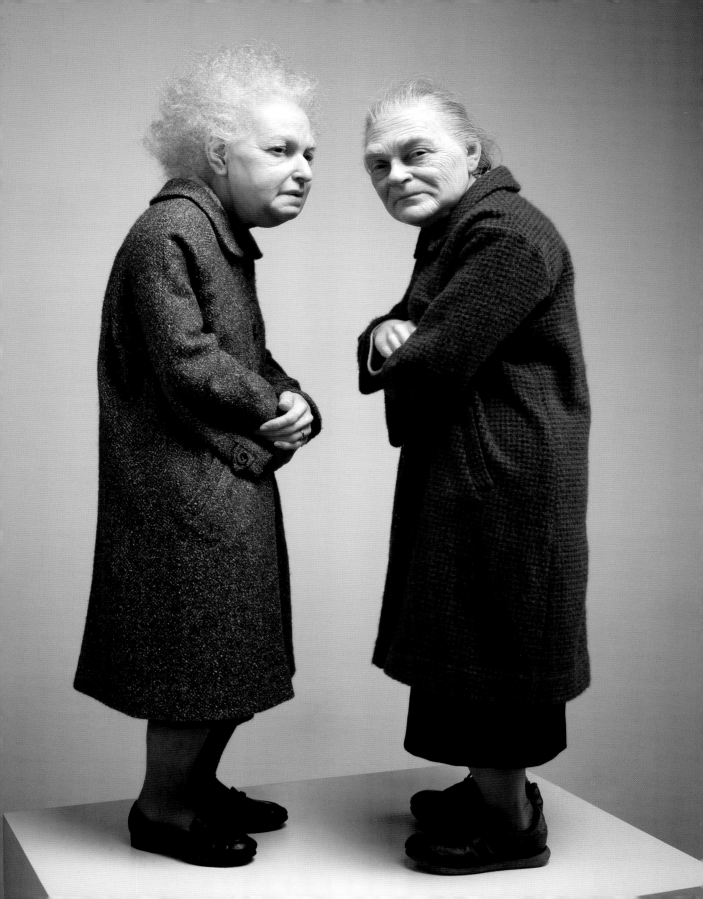

Takashi Murakami

1962 born in Tokyo, lives and works in Tokyo, Japan, and New York (NY), USA

Takashi Murakami virtually embraces today's lack of distinction between high art and fashionable consumer goods. His 2007 retrospective at the LA MOCA included a merchandize shop for all the mass-produced objects and craftworks that bear his name, displayed behind glass, and even more controversially an exclusive Louis Vuitton boutique installed comfortably in the exhibition. There, amongst wall-to-wall white enamel display cases that evoked the "hush" that normally falls over those walking into a museum, visitors could purchase one of Murakami's signature Vuitton handbags. Unafraid of any potential confusion between his unique works and commercial products, he most likely has delighted in the flood of cheap knock-offs his handbags have spawned. Contrary to the romanticized idea of the solitary artist, Murakami is firmly in control of his own image or "brand". He oversees a fully-fledged enterprise, the Kaikai Kiki company, which operates partly as an artist's collective and partly as an industrial assembly line to produce the full gamut of his artistic output, from sculptures and paintings to key rings, toys and T-shirts. These products usually feature a cast of subversive characters in cartoon fantasylands reminiscent of video games, fusing Western pop and Japanese *manga* and *anime*. Mr. DOB, Murakami's most prominent character, was deliberately modelled after long-lived and popular cuddly creatures like Hello Kitty and Doraemon, which are ubiquitous in Japan. Like them, Murakami's inventions are now so widely recognized that they have become successful self-perpetuating promotional devices for the Murakami brand.

Takashi Murakami durchschaut die heute herrschende Unfähigkeit, zwischen hoher Kunst und modernen Konsumgütern zu unterscheiden. In seiner Retrospektive 2007 im LA MOCA gab es einen Merchandise-Shop hinter Glas für all die massenproduzierten Objekte und Kunstgegenstände, die seinen Namen tragen, und, noch umstrittener, eine exklusive Boutique von Louis Vuitton inmitten der Ausstellung. Dort, zwischen weißen, die ganze Wand ausfüllenden emaillierten Verkaufsvitrinen, welche die ehrfürchtige Stille hervorriefen, die normalerweise den Museumsbesucher befällt, konnte man eine der von ihm entworfenen Vuitton-Taschen erwerben. Furchtlos, was die mögliche Verwechslung von seinen Einzelstücken mit seinen kommerziellen Produkten angeht, hatte er wahrscheinlich an der Flut billiger Kopien, die seine Handtaschen bald hervorbrachten, selbst am meisten Spaß. Im Gegensatz zur romantisierten Vorstellung des einzelgängerischen Künstlers, hat Murakami sein eigenes Image und seinen „Markennamen" fest im Griff. Er steht einem ausgewachsenen Unternehmen vor, Kaikai Kiki, das teilweise wie ein Künstlerkollektiv und teilweise wie eine industrielle Maschinerie funktioniert, um die volle Skala seines künstlerischen Schaffens herzustellen: von Skulpturen und Gemälden zu Schlüsselanhängern, Spielsachen und T-Shirts. Auf diesen Produkten ist in der Regel eine Reihe von subversiven Figuren aus Cartoon-Fantasiewelten zu sehen, die an Videospiele erinnern und westlichen Pop mit japanischem Manga und Anime verbinden. Mr. DOB, Murakamis populärste Figur, wurde altbekannten und beliebten Schmusewesen frei nachgebildet, die in Japan allgegenwärtig sind, wie Hello Kitty und Doraemon. Auch Murakamis Schöpfungen sind inzwischen so bekannt, dass sie ein erfolgreiches selbstlaufendes Werbemittel für die Marke Murakami geworden sind.

Takashi Murakami se joue en quelque sorte de la confusion qui règne actuellement entre grand art et biens de consommation à la mode. Sa rétrospective de 2007 au MOCA de Los Angeles intégrait une boutique avec tous les objets industriels et artisanaux portant son nom, présentés derrière des vitrines et, plus controversée encore, une boutique Louis Vuitton en exclusivité, confortablement installée dans l'exposition. Parmi des vitrines murales vernies blanches, évoquant le silence pesant sur les visiteurs qui déambulent dans un musée, ces derniers pouvaient acheter l'un des sacs à main signés par l'artiste. Loin de redouter une éventuelle confusion entre ses pièces uniques et les produits commerciaux, il s'est très certainement délecté de l'avalanche d'imitations bon marché suscitées par ses sacs à main. À l'opposé de l'idée romantique de l'artiste solitaire, Murakami contrôle résolument sa propre image ou « marque ». Il supervise une entreprise à part entière, la société Kaikai Kiki, qui fonctionne à la fois comme un collectif d'artistes et une chaîne d'assemblage industrielle, chargée de produire toute la gamme de sa production artistique, depuis les sculptures et tableaux jusqu'aux porte-clés, jouets et T-shirts. Ces produits mettent généralement en scène un casting de personnages subversifs dans des univers imaginaires qui rappellent les jeux vidéos et mêlent culture pop occidentale d'une part et *mangas* et *animes* japonais d'autre part. C'est délibérément que Mr. DOB, figure la plus célèbre de Murakami, s'inspire des sympathiques Hello Kitty et Doraemon, des personnages populaires et d'une grande longévité, omniprésents au Japon. À l'instar de ces figures, les inventions de Murakami bénéficient aujourd'hui d'une telle notoriété qu'elles sont devenues pour la marque Murakami des outils promotionnels efficaces et capables de s'auto-générer.

CH. L.

SELECTED EXHIBITIONS →
2007 *Takashi Murakami: ©Murakami*, The Greffen Contemporary at MOCA, Los Angeles; Brooklyn Museum of Art, Brooklyn; MMK Frankfurt. *Takashi Murakami: Jellyfish Eyes*, MCA, Chicago. *INSIGHT?*, Gagosian Gallery/Red October Chocolate Factory, Moscow. *Red Hot: Contemporary Asian Art Rising*, Museum of Fine Arts, Houston. *Comic Abstraction*, MoMA, New York. **2006** *Get Ready, Land of the Rising Sun! Contemporary Japanese Art from Taikan Yokoyama to the Present*, Osaka City Museum of Modern Art, Osaka

SELECTED PUBLICATIONS →
2007 *Takashi Murakami: ©MURAKAMI*, Rizzoli, New York. *INSIGHT?*, Gagosian Gallery/Red October Chocolate Factory, Moscow
2005 *Takashi Murakami: Little Boy*, Kaikai Kiki Co. Ltd, New York. *Takashi Murakami: Summon Monsters? Open The Door? Heal? Or Die?*, Trucatriche, Chula Vista

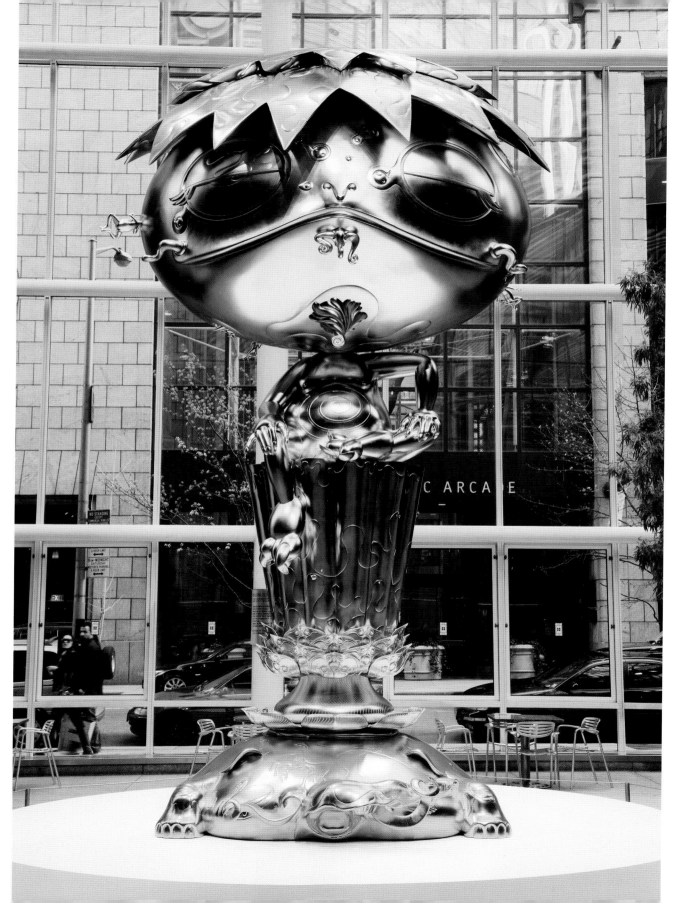

1 **Oval Buddha**, 2007, aluminium and platinum leaf, 568 x 318.9 x 311.5 cm. Photo: GION
2 **Flower Matango (b)**, 2001–06, **Kawaii! Vacances d'été**, 2002 (painting), **Cosmos**, 2003 (wallpaper). Installation view, © *Murakami*, Brooklyn Museum, New York, 2008. Photo: GION
3 **Second Mission Project ko² Advanced**, 1999–2007, oil, acrylic, fibreglass, iron, installation at the Brooklyn Museum, 2008
All artworks © 1999–2008 Takashi Murakami/Kaikai Kiki Co., Ltd. Photos on this spread: GION

„Wenn meine Arbeit ein Massenpublikum findet, dann bedeutet das, dass ich gut kommunizieren kann ... Ich will ein großes Publikum, damit meine Werke in der Zukunft weiterleben."

« Quand mes œuvres touchent un public de masse, cela signifie que je communique correctement... Je veux un large public, de manière à ce que que mes objets survivent dans le futur. »

"When my work reaches a mass audience, then it means I'm able to communicate well... I want a big audience so that my pieces can survive in the future."

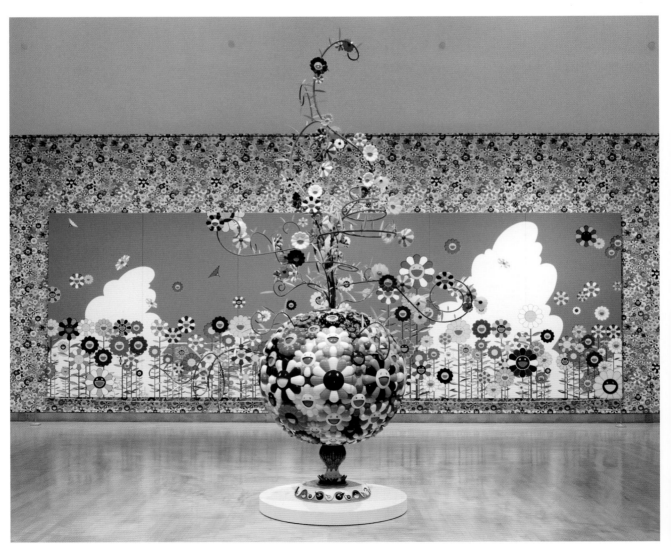

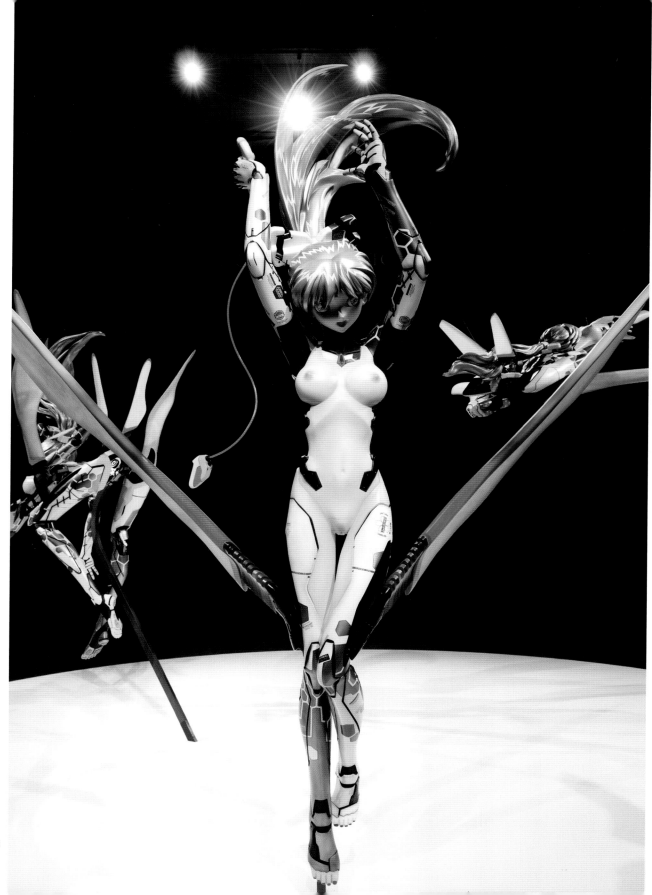

Wangechi Mutu

1972 born in Nairobi, Kenya, lives and works in New York (NY), USA

Wangechi Mutu's collages of women's bodies, plant-like or animal-like elements and intertwined abstract patterns initially captivate the viewer with their opulent, exuberant colours, but on closer inspection they reveal twisted postures, grotesque contortions and anatomic obscenities. The female body – what is projected onto it and how it is represented – is at the centre of Mutu's oeuvre. The collage A'Gave You (2008), for example, which stands over two metres high, depicts a female body in a strange kneeling position. At her feet is a threatening horde of snaking creatures, while an octopus-like monster leans over her from behind, its long, tubular tentacle lurking over her face. The woman is both mythical and contemporary, a simultaneous portrait of threat and seduction. The characters in the eight-part Chorus Line (2008) are also strange hybrid creatures. Here, they form a dancing troupe of half-woman, half-animal fantasy creatures in disjointed poses, balancing on delicate and much too small legs – sometimes only on one. As always, Mutu's work deals with the misrepresentation of women, but here it no longer exclusively refers to the image of the African woman as a mythical, oppressed and sexualized being. Suspended Playtime (2008), one of Mutu's large new sculptural installations, consists of forty-four bundles of rubbish bags – something African children often play with – suspended in the space and snared like a spider's catch. The concrete socio-political reference is thus "packaged" in a poetic and yet threatening form.

Wangechi Mutus Collagen aus Frauenkörpern, Pflanzlichem, Tierhaftem und verschlungen-abstrakten Mustern ziehen den Betrachter auf den ersten Blick durch ihre opulente Farbenfreude in ihren Bann, doch bei genauer Betrachtung fallen sogleich verdrehte Körperhaltungen, groteske Verzerrungen und anatomische Obszönitäten ins Auge. Der weibliche Körper, was auf ihn projiziert und wie er repräsentiert wird, steht im Zentrum von Mutus Œuvre. Die über zwei Meter hohe Collage A'Gave You (2008) etwa zeigt einen Frauenkörper in einer merkwürdig knienden Haltung. An den Füßen wird er von einer Horde schlangenartiger Wesen bedrängt, von hinten beugt sich ein krakengleiches Ungetüm, aus dem ein langer, schlauchförmiger Tentakel herauswächst, lauernd über das Gesicht der Frau. Es ist eine mythische und zeitgenössische Frau, ein Bildnis von Bedrohung und Verführung zugleich. Auch das Bildpersonal der achtteiligen Arbeit Chorus Line (2008) besteht aus seltsamen Mischwesen, die hier das Personal der Tanztruppe bilden: halb Frau, halb Tier, fantastische Gestalten in verrenkten Posen, die auf viel zu kleinen, zarten Beinen – manchmal auch nur einem einzigen – balancieren. Mutus Werk beschäftigt sich hier immer noch mit der, im wahrsten Wortsinne, Missrepräsentation der Frau, hat sich jedoch von seinem ausschließlichen Bezug auf das Bild der afrikanischen Frau als mythisierter, geschundener und sexualisierter Kreatur gelöst. Suspended Playtime (2008) etwa, eine von Mutus neuen großen skulpturalen Installationen, besteht aus 44 im Raum hängende Knäueln aus Müllbeuteln – häufiges Spielzeug afrikanischer Kinder –, die wie die Beute einer Spinne eingeschnürt sind. Der konkrete politisch-soziale Bezug ist sozusagen verpackt in eine poetische und zugleich bedrohliche Form.

Les collages réalisés par Wangechi Mutu avec des corps de femmes, des éléments végétaux ou animaliers et des entrelacs de motifs abstraits fascinent d'abord le spectateur par leurs opulentes couleurs. Mais un regard plus approfondi y relève immédiatement des postures corporelles distordues, des déformations grotesques et des obscénités anatomiques. Le corps féminin, avec les projections qui s'y attachent et la manière dont il est représenté, est au centre de l'œuvre de Mutu. Ainsi, A'Gave You (2008), un collage de plus de deux mètres de haut, montre un corps de femme dans un étrange agenouillement. D'en bas, la femme est assaillie par un grouillement d'êtres serpentins, de derrière, un monstre apparenté à une pieuvre d'où pousse un long tentacule en forme de tuyau se penche sur son visage. Il s'agit à la fois d'une femme mythique et contemporaine, d'un portrait de menace autant que de séduction. De même, les personnages de l'œuvre octopartite Chorus Line (2008) sont des hybrides bizarres qui composent ici une troupe de danse : figures fantastiques mi-femmes, mi-animales, dans des postures contorsionnées, en équilibre sur des jambes beaucoup trop petites et trop grêles – parfois sur une seule. Si l'œuvre de Mutu continue d'aborder la représentation littéralement monstrueuse de la femme, il s'est aujourd'hui éloigné de son intérêt exclusif pour l'image de la femme africaine en tant que créature mythifiée, écorchée et sexualisée. Suspended Playtime (2008) par exemple, une des grandes sculptures-installations récentes de l'artiste, est constituée de quarante-quatre ballots de sacs-poubelles – jouet fréquent des enfants africains – suspendus dans l'espace d'exposition et emmaillotés comme la proie d'une araignée. La référence sociopolitique concrète est en quelque sorte emballée dans une forme à la fois poétique et menaçante.

A. M.

SELECTED EXHIBITIONS →
2008 Wangechi Mutu, Kunstverein Wien, Vienna. U-TURN 2008, U-TURN Quadrennial for Contemporary Art, Copenhagen **2007** Global Feminisms: New Directions in Contemporary Art, Brooklyn Museum, New York **2006** BIACS 2, Biennale Sevilla. USA Today, Royal Academy of Art, London. Star Power: Museum as Body Electric, Museum of Contemporary Art, Denver **2005** Wangechi Mutu: The Chief's Lair's A Holy Mess, SFMOMA, San Francisco

SELECTED PUBLICATIONS →
2008 Wangechi Mutu: A Shady Promise, Damiani, Bologna **2007** Global Feminisms: New Directions in Contemporary Art, Brooklyn Museum of Art, Brooklyn; Merrell Publishers, London, New York **2006** Painting People: The State of the Art, Thames and Hudson, London. New York, Interrupted, PKM Gallery, Beijing. Entangled: Approaching Contemporary African Artists, Volkswagen-Stiftung, Hanover

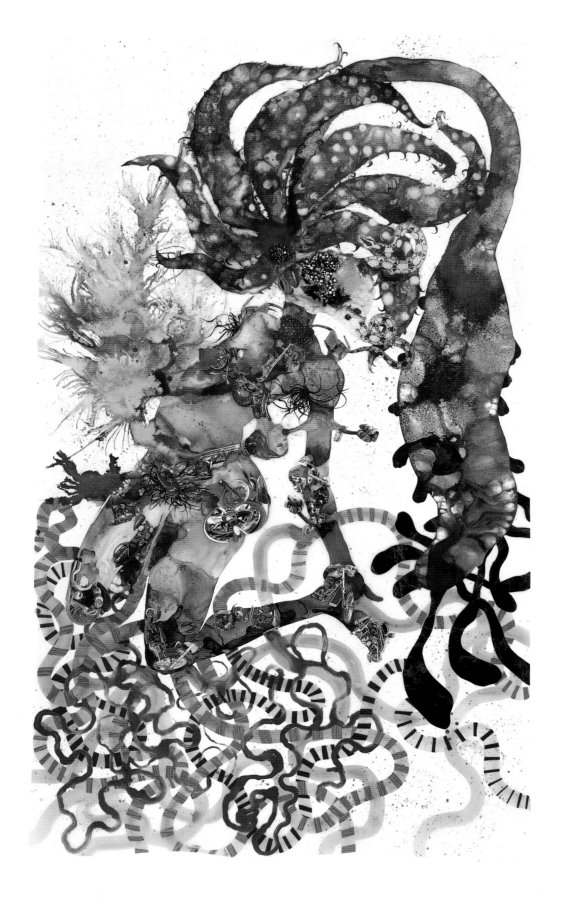

1 **A'Gave You**, 2008, mixed media collage on Mylar, 236.2 x 137.2 cm
2/3 **Chorus Line**, 2008 (details), watercolour, collage on paper, 8 parts, 78.7 x 137.2 cm

4 **Suspended Playtime**, 2008, garbage bags, twine, gold string, 44 parts, ø 5.1–20.3 cm, dimensions variable
5–13 **Histology of the Different Classes of Uterine Tumors**, 2006, mixed media collage, 9 of 12 works, 58.4 x 43.2 cm (each)

„Ich kann Täter und Opfer sein, ich kann diejenige sein, die das Bild manipuliert, aber ich kann auch die Manipulierte sein. Ich denke Kunst kann beide Positionen zur selben Zeit in sich tragen, und sie kann die Wahrnehmung der Menschen komplexer machen."

« Je peux jouer le bourreau ou la victime ; je peux jouer le rôle du manipulateur d'images, mais aussi celui du manipulé. Je pense que l'art peut véhiculer ces deux positions simultanément et compliquer la manière dont les autres vous perçoivent. »

"I can act out the victimizer or the victim; I can perform the role of the manipulator of the image but also the manipulated. I think art can carry those two positions at the same time, and it can complicate how people see things."

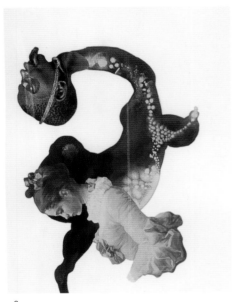

2

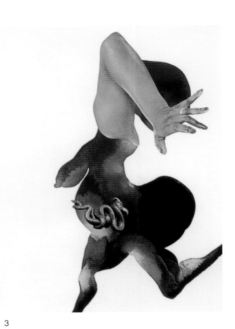

3

4

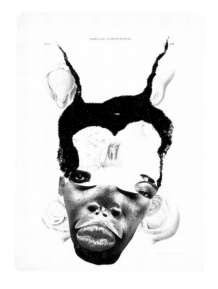
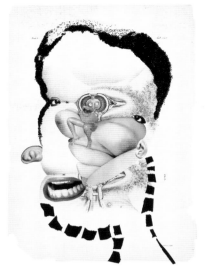
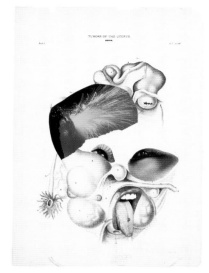
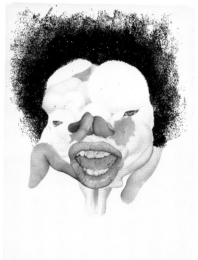

Ernesto Neto

1964 born in Rio de Janeiro, lives and works in Rio de Janeiro, Brazil

When Ernesto Neto installed *Léviathan Thot* (2006) at the Paris Panthéon, he created a sculpture that established one of the most prolific dialogues between art and architecture seen in recent times. The large sculpture, made from tulle and polystyrene, hung throughout the building's full central nave like a creature with soft, tube-like limbs. Its voluptuous organic forms created a baroque dialogue with the Panthéon's strict classicism. Neto's interest in a sculptural architecture is deeply layered with corporeal and sensory notions – a legacy of the sensuous geometry of Brazilian neo-concretism. Weight, mass, volume, but also tension, transparence and gravity are set against colonnades, ornaments and the building's profoundly republican sense, creating a permanent exchange between the inside and the outside, between individuality and collectivity. From his early beginnings, Neto has related the most classical issues of sculpture and composition to an idea of penetration, pregnancy and a presence of the spectator's body in the artwork. He has described his works as an exploration and a representation of the body's landscape from within, one which the viewer should interact with and physically experience by feeling, smelling and touching it. In *The Malmö Experience* (2006), a sculpture made of several sculptures, the artist offered such a landscape to be entered, travelled and experienced by the spectator: an organic labyrinth of fabrics, shapes and scented spices, the diverse topological elements inside destabilized the spectator's perception with olfactory and tactile sensations, with passages of light and labyrinthine pathways.

Als Ernesto Neto *Léviathan Thot* (2006) im Pariser Panthéon installierte, schuf er eine Skulptur, die einen der fruchtbarsten Dialoge zwischen Kunst und Architektur in den letzten Jahren anregte. Die große Skulptur aus Tüll und Styropor hing im Hauptschiff des Gebäudes wie ein Lebewesen mit weichen röhrenartigen Gliedern. Seine ausschweifenden organischen Formen schufen einen barocken Dialog mit dem strengen Klassizismus des Panthéon. Netos Interesse an skulpturaler Architektur ist tief mit Vorstellungen zu Körper und Wahrnehmung verbunden – ein Erbe der sinnlichen Geometrie der brasilianischen Neo-Konkretismus. Gewicht, Masse, Volumen, aber auch Spannung, Transparenz und Schwerkraft werden gegen die Kolonnaden, Ornamente und die tief republikanische Ausstrahlung des Gebäudes gesetzt. So schaffen sie einen permanenten Austausch zwischen Innen und Außen, Individuum und Kollektiv. Seit seinen Anfängen hat Neto die klassischen Fragen von Skulptur und Komposition in Zusammenhang gebracht mit einer Idee des Eindringens, der Schwangerschaft, der körperlichen Gegenwart des Betrachters im Kunstwerk. Er hat seine Arbeiten als eine Erkundung und eine Darstellung der Landschaft des Körpers von innen beschrieben, mit der der Betrachter interagieren und sie durch Fühlen, Riechen und Berühren physisch erfahren soll. Mit *The Malmö Experience* (2006), einer Skulptur aus mehreren Skulpturen, bot der Künstler dem Betrachter solch eine Landschaft zum Betreten, Durchreisen und Berühren: ein organisches Labyrinth aus Gewebe, Formen und duftenden Gewürzen, verschiedenen topologischen Elementen, die die Wahrnehmung des Betrachters mit Geruchs- und Tastempfindungen, mit Lichtdurchgängen und labyrinthischen Wegen ins Schwanken brachten.

Avec l'installation de *Léviathan Thot* (2006) au Panthéon à Paris, Ernesto Neto a établi l'un des dialogues les plus féconds de ces dernières années entre art et architecture. L'énorme sculpture, faite de tulle et de polystyrène, était suspendue à travers toute la nef centrale du bâtiment, telle une créature aux membres tubulaires souples. Ses formes organiques voluptueuses créaient un échange baroque avec le classicisme strict du Panthéon. L'intérêt de Neto pour une architecture sculpturale est fortement chargé de concepts corporels et sensoriels – un héritage de la géométrie sensuelle du néo-concrétisme brésilien. Poids, masse et volume, ainsi que tension, transparence et attraction, confrontés à un contexte de colonnades, d'ornements et du sens fortement républicain du bâtiment, créent un échange permanent entre l'intérieur et l'extérieur, entre l'individuel et le collectif. Neto a relié très tôt les points les plus classiques de la sculpture et de la composition à l'idée de pénétration, de grossesse et de présence du corps du spectateur dans l'œuvre d'art. Il a décrit ses œuvres comme une exploration et une représentation de l'intérieur du paysage humain, une représentation avec laquelle le spectateur doit dialoguer et qu'il doit éprouver physiquement par le toucher et l'odorat. Dans *The Malmö Experience* (2006), une sculpture composée de plusieurs sculptures, le spectateur devait pénétrer dans un paysage, y voyager, l'éprouver. Les différents éléments topologiques à l'intérieur de ce labyrinthe organique de textiles, de formes et de senteurs épicées, les corridors de lumière et les chemins dédaléens déstabilisaient la perception et les sens du spectateur – son toucher et son odorat.

R. M

SELECTED EXHIBITIONS →
2008 *Ernesto Neto: 1/3*, Fondazione Volume!, Roma. *Ernesto Neto: While Nothing Happens*, Museo d'Arte Contemporanea, Roma **2007** *Ernesto Neto*, Marugame Genichiro-Inokuma, Museum of Contemporary Art, Kagawa. *Ernesto Neto*, Museum of Contemporary Art San Diego. *To Be Continued...*, Magasin 3 Stockholm Konsthall, Stockholm **2006** *Ernesto Neto: The Malmö Experience*, Malmö Konsthall, Malmö. *Ernesto Neto: Léviathan Thot*, 35e Festival d'Automne, Panthéon, Paris. *Surprise Surprise*, ICA, London

SELECTED PUBLICATIONS →
2008 *Ernesto Neto: From Sebastian to Olivia*, Galerie Max Hetzler, Holzwarth Publications, Berlin **2007** *Olaf Nicolai, Ernesto Neto, Rebecca Warren*, Parkett 78, Zürich. *Held Together with Water. Kunst der Sammlung Verbund*, Hatje Cantz, Ostfildern **2006** *Léviathan Thot*, Festival d'Automne, Paris. *The Malmö Experience*, Malmö Konsthall, Malmö. *Carbonic Anhydride*, Galerie Max Hetzler, Berlin

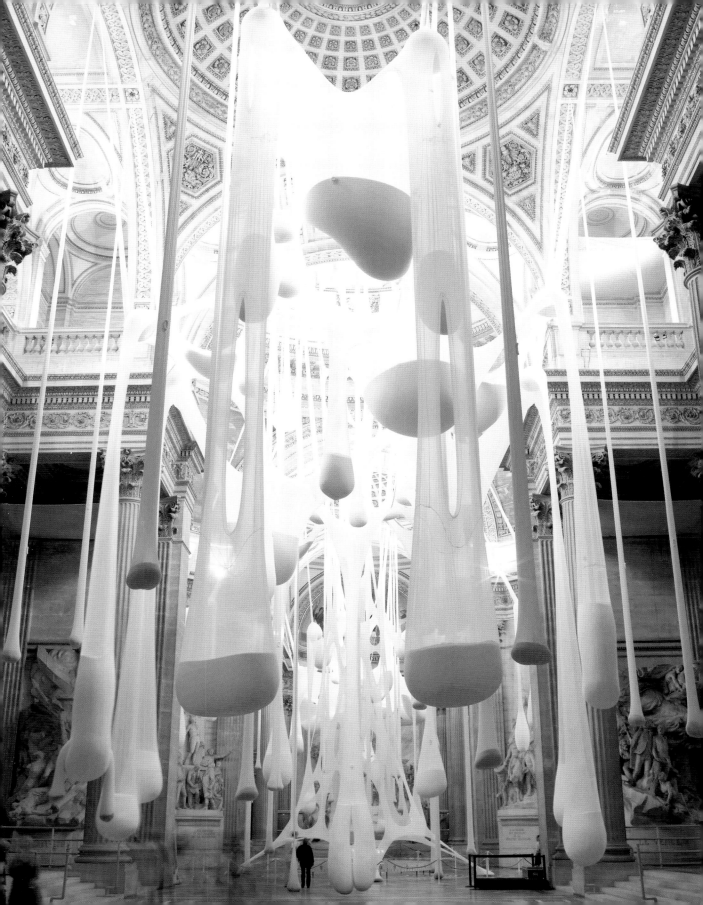

1 **Léviathan Thot**, 2006, polyamide, styrofoam balls, 5300 x 6200 x 5600 cm.
Installation view, Panthéon, Paris
2 **Meditation on Colour Vibration – Matter Colour**, 2007, cotton fabric,
plastic rings, 240 x 277 cm
3 **The Creature, Malmö Experience**, 2006, cotton textile, polyamide, cotton
cloth, polyurethane foam, plastic pipes (bones), sand, polypropylene,

glass beads, plastic spheres, polystyrene pellet, turmeric, clove,
lavender, cumin, black pepper, 350 x 6500 x 2300 cm. Installation view,
Malmö Konsthall, Malmö
4 **Now BTTA**, 2007, polyamide, cumin, clove, pepper, turmeric,
512 x 840 x 616 cm, dimensions variable. Installation view, Galerie Max
Hetzler Temporary, OsramHöfe, Berlin

„Ich will nicht etwas schaffen, das einen sinnlichen Körper darstellt –
ich will, dass es ein Körper ist, als Körper existiert oder wenigstens als
Idee davon."

« Je ne veux pas faire une œuvre qui décrive un corps sensuel – je veux
qu'elle soit un corps, qu'elle existe en tant que corps ou en tant qu'idée de
ce corps. »

"I don't want to make work that depicts a sensual body – I want it to be a body, exist as a body or as an idea of it."

2

3

Frank Nitsche

1964 born in Görlitz, lives and works in Berlin, Germany

Frank Nitsche's abstract painting is opulent, and it inoculates tastefulness with a certain resistance. Over the years, his visual language has become increasingly radicalized; he constructs suggestive pictorial spaces from dynamic lines, modulated, complex, interlocking surfaces and cool colourfulness. Recent works such as *Bil-07-2008* (2008) have an association to this visual language but are less tectonic. The colour palette has changed from typical Nitsche combinations of burnt red, fleshy pink and neutral beige to light-coloured sweetness: mint green and light blue, citron yellow and delicate violet or apricot are combined to create shimmering contrasts. These are candy colours – indeed Nitsche ironically named one of his solo exhibitions *Drops*. Forms increasingly stand alone within the pictorial space, and at times abstraction takes on comic-like figurative features. Nitsche's painting is rooted just as much in popular culture as in the tradition of abstraction: he himself locates the consciously synthetic climate of his paintings "somewhere between design, crash and colourfield painting". He expressly refers to his images as "unnatural", as if they had emerged from "being moved by the atmosphere of a business lounge and the thought of destroying it". As per the transformed slipperiness of the zeitgeist, Nitsche turns the destruction of form into a formal aspect, which could be interpreted as an intensification and exaggeration of socially coded surfaces. His elaboration of form is performed in a thoroughly traditional manner – he enters the painting process without a preliminary draft, puts down a form, paints over it, adds to it, paints over it again and so on until a structure is set. It's not something that can be planned: the pictorial concept and the invention of form remain directly linked to the act of painting.

Frank Nitsches abstrakte Malerei ist opulent, und sie impft das Geschmackvolle mit Widerständigkeit. Er hat seine Bildsprache im Laufe der Jahre immer weiter radikalisiert, baut aus modulierten, komplex verzahnten Flächen, dynamisierenden Linien und mit kühlem Kolorit suggestive Bildräume auf. Neueste Arbeiten wie *Bil-07-2008* (2008) knüpfen daran an, fallen aber weniger tektonisch aus. Die Farbpalette verschiebt sich von typischen Nitsche-Kombinationen aus gebranntem Rot, fleischigem Pink und neutralisierendem Beige zu helltoniger Süße: Mal fügen sich da Mintgrün und Hellblau, mal Zitronengelb und zartes Violett oder Apricot zu flimmernden Kontrasten. Das darf man wohl Bonbonfarben nennen, schließlich hat Nitsche selbst eine Einzelschau ironisch *Drops* betitelt. Formen stehen inzwischen stärker solitär im Bildraum, Abstraktion erhält teils figurativ-comichafte Züge. Nitsches Malerei ist mindestens so sehr in Popkultur verwurzelt wie in Traditionslinien der Abstraktion. Das bewusst synthetisch gehaltene Klima seiner Bilder verortet er denn auch „irgendwo zwischen Design, Crash und Farbflächenmalerei". Ausdrücklich nennt er seine Bilder „unnatürlich", wie hervorgegangen aus dem „Berührtsein von der Atmosphäre einer Businesslounge und dem Gedanken, sie zu zerstören". Im Modus transformierter Zeitgeist-Glätte macht Nitsche Destruktion der Form zum Formaspekt, was sich eben auch als Zu- und Überspitzung von gesellschaftlich codierten Oberflächen lesen lässt. Handwerklich erarbeitet er Form aber durchaus traditionell, steigt ohne Vorentwurf in den Malprozess ein: setzt eine Form, übermalt, ergänzt, übermalt erneut – so lange, bis ein Gefüge sitzt. Das ist nicht planbar, Bildidee und Formerfindung bleiben direkt an Malerei gebunden.

L'opulente peinture abstraite de Frank Nitsche inocule au bon goût un venin subtil. Au fil des ans, Nitsche n'a cessé de radicaliser son langage, élaborant des espaces picturaux suggestifs à partir de surfaces modulées, d'imbrications complexes, de lignes dynamiques traitées dans des tons froids. Ses œuvres récentes comme *Bil-07-2008* (2008) s'inscrivent dans cette recherche tout en étant moins tectoniques, la palette passant des combinaisons propres à Nitsche – rouge brûlé, rose chair, beige neutralisateur – à une clarté doucereuse où s'agencent en vibrants contrastes de tons de vert menthe, bleu ciel, jaune citron, violet suave ou abricot. On peut les qualifier de « bonbons acidulés », Nitsche ayant intitulé ironiquement une exposition personnelle *Drops*. Les formes sont aujourd'hui plus isolées dans l'espace pictural et l'abstraction prend parfois des traits figuratifs proches de la bande dessinée. La peinture de Nitsche est enracinée dans la culture pop autant que dans les courants de la tradition abstraite. Lui-même situe l'atmosphère délibérément synthétique de ses œuvres « quelque part entre design, crash et colourfield painting » et qualifie expressément ses tableaux d'« artificiels », comme sortis du « contact entre l'ambiance d'un *business lounge* et l'idée de le détruire. » Sur le mode d'une transformation de l'uniformité du *Zeitgeist*, Nitsche fait de la destruction de la forme un aspect formel qu'on lit comme une exacerbation des surfaces codées socialement. En termes de métier, la forme est en revanche élaborée de manière résolument traditionnelle : Nitsche entre dans le processus pictural sans projet prédéfini, posant une forme, repeignant, complétant, repeignant – jusqu'à ce qu'une structure ait trouvé son assise. Cela ne peut être planifié, l'idée picturale et l'invention formelle restent intimement liées à l'acte pictural.

J. A.

SELECTED EXHIBITIONS →
2008 *Living Landscapes: A Journey through German Art*, National Art Museum of China, Beijing **2007** *Frank Nitsche*, Musée d'art moderne et contemporain, Strasbourg; FRAC Auvergne, Clermont Ferrand. *Imagination Becomes Reality*, ZKM, Karlsruhe **2006** *Deutsche Wandstücke: Seven Scenarios of New German Painting*, Museion, Bolzano. *Painting as Presence*, Künstlerhaus Bethanien, Berlin **2005** *Prague Biennale 2*, Prague

SELECTED PUBLICATIONS →
2007 *Frank Nitsche 1999–2007*, Musée d'art moderne et contemporain, Strasbourg; FRAC Auvergne, Clermont Ferrand; Verlag der Buchhandlung Walther König, Cologne **2006** *Deutsche Wandstücke: Seven Scenarios of New German Painting*, Museion, Bolzano; Charta, Milan. *New German Painting*, Prestel, Munich. *Imagination Becomes Reality: Part II*, Sammlung Goetz, Munich. *Carbonic Anhydride*, Galerie Max Hetzler, Berlin; *Painting S(e)oul*, Kukje Gallery, Seoul; Verlag der Buchhandlung Walther König, Cologne

1

1 **BIL-07-2008**, oil on canvas, 280 x 300 cm
2 **APG-14-2005**, oil on canvas, 200 x 170 cm

3 **EGO-01-2008**, oil on canvas, 200 x 175 cm
4 **BEC-32-2005**, oil on canvas, 175 x 160 cm

"Smoking kills – Rauchen kann tödlich sein – Fumer tue"

2

3

Tim Noble and Sue Webster

Tim Noble, 1966 born in Stroud, and Sue Webster, 1967 born in Leicester; live and work in London, United Kingdom

Artist duo Tim Noble & Sue Webster carved out a place for themselves in the British art scene of the 1990s – at the tail end of the Young British Artists movement – with work that falls somewhere between trashy punk-inspired art, light projections of shadow images and installations imbued with Las Vegas romanticism. They have become known above all for their ironic self-portraits made from household junk and dead animals, sometimes with a Neanderthal physiognomy. In their recent works Noble & Webster have cleaned up their materials and forms: the rubbish has been replaced by steel, for example (as in *The Glory Hole*, a group of sculptures from 2005). They haven't stopped working with light, however. The kinetic light sculpture *Sacrificial Heart* (2007) mixes Christian symbolism with biker iconography, and for their monumental *Electric Fountain* (2008), installed in front of New York's Rockefeller Center, they turned 3390 LED bulbs and 527 metres of neon tubing into a three-dimensional electric fountain. The colour and strength of the light changes according to the weather. In London's Freud Museum, on the other hand, Noble & Webster emphasized the shock factor. The installation *Scarlett* (2006), part of the project *Polymorphous Perverse*, shows a workbench on which bizarre mechanical devices – bastardized versions of children's toys – evoke sexual fantasies. This all relates to Freud, of course, who diagnosed a state of sexual chaos during childhood that is regarded as perverse from an adult perspective. Noble & Webster have ultimately remained true to themselves: they investigate the workings of consumerism, commerce and sexuality, all of which are core elements of modern market-economy-based society.

Das englische Künstlerpaar Tim Noble & Sue Webster hat sich in den 1990er-Jahren in der Folge der Young British Artists zwischen Trash Art mit Punk-Gestus, Lichtkunst mit Schattenbildern und Installationen mit Las-Vegas-Romantik positioniert. Vor allem ihre ironischen Selbstporträts, bestehend aus Haushaltsmüll und toten Tieren, zuweilen geformt in Neandertaler-Physiognomik, brachten ihnen erhöhte Aufmerksamkeit. Bei neueren Arbeiten räumen Noble & Webster mit ihrem Material- und Formenvokabular auf, der Müll etwa verschwindet zugunsten von Stahl (Skulpturengruppe *The Glory Hole*, 2005). Lichtwirkungen bleiben ihnen dabei weiterhin ein Anliegen. Sei es bei der kinetischen Leuchtskulptur *Sacrificial Heart* (2007), die christliche Symbolik mit Biker-Ikonografie mischt, oder sei es beim monumentalen *Electric Fountain* (2008) vor dem Rockefeller Center in New York. Noble & Webster verarbeiteten dafür 3390 LED-Glühbirnen und 527 Meter Neonschlauch, um einen elektrischen 3D-Springbrunnen herzustellen, dessen Farbe und Lichtstärke sich mit der Wettersituation ändert. Im Londoner Freud Museum hingegen frönten sie ihrer Lust am Schrecken. Die Installation *Scarlett* (2006) im Rahmen des Projekts *Polymorphous Perverse* zeigt eine Werkbank, auf der bizarre mechanische Geräte als bastardisierte Versionen von Kinderspielzeug sexuelle Phantasien inkludieren. Das Ganze geschieht mit Bezug zu Freud, welche bei der Kindesentwicklung einen Zustand sexueller Chaotik diagnostizierte, der aus Erwachsenenperspektive als pervers gewertet wird. Letztlich bleiben sich Noble & Webster somit treu: Sie untersuchen die Funktionsweise von Konsum, Kommerz und Sexualität, mithin Kernelemente dessen, was eine marktwirtschaftlich orientierte Gesellschaft ausmacht.

Pendant les années 1990, le couple d'artistes anglais Tim Noble & Sue Webster s'est inscrit dans le sillage des Young British Artists entre art trash avec attitude punk, projections lumineuses d'ombres et installations empreintes d'un romantisme de style Las Vegas. Ce sont surtout leurs autoportraits ironiques faits d'ordures ménagères et d'animaux morts, aux traits parfois néandertaliens, qui leur ont valu une forte notoriété. Les œuvres récentes de Noble & Webster font le ménage dans leur vocabulaire formel et leurs matériaux : les ordures disparaissent au profit de l'acier (groupe de sculptures *The Glory Hole*, 2005) tandis que les effets de lumière continuent de les intéresser, que ce soit avec la sculpture cinétique lumineuse *Sacrificial Heart* (2007), qui mêle symbolique chrétienne et iconographie des motards, ou avec la monumentale *Electric Fountain* (2008) réalisée au pied du Rockefeller Center à New York. Pour celle-ci, Noble & Webster ont utilisé 3390 ampoules à leds et 527 mètres de tube néon formant une fontaine électrique en 3D dont les couleurs et l'intensité lumineuse varient en fonction des conditions météorologiques. Au Freud Museum de Londres, ils ont en revanche donné libre cours à leur goût de l'horreur. L'installation *Scarlett* (2006) réalisée dans le cadre du projet *Polymorphous Perverse* montre un établi sur lequel d'étranges outils, versions bâtardes de jouets d'enfants, évoquent des fantasmes sexuels. Le tout est une référence à Freud et à la sexualité chaotique dans laquelle il avait vu une étape du développement de l'enfant et que les adultes considèrent comme une perversité. En définitive, Noble & Webster restent donc fidèles à eux-mêmes : ils étudient le mode fonctionnel de la consommation, du commerce et de la sexualité, éléments qui déterminent si souvent une société régie par l'économie de marché. H. L.

SELECTED EXHIBITIONS →
2008 *Tim Noble & Sue Webster*, Goss-Michael Foundation, Dallas. *Tim Noble & Sue Webster: Electric Fountain*, Rockefeller Center, New York. *True Romance*, Kunsthalle Wien, Vienna; Villa Stuck, Munich; Kunsthalle Kiel **2007** *Images of Man Today*, Arken Museum, Copenhagen **2006** *Tim Noble & Sue Webster: Polymorphous Perverse*, The Freud Museum, London. *Masquerade*, Museum of Contemporary Art, Sydney **2005** *Tim Noble & Sue Webster: The New Barbarians*, CAC Málaga

SELECTED PUBLICATIONS →
2008 *Tim Noble & Sue Webster: Polymorphous Perverse*, White Cube; Other Criteria, London **2007** *Traum und Trauma*, MUMOK, Vienna; Hatje Cantz, Ostfildern **2006** *Tim Noble & Sue Webster: Wasted Youth*, Rizzoli, New York **2005** *Tim Noble & Sue Webster: The New Barbarians*, CAC Málaga, Málaga

1 **Electric Fountain**, 2007, steel, 3390 LED bulbs, 52700 cm of neon tubing, 1067 x ø 914 cm. Installation view, Rockefeller Center, New York
2 **Spinning Heads**, 2005, painted bronze, Tim (black) 38 x 34 x 34 cm, Sue (white) 38 x 35 x 35 cm
3 **Black Narcissus**, 2006, black poly-sulphide rubber, wood, light projector, 38 x 72 x 60 cm

4 **Scarlett**, 2006, workbench table, studio detritus, taxidermy animals, mechanical assemblages, electric motors, urine, theatre blood, cooking oil, peanut butter, 185 x 189 x 144 cm. Installation view, Deitch Projects, New York, 2008

„Ein Mann wacht des Morgens auf, die Sonne scheint, die Vögel singen, es ist ein wunderschöner, optimistischer Tag. Er nimmt einen tiefen Luftzug, trommelt auf seine Brust und fühlt sich unbesiegbar ... Der selbe Mann wacht am nächsten Tag auf, versteckt sich zitternd unter der Decke, hat zu viel Angst, um die Sicherheitszone des eigenen Betts zu verlassen ... Der Himmel ist grau und düstere Gedanken treiben über seinem Kopf. Er fühlt sich überflüssig, verloren und verletzlich – völlig allein in der Welt ... Das ist das Leben eines Künstlers."

« Un homme se réveille de bon matin, le soleil brille ; les oiseaux chantent, c'est une journée radieuse et pleine d'optimisme. Il respire profondément l'air frais, frappe sa poitrine et se sent invincible... Le même homme se réveille le lendemain, se recroqueville et frissonne sous ses draps, trop apeuré pour quitter la sécurité de son lit... Le ciel est gris, de sombres pensées flottent au-dessus de sa tête. Il se sent inutile, perdu et vulnérable – complètement seul au monde... Telle est la vie de l'artiste. »

"A man wakes up in the morning, the sun is shining, the birds are singing, it's a beautifully optimistic day. He takes a deep breath of fresh air, beats his chest and feels invincible... The same man wakes up the next day, he cowers and shivers beneath the sheets, too afraid to leave the safety of his own bed... The sky is grey and there are dark thoughts floating above his head. He feels redundant, lost and vulnerable – totally alone in the world... This is the life of an artist."

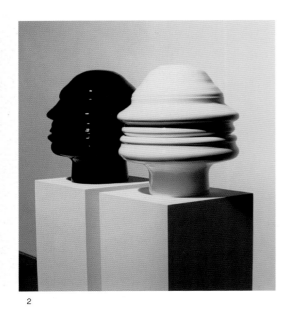

2

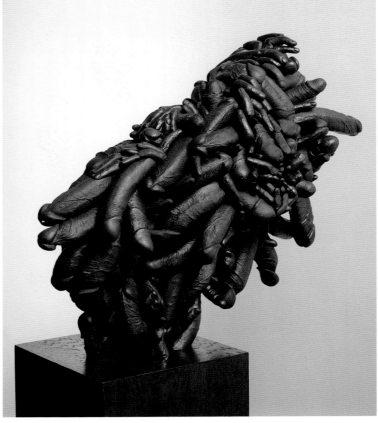

3

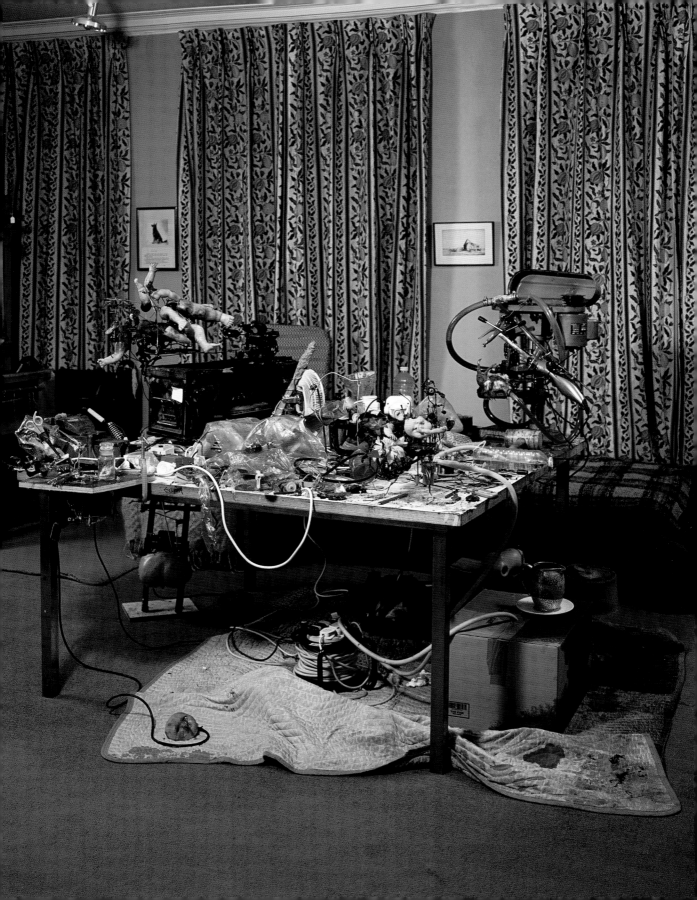

Albert Oehlen

1954 born in Krefeld, Germany, lives and works in Switzerland and Spain

After an early realization that the best way to critique painting is, in fact, to paint, Albert Oehlen, the good object of "bad" German painting, has wittily bastardized the medium's lofty pretensions for decades with a smorgasboard of figurative and non-objective offerings: "post-non-representational" abstract paintings, grey paintings, mirror paintings, computer paintings, posters and collages. Something of an aesthetic magpie, Oehlen has nonetheless – temporarily at least – alighted on rather luminous compositions, exhibited in his cheekily titled New York show, *Painter of Light*. Works including *(Durch die) rosa Brille* (2006) flaunt a spectrum of washes (pea green, goldenrod, the pink of the title) layered with arabesque ribbons and crossed with gooey drips. Fragmentary forms surface in other compositions, making clear the fact that Oehlen uses collage, albeit in a self-annihilating manner, as the basis for most paintings. Recent pieces such as *Hey* (2007) play image against word in an elaborate game of cat and mouse: the painting's text is obstructed by a nebulous grey blur and Lichtenstein-worthy explosion marks, all of which bursts beyond the confines of a frame within the frame which also contains an assortment of kitchen pots. These juxtapositions suggest a stream of consciousness that foregrounds the arbitrary nature of most signs and marks alike. Though he came of age at the peak of neo-expressionism, Oehlen was influenced by an interest in music and Gestalt theory as much as by the art of Jörg Immendorf and Sigmar Polke, and he might be thought of as a kind of latter-day surrealist pushing the limits of representation to exquisitely absurd failure.

Nachdem er früh erkannt hatte, dass der beste Weg, Bilder zu kritisieren, der ist, selbst welche zu malen, untergräbt Albert Oehlen, die gute Hauptfigur des deutschen „bad painting", seit Jahrzehnten absichtlich die hohen Ansprüche des Mediums mit einem Reichtum von figurativen und abstrakten Arbeiten: „post-ungegenständliche" abstrakte Gemälde, graue Gemälde, Spiegelbilder, Collagengemälde, Computergemälde und Poster. Oehlen, der so etwas wie eine ästhetische Elster ist, hat sich in letzter Zeit – zumindest vorübergehend – auf leuchtendere Kompositionen eingelassen, wie er sie in seiner hintergründig betitelten New Yorker Ausstellung *Painter of Light* zeigte. Arbeiten wie *(Durch die) rosa Brille* (2006) leuchten durch die Vielzahl von Farbtönen (Erbsengrün, Ocker und das namensgebende Rosa), die von arabesken Bändern und von zähen Tropfen überlagert werden. Fragmentarische Formen tauchen auch in anderen Kompositionen auf und unterstreichen die Tatsache, dass Oehlen heute die Collage, wenn auch in einer selbstzerstörerischen Weise, als Grundlage der meisten Bilder verwendet. In jüngsten Arbeiten wie *Hey* (2007) spielen Bild und Wort miteinander ein kunstvolles Katz- und Mausspiel: Der Text des Bildes wird von nebelhaften grauen Flecken und einer Explosion à la Lichtenstein verdeckt; diese sprengt die Grenzen eines Rahmens im Rahmen, in dem sich auch eine Reihe von Kochschüsseln befindet. Dieses Nebeneinander deutet einen Bewusstseinsstrom an, der die Zufälligkeit der meisten Zeichen in den Vordergrund stellt. Obwohl er in der Zeit des Neoexpressionismus groß wurde, ließ sich Oehlen ebenso von Musik und Gestalttheorie beeinflussen wie von Jörg Immendorf und Sigmar Polke; man könnte ihn eine Art modernen Surrealisten nennen, der die Grenzen der Darstellung hin zu einer erlesenen Form des absurden Scheiterns verschiebt.

Après s'être rendu compte très tôt que la meilleure façon de critiquer la peinture était encore de peindre, Albert Oehlen, le bon sujet de la « mauvaise » peinture allemande, a malmené avec esprit pendant des années les prétentions de ce moyen d'expression avec tout un assortiment d'offres non-figuratives : peintures abstraites « post non-figuratives », peintures grises, peintures de miroir, peintures générées par ordinateur, affiches et collages. En collectionneur de l'esthétique, Oehlen s'est néanmoins – du moins temporairement – arrêté à des compositions plus lumineuses, présentées avec insolence dans une exposition à New York intitulée *Painter of Light*. Des œuvres comme *(Durch die) rosa Brille* (2006) affichent des lavis (vert pomme, bouton d'or, rose éponyme) pourvus de rubans en arabesque et de coulures sirupeuses. D'autres compositions font apparaître des formes fragmentaires, dévoilant la technique du collage utilisée, quoique s'auto-anéantissant, comme base pour la plupart de ses peintures. Des pièces récentes, comme *Hey* (2007), jouent image contre mot dans un jeu complexe du chat et de la souris : le texte de la peinture est brouillé par un gris nébuleux et des traces d'explosion dignes de Lichtenstein. Le tout jaillit au-delà des limites d'un cadre dans le cadre contenant un assortiment de pots de cuisine. Ces juxtapositions suggèrent un état de conscience qui met en relief la nature arbitraire de la plupart des signes et des traces. Bien qu'arrivé à maturité à l'apogée du néo-expressionnisme, Oehlen a été influencé par la musique et la *Gestalt*, par les œuvres de Jörg Immendorf et de Sigmar Polke, et pourrait être considéré comme une sorte de surréaliste des temps modernes, poussant les limites de la représentation jusqu'à l'échec absurde.

S. H.

SELECTED EXHIBITIONS →
2008 *Bad Painting – Good Art*, MUMOK, Vienna **2007** *Klio: Eine kurze Geschichte der Kunst in Euramerika nach 1945*, ZKM, Karlsruhe **2006** *Albert Oehlen*, Whitechapel Art Gallery, London; Arnolfini, Bristol. *Albert Oehlen/Marc Goethals*, Museum Dhondt-Dhaenens, Deurle. *Die Götter im Exil: Salvador Dalí, Albert Oehlen u.a.*, Kunsthaus Graz. **2005** *Albert Oehlen: I Know Whom You Showed Last Summer*, MOCA, North Miami. *Albert Oehlen: Selbstportrait mit 50millionenfacher Lichtgeschwindigkeit*, Kunsthalle Nürnberg, Nuremberg

SELECTED PUBLICATIONS →
2008 *Albert Oehlen*, Thomas Dane Gallery, London **2007** *Jon Kessler, Marilyn Minter and Albert Oehlen*, Parkett 79, Zürich **2006** *Albert Oehlen*, Galerie Max Hetzler, Berlin. *Albert Oehlen: I Will Always Champion Good Painting. I Will Always Champion Bad Painting*, Whitechapel Art Gallery, London; Arnolfini, Bristol. *Albert Oehlen: Mirror Paintings*, Galerie Max Hetzler, Holzwarth Publications, Berlin. *Albert Oehlen: The Painter of Light*, Luhring Augustine Gallery, New York **2004** *Albert Oehlen*, Secession, Vienna

350

1 **Das Grün**, 2007, oil, paper on canvas, 230 x 190 cm
2 **(Durch die) rosa Brille**, 2006, acrylic, oil on canvas, 280 x 340 cm

3 **Hey**, 2007, oil, acrylic, paper on canvas, 230 x 200 cm

„Als ich 15 war, gab es ein einfaches Rezept. Je härter oder komplizierter die Rockmusik war, um so mehr war sie gegen den Mainstream. Bei Kunst würde ich nicht von Härte sprechen, weil das blöd klingt. Meinen würde ich es aber trotzdem."

« Quand j'avais 15 ans, il y avait une recette toute simple. Plus la musique rock était dure ou compliquée, plus elle allait contre le courant dominant. Concernant l'art, je ne parlerais pas de dureté parce que ça a l'air débile. Mais c'est quand même ce que je penserais. »

"When I was 15, there was a simple recipe: the heavier or more complicated rock music was, the more it was against the mainstream. As far as art is concerned, I wouldn't say it's heavy, because that sounds stupid. But I still think that way."

2

Chris Ofili

1968 born in Manchester, United Kingdom, lives and works in Trinidad and Tobago

Chris Ofili is one of the so-called Young British Artists. Of Nigerian descent, he grew up in Manchester and now lives in Trinidad. This background contextualizes the trans-cultural working methods of the Turner Prize winner, who combines elements from different cultural areas, including African, East European and Pacific folk culture, European art and the pictorial traditions of India. A similar combination of influences is visible in Ofili's recent series *The Blue Rider Extended Remix* (2006), in which he refers to the Munich-based expressionist movement, and in particular to Franz Marc and Wassily Kandinsky. Above all, Ofili takes up the fusion of folk art and increasingly abstract imagery evident in Kandinsky's fairytale paintings. Beyond the predominantly blue tones – a colourful homage to Der Blaue Reiter – Ofili's paintings depict creatures of popular myth such as sirens in an exotic, abstract world of water and plants. The stylistic vestiges of Kandinsky or Marc can be easily identified, but the *Extended Remix* reaches further: the elegant lines of Beardsley or Matisse and the stronger pictorial shapes of Gauguin or Picasso are equally present. However, a remix would not be successful if it wasn't able to turn its sources into something new. In this respect, the materiality of Ofili's works plays a key role: in his paintings he employs unusual materials like aluminium foil and leather. These break open the stylistic references, because they were not used by his historical precursors. An aesthetic tension is created between recognizable styles and unfamiliar materials, compounded by the thematic contrast between exotic paradise (painting) and bawdy burlesque (sculpture).

Chris Ofili zählt zu den sogenannten Young British Artists. Er ist nigerianischer Abstammung, wuchs in Manchester auf und lebt heute auf Trinidad. Vor diesem Hintergrund ist auch die transkulturelle Arbeitsweise des Turner-Preisträgers zu situieren. Dabei werden Elemente aus verschiedenen Kulturbereichen, etwa afrikanische, osteuropäische und pazifische Volkskunst, europäische Kunst und indische Bildtradition, miteinander verknüpft. Ähnlich verhält es sich auch bei der neueren Werkserie *The Blue Rider Extended Remix* (2006), in der sich Ofili auf die Expressionisten-Vereinigung Der Blaue Reiter, besonders auf Franz Marc und Wassily Kandinsky, bezieht. Ofili nimmt vor allem die Verbindung von Volkskunst mit abstrahierender Malerei auf, wie sie in Kandinskys Märchenbildern zu finden ist. Über die dominanten Blautöne hinaus, eine farbliche Hommage an den Blauen Reiter, erscheinen in Ofilis Bildern Fabelwesen aus dem Volksglauben, Sirenen etwa, in einer abstrahierten, exotisch anmutenden Pflanzen- und Wasserwelt. Stilistisch ist der Bezug zu Kandinsky oder Marc zu spüren, jedoch greift der *Extended Remix* weiter aus: Die eleganten Linien von Beardsley oder Matisse sind genau so präsent wie die kräftigeren Formbildungen von Gauguin und Picasso. Doch ein Remix wäre kein erfolgreicher, wenn er nicht etwas Neues aus dem Vorhandenen liefern würde. Hierbei spielt die Materialität von Ofilis Arbeiten eine entscheidende Rolle, insofern er ungewöhnliche Materialien wie Aluminiumfolie und Leder bei Gemälden einsetzt. Sie brechen die stilistischen Bezüge auf, weil sie von den historischen Vorbildern nicht genutzt worden sind. Dadurch entsteht eine ästhetische Spannung aus bekannter Stilistik und ungewöhnlichem Materialeinsatz. Eine Spannung, die ihre Ergänzung in der thematischen Gegensätzlichkeit von exotischem Paradies (Malerei) und derber Burleske (Skulptur) erfährt.

Chris Ofili fait partie de ceux qu'on a appelés les Young British Artists. D'origine nigérienne, il a grandi a Manchester et vit aujourd'hui à Trinité. C'est sur cette toile de fond que se déploie la démarche transculturelle du lauréat du Prix Turner, qui associe des éléments issus de différents domaines – arts populaires d'Afrique, d'Europe de l'Est et d'Océanie, art européen et iconographie indienne. La même chose vaut pour la récente série *The Blue Rider Extended Remix* (2006), référence au groupe d'artistes expressionnistes du Cavalier bleu, plus particulièrement à Franz Marc et Vassily Kandinsky. Ofili y reprend surtout la combinaison entre art folklorique et peinture de tendance abstraite qui caractérise les tableaux inspirés de contes de fées réalisés par Kandinsky. Au-delà de la dominante de tons bleus du groupe expressionniste, les tableaux d'Ofili présentent des êtres fabuleux issus des croyances populaires – notamment des sirènes – au sein d'un monde végétal et aquatique de tendance abstraite à connotation exotique. Sur le plan stylistique, on perçoit la référence à Marc ou à Kandinsky, mais le champ de références de l'*Extended Remix* est plus vaste : les lignes élégantes de Beardsley et de Matisse sont aussi présentes que les structures plus robustes de Gauguin et de Picasso. Mais un *remix* ne serait pas réussi s'il ne générait de l'inédit à partir de l'existant. Ici, la matérialité des œuvres d'Ofili joue un rôle décisif en introduisant des matériaux inusités comme la feuille d'aluminium et le cuir. Ces matériaux ouvrent les références stylistiques en ceci qu'ils n'ont pas été utilisés par les modèles historiques. Il en résulte une tension esthétique entre stylistique connue et emploi de matériaux inhabituels, tension qui trouve son complément dans l'opposition thématique entre paradis exotique (peinture) et burlesque grossier (sculpture).

H. L.

SELECTED EXHIBITIONS →
2008 *...Same As It Ever Was*, University of the Arts, London. *Fractured Figure*, Deste Foundation, Athens **2007** *True Romance*, Kunsthalle Wien, Vienna; Villa Stuck, Munich; Kunsthalle zu Kiel **2006** *Chris Ofili: The Blue Rider Extended Remix*, Kestnergesellschaft, Hanover. *Surprise, Surprise*, ICA London. *Tokyo Blossoms*, Hara Museum, Tokyo **2005** *Chris Ofili: The Upper Room*, Tate Britain, London

SELECTED PUBLICATIONS →
2008 *Chris Ofili: Devil's Pie*, David Zwirner, New York; Steidl, Göttingen. *...Same As It Ever Was*, University of the Arts, London **2007** *True Romance*, Kunsthalle Wien, Vienna, et al.; DuMont, Cologne **2006** *Chris Ofili: The Blue Rider*, David Zwirner, New York; Verlag der Buchhandlung Walther König, Cologne

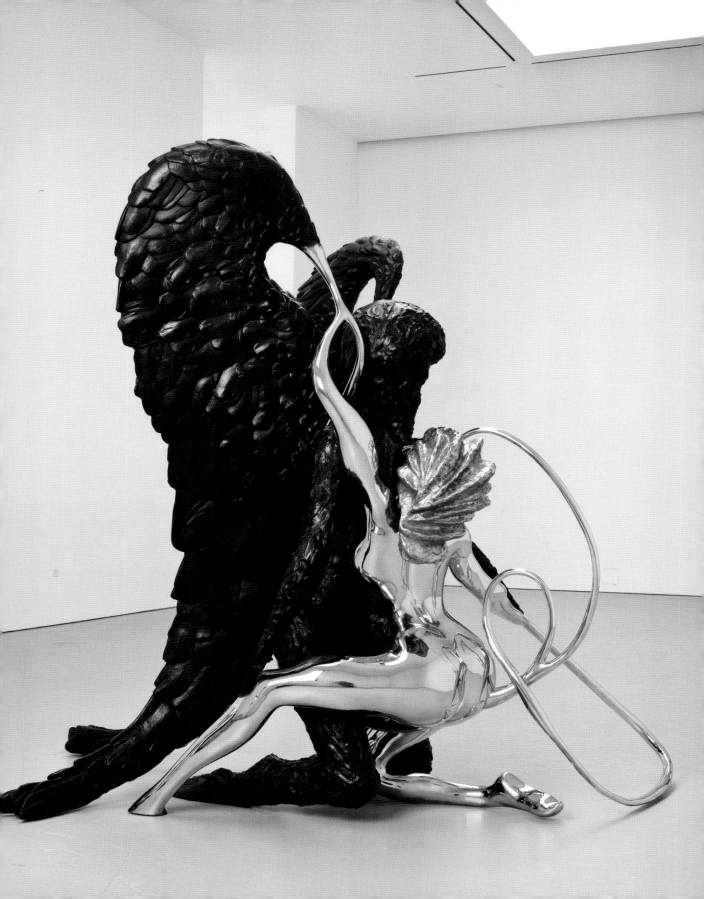

1 **Annunciation**, 2006, bronze, 201 x 213 x 119 cm
2 Installation view, *Chris Ofili: The Blue Rider Extended Remix*,
 Kestnergesellschaft, Hanover, 2006

3 **Siren Six**, 2005/06, oil, aluminium foil on canvas, 195.5 cm x 281.5 cm
4 **Confession (Red)**, 2006/07, oil, charcoal on canvas, 80 x 50.5 cm

„Meine Gemälde sind am Anfang sehr bleich und werden dann immer dunkler. Am Ende hat man dann das Gefühl, dass das Licht von innen kommt."

« Donc, ma peinture commence très pâle pour progresser ensuite vers l'obscurité. Au bout du compte, on a le sentiment que la lumière vient de l'intérieur. »

"So my painting starts off very, very pale and then proceeds towards darkness. In the end, you get the feeling that the light is coming from within."

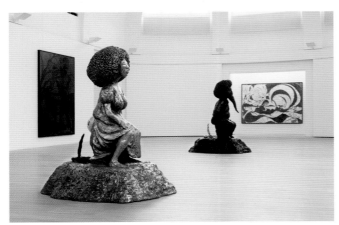

2

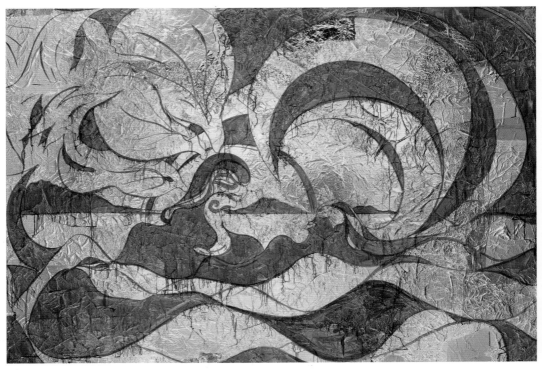

3

Paulina Olowska

1976 born in Gdansk, lives and works in Warsaw, Poland

Paulina Olowska's contribution to the 5th Berlin Biennial was a dialogue with the work of Polish artist Zofia Stryjeńska (1891–1974). Olowska's series of monumental gouaches consists of copies of Stryjeńska's colourful work, which was inspired by art deco, Slavic mythology and folk art. However, the copies were done in shades of grey, recalling the reproductions in old books. This enabled Olowska to concentrate on particular elements of the composition such as the constellations of figures. She also showed original paintings by Stryjeńska alongside Polish mass-produced goods inspired by her art and a floor piece based on the design of the Polish pavilion at the 1925 World Exhibition of Decorative Arts in Paris, for which Stryjeńska conceived her paintings. Olowska's oeuvre, which includes drawing, collage, painting, installation and performance works, is an idiosyncratic iconography of recent (Polish) history. Amongst other things, Olowska focuses on 1960s propaganda material as well as on female protagonists and their representation – such as the British pop artist Pauline Boty (1938–66) in the oil collages in her exhibition *Hello to You Too* (2006), or the fashion designer Elsa Schiaparelli (1890–1973). The exhibition *Attention à la peinture* (2008) referred to a collection of the same name by Schiaparelli and featured items of clothing made of painted canvas and placed on plinths, while the rest of the cut-up pictures were displayed on the wall. Olowska not only refers to other artists; direct collaboration with colleagues such as the Scottish painter Lucy McKenzie is also an important aspect of her practice.

Paulina Olowskas Beitrag zur 5. Berlin Biennale war ein Dialog mit dem Werk der polnischen Künstlerin Zofia Stryjeńska (1891–1974). Ihre Serie monumentaler Gouachen bestand aus Kopien der farbigen, von Art Déco, slawischer Mythologie und Volkskunst inspirierten Arbeiten Stryjeńskas. Die Kopien waren allerdings in Grautönen umgesetzt, was an Reproduktionen in älteren Büchern erinnerte. Die farbliche Reduktion erlaubte Olowska, sich auf bestimmte Elemente der Komposition wie etwa die Figurenkonstellationen zu konzentrieren. Sie zeigte zudem Originale Stryjeńskas neben von ihr inspirierten Gegenständen aus polnischer Massenproduktion, sowie eine Bodengestaltung, die sich auf das Design des polnischen Pavillons bei der Weltausstellung dekorativer Künste 1925 in Paris bezog, für den Stryjeńska ihre Gemälde konzipiert hatte. Olowskas Werk, das Zeichnung, Collage, Malerei, Installation bis Performance umfasst, ist eine persönlich geprägte Ikonografie der jüngeren (polnischen) Geschichte. Olowska konzentriert sich dabei u. a. auf Propagandamaterial der 1960er-Jahre sowie auf weibliche Protagonistinnen und deren Repräsentation – etwa die britische Pop-Art-Künstlerin Pauline Boty (1938–66) in den Ölcollagen der Ausstellung *Hello to You Too* (2006) oder die Modedesignerin Elsa Schiaparelli (1890–1973). Die Ausstellung *Attention à la peinture* (2008) nahm Bezug auf eine gleichnamige Kollektion Schiaparellis und zeigte aus bemalter Leinwand gefertigte Kleiderobjekte auf Sockeln, während die Reste der zerschnittenen Bilder an der Wand hingen. Olowska bezieht sich in ihren Arbeiten nicht nur auf andere Künstler, sondern die Zusammenarbeit mit ihnen – etwa mit der schottischen Malerin Lucy McKenzie – ist gleichfalls ein wichtiger Aspekt in ihrem Werk.

La proposition de Paulina Olowska à la 5ᵉ Biennale de Berlin consistait en un dialogue avec l'œuvre de l'artiste polonaise Zofia Stryjeńska (1891–1974). La série de gouaches monumentales était constituée de copies des œuvres originales et reproduisait à l'identique les scènes colorées d'inspiration Art déco, de la mythologie slave et de l'art populaire. Les copies avaient été réalisées en tons de gris évoquant les reproductions de livres anciens, réduction chromatique qui permettait à Olowska de se concentrer sur certains éléments de composition, notamment les constellations de figures. Olowska présentait aussi des originaux de Stryjeńska, des objets de production de masse inspirés de son œuvre, ainsi qu'un aménagement de sol se référant au design du pavillon polonais de l'Exposition internationale des Arts décoratifs et industriels modernes de Paris en 1925, pavillon pour lequel Stryjeńska avait conçu ses peintures. L'œuvre d'Olowska, qui englobe dessin, collage, peinture, installation et performance, est une iconographie personnelle imprégnée des transformations de l'histoire (polonaise) récente. Olowska se concentre notamment sur des éléments de propagande des années 1960 et sur certaines protagonistes féminines et leur représentation – par exemple l'artiste pop Pauline Boty (1938–66) dans les collages à l'huile de l'exposition *Hello to You Too* (2006), ou la styliste Elsa Schiaparelli (1890–1973). L'exposition *Attention à la peinture* (2008) se référait à une collection homonyme de Schiaparelli et présentait des vêtements-objets exposés sur des socles et réalisés à partir de peintures sur toiles, les restes des tableaux découpés étant accrochés au mur. Olowska ne se contente pas de faire référence à d'autres artistes, la collaboration directe, notamment avec la peintre écossaise Lucy McKenzie, est également un aspect important de son œuvre.

E. S.

SELECTED EXHIBITIONS →
2008 U-TURN Quadrennial for Contemporary Art, Copenhagen. *5th Berlin Biennial for Contemporary Art*, Berlin **2007** *Paulina Olowska/Bonnie Camplin: Salty Water*, Portikus, Frankfurt am Main. *Expats/Clandestines*, wiels, Brussels. *Le Nuage Magellan*, Centre Georges Pompidou, Paris **2006** *The Subversive Charm of the Bourgeoisie*, VanAbbe Museum, Eindhoven. *If I Can't Dance ... Edition II*, De Appel, Amsterdam

SELECTED PUBLICATIONS →
2007 *Paulina Olowska/Bonnie Camplin: Salty Water*, Portikus, Frankfurt am Main. *Paulina Olowska & Lucy McKenzie: Hold the Colour*, Sammlung Goetz, Munich **2005** *Paulina Olowska: Metamorphosis*, Museum Abteiberg Mönchengladbach; Revolver, Frankfurt am Main **2004** *Paulina Olowska*, Kunstverein Braunschweig, Braunschweig

1 **4 Nowa Scena**, 2006, acrylic, collage on canvas, 248.9 x 139.7 cm
2 **Zofia Stryjeńska**, 2008, gouache on canvas, 230 x 240 cm
3 **Abendkleid**, 2007, gouache on paper, 219 x 141 cm

4 **Festliches Kleid**, 2007, gouache on paper, 198 x 126 cm
5 Installation view, *Paulina Olowska: Attention à la Peinture*, Galerie Daniel Buchholz, Cologne, 2008

2

3

4

Gabriel Orozco

1962 born in Jalapa, lives and works in Mexico City, Mexico, and New York (NY), USA

Gabriel Orozco's "drawing" *Dark Wave* (2006) is the artist's most spectacular work to date: the 14 metre long suspended skeleton of a Rorqual whale whose every knob, curve and crevice, tusky protrusion and flipper bone, is drawn over in black graphite in a concentric, geometric pattern, that leaves the creamy ivory surface visible in reverse. It is as if Orozco had mapped the beast not simply to acquaint himself with it, but to know how to orient himself in relationship to it. A curiosity for the topography of things, both the everyday and the out-of-the-ordinary, drives much of Orozco's art. Working across a range of traditional and new media, Orozco's is a tactile, rather than strictly ocular approach: seeing is absolutely not equivalent with knowing. The painting series *Dépliages* (2007), made from blobs of oil paint folded into small squares of paper, then unfolded, and his sculptures yielded from confronting his body mass with hunks of clay (e.g. *Pelvis*, 2007), seem born not so much from some age-old struggle between the artist and his materials, but from the simple positing of the question: "What if?" There is something deeply systematic and calculated about the exquisite play of red, white and blue tempera circles and gold-leaf of the *Samurai Tree* series (2006/07), the compositions of which are based in the principles of chess and the limits of a square, yet one still senses strong intuition at work in the seemingly organic multiplication of forms within the area of a quadrangle. With Orozco, the tension between the constraints of a system and his vital need for improvisation open up an extraordinarily fertile creative space.

Gabriel Orozcos „Zeichnung" *Dark Wave* (2006) ist die bislang bemerkenswerteste Arbeit dieses Künstlers: ein 14 Meter langes aufgehängtes Finnwalskelett, dessen Wülste, Bögen und Furchen, Rostrum und Flossen mit einem geometrischen, konzentrischen Muster in schwarzem Graphit überzogen sind, unter dem das cremige Elfenbeinweiß der Knochen hervorschimmert. Als hätte Orozco das Geschöpf kartografisch erfasst, um es zu erkunden und darüber hinaus die eigene Position in diesem Bezugssystem festzulegen. Viele seiner Werke entstehen aus einer Neugier für die Topografie sowohl gewöhnlicher als auch ungewöhnlicher Dinge. Orozco arbeitet in der Bandbreite traditioneller und neuer Medien und bedient sich einer eher taktilen als optischen Herangehensweise: Sehen und Verstehen sind nicht absolut äquivalent. Die Gemäldeserie *Dépliages* (2007), für die er kleine Papierquadrate mit Ölfarbe bekleckste, zusammen und wieder auseinander faltete, wie auch die Skulpturen, die aus seinem eigenen Körper aufgedrückten Tonklumpen entstanden (z.B. *Pelvis*, 2007), scheinen nicht so sehr aus dem uralten Ringen zwischen dem Künstler und seinem Material hervorgegangen zu sein, als vielmehr aus der einfachen Fragestellung: „Was wäre, wenn?" Strenge Systematik und Kalkül zeigen sich in dem exquisiten Zusammenspiel von roten, weißen und blauen Kreisen in Tempera und dem Blattgold in der Serie *Samurai Tree* (2006/07), deren Gestaltung auf den Prinzipien des Schachspiels und der Begrenzung eines Quadrats basiert, und doch spürt man noch die starken intuitiven Kräfte in der scheinbar organischen Multiplizierung der Formen innerhalb des Vierecks. Bei Orozco weitet sich die Spannung zwischen einschränkender Anordnung und vitalem Improvisationsdrang in einen ungemein fruchtbaren, schöpferischen Raum.

Le « dessin » de Gabriel Orozco intitulé *Dark Wave* (2006) est son œuvre la plus spectaculaire à ce jour : le squelette en suspension d'une baleine bleue de 14 mètres de long dont il a recouvert de graphite noir les moindres bosses, courbes, fissures, protubérances et os de nageoire d'un motif géométrique concentrique qui laisse transparaître la structure de couleur ivoire. C'est comme si Orozco avait cartographié l'animal, non seulement pour en faire sa connaissance, mais aussi pour entrer en relation avec lui. Une curiosité pour la topographie des choses, celles du quotidien comme celles sortant de l'ordinaire, sous-tend une grande partie de son œuvre. Travaillant avec une palette de techniques nouvelles et traditionnelles, Orozco a une approche plus tactile que visuelle dans son travail : la vue n'équivaut absolument pas à la connaissance. Sa série de peintures *Dépliages* (2007), composée de grosses gouttes de peinture à l'huile dans de petits carrés de papier pliés puis dépliés, ainsi que ses sculptures issues de la rencontre de la masse de son corps avec des blocs d'argile (par exemple *Pelvis*, 2007), semblent être nées non pas tant de la lutte ancestrale entre l'artiste et ses matériaux que de la simple question : « Et si ? » Il y a quelque chose de systématique et profondément calculé dans le jeu exquis des cercles à la feuille d'or et du rouge, blanc et bleu à la tempera de la série *Samurai Tree* (2006/07), dont l'agencement délimité par un carré est basé sur le principe de l'échiquier. L'on ressent pourtant une profonde intuition dans la multiplication, en apparence organique, de formes à l'intérieur d'un quadrilatère. Chez Orozco, la tension entre les contraintes d'un système et son besoin vital d'improvisation ouvre un champ créatif extraordinairement fertile. V. R.

SELECTED EXHIBITIONS →
2008 *L'Argent*, FRAC Ile-de-France/Le Plateau, Paris. *The Implications of Image*, Museo Universitario de Ciencias y Arte, MUCA, Mexico City **2007** *Gabriel Orozco: Inner Circles of the Wall*, Dallas Museum of Art, Dallas. *Gabriel Orozco*, FRAC Picardie, Amiens. *What Is Painting?*, MoMA, New York. *The Shapes of Space*, Guggenheim Museum, New York **2006** *blueOrange Kunstpreis 2006: Gabriel Orozco*, Museum Ludwig, Cologne

SELECTED PUBLICATIONS →
2007 *Gabriel Orozco*, Museo del Palacio de Bellas Artes in Mexico City; Conaculta Publishers, Mexico City. *Gabriel Orozco: The Samurai Tree in Variants*, Verlag der Buchhandlung Walther König, Cologne **2005** *Gabriel Orozco: Catalogo De La Exposicion El Palacio De Cristal*, Madrid; Turner, Nashville **2004** *Gabriel Orozco: Trabajo 1992–2002*, Verlag der Buchhandlung Walther König, Cologne

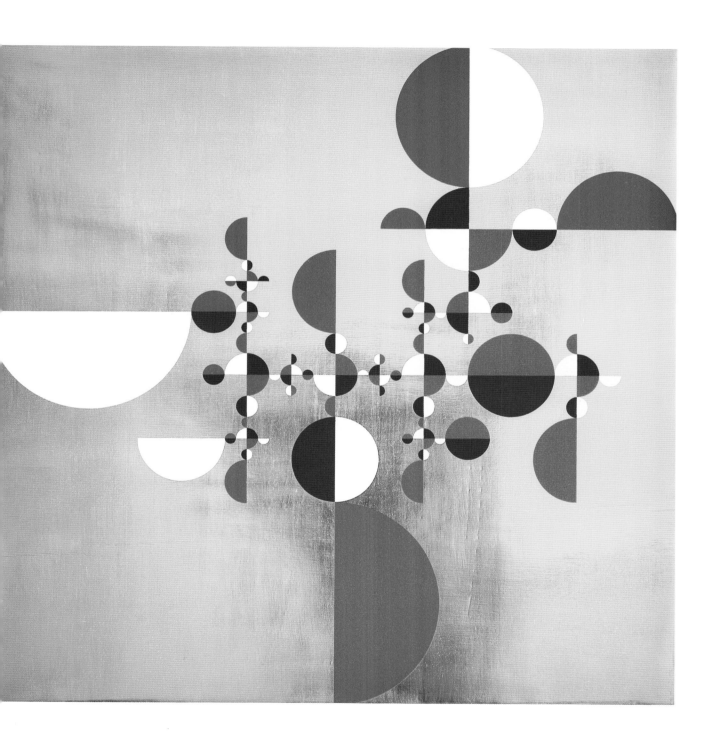

1 **Samurai Tree 2H**, 2006, tempera, burnished gold leaf on cedar wood, 66.5 x 66.5 cm
2 **Dépliage, White 10**, 2007, oil on linen, 66 x 66 x 1.9 cm
3 **Pelvis**, 2007, bronze, 25.4 x 31.1 x 12.7 cm

4 **Dark Wave**, 2006, calcium carbonate, resin with graphite, 304 x 392 x 1375 cm
5 **Kytes Tree**, 2005, acrylic on linen, 200 x 200 cm

„Das Machen ist ein Teil des Resultats, des Ausgangs einer Geschichte. Und deshalb ist hier der Körper in Aktion, das Individuum in seiner Beziehung zum sozialen Raum, den sozialen Materialien und deren Ökonomie sehr wichtig."

« La réalisation fait partie du résultat final, elle fait partie de la fin de l'histoire. Et c'est pourquoi le corps en action, l'individu en action, en relation avec le champ social, les matériaux sociaux et leur économie sont très importants. »

"Making is part of the final result, is part of the final end of the story. And that's why the body in action, the individual in action, in relation with the social space, the social materials and economics of these is very important."

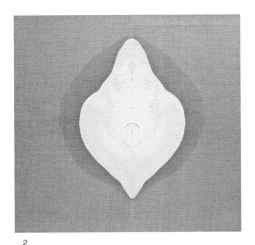

2

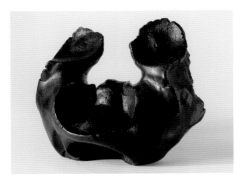

3

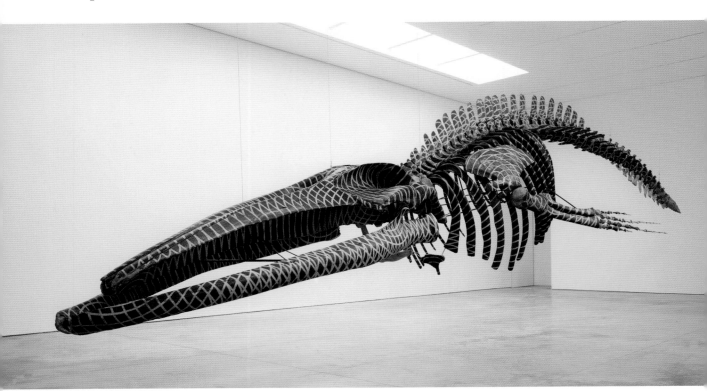

Jorge Pardo

1963 born in Havana, Cuba, lives and works in Los Angeles (CA) and New York (NY), USA

Lamps occur frequently in the work of Jorge Pardo for whom their innate reflexivity is significant: as a functional means to illuminate their surroundings they in turn illuminate themselves as autonomous art objects. This hermeneutic circularity threads through all of Pardo's oeuvre, characterized by a vernacular of cut-out curlicue forms and vivid colours that conjure interior design of the 1950s and 60s and its alluring, tactile materials. Engaging art at the discursive boundaries of sculpture, painting, design and architecture, his output encompasses everything from discreet functional objects and computer-generated paintings, to projects such as *4166 Sea View Lane* (1998) – his Los Angeles home, designed on the occasion of a solo exhibition at LA's Museum of Contemporary Art. Taking his cue from minimalism's expanded notion of sculpture, Pardo is concerned with the context in which art is displayed as much as with the objects themselves, subverting the modernist white cube through design interventions that bring in the functional realities of daily life. In a project for the Fundació La Caixa in Barcelona (2004), Pardo designed an opulent *mise en scène* for a selection of minimalist sculptures from the museum's collection, covering the white walls of the space with moulded red wooden panels and hanging a number of his own chandelier-like lamps. Taking this one step further, his mid-career survey *House* (2007) displayed his work grouped according to the function of different rooms in a house. In these installations, Pardo challenges the autonomy of the work of art, making us question how, as much as what, we see.

In den Arbeiten von Jorge Pardo tauchen oft Lampen auf – die ihnen eingeschriebene Reflexivität macht sie für den Künstler interessant. In ihrer zentralen Funktion als Lichtquelle zur Beleuchtung der Umgebung, beleuchten sie sich gleichzeitig selbst als autonome Kunstobjekte. Diese hermeneutische Zirkularität durchzieht Pardos gesamtes Œuvre mit seinem charakteristischen Vokabular von ausgeschnittenen Schnörkelformen und lebhaften Farben, in denen das Wohndesign der 1950er- und 60er-Jahre und deren sinnliche, taktile Materialien anklingen. Da Pardo seine Kunst im theoretischen Schnittpunkt von Skulptur, Malerei, Design und Architektur platziert, reicht die Spannbreite seines Werks von dezent funktionalen Gegenständen und computergenerierten Gemälden bis hin zu Projekten wie *4166 Sea View Lane* (1998) – seinem Wohnhaus in Los Angeles, das der Künstler anlässlich einer Einzelausstellung im Museum of Contemporary Art in L.A. schuf. Ausgehend von dem erweiterten Skulpturbegriff des Minimalismus interessiert sich Pardo sowohl für den Kontext der Präsentation von Kunstwerken als auch für die Objekte selbst, wobei er den modernistischen White Cube durch Design-Eingriffe mit Bezug auf die Alltagswirklichkeit unterwandert. In einem Projekt für die Fundació La Caixa in Barcelona (2004) gestaltete Pardo eine opulente *mise en scène* für eine Anzahl minimalistischer Skulpturen der musealen Sammlung, indem er die weißen Wände des Ausstellungsraums mit gefrästen roten Holzplatten bedeckte und mehrere eigene, Kronleuchtern nachempfundene Lampen hinein hängte. Noch einen Schritt weiter ging er in seiner Retrospektive *House* (2007), indem er seine Werke nach der unterschiedlichen Funktion einzelner Wohnräume zusammenfasste. In diesen Installationen untergräbt Pardo die Autonomie des Kunstwerks, indem er unsere Sehgewohnheiten in Frage stellt.

Les lampes sont un élément récurrent de l'œuvre de Jorge Pardo, pour qui leur réflexivité naturelle en tant qu'objets est significative : moyen fonctionnel d'éclairer autour d'elles, elles s'éclairent elles-mêmes en retour en tant qu'objet d'art autonome. Cette circulation herméneutique se retrouve dans l'ensemble de son œuvre, caractérisé par des formes ornementales découpées, des couleurs vives qui évoquent le design d'intérieur des années 1950 et 1960, des matières attrayantes et tactiles. Menant l'art aux frontières discursives de la sculpture, de la peinture, du design et de l'architecture, sa production se considère comme un ensemble englobant de discrets objets fonctionnels à la peinture générée par ordinateur en passant par des projets comme *4166 Sea View Lane* (1998) – sa maison de Los Angeles construite à l'occasion d'une exposition personnelle au musée d'art contemporain de la ville. Se référant à la notion de sculpture élargie du minimalisme, Pardo se préoccupe autant du contexte d'exposition que des objets eux-mêmes, pour subvertir le cube blanc moderniste à travers des interventions en design qui rappellent les réalités fonctionnelles de la vie quotidienne. Dans un projet pour la Fundació La Caixa de Barcelone (2004), Pardo a conçu une mise en scène somptueuse pour une sélection de sculptures minimalistes de la collection du musée, couvrant les murs blancs de l'espace de panneaux de bois rouges fraisés et y suspendant une partie de ses luminaires en forme de chandelier. Il va encore plus loin dans sa recherche lors de la rétrospective *House* (2007), exposant ses œuvres selon les fonctions des différentes pièces de la maison. Dans ces installations, Pardo conteste l'autonomie de l'art et nous questionne à la fois sur notre manière de regarder et sur l'objet de notre regard. A. B.

SELECTED EXHIBITIONS →
2008 *abstrakt / abstract*, Museum Moderner Kunst Kärnten, Klagenfurt **2007** *Jorge Pardo: House*, MOCA, North Miami; Museum of Contemporary Art Cleveland. *Sculptors Drawing*, Aspen Art Museum, Aspen. *Köln Skulptur 4*, Cologne **2006** *All Hawaii Entrées/ Lunar Reggae*, Irish Museum of Modern Art, Dublin. *Manipulacje*, Laznia Centre for Contemporary Art, Gdansk. *6th Shanghai Biennale 2006*, Shanghai. *Lichtkunst aus Kunstlicht*, ZKM, Karlsruhe

SELECTED PUBLICATIONS →
2008 *Jorge Pardo*, Phaidon Press, London **2007** Liam Gillick: *Ice Sculpture/Important Postmen, Proxemics: Selected Writings (1988–2006)*, JRP Ringier, Zürich **2006** *Lichtkunst aus Kunstlicht – Licht als Medium der Kunst im 20. und 21. Jahrhundert*, ZKM, Karlsruhe

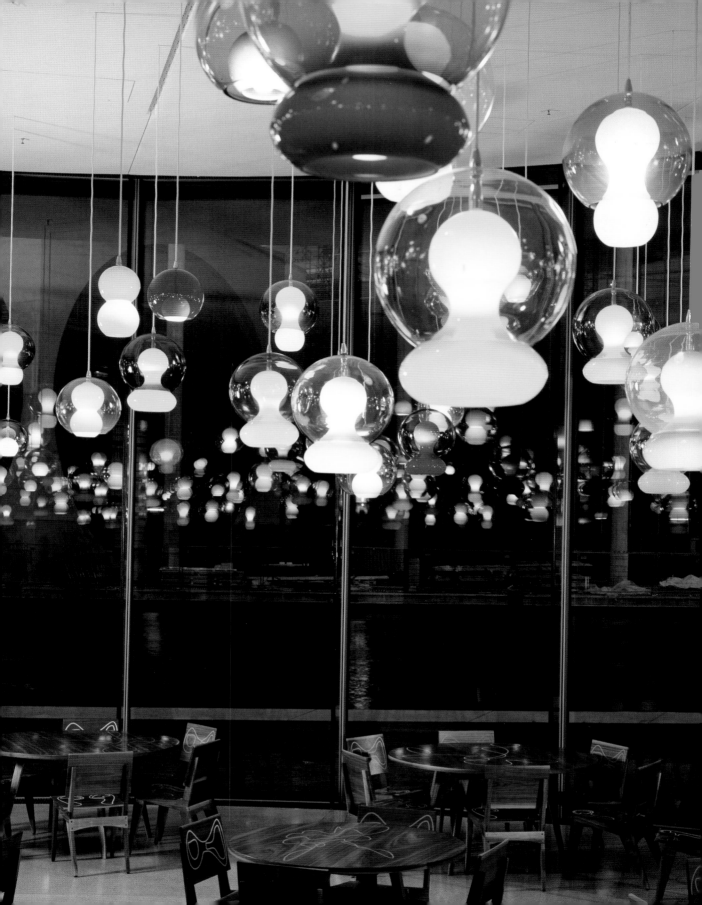

1 **Untitled (Restaurant)**, 2002, walnut wood, bondo (coloured spackle inlay), blown coloured glass, polished aluminium, light fixtures, 186 lamps, tables, chairs, overall dimensions ca 950 x ø 1950 cm

2 **Untitled**, 2005, MDF, acrylic, outer structure 384 x ø 460 cm, inner construction 249 x 168 x 227 cm. Installation view, *Kiss the Frog! The Art of Transformation*, Nasjonalmuseet, Oslo

3/4 Installation view, *Jorge Pardo: House*, Museum of Contemporary Art, North Miami, 2007

„Es sind eher die Traditionen des Bildes, des Raums und der Wahrnehmung, die mich interessieren. Ich spreche von Ästhetik, nicht von einem tollen Toaster."

« Les questions qui m'intéressent ont plus à voir avec les traditions picturales, spatiales et perceptives. C'est d'esthétique dont je parle, pas d'un grille-pain à la mode. »

"The issues I'm interested in have more to do with pictorial, spatial, perceptual traditions. I'm talking about aesthetics, not a cool toaster."

2

Manfred Pernice

1963 born in Hildesheim, lives and works in Berlin, Germany

The sculptural objects in Manfred Pernice's laconically titled exhibition *Neue Arbeiten* (New Works, 2008) initially quote the old and the familiar: the formal vocabulary of modernism and details of contemporary architecture provide the source for new objects lacking in any function, and thus seemingly mocking all that is dear to the material aesthetic. This is compounded by his choice of materials: pressboard, plywood, glazed tiles and other construction materials, almost kitsch in their colourfulness from the addition of spray paint – a new venture for Pernice. Museum stanchion ropes complete this critical-ironic examination of seemingly unquestionable aesthetic and institutional settings. In his work Pernice tests the boundaries of sculpture, architecture and furniture, making Nuremberg's Neues Museum with its art and design collections a particularly suitable institutional framework for its display. In the exhibition *Que-Sah* (2008), Pernice furnished the foyer and built a platform in the exhibition space on which he juxtaposed old and new works. *Sonderausstellung (wischi-waschy)* (2008), an exhibition-within-an-exhibition, was a further ironic commentary on museum practice. Older pieces such as *Fiat* were modified for the occasion. Taking as its starting point a significant work of architecture – common practice in Pernice's work – *Fiat* relates to the famous test track on the roof of the Lingotto, the Fiat factory in Turin. In Nuremberg the piece was transformed into a walk-in installation. With *1. Allgemeine Verkstatt Ausstellung*, also in 2008, Pernice gave Berlin's Schinkel Pavilion – a prime example of flamboyant, faux-historical East German architecture – an ironic and posthumous reality check in the form of a store filled with GDR products.

In seiner lakonisch *Neue Arbeiten* (2008) betitelten Ausstellung zitiert Manfred Pernice mit skulpturalen Objekten zunächst Altes und Bekanntes: Das Formvokabular der Moderne sowie Details zeitgenössischer Architektur werden als Fundus für neue Objektbildungen genutzt, die in ihrer Funktionslosigkeit und Materialwahl allem spotten, was der Materialästhetik teuer ist: Pressspan- und Tischlerplatten, gefugte Kacheln und weiteres Gebrauchsmaterial, beinahe kitschig bunt gefärbt – und das ist neu für Pernice – mit Sprühfarbe. Absperrseile, wie man sie aus Museen kennt, vervollständigen diese kritisch-ironische Hinterfragung scheinbar nicht hinterfragbarer ästhetischer Setzungen. Einen in mehrerlei Hinsicht geeigneten institutionellen Rahmen für Pernices Arbeiten, mit denen er die Grenzen von Skulptur, Architektur und Mobiliar auslotet, bildete das Neue Museum Nürnberg mit seiner Sammlung von Kunst und Design. Für die Ausstellung *Que-Sah* (2008) möblierte Pernice das Foyer und baute im Ausstellungsraum ein Podest ein, auf dem alte und neue Arbeiten in Bezug gesetzt wurden. *Sonderausstellung (wischi-waschy)* (2008) gab als Ausstellung-in-der-Ausstellung einen weiteren ironischen Kommentar zur Museumspraxis ab. Arbeiten wie etwa *Fiat* wurden für den Anlass aktualisiert: *Fiat* nimmt, wie oft bei Pernice, eine markante Architektur zum Ausgangspunkt, hier die legendäre Teststrecke auf dem Dach des Lingotto, des Turiner Fiat-Werks, und wurde hier erstmals als begehbare Installation realisiert. Ebenfalls 2008 verlieh Pernice dem Berliner Schinkel Pavillon – ein Paradebeispiel historisierender Prunkarchitektur aus der DDR-Zeit – unter dem Titel *1. Allgemeine Verkstatt Ausstellung* sozusagen posthum einen ironischen Realitätsbezug in Form einer Art Ladeneinrichtung mit DDR-Produkten.

Dans son exposition laconiquement intitulée *Neue Arbeiten* (Nouvelles Œuvres, 2008), les sculptures-objets de Manfred Pernice citent d'abord des références connues. Le vocabulaire formel de la modernité et des détails d'architecture contemporaine servent de toile de fond à de nouvelles créations dont l'inanité fonctionnelle et les matériaux semblent se moquer de tout ce qui est cher à l'esthétique des matériaux – panneaux de bois ou de contreplaqué, carreaux jointoyés et autres matériaux utilitaires teintés de couleurs presque kitsch et, fait inédit chez Pernice, peintes au spray. Des cordons de sécurité comme on en voit dans les musées complètent le questionnement ironico-critique des règles esthétiques et institutionnelles admises. Le Neues Museum de Nuremberg avec sa collection d'œuvres d'art et d'objets de design a fourni un cadre institutionnel approprié par bien des aspects à ces œuvres avec lesquelles Pernice sonde les limites de la sculpture, de l'architecture et du mobilier. Pour l'exposition *Que-Sah* (2008), Pernice devait meubler le foyer du musée ; dans les salles d'exposition, il construisit une estrade sur laquelle des œuvres anciennes et nouvelles étaient mises en relation. *Sonderausstellung (wischi-waschy)* (2008), une « exposition dans l'exposition », livrait un autre commentaire ironique sur la pratique muséale. Des œuvres comme *Fiat* ont été actualisées à cet effet : comme souvent chez Pernice, *Fiat* part d'une architecture marquante – en l'occurrence la légendaire piste d'essai aménagée sur le toit de l'usine Fiat de Turin – réalisée ici pour la première fois comme installation visitable. Également en 2008, à titre en quelque sorte posthume et sous le titre *1. Allgemeine Verkstatt Ausstellung*, Pernice a transformé le pavillon Schinkel (Berlin) – illustre exemple d'une pompeuse architecture historisante de l'ère socialiste – en référence ironique à la réalité sous la forme d'un magasin de produits de la RDA. E. S.

SELECTED EXHIBITIONS →
2008 *Vertrautes Terrain – Aktuelle Kunst in und über Deutschland*, ZKM, Karlsruhe. *Manfred Pernice: Que-Sah*, Neues Museum Nuremberg **2007** *DC: Manfred Pernice – Haldensleben...*, Museum Ludwig, Cologne. *Skulptur Projekte Münster 07*, Münster **2006** *Manfred Pernice*, Leopold Hoesch Museum, Düren. *Manfred Pernice*, The Modern Institute, Glasgow

SELECTED PUBLICATIONS →
2008 *Manfred Pernice: Rückriem/Böll-Peilung*, Andere &, Nicolai, Berlin **2007** *Skulptur Projekte Münster 07*, Verlag der Buchhandlung Walther König, Cologne **2004** *Werke aus der Sammlung Boros*, ZKM, Karlsruhe; Hatje Cantz, Ostfildern

Beginn
der
Wende
und
Erneuerung

1 **Untitled**, 2008, wood, metal, ropes, enamel, spray paint, photocopy, 210 x 96 x 120 cm
2 **Untitled**, 2008, wood, metal, enamel, spray paint, 201 x 82 x 82 cm
3 Installation view, *Manfred Pernice: 1. Allgemeine Verkstatt Ausstellung*, Schinkel Pavillon, Berlin, 2008
4 **Fiat V**, 2008. Installation view, *Manfred Pernice: Que-Sah*, Neues Museum, Nuremberg
5 Installation view, *Manfred Pernice: Que-Sah*, Neues Museum, Nuremberg, 2008

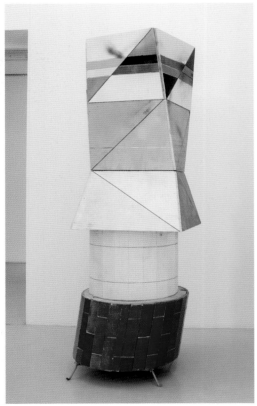

2

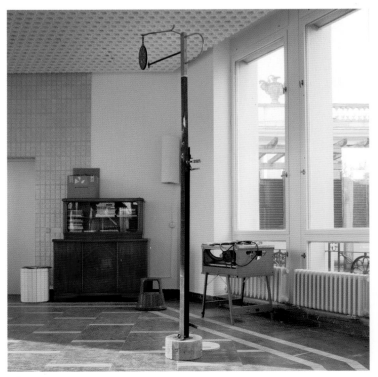

3

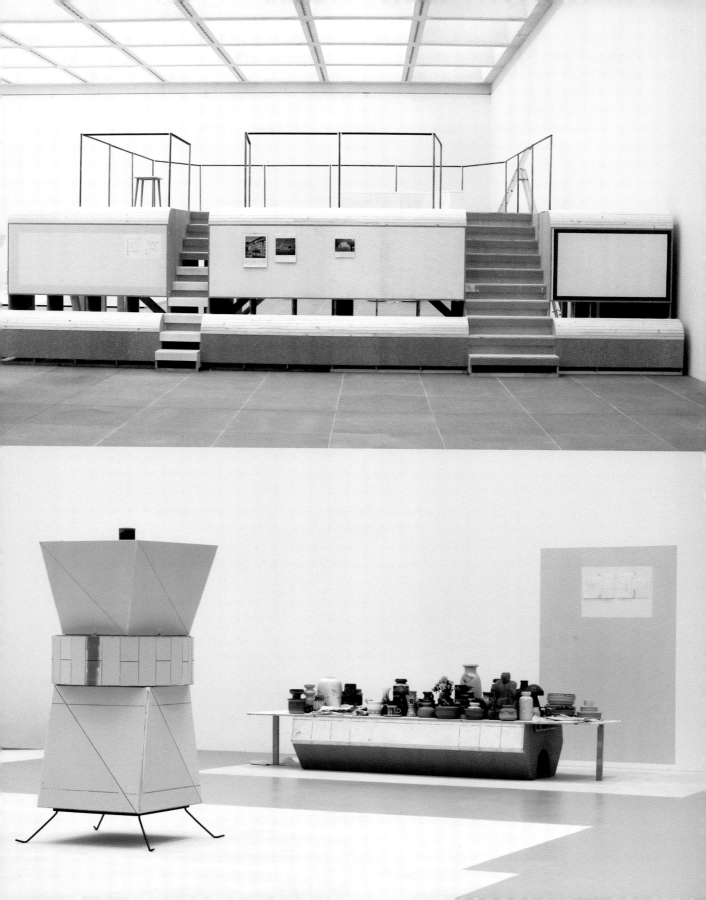

Raymond Pettibon

1957 born in Tucson (AZ), lives and works in Herosa Beach (CA), USA

Never one to mince words in his prolific ink and watercolour drawings, Raymond Pettibon nonetheless has recently employed language in the service of a surprisingly overt politics: a New York show in 2007, *Here's Your Irony Back (The Big Picture)*, featured the artist's name and show title scrawled in red, dripping down the chalky wall like B-movie blood; banners painted directly on the gallery wall drolly trumpeting "TWO CHEERS FOR THE RED WHITE AND BLUE" and equivocating Israel is "MORAL" with an insertion symbol wedging a "T" between the "R" and "A" to configure a reading of "MORTAL"; and a plethora of page-sized denunciations of the Iraq war, travesties of American foreign policy and failures of the regime of George W. Bush more generally. These aggregated drawings betray a deftness long associated with Pettibon's DIY, Los Angeles punk aesthetic – honed in the late 1970s and the 1980s while the artist was affiliated with SST Records and his brother's punk band Black Flag, designing their album covers, concert flyers and fanzines – though they point to more topical concerns than those explored in the past. Known for his musings on literary and philosophical sources as well as such quotidian mainstays as movies, music, sports, sex, Gumby and Superman, his incisive address of politics and social concerns becomes all the more compelling for its style. If Pettibon's installations assume the feel of a dorm room with a profusion of pasted images, his individual sketches suggest the work of a brilliant slacker rendering his ideas furiously into his notebook while slumped over his desk, who can only pretend to be too cool to care for so long.

Raymond Pettibon, der in seinen zahlreichen Tinten- und Aquarellzeichnungen nie ein Blatt vor den Mund nahm, hat sich in Werken jüngster Zeit dennoch überraschend offenkundig zur Politik geäußert. In der New Yorker Ausstellung *Here's Your Irony Back (The Big Picture)* (2007) waren der Name des Künstlers und der Ausstellungstitel mit roter Farbe wie in B-Movie-Blut an die weiße Wand gespritzt; direkt auf die Wand gemalte Tafeln schrien lustig „TWO CHEERS FOR THE RED WHITE AND BLUE" und ein zwischen „R" und „A" eingefügtes „T" hatte Israels „MORAL" zu „MORTAL" verändert. Hinzu kam eine Flut seitengroßer Blätter, auf denen der Irakkrieg angeprangert und die amerikanische Außenpolitik wie auch allgemeinere Fehler der Regierung Bush karikiert wurden. Obgleich diese Ansammlung von Zeichnungen im Vergleich zu früher eine konkretere Kritik darstellt, bleibt sie ganz im Sinne von Pettibons autodidaktischer Los Angeles Punk-Ästhetik – die ab Ende der 1970er und in den 1980ern eine Weiterentwicklung erfuhr, als der Künstler für das Label SST und die Punkband Black Flag seines Bruders Plattencover, Konzertflyer und Comichefte gestaltete. Ehemals bekannt dafür, dass er über literarische und philosophische Quellen sowie alltägliche Themen wie Film, Musik, Sport, Sex, Gumby und Superman sinnierte, wird seine scharfsinnige Beschäftigung mit politischen und sozialen Themen durch diesen Stil nun umso beeindruckender. Wenn Pettibon in seinen Installationen mit einer Überfülle aufgeklebter Bilder die Atmosphäre eines Internatsschlafsaals vermittelt, so deuten seine individuellen Skizzen auf die Arbeit eines hoch talentierten Slackers, der in zusammengesunkener Haltung über seinem Schreibtisch mit Verve seine Ideen in sein Notizbuch überträgt – einer, der seine Coolness offenbar nur vorgibt.

Ne mâchant déjà pas ses mots dans son abondante production de dessins à l'encre et à l'aquarelle, Raymond Pettibon met le langage au service d'idées politiques franchement affirmées : *Here's Your Irony Back (The Big Picture)*, son exposition new-yorkaise de 2007, étalait le nom de l'artiste et le titre de l'exposition au mur en lettres de sang dégoulinantes dignes d'un film de série B ; des banderoles peintes à même les murs de la galerie clabonant « TWO CHEERS FOR THE RED WHITE AND BLUE » et parlant de façon équivoque d'un Israël « MORAL », avec un signe intercalant un « T » entre le « R » et le « A » pour qu'on y lise « MORTAL » ; et une pléthore de petits dessins dénonçant la guerre en Irak, parodiant la politique étrangère américaine et faisant état, plus généralement, des échecs du régime de George W. Bush. Ces dessins regroupés révèlent une dextérité longtemps associée à l'esthétique bricolo-punk de Pettibon – aiguisée à Los Angeles à la fin des années 1970 et dans les années 1980, alors que l'artiste dessinait pochettes d'album, tracts de concerts et fanzines pour Black Flag, le groupe punk de son frère, et son label SST Records – même s'ils font état de préoccupations plus liées à l'actualité que par le passé. Connu pour ses songeries ayant pour fondements la littérature ou la philosophie mais aussi les films, la musique, le sport, le sexe, Gumby ou Superman, son discours incisif sur les questions politiques et sociales en devient d'autant plus convaincant de par son style. Si les installations de Pettibon empruntent à l'atmosphère d'un foyer d'étudiants avec sa profusion d'images collées, ses croquis suggèrent l'œuvre d'un fainéant de génie, affalé à son bureau, mais remplissant frénétiquement son carnet de ses idées, tout en faisant semblant d'être trop cool pour vraiment s'en soucier. S. H.

SELECTED EXHIBITIONS →
2008 *Raymond Pettibon: Thank You for Staying*, Riverside Art Museum, Riverside **2007** *Think with the Senses – Feel with the Mind*, 52nd Venice Biennale, Venice. *Raymond Pettibon*, Kestnergesellschaft, Hanover. *Imagination Becomes Reality*, ZKM, Karlsruhe **2006** *Raymond Pettibon*, CAC Málaga. *Into Me/Out Of Me*, P.S.1, Contemporary Art Center, Long Island City; KW Institute for Contemporary Art, Berlin **2005** *Raymond Pettibon*, Whitney Museum of American Art, New York.

SELECTED PUBLICATIONS →
2008 *The Pages Which Contain Truth Are Blank*, Museion, Bolzano; Skarabäus. Innsbruck. *Raymond Pettibon: The Books 1978–1998*, Distributed Art Publishers, New York **2007** *Raymond Pettibon*, Phaidon Press, London. *Raymond Pettibon: Whatever It Is Youre Looking For You Won't Find It Here*, Kunsthalle Wien, Vienna; Verlag für Moderne Kunst, Nuremberg

1 **No Title (Don't Make A)**, 2006, pen, ink on paper, 121.9 x 91.4 cm

2 Installation View, *Raymond Pettibon: Here's Your Irony Back (The Big Picture)*, David Zwirner, New York, 2007

„Wenn meine Arbeit gelungen ist ... nun, eine meiner wenigen Richtlinien besteht darin, dass ich das Bild betrachte und mir sage, dass es auf der Welt keinen anderen gibt, der es hätte machen können."

« Je crois que quand mon travail est apprécié... eh bien, je me donne comme seul critère de regarder l'image et de me dire que personne d'autre que moi n'aurait pu le faire. »

"I think when my work is successful... well, one of the only standards I use is to look at the image and consider that this is something no one else in the world could have come up with."

Elizabeth Peyton

1965 born in Danbury (CT), lives and works in New York (NY), USA

Since her 1993 debut at New York's Chelsea hotel, Elizabeth Peyton often has been characterized as a kind of fairy tale protagonist: with a beseeching kiss, she awakened the slumbering hero – portrait painting. Her thinly washed, colour-saturated, diminutively scaled paintings of gorgeously androgynous friends, celebrities and historical personages (Sid Vicious, Kurt Cobain and Susan Sontag brush shoulders with Napoleon, Marie Antoinette and Queen Elizabeth) evince neo-romantic longing, whether for the objects of her pictorial affections or the intensity of feeling in the representations as such. Through a diaristic approach reminiscent of David Hockney or Billy Sullivan, Peyton intimately chronicles moments of unadulterated narcissism, paying rapt attention to metonymic details of swoony, almost sentimental desire: popsicle-stained lips, webs of tattoos, attenuated limbs and halos of perfectly tussled hair. While some of her works take the likes of magazine photographs and record covers as their sources and train their gaze on the idle young, she has more recently turned to painting and drawing – noticeably older sitters or still lifes – from life or from her own snapshots, with an altogether more vulnerable affect. A picture of a stony, steel-jawed Matthew Barney, *Matthew* (2008), reveals deep circles under his eyes, which seem to gaze inward, avoiding the viewer. Even a casual view of downtown Manhattan, *NYC* (2008), feels like a poignant requiem despite its nervy urban intensity. In these and other new works, Peyton exhibits an interest in psychic intensity, supplanting the proverbial lightness of being for something heavier.

Seit ihrer ersten Ausstellung 1993 im Chelsea Hotel in New York ist Elizabeth Peyton immer wieder als Hauptdarstellerin einer Märchen-welt charakterisiert worden, deren inniger Kuss einem schlafenden Helden wieder Leben eingehaucht hat: der Porträtmalerei. Ihre dünn lasierten, farbenprächtigen, kleinformatigen Porträts glamouröser androgyner Freunde, Prominenter und historischer Persönlichkeiten (die Liste umfasst Namen wie Sid Vicious, Kurt Cobain, Susan Sontag, Napoleon, Marie Antoinette und Queen Elizabeth) zeigen neo-romantische Anklänge, in der Verehrung der Dargestellten durch Idealisierung wie auch in der dichten Bildatmosphäre. Durch eine tagebuchartige Vorgehensweise, die an David Hockney oder Billy Sullivan erinnert, gelingen Peyton intime Momentaufnahmen unverfälschter, narzisstischer Schönheit, die Symbole eines ohnmächtigen, fast sentimentalen Begehrens verbindet: scharlachrote Lippen, verschlungene Tattoos, langgezogene Gliedmaßen und zum Glorienschein stilisierte Haare. Während einige ihrer Arbeiten auf Zeitschriften oder Plattencovern entnommenen Fotografien basieren, die den Blick auf eine dekadente Jugend lenken, entstehen ihre neueren Zeichnungen und Gemälde mit merklich älteren Modellen oder Stillleben direkt nach dem Leben oder eigenen Schnappschüssen, was sie insgesamt noch zerbrechlicher wirken lässt. Ein Porträt des hart blickenden Matthew Barney, *Matthew* (2008), enthüllt die tiefen Ringe unter seinen Augen, die vom Betrachter weg, gleichsam nach innen gerichtet ist. Selbst eine flüchtige Ansicht von Downtown Manhattan wie *NYC* (2008) wird trotz ihrer nervenaufreibend urbanen Intensität ergreifend wie ein Requiem. In diesen und anderen neuen Bildern zeigt Peyton ein Interesse für psychologische Dichte, auf der Suche nach mehr Gewicht hinter der vermeintlichen Leichtigkeit des Seins.

Depuis ses débuts au Chelsea Hotel à New York en 1993, on a souvent perçu Elizabeth Peyton comme une sorte d'héroïne de conte de fée : d'un baiser implorant, elle réveillait le héros endormi : la peinture de portrait. Les petits portraits, à peine délavés, aux couleurs saturées, de ses amis superbement androgynes, de célébrités ou de personnages historiques (Sid Vicious, Kurt Cobain et Susan Sontag y côtoient Napoléon, Marie-Antoinette et la reine Elizabeth) dénotent une nostalgie néo-romantique, que ce soit pour les objets de son affection picturale ou pour l'intensité du sentiment dans les représentations en tant que telles. À travers une approche en forme de chronique qui rappelle David Hockney ou Billy Sullivan, Peyton relate de façon intime des moments de pur narcissisme, prêtant une attention considérable à des détails métonymiques de désir défaillant, voire sentimental : des lèvres maculées de glace à l'eau, des entrelacs de tatouages, des membres amincis et des auréoles de cheveux emmêlés à la perfection. Mais, alors que certaines de ses œuvres puisaient leur source dans les photos de maga-zines ou de pochettes de disques, et portaient leur regard sur une jeunesse oisive, elle s'est mise à peindre et à dessiner – des modèles nettement plus vieux ou des natures mortes – à partir du réel ou de ses propres photos, avec quelque chose de beaucoup plus vulnérable. *Matthew* (2008), le portrait d'un Matthew Barney, figé et mâchoires crispées, révèle des cernes profonds sous les yeux dont le regard intros-pectif évite le spectateur. Même *NYC* (2008), une vue ordinaire de Manhattan, s'apparente à un poignant requiem malgré sa nerveuse puissance urbaine. La plupart de ses œuvres exprime son intérêt pour une force psychique, évinçant la légèreté de l'être au profit de l'intensité. S. H.

SELECTED EXHIBITIONS →
2008 *Elizabeth Peyton: Live Forever*, New Museum, New York; Walker Art Center, Minneapolis; Whitechapel Art Gallery, London; Bonne-fantenmuseum, Maastricht. *Elizabeth Peyton*, Aldrich Contemporary Art Museum, Ridgefield. *The Painting of Modern Life*, Castello di Rivoli, Turin **2007** *True Romance*, Kunsthalle Wien, Vienna. *Like Color in Pictures*, Aspen Art Museum, Aspen **2006** *Faster! Bigger! Better!*, ZKM, Karlsruhe. *Surprise, Surprise*, ICA, London. *Since 2000: Printmaking Now*, MoMA, New York

SELECTED PUBLICATIONS →
2008 *Elizabeth Peyton: Live Forever*, New Museum, New York; Phaidon Press, London. *Art & Today*, Phaidon Press, London **2007** *Collection Art Contemporain*, Centre Georges Pompidou, Paris **2006** *Faster! Bigger! Better!*, ZKM, Karlsruhe; Verlag der Buch-handlung Walther König, Cologne. **2005** *Elizabeth Peyton*, Rizzoli, New York

1　**The Age of Innocence**, 2007, oil on board, 36.2 x 25.4 cm
2　**Elizabeth and Georgia (Elizabeth Arden and Georgia O'Keefe 1936)**, 2005, oil on board, 25.4 x 20.3 cm

3　**Matthew**, 2008, oil on board, 31.8 x 22.9 cm
4　**Flowers & Diaghilev**, 2008, oil on linen over board, 33 x 22.9 cm

„Für mich spielt sich alles in den Gesichtern ab. Sie sind wirklich Geschichte. Die vergeht und sie verändern sich, und das ist es."

« Je crois juste que tout est dans le visage des gens. Ce sont vraiment eux, l'histoire. Et elle passe et ils changent, et voilà. »

"I just think it's all in people's faces. They really are history. And it passes and they change, and that's it."

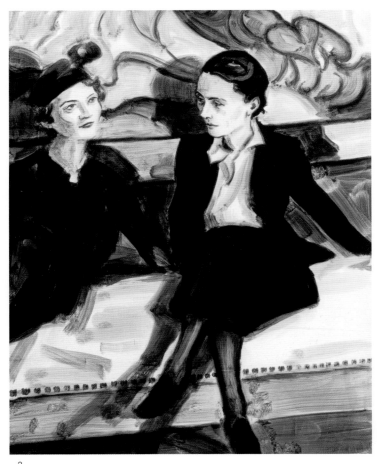

2

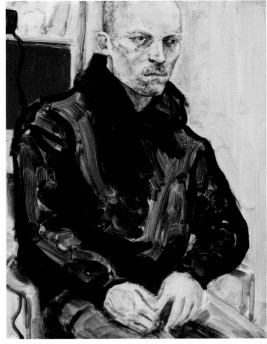

3

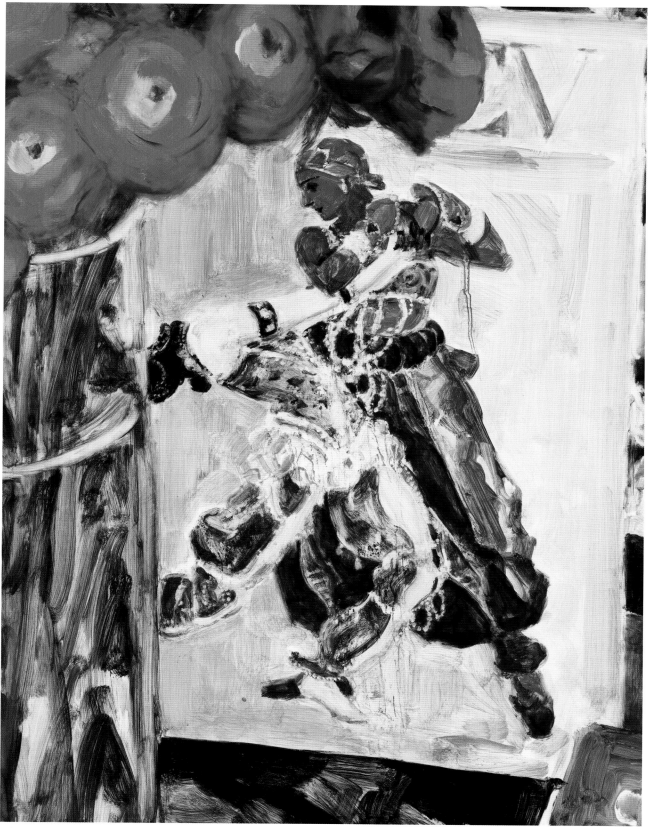

Richard Phillips

1962 born in Marblehead (MA), lives and works in New York (NY), USA

Hasn't everything there is to say on canvas already been said? Richard Phillips certainly doesn't think so. But rather than naively continue to paint away, he engages with this very question. Pop artists like Andy Warhol and Mel Ramos are his main points of reference, not just stylistically or thematically but because he, too, questions the status and function of images. The paintings in the exhibition *Michael Fried* (2006) initially present Phillips' typical motifs, derived from the spirit of pop art – aged soft porn images form the basis of many of his works. However, the way in which the exhibition is installed is central to his critical approach to painting. As in a chapel, the paintings are grouped together around an image of a completely different kind: a portrait of the influential art critic Michael Fried. Phillips thus incorporates a firm theoretical stance into his installation: Fried was of the opinion that art which prompts reflection upon how it is viewed loses its power to transport the viewer out of everyday life. Phillips places the authoritative portrait of Fried in a context that cunningly fulfils the critic's demand. With their affirmative means of depiction, the images do not seem to reflexively subvert the porn theme. In terms of subject matter, however, they are to be attributed to "low art" and a questionable form of absorption, which would hardly please Fried. Perhaps the painting *Herzausreisser* (2005), in which a femme fatale holds out a heart to the viewer, is also aimed at Fried? Phillips goes a step further with *Girl with Cigarette* (2008); its visual smoothness hinders reflection at the cost of vacuity – and is effective precisely for this reason. In this way painting lives on, ferocious and self-critical.

Ist auf der Leinwand schon alles gesagt? Richard Phillips ist keinesfalls dieser Ansicht. Er malt jedoch nicht naiv weiter, sondern setzt sich mit dieser Frage auseinander. Vor allem Pop-Art-Künstler wie Andy Warhol und Mel Ramos liefern ihm Bezugspunkte, nicht nur in stilistischer oder motivischer Hinsicht. Denn es geht ihm um die Frage nach dem Status und der Funktion von Bildern. Auf den ersten Blick bieten die Gemälde der Ausstellung *Michael Fried* (2006) jene für Phillips typischen Motive, die er aus dem Geiste der Pop Art holt: Zeitlich patinierte Softporno-Bilder liegen vielen seiner Arbeiten zugrunde. Zentral für das Verständnis seiner malereikritischen Vorgehensweise ist jedoch der installative Aufbau der Ausstellung. Wie in einer Kapelle sind die Bilder um ein gänzlich anders geartetes Bild gruppiert, ein Porträt des einflussreichen Kritikers Michael Fried. Phillips holt damit eine dezidierte Position in seine Installation hinein: Fried vertritt die Ansicht, dass Kunst, die eine Reflexion über ihr Betrachten auslöst, die Kraft, den Betrachter vom Alltag zu absorbieren, verlieren würde. Das autoritative Porträt Frieds stellt Phillips nun in einen Kontext, welcher die Forderung Frieds tückisch erfüllt. Die Bilder scheinen die Porno-Motivik mit ihrer affirmativen Darstellungsweise nicht reflexiv aufzubrechen, sind jedoch motivisch der Low Art und einem fragwürdigen Absorbieren zuzurechnen, was wiederum Frieds Herz kaum höher schlagen lassen dürfte. Vielleicht ist das Gemälde *Herzausreisser* (2005), bei dem eine Femme fatale dem Betrachter ein Herz entgegenhält, auch auf Fried gemünzt? Einen Schritt weiter geht Phillips mit *Girl with Cigarette* (2008). Dessen visuelle Glätte verhindert Reflexion bis um den Preis der Entleerung – und gerade dadurch wird sie thematisiert. So kann die Malerei weiterleben, bösartig und selbstkritisch.

Tout a-t-il déjà été dit en peinture ? Richard Phillips n'est nullement de cet avis. Il ne se contente pas de continuer de peindre de manière irréfléchie, mais travaille sur cette question. Ses références – pas seulement en termes de motif ou de style – sont surtout des artistes pop comme Andy Warhol et Mel Ramos. Pour Phillips, la question cruciale est en effet celle du statut et de la fonction de l'image. À première vue, les tableaux de l'exposition *Michael Fried* (2006) proposaient ses motifs habituels conçus dans l'esprit du Pop Art – nombre de ses œuvres reposent sur des images porno soft patinées par le temps. Mais un aspect central de sa critique picturale et de sa démarche était la présentation installative de l'exposition : ses tableaux étaient groupés comme dans une chapelle autour d'un tout autre tableau, un portrait du critique influent Michael Fried, qui introduisait une position nettement marquée dans l'installation. Fried prône l'idée que tout art qui induit une réflexion sur sa contemplation perd la capacité d'absorber le spectateur hors de sa vie quotidienne. Phillips place donc le portrait de Fried dans un environnement qui exauce de manière fallacieuse l'exigence du critique. Les tableaux ne semblent produire aucun démontage réflexif des sujets pornographiques et de leur mode affirmatif, mais doivent être associés au *low art* et à une forme d'absorption douteuse, ce qui ne saurait plaire davantage à Fried. Peut-être la peinture *Herzausreisser* (2005), dans laquelle une femme fatale tend un cœur au spectateur, vise-t-elle également Fried ? Phillips va plus loin avec *Girl with Cigarette* (2008), dont le « léché » visuel empêche toute réflexion jusqu'à l'inanité – thématisant ainsi, précisément, l'inanité. Sous ce signe, la peinture peut bien continuer d'exister, pernicieuse et autocritique. H. L.

SELECTED EXHIBITIONS →
2008 *Blasted Allegories: Werke aus der Sammlung Ringier*, Kunstmuseum Luzern. *Out of Shape: Stylistic Distortions of the Human Form in Art*, The Frances Lehman Loeb Art Center, Poughkeepsie **2007** *INSIGHT?*, Gagosian Gallery/Red October Chocolate Factory, Moscow. *Timer.01: Intimacy*, Triennale Bovisa, Milan **2006** *Dark Places*, Santa Monica Museum of Art, Santa Monica **2004** *Richard Phillips Paintings and Drawings*, Le Consortium, Dijon

SELECTED PUBLICATIONS →
2008 *Always There*, Galerie Max Hetzler, Berlin **2007** *Richard Phillips*, Gagosian Gallery, New York. *INSIGHT?*, Gagosian Gallery/Red October Chocolate Factory, Moscow. *Pop Art Is*, Gagosian Gallery, London **2006** *Richard Phillips: Early Works on Paper*, Galerie Max Hetzler, Berlin; Holzwarth Publications, Berlin. *Richard Phillips*, Le Consortium, Dijon; JRP Ringier, Zürich **2005** *Richard Phillips: Michael Fried*, White Cube, London; Friedrich Petzel, New York

382

1 **Girl with Cigarette**, 2008, oil on canvas, 304.8 x 214.6 cm
2 **Free Base**, 2007, oil on canvas, 290 x 347.3 cm
3 **Herzausreisser**, 2005, oil on canvas, 218.4 x 162.6 cm

4 **Frieze**, 2007, charcoal, white chalk on grey toned paper, 37.5 x 50.2 cm
5 **Hell**, 2007, oil on canvas, 289.6 x 367.7 cm

„Meine Arbeit distanziert sich von sich selbst wie ein losgerissener Abschnitt aus einem Cadavre exquis. Wie beim grün-blauen Bein eines zerstückelten Drogenkuriers, das durch den Hafen von New York treibt, fragt man sich, ob unsere Kokainsucht sie hätte retten können."

« Mon œuvre se dissocie de lui-même comme le segment isolé d'un cadavre exquis. Comme la jambe bleu-vert d'un passeur de drogue démembré flottant dans le port de New York, on se demande si notre addiction à la coke aurait pu la sauver. »

"My work disassociates from itself like the torn off segment of an exquisite corpse. Like the blue green leg of a dismembered drug mule floating in New York harbour, one wonders if their coke habit could have saved her."

2

3

4

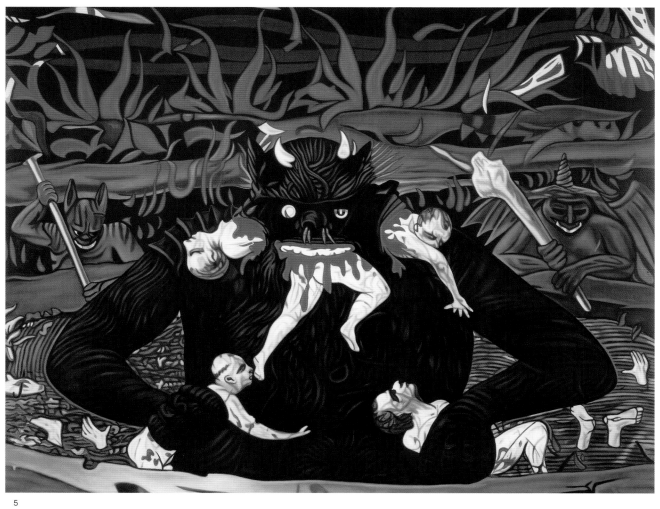

Richard Prince

1949 born in Panama Canal Zone, lives and works in New York (NY), USA

Appropriating everyday objects and bringing them into the realm of art has been a strategy of artists ever since Duchamp. In 1930, Louis Aragon linked this to a new definition of the artist: the artist was no longer someone who created original works, but someone who selected, and thus made conscious decisions. Richard Prince, a central figure of appropriation art, has made a number of such decisions, appropriating themes that are closely related to the American way of life, such as Marlboro cowboys, biker gangs or celebrities. Since the 1970s, he has reproduced and reworked these motifs in photographs and paintings, putting special emphasis on the darker side of society. His text/image paintings increasingly involve jokes on topics that are otherwise repressed, as well as soft-porn photographs, which he overpaints in the style of de Kooning. In his latest works he attempts to take appropriation art a step further by not only appropriating available images or de Kooning's painting style, or by venturing into product design and appropriating luxury goods as the "canvases" for his art. Prince collaborated with Marc Jacobs on the fashion designer's 2008 spring collection for Louis Vuitton, *After Dark* (2008). The artist traced monograms onto the bags or had them spray-painted with short jokes on his preferred themes of gender, race or poverty – fundamental issues of social coexistence that do not usually concern the average Louis Vuitton customer. In this way Prince cunningly appropriates platforms for his culturally critical works and turns Duchamp's approach back on itself by bringing art into the everyday.

Sich Dinge aus der Alltagswelt anzueignen, um sie in jene der Kunst zu holen, ist eine künstlerische Strategie, die seit Duchamp praktiziert wird. 1930 sah Louis Aragon damit eine Neudefinition des Künstlers verbunden. Dieser ist nicht länger Schöpfer eines originären Werkes, sondern jemand, der auswählt und damit gezielt Entscheidungen trifft. Richard Prince, zentrale Figur der Appropriation Art, hat eine Reihe solcher Entscheidungen getroffen und sich Motive angeeignet, wie etwa Marlboro-Cowboys, Biker-Gangs und Celebrities, die mit dem American Way of Life verknüpft sind. Diese Motive hat er seit den 1970er-Jahren fotografisch und malerisch reproduziert und bearbeitet, dabei legt er besonderen Wert auf die dunklen Seiten der Gesellschaft. Vor allem seinen neueren malerischen Bild-Text-Werken widmet er sich verstärkt Witzen, die Verdrängtes thematisieren, sowie Soft-Porno-Fotografien, die er im Stile de Koonings übermalt. Mit seinen neueren Werken versucht er, die Appropriation Art weiterzuführen. Sei es, indem er sich nicht nur bereits vorhandene Bilder aneignet, sondern zudem de Koonings Malstil. Sei es, indem er ausgreift in das Produktdesign und sich Waren als Träger seiner Kunst aneignet. Mit Marc Jacobs kooperierte er für die Frühjahrskollektion *After Dark* (2008) von Louis Vuitton. Prince versieht die Taschen mit nachgezeichneten Cartoons oder kurzen Witztexten. Sie drehen sich, typisch für Prince, um Geschlechter- und Rassenproblematik oder Geldmangel. Und damit um grundlegende Fragen des sozialen Miteinanders, mit denen die üblichen Louis-Vuitton-Kundinnen kaum je posieren würden. Auf subtile Weise eignet sich Prince so Flächen für seine kulturkritischen Arbeiten an und wendet Duchamps Ansatz: Er holt die Kunst in die Alltagswelt hinein.

S'approprier des objets du monde quotidien pour les faire entrer dans le monde de l'art est une stratégie pratiquée depuis Duchamp. En 1930, Aragon y voyait une nouvelle définition de l'artiste, qui n'est plus le créateur d'une œuvre inédite, mais quelqu'un qui choisit et prend des décisions ciblées. Richard Prince, figure centrale de l'appropriationnisme, a pris une série de décisions de ce genre et s'est approprié des motifs liés à l'*American way of life* comme les cow-boys Marlboro, les gangs de motards et les célébrités, qu'il a reproduits et travaillés en peinture et en photographie depuis les années 1970, détaillant ainsi les faces les plus sombres de la société. Dans ses peintures récentes, qui joignent le texte à l'image, il s'attache à des plaisanteries qui touchent souvent des aspects refoulés, mais aussi à des photographies porno soft peintes dans le style de de Kooning. Prince tente ainsi de pousser plus loin l'appropriationnisme. Il ne s'empare plus seulement des images existantes, mais fait sien le style pictural de de Kooning ou étend son champ pictural au design de produits et s'approprie des biens de consommation comme nouveaux supports pour son art. Prince a ainsi collaboré avec Marc Jacobs à la collection de printemps *After Dark* (2008) de Louis Vuitton. Il affuble les sacs de *cartoons* redessinés ou de courtes blagues écrites. Comme souvent chez Prince, ils tournent autour de problèmes sexuels et raciaux ou de manque d'argent, et problématisent des questions fondamentales sur la cohabitation sociale que les clientes habituelles de Louis Vuitton ne se poseraient sans cela jamais. Prince s'approprie ainsi subtilement de nouveaux supports pour sa critique culturelle et inverse la démarche de Duchamp en faisant entrer l'art dans le monde quotidien.

H. L.

SELECTED EXHIBITIONS →
2008 *Richard Prince: Continuation*, Serpentine Gallery, London **2007** *Richard Prince: Spiritual America*, Solomon R. Guggenheim Museum, New York; Walker Art Center, Minneapolis; Serpentine Gallery, London. *Richard Prince: Panama Pavilion*, Venice. *Frieze Projects*, Frieze Art Fair, London **2006** *Richard Prince: Canaries in the Coal Mine*, Astrup Fearnley Museum, Oslo. *The 80's: A Topology*. Museo Serralves, Porto **2004** *Richard Prince*, Sammlung Goetz, Munich

SELECTED PUBLICATIONS →
2007 *Richard Prince*, Guggenheim Museum, New York; Hatje Cantz, Ostfildern. *Richard Prince: Canaries in the Coal Mine*, Astrup Fearnley Museet for Moderne Kunst, Oslo. *INSIGHT?*, Gagosian Gallery/Red October Chocolate Factory, Moscow. **2006** *Richard Prince: Jokes & Cartoons*, JRP Ringier, Zürich **2005** *Richard Prince: Hippie Drawings*, Sadie Coles HQ, London; Hatje Cantz, Ostfildern **2004** *Richard Prince: Man*, JRP Ringier, Zürich

A Nurse
Involved

O'More

1 **A Nurse Involved**, 2002, inkjet print, acrylic on canvas, 182.9 x 114.3 cm
2 **Big Foot**, 2004/05, cast polyurethane, 64 x 112 x 112 cm

3 **Untitled (cowboy)**, 2003, ektacolour photograph, 101.6 x 76.2 cm

„Für mich hat sich immer die Frage gestellt: ‚Was glaubst du, wer du bist?'
Der Wunsch ein Anderer zu sein, eine Rolle zu spielen, für eine andere
Persönlichkeit einzuspringen, ist entweder Zeichen von Unsicherheit oder
einer mächtigen Selbstgewissheit."

« La question a toujours été pour moi : "Pour qui te prends-tu ?" L'envie d'être
quelqu'un d'autre, de jouer un rôle, d'endosser un personnage, d'être une
doublure, est l'expression d'une insécurité ou d'un immense ego. »

"The question for me has always been, 'Who do you think you are?' The desire to be someone else, to play a part, take on a role, to be an understudy is either part of an insecurity or a huge ego."

2

Neo Rauch

1960 born in Leipzig, lives and works in Leipzig, Germany

With solo exhibitions at the Metropolitan Museum in New York (2007) and the Max Ernst Museum in Brühl (2008), Neo Rauch has truly arrived. The first confirmed his international reputation, the second contextualized his work and linked it to one of the leading exponents of surrealism. Attempting to characterize his pictorial worlds leads us to his working method: various points of reference, objects and stylistic elements are brought together like a collage. This often leads to a condensation of meanings and styles which is one of the most distinctive qualities of Rauch's art. It generates multiple tensions between utopian and nostalgic elements, idyll and horror, cartoon-like depiction and expressiveness, bold advertising and glittering pearls of meaning. Particularly characteristic of his paintings are combinations of several temporal strands. For example, *Das Gut* (2008) shows a car from the 1950s, a man wearing dandyish clothing from the 19th century and a cast of figures that appear twice, as in medieval simultaneous staging. The second man's body ends in a fishtail, representing a kind of siren figure. Mythology is evoked – and immediately transformed: Rauch paints the male siren involved in a fight. Although Rauch continues to stage the clash of symbols in his latest works, the fields of reference have shifted: above all, the 19th and 20th centuries now converge in combination with a mythological antiquity. Increasingly he is also focusing on his own activities: artists appear in front of canvases or sketchpads, usually pondering what to paint (*Parabel*, 2008). Rauch has certainly come into his own – and not just by making self-reflection his subject.

Neo Rauch ist doppelt angekommen: mit einer Soloausstellung im Metropolitan Museum in New York (2007) und im Max Ernst Museum in Brühl (2008). Die erste bestätigt seinen internationalen Rang, die zweite kontextualisiert seine Arbeiten und verbindet sie mit einer Hauptfigur des Surrealismus. Der Versuch, seine Bildwelten zu charakterisieren, führt zu seiner Vorgehensweise: collagenartig werden ganz verschiedene Bezugspunkte und Objekte, aber auch Stilelemente zusammengeführt. Das führt immer wieder zu Komprimierungen von Bedeutungen und Stilen, worin eine Qualität von Rauchs Arbeiten liegt. So entsteht ein mehrfaches Spannungsfeld von utopischen und nostalgischen Elementen, von Idylle und Horror, von Comicstil und Expressivität, von plakativer Werbung und schillernden Bedeutungsdiamanten. Besonders kennzeichnend für seine Bilder sind Kombinationen mehrerer Zeitzustände. So zeigt etwa *Das Gut* (2008) ein Automobil aus den 1950er-Jahren, eine Person trägt dandyhafte Kleidung aus dem 19. Jahrhundert und das gesamte Personal erscheint, wie in einem mittelalterlichen Simultanbild, zweimal. Der Körper des Mannes endet in einem Fischschwanz, solcherart eine Sirene darstellend. Mythologie wird aufgerufen – und sogleich gewandelt: Rauch malt eine männliche Sirene als Kämpfenden. In seinen jüngsten Werken inszeniert Rauch weiterhin den Zusammenprall von Zeichen, verschiebt jedoch die Referenzfelder: Vor allem 19. und 20. Jahrhundert treffen aufeinander, kombiniert mit mythologischer Antike. Und immer stärker thematisiert Rauch sein eigenes Tun: Künstler erscheinen vor Leinwänden oder Zeichenblöcken, meist mit der Frage befasst, was zu malen sei (*Parabel*, 2008). Rauch ist ganz bei sich angekommen, nicht nur in der Selbstreflexion als Sujet.

Avec une exposition personnelle au Metropolitan Museum de New York (2007) et une autre au Max Ernst Museum de Brühl (2008), Neo Rauch a été accueilli à juste titre: la première exposition confirme sa stature internationale, la seconde contextualise ses œuvres et les associe à une grande figure du surréalisme. Caractériser les univers iconiques de Rauch conduit à décrire sa manière de procéder : ses tableaux regroupent toutes sortes d'objets et de références, mais aussi d'éléments stylistiques à la manière d'un collage. Ceci produit des compressions de sens et de styles qui font la qualité de ses œuvres. De l'ensemble résulte un champ de tensions multiples composé d'éléments utopiques et nostalgiques, d'idylle et d'horreur, de bande dessinée et d'expressivité, de publicité criarde et de scintillants joyaux de sens. Un aspect caractéristique de ses tableaux est la combinaison de plusieurs états. Le tableau *Das Gut* (2008) montre une voiture des années 1950, une personne y est habillée en dandy du XIXᵉ siècle et tous les personnages apparaissent deux fois comme dans les scènes simultanées d'une peinture médiévale. Le corps de l'homme se termine en queue de poisson, la mythologie est invoquée et immédiatement transformée : Rauch peint un combattant sous forme de sirène masculine. Dans ses œuvres récentes, Rauch continue de mettre en scène le choc des signes mais déplace ses champs de références. Aujourd'hui se télescopent surtout les XIXᵉ et XXᵉ siècles associés à la mythologie antique. Rauch prend en outre de plus en plus souvent pour sujet sa propre activité : des artistes apparaissent devant des toiles ou des blocs de papier à dessin, généralement hantés par la question de savoir ce qui doit être peint (*Parabel*, 2008). Rauch s'est trové lui-même – et pas seulement à travers l'autoréflexion comme sujet.

H. L.

SELECTED EXHIBITIONS →
2008 *Neo Rauch*, Max Ernst Museum, Brühl. *Third Guangzhou Trianniel*, Guangdong Museum of Art, Guangzhou **2007** *Neo Rauch: Para*, Metropolitan Museum of Art, New York. *The Present – Acquisition Monique Zajfen*, Stedelijk Museum, Amsterdam **2006** *Neo Rauch*, Musée d'art contemporain de Montreal. *Neo Rauch: Neue Rollen. Bilder 1993 bis heute*, Kunstmuseum Wolfsburg. *Surprise, Surprise*, ICA, London **2005** *Neo Rauch*, CAC Málaga **2004** *Neo Rauch*, Albertina, Vienna

SELECTED PUBLICATIONS →
2008 *Neo Rauch*, David Zwirner, New York; Steidl, Göttingen. *Stations. Die Elisabethkapelle im Naumburger Dom mit den von Neo Rauch gestalteten Glasfenstern*, Imhof, Petersberg **2007** *Neo Rauch: Para*, Metropolitan Museum of Art, New York; DuMont, Cologne **2006** *Neo Rauch: Der Zeitraum*, DuMont, Cologne. *Neo Rauch*, Musée d'art contemporain de Montreal, Montreal. *Neo Rauch: Neue Rollen. Bilder 1993–2006*, Kunstmuseum Wolfsburg; DuMont, Cologne

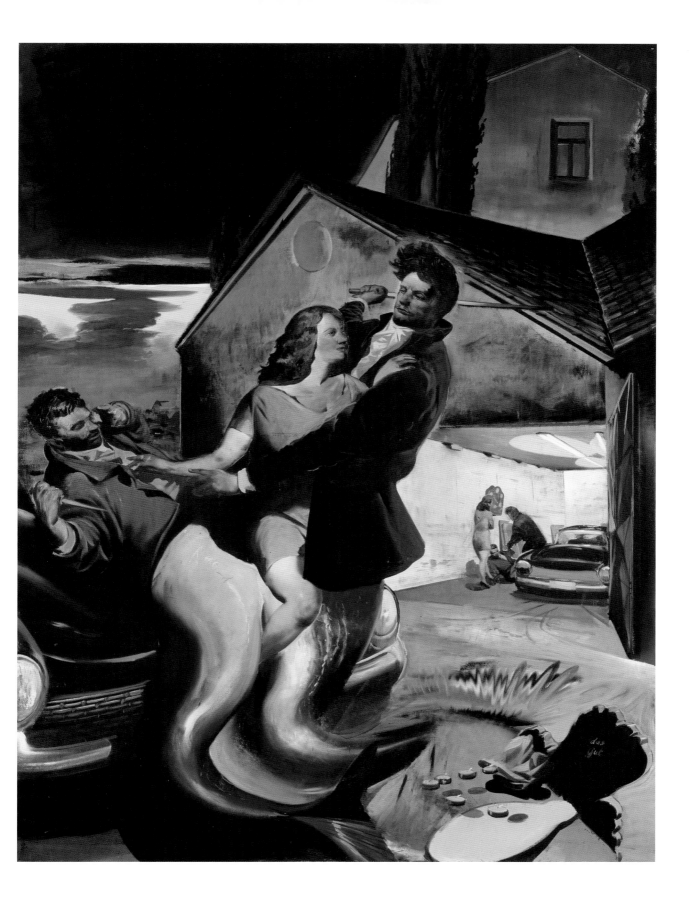

1 **Das Gut**, 2008, oil on canvas, 280 x 210 cm
2 **Vater**, 2007, oil on canvas, 200 x 150 cm
3 **Das Blaue**, 2006, oil on canvas, 300 x 420 cm

4 **Der Garten des Bildhauers**, 2008, oil on canvas, 300 x 420 cm
5 **Parabel**, 2008, oil on canvas, 300 x 210 cm

„Zumindest können wir davon ausgehen, dass die figurative Malerei eine ganze Reihe von Minen, von Fettnäpfchen, von Bananenschalen bereithält, mit denen man es zu tun bekommen kann, und das reizt mich."

« Nous pouvons du moins partir du principe que la peinture figurative recèle toute une série de mines, de bévues, de peaux de bananes auxquelles on peut avoir affaire, et c'est ce qui m'intéresse au plus haut point. »

"We can at least assume that figurative painting hides a whole series of booby traps, cowpats and banana skins that you have to deal with, and that's what excites me."

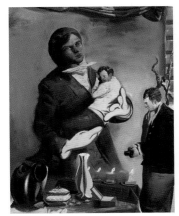

2

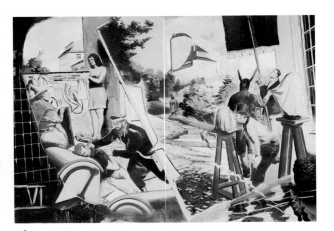

3

4

Tobias Rehberger

1966 born in Esslingen am Neckar, lives and works in Frankfurt am Main, Germany

Tobias Rehberger regards art as a communicative breakdown. The "chicken and egg" problem is a typical disruption of logic – what came first? Rehberger took this as the starting point for his exhibition *Die „Das-kein-Henne-Ei-Problem"-Wandmalerei* (2008). He was invited to present work from the last fifteen years, but instead transformed the tired format of the retrospective into a paradox. Pieces from twenty-four work groups were shown along seventy metres of wall space and illuminated by spotlights, so that they threw shadows onto the painted wall opposite – it became a new work, a mural made of colour, light and shadow. Rehberger worms his way through issues of definition and simultaneously exposes them: Can the new work stand for itself? How does it relate to the old works, given that it only assumes form through them? Are the old ones still independent artworks or materials of the new one? Rehberger took a similarly disorienting approach in film – a new medium for him – with *On Otto* (2007). Turning the usual production process on its head, he began with the film poster, followed by the title design, soundtrack, editing, filming and the screenplay. Lastly he built a viewing room. By reversing the process, the idea of film as a collaborative art form became a permanent disruption for those involved – one that also demanded repositioning and thus formed the creative basis for a new approach to the medium. Sequential order, hierarchies of value, social identities, authorship and modes of reception: Rehberger's work addresses these issues within the system of art in order to gain, through communicative disruptions, nothing less than clarity.

Tobias Rehberger begreift Kunst als kommunikativen Störfall. Eine typische Störung in der Logik ist das so genannte Henne-Ei-Problem – was war zuerst? Dieses Problem nahm Rehberger als Ausgangspunkt für seine Ausstellung *Die „Das-kein-Henne-Ei-Problem"-Wandmalerei* (2008). Auf Einladung sollte Rehberger Werke aus 15 Jahren präsentieren, er überführte jedoch das abgenutzte Format der Retrospektive in ein Paradox. Zwar stellte er auf 70 Metern Länge Arbeiten aus 24 Werkgruppen aus dem gewünschten Zeitraum aus. Er beleuchtete diese jedoch frontal mit Scheinwerfern, so dass alle Werke Schatten auf die gegenüberliegende, mit farbigen Motiven versehene Wand warfen. So entstand ein neues Werk, eine Wandmalerei aus Farbe, Licht und Schatten. Solcherart schlängelt sich Rehberger durch die Definitionsproblematik und exponiert sie zugleich: Ist das neue Werk eine eigenständige Installation? Wie verhält es sich zu den alten Werken, wo es doch nur durch diese Form gewinnt? Sind die alten Werke noch eigenständige Kunstwerke oder nunmehr Material für ein neues? Ähnlich verunsichernd machte sich Rehberger mit *On Otto* (2007) an ein für ihn neues Medium, den Film. Er wendete die üblichen Produktionsschritte um 180 Grad und begann mit dem Filmplakat. Dann folgten Titeldesign, Musik, Schnitt, Filmdreh sowie das Drehbuch. Zuletzt baute er einen Kinoraum. Die Idee des Films als kollaborative Kunstform wurde dabei in der Verdrehung der Produktionsschritte eine permanente Störung für alle Beteiligten. Eine Störung, die zugleich eine Neupositionierung erforderte und damit den kreativen Boden bildete für eine neue Herangehensweise an das Medium Film. Ordnungen von Abläufen, Wertigkeitshierarchien, soziale Identitäten, Autorschaft und Rezeptionsweisen – an diesen Punkten des Systems Kunst setzt Rehberger mit seinen Arbeiten an, um mittels kommunikativer Störungen nichts anderes als Klarheit zu gewinnen.

Tobias Rehberger comprend l'art comme un incident de communication. Une perturbation classique de la logique est le problème de l'antériorité de l'œuf ou de la poule. Rehberger est parti de ce cas de figure pour son exposition *Die „Das-kein-Henne-Ei-Problem"-Wandmalerei* (2008). Invité à présenter ses œuvres des quinze dernières années, il décida de transformer le format usé de la rétrospective en paradoxe : il exposa sur une longueur de soixante-dix mètres des œuvres réalisées pendant la dite période, mais les éclaira de faisceaux lumineux de sorte que toutes projetaient une ombre sur le mur opposé, orné de motifs colorés. Il produisit ainsi une nouvelle œuvre : une peinture murale de couleur, d'ombre et de lumière. Rehberger se jouait ainsi de la problématique des définitions tout en l'exposant : la nouvelle œuvre est-elle une installation autonome ? Quel est son rapport avec les anciennes œuvres alors que ce sont elles qui la produisent ? Les anciennes œuvres sont-elles encore des œuvres d'art autonomes ou seulement le matériau d'une nouvelle œuvre ? Avec *On Otto* (2007), Rehberger s'attaquait de manière tout aussi troublante à un nouveau médium : le cinéma. Il inversa les phases de production habituelles en commençant par l'affiche. Vinrent ensuite le lettrage, la musique, le montage, le tournage et le scénario. Pour finir, il construisit une salle de cinéma. Avec cette inversion, le cinéma, forme d'art collaborative par excellence, devenait pour les participants une perturbation permanente obligeant à un repositionnement et fournissant le terreau créatif d'une nouvelle approche du médium. Phases de travail, hiérarchies des valeurs, identités sociales, paternité de l'auteur et modes de réception – en s'attaquant à ces points du système de l'art au moyen d'incidents de communication, Rehberger ne cherche rien de moins qu'à gagner en compréhensibilité.

H. L.

SELECTED EXHIBITIONS →
2008 *Tobias Rehberger: the chicken-and-egg-no-problem wall-painting*, Stedelijk Museum, Amsterdam; Museum Ludwig, Cologne. *Ad Absurdum*, MARTa Herford **2007** *Tobias Rehberger: On Otto*, Fondazione Prada, Milan. *Wouldn't it be nice*, Centre d'Art Contemporain, Geneva **2005** *Tobias Rehberger – I die every day. 1 Cor. 15,31*, Palacio de Cristal, Museo Nacional Centro de Arte Reina Sofía, Madrid; Hospitalhof Stuttgart

SELECTED PUBLICATIONS →
2008 *Tobias Rehberger: The chicken-and-egg-no-problem wall-painting*, Stedelijk Museum, Amsterdam; Museum Ludwig, Cologne. *Tobias Rehberger 1993–2008*, DuMont, Cologne **2007** *Tobias Rehberger: On Otto*, Fondazione Prada, Milano **2006** *Tobias Rehberger: Private Matters*, JRP Ringier, Zürich **2005** *Tobias Rehberger: I die every day. 1 Cor. 15,31*, Palacio de Cristal, Museo Nacional Centro de Arte Reina Sofía, Madrid. *Tobias Rehberger: Private Matters*, Whitechapel Gallery, JRP Ringier, Zürich

1 **Infections**, 2008, 33 Velcro lamps, cable, light bulbs, dimensions variable
2–4 Installation views, *Tobias Rehberger: On Otto*, Fondazione Prada, Milan, 2007

5 Installation view, *Tobias Rehberger: I die every day, 1 Cor. 15,31*, Museo Nacional Centro de Arte Reina Sofía, Madrid, 2005

„Mir gefällt die Vorstellung, dass etwas Ausgearbeitetes und Endgültiges den Ausgangspunkt für etwas Vages und Skizzenhaftes bilden kann."

« J'aime bien l'idée qu'une chose aboutie et définitive puisse être à l'origine de quelque chose de vague et d'ébauché. »

"I like the idea that something worked-out and definitive can form the starting point for something vague and sketchy."

2

3

Anselm Reyle

1970 born in Tübingen, lives and works in Berlin, Germany

Anselm Reyle's works always look a bit like "modern art", but this is deliberate, as he works with stylistic quotations from abstract art that hang, slightly worse for wear, in our pictorial memory store. He is fascinated by the persuasiveness of the cliché, the formulaic in the form. His works are based on found objects, which can just as easily be stylistic formulae or things he has literally found. When he explores tachism or colourfield painting; when he reworks Art Informel sculpture; when he uses *objets trouvés* – painting a hay cart neon yellow, or combining paint with broken fragments and electrical scrap – he adapts the gestures of what was once advanced visual language, emptying them out while increasing their potency as surface and effect. "I'm interested in things that have the power to become a cliché," he says. "I try to get to the core and exaggerate it so much that it really does move you again." Reyle continues along this path, while the field of stylistic references has opened up and his combination of materials has become more experimental. Some works recall Vasarely, Armand or Manzoni. Materials and gestures are now used more drastically, for example in his *Black Earth* pictures (2007); in others he hits the precise spot where you don't know whether it reminds you of Art Informel or an arty calendar from a poster shop. He pushes the boundaries of taste and exaggeration, and, having already used neon paint "like a cranked-up electric guitar", he now makes use of striking textural pastes, ripple lacquer, steel frames, airbrush and LED light effects. "Part of my work is dealing with what is too much," Reyle says. "It's a balancing act that can end up hurting."

Arbeiten von Anselm Reyle sehen immer ein bisschen nach „moderner Kunst" aus. Das hat Methode, denn Reyle arbeitet mit Stilzitaten der Abstraktion, die heute ein wenig abgenutzt in unserem Bildgedächtnis hängen. Ihn fasziniert die Überzeugungskraft des Klischees, das Formelhafte an der Form. So basieren seine Arbeiten eigentlich auf Fundstücken, und das können ebenso gut Stilformeln wie gefundene Objekte sein: Wenn er Tachismus oder Colourfield Painting aufgreift, wenn er informelle Skulptur re-inszeniert, wenn er mit *objets trouvés* arbeitet, etwa einen Heuwagen mit gelber Neonfarbe überzieht oder in Materialbildern die Malerei mit Scherben und Elektroschrott verbindet – dann adaptiert er Gesten einst avancierter Bildsprachen, entleert sie, steigert aber zugleich ihre Wirksamkeit als Oberfläche und Effekt. „Mich interessiert etwas, das überhaupt die Qualität hat, ein Klischee zu sein", sagt er. „Ich versuche, den Kern zu erfassen und so zu überzeichnen, dass es einen schon wieder wirklich bewegt." Reyle hat das zuletzt noch fortgeführt, das Feld stilistischer Bezüge ist offener, die Materialkombination experimenteller geworden. Manche Arbeiten lassen an Vasarely, Armand oder Manzoni denken. Material und Geste werden drastischer verwendet, etwa in den neueren *Black-Earth*-Bildern (2007), in anderen trifft er perfekt den Tonfall, bei dem man nicht mehr weiß, ob das an Informel oder ans Kunstkalenderblatt aus der Postergalerie erinnert. Reyle reizt Grenzen zu geschmacklichem Tabu und Übertreibung aus, und hat er schon Neonfarben „wie eine stark aufgedrehte E-Gitarre" benutzt, setzt er inzwischen effektvolle Texturpasten und Reißlack, Stahlrahmen, Airbrush und LED-Lichteffekte ein. „Mit dem Zuviel umzugehen ist Teil meiner Arbeit", sagt Reyle, „das ist eine Gratwanderung, die durchaus wehtun kann."

Les œuvres d'Anselm Reyle ont toujours un côté « art moderne ». Reyle travaille méthodiquement avec des citations de styles de l'art abstrait quelque per usées, conservées dans notre mémoire iconique. Il est fasciné par la force de conviction du cliché, de la forme poussée jusqu'à la formule. Ses œuvres s'appuient sur des trouvailles qui peuvent être des formules stylistiques aussi bien que des objets trouvés. En faisant appel au tachisme ou au colourfield painting, en restaurant la sculpture informelle, en travaillant avec des objets trouvés comme une charrette de foin peinte en jaune fluo ou en combinant peinture, tessons et déchets électriques dans des tableaux d'assemblages – il adapte des langages iconiques naguère avant-gardistes, les vide de leur substance, mais intensifie en même temps l'efficacité des effets de surface. « Ce qui m'intéresse, c'est très généralement tout ce qui a la qualité d'être un cliché », dit-il. « Je cherche à cerner le noyau et à l'exacerber au point qu'il finit par vous toucher à nouveau. » Récemment, Reyle est allé encore plus loin : les références stylistiques sont plus vastes, les combinaisons de matériaux plus expérimentales. Certaines œuvres rappellent Vasarely, Armand ou Manzoni, matériau et position sont utilisés plus radicalement, comme dans les nouveaux tableaux de la série *Black-Earth* (2007). Dans d'autres, Reyle trouve le ton exact où l'on ne sait plus s'il faut y voir de l'informel ou un poster de calendrier d'art. Reyle joue des limites du tabou du bon goût et de l'exagération, et s'il se sert de couleurs fluo « comme d'une guitare électrique à pleine puissance », il introduit aujourd'hui des textures efficaces comme du vernis à craqueler, des cadres en acier, de la peinture au pistolet et des leds. « Travailler avec l'excès fait partie de mon travail », dit Reyle, « c'est une promenade sur le fil du rasoir qui peut parfois faire mal. »
J. A.

SELECTED EXHIBITIONS →
2008 *Vertrautes Terrain – Aktuelle Kunst in und über Deutschland*, ZKM, Karlsruhe. *abstrakt/abstract*, Museum Moderner Kunst Kärnten, Klagenfurt **2007** *Anselm Reyle: The 5th Dream*, Modern Institute, Glasgow. *The Artist's Dining Room: Manfred Kuttner, Anselm Reyle, Thomas Scheibitz*, Tate Modern, London. *Ruinöse Abstraktion: Es gibt Dinge, die kann man nicht erklären*, Bonner Kunstverein, Bonn. *Sequence 1*, Palazzo Grassi, Venice **2006** *Anselm Reyle: Ars Nova*, Kunsthalle Zürich

SELECTED PUBLICATIONS →
2007 *Sequence 1*, Palazzo Grassi, Venice; Skira, Milan. *Minimalism and After*, Hatje Cantz, Ostfildern **2006** *Anselm Reyle: Ars Nova*, Kunsthalle Zürich, Zürich. *Painting in Tongues*, MOCA, Los Angeles **2005** *Etwas von etwas. Abstrakte Kunst*, Verlag der Buchhandlung Walther König, Cologne **2004** *Anselm Reyle*, Galerie Giti Nourbakhsch, Berlin

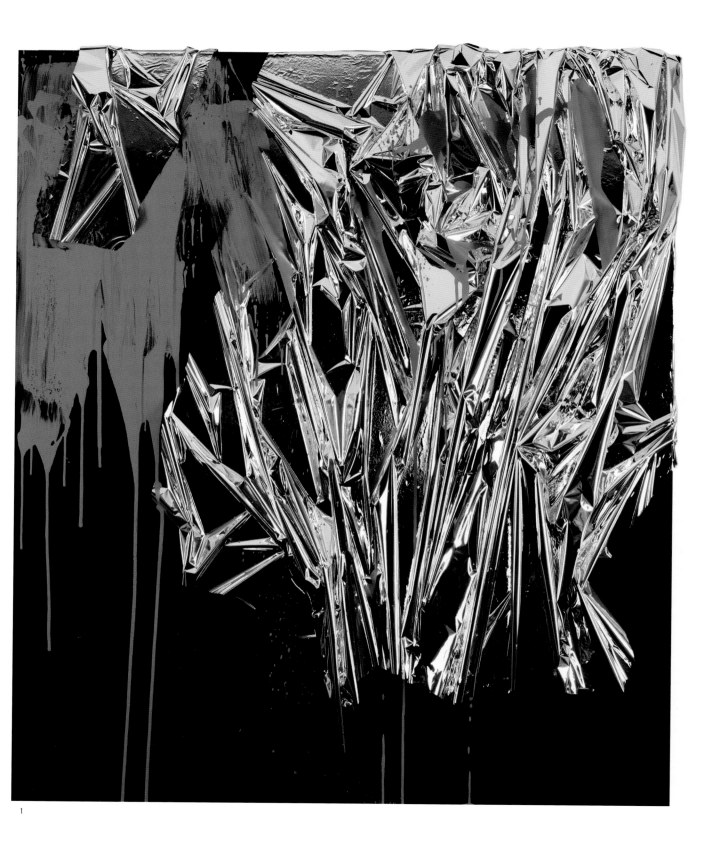

1 **Untitled**, 2006, mixed media on canvas, foil, acrylic glass,
 234 x 199 x 25 cm
2 **Untitled**, 2008, mixed media on canvas, found objects, crinkle lacquer,
 metal frame, 135 x 114 cm
3 **Harmony**, 2007, bronze, chrome, enamel varnish, veneer pedestal
 (makassa wood), 98 x 108 x 46 cm, pedestal 90 x 90 x 40 cm

4 Installation view, *Painting in Tongues*, The Museum of Contemporary Art,
 Los Angeles, 2006
5 **Heuwagen**, 2008, found object, wood, metal, neon-yellow lacquer, black
 light lamps, dimensions variable

„Mich interessieren vor allem die Sackgassen der Moderne." « Ce qui m'intéresse avant tout, ce sont les impasses de la modernité. »

"What interests me most are the dead ends of modernism."

2

3

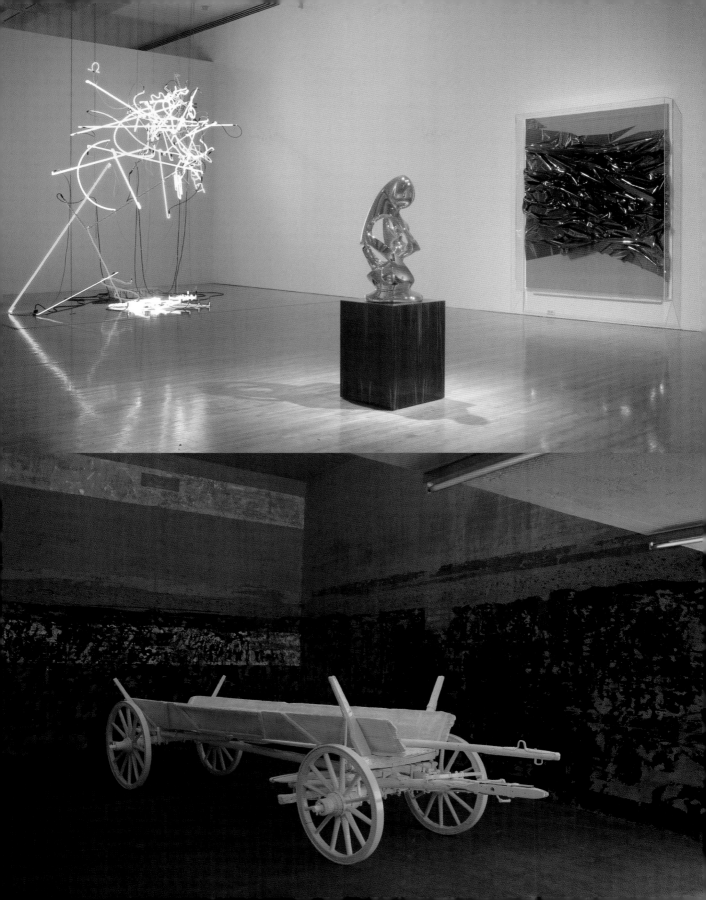

Daniel Richter

1962 born in Eutin, lives and works in Berlin and Hamburg, Germany

Ever since Daniel Richter moved away from psychedelic-ornamental abstraction in favour of more allegorical – although no less psyche-delic – figuration around the start of the decade, he has developed his oeuvre towards large-scale, vibrantly coloured paintings with a political background. He skilfully combines painting styles of the last few centuries with a maximization of effect and a picture archive drawn from art-historical, mass-media and pop-cultural sources. Whereas he initially alienated images from the print media and placed them in a new context, today his compositions are more dream-like and studded with quotations. *Revidyll* (2006) shows a figure dissolving in a fiery blaze and plunging head over heels into the depths. At the top left, a skeleton in a red cloak stands on El Lissitzky's rostrum for Lenin, while below there is a pastoral landscape with Lenin und Shostakovich. While the painting could be interpreted as a swan song for socialist revolution and modernism, the falling figure also recalls images of 9/11. *Alles ohne Nichts* (2007) depicts a skeleton in front of a colour screen reminiscent of Gerhard Richter, embracing a feathered figure on a pedestal – associations with Max Ernst's paintings or with torture victims from Abu Ghraib are evoked. Glowing, zombie-like figures and crowds frequently inhabit Richter's images; in *The Owner's Historic Lesson* (2007), for example, they gather together for a kind of zombie hearing around a figure discernible only as a dark form. The toxic colour palette is inspired by infrared surveillance cameras or drug-induced trips. Richter differentiates between history painting and dream images, but above all he eschews one-sided interpretations of his work and confronts the mendacity of media images with conscious ambivalence.

Seit Daniel Richter um 2000 die psychedelisch-ornamentale Abstraktion zugunsten einer eher allegorischen, jedoch nicht minder psyche-delischen Figuration aufgegeben hat, entwickelt er seine Malerei als farbenreiches Großformat mit politischem Hintergrund konsequent weiter. Virtuos verbindet er Malstile der letzten Jahrhunderte mit Effektmaximierung und einem Bildarchiv aus Kunstgeschichte, Massenmedien und Popkultur. Waren es anfangs Pressebilder, die verfremdet und neu kontextualisiert wurden, sind es heute eher traumartige, von Zitaten gespickte Kompositionen. *Revidyll* (2006) zeigt eine sich in gleißendem Feuer auflösende Figur, die kopfüber in die Tiefe stürzt. Links oben erkennt man ein rot gewandetes Skelett auf El Lissitzkys Rednertribüne für Lenin, unten eine pastorale Landschaft sowie Lenin und Schostakowitsch. Man könnte das Bild als Abgesang auf die sozialistische Revolution und die Moderne deuten, gleichzeitig erinnert die fallende Figur an Bilder von 9/11. *Alles ohne Nichts* (2007) zeigt vor einem an Gerhard Richter erinnernden Farbraster ein Skelett, das eine zerfederte Figur auf einem Podest umklammert – Assoziationen an Max Ernsts Gemälde oder die Folteropfer von Abu Ghraib tauchen auf. Immer wieder bevölkern zombiehafte, glühende Einzelfiguren oder Menschenmengen die Bilder. In *The Owner's Historic Lesson* (2007) etwa versammeln sie sich zu einer Art Zombie-anhörung um eine nur als dunkle Form zu erkennende Figur. Die giftige Palette ist inspiriert von Infrarotüberwachungskameras oder Drogenerfahrungen. Richter unterscheidet zwischen Historienmalerei und Traumbildern, vor allem aber verwehrt er sich gegen eine eindeutige Auslegbarkeit seiner Bilder und begegnet der Verlogenheit der Medienbilder mit bewusster Ambivalenz.

Vers 2000, Daniel Richter abandonnait l'abstraction psychédélico-ornementale au profit d'une figuration plus allégorique, mais non moins psychédélique. Depuis, il développe sa peinture de manière cohérente dans de grands formats hauts en couleurs, avec un arrière-plan politique et combine en virtuose styles picturaux des derniers siècles, potentialisation des effets, archivage iconique mêlant histoire de l'art, massmedia et culture pop. Après avoir détourné et recontextualisé des images de presse, il réalise aujourd'hui des compositions plus oniriques truffées de citations. Dans *Revidyll* (2006), une figure se dissout dans un feu éblouissant et s'abîme dans les profondeurs. En haut à gauche, un squelette vêtu de rouge apparaît à la tribune créée par El Lissitzky pour Lénine ; en bas, on voit un paysage bucolique avec Lénine et Chostakovitch. On pourrait interpréter ce tableau comme le chant du cygne de la révolution socialiste et de la modernité, mais la figure qui chute évoque aussi des images du 11 Septembre. Devant une trame de couleurs qui rappelle Gerhard Richter, *Alles ohne Nichts* (2007) montre un squelette s'agrip-pant à une figure emplumée posée sur un piédestal, éveillant des associations indirectes avec les peintures de Max Ernst ou les victimes de la prison d'Abu Ghraib. Les tableaux sont régulièrement peuplés de figures rougeoyantes aux allures de zombies, isolées ou en foules. Dans *The Owner's Historic Lesson* (2007), une sorte de procès les réunit autour d'un personnage qu'on discerne seulement comme une forme obscure. La palette vénéneuse est inspirée des caméras de surveillance infrarouges ou des expériences de drogue. Si Richter distingue entre peinture d'histoire et images oniriques, son ambivalence maîtrisée défend surtout ses tableaux contre toute interprétation univoque et contre la duplicité des images médiatiques.

E. S.

SELECTED EXHIBITIONS →
2008 *Daniel Richter: A Major Survey*, Denver Art Museum, Denver
2007 *Daniel Richter*, Hamburger Kunsthalle, Hamburg; Gemeenten-museum, Den Haag; CAC Málaga **2006** *Daniel Richter: Die Peitsche der Erinnerung*, Kunsthaus Stade; Kunstverein Rosenheim; Helms Museum, Hamburg **2005** *Daniel Richter: Pink Flag – White Horse*, The Power Plant, Toronto; National Gallery of Canada, Ottawa; Morris and Helen Belkin Art Gallery, Vancouver

SELECTED PUBLICATIONS →
2008 *Stations: 100 Meisterwerke Zeitgenössischer Kunst*, DuMont, Cologne **2007** *Daniel Richter. Die Palette 1995–2007*, DuMont, Cologne. **2006** *Daniel Richter, Huntergrund*, Kunstmuseum Basel, Basle; Hatje Cantz, Ostfildern. *Jonathan Meese, Daniel Richter: Die Peitsche der Erinnerung*, Stadt Stade **2005** *Daniel Richter: Pink Flag – White Horse*, The Power Plant, Toronto

1 **Revidyll**, 2006, oil on canvas, 378 x 248 cm
2 **Alles ohne Nichts**, 2006/07, oil on canvas, 230.3 x 319.9 x 4.5 cm

3 **Die Wahrheit bei Nacht**, 2007, oil on canvas, 230 x 330 cm
4 **The Owner's Historic Lesson**, 2007, oil on canvas, 378 x 248 cm

„Hier ist der Maler und da die Gemälde. Der Maler und die Haltung halten das Bild zusammen. Wenn du zwei Gemälde von mir hast, dann haben die nicht unbedingt viel miteinander zu tun. Ein Bild mag zum Ziel haben, ganz flach, banal und nervös zu sein, während ein anderes ziemlich lose gestrickt ist und einfach nur eine vorbeiziehende Gestalt oder einen schlappen Geist darstellt. Auf der formalen Ebene haben die nicht viel gemeinsam."

« D'un côté le peintre, de l'autre les peintures. Le peintre et la posture assurent la cohésion du tableau. Quand tu vois deux de mes tableaux, ils n'ont pas forcément grand chose à voir l'un avec l'autre. L'un peut avoir pour but d'être complètement plat, banal et nerveux, tandis que l'autre est composé de manière plutôt dissolue et ne représente qu'une figure qui passe ou un esprit flottant. Du point de vue formel, ils n'ont pas grand chose en commun. »

"There is the artist and then there are the paintings, which are more speculations on everyday life and history. The painter and the attitude hold the work together. If you have two paintings of mine they don't necessarily have a lot to do with each other. One painting might have the aim of being super-flat, banal and edgy, while another might be quite loose and just portray a drifting figure or a ghost. On a formal level they do not have so much in common."

2

Thomas Ruff

1958 born in Zell am Harmersbach, lives and works in Düsseldorf, Germany

In 2008 Thomas Ruff temporarily put aside his favourite medium – photography – to experiment with inkjet drawings on canvas. This new series, entitled *zycles* (2008), comprises large-scale works depicting sinuous lines flowing on the surface of the images in an elegant dance of geometrical forms. Finding inspiration in 19th century engravings on electromagnetism, Ruff used a 3-D program to translate mathematical cycloids into mesmerizing structures, turning them into graceful shapes that still preserve their scientific quality. Though distant from Ruff's previous works, these drawings expand the artist's investigation of the potential of reproduction technologies. They also connect to his interest in found materials and the circulation of images. From his early portraits to his most recent enlarged prints of images downloaded from the internet, Ruff has been testing out the limits of photography. As an extension of his *Nudes* and *Substrate* series, Ruff's more recent *jpeg* series appropriates familiar images from the web to explore the transformation and degeneration images undergo when they are distributed electronically. His monumental prints of pixellated jpegs create an almost impressionist effect that gets a very sharp turn with recent *jpegs* that engage with current events such as terrorism, war and ecological disasters (*jpeg ib02*, 2007). Ruff uses these images less to focus on our fixation with images of destruction but to investigate – as in the form er *jpegs* of landscapes, for example – the process of abstraction linked to the digitization of images and how this process affects the medium of photography and our common memory.

2008 legte Thomas Ruff sein bevorzugtes Medium – die Fotografie – vorläufig beiseite, um mit Inkjet-Zeichnungen auf Leinwand zu experimentieren. Die neue Serie *zycles* (2008) umfasst großformatige Bilder von in Schwingung versetzten Linien, die in eleganten geometrischen Formen über die Bildfläche fließen. Inspiriert von der Darstellung elektromagnetischer Felder auf Kupferstichen des 19. Jahrhunderts, verwendete Ruff ein 3-D-Computerprogramm für die Übersetzung mathematischer Kurven in faszinierende Linienstrukturen, deren formaler Schönheit noch immer der wissenschaftliche Hintergrund anzusehen ist. Auch wenn diese Zeichnungen sehr verschieden von Ruffs früheren Arbeiten scheinen, führen sie doch seine Untersuchung der Möglichkeiten von Reproduktionstechnologien fort. Ebenso knüpfen sie an sein Interesse für vorgefundene Materialien und die Verbreitung bestimmter Bilder an. Von seinen frühen Porträts bis zu den jüngsten Prints vergrößerter Fundstücke aus dem Internet lotet Ruff die Grenzen der Fotografie aus. Im Anschluss an seine Serien *Nudes* und *Substrate* eignet sich der Künstler in der neueren *jpeg*-Serie vertraute Bilder aus dem Netz an, um sich mit den Auswirkungen der Transformation und Degeneration zu beschäftigen, deren sie zwecks elektronischer Verbreitung unterzogen werden. Seine monumentalen pixeligen Internet-Blow-ups erzeugen einen fast impressionistischen Eindruck, bei aller inhaltlichen Schärfe in den neuen *jpegs* zu aktuellen Ereignissen im Kontext von Terrorismus, Krieg und Umweltkatastrophen (*jpeg ib02*, 2007). Statt unsere Fixierung auf Bilder der Zerstörung zu fokussieren, benutzt Ruff diese Abbildungen, um – wie etwa in den früheren Landschafts-*jpegs* – den mit der Digitalisierung von Bildern verbundenen Abstraktionsvorgang und seinen Einfluss auf das fotografische Medium und unser kollektives Gedächtnis zu erforschen.

En 2008, Thomas Ruff met provisoirement de côté son médium de prédilection, la photographie, pour s'essayer au dessin au jet d'encre sur toile. Cette nouvelle série, intitulée *zycles* (2008), comporte des œuvres de grand format où apparaissent des lignes sinueuses flottant sur la surface des images, tel un élégant ballet de formes géométriques. Puisant son inspiration dans des gravures du XIXᵉ siècle sur l'électromagnétisme, Ruff a utilisé un programme 3D pour traduire des cycloïdes mathématiques en structures hypnotiques et en faire des formes gracieuses dont les qualités scientifiques sont préservées. S'ils se démarquent des œuvres précédentes de Ruff, ces dessins prolongent la recherche de l'artiste sur le potentiel des technologies de reproduction. Ces travaux sont aussi liés à l'intérêt de Ruff pour les matériaux trouvés et pour la circulation des images. Depuis ses premiers portraits jusqu'à ses plus récentes impressions élargies d'images téléchargées sur Internet, Ruff teste les limites de la photographie. Dans le prolongement de ses séries *Nudes* et *Substrate*, la série plus récente *jpeg* s'approprie les images familières de l'Internet pour interroger les effets de la transformation et de la dégénérescence auxquelles les images sont soumises lorsqu'elles sont distribuées via l'Internet. Les impressions monumentales de photos pixellisées créent un effet quasi impressionniste particulièrement marquant sur la récente série *jpeg* qui traite d'évènements d'actualité comme le terrorisme, la guerre et les catastrophes écologiques (*jpeg ib02*, 2007). Pour Ruff, il s'agit moins de pointer notre obsession des images de destruction que d'explorer – comme dans les précédents paysages *jpeg* – le processus d'abstraction lié à la numérisation des images et la manière dont ce processus affecte à la fois la photographie et notre mémoire commune.

C. A.

SELECTED EXHIBITIONS →
2008 *Translocalmotion*, 7th Shanghai Biennale, Shanghai. *Street & Studio*, Tate Modern, London. *That Was Then...This Is Now*, P.S.1, Contemporary Art Centre, Long Island City **2007** *Thomas Ruff: jpegs*, Moderna Museet, Stockholm. *The Sprengel Project*, Sprengel Museum, Hanover. *Depth of Field: Modern Photography*, MoMA, New York **2006** *Thomas Ruff: The Grammar of Photography*, Fondazione Bevilacqua La Masa, Venice

SELECTED PUBLICATIONS →
2006 *Thomas Ruff: The Grammar of Photography*, Fondazione Bevilacqua La Masa, Venice **2005** *Thomas Ruff: m.d.p.n.*, Charta, Milan. *Thomas Ruff: jpeg NY03*, Salon, Cologne

1 **jpeg ib02**, 2007, C-print, 243 x 188 cm
2 **jpeg icbm01**, 2007, C-print, 246 x 188 cm

3 **zycles 3048**, 2008, inkjet print on canvas, 295 x 230 cm

„Ich sehe Bilder und weiß nicht, wie sie gemacht wurden; ich möchte wissen, wie das Bild funktioniert, wie wir es wahrnehmen. Wir nehmen die sichtbare Welt mit den Augen wahr, aber das Gehirn generiert die Bilder und unseren Erfahrungsschatz, der allem, was wir sehen, Bedeutung verleiht.“

« Je vois les images et je ne sais pas comment elles ont été faites ; je dois découvrir comment l'image fonctionne, comment nous la percevons. Le monde visible est vu par les yeux, mais c'est notre cerveau qui génère les images et l'ensemble de notre expérience qui donne du sens à ce que l'on voit dans le monde. »

“I see images, and I don't know how they were done; I have to find out how the image works, how we perceive it. The visible world is seen through the eyes, but it's our brain that creates the images and our whole experience that gives meaning to what you see in the world.”

2

Anri Sala

1974 born in Tirana, Albania, lives and works in Berlin, Germany

Anri Sala works with alienation effects that subvert familiar experiences of seeing and hearing in order to enable new forms of reception. For the Frankfurt exhibition *Three Minutes*, Sala reworked his silent video *Cymbal* (2004) into a video installation entitled *After Three Minutes* (2007). *Cymbal* is a close-up of a drum cymbal reflecting the flash of a strobe light, which creates a kind of optical sound effect. In *After Three Minutes*, Sala took the interaction between withholding and providing information onto a new level: a slightly modified version of *Cymbal* is shown on one screen of the double projection, while the same video is presented on the other screen, but filmed by the surveillance cameras in a museum so that it is shown from different angles and with a different image quality. In other works, Sala passes acoustic rather than optical information through a series of filters and media. *Air Cushioned Ride* (2006) documents an atmospheric coincidence. While driving around a car park, Sala heard how his car radio picked up two music stations at once. This was caused by the presence of a number of large trucks nearby, which deflected or blocked the radio waves. The camera circles the parked lorries repeatedly and the sound alternates between baroque chamber music and Country & Western. Sala had the resulting soundtrack transcribed and played live in a joint performance by a baroque trio and a Country & Western band; such a musical performance is documented in the video *A Spurious Emission* (2007). The score also exists under the same title, enabling further permutations of what started out as a form of (co-)incidental music.

Anri Sala arbeitet mit Verfremdungseffekten, die gewohnte Seh- und Hörerlebnisse unterlaufen, um neue Rezeptionsformen zu ermöglichen. Salas Videoinstallation *After Three Minutes* (2007) verarbeitet sein stummes Video *Cymbal* (2004) für die Frankfurter Ausstellung *Three Minutes*. Das Video zeigt in Nahaufnahme das Becken eines Schlagzeugs, das grelles Licht eines Stroboskops reflektiert und so eine Art optischen Klangeffekt simuliert. In *After Three Minutes* hat Sala das Wechselspiel zwischen Informationsentzug und -gewinn um eine zusätzliche Ebene erweitert: Die Doppelprojektion zeigt auf dem einen Bildschirm eine leicht modifizierte Fassung von *Cymbal*, auf dem anderen das gleiche Video, jedoch abgefilmt von den Überwachungskameras eines Museums, so dass es nun mit anderer Bildqualität aus verschiedenen Blickwinkeln wiedergegeben wird. In weiteren Arbeiten lässt Sala nicht optische, sondern akustische Informationen eine Reihe von Filtern und Medien durchlaufen. *Air Cushioned Ride* (2006) ist die Dokumentation eines atmosphärischen Zufalls. Beim Befahren eines Parkplatzes erlebte Sala, wie zwei Musiksender zugleich in den Frequenzbereich seines Radios gerieten, verursacht durch eine Reihe großer Trucks, die Funkwellen ablenkten oder blockierten. Die Kamera umkreist mehrfach die geparkten LKWs, die Tonspur gibt abwechselnd barocke Kammermusik und Country-Musik wieder. Der so entstandene Soundtrack wurde im Anschluss transkribiert und von einem Barocktrio und einer Country-Band gemeinsam live aufgeführt. Das Video *A Spurious Emission* (2007) ist die Aufnahme einer solchen musikalischen Darbietung, unter gleichem Titel existiert ferner die dazugehörige Partitur, die wiederum weitere Manifestationen dieser zunächst so zufällig entstandenen Musik erlaubt.

Anri Sala travaille avec des effets de distanciation qui court-circuitent les expériences visuelles et auditives habituelles pour produire de nouvelles formes de réception. L'installation vidéo *After Three Minutes* (2007) reprenait la vidéo muette *Cymbal* (2004) réalisée pour l'exposition *Three Minutes* présentée à Francfort. *Cymbal* montrait en plan rapproché la caisse d'une batterie reflétant la lumière aveuglante d'un stroboscope, simulant ainsi visuellement une sorte d'effet sonore. Dans *After Three Minutes*, Sala a étendu l'interaction entre la rétention et la diffusion d'information en l'enrichissant d'un niveau supplémentaire : un des écrans de la double projection montre une version légèrement modifiée de *Cymbal*, l'autre montre la même vidéo, mais filmée par les caméras de surveillance d'un musée, et donc restituée dans une qualité d'image et à partir de points de vue différents. Dans d'autres œuvres, Sala fait passer un ensemble d'informations – acoustiques cette fois-ci – par toute une série de filtres et de médiums. *Air Cushioned Ride* (2006) est le documentaire d'une péripétie atmosphérique : en circulant sur un parking, Sala fut interpellé par la manière dont deux stations émettrices entraient simultanément dans le champ de fréquence de sa radio à cause de grands camions qui bloquaient ou déviaient les ondes. La caméra tourne plusieurs fois autour des camions, la bande son diffuse alternativement de la musique de chambre baroque et de la musique country. La bande son ainsi obtenue fut ensuite transcrite et jouée live par un trio baroque et un groupe de country. La vidéo *A Spurious Emission* (2007) est la prise de vue d'un tel événement musical. Sous le même titre existe aussi la partition correspondante, laquelle permet à son tour de rejouer cette musique née de manière si aléatoire. A. M.

SELECTED EXHIBITIONS →
2008 *Anri Sala*, MOCA, North Miami. *Anri Sala*, Kabinett für aktuelle Kunst, Bremerhaven. *Der große Wurf: Faltungen in der Gegenwartskunst*, Kaiser Wilhelm Museum; Museum Haus Lange, Krefeld **2007** *Rethinking Dissent*, 4th Göteborg International Biennial, Göteborg. *Air de Paris*, Centre Pompidou, Paris **2006** *Zones of Contact*, 15th Biennale of Sydney. *Of Mice and Men*, 4th Berlin Biennial for Contemporary Art, Berlin **2005** *Anri Sala*, Centre for Contemporary Art, Warsaw

SELECTED PUBLICATIONS →
2008 *Der große Wurf. Faltungen in der Gegenwartskunst*, Kunstmuseen Krefeld; modo Verlag, Freiburg **2006** *Anri Sala*, Phaidon Press, London. *Vitamin Ph: New Perspectives in Photography*, Phaidon Press, London. *Zones of Contact*, Biennale of Sydney, Sydney. *Of Mice and Men*, 4th Berlin Biennial for Contemporary Art, Berlin; Hatje Cantz, Ostfildern **2005** *Anri Sala*, Centre for Contemporary Art, Warsaw

1 **Flutterby**, 2007, colour photograph on dibond, 80.2 x 56.5 cm,
from the series *4 Butterflies*, a performance for *Il Tempo del Postino*,
Manchester International Festival, 2007
2 **A Spurious Emission**, 2007, video projection, colour, sound, 7 min 33 sec

3 **Air Cushioned Ride**, 2006, video projection, colour, sound, 6 min 4 sec
4 **After Three Minutes**, 2007, video, double-channel projection, colour,
no sound, 3 min
5/6 **Title Suspended**, 2008, resin, nitrile, electric motor, 20 x 82 x 20 cm

„Genau wie mein Leben ist meine Arbeit durch Brüche, durch Übergänge und Zwischenstationen geformt, inspiriert und beschränkt."

« Comme ma vie, mon travail est continuellement modelé, inspiré et dicté par la rupture et les étapes transitoires ou intermédiaires. »

"Like my life, my work is continuously shaped, inspired and constrained by rupture, and transitory or intermediate stations."

2

3

4

Wilhelm Sasnal

1972 born in Tarnów, lives and works in Tarnów and Warsaw, Poland

Wilhelm Sasnal is not just a passionate painter but also a versatile filmmaker. In both media he explores the potential of images to refer to things which have been seen or which once were. Despite the broad scope of his subject matter, a preoccupation with the history of his homeland is a recurrent theme in his work. Sasnal interprets Poland's political and cultural transformation since the 1960s with the aid of pop-cultural references such as book or record covers and images from the press or advertising. His main concern is to examine the collective memory of his own generation – a society trapped in its past but still looking to the future. While Sasnal's paintings have recently been moving away from specific source images, his films make increasing use of moving images that already exist. In *Let Me Tell You a Film* (2007), for example, he recorded the television broadcast of a Polish feature film with a video camera, cut it down into a ten-minute silent film, added text inserts and copied it back onto film. The original film tells the true story of two friends who sell methyl alcohol as vodka and through this act of negligence cause someone's death. Sasnal looks on this historical fragment – a tale of guilt and responsibility – as a story that has already been told and asks how it would look from a different angle – in terms of content as well as medium. A series of paintings are clustered thematically around the film, whereby their subject matter, spatial arrangement and coloration convey an almost physical feeling of unease, the sensation of a painful awakening – which in Sasnal's case can most certainly be understood in a broader sense.

Wilhelm Sasnal ist nicht nur ein leidenschaftlicher Maler, sondern auch ein umtriebiger Filmemacher. In beiden Medien erforscht er das Potenzial von Bildern, auf Gesehenes oder Gewesenes zu verweisen. Trotz der großen Bandbreite seiner Sujets zieht sich die Beschäftigung mit der Geschichte seines Heimatlandes wie ein roter Faden durch sein Werk. Er interpretiert die kulturelle und politische Transformation Polens seit den 1960er-Jahren, indem er unter anderem popkulturelle Referenzen wie Buch- und Plattencover sowie Bilder aus Presse und Werbung verarbeitet. Sein Fokus liegt dabei auf der Untersuchung des kollektiven Gedächtnisses seiner eigenen Generation – einer Gesellschaft, die in ihrer Vergangenheit gefangen ist und dabei trotzdem in die Zukunft blickt. In jüngster Zeit beruhen Sasnals Gemälde immer weniger auf konkreten Vorlagen, seine Filme dagegen immer mehr auf bereits existierenden bewegten Bildern. So hat Sasnal für *Let Me Tell You a Film* (2007) einen polnischen Spielfilm während seiner Ausstrahlung im Fernsehen per Videokamera aufgenommen, auf einen zehnminütigen Stummfilm zusammengeschnitten, mit Texteinschüben versehen und wieder auf Film rückkopiert. Der ursprüngliche Film erzählt die wahre Begebenheit zweier Freunde, die Methylalkohol als Wodka verkaufen und damit fahrlässig den Tod eines Menschen verursacht haben. Sasnal betrachtet dieses historische Fragment, diese Erzählung um Schuld und Verantwortung als bereits vermittelte Geschichte und fragt danach, wie eine erneute Betrachtung aussehen kann – auf der inhaltlichen wie der medialen Ebene. Um den Film schart sich thematisch eine Reihe von Gemälden, deren Themen, Raumgestaltung und Farbigkeit ein nahezu physisches Unbehagen vermitteln, das Gefühl eines schmerzhaften Erwachens – was bei Sasnal durchaus im übertragenen Sinne zu verstehen ist.

Wilhelm Sasnal n'est pas seulement un peintre passionné, mais aussi un cinéaste très actif. Dans ces deux médiums, il explore la propriété qu'ont les images à nous renvoyer à une chose vue ou à un événement passé. Malgré la grande diversité de ses sujets, le travail sur l'histoire de son pays natal parcourt son œuvre comme un fil conducteur. Sasnal interprète l'évolution culturelle et politique de la Pologne depuis les années 1960 en travaillant sur certaines références de la culture populaire – couvertures de livres et pochettes de disques, images de presse et publicités. Dans ce contexte, son intérêt porte principalement sur l'étude de la mémoire collective de sa génération, société prisonnière de son passé, mais néanmoins tournée vers l'avenir. Dans ses peintures récentes, Sasnal s'appuie de moins en moins sur des modèles existants, alors que ses films partent de plus en plus souvent d'images animées existantes. C'est ainsi que pour *Let Me Tell You a Film* (2007), il a réalisé l'enregistrement vidéo d'un film polonais lors de sa diffusion à la télévision, en a remonté une version muette réduite à dix minutes et l'a agrémentée d'insertions textuelles avant de la recopier au format cinématographique. Le film original racontait l'histoire vraie de deux amis qui avaient vendu du méthanol pour de la vodka, causant ainsi la mort d'un homme. Sasnal considère ce fragment d'histoire, ce récit autour de la faute et de la responsabilité, comme de l'histoire déjà transmise et se demande à quoi pourrait ressembler une nouvelle approche – sur les plans sémantique autant que médiatique. Autour du film viennent se grouper thématiquement toute une série de peintures dont les sujets, le traitement de l'espace et de la couleur communiquent un malaise presque physique, le sentiment d'un réveil douloureux – ce qui, chez Sasnal, doit être pris au sens figuré.

A. M.

SELECTED EXHIBITIONS →
2008 *Back to Black. Die Farbe Schwarz in der aktuellen Malerei*, Kestnergesellschaft, Hanover. *Peripheral Vision and Collective Body*, Museion, Bolzano **2007** *Wilhelm Sasnal, Years of Struggle*, Zacheta National Gallery of Art, Warsaw; Galleria Civica di Arte Contemporanea di Trento. *What Is Painting?*, MoMA, New York **2006** *Wilhelm Sasnal*, Van Abbemuseum, Eindhoven. *Wilhelm Sasnal: Ist das Leben nicht schön?*, Frankfurter Kunstverein, Frankfurt am Main

SELECTED PUBLICATIONS →
2007 *Wilhelm Sasnal, Years of Struggle*, Zacheta National Gallery of Art, Warsaw; Galleria Civica di Arte Contemporanea di Trento, Trento **2006** *The Vincent*, The Vincent van Gogh Biennial Award for Contemporary Art in Europe, Stedelijk Museum, Amsterdam. *Wilhelm Sasnal: Paintings & Films*, Van Abbemuseum, Eindhoven; Veenman Publishers, Rotterdam **2005** *The Triumph of Painting: The Saatchi Collection, Vol. 2*, Saatchi Gallery, London; Verlag der Buchhandlung Walther König, Cologne

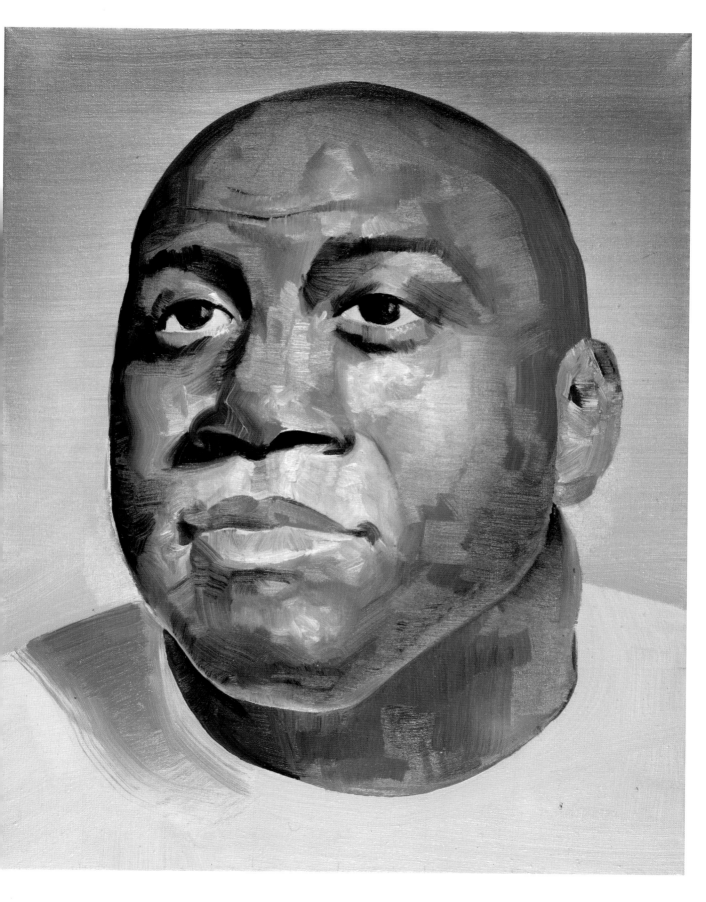

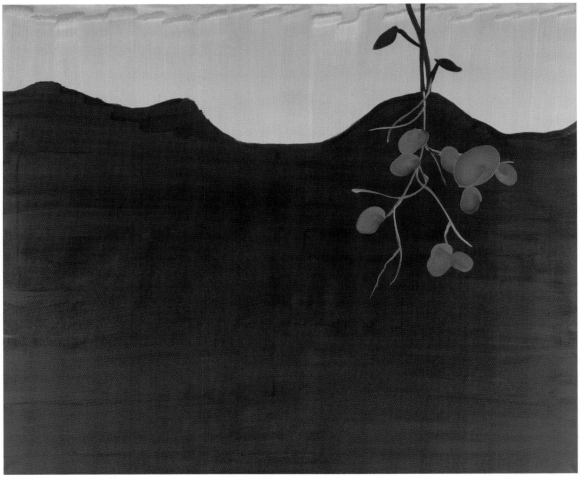

1 **Magic Johnson**, 2006, oil on canvas, 40 x 35 cm
2 **Section through the Ground with Potatoes 1**, 2006, oil on canvas, 99.7 x 139.7 cm

3 **Section through a Fuselage**, 2006, oil on canvas, 190 x 190 cm

„Wenn ich jemanden male, erschaffe ich eine ganze Welt. Ich glaube, das ist wie beim Film – eine gewisse Festigkeit, eine Dichte des Mediums, wie Ölfarbe. Wie man es dann zeigt spielt auch eine Rolle – ein projiziertes Bild hat seine ganz besondere Qualität."

« Quand je peins quelqu'un, je crée une sorte d'univers. Je pense qu'un film a un effet analogue – une certaine solidité, une densité du médium, comme la peinture à l'huile. La présentation a elle aussi son importance – l'image projetée par un projecteur possède une qualité tout à fait unique. »

"When I paint someone, I create a kind of universe. I think film produces a similar effect – a certain solidness, a density of the medium, like oil paint. The way you show it also matters – the image thrown by the projector has its unique quality."

2

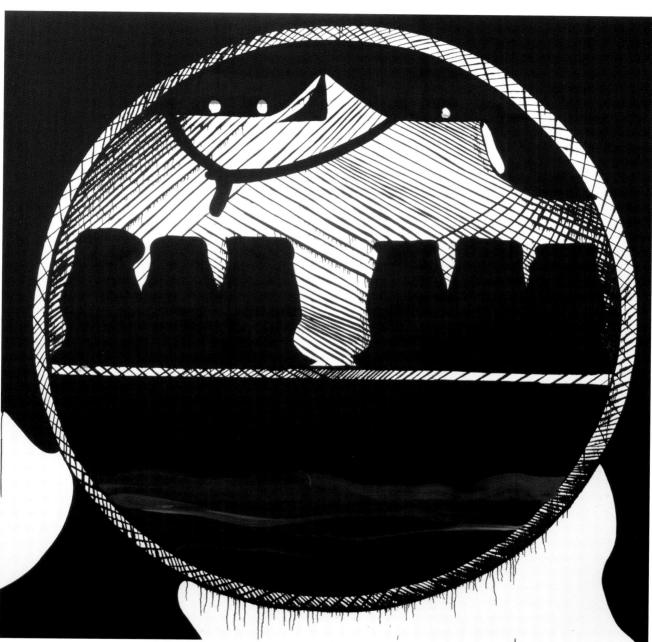

Matthias Schaufler

1964 born in Laichingen, lives and works in Berlin, Germany

In Matthias Schaufler's paintings, ethereal apparitions hover ambiguously in front of a background that is composed from a palette of chartreuse, marigold, lavender and taupe, smeared and blended like patches of fog or obscured as if seen through a blurry kaleidoscope. The attenuated figures that populate the colourful atmospheric fields in paintings like *Ficken 2007* (2006) recall the dancing figures in Henri Matisse's *La Danse* (1909), while the colours sometimes lead into Nabi territory. But Schaufler does not aim at spinning a web of art-historical cross-references, his true strength lies in the psychology of these paintings. The facial and bodily features of his sexually ambiguous, apparently nude human beings remain strangely undefined, relying on gestures and poses for their expressiveness. They stretch and twist their limbs like ballet dancers, appearing to cower or skip, to strike poses or dive into invisible pools, but they cannot escape the flatness of the picture plane. Especially in the more sparse paintings the fog lifts and the figures become clearer, they seem to act out an important act, resembling the personage in a not quite defined history painting. Schaufler's *Selbstporträt* (2008) portrays the artist as a sketchy figure standing starkly against a white ground, surrounded by multi-coloured scribbled circles, as if he couldn't decide on a fitting background motif. Like this raw figure, Schaufler's paintings exist in an indeterminate state. They carry the psychological heft of free-hand studies of nude models that refuse to surrender and become finished portraits, still they are rounded works that do not deny their blemishes, they are "almost perfect", in the words the artist himself uses to describe the ideal work of art.

In Matthias Schauflers Gemälden scheinen ätherische Wesen vor einem Bildhintergrund von Chartreusegrün, Sumpfdottergelb, Lavendel und Taupe zu schweben, wie verschwimmende, nebelhafte Formen oder auch verdunkelt und diffus wie in einem unscharfen Kaleidoskop. Die schemenhaften Gestalten in den farbigen, atmosphärisch dichten Malfeldern wie *Ficken 2007* (2006) erinnern an die tanzenden Figuren von Henri Matisses *La Danse* (1909), die Farben manchmal eher an die Nabis. Aber Schaufler will keine Vernetzungen kunstgeschichtlicher Referenzen, seine wahre Stärke liegt in der Psychologie dieser Bilder. Die Gesichts- und Körpermerkmale seiner geschlechtlich uneindeutigen, anscheinend nackten menschlichen Figuren bleiben seltsam ausdruckslos, die Expressivität liegt in den Gesten und Haltungen. Wie Ballett-tänzer scheinen sie sich mit gestreckten und verdrehten Gliedern zu ducken und zu springen, Posen einzunehmen oder in unsichtbare Teiche einzutauchen, aber ohne der Zweidimensionalität der Bildfläche zu entkommen. Insbesondere in den sparsameren Gemälden erscheinen die Figuren schärfer konturiert, als führten sie, Charakteren in einem nicht näher bezeichneten Historiengemälde gleich, eine bedeutsame Tat aus. In Schauflers *Selbstporträt* (2008) steht die skizzenhafte Künstlergestalt steif vor dem weißen Hintergrund, inmitten bunter kreisförmiger Kleckse, scheinbar unschlüssig, welches Motiv am besten passen würde. Wie diese unklare Figur existieren auch Schauflers Gemälde in einem unfertigen Zustand. Sie transportieren die psychologische Tiefe von Freihandzeichnungen nach Aktmodellen, die sich dem Zustand ihrer Vollendung verweigern, und doch sind es ausgewogene Arbeiten, die zu ihren Unvollkommenheiten stehen. Sie sind „fast perfekt" – wie der Künstler selbst einmal das ideale Kunstwerk beschrieb.

Dans les tableaux de Matthias Schaufler, des apparitions éthérées et incertaines errent sur fond de palette chartreuse, rose indien, lavande et taupe, étalées et mélangées telles des nappes de brume ou assombrie, comme vues à travers un kaléidoscope flou. Les fines silhouettes qui peuplent les ambiances colorées de peintures telles que *Ficken 2007* (2006) rappellent celles de *La Danse* (1909) d'Henri Matisse, alors que la palette fait plutôt songer aux Nabis. Mais Schaufler ne cherche pas à tisser une toile de références à l'histoire de l'art. Sa véritable force se trouve dans la psychologie de ses tableaux. Les traits et particularités physiques de ses personnages, apparemment nus, à l'identité sexuelle indéfinie, restent bizarrement imprécis : l'expressivité vient de leurs gestes et attitudes. Tels des danseurs, ils s'étirent et se tordent, semblent se tapir ou bondir, prendre la pose ou plonger dans d'invisibles bassins, mais ils ne peuvent pas s'évader du plan de l'image. Surtout dans les tableaux moins fournis, la brume se dissipe et les silhouettes deviennent plus nettes, elles semblent même jouer une scène importante, reprenant un personnage d'un tableau historique à peine évoqué. Dans *Selbstporträt* (2008), l'artiste se représente en silhouette vague sur fond blanc contrasté, entouré d'un gribouillis de cercles multicolores, comme s'il ne pouvait trouver un motif de fond adéquat. À l'instar de cette silhouette brute, les tableaux de Schaufler existent à l'état indéterminé. Ils portent le poids psychologique d'études de nus à main levée qui refusent de devenir des portraits achevés. Pourtant, ce sont des œuvres harmonieuses qui ne renient pas leurs imperfections, qui sont « presque parfaites », selon les mots de l'artiste pour décrire l'œuvre d'art idéale.

CH. L.

SELECTED EXHIBITIONS →
2008 *Inside* (with Tim Berreshein), Hammelehle und Ahrens, Cologne **2007** *Matthias Schaufler*, Patrick Painter Inc., Santa Monica. *1/2 Golden Year*, FYW Ausstellungsraum, Cologne **2006** *Matthias Schaufler*, Saarlandmuseum, Saarbrücken **2004** *Heiden*, Brother-slasher, Cologne

SELECTED PUBLICATIONS →
2006 *Matthias Schaufler*, Stiftung Saarländischer Kulturbesitz, Saarbrücken **2004** *Matthias Schaufler: Heiden*, Brotherslasher, Cologne

1 **Februar**, 2008, oil on canvas, 300 x 200 cm
2 **Selbstporträt**, 2005, oil on canvas, 100 x 80 cm

3 **Ficken 2007**, 2006, oil on canvas, 240 x 400 cm (240 x 200 cm each)
4 **Selbstporträt**, 2008, oil on canvas, 200 x 200 cm

„Schönheit hat alles, was den Tod überwindet und der Welt zugewandt ist." "La beauté est ce qui triomphe de la mort et se tourne vers le monde."

"That which conquers death and turns its face towards the world, is beautiful."

2

3

Thomas Scheibitz

1968 born in Radeberg, lives and works in Berlin, Germany

Thomas Scheibitz's sculpture *Captain Amely* (2007) almost looks like it might be found in a corporate plaza or on a children's playground – but it wouldn't rest comfortably in either location. Constructed out of MDF – an inexpensive building material and Scheibitz's favoured medium – it consists of a circular form, painted a misfit chartreuse colour and balancing on a curved slab. The combination resembles a wheel of cheese tumbling down a children's slide. Scheibitz's sculptures typically exist on this human scale, too unwieldy to be models and too quirky to look convincingly monumental, more as if they were on their way to becoming something else. Their shapes are harmonious but nonsensical – they may reference the forms of generic logos, tasteless public sculptures or maquettes for imaginary skyscrapers, as if they were poking fun at classical sculpture and architecture – or at themselves. Scheibitz's paintings and sculptures are close relatives; glimpses of one appear in the other. His canvases combine fluid or rounded forms with sharp, geometric ones, adding visual puns on painting's inevitable flatness, such as corners that appear to be turned up or circles that suggest openings in the canvas. As in his sculptures, the forms in his paintings are occasionally reminiscent of figures – they sometimes seem to look at us, even smile or show off, before returning to abstraction. The titles Scheibitz chooses for his sculptures and paintings, like their evasive iconography, are red herrings that give us clues to possible associations, but are never entirely revealing. His works remain peculiarly, but pleasingly, unresolved.

Thomas Scheibitz' Skulptur *Captain Amely* (2007) sieht beinahe aus, als könnte man sie auf der Plaza vor einem großen Bürokomplex oder auf einem Kinderspielplatz finden – aber einen wirklich passenden Standort gibt es nicht dafür. Die MDF-Konstruktion – ein preisgünstiges Baumaterial und Scheibitz' bevorzugtes Medium – besteht aus einem kreisförmigen, in einem absonderlichen Gelbgrün bemaltem Gebilde, das auf einem geschwungenen Ständer balanciert. Die Kombination erinnert an ein Käserad auf einer Kinderrutsche. Typisch für Scheibitz' Skulpturen ist eine menschliche Dimension; zu sperrig für ein Modell und zu extravagant für ein Kulturdenkmal, scheinen sie noch in einem Stadium der Entwicklung zu sein. Ihre Formen sind harmonisch, aber unsinnig. Möglicherweise verweisen sie auf generische Signets, geschmacklose öffentliche Skulpturen oder Architekturmodelle für imaginäre Wolkenkratzer, als ob sie sich über klassische Skulpturen und Architekturen lustig machten – oder auch über sich selbst. Scheibitz' Bilder und Skulpturen sind enge Verwandte, die untereinander Ähnlichkeiten aufweisen. Seine Bilder kombinieren weiche oder runde mit spitzen, geometrischen Formen sowie einen augenzwinkernden Umgang mit der unvermeidlichen Flächigkeit der Bilder, etwa durch scheinbar umgebogene Ecken oder Kreise, die optisch eine Öffnung in der Leinwand vortäuschen. Sowohl die Skulpturen als auch die bildhaften Formen erinnern zuweilen an Gesichter – die uns ansehen, ja sogar schemenhaft zulächeln können, bevor sie wieder in den abstrakten Zustand eintauchen. Durch die Titelwahl seiner Bilder und Skulpturen und deren schwer fassbare Motivwelt kann Scheibitz uns zwar assoziative Brücken bauen, die aber nie eine eindeutige Lesart zulassen. Seine Arbeiten bleiben seltsam, aber angenehm unklar.

On pourrait imaginer la sculpture *Captain Amely* de Thomas Scheibitz (2007) au centre d'une place d'un quartier d'affaires ou dans une aire de jeux pour enfants, mais elle ne se sentirait à l'aise dans aucun des deux lieux. Construite en MDF – matériau de construction économique apprécié de Scheibitz – elle est constituée d'une forme circulaire dont la largeur est peinte en vert chartreuse, posée en équilibre sur un plan incurvé. Comme si une meule de fromage dévalait un toboggan. Ses sculptures existent à cette échelle humaine : trop intransportables pour être des maquettes et trop bizarres pour l'espace public, elles sont en transformation vers autre chose. Leurs formes sont harmonieuses et incohérentes – elles peuvent renvoyer à celles de logos, de sculptures publiques insipides ou de maquettes de gratte-ciels imaginaires, comme si elles se moquaient de la sculpture et de l'architecture classiques – voire d'elles-mêmes. Les peintures et les sculptures de Scheibitz sont similaires ; on reconnaît dans les unes certains traits des autres. Ses toiles, qui combinent formes fluides ou arrondies et figures géométriques, jouent visuellement avec l'inévitable « platitude » du tableau, suggérant des coins qui se redressent ou des cercles saillant de la toile. Comme dans ses sculptures, les formes peintes évoquent parfois des visages – nous avons parfois l'impression qu'elles nous regardent, qu'elles nous sourient ou posent devant nous, avant de retourner à l'abstraction. Les titres des œuvres de Scheibitz, comme leur iconographie insaisissable, sont de fausses pistes : ils fournissent des indices sur de possibles associations, mais n'en donnent jamais la clé. Son travail demeure ainsi distinctement, mais agréablement, irrésolu.

CH. L.

SELECTED EXHIBITIONS →
2007 *Thomas Scheibitz: About 90 Elements / Tod im Dschungel*, Irish Museum of Modern Art, Dublin; Camden Arts Centre, London; Musée d'Art Moderne Grand-Duc Jean, Luxembourg. *The Artist's Dining Room: Manfred Kuttner, Anselm Reyle, Thomas Scheibitz*, Tate Modern, London **2006** *Von Richter bis Scheibitz*, Kunstmuseum Winterthur. *Construction New Berlin*, Phoenix Art Museum, Phoenix **2005** *Thomas Scheibitz* (with Tino Sehgal), German Pavilion, 51st Venice Biennale, Venice

SELECTED PUBLICATIONS →
2007 *Thomas Scheibitz: About 90 Elements / Tod im Dschungel*, Irish Museum of Modern Art, Dublin; Camden Arts Centre, London **2006** *Thomas Scheibitz: Low Sweetie # Omega Haus*, Produzentengalerie Hamburg, Hamburg **2005** *Thomas Scheibitz: Film, Music and Novel*, Other Criteria, London. *Thomas Scheibitz & Tino Sehgal*, German Pavilion, Snoeck, Cologne **2004** *Thomas Scheibitz: ABC – I II III. Skulpturen 1998–2003*, Verlag der Buchhandlung Walther König, Cologne

1 **Tonika**, 2007, oil on canvas, 300 x 190 cm
2 **Captain Amely**, 2007, MDF, wood, vinyl, lacquer, 163 x 130 x 45 cm

3 **Stilleben 25**, 2008, oil on canvas, 295 x 185 cm

„Ich kann nichts erfinden, aber ich suche die Nähe der Erfindung. Mich interessieren Dinge, die die größtmögliche bildnerische Unabhängigkeit besitzen."

« Je ne peux rien inventer, mais je cherche à me rapprocher de l'invention. Je suis intéressé par les choses qui possèdent la plus grande autonomie plastique possible. »

"I cannot invent anything, but I want to be close to invention. I am interested in things which possess as much visual independence as possible."

2

Gregor Schneider

1969 born in Rheydt, lives and works in Rheydt, Germany

The spatial and conceptual artist Gregor Schneider gained international attention with the presentation of his work *Haus ur* at the Venice Biennale in 2001, and media coverage has not let up since. Two projects in particular have provoked heated public debate: one was *Cube*, a 14-metre-high black cube that was prohibited from being realized in Venice and Berlin because it was regarded as a political and religious risk. The clear allusion to a Muslim shrine – the Kaaba in Mecca – obviously raised fears, which were however allayed in 2007 when the cube was erected for the exhibition *Das schwarze Quadrat: Hommage an Malewitsch* at the Hamburger Kunsthalle – proving how crucial the actual real-ization of the work is to Schneider's artistic practice. Another project, not yet realized, elicited an even more vehement response. The very an-nouncement in spring 2008 that the artist was looking for a dying or recently deceased person to exhibit in an art space sparked huge protests and even death threats. At a time when assisted suicide was in public debate, the work was regarded as a threat to human dignity. Schneider's announcement broke a taboo and was often misunderstood in the realm between reality TV, ghost trains and Gunther von Hagen's *Body Worlds*. Schneider's concern, however, is to construct spaces that address socially relevant issues; his planned public dying space focuses on a humane approach to death and the dying. Such a space would be the antithesis of those in the exhibition *Weiße Folter* at K21 (2007) where, in the ab-sence of functional designations, long corridors and narrow cells recalled intensive care wards or solitary confinement units.

Der Raum- und Konzeptkünstler Gregor Schneider erlangte 2001 bei der Biennale Venedig mit dem Bau seines *Haus ur* verstärkt interna-tionale Aufmerksamkeit. In den letzten Jahren hat seine Medienpräsenz nicht abgenommen. Vor allem zwei Projekte sorgten für Diskussionen in der Öffentlichkeit. Dazu zählt das Projekt *Cube*, ein 14 Meter hoher schwarzer Würfel, dessen Realisierung in Venedig und Berlin als politisch und religiös zu riskant verboten wurde. Der erkennbare Bezug auf das Heiligtum der Moslems, die schwarze Kaaba in Mekka, löste wohl Ängste aus. Ängste, die sich dann, als der Würfel 2007 im Rahmen der Ausstellung *Das schwarze Quadrat: Hommage an Malewitsch* der Hamburger Kunsthalle errichtet wurde, verflüchtigten – was zeigt, wie zentral eine tatsächliche Realisierung im Raum von Schneiders Arbeiten ist. Noch stärkere Resonanz brachte dem Künstler ein bislang unrealisiertes Projekt ein. Allein die Ankündigung im Frühjahr 2008, einen sterbenden oder gerade gestorbenen Menschen zu suchen, um ihn in einem Kunstraum auszustellen, rief enorme Proteste bis hin zu Morddrohungen hervor. Man sah die Würde des Menschen in Gefahr, zu einem Zeitpunkt, an dem Sterbehilfe immer stärker in das öffentliche Gespräch rückte. Schneider initiierte mit seiner Ankündigung einen Tabubruch, der zuweilen zwischen Reality TV, Geisterbahn und Gunther von Hagens Leichenshow *Kör-perwelten* missverstanden wurde. Jedoch geht es Schneider vielmehr darum, Räume zu bauen, die gesellschaftsrelevante Themen angehen. So auch mit dem geplanten öffentlichen Sterberaum, der einen humanen Umgang mit dem Tod thematisieren soll. Er steht in Antithese zu den Räumen für die Ausstellung *Weiße Folter* im K21 (2007). Dort erinnerten lange Korridore und enge Zellen mangels funktionaler Kennzeichnung an Intensivstationen oder Isolationshaft.

L'artiste conceptuel et créateur d'espaces Gregor Schneider a attiré une attention internationale accrue en 2001 avec la construction de *Haus ur* à la Biennale de Venise. Ces dernières années, sa présence médiatique n'a pas décru. Deux projets ont alimenté le débat public plus que d'autres : la réalisation de *Cube*, projet d'un cube de 14 mètres de haut, fut interdite à Venise et à Berlin en raison des risques politiques et religieux. La référence évidente à la Kaaba noire, sanctuaire musulman de la Mecque, suscita sans doute des peurs qui se dissipèrent quand le cube fut érigé en 2007 dans le cadre de l'exposition *Das schwarze Quadrat : Hommage an Malewitsch* organisée à la Kunsthalle de Ham-bourg – ce qui montre à quel point la réalisation des œuvres de Schneider joue un rôle central. Un autre projet non réalisé à ce jour a attiré encore plus l'attention : au printemps 2008, la seule annonce de vouloir trouver un homme mourant ou mort récemment pour le présenter dans le cadre d'une exposition d'art souleva de violentes protestations et même des menaces de mort. La dignité humaine semblait menacée alors que l'accompagnement de fin de vie entrait peu à peu dans le débat public. Avec son annonce, Schneider s'attaquait à un tabou : son acte fut parfois – et à tort – assimilé à un *reality show*, à un train fantôme ou à l'exposition de cadavres *Le Monde des corps* de Gunther von Hagens. Mais le propos de Schneider est bien plutôt de bâtir des espaces qui abordent des sujets pertinents en termes de société. Ceci vaut également pour l'espace funéraire, dont le thème était une approche humaine de la mort. Il constitue une antithèse des espaces de l'exposition *Weiße Folter* au K21 (2007) dans laquelle, en l'absence de caractérisation fonctionnelle, les longs corridors et les cellules exiguës évoquaient des services de réanimation ou des quartiers de haute sécurité.

H. L.

SELECTED EXHIBITIONS →
2008 *Gregor Schneider: Cube Venice – Design and Conception*, Fondazione Bevilacqua La Masa, Venice **2007** *Gregor Schneider: Weiße Folter*, K21 Kunstsammlung Nordrhein-Westfalen, Düsseldorf. *Das Schwarze Quadrat. Hommage an Malewitsch*, Hamburger Kunsthalle, Hamburg. *Bondi Beach, 21 Beach Cells*, Kaldor Art Projects, Bondi Beach, Sydney. **2006** *Into Me/Out of Me*, P.S.1 Contemporary Art Center, Long Island City; KW Institute for Contemporary Art, Berlin

SELECTED PUBLICATIONS →
2007 *Gregor Schneider: Weiße Folter*, K21 Kunstsammlung Nord-rhein-Westfalen, Düsseldorf. *Das Schwarze Quadrat. Hommage an Malewitsch*, Hamburger Kunsthalle, Hamburg **2006** *Cubes: Art in the Age of Global Terrorism*, Charta, Milan. *Gregor Schneider: Die Familie Schneider*, Steidl, Göttingen. *Into Me/Out of Me*, P.S.1 Contemporary Art Center, Long Island City; KW Institute for Contemporary Art, Berlin; Hatje Cantz, Ostfildern

1/2 **Bondi Beach, 21 Beach Cells**, 2007, typical Australian fencing, air mattress, beach umbrella, garbage bag, 250 x 2000 x 2000 cm, each cell 250 x 400 x 400 cm. Installation view, Bondi Beach, Sydney

3–5 **Cube Hamburg**, 2007, glued wood panels, steel construction, black velvet fabric, pedestal: white concrete, 1400 x 1400 x 1400 cm. Installation view, Hamburger Kunsthalle, Hamburg

6 **Weiße Folter**, 2007, room within a room, coated chipboard on wood, 14 doors, 3 lamps, grey linoleum, white paint, insulating material,

corridor 230 x 1500 x 200 cm. Installation view, corridor, Kunstsammlung Nordrhein-Westfalen, Düsseldorf

7 **Weiße Folter**, 2007, room within a room, coated chipboard on wood, door, mattress, stainless steel toilet, grey linoleum, white paint, black arrow sticker (oriented towards Mecca), cell 230 x 338 x 220 cm. Installation view, high security and isolation cell, Kunstsammlung Nordrhein-Westfalen, Düsseldorf

„Die Arbeit ist als wandere man durch die Schichtungen und Schalungen des eigenen Hirns und gehe dort den Mechanismen der Wahrnehmung und des Wissens nach."

« Ce travail, c'est comme si on se promenait dans les couches et les circonvolutions de son propre cerveau et qu'on y suivait la trace des mécanismes de la perception et de la connaissance. »

"The work is as if one were wandering through the layerings and shutterings of one's own brain, following the mechanisms of perception and knowledge."

3

4

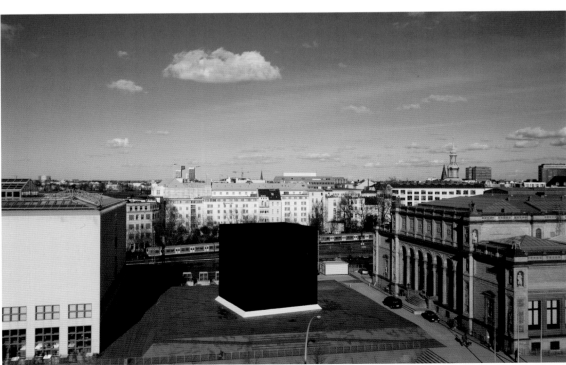

5

Raqib Shaw

1974 born in Calcutta, India, lives and works in London, United Kingdom

Raqib Shaw's monumentally intricate paintings employ a wilful cross-pollination of carefully chosen references: images drawn from sources as varied as Renaissance painting and Japanese woodcuts, Hindu iconography or the aesthetics of traditional Indian handicraft promiscuously intertwine on the same glittering surfaces. Achieved through the use of materials such as metallic car paints, gold stained-glass enamel and glitter, the paintings' jewel-like quality works to draw viewers up close to confront them with scenes that oscillate between the beautiful and the grotesque, where erotic pleasure at any moment might become abuse. Shaw's use of opulent materials combined with his voracious imagery and interest in medieval and Renaissance morality tales infuse his work with a critical questioning of the desire for luxury that his creations on first impression seem to flaunt. In *Jane* (2006), his abject embellishments all but hide Jane Seymour's iconic image behind a fish-like mask, defiling the painting's placid composure and invoking the violent turmoil of the period. Shaw first came to international prominence with his series *Garden of Earthly Delights* (2003–05) – a sequence of painted panels that allude to the vivid visions depicted in Hieronymus Bosch's eponymous painting (circa 1500). Hybrid creatures wrestle and copulate amidst a blue and gold-flecked landscape textured with minutely detailed flora and fauna. Shaw's deliciously debauched scenes seduce and confront their greedy viewer with the darker fantasies of their imagination.

In Raqib Shaws monumental vielschichtigen Gemälden befruchten sich die sorgfältig ausgewählten Referenzen gegenseitig: Bilder aus verschiedenen Quellen wie Renaissancegemälden und japanischen Holzschnitten, Hindu-Ikonografie und traditionellem indischem Kunsthandwerk verbinden sich buntgewürfelt auf denselben glänzenden Oberflächen. Durch die Verwendung von Materialien wie metallischem Autolack, goldgefärbtem Glas, Email und Glitter bekommen die Bilder eine juwelenartige Beschaffenheit, die den Betrachter nah an sich heranzieht, um ihn mit Szenen zu konfrontieren, die zwischen Schönheit und Groteske oszillieren, in denen erotische Lust jederzeit zur Misshandlung werden kann. Shaws Verwendung von kostbarem Material, sein hemmungsloses Bildrepertoire und sein Interesse an Fabeln des Mittelalters und der Renaissance hinterfragen kritisch die Gier nach Luxus, die seine Schöpfungen auf den ersten Blick zur Schau zu stellen scheinen. Zu einer jüngeren Serie von Arbeiten ließ sich Shaw von Hans Holbeins Porträts der Frauen von Heinrich VIII. inspirieren. In *Jane* (2006) verbergen seine grässlichen Verzierungen Jane Seymours ikonisches Gesicht hinter einer fischartigen Maske, verunreinigen die glatte Komposition des Bildes und beschwören das grausame Chaos jener Zeit herauf. Shaw gelangte mit seiner Serie *Garden of Earthly Delights* (2003–05) zu internationaler Bekanntheit – einer Reihe von Gemälden, die auf die lebhaften Visionen des gleichnamigen Bildes von Hieronymus Bosch (um 1500) verweisen. Mischwesen kämpfen und kopulieren in einer blau- und goldgefleckten Landschaft, die von minuziös detaillierten Pflanzen und Tieren strukturiert wird. Shaws herrlich ausschweifende Szenen verführen und konfrontieren den gierigen Betrachter mit den dunkleren Fantasien seiner Vorstellungskraft.

Les grandes peintures extrêmement détaillées de Raqib Shaw sont construites selon un agencement savant de références soigneusement choisies. Les motifs, tirés de sources aussi variées que la peinture de la Renaissance, la gravure japonaise, l'iconographie hindoue ou l'artisanat traditionnel indien, s'enchevêtrent sur la surface brillante des toiles. L'utilisation de matériaux comme des peintures métalliques pour carrosserie, des émaux dorés ou scintillants employés pour les vitraux, donnent aux tableaux l'allure de bijoux, attirant l'œil du spectateur qui se retrouve alors nez-à-nez avec des scènes qui alternent entre le beau et le grotesque, et où le plaisir érotique menace à chaque instant de dégénérer en violence physique. L'emploi de matières luxuriantes, combiné au goût prononcé de Shaw pour l'imagerie des fables morales du Moyen Âge et de la Renaissance, inscrivent son œuvre dans une remise en question critique du désir de luxe des hommes, que ses tableaux semblent à première vue exhiber. Une série récente de travaux de Shaw s'inspire de portraits d'épouses d'Henri VIII réalisés par Hans Holbein. Dans *Jane* (2006), ses enjolivements abjects cachent presque entièrement le visage iconique de Jane Seymour derrière un masque en forme de tête de poisson, profanant la composition placide du portrait original pour mieux rappeler les troubles violents de l'époque. Shaw s'est imposé sur la scène internationale avec sa série *Garden of Earthly Delights* (2003–05) – une séquence de panneaux peints faisant allusion aux visions enfiévrées du *Jardin des délices* de Jérôme Bosch (env. 1500). Des créatures hybrides luttent et copulent dans un paysage pailleté de bleu et d'or, rehaussé d'une flore et d'une faune minutieusement détaillées. La délicieuse débauche des scènes de Shaw séduit le spectateur autant qu'elle le renvoie aux fantasmes les plus sombres logés dans son imagination.

A. B.

SELECTED EXHIBITIONS →
2007 *Panic Room – Works from the Dakis Joannous Collection*, Deste Foundation Centre for Contemporary Art, Athens **2006** *Raqib Shaw: Garden of Earthly Delights*, MOCA, North Miami. *Art Now: Raqib Shaw*, Tate Britain, London. 6th Gwangju Biennale, Gwangju. *Without Boundary: Seventeen Ways of Looking*, MoMA, New York. *Around the World in Eighty Days*, ICA, London. *Passion for Paint*, The National Gallery, London; Bristol City Museum and Art Gallery, Bristol; Laing Art Gallery, Newcastle

SELECTED PUBLICATIONS →
2005 *Raqib Shaw: Garden of Earthly Delights*, Deitch Projects, New York. *Expanded Painting*, Prague Biennale, Prague

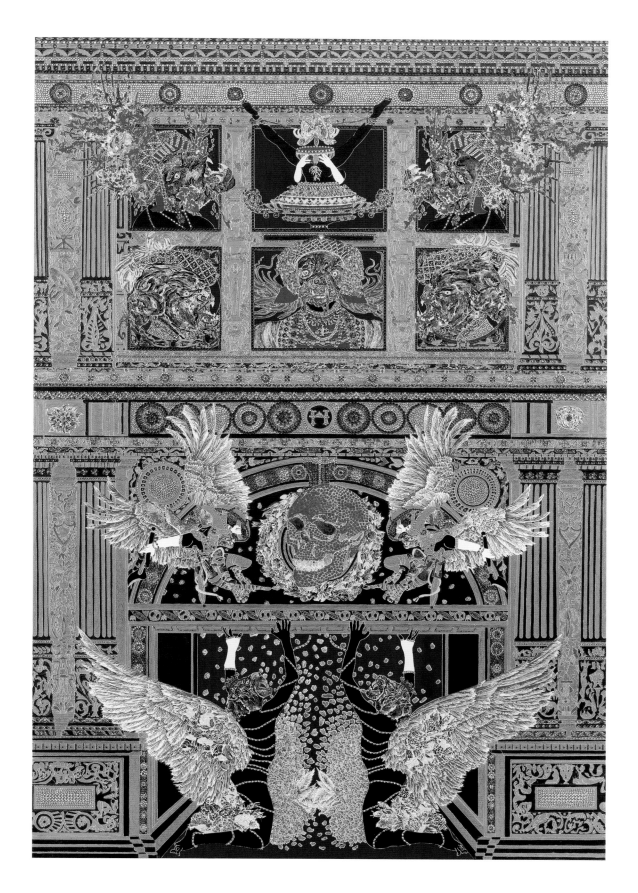

1 **Absence of God I**, 2007, acrylic paint, industrial paint, glitter, semi-precious crystals, 182.6 x 121.9 cm
2 **Untitled**, 2005, mixed media on paper, 41.9 x 59.4 cm

3 **The Garden of Earthly Delights XII**, 2005, mixed media on board, 152.4 x 243.8 cm
4 **Jane**, 2006, mixed media on paper, 92 x 58 cm

„Seit meiner Kindheit befinden sich in meinem Kopf die Stereotypen von Wirklichkeit und Fantasie (was immer Wirklichkeit bedeuten mag) in andauerndem Durcheinander und sogar im Streit."

« Depuis l'enfance, il y a dans mon esprit une confusion persistante et même une collision entre des versions stéréotypées de la réalité et de la fantaisie (quel que soit le sens du mot "réalité"). »

"Since childhood there is a persistent confusion or even collision between stereotypes of reality and fantasy (whatever reality means) in my mind."

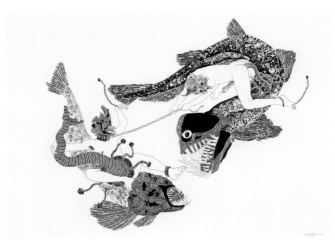

2

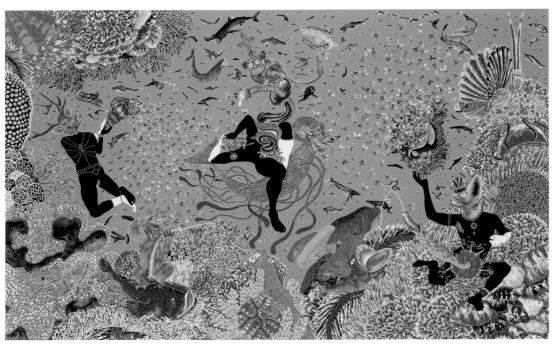

3

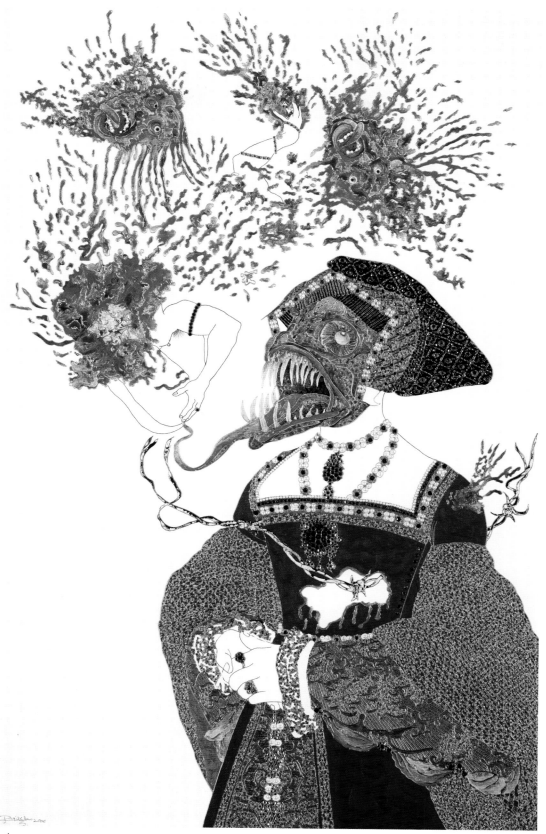

Cindy Sherman

1954 born in Glen Ridge (NJ), lives and works in New York (NY), USA

For over thirty years Cindy Sherman has masqueraded as everything from actresses and fashion victims to suburban housewives and decaying corpses in a form of photographic portraiture in which she is simultaneously director, photographer and actor. Her most recent untitled series of photographs features a comprehensive cast of middle-aged women fighting against encroaching age through fashion statements and exaggerated make-up. Shot against digitally manipulated, colour-saturated backgrounds – a recent development in Sherman's work – each tragic-comic image stages a withering critique of the standardized ideals of female beauty depicted by the mass media. This is in continuation with Sherman's artistic concerns from the beginning of her career: she gained critical acclaim as part of the "Pictures" generation of artists who emerged in the late 1970s with the discourses surrounding postmodernism and the media. Her re-enactments of female tropes from 1950s and 60s B-movies in the seminal series *Untitled Film Stills* (1977–80) unfolded as a perceptively staged succession of female stereotypes that unravelled these instantly recognizable tropes. Read as an ongoing narrative, Sherman's work has staged a specifically feminine form of aggressivity, from the vacant starlets of the *Untitled Film Stills* through the overtly sexualized and dismembered forms in the *Sex Pictures* (1992) to the eventual replacement of the body altogether in the series *Broken Dolls* (1999). Disappearing behind an endless cast of characters, Sherman's masked and made-up physical presence becomes a mirror in which the desires (and fears) of the viewers themselves are reflected.

Seit über dreißig Jahren verkleidet sich Cindy Sherman für ihre fotografischen Porträts, bei denen sie gleichzeitig Regisseurin, Fotografin und Darstellerin ist: als Schauspielerin und Fashion-Victim, als Vorstadthausfrau und als verwesender Körper. Ihre jüngste titellose Serie von Fotografien handelt von einer umfangreichen Gruppe von mittelalten Frauen, die mit Modestatements und übertriebenem Make-up gegen das herannahende Alter kämpft. Aufgenommen vor digital bearbeiteten, farbgesättigten Hintergründen – eine neue Entwicklung in Shermans Arbeiten der letzten Zeit –, stellt jedes dieser tragikomischen Bilder eine vernichtende Kritik an dem von den Massenmedien geprägten Standardideal weiblicher Schönheit dar. Dies bedeutet eine Kontinuität in Shermans künstlerischem Anliegen vom Beginn ihrer Karriere an: Sie verdiente sich den Beifall der Kritik als Teil der „Pictures Generation", die in den späten 1970er-Jahren mit den Diskursen um Postmoderne und Medien aufkam. Ihre Neuinszenierungen von weiblichen Geschlechterrollen aus B-Movies der 1950er- und 60er-Jahre in der bahnbrechenden Serie *Untitled Film Stills* (1977–80) war eine unverkennbar inszenierte Abfolge von weiblichen Stereotypen, die diese unmittelbar erkennbaren Tropen enträtselt. Als eine fortlaufende Erzählung gelesen, inszeniert Shermans Arbeit eine spezifisch weibliche Form von Aggressivität, von den ausdruckslosen Starlets der *Untitled Film Stills* über die übersexualisierten und zerlegten Formen in den *Sex Pictures* (1992) bis zum völligen Ersatz des Körpers in der Serie *Broken Dolls* (1999). Indem sie hinter einer endlosen Reihe von Charakteren verschwindet, wird Shermans maskierte und geschminkte körperliche Gegenwart zu einem Spiegel, in dem das Verlangen (und die Angst) der Betrachter reflektiert werden.

En plus de trente ans de carrière, Cindy Sherman s'est glissée dans toutes sortes d'identités, jouant l'actrice, la victime de la mode, la femme au foyer et jusqu'au corps en décomposition, dans des formes de portraits photographiques dont elle est tout à la fois le metteur en scène, la photographe et le modèle. Sa série de photographies la plus récente, non titrée, présente un ensemble représentatif de femmes âgées autour de la cinquantaine luttant contre les stigmates de l'âge à travers leurs choix vestimentaires et leur maquillage appuyé. Prises devant des arrière-plans traités numériquement, saturés de couleurs – un développement récent dans l'œuvre de Sherman – ces images tragicomiques proposent une critique acerbe des idéaux standardisés de la beauté féminine véhiculés par les médias. Ce travail s'inscrit dans la lignée des préoccupations artistiques de Sherman depuis le début de sa carrière et le succès critique qu'elle remporta avec les autres artistes membres de la génération « Pictures » apparus à la fin des années 1970 dans le contexte des théories du postmodernisme et des médias. Ses reconstitutions des tropes féminins issus des films de série B des années 1950–1960 dans la série fondatrice *Untitled Film Stills* (1977–80) s'imposèrent comme une mise en scène subtile et une critique efficace des stéréotypes féminins en vigueur. Prise comme un ensemble narratif, l'œuvre de Sherman présente une forme spécifiquement féminine d'agressivité, depuis les starlettes vaporeuses des *Untitled Film Stills*, aux formes ouvertement sexuelles écartelées des *Sex Pictures* (1992), jusqu'à l'effacement ultime du corps dans la série des *Broken Dolls* (1999). Lorsqu'elle disparaît derrière un nombre infini de personnages, la présence physique de Sherman, sous ses masques et ses maquillages, devient un miroir dans lequel se reflètent les désirs comme les peurs des spectateurs.

A. B.

SELECTED EXHIBITIONS →
2008 *Female Trouble*, Pinakothek der Moderne, München. *Street & Studio*, Tate Modern, London; Museum Folkwang, Essen **2007** *Imagination Becomes Reality*, ZKM, Karlsruhe **2006** *Cindy Sherman: Rétrospective*, Jeu de Paume, Paris; Kunsthaus Bregenz; Louisiana Museum of Modern Art, Humlebaek; Martin Gropius Bau, Berlin. *Into Me/Out of Me*, P.S.1 Contemporary Art Center, Long Island City; KW Institute for Contemporary Art, Berlin

SELECTED PUBLICATIONS →
2007 *Cindy Sherman*, Thames & Hudson, London. *Cindy Sherman: A Play of Selves*, Metro Pictures, New York; Sprüth Magers, Cologne; Hatje Cantz, Ostfildern. *Cindy Sherman*, Mondadori, Milan. *Cindy Sherman*, MIT Press, Cambridge. *Cindy Sherman*, Jeu de Paume & Flammarion, Paris **2006** *The Cindy Shermans: Inszenierte Identitäten. Fotogeschichten von 1840 bis 2005*, Böhlau, Cologne/Weimar

1 **Untitled**, 2007/08, colour photograph, 156.5 x 124.8 cm
2 **Untitled**, 2007/08, colour photograph, 155.1 x 104.5 cm

3 **Untitled**, 2007/08, colour photograph, 115.9 x 89.2 cm
4 **Untitled**, 2007/08, colour photograph, 198.8 x 150.2 cm

„Ich wollte keine ‚hohe' Kunst machen, ich hatte an Farbe kein Interesse, ich wollte etwas finden, zu dem sich jeder in Beziehung setzen kann, ohne etwas über zeitgenössische Kunst zu wissen."

« Je ne voulais pas faire de l'art avec un grand A, faire de la peinture ne m'intéressait pas, je voulais trouver une forme d'expression à laquelle quiconque puisse avoir accès sans connaître quoi que ce soit de l'art contemporain. ».

"I didn't want to make 'high' art, I had no interest in using paint, I wanted to find something that anyone could relate to without knowing about contemporary art."

2

3

Santiago Sierra

1966 born in Madrid, Spain, lives and works in Mexico City, Mexico

Santiago Sierra occasionally uses his piece *Door Plate* (2006) to "regulate" entry to his exhibitions. The sign bars entry to all undesirables: untidy and smelly people, employees, pregnant women, terrorists, jokers and cynics. Nevertheless, the sign's acerbic irony still seems harmless when compared to some of the artist's other works – mostly of a performative nature and documented on video or in photographs – which he uses to address highly controversial social and moral issues. For *1549 State Crimes* (2007), Sierra had the names of 1549 people who disappeared in Mexico between 1968 and 2007 read out over a period of 72 hours. *21 Anthropometric Modules Made from Human Faeces by the People of Sulabh International, India* (2005/06) consists of human excrement from members of the "untouchable" caste – who are responsible for cleaning latrines in India. The faecal matter was stored for three years, mixed with a bonding agent and formed into rectangular blocks. Sierra pushes cynicism to the extreme by thanking the Dalits, who weren't paid for their work, for their sponsorship. In addition to social exclusion and exploitation in the global capitalist market economy, Sierra also focuses on the topic of environmental pollution – in works that are as unecological as possible. In *Four Black Vehicles with the Engine Running inside an Art Gallery* (2007), exhaust fumes from cars installed inside the exhibition space were channelled through pipes into the atmosphere outside; for *Audience Lit by a Petrol Operated Generator* (2008), a petrol generator fuels a bank of bright floodlights – dazzling the audience whilst bombarding it with CO_2.

Santiago Sierra setzt seine Arbeit *Door Plate* (2006) gelegentlich ein, um den Zutritt zu seinen Ausstellungen zu „regeln". Das Schild untersagt allen möglichen Unerwünschten den Zutritt: unordentlichen und stinkenden Menschen, Angestellten, Schwangeren, Terroristen, Witzbolden und Zynikern. Doch scheint die beißende Ironie des Schildes noch harmlos, verglichen mit anderen Arbeiten – meist performativer Natur, in Video oder Fotografien dokumentiert –, mit denen der Künstler immer wieder höchst kontrovers gesellschaftliche und moralische Fragen thematisiert. Für *1549 State Crimes* (2007) ließ Sierra über 72 Stunden lang die Namen von 1549 zwischen 1968 und 2007 in Mexiko verschwundenen Personen verlesen. *21 Anthropometric Modules Made from Human Faeces by the People of Sulabh International, India* (2005/06) besteht aus menschlichen Fäkalien, die von Zugehörigen der Unberührbaren Kaste – in Indien für das Reinigen der Latrinen zuständig – gesammelt, drei Jahre gelagert, dann mit Bindemittel vermischt und zu rechteckigen Blöcken geformt wurden. Sierra treibt den Zynismus auf die Spitze, wenn er den Dalits, die für ihre Arbeit keinen Lohn gezahlt bekamen, als Sponsoren dankt. Neben sozialer Ausgrenzung und Ausbeutung in der globalisierten kapitalistischen Marktwirtschaft setzt Sierra sich auch mit dem Thema Umweltverschmutzung auseinander – mit Arbeiten, die so unökologisch wie möglich sind. Bei *Four Black Vehicles with the Engine Running inside an Art Gallery* (2007) wurden Abgase von in den Ausstellungsräumen befindlichen Autos durch Schläuche nach außen in die Atmosphäre geleitet, für *Audience Lit by a Petrol Operated Generator* (2008) versorgte ein Benzingenerator eine Scheinwerferwand mit gleißendem Licht – eine CO_2-haltige Publikumsblendung.

Santiago Sierra expose parfois son œuvre *Door Plate* (2006) pour « réguler » l'accès à ses expositions. La plaque interdit l'accès à toutes les personnes indésirables possibles : aux gens débraillés et puants, aux farceurs, aux cyniques, aux employés, aux femmes enceintes et aux terroristes. Mais l'ironie caustique de la plaque paraît plutôt anodine comparée à d'autres œuvres de Sierra – généralement performatives, documentées par des vidéos ou des photographies – qui soulèvent sans cesse des questions sociales ou morales fortement controversées. Pour *1549 State's Crimes* (2007), l'artiste a fait lire pendant 72 heures les noms de 1549 personnes disparues au Mexique entre 1968 et 2007. *21 Anthropometric Modules Made from Human Faeces by the People of Sulabh International, India* (2005/06) sont des excréments humains recueillis, entreposés trois ans puis mélangés de liant pour être formés en blocs rectangulaires par des membres de la caste des intouchables – responsables en Inde du nettoyage des latrines. Sierra pousse le cynisme jusqu'à remercier les Dalits, qui n'ont pas été payés pour ce travail, en qualité de sponsors de l'œuvre. À côté de l'exclusion et de l'exploitation par une économie capitaliste globalisée, Sierra aborde aussi le thème de la pollution de l'environnement avec des œuvres aussi anti-écologiques que possible. Pour *Four Black Vehicles with the Engine Running inside an Art Gallery* (2007), les gaz d'échappement des voitures présentées dans les salles d'exposition étaient recueillis par des tuyaux pour être rejetés à l'extérieur, dans l'atmosphère. Pour *Audience Lit by a Petrol Operated Generator* (2008), un générateur à essence alimentait en électricité un mur de spots éblouissants – un aveuglement du public à forte teneur en CO_2.

E. S.

SELECTED EXHIBITIONS →
2008 *Re-Reading the Future*, International Triennale of Contemporary Art, Prague. *All-Inclusive – Die Welt des Tourismus*, Schirn Kunsthalle, Frankfurt **2006** *Santiago Sierra*, CAC, Málaga. *Santiago Sierra: 245 m3*, Synagoge Stommeln, Pulheim. *Into Me/Out of Me*, P.S.1 Contemporary Art Center, Long Island City; KW Institute for Contemporary Art, Berlin **2005** *Santiago Sierra: Haus im Schlamm*, Kestnergesellschaft, Hanover

SELECTED PUBLICATIONS →
2008 *Moralische Fantasien: Aktuelle Positionen zeitgenössischer Kunst in Zusammenhang mit der Klimaerwärmung*, Verlag für moderne Kunst, Nuremberg. *All-Inclusive: Die Welt des Tourismus*, Snoeck Verlag, Cologne **2007** *Santiago Sierra: 7 Trabajos = 7 Works*, Verlag der Buchhandlung Walther König, Cologne **2005** *Santiago Sierra: Haus im Schlamm*, Kestnergesellschaft, Hanover; Hatje Cantz, Ostfildern

1 **Audience Lit by a Petrol Operated Generator**, 2008, b/w photograph. Installation view, Helga de Alvear Gallery, Madrid
2 **245 m3**, 2006, b/w photograph. Installation view, Synagoge Stommeln, Pulheim
3 **The Anarchists**, 2006, b/w photograph. Performance, Volume, Rome

4 **Submission (Formerly Word of Fire)**, 2006/07, b/w photograph. Installation view, Anapra, Ciudad Juarez
5 **Economical Study on the Skin of Caracans**, 2006, b/w photograph. Study, Caracas

„Der Kapitalismus interessiert sich nicht für deine Hautfarbe, er will nur mehr Geld. Jeder Grund oder jede Ausrede reicht aus, wenn sie zur Begründung taugt, warum jemand seine schlechte Lage verdient hat; du kannst fett sein, eine Frau, was auch immer."

« Le capitalisme se moque de votre couleur de peau, tout ce qu'il veut, c'est plus d'argent. Toute excuse ou raison pour justifier que quelqu'un mérite d'être en position subalterne est bonne à prendre, que vous soyez femme, obèse ou n'importe quoi d'autre. »

"Capitalism doesn't care what colour your skin is; it only wants more money. Any excuse or reason to justify why someone deserves to be in an inferior position will do; you could be fat, female, anything."

2

3

4

0 USD

Dash Snow

1981 born in New York (NY), lives and works in New York (NY), USA

Dash Snow made trashing hotel rooms – usually the preserve of rock stars – almost acceptable when he and Dan Colen exhibited one of his infamous hamster nests in a New York gallery. *Nest* (2007) was a sort of re-enactment with a happening-like feel. Previously, Snow often had to flee from hotels in the middle of the night after party-like events where he and friends such as Colen or the photographer Ryan McGinley had built a nest from shredded telephone books and bodily and other fluids. In the gallery, this now became a staged event. But Snow, who belongs to one of North America's most influential artistic dynasties, never originally planned to become an artist. He started his career in downtown Manhattan as a graffiti sprayer and self-declared shoplifter; he maintains that he only took Polaroids so as to remember next morning what had happened the night before. Snow transformed the Polaroids – a format he still uses – into art in his *Polaroid Wall* (2005), that seemed to reference Nan Goldin. For his collages he often uses the yellowing pages of old books, on which he dissects words and pictures in a dadaist style. The result is like a collaboration between Hannah Höch and the Sex Pistols under the auspices of graffiti. Anarchy and nostalgia are never far apart in Snow's art, and are frequently paired with allusions to current social or political events – for example, in the caustic word collage *High School* (2006) or *The Government That Will Bring Paradise* (2007). For his Saddam Hussein series, Snow ejaculated onto the front pages of newspapers celebrating Hussein's death and strewed glitter over them as a commentary on American foreign policy and triumphalism.

Dash Snow hat die meist Rockstars vorbehaltene Tradition der „Hotelzimmer Trashings" salonfähig gemacht, als er zusammen mit Dan Colen eines seiner berüchtigten Hamsterneste in einer New Yorker Galerie ausstellte. *Nest* (2007) war eine Art Reenactment mit Happeningcharakter. Früher musste Snow nachts aus Hotels flüchten, nachdem er mit Freunden wie Colen oder dem Fotografen Ryan McGinley aus zerfetzten Telefonbüchern, Körper- und sonstigen Flüssigkeiten in einer partyhaften Aktion ein Nest gebaut hatte. In der Galerie wurde dies nun zum inszenierten Ereignis. Dabei hatte es Snow, der aus einer der einflussreichsten Kunstdynastien Nordamerikas stammt, ursprünglich nicht darauf angelegt, Künstler zu werden. Er begann seine Karriere in Downtown Manhattan als Graffiti-Sprayer und bekennender Ladendieb und machte nach eigenen Angaben nur Polaroids, um sich hinterher an das erinnern zu können, was in den Nächten zuvor geschehen war. Snow überführte die Polaroids – ein Format, das er auch weiterhin nutzt – in seiner an Nan Goldin erinnernden *Polaroid Wall* (2005) in Kunst. Für seine Collagen verwendet er oft vergilbte Seiten alter Bücher, auf denen er Wort und Bild in dadaistischer Manier seziert. Das Ergebnis gleicht einer Kollaboration von Hannah Höch mit den Sex Pistols unter den Vorzeichen von Graffiti. Anarchie und Nostalgie liegen hier nahe beieinander, häufig gepaart mit Anspielungen auf aktuelle gesellschaftliche oder politische Ereignisse, etwa in der bissigen Wortcollage *High School* (2006) oder in *The Government That Will Bring Paradise* (2007). Für seine Saddam Hussein-Serie ejakulierte er auf Titelseiten von Zeitungen, die den Tod Husseins feierten, und streute Glitter darüber, als Kommentar zur amerikanischen Außenpolitik und Siegesmentalität.

En exposant dans une galerie new-yorkaise un de ses nids de hamster tristement célèbres avec Dan Colen, Dash Snow a rendu convenable une tradition normalement réservée aux rock-stars : le « trashage de suite d'hôtels ». *Nest* (2007) a été une réactivation sous forme de happening. Autrefois, Snow devait quitter des hôtels en pleine nuit après avoir fait la « teuf » avec des amis comme Colen ou le photographe McGinley et y avoir construit un « nid » à partir de bottins déchirés et de fluides corporels ou autres. Dans la galerie, ceci devient la mise en scène d'un événement. Issu d'une des plus influentes dynasties artistiques d'Amérique du Nord, Snow ne s'était pas destiné à cette carrière. Il avait débuté à Downtown Manhattan comme graffiteur et voleur à l'étalage déclaré ; il se contentait de réaliser des polaroïds pour se rappeler ce qui s'était passé les nuits précédentes. Snow a aussi fait passer ses polaroïds – format qu'il continue d'utiliser – dans le domaine de l'art avec son *Polaroid Wall* (2005), qui n'est pas sans rappeler le travail de Nan Goldin. Pour ses collages, il se sert souvent de feuilles jaunies d'anciens livres sur lesquelles il dissèque des mots et des images à la manière dadaïste. Le résultat tient d'une collaboration entre Hannah Höch et les Sex Pistols placée sous le signe du graffiti, dans laquelle se côtoient l'anarchie et la nostalgie, souvent parsemées d'allusions aux évènements de l'actualité sociale ou politique, comme le montrent le collage textuel caustique *High School* (2006) ou *The Government That Will Bring Paradise* (2007). Pour sa série sur Saddam Hussein, Snow devait éjaculer sur les unes de journaux qui célébraient la mort du dictateur avant de les saupoudrer de paillettes en guise de commentaire sur le caractère impérialiste de la politique étrangère américaine.　　　　　　　　　　　E. S.

SELECTED EXHIBITIONS →
2008 *Babylon – Mythos und Wahrheit*, Pergamonmuseum, Berlin
2007 *Compulsive*, Magazine Jalouse, Palais de Tokyo, Paris
2006 *Defamation of Character*, P.S.1 Contemporary Art Center, Long Island City. *Day For Night*, Whitney Biennial 2006, Whitney Museum, New York

SELECTED PUBLICATIONS →
2008 *Nest: Dash Snow, Dan Colen*, Deitch Projects, New York
2007 *Dash Snow: The End of Living, The Beginning of Survival*, Verlag der Buchhandlung Walther König, Cologne **2006** *A Dash of Daring: Carmel Snow and Her Life in Fashion, Art and Letters*, Atria, Memphis

TARGET: Madonna

Legal bid to stop Madge's adoption

By TOM PETTIFOR

MADONNA'S adoption of African baby David Banda could be halted today by a new court action.

A Malawian human rights group has launched the proceedings claiming the 13-month-old's father Yohane, 32, did not understand what he was doing when he let his son go.

A high court judge in the capital Lilongwe will be asked to impose an injunction forcing Madonna, 48, and husband Guy Ritchie, 38, to return to face a full screening process in Africa.

Undule Mwakasungule, of the Centre for Human Rights and Rehabilitation in Malawi, expressed concern about the speed and secrecy of the interim adoption. He added: "The family is divided. Some feel that because the boy is with Madonna all their lives will change.

"Others are concerned at the way it's been done.

"What is not right is that the father still thinks the boy is his. He doesn't understand he is completely and forever going to be out of his custody."

Nick Glanville, of the Adoption Information Line said: "She has set a terrible example bypassing red tape in Britain."

Meanwhile, Madonna was yesterday targeted by "comedy terrorist" Aaron Barschak who gatecrashed Prince William's 21st birthday party in 2003.

As she left a London gym Barschak, 40, in a nappy yelled at her car: "Mummy adopt me, make me part of your family."

● *IF you adopted a Malawian child or were adopted from there, please contact us free on 0800 282 591.*

Why's Amy been told to stop boozing?

PAGES 12&13

FUZZY BEAR

HUNT officials got a tame bear drunk on vodka so it was easier for King Carlos of Spain to shoot on a visit to Vologda, Russia.

AT LEAST THEY DIED TOGETHER

1 **Untitled (At Least They Died Together)**, 2007, collage, 40 x 28.6 cm
2 **Untitled (Circles Psychedelic)**, 2007, collage, 45.1 x 60.3 cm
3 Installation view, *Dash Snow/Dan Colen: Nest*, Deitch Projects, New York, 2007

4 **Untitled (Cum in Mouth/Circles)**, 2007, collage, 20.3 x 12.7 cm
5 **Society for Cutting Up Men**, 2006/07, collage, 39 x 22.8 cm
6 **Untitled (Dirty Bomb Scare)**, 2007, collage, 59.7 x 24.6 cm
7 **Untitled (Saddam & Gomorrah)**, 2006, collage, 36 x 28.8 cm

2

3

Rudolf Stingel

1956 born in Merano, lives and works in Bolzano, Italy, and New York (NY), USA

The sheer beauty of Rudolf Stingel's paintings often distracts giddy viewers from the banality of the ready-made materials from which they are made. Whether abstract or photorealistic canvases, a carpet laid on a floor or hung on a wall or a room lined with silver insulation material, Stingel describes each work he makes as a painting. Playing with the essential ingredients of the medium – a culinary approach adopted in *Instructions* (1989), a step-by-step guide to making a "real Rudolph Stingel" painting – Stingel ruptures painting's autonomy, dislocating and unfolding its surfaces into architectural space with a knowing decorative appeal that collides spectacle and reality. A recurrent gesture sees Stingel lining entire rooms with reflective insulation panelling, creating an open invitation for viewers to leave marks or attach objects to its surfaces. Like the marks that accumulate on the carpets he installs on gallery floors or walls, or the surfaces of his Styrofoam pieces eaten away by footprints, Stingel's works record the presence of both artist and viewer and are at once activated and destroyed through the processes of viewing and making. His series of large-format photorealist self portraits based on photographs taken by his friend Sam Samore, or his recent *Untitled* (2007), a distorted remake of Francis Bacon's triptych *Study for Self-Portrait* (1985) copied from a black-and-white photographic reproduction, might at first suggest a return to more traditional values of image-making, yet they inevitably return our focus to their expertly rendered surfaces which mark that unstable threshold between the real and its manufactured image.

Die reine Schönheit der Bilder Rudolf Stingels lässt den hingerissenen Betrachter gar nicht sehen, aus was für einfachen, vorgefundenen Materialien sie gemacht sind. Für Stingel ist jedes seiner Werke ein Gemälde – abstrakte oder fotorealistische Bilder genauso wie ein auf dem Boden liegender oder an der Wand hängender Teppich oder ein mit silbernem Dämmmaterial verkleideter Raum. Im Spiel mit den essenziellen Bestandteilen des Mediums – in *Instructions* (1989) zeigt er nach Art eines Kochrezepts Schritt für Schritt, wie ein „echter Rudolph Stingel" zustande kommt – untergräbt Stingel die Autonomie des Gemäldes, indem er dessen Oberflächen verrückt und in architektonische Räume auffächert: Aus dem Zusammenprall zwischen Inszenierung und Realität entsteht so ein kluger dekorativer Reiz. Häufig kleidet Stingel auch ganze Räume mit reflektierender Isolierfolie aus – eine offene Einladung an die Betrachter, ihre Spuren zu hinterlassen oder Objekte an die Wandflächen zu heften. So wie die zahllosen Spuren auf den Teppichen auf Böden oder an Wänden von Galerien oder wie die unter Fußabdrücken wegbrechenden Flächen seiner Werke aus Styropor dokumentieren Stingels Arbeiten die Präsenz des Künstlers wie die des Betrachters: Durch die Prozesse des Sehens und Machens werden sie zugleich aktiviert und zerstört. Seine Serie großformatiger fotorealistischer Selbstporträts nach Aufnahmen seines Freundes Sam Samore oder sein neueres Werk *Untitled* (2007), ein verzerrtes Remake nach einer Schwarzweißkopie von Francis Bacons Triptychon *Study for Self-Portrait* (1985), könnten auf den ersten Blick eine Rückkehr zu traditionelleren Werten des Bildermachens vermuten lassen, doch zwangsläufig lenken sie unser Interesse erneut auf die meisterhafte Behandlung der Oberflächen, jene schwankende Grenze zwischen dem Realen und seinem künstlich produzierten Abbild.

Souvent, la pure beauté des peintures de Rudolf Stingel détourne les visiteurs ébahis des matériaux ordinaires dont elles sont composées. Qu'il s'agisse de toiles abstraites ou photoréalistes, d'un tapis jeté sur un plancher ou accroché à un mur, ou encore d'une chambre tapissée de matériau d'isolation argenté, Stingel décrit chacune de ses œuvres comme une peinture. Jouant avec les ingrédients essentiels de ce médium – une approche culinaire qu'il a adoptée dans *Instructions* (1989), un manuel pour réaliser une « vraie toile Rudolph Stingel » – Stingel fracture l'autonomie de la peinture, disloque et déplie sa surface dans l'espace architectural avec un sens de la décoration évident, où spectacle et réalité sont renvoyés dos à dos. Parmi les gestes récurrents dans l'œuvre de Stingel, il y a ces pièces tapissées de panneaux isolants et réfléchissants, où les spectateurs sont invités à laisser des traces ou à y accrocher des choses. Comme les marques qui s'accumulent sur les tapis étendus sur les sols ou les murs des galeries, ou à la surface de ses œuvres en polystyrène dégradées par les empreintes de pas, les œuvres de Stingel enregistrent la présence à la fois de l'artiste et du visiteur. Elles s'activent et sont détruites dans un même élan, à travers le processus de leur exposition et de leur fabrication. Sa série d'autoportraits photoréalistes en grand format réalisés à partir de photos prises par son ami Sam Samore, ou son récent *Untitled* (2007), nouvelle version distordue du triptyque de Francis Bacon, *Étude pour un autoportrait* (1985), que Stingel a élaborée à partir d'une reproduction en noir et blanc, pourraient laisser penser que l'artiste revient à des valeurs iconographiques plus traditionnelles ; cependant, là encore, ces œuvres dirigent le regard du spectateur principalement vers ces surfaces admirablement travaillées qui marquent le seuil instable entre le réel et son image fabriquée.

A. B.

SELECTED EXHIBITIONS →
2008 *Life on Mars – 55th Carnegie International*, Carnegie Museum of Art, Pittsburgh **2007** *Rudolf Stingel*, Whitney Museum, New York. *Rudolf Stingel*, MCA, Chicago. *Sequence 1 – Pittura e Scultura nella Collezione François Pinault*, Palazzo Grassi, Venice **2006** *Day for Night*, Whitney Biennial 2006, Whitney Museum, New York. *Infinite Painting – Contemporary Painting and Global Realism*, Villa Manin, Codroipo

SELECTED PUBLICATIONS →
2008 *Life on Mars – 55th Carnegie International*, Carnegie Museum of Art, Pittsburgh **2007** *Sequence 1 – Pittura e Scultura nella Collezione François Pinault*, Skira, Milan. *Rudolf Stingel: Painting, 1987–2007*, Yale University Press, New Haven **2006** *Rudolf Stingel – Louvre (after Sam)*, Inverleith House, Royal Botanic Garden, Edinburgh; Sadie Coles HQ, London. *Infinite Painting – Contemporary Painting and Global Realism*, Villa Manin, Codroipo

446

„Wenn man die Dinge aus dem Zusammenhang reißt und den Maßstab verändert, werden sie ganz unheimlich. Aber geht es in der Kunst nicht genau darum? Um Verrückungen?"

« Les choses deviennent très inquiétantes lorsqu'on les sort de leur contexte ou qu'on en modifie l'échelle. Mais n'est-ce pas là l'objet même de l'art ? La dislocation ? »

"Things become very scary when you take them out of context and change the scale. But isn't that what art is about? Dislocation?"

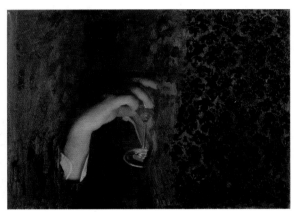

2

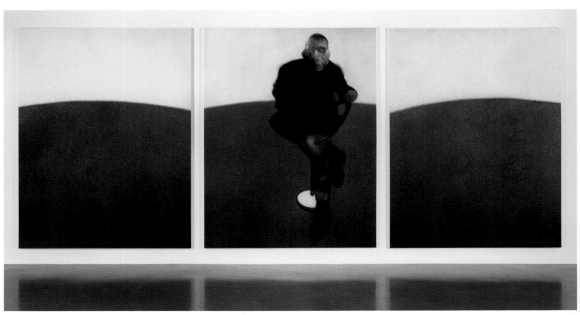

3

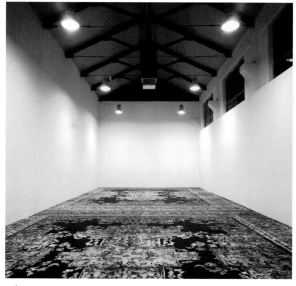

4

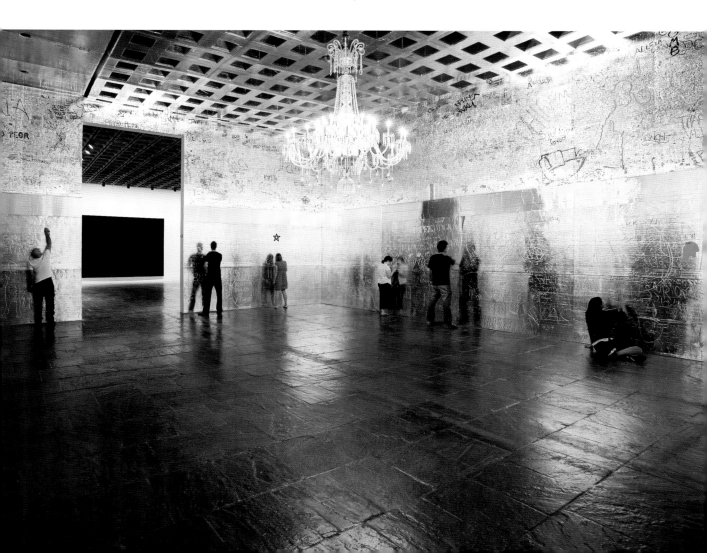

Thomas Struth

1954 born in Geldern, lives and works in Düsseldorf, Germany

It's no coincidence that Thomas Struth's most recent continuation of his series of "museum photographs" focuses on spectators at the Museo del Prado in front of Diego Velázquez's *Las Meninas*. The painting is famous for the complex construction of gazes, especially for the artist's inclusion of his self-portrait, which seems to confront the viewer directly. Struth's "museum photographs" – ongoing since 1989 – are exploring the relationship between the viewer and the artwork, they are multilayered studies of the ways we observe and understand art. In the images taken at the Museo del Prado (2005), the groups gathered around Velázquez's famous painting show a variety of different reactions: from concentrated viewers who listen attentively to a guide's explanations to elementary school students whose attentions are largely directed else-where – a playful contrast with the formal correspondence between their plaid uniform skirts and the elaborate skirts of the girls in the painting. A former student of Bernd and Hilla Becher at the Kunstakademie Düsseldorf, Struth's photographic approach reflects the influence of their objective view. Over the years Struth has captured every major genre explored by his medium's predecessor, painting. He has photographed land- and cityscapes that are eerily quiet, family portraits that are meticulously composed, and still lifes of dense green rainforests. But most of all his work is concerned with the social relations within the collective activity of viewing art. Struth, seeing through his camera, has made himself an intractable part of a complicated accumulation of looks and gazes, in which the camera is only one of many observers.

Dass Thomas Struth in der jüngsten Bildfolge seiner Serie von Museumsfotografien im Museo del Prado die Besucher vor dem Gemälde *Las Meninas* von Diego Velázquez ins Blickfeld rückt, ist kein Zufall. Das Werk ist bekannt für seine komplexen Beziehungen zwischen den Dargestellten, insbesondere für das Selbstporträt des Künstlers, das in direktem Blickkontakt mit dem Betrachter zu stehen scheint. Struths Museumsfotografien – mit denen er 1989 begann – untersuchen das Verhältnis zwischen Betrachter und Kunstwerk in vielschichtigen Studien über unsere Wahrnehmung und unser Verständnis von Kunst. Die Aufnahmen von Besuchergruppen vor dem Meisterwerk von Velázquez im Museo del Prado (2005) dokumentieren die vielfältige Bandbreite von Reaktionen: angefangen bei interessiert und konzentriert lauschenden Teilnehmern einer Führung bis hin zu Schulkindern, deren Aufmerksamkeit in alle Richtungen abgelenkt wird – in spielerischem Kontrast zu der formalen Korrespondenz zwischen den einheitlich buntkarierten Schuluniformröcken und den kunstvoll herausgearbeiteten Röcken der Mädchen auf dem Bild. Struths fotografische Vorgehensweise reflektiert den objektiven Blick seiner ehemaligen Lehrer Bernd und Hilla Becher an der Kunstakademie Düsseldorf. Über Jahre hinweg hat Struth jedes wichtige Genre der Malerei, des Vorgängermediums der Fotografie, fortgesetzt. Er fotografierte geisterhaft ruhige Landschaften und Stadträume, extrem durchkomponierte Familienporträts und Stillleben von dichtem, grünem Regenwald. Doch meistens thematisieren seine Werke die sozialen Interaktionen hinter der Gemeinschaftsaktivität Kunstbetrachtung. Struth wird als Beobachter durch die Linse selbst zu einem festen Teil der komplizierten Korrelation der Blickbeziehungen, in der die Kamera nur ein Betrachter unter vielen ist.

Ce n'est pas un hasard si la composante la plus récente de la série de « photographies de musée » de Thomas Struth se concentre sur les visiteurs du Museo del Prado regardant *Las Meninas* de Diego Velázquez. Ce tableau est célèbre pour le jeu de regards créé entre ses protagonistes, dont l'artiste lui-même à travers son autoportrait qui semble provoquer le spectateur. Les « photographies de musées », série qu'il poursuit depuis 1989, explorent la relation entre le spectateur et l'œuvre d'art. Il s'agit d'études à plusieurs niveaux des manières dont nous observons et comprenons l'art. Dans les photos prises au Prado (2005), les groupes assemblés autour de la fameuse toile de Velázquez livrent un éventail de réactions : certains, concentrés, écoutent les explications que dispense un guide, tandis que des élèves d'école primaire s'inté-ressent manifestement à autre chose – contraste amusant avec la correspondance formelle entre les jupes de plaid qui compose l'uniforme des enfants et celles sophistiquées des filles présentent sur la toile. L'influence de la vision objective chère au couple Becher, dont Struth a été l'élève à la Kunstakademie de Düsseldorf, se ressent clairement dans son approche photographique. Au fil des années, Struth a saisi tous les principaux genres explorés par le médium qui prévalait avant le sien, la peinture. Il a photographié des paysages et des villes mélancoliques, des portraits de famille méticuleusement composés et des natures mortes de denses forêts tropicales vertes. Mais la plus grande part de son travail s'attache aux relations sociales qui se nouent à travers l'activité collective de la contemplation de l'art. Struth, à travers son objectif, devient un élément intrinsèque de cette accumulation complexe de regards, dans laquelle l'appareil photo n'est qu'un observateur parmi beaucoup d'autres.

CH. L.

SELECTED EXHIBITIONS →
2008 *Thomas Struth*, Museo Madre, Museo d'Arte Contemporanea Donna Regina, Naples. *Thomas Struth: Familienleben*, SK Stiftung Kultur, Cologne. *Forgetting Velázquez. Las Meninas*, Museu Picasso, Barcelona **2007** *Thomas Struth: Making Time*, Museo Nacional del Prado, Madrid. *Private/Public*, Musem Boijmans van Beuningen, Rotterdam. *What Does the Jellyfish Want?* Museum Ludwig, Cologne **2006** *The 80's: A Topology*. Museo Serralves, Porto **2005** *Thomas Struth: Imágenes del Perú*, Museo de Arte Lima

SELECTED PUBLICATIONS →
2008 Hans Belting: *Writings on Thomas Struth*, Schirmer/Mosel, Munich. *Thomas Struth: Familienleben / Family Life*, SK Stiftung Kultur, Cologne; Schirmer/Mosel, Munich. Annette Emde: *Thomas Struth: Stadt- und Straßenbilder*, Jonas Verlag, Marburg. *Thomas Struth*, Mondadori, Milan **2007** *Thomas Struth: Making Time*, Museo Nacional del Prado, Madrid; Schirmer/Mosel, Munich. **2005** *Thomas Struth: Museum Photographs*, Schirmer/Mosel, Munich

1 **Hermitage 5, St. Petersburg**, 2005, C-print, 114 x 144.8 cm
2 **Hermitage 2, St. Petersburg**, 2005, C-print, 114 x 144.8 cm
3 **The Felsenfeld/Gold Families, Philadelphia**, 2007, C-print, 179.2 x 217 cm

4 **Domingo Milella & Gabriella Accardo, New York**, 2007, C-print, 97 x 112 cm
5 **Paradiese 34, The Big Island (Hawaiian Islands)**, 2006, C-print, 178.1 x 219.4 cm

„Ein Kunstwerk stirbt, wenn es zum Fetisch wird." « Quand une œuvre d'art devient un fétiche, elle meurt. »

"When a work of art becomes fetishized, it dies."

4

Mickalene Thomas

1971 born in Camden (NJ), lives and works in Brooklyn (NY), USA

With titles like *Afro Goddess Looking Forward* (2007), *This Girl Could Be Dangerous* (2007) and *How Can I Make Sweet Love to You if You Won't Stand Still?* (2007), Mickalene Thomas' works assert forthright, full-bodied and fervent feminine intentions. Thomas hit her stride with painted and photographic portraits of African-American women posed in riotously decorated 1970s style home interiors, in which creamy avocado and acidic orange patterned fabrics clash in a patchwork of ersatz wood panelling, hard geometric and exotic safari prints that serve as the setting for sensually poised, voluptuous ladies, occasionally nude, but mainly costumed in sexy clothing and sporting afro hairstyles. Thomas' work can be seen as investigating the artist-model relationship, whose long lineage she nods to in her *Odalisque* series (2007), but from an updated perspective of female inter-subjectivity and same-sex desire (*La Leçon d'amour*, 2008). She engages all at once with Western art-historical traditions, blaxploitation films, afrofuturism, African contemporary art, seventies fashion and interior design. Rhinestones and crystals incrusted in the surface of her acrylic and enamel surfaces add a sparkly layer of "bling" that situates her work squarely within current issues around black identity and popular culture. Thomas has recently been reproducing her photographed interiors as installations in which she hangs her portraits (*What's Love Got to Do with It*, 2008, after Tina Turner's poignant solo anthem), and has expanded her repertoire to include less obviously celebratory representations, such as her *FBI/Serial Portraits* (2008) of black female mug shots.

Werktitel wie *Afro Goddess Looking Forward* (2007), *This Girl Could Be Dangerous* (2007) und *How Can I Make Sweet Love to You if You Won't Stand Still?* (2007) zeigen, dass Mickalene Thomas ganz eindeutig und konsequent weibliche Intentionen verfolgt. Einen Namen machte sie sich mit gemalten und fotografischen Porträts von Afroamerikanerinnen, die in wild dekorierten Interieurs im Stil der 1970er-Jahre dargestellt sind: Ein Mischmasch aus gemusterten Stoffen in weichen Avocado- und grellen Orangefarben, Kunstholztäfelung und harten geometrischen und exotischen Safaridrucken bildet die Kulisse für sinnlich daliegende, üppige Frauen im Afrolook, die gelegentlich nackt sind, meistens aber sexy Kleidung tragen. In ihrem Werk geht es Thomas offensichtlich um die Beziehung zwischen Künstler und Modell, auf deren lange Tradition sie in ihrer *Odalisque*-Serie (2007) anspielt, allerdings aus einer heutigen Perspektive weiblicher Intersubjektivität und gleichgeschlechtlicher Lust (*La Leçon d'amour*, 2008). Sie thematisiert gleichzeitig kunsthistorische Traditionen des Westens, Blaxploitation-Filme, Afrofuturismus, moderne afrikanische Kunst, Mode und Innenarchitektur der 1970er-Jahre. Inkrustierte Kristallsteine auf den Oberflächen ihrer Acryl- und Emailbilder verleihen ihrem Werk einen funkelnden Glanz, der es unmittelbar in der gegenwärtigen Thematik von schwarzer Identität und Popkultur ansiedelt. Neuerdings reproduziert Thomas ihre fotografierten Interieurs als Installationen, in die sie ihre Porträts hängt (*What's Love Got to Do with It*, 2008, nach Tina Turners ergreifendem Solosong), und hat ihr Repertoire auch um weniger glamouröse Darstellungen erweitert, etwa die *FBI/Serial Portraits* (2008) mit Verbrecherfotos von schwarzen Frauen.

En donnant à ses œuvres des titres comme *Déesse afro regardant droit devant* (2007), *Cette Fille pourrait être dangereuse* (2007) ou *Comment veux-tu que je te fasse l'amour si tu ne te tiens pas tranquille ?* (2007), Mickalene Thomas affiche la féminité directe, essentielle, fervente de ses intentions. Thomas s'est rendue célèbre avec une série de portraits photographiques et peints de femmes afro-américaines posant dans des intérieurs outrageusement décorés, style années 1970. Dans ces environnements, où des tissus à motifs avocat ou orange acidulé, tantôt géométriques, tantôt exotiques, se combinent à la manière d'une marqueterie, des femmes voluptueuses, parfois nues mais le plus souvent habillées de façon sexy et coiffées à la mode afro, sont figurées dans des poses lascives. Le travail de Thomas peut être considéré comme une recherche sur la relation artiste-modèle et l'histoire de celle-ci – elle y fait directement référence dans sa série *Odalisque* (2007) – mais sous l'angle nouveau de l'intersubjectivité féminine et du désir homosexuel (*La Leçon d'amour*, 2008). Elle convoque dans ses œuvres aussi bien l'histoire de l'art occidental que les films Blaxploitation, l'afrofuturisme, l'art contemporain africain, la mode des années 1970 ou la décoration d'intérieur. Les faux diamants ou cristaux incrustés dans ses surfaces acryliques et émaillées ajoutent une touche "clinquante" et positionnent très clairement son travail sur certaines problématiques de la culture populaire et l'identité noire. Thomas a récemment reproduit ses intérieurs photographiés dans des installations, où elle accroche ses portraits (*What's Love Got to Do with It*, 2008, d'après l'hymne d'indépendance poignant de Tina Turner) et étend son répertoire à des représentations moins épicuriennes, comme sa série *FBI/Serial Portraits* (2008), réalisée à partir de photos d'identité judiciaire de femmes noires.

V. R.

SELECTED EXHIBITIONS →
2008 *Mickalene Thomas: What's Love Got to Do with It?*, Contemporary Arts Forum, Santa Barbara. *21: Selections of Contemporary Art from the Brooklyn Museum*, Brooklyn Museum, Brooklyn. *Black is Black Ain't*, The Renaissance Society, Chicago **2007** *Sex in the City*, Dumbo Arts Centre, New York **2006** *The Pulse of New Brooklyn*, MoCADA Museum, Brooklyn **2005** *Greater New York*, P.S.1 Contemporary Art Center, Long Island City

SELECTED PUBLICATIONS →
2008 *Flava: Wedge Curatorial Projects 1997–2007*, Wedge Curatorial Projects, Toronto **2007** *Taking Aim – Selections from the Elliot L. Perry Collection*, Clough-Hanson Gallery, Rhodes College, Memphis **2005** *Greater New York*, P.S.1 Contemporary Art Center, Long Island City; MoMA, New York

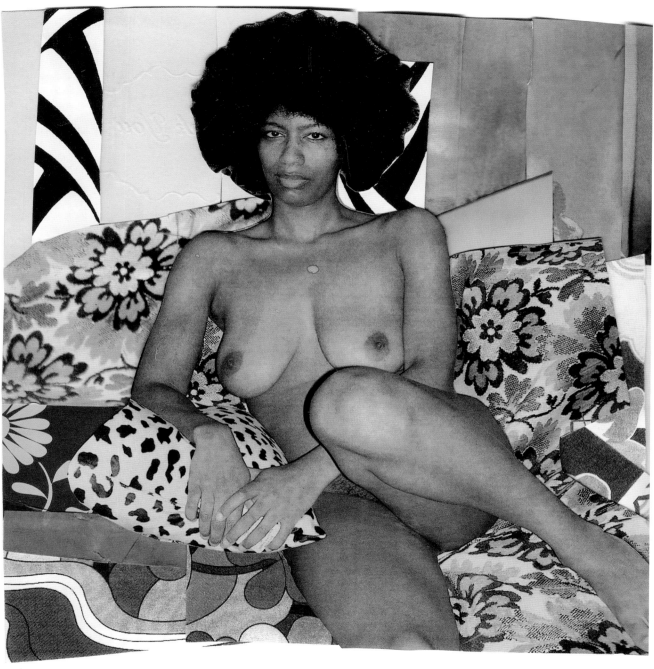

1

1 **Afro Goddess Looking Forward**, 2007, photograph, paper, tape, 22.2 x 21 cm
2 **FBI/Serial Portraits**, 2008, rhinestones, acrylic on panel, 12 panels, 61 x 50.8 cm (each)
3 **Les Trois Femmes Noires**, 2006, rhinestones, acrylic, enamel on wood panel, 213.4 x 243.9 cm
4 **What's Love Got to Do with It?**, 2008, dimensions variable

„Ich gehöre zu jener Art von Künstlern, die sich zwischen der romantischen Vorstellung von Malerei einerseits und der Auseinandersetzung mit der Kunstgeschichte in ihrem Bezug zur Stellung von Afroamerikanerinnen andererseits bewegen. Mein Stil ist auf unberechenbare Weise konsequent."

« Je suis le genre d'artiste qui oscille entre une approche romantique de la peinture et un débat sur la représentation des femmes afro-américaines dans l'histoire de l'art. Mon style est d'une cohérence imprévisible. »

"I'm the type of artist that oscillates between the romantic notion of painting and engaging in a conversation around art history as it relates to the positioning of African American women. My style is unpredictably consistent."

2

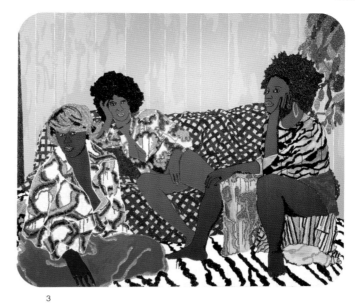

3

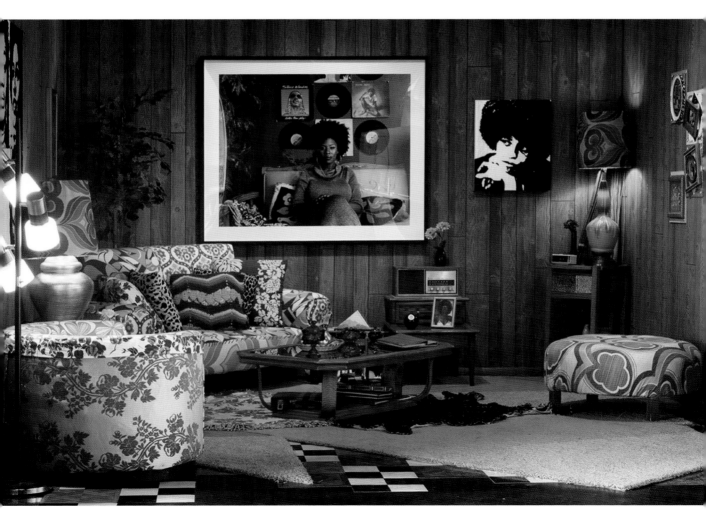

Wolfgang Tillmans

1968 born in Remscheid, Germany, lives and works in London, United Kingdom, and Berlin, Germany

Ever since its invention, photography has been used as a tool to document and categorize. Wolfgang Tillmans photographs the people, places and objects of the world around him with the same desire to record and bring subjects to light, yet pursued with an innately democratic approach to image-making that rejects a categorizing impulse. From his emergence in the early 1990s, he assumed non-hierarchical methods to exhibiting his work, valuing with equal measure the white walls of the gallery, the carefully arranged pages of a book or the visually contested site of the magazine page. Dispelling any sense of linearity or imposed order, Tillmans' installations bring together old and new works, printed in different sizes or techniques, some framed others casually taped to the walls; while seemingly scattershot in their hang, each installation is a carefully choreographed interplay of form and narrative. In his ongoing project *Truth Study Center* (2005–) Tillmans photographs and displays newspaper and magazine cuttings alongside his own photographs displayed on low wooden glass-topped tables. Highlighting the propensity for those in the public sphere to impose claims for absolute truths, Tillmans' pseudo-scientific structure provides a literal and metaphorical framework within which these claims might be objectively examined. Tillmans' recent *Lighter* series (2006–) extends his investigations into the abstract image with additions of folds or creases that open them up into three-dimensional space. Representational in as much as they become objects that represent themselves, Tillmans' abstractions operate at the heart of his investigations into the politics of image making.

Seit ihrer Erfindung dient die Fotografie zur Dokumentation und Kategorisierung. Wolfgang Tillmans fotografiert die Menschen, Orte und Gegenstände der Welt um ihn herum mit genau diesem Verlangen, etwas festzuhalten und Objekte ans Licht zu bringen, aber seine persönliche, demokratische Herangehensweise an die Fotografie schließt eine Kategorisierung von Vornherein aus. Seit Beginn seiner Karriere in den frühen 1990ern präsentierte er seine Arbeiten ohne Rücksicht auf Hierarchien und maß den weißen Räumen der Galerie, der sorgfältig arrangierten Buchseite und der optisch anspruchsvollen Magazinseite denselben Wert bei. Da er jede Linearität oder erzwungene Ordnung ablehnt, bringen Tillmans' Ausstellungen alte und neue Arbeiten zusammen, in verschiedenen Größen und Techniken gedruckt, einige gerahmt, andere beiläufig an die Wand geklebt. Während ihre Hängung wahllos erscheint, ist jede Ausstellung ein sorgfältig choreografiertes Wechselspiel von Form und Erzählung. In seinem derzeitigen Projekt *Truth Study Center* (2005–) fotografiert und präsentiert Tillmans Ausschnitte aus Zeitungen und Magazinen neben seinen eigenen auf den Glasoberflächen niedriger hölzerner Tische ausgelegten Fotografien. Indem er den Anspruch von Personen des öffentlichen Lebens auf absolute Wahrheiten hervorhebt, bietet Tillmans' pseudo-wissenschaftliche Struktur einen wörtlichen und metaphorischen Rahmen, in dem diese Ansprüche objektiv geprüft werden können. Tillmans erweitert mit seiner jüngsten Serie *Lighter* (2006–) seine Untersuchungen am abstrakten Bild durch Falten oder Knicke, die das Bild ins Dreidimensionale öffnen. Seine Abstraktionen – die gegenständlich werden, insofern sie Objekte sind, die sich selbst darstellen – stehen im Zentrum seiner Erforschung der Politik des Bildermachens.

Dès son invention, la photographie a été utilisée comme un outil de documentation et de classification. Wolfgang Tillmans photographie ses sujets – les gens, les endroits et les objets du monde qui l'entoure – dans ce but précis de les mettre en lumière et de conserver leur trace, mais il est cependant animé d'une idée foncièrement démocratique de la production d'images et rejette tout dessein de classification. Dès son apparition sur la scène artistique au début des années 1990, il a mis en place des modes d'exposition non-hiérarchisés, investissant avec la même rigueur les murs blancs d'une galerie, la mise en page d'un livre ou l'espace visuellement enchevêtré du magazine. Repoussant toute impression de linéarité ou d'ordre préétabli, ses installations réunissent des œuvres à la fois récentes et anciennes, au format et au procédé différents, parfois encadrées, parfois simplement scotchées au mur. Malgré l'apparence aléatoire de l'accrochage, chaque installation résulte d'un va-et-vient soigneusement chorégraphié entre forme et narration. Avec son projet *Truth Study Center* (2005–), Tillmans photographie et expose dans des vitrines des images découpées dans des journaux ou des magazines aux côtés de ses propres photographies. Le dispositif pseudo-scientifique de Tillmans met en lumière la propension des acteurs de la sphère publique à revendiquer des vérités absolues, et fournit un cadre tant littéral que métaphorique au travers duquel ces prétentions peuvent être examinées avec objectivité. Avec la série *Lighter* (2006–) Tillmans développe sa recherche sur l'image abstraite en y ajoutant des plis ou des froissements qui invitent ces images dans l'espace à trois dimensions. Les abstractions de Tillmans, qu'on pourrait qualifier de représentationnelles dans la mesure où elles deviennent des objets qui se représentent eux-mêmes, sont au cœur de son exploration de la dimension politique de la production d'images.

A. B.

SELECTED EXHIBITIONS →
2008 *Wolfgang Tillmans: Lighter*, Hamburger Bahnhof, Berlin
2007 *Wolfgang Tillmans: Faltung*, Camera Austria, Graz. *Wolfgang Tillmans: Bali*, Kestnergesellschaft, Hanover. *The Turner Prize: A Retrospective*, Tate Britain, London **2006** *Wolfgang Tillmans: Freedom From The Known*, P.S.1 Contemporary Art Center, Long Island City. *Wolfgang Tillmans*, Museum of Contemporary Art, Chicago; Hammer Museum, Los Angeles; Hirshhorn Museum and Sculpture Garden, Washington

SELECTED PUBLICATIONS →
2008 *Wolfgang Tillmans: Lighter*, Hamburger Bahnhof, Berlin; Hatje Cantz, Ostfildern **2007** *Wolfgang Tillmans: Manual*, Verlag der Buchhandlung Walther König, Cologne **2006** *Wolfgang Tillmans*, Yale University Press, New Haven **2005** *Wolfgang Tillmans: truth study center*, Taschen, Cologne

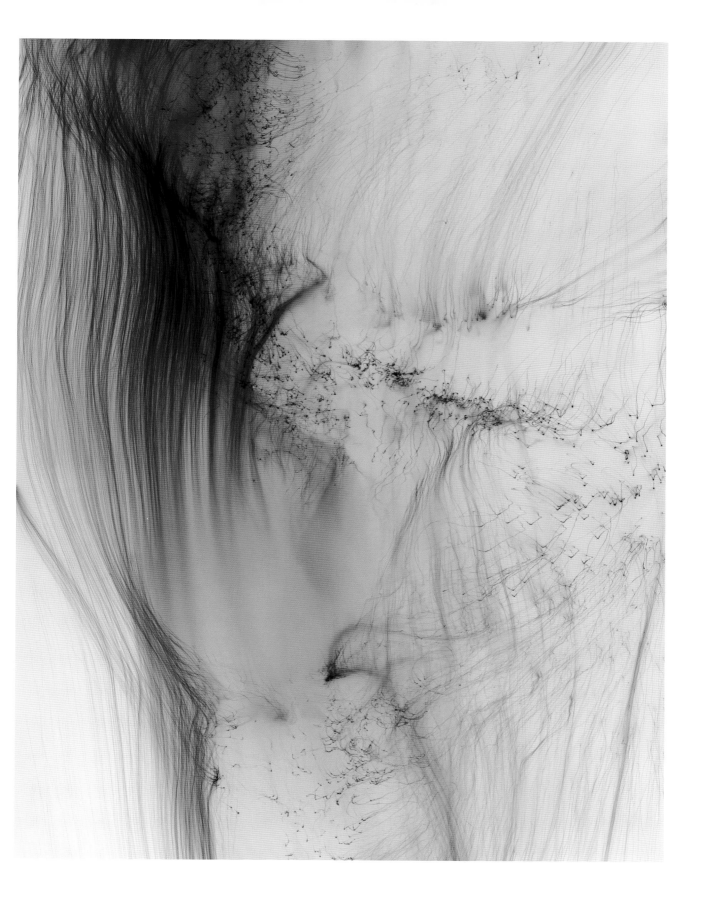

1 **Freischwimmer 20**, 2003, C-print, 237 x 181 cm
2 Installation view, Museum of Contemporary Art Chicago, 2006
3 **Cameron**, 2007, C-print, dimensions variable

4 **Truth Study Center (Table 25)**, 2007, C-prints, Xerox on wooden table, glass, 76 x 198 x 93 cm
5 **Lighter 69**, 2007, C-print, 61 x 50.8 cm

„Obwohl ich weiß, dass die Kamera lügt, halte ich doch fest an der Idee von einer fotografischen Wahrheit."

« Bien que je sache que la caméra ment, je m'accroche à l'idée d'une vérité photographique. »

"Even though I know that the camera lies, I still hold on to the idea of a photographical truth."

3

2

4

Rirkrit Tiravanija

1968 born in Buenos Aires, Argentina, lives and works in New York (NY), USA, and Berlin, Germany

Known for more than one decade for transporting domestic environments into museums and galleries, Rirkrit Tiravanija also takes landmarks of modern architecture such as buildings by Rudolph Schindler, Mies van der Rohe and Philip Johnson as starting points for his work. At the 2006 São Paulo Biennial the artist showed a project he developed after Jean Prouvé's Tropical House designed for the French colonial administration in the Congo. By reconstructing this prototype in the context of an art exhibition, the artist explored its possibilities as an element of cultural translation as well as a platform he made available for public participation, where people could cook and dine and even live. Some of Tiravanija's installations have been open for 24 hours a day with an open invitation for everybody to stay as long as they wish. As a radicalization of Duchamp's legacy, this open status of the work of art is key to many projects by the artist: the exhibition *Rirkrit Tiravanija: A Retrospective (tomorrow is another fine day)* (2004/05) travelled to several institutions and at each new staging adopted different strategies for the re-enactment of the artworks that were not shown but only described and interpreted by guides in temporary architectural settings. Openness, collaboration and passage provide the basis of Tiravanija's practice, an artist who claims that none of his shows are solo, for his pursuit to activate the relationship between the public and the artist is central to his artistic creed. However, his attitude cannot be mistaken for populism. To him, the collective experience is more akin to real life than to the chimeras of contemporary democracy.

Rirkrit Tiravanija, der seit mehr als einem Jahrzehnt dafür bekannt ist, dass er häusliche Environments in öffentliche Museen und Galerien verpflanzt, nimmt auch Ikonen der modernen Architektur – etwa Bauten von Rudolph Schindler, Mies van der Rohe und Philip Johnson – als Ausgangspunkt für seine Arbeit. Auf der Biennale von São Paulo 2006 zeigte der Künstler ein Projekt, das er nach der von Jean Prouvé für die französische Kolonialverwaltung entworfenen Maison Tropicale entwickelte. Mit der Rekonstruktion dieses Prototyps im Rahmen einer Kunstausstellung untersuchte er sein Potenzial als Element in einem Kulturtransfer. Er schuf eine Plattform für die Öffentlichkeit, die sich in Form von gemeinsamem Kochen, Essen und sogar Leben beteiligen konnte. Manche Installationen Tiravanijas waren 24 Stunden am Tag geöffnet, so dass jeder bleiben konnte, solange er wollte. Dieser offene Status des Kunstwerks – eine Radikalisierung des Erbes Duchamps – liefert den Schlüssel zu vielen Projekten des Künstlers: Die Ausstellung *Rirkrit Tiravanija: A Retrospective (tomorrow is another fine day)* (2004/05) war in mehreren Institutionen zu sehen, und jedes Mal gab es andere Strategien zur Neuinszenierung der Kunstwerke, die nicht gezeigt, sondern in den provisorischen architektonischen Einbauten vom Museumspersonal beschrieben und interpretiert wurden. Offenheit, Partizipation und Wandel bilden die Grundlage der Arbeitsweise Tiravanijas, eines Künstlers, der für keine seiner Ausstellungen Einmaligkeit reklamiert und dem es vorrangig darum geht, die Beziehung zwischen Publikum und Künstler anzuregen. Diese Einstellung ist jedoch alles andere als Populismus. Für ihn hat das kollektive Erleben mehr mit dem wirklichen Leben zu tun als mit den Chimären der zeitgenössischen Demokratie.

Connu depuis plus de dix ans pour transporter des environnements domestiques dans des musées et des galeries, Rirkrit Tiravanija prend aussi pour point de départ de son travail des œuvres phares de l'architecture moderne, comme des réalisations de Rudolph Schindler, Mies van der Rohe et Philip Johnson. À la Biennale de São Paulo en 2006, l'artiste a présenté un projet développé d'après la maison tropicale de Jean Prouvé, réalisée pour l'administration coloniale française au Congo. En reconstituant ce prototype dans le contexte d'une exposition artistique, l'artiste a exploré le potentiel de cette maison comme traduction culturelle et comme support pour la participation du public : les gens pouvaient y cuisiner, y dîner et même y vivre. Certaines des installations de Tiravanija étaient ouvertes au public 24 heures par jour, chacun étant invité à rester aussi longtemps qu'il le souhaitait. Radicalisation de l'héritage de Duchamp, ce statut ouvert de l'œuvre d'art est la clé de nombreux projets de cet artiste : l'exposition *Rirkrit Tiravanija : A Retrospective (tomorrow is another fine day)* (2004/05) a voyagé dans plusieurs institutions, adoptant à chaque nouvelle étape une stratégie différente pour remettre en scène les œuvres qui n'étaient pas montrées, mais seulement décrites et interprétées par des guides dans des dispositifs architecturaux provisoires. Ouverture, collaboration et passage constituent la base du travail de Tiravanija, un artiste qui affirme qu'aucune de ses expositions n'est solo car la recherche d'une relation active entre le public et l'artiste est au centre de ses convictions artistiques. Cependant, il ne faut pas prendre son attitude pour de la démagogie. Pour lui, l'expérience collective est plus proche de la vie réelle que des chimères de la démocratie contemporaine.

R. M.

SELECTED EXHIBITIONS →
2008 *Rirkrit Tiravanija: Demonstration Drawings*, The Drawing Center, New York. Yokohama Triennale 2008, Yokohama **2007** *Rirkrit Tiravanija: An Untitled Concert, Untitled 2007 (orchestral score for Luis Buñuel)*, Theater Basel, Basle. *Show Me Thai*, Museum of Contemporary Art, Tokyo. *Neue Asiatische Kunst. Thermocline of Art*, ZKM, Karlsruhe **2006** *Into Me/Out Of Me*, P.S.1 Contemporary Art Center, Long Island City; KW Institute for Contemporary Art, Berlin

SELECTED PUBLICATIONS →
2008 *Rirkrit Tiravanija: Demonstration Drawings*, The Drawing Center, New York **2007** *Rirkrit Tiravanija: A Retrospective (tomorrow is another fine day)*, JRP Ringier, Zurich **2006** *Rirkrit Tiravanija's Soccer Half-Time Cookery-Book*, Verlag für moderne Kunst, Nuremberg. *Into Me/Out Of Me*, P.S.1 Contemporary Art Center, Long Island City; KW Institute for Contemporary Art, Berlin; Hatje Cantz, Ostfildern

462

1 **Untitled (Foster, You're Dead)**, 2008, in collaboration with Neil Logan,
 puzzle, 103 x 83 cm
2/4/5 **Untitled (non-gab-din, kim-gab-sai / sleep on earth, eat on sand)**, 2005,
 cooking performance, trailer sealed on one side by Plexiglas plane,
 4 gas cookers, 4 woks, remnants of phad thai food, plastic, cardboard,
 Styrofoam boxes, plastic utensils, kitchen tools, glass, plastic bottles,

trailer ca 300 x 200 x 300 cm. Installation view, *Politics of Fun*,
Haus der Kulturen der Welt, Berlin
3 **Untitled (Tilted Teahouse with Coffeemachine)**, 2005, stainless steel,
plywood, coffee machine, 430 x 300 x 300 cm. Installation view, *Luna Park.
Fantastic Art – Sculptures in the Park*, Villa Manin, Codroipo

„Kunst hat viel mit der Idee oder mit dem Idealismus zu tun, sich einen Raum
für die Diskussion über Freiheit zu erobern."

« L'art se rapproche de l'idée ou de l'idéalisme visant à obtenir un espace
pour débattre de la liberté. »

"Art comes close to the idea or the idealism of obtaining a space to discuss freedom."

2

3

4

Gert & Uwe Tobias

1973 born in Brasov, Romania, live and work in Cologne, Germany

The art of twin brothers Gert and Uwe Tobias is rife with references to the past: they have revived the archaic craft of the woodcut on paper, printing large-format images that require multiple printing blocks. The colours are vivid, the compositions bold and original. Some of the works are abstract, their forms seem reminiscent of earlier art, Russian constructivism clashes against art-nouveau patterns, emoticons against vintage movie posters, like a pop take on the history of abstraction. Other works show slightly geometrized figures that have an impish appearance, their haunting quality has often been linked to the artists' Transylvanian heritage – but the folk and somewhat fairy-tale-like aspect of their images possibly also relates to the modern tradition of a Paul Klee, who spotted in primitive sources a way to renovate art. In a third group of signature pieces, strange characters are painstakingly rendered in whimsical typewriter drawings, revealing a less scary and even fun bestiary. While a strong sense of their birthland's cultural background seems to inform these works, this is nevertheless completely translated into meticulous compositions that combine the sensibilities of artists steeped in the history of their genre and of the contemporary graphic designer. The Tobias' duo shows extend these compositions into the exhibition space, as seen perhaps most impressively at their 2007 exhibition in New York's Museum of Modern Art: with painted walls that structured the room or suggested windows, with pictures hung at varying heights in a complex dialogue, revolving around a sculptural piece that made the complete space into a multi-medial artwork.

Die Kunst der Zwillingsbrüder Gert und Uwe Tobias enthält zahlreiche Bezüge zur Vergangenheit: Sie haben das archaische Kunsthandwerk des Holzschnitts auf Papier neu belebt und drucken großformatige Bilder, die mehrere Druckstöcke erfordern. Die Farben sind lebhaft, die Kompositionen kühn und originell. Einige Arbeiten sind abstrakt und scheinen formal an frühere Kunst zu erinnern: Russischer Konstruktivismus prallt auf Jugendstil-Muster, Emoticons kontrastieren mit Motiven aus Stummfilmplakaten – die Geschichte der Abstraktion gewissermaßen in Pop-Version. Andere Werke zeigen leicht geometrisierte, skurrile Figuren, deren unheimliche Anmutung oft mit dem transsilvanischen Erbe der Künstler in Zusammenhang gebracht wurde – allerdings könnte der folkloristische, etwas märchenhafte Charakter ihrer Bilder auch Bezug zur modernen Tradition eines Paul Klee haben, der primitive Quellen als Möglichkeit zur Erneuerung der Kunst betrachtete. Eine dritte Gruppe von Arbeiten besteht aus humorigen Schreibmaschinenzeichnungen mit merkwürdigen Schriftzeichen, die ein weniger schauriges, geradezu witziges Bestiarium offenbaren. Diese Arbeiten sind offenbar von einem starken Gefühl für den kulturellen Hintergrund ihres Heimatlandes beeinflusst, doch äußert sich dies durchweg in akribischen Kompositionen, welche die Sensibilitäten von Künstlern kombinieren, die von der Geschichte ihres Genres und der des modernen Grafikers erfüllt sind. Bei Ausstellungen der Brüder Tobias entfalten diese Kompositionen raumgreifende Eigenschaften, wie es am beeindruckendsten vielleicht 2007 im New Yorker Museum of Modern Art zu sehen war: Bemalte Wände strukturierten den Raum oder deuteten Fenster an, aus unterschiedlich hoch hängenden Bildern ergab sich ein komplexer Dialog, der um eine skulpturale Arbeit in der Mitte kreiste und den gesamten Raum zu einem multimedialen Kunstwerk machte.

L'art des jumeaux Gert et Uwe Tobias abonde de références au passé : ils ont redonné vie à la technique archaïque de la gravure sur bois imprimée sur papier, produisant des images de grand format qui nécessitent une impressionnante quantité de blocs d'impression. Les couleurs sont vives, les compositions audacieuses et originales. Certaines de leurs œuvres abstraites convoquent des formes passées : le constructivisme russe s'entrechoque avec des motifs Art nouveau, des émoticones côtoient les affiches de classiques du cinéma, telle une incursion pop dans l'histoire de l'abstraction. D'autres œuvres présentent des personnages un peu géométriques, à l'allure malicieuse. Leur présence a souvent été mise en relation avec les origines transylvaniennes des deux frères – mais l'aspect populaire et féerique de leur iconographie renvoie aussi bien à la tradition moderne telle qu'incarnée par Paul Klee, qui identifia dans des sources primitives le moyen de renouveler l'art de son époque. Un troisième groupe de travaux rassemble d'étranges personnages savamment esquissés à l'aide d'une typographie fantasque, dévoilant un bestiaire moins effrayant et même ludique. Si le patrimoine culturel de leur région d'origine semble imprégner leur œuvre, il s'incorpore totalement dans ces compositions méticuleuses qui révèlent la sensibilité d'un duo d'artistes maîtrisant parfaitement l'histoire de leur pratique comme le graphisme le plus contemporain. Dans leurs expositions, les frères Tobias développent leurs compositions dans l'espace, comme ce fut le cas, notamment, au Museum of Modern Art de New York, où ils peignirent les murs de façon à structurer la pièce et suggérer des fenêtres. Les tableaux, accrochés à diverses hauteurs afin d'instaurer entre eux un dialogue complexe, tournaient autour d'une pièce sculpturale : l'espace entier était alors transformé en une œuvre multimédia.

R. M.

SELECTED EXHIBITIONS →
2008 *Gert und Uwe Tobias*, Kunstmuseum Bonn **2007** *Gert und Uwe Tobias: Projects 86*, MoMA, New York. *Gert und Uwe Tobias: Utstillingsplakater*, Bergen Kunsthall, Bergen. *Gert und Uwe Tobias: Nichts brennt an, nichts kocht über*, Kunstverein Heilbronn. *Gert und Uwe Tobias: If You Build it, They Will Come*, Brukenthal Museum, Sibiu. *Made in Germany. Aktuelle Kunst aus Deutschland*, Kestnergesellschaft; Sprengel Museum; Kunstverein Hannover, Hanover

SELECTED PUBLICATIONS →
2008 *Gert und Uwe Tobias*, Kunstmuseum Bonn **2007** *Gert & Uwe Tobias*, Snoeck, Cologne. *Aktuelle Kunst aus Deutschland*, Kestnergesellschaft; Sprengel Museum, Hanover; Hatje Cantz, Ostfildern **2005** *Come and See before the Tourists Will Do – The Mystery of Transsylvania*, Galerie Michael Janssen, Cologne

1

1 **Untitled**, 2006, coloured woodcut on paper, Plexiglas, 214 x 194 cm (framed)
2 Installation view, *Gert and Uwe Tobias: Frieze*, Frieze Art Fair, London, 2007

3 **Untitled**, 2007, coloured woodcut on paper on canvas, 268 x 401.7 cm
4 **Untitled**, 2006, coloured woodcut on paper, Plexiglas, 205 x 196 cm (framed)

„Wir machen Kunst, weil es Spaß macht."

« Nous faisons de l'art parce que ça nous amuse. »

"We make art because it's fun."

2

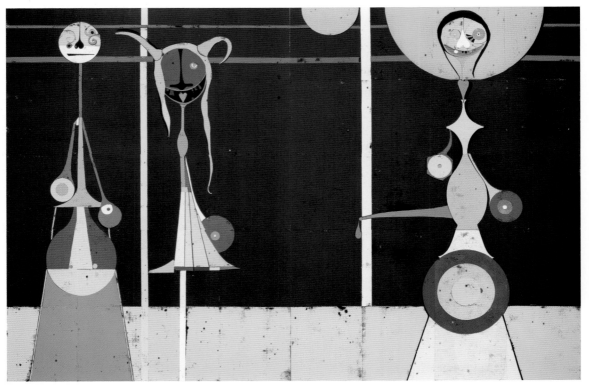

3

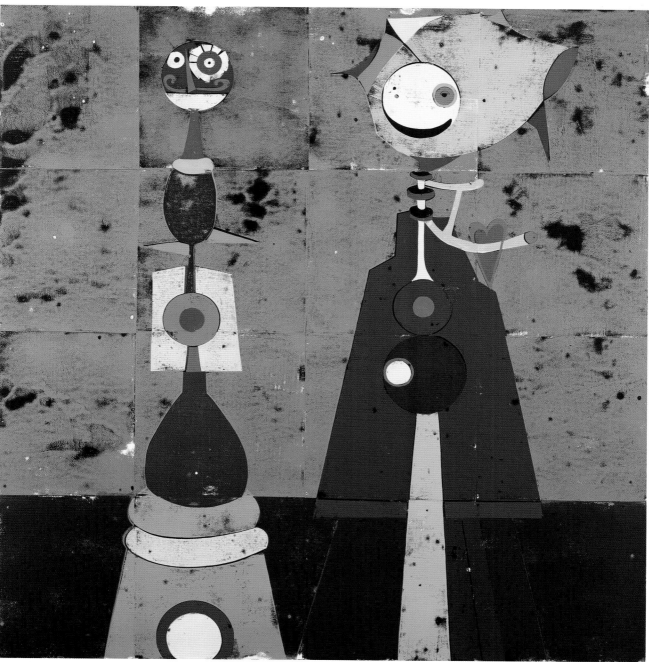

Fred Tomaselli

1956 born in Santa Monica (CA), lives and works in Brooklyn (NY), USA

Seen from a distance, Fred Tomaselli's pictures resemble a postmodern agglomeration of styles. Arcimboldo's allegories and Rousseau's landscapes can be discerned, as can the night skies of German romanticism, floral Arts and Crafts patterns, Islamic ornament, Indian mandalas and even explosive elements drawn from psychedelia or punk graphics. The whole lot is then subjected to a neo-baroque allover and as-much-as-possible to create a dense whirl of information. However, the viewer often only accesses the more important information by looking closely at the surfaces of the paintings, where another source of Tomaselli's works – surrealism – is revealed. Like the surrealists, he assembles motifs or combines them in collages; however he does not just use natural elements or pictorial extracts from books or newspapers; his specific medium are medicines and drugs – beneath the shiny resin, the motifs consist of brightly coloured pills, cannabis leaves, ecstasy tablets and mescaline. The transformative power of art when applied to everyday life has been acknowledged since the dadaists and surrealists, and it is thanks to them that everyday images and materials can appear in artworks and be transformed into artistic elements. Tomaselli converts intoxicating substances that usually offer only a brief sojourn in Baudelaire's *Artificial Paradises* into something more long-lasting – cosmologies, birds of paradise and leafy worlds, for example, remain fixed in the paintings rather than disintegrating under the influence of time in a narcotic haze (*Migrant Fruit Thugs*, 2006). The baroque idea of Vanitas, which also aptly applies to drug intoxication, is thus transformed into something durable, because art holds the balance over time.

Von Ferne betrachtet wirken die Bilder Fred Tomasellis wie eine postmoderne Stilballung. Arcimboldos Allegorien und Rousseaus Landschaften scheinen durch, ebenso die Nachthimmel der deutschen Romantik, die floralen Muster von Arts and Crafts, islamische Ornamentik, indische Mandalas, aber auch explosionsartige Elemente von Psychedelic Art oder Punkgrafik. Das Ganze wird dann einem neobarocken *all over* und *as much as possible* unterworfen, so dass eine schwirrende Informationsdichte entsteht. Doch die wichtigeren Informationen bekommt der Betrachter oft erst bei näherer Ansicht der Bildoberflächen. Hier offenbart sich eine weitere Quelle von Tomasellis Arbeiten, der Surrealismus. Seine Motive sind im Wesentlichen collagiert und assembliert, wie jene der Surrealisten. Tomaselli nutzt jedoch nicht nur Naturelemente oder Bildelemente aus Büchern und Zeitschriften, sein spezielles Gestaltungsmittel sind Arzneien und Drogen: bunte Pillen, Cannabisblätter, Ecstasytabletten und Mescalin stecken unter dem Kunstharz-Hochglanz und formen die Motive. Seit den Dadaisten und Surrealisten ist die transformative Kraft von Kunst bezogen auf den Alltag bekannt: Dank ihr können Alltagsbilder und Alltagsmaterialien in Kunstwerken erscheinen und zu künstlerischen Elementen gewandelt werden. Tomaselli nun überführt Rauschmittel, mit denen man ansonsten nur kurzzeitig in Baudelaires *Künstliche Paradiese* gelangt, in ebensolche von Dauer – Kosmologien, paradiesische Vögel- und Blätterwelten etwa bleiben in den Bildern fixiert, ohne wie beim Drogenrausch unter dem Einfluss der Zeit zu zerfallen (*Migrant Fruit Thugs*, 2006). Und so wird die barocke Idee der Vanitas, welche gerade auch den Drogenrausch betrifft, in Beständigkeit transformiert, denn die Kunst hält gegen die Zeit.

Considérés de loin, les tableaux de Fred Tomaselli font l'effet d'une compilation de styles d'inspiration postmoderne. Les allégories d'Arcimboldo et les paysages du Douanier Rousseau y transparaissent aussi bien que le ciel nocturne du romantisme allemand, les motifs floraux des Arts and Crafts anglais, l'ornement islamique, les mandalas indiens ou encore des éléments d'art psychédélique et de graphisme punk. L'ensemble est ensuite soumis à un *allover* et à un *as much as possible* néo-baroque dont résulte une foisonnante densité d'informations. Quant à l'information cruciale, le spectateur ne la reçoit souvent qu'après avoir examiné de plus près les surfaces des tableaux : une autre source des œuvres de Tomaselli s'y révèle, le surréalisme. A la manière des surréalistes, les motifs sont essentiellement des collages ou assemblages. Cela dit, Tomaselli n'utilise pas seulement des éléments naturels ou picturaux tirés de livres ou de revues. Son moyen de création particulier, ce sont les médicaments et les drogues : pilules multicolores, feuilles de cannabis, comprimés d'ecstasy et mescaline se cachent sous la résine polie et créent le motif. Depuis les dadaïstes et les surréalistes, la puissance transformatrice de l'art référée au quotidien est un fait connu : les images et matériaux quotidiens peuvent ainsi paraître dans les œuvres d'art et être transformés en éléments artistiques. Tomaselli, lui, transforme les stupéfiants, qui ne donnent que temporairement accès aux *Paradis artificiels* de Baudelaire, en paradis pérennes : cosmologies, univers aviaires et feuillages paradisiaques restent fixés dans ses tableaux sans se dissiper sous l'effet du temps, contrairement aux extases psychotropes (*Migrant Fruit Thugs*, 2006). L'idée baroque de la vanité, qui précisément concerne aussi les paradis artificiels, est ainsi transformée en durée, car l'art s'oppose à la fuite du temps.

H. L.

SELECTED EXHIBITIONS →
2008 *Prospect. 1*, New Orleans Biennal, New Orleans. *Art Is for the Spirit: Works from the UBS Art Collection*, Mori Art Museum, Tokyo **2007** *If Everybody Had an Ocean – Brian Wilson: An Art Exhibition*, Tate St. Ives; CAPC – Musée d'art contemporain de Bordeaux **2006** *Day for Night*, Whitney Biennial 2006, Whitney Museum, New York. *Over + Over: Passion for Process*, Krannert Art Museum, University of Illinois, Urbana-Champaign; Austin Museum of Art, Austin **2005** *Ecstasy: In and About Altered States*, MOCA, Los Angeles

SELECTED PUBLICATIONS →
2006 *No.1: First Works of 362 Artists*, Thames & Hudson, London. *Over + Over: Passion for Process*, Krannert Art Museum, University of Illinois, Urbana-Champaign **2005** *Ecstasy: In and about Altered States*, MOCA, Los Angeles **2004** *Fred Tomaselli: Monsters of Paradise*, Rose Art Museum, Waltham

1 **Migrant Fruit Thugs**, 2006, photo collage, leaves, acrylic, gouache, resin on wood panel, 243.8 x 189.1 cm
2 **Raven**, 2008, photo collage, acrylic, gouache, resin on wood panel, 61 x 76.2 cm

3 **Tower of Peace Towers**, 2008, photo collage, acrylic, gouache, resin on wood panel, 152.4 x 152.4 cm
4 **Abductor**, 2006, leaves, photo collage, acrylic, resin on wood panel, 243.8 x 198.1 cm

„Meine Arbeiten beginnen mit etwas Nichtssagendem, einem Stück Holz, und dann baut sich durch tausende und abertausende kleinster Bewegungen etwas auf, wie ein Organismus aus Zellen."

« Mon œuvre commence comme quelque chose de vierge, un bout de bois, ensuite, par des milliers et des milliers de micro-actes, cette chose s'élabore elle-même comme le fait un organisme à partir des cellules. »

"My work starts out as a blank thing, a piece of wood, and through thousands and thousands of little micro-moves, this thing builds itself up like an organism out of cells."

2

3

Janaina Tschäpe

1973 born in Munich, Germany, lives and works in Brooklyn (NY), New York

Janaina Tschäpe grew up in Brazil and Germany and has become known for performative videos and photographs in which she often appears with biomorphic body extensions in a variety of staged natural and cultural settings. In recent years, however, she has increasingly gone back to her original medium of painting. Her organic-ornamental compositions combine myths and fairytales with the visual language of abstract painting. Her drawings and paintings are not geared towards narration, but instead pursue aims analogous to her photographs and videos, also using a related pictorial language. Echoes of abstract expressionism, Arshile Gorky's organic compositions or the ornamental vocabulary of Gustav Klimt are just as present as microscopic views – offering fantastic insights into the mysterious organisms of nature (*Lair*, 2008). The large-scale diptych *Monsoon* (2007) deals with a recurring element in Tschäpe's works: water. Tschäpe makes repeated reference to Yumeira, the Queen of the Sea in Brazilian mythology. In Tschäpe's performances, videos and photographs, allusions to mythological or fabulous beings also recur in her staged portrayals of alienated bodies. The body extensions made of fabric, silicon, tubes or balloons distantly recall Lygia Clark's sculptural transformations, Ernesto Neto's organic sculptures or Hans Bellmer's deformed dolls. But for Tschäpe, the female body is not a voyeuristically deformed object as in the latter case, but instead a wilfully evolving organism within a female-centred mythology – as in the photograph *Glandulitera Maris* (2005), where it poses as a colourful seaweed that seems ready to go ashore and spread.

Die in Brasilien und Deutschland aufgewachsene Künstlerin Janaina Tschäpe wurde bekannt durch performative Videos und Fotografien, in denen sie sich oft mit biomorphen Körpererweiterungen in verschiedenen Natur- und Kulturräumen inszenierte. In den letzten Jahren ist sie jedoch verstärkt zu ihrem Ursprungsmedium, der Malerei, zurückgekehrt. In ihren organisch-ornamentalen Kompositionen vermischen sich Mythen und Märchen mit der Bildsprache abstrakter Malerei. Zeichnung und Malerei sind jedoch nicht narrativ ausgerichtet, sondern sie verfolgen in verwandter Bildsprache Ziele analog zu Tschäpes Fotografien und Videos. Anklänge an den abstrakten Expressionismus, an die organischen Kompositionen Arshile Gorkys oder die ornamentale Bildsprache Gustav Klimts sind ebenso präsent wie der mikroskopische Blick – ein fulminantes Eintauchen in die geheimnisvollen Organismen der Natur (*Lair*, 2008). Das großformatige Diptychon *Monsoon* (2007) behandelt ein in Tschäpes Werk wiederkehrendes Element: Wasser. Immer wieder erinnert Tschäpe an ihre Namensverwandte Yumeira – die Königin des Meeres in der brasilianischen Mythologie. Auch in Tschäpes Performances, Videos und Fotografien kehren Anklänge an mythologische und märchenhafte Wesen in den Inszenierungen verfremdeter Körper stets wieder. Die Körpererweiterungen mittels Stoff, Silikon, Schläuchen oder Ballons erinnern entfernt an die skulpturalen Transformationen Lygia Clarks, die organischen Skulpturen Ernesto Netos, aber auch an die deformierten Puppen Hans Bellmers. Doch ist der weibliche Körper bei Tschäpe nicht wie bei letzterem voyeuristisch deformiertes Objekt, sondern ein sich eigenwillig ausbreitender Organismus in einer weiblich geprägten Mythologie. So wie in der Fotografie *Glandulitera Maris* (2005), wo er als farbenfroher Seetang posiert, der bereit scheint, nun das Land zu erobern.

Janaina Tschäpe, qui a grandi au Brésil et en Allemagne, s'est fait connaître par ses vidéos et ses photographies performatives dans lesquelles elle se met souvent en scène avec des ajouts corporels biomorphiques, dans différents environnements naturels ou culturels. Au cours des dernières années, elle est toutefois revenue plus fortement à son médium d'origine, la peinture. Dans ses compositions organico-ornementales, contes et mythes se mêlent au langage visuel de la peinture abstraite, sachant que le dessin et la peinture n'y relèvent pas d'une tendance narrative, mais poursuivent dans un langage iconographique similaire des buts analogues à ceux de ses photographies et de ses vidéos. Les références à l'expressionnisme abstrait, aux compositions organiques d'Ashile Gorky ou au vocabulaire ornemental de Gustav Klimt y sont aussi présentes que le regard microscopique, fulgurante plongée dans les organismes mystérieux de la nature (*Lair*, 2008). Le grand diptyque *Monsoon* (2007) traite d'un élément récurrent dans l'œuvre de Tschäpe : l'eau. Tschäpe évoque régulièrement Yumeira, sa parente nominale, reine de la mer dans la mythologie brésilienne. Les mises en scènes de corps dénaturés de ses performances, vidéos et photographies présentent aussi des références récurrentes à des êtres mythologiques ou merveilleux. Les ajouts corporels réalisés à l'aide de tissus, de silicone, de tuyaux ou de ballons rappellent vaguement les transformations sculpturales de Lygia Clark, les sculptures organiques d'Ernesto Neto, mais aussi les poupées de Hans Bellmer. Cela dit, contrairement à ce dernier, chez Tschäpe, le corps de la femme n'est pas un objet déformé par une approche voyeuriste, mais un organisme qui se développe volontairement dans une mythologie empreinte fémininité. Comme le corps dans la photographie *Glandulitera Maris* (2005), qui à la manière d'une algue colorée se déploie sur le rivage. E. S.

SELECTED EXHIBITIONS →
2008 *Janaina Tschäpe: Chimera*, Irish Museum of Modern Art, Dublin. *Garten Eden: Der Garten in der Kunst seit 1900*, Kunsthalle Emden **2007** *Fairy Tale: Contemporary Art and Enchantment*, The New Art Gallery Walsall; Chapter, Cardiff; Leeds Art Gallery, Leeds **2006** *Janaina Tschäpe*, Tokyo Wonder Site, Tokyo. *Janaina Tschäpe: Camaleoas*, Z Platz, Fukuoka. *Janaina Tschäpe: Melantropics*, Contemporary Museum of Arts, St Louis

SELECTED PUBLICATIONS →
2008 *Janaina Tschäpe: Chimera*, Irish Museum of Modern Art, Dublin. *Photo Art – The New World of Photography*, Thames & Hudson, London. *Photo Art – Photography in the 21st Century*, Aperture, New York **2007** *Photo Art – Fotografie im 21. Jahrhundert*, DuMont, Cologne. *Fairy Tale: Contemporary Art and Enchantment*, The New Art Gallery Walsall **2006** *Janaina Tschäpe: Melantropics*, Contemporary Art Museum, St. Louis. *Janaina Tschäpe*, Paço das Artes, São Paulo

1 **Untitled 1**, 2006, tempera on paper, 152 x 104 cm
2 **Melantropics I Series: Glandulitera Maris**, 2005, glossy C-print, 102 x 127 cm

3 **Untitled 4**, 2006, tempera on paper, 152 x 104 cm
4 **Monsoon**, 2007, watercolour on paper, diptych, 229.2 x 152.4 (each)
5 **Lair**, 2008, oil on canvas, 299.6 x 601.8 cm

„Ich glaube, ich möchte eine Landschaft aus meiner Erinnerung finden. Manchmal denkt man an irgendwas und man entwirft eine seltsame Welt, und man sucht nach etwas, weiß aber nicht genau wonach. Danach auf der Leinwand zu suchen, diese Erinnerung an eine Landschaft, an eine Idee – das ist ungefähr wie eine Suchaktion im Gedächtnis."

« Je crois que j'essaie de trouver un paysage enfoui dans ma mémoire. Parfois ne serait-ce qu'en pensant à des sujets qui me font dessiner ce drôle de monde où nous cherchons quelque chose sans savoir exac... Je crois que je le cherche sur la toile, en sondant la mémoire ... d'une idée. D'une certaine manière, c'est comme une recherch... »

"I think I'm trying to find a landscape that is in my memory. Sometimes jus... thinking of stuff that makes you draw this funny world where you're looking for something, but you don't exactly know what it is? To look for it on canvas, searching for this memory of a landscape, of an idea – it's just like a memory search somehow."

2

3

4

5

Luc Tuymans

1958 born in Mortsel, lives and works in Antwerp, Belgium

His sketchy, alternately vaporous or bleached-out paintings address the potential inadequacy and "belatedness" of the medium, as Luc Tuymans himself puts it. Still, Tuymans might be thought of as a deeply analytic postmodern history painter, working over the embers of painting as well as over the political and social subjects for which, once upon a time, painting was pressed gainfully into service. This time around though, "grand" style painting is whittled down in size and derived from photography, television and the movies; it is far from laboured over despite the fact that Tuymans' considered – even sober – surfaces hardly admit that he completes each painting in the course of a day, a habitual, not to say compulsive action (the traces of which linger mostly in the passages where one can see that the paint has been applied wet-into-wet). With subjects ranging from the Holocaust or Belgian Congo politics to such trifles as Christmas decorations, his wan portrayals exist in the gap between image and the event to which it is rendered ambiguously oblique. Even portraits like *The Secretary of State* (2005), a close-up of Condoleezza Rice, eyes squinty and lacquered lips pursed, are oddly unsettling in their aloofness for all their proximity. The most mute of objects can become equally sinister without us knowing why. Tuymans prefers to leave much outside the frame, such that titles come to play a critical role in securing meaning, but neither does Tuymans offer easy consolations even once references are known. Instead, his paintings are invitations to associations that make clear how circumstantial readings of pictures can be.

Seine skizzenhaften Gemälde – mal hingehaucht, mal ausgebleicht – thematisieren die potenzielle Unzulänglichkeit und „Verspätung" des Mediums, wie Luc Tuymans es selbst formuliert. Dennoch könnte man ihn als zutiefst analytischen, postmodernen Historienmaler sehen, der sich mit der Tradition der Malerei ebenso beschäftigt wie mit den politischen und gesellschaftlichen Themen, denen sie früher einmal nutzbringend zu Diensten zu sein hatte. Heutzutage jedoch wird die repräsentative Malerei im Format zurecht gestutzt, ihre Modelle kommen aus Fotografie, Fernsehen und Filmen; sie wird auch nicht bis zum sorgfältigen Finish immer wieder überarbeitet, selbst wenn Tuymans' durchdachte – sogar nüchterne – Oberflächen kaum erkennen lassen, dass er jedes Gemälde im Laufe eines Tages vollendet, eine gewohnheitsmäßige, um nicht zu sagen zwanghafte Praxis (deren Spuren hauptsächlich dort zu erkennen sind, wo die Farbe nass-in-nass aufgetragen wurde). Seine fahlen Darstellungen mit Sujets, die vom Holocaust oder belgischer Kongo-Politik bis zu Banalitäten wie Weihnachtsschmuck reichen, sind in der Lücke zwischen dem Bild und dem Ereignis angesiedelt, das es in schiefer Zweideutigkeit wiedergibt. Selbst Porträts wie *The Secretary of State* (2005), eine Nahaufnahme von Condoleezza Rice mit zusammengekniffenen Augen und grell geschminkten Lippen, wirken in ihrer Reserviertheit, die sie trotz aller Nähe haben, merkwürdig irritierend. Noch das stummste Objekt kann ebenso unheimlich werden, ohne dass wir wüssten, warum. Tuymans lässt gerne viel außerhalb des Bildfläche, so dass den Titeln eine wichtige Rolle als Bedeutungsträger zukommt, doch selbst wenn die Bezüge bekannt sind, verweigern sich seine Bilder einem allzu leichten Verständnis. Vielmehr laden sie zu Assoziationen ein, die das Willkürliche von Bildinterpretationen deutlich machen.

Les peintures aux allures d'esquisses, tantôt translucides, tantôt délavées, de Luc Tuymans traitent du caractère potentiellement inadapté ou « en retard » de la peinture, pour reprendre une de ses expressions. Toutefois, on peut considérer Tuymans comme un peintre profondément analytique de l'histoire postmoderne, qui travaille sur les braises encore chaudes de la peinture, et autour des sujets politiques et sociaux pour lesquels la peinture était autrefois brillamment convoquée. Cependant, chez lui, la « grande peinture » est réduite en taille et s'inspire de la photographie, de la télévision et du cinéma ; elle n'est pas extrêmement travaillée, même s'il est difficile de croire que ses toiles, même sobres, puissent être achevées en un jour. Elles le sont pourtant, grâce à une action permanente, pour ne pas dire compulsive comme en témoignent les endroits où la peinture a été appliquée sans attendre que la couche inférieure sèche. Avec des sujets qui vont de l'holocauste à des frivolités comme les décorations de Noël, en passant par la politique menée au Congo belge, ses représentations blêmes prennent vie dans l'intervalle entre l'image et l'événement dont elle rend compte de façon ambiguë, oblique. Mêmes les portraits comme *The Secretary of State* (2005), un gros plan montrant une Condoleezza Rice aux yeux bigles et aux lèvres laquées et pincées, dérangent par la distance que leur proximité brutale installe. Le plus muet des objets peut devenir tout aussi sinistre sans que nous comprenions pourquoi. Tuymans préfère laisser une grande partie du sens hors du cadre et les titres jouent un rôle crucial dans l'appréhension de ses œuvres. Mais connaître les influences et références de Tuymans ne rend pas son œuvre limpide pour autant. Ses peintures nous invitent plutôt à faire des associations qui montrent combien l'interprétation des images peut être contingente.

S. H.

SELECTED EXHIBITIONS →
2008 *Luc Tuymans: Come and See*, Zacheta National Gallery of Art, Warsaw. *Luc Tuymans: The Occupied Heart*, Vestfossen Kunst-laboratorium, Vestfossen. *Luc Tuymans: Wenn der Frühling kommt*, Haus der Kunst, Munich **2007** *Luc Tuymans: Retrospective*, Mücsarnok Kunsthalle, Budapest; Haus der Kunst, Munich; Zacheta National Gallery of Art, Warsaw. *Luc Tuymans: I Don't Get It*, MuHKA, Antwerp **2006** *Luc Tuymans: Dusk/Penumbra*, Museu Serralves, Porto

SELECTED PUBLICATIONS →
2008 *Stations. Hundert Meisterwerke zeitgenössischer Kunst*, DuMont, Cologne. *Art & Today*, Phaidon Press, London **2007** *Luc Tuymans: Retrospective*, Mücsarnok Kunsthalle, Budapest; Zacheta National Gallery of Art, Warsaw. *I Don't Get It*, Ludion, Ghent. *The Painting of Modern Life – 1960s to Now*, Hayward Publishing, London **2006** *Luc Tuymans: Dusk/Penumbra*, Museu Serralves, Porto

1 **W**, 2008, oil on canvas, 188 x 119.4 cm
2 **The Secretary of State**, 2005, oil on canvas, 45.5 x 61.5 cm

3 **Three Moons**, 2007, oil on canvas, 172.5 x 132.2 cm

„Sagen wir so: Manchmal überarbeite ich das Bild noch mal, klar, aber das sind dann wirklich nur kleine Details. Aber wenn das Bild nicht während des Tages fertig wird, dann kommt es nie zustande."

« Oui, bon, disons qu'il m'arrive de revenir sur une peinture, bien sûr, mais il s'agit vraiment toujours de tout petits détails ; je veux dire que si un tableau n'apparaît pas dans la journée, il n'apparaîtra jamais. »

"Well let's say that sometimes I come back at the painting, I surely do, but it is really very small details, I mean when the painting does not appear during the day it will never appear."

2

Piotr Uklański

1968 born in Warsaw, lives and works in Warsaw, Poland, and New York (NY), USA

The desire to look behind the signs into the mechanism of their coding is something that continually drives contemporary artists. Gaining insight into the encoding mechanism ultimately holds the promise of developing expertise in using the signs. In this context, clichés seem particularly suitable because of the density of sign-construction features they contain. In his work, Piotr Uklański repeatedly employs clichés, cleverly alluding to them, changing them and playing them out. This applies to his latest works, which he has brought together for an exhibition entitled Biało-Czerwona (*White-Red*, 2008), but also to other exhibitions such as *A Retrospective* (2007) and *Joy of Photography* (2007), as well as the western film *Summer Love* (2006). Many of the works in *Biało-Czerwona* allude to Polish symbols and colours, thereby addressing Uklański's own identities as an "international" artist and guest worker in New York, as well as his Polish roots. But in the same way as its propaganda gestures ultimately come to nothing, and in *Joy of Photography* the effectiveness of the eponymous handbook from the age of analogue photography is lost, in *Summer Love* not only the plot implodes but also the very genre of the Western. A sheriff points to an orange-coloured rock and asks his partners, "You know what that means?" before answering his own question: "Absolutely nothing. But you did not know that." Consequently, his posse mainly manages to injure only themselves in the manhunt and end up burying alive one of their own men. With a sure hand, Uklański evokes familiar elements of American and European westerns; however, he does not just play with clichés, he plays them out – to the bitter end. Because he has gained insight into their encoding mechanism.

Einen Blick hinter die Zeichen zu werfen, in das Uhrwerk ihrer Codierung, ist eine Sehnsucht, die zeitgenössische Künstler immer wieder umtreibt. Verspricht doch der Einblick in die Mechanismen der Codierung nicht zuletzt einen meisterhaften Umgang mit ihnen. Besonders geeignet erscheinen in diesem Zusammenhang Klischees, denn bei ihnen verdichten sich Merkmale der Zeichenkonstruktion. Piotr Uklański setzt bei seinen Arbeiten immer wieder auf Klischees, die er virtuos anspielt, wendet und ausspielt. Das gilt auch für seine neueren Arbeiten, die er unter dem Ausstellungstitel Biało-Czerwona (*Weiß-Rot*, 2008) zusammengefasst hat, aber ebenso für die Ausstellungen *A Retrospective* (2007) und *Joy of Photography* (2007) sowie den Western *Summer Love* (2006). Viele der Werke bei *Biało-Czerwona* nehmen Bezug auf polnische Symbole und Farben und thematisieren damit zugleich Uklańskis eigene Identität zwischen „internationalem" Künstler, Gastarbeiter in New York und polnischem Ursprung. Doch genauso, wie dabei Propagandagesten ins Leere laufen, bei *Joy of Photography* die Effektivität des gleichnamigen Handbuchs aus den Zeiten der analogen Fotografie verblasst, implodiert in *Summer Love* nicht nur die Handlung, sondern auch die Gattung des Westerns. So deutet der Sheriff auf einen orangefarbenen Felsen und fragt seine Mitstreiter: „You know what that means?" Und beantwortet es sich selbst: „Absolutely nothing. But you did not know that." Folgerichtig verletzt seine Truppe sich vor allem selbst bei der Menschenjagd und begräbt einen der ihren lebendig. Uklański ruft mit sicherer Hand gängige Elemente des amerikanischen und europäischen Westerns auf, aber er spielt nicht allein mit Klischees, er spielt sie aus. Bis ans Ende. Denn er hat in das Uhrwerk der Codierung geblickt.

Un désir qui anime régulièrement des artistes contemporains est de jeter un regard derrière les signes, dans l'horlogerie de leur codage. La compréhension des mécanismes qui régissent leur production promet en effet d'en tirer notamment un magistral maniement des codes eux-mêmes. Les clichés semblent particulièrement utiles à cette démarche car ils concentrent en eux certaines caractéristiques de l'élaboration des signes. Dans ses œuvres, Piotr Uklański mise régulièrement sur des clichés qu'il évoque, retourne et décline en virtuose. Ceci vaut également pour les œuvres récentes réunies sous le titre d'exposition Biało-Czerwona (*Blanc-Rouge*, 2008) aussi bien que pour les expositions *A Retrospective* (2007) et *Joy of Photography* (2007), ou encore pour le western *Summer Love* (2006). Nombre des œuvres de *Biało-Czerwona* se réfèrent à des couleurs et à des symboles polonais, thématisant ainsi l'identité d'Uklański entre artiste « international », travailleur immigré à New York et origines polonaises. Mais de même que les positions propagandistes y tournent à vide, et de même que *Joy of Photography* fait pâlir l'efficacité du manuel homonyme paru à l'époque de la photographie analogique, de même *Summer Love* fait imploser non seulement l'action, mais aussi le genre cinématographique du western. Le shérif montre par exemple un rocher orangé et demande à ses adjoints : « You know what that means ? » avant de donner lui-même la réponse : « Absolutely nothing. But you did not know that. » Très logiquement, pendant la chasse à l'homme, sa troupe se blesse surtout elle-même et enterre vivant un de ses membres. Évoquant d'une main sûre des éléments courants du western américain et européen, Uklański ne se contente pas de jouer avec les clichés, il les pousse dans leurs derniers retranchements, car il a jeté un regard dans le mécanisme de leur codage.

H. L.

482

1 Installation view, Gagosian Gallery, New York, 2008, center: **Untitled (The Fist)**, 2007, steel tube, varnish, 500 x 343 x 12 cm
2 **Untitled (Bullethole)**, 2007, gouache on Lanaquarelle paper collage, torn, pasted on plywood, 305 x 305 cm
3 **Untitled (Eagle, Polish)**, 2005, carved Styrofoam, 333 x 300 x 18 cm

4 **Summer Love**, 2006, 35mm film, colour, sound, 93 min. Promotional poster for Venezia 63rd Film Festival, offset print, 99 x 69 cm
5 **Untitled (Stephanie Seymour, the Supermodel)**, 2007, inkjet print on PVC, 330 x 589 cm

„Wenn wir annehmen, dass Kunst oder eine andere kreative Aktivität in der Lage ist, die Wahrheit über die menschliche Existenz zu reflektieren, sollte sie diese Existenz nicht nachahmen, sondern eine künstliche Realität oder Form schaffen."

« En admettant que l'art ou toute autre activité créatrice soit à même de refléter la vérité de l'existence humaine, l'art ne devrait pas imiter cette existence, mais créer une réalité ou forme artificielle. »

"If we accept that art or any other creative activity is able to reflect the truth of human existence, then it should not imitate this existence but instead create an artificial reality or form."

4

Francesco Vezzoli

1971 born in Brescia, lives and works in Milan, Italy

The distinction between fact and fiction has long become blurred in mass media society, prompting artists such as Francesco Vezzoli to contemplate what it is that ties us to the mass media when they no longer convey facts. Among other things, Vezzoli has created a trailer for a fictitious film (*Caligula*, 2005) and faked campaign spots for the US presidential elections (*Democrazy*, 2007) or an advert for Sotheby's featuring gay cowboys. He goes to great lengths to produce these fakes, and many well-known stars appear on the cast: Sharon Stone, Milla Jovovic, Catherine Deneuve, Marianne Faithfull, Jeanne Moreau. Perhaps his fakes are actually pursuing the truth of glamour, which binds us to the mass media regardless of fact and fiction. It is a similar situation with Vezzoli's second field of activity: embroidery. Here, too – as a man pushing gender boundaries – he devotes himself to icon worship with embroidered images of fashion, film and television divas, but never without reflecting upon it. His film installation *Marlene Redux: A True Hollywood Story!* (2006) involves, amongst others, Anni Albers – a textile artist and the wife of Josef Albers – and Marlene Dietrich. The film is accompanied by embroidered works that subtly play with Anni Albers' role, as Josef Albers' famous *Homage to the Square* series (1949–76) is reproduced using his wife's "female" weaving techniques – but with an unsewn thread left hanging as an ironic break with the radical severity of his squares. The juxtaposition of Anni Albers and Marlene Dietrich opens up a different aspect: which of them is really the star – the actress, or the woman who entered the male-dominated art world?

Die Unterscheidung von Fake und Tatsache ist in der Mediengesellschaft längst aufgeweicht. Künstler wie Francesco Vezzoli beschäftigen sich daher mit der Frage, was uns an die Massenmedien fesselt, wenn sie keine Tatsachen mehr vermitteln. Vezzoli liefert einen Trailer für einen erfundenen Film (*Caligula*, 2005), er fingiert Wahlspots für die US-Präsidentschaftswahl (*Democrazy*, 2007) oder eine Anzeige für Sotheby's mit schwulen Cowboys. Dabei arbeitet er mit großem Aufwand an den Fakes, die Besetzungslisten verzeichnen Star auf Star: Sharon Stone, Milla Jovovic, Catherine Deneuve, Marianne Faithfull oder Jeanne Moreau. Vielleicht gehen seine Fakes eher der Wahrheit des Glamours nach, die uns jenseits von Fakt und Fiktion an die Massenmedien bindet? Ähnlich verhält es sich bei Vezzolis zweitem Tätigkeitsbereich, der Stickerei. Auch hier widmet er sich, als Mann mit der Gendergrenze spielend, der Ikonenverehrung mit Stickbildern von Diven aus Mode, Film und Fernsehen – doch geschieht dies niemals unreflektiert. Seine Filminstallation *Marlene Redux: A True Hollywood Story!* (2006) bringt unter anderem Anni Albers, die Kunstweberin und Frau von Josef Albers, sowie Marlene Dietrich ins Spiel. Begleitet wird der Film von Stickarbeiten, die subtil mit der Rolle von Anni Albers spielen, insofern Josef Albers' berühmte Serie *Homage to the Square* (1949–76) in Annis „weiblicher" Webtechnik ausgeführt wurde. Allerdings mit einem unvernähten, abhängenden Faden – ein ironischer Bruch mit der radikalen Strenge von seinen Quadraten. In der Konfrontation von Anni Albers und Marlene Dietrich scheint zudem ein weiterer Aspekt auf: Wer ist der wirkliche Star? Die Schauspielerin oder jene Frau, die in die Männerdomäne der Kunst eintrat?

Dans la société médiatique, la frontière entre fait réel et montage de toutes pièces est depuis longtemps devenue poreuse. Certains artistes – comme Francesco Vezzoli – s'intéressent à qui nous enchaîne aux mass media quand ceux-ci ne communiquent plus des faits. Vezzoli produit ainsi une bande-annonce pour un faux film (*Caligula*, 2005), réalise de faux spots pour l'élection présidentielle américaine (*Democrazy*, 2007) ou une annonce pour Sotheby's avec des cow-boys gays. Cela dit, il réalise ses contrefaçons à grands renforts de moyens, et c'est ainsi que les affiches de ses films égrènent les noms de grandes stars : Sharon Stone, Milla Jovovic, Catherine Deneuve, Marianne Faithfull ou Jeanne Moreau. Ses faux suivraient-ils plutôt la vérité du glamour qui nous lie aux médias indépendamment des faits et de la fiction ? Il en va un peu de même dans son deuxième domaine d'activité : la broderie. Vezzoli y joue – en tant qu'homme – sur la frontière entre les sexes et s'adonne à la vénération des icônes dans les tableaux brodés de divas de la mode, du cinéma et de la télévision, mais jamais gratuitement. Son installation filmique *Marlene Redux : A True Hollywood Story!* (2006) évoque notamment Marlene Dietrich et Anni Albers, tisserande d'art et épouse de Josef Albers. Le film est accompagné d'ouvrages de broderie qui jouent subtilement sur le rôle d'Anni Albers : la célèbre série de Josef Albers *Homage to the Square* (1949–76) est exécutée dans la technique « féminine » du tissage utilisée par Anni Albers – mais avec un fil pendant librement, rupture ironique avec la rigueur des carrés d'Albers. La mise en regard d'Anni Albers et de Marlene Dietrich met encore en évidence un autre aspect : qui est la vraie star ? L'actrice ou la femme qui est entrée dans le domaine des hommes ? H. L.

SELECTED EXHIBITIONS →
2008 *The Cinema Effect: Part II Realisms*, Hirshhorn Museum and Sculpture Garden, Washington **2007** *Senso Unico*, P.S.1 Contemporary Art Center, Long Island City. *Think with the Senses – Feel with the Mind*, 52nd Venice Biennale, Venice. *Francesco Vezzoli*, Pinakothek der Moderne, Munich **2006** *Hyper Design*, 6th Shanghai Biennale, Shanghai **2005** *Francesco Vezzoli: Trilogia della morte I, II*, Fondazione Prada, Milan. *Francesco Vezzoli*, Museo Serralves, Porto

SELECTED PUBLICATIONS →
2008 *Francesco Vezzoli: Right You Are (If You Think You Are)*, Gagosian Gallery, London; Charta, Milan **2007** *Francesco Vezzoli: Democrazy*, Italian Pavilion, 52nd Venice Biennale, Venice; Mondadori Electa, Milan **2006** *Francesco Vezzoli*, Fondazione Prada, Progetto Prada Arte, Milan

all
about
Anni

ANNI vs
MARLENE

1 **All About Anni – Anni vs Marlene (The Saga Begins)**, 2006, digital print on glossy paper, 290 x 200 cm
2 **Untitled (Marlene Redux: A True Hollywood Story! Part Two)**, 2006/07, wool, handmade gobelin tapestry, needle, 300 x 300 cm
3 **Untitled (Marlene Redux: A True Hollywood Story! Part Four)**, 2006/07, wool, handmade gobelin tapestry, needle, 300 x 300 cm

4 **The Return of Bruce Nauman's Bouncing Balls**, 2006, video, ca 8 min
5 **Trailer for a Remake of Gore Vidal's Caligula**, 2005, 35mm film transferred to DVD, ca 5 min
6 **Election Posters for Democrazy (Bernard-Henri Lévy vs Sharon Stone)**, 2007, digital print on paper, 2 parts, dimensions variable

„Ich kann mir meine Arbeit nicht vorstellen ohne Menschen, die sie sich ansehen. Wenn ich ehrlich bin, ist das einzige, was mich an moderner Kunst schockiert, das Publikum, es werden immer mehr Zuschauer."

« Je n'imagine pas mon travail sans des gens pour le regarder. Pour être honnête, la seule chose que je trouve choquante dans le monde de l'art contemporain, c'est le public, l'immensité du public actuel. »

"I don't imagine my work without people who look at it. If I have to be honest, then the only thing shocking about the contemporary art world today is the audience, how big the audience has become."

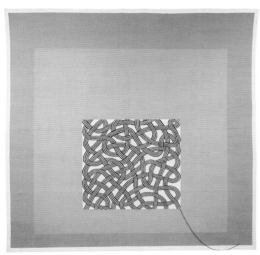

2

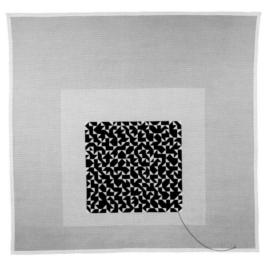

3

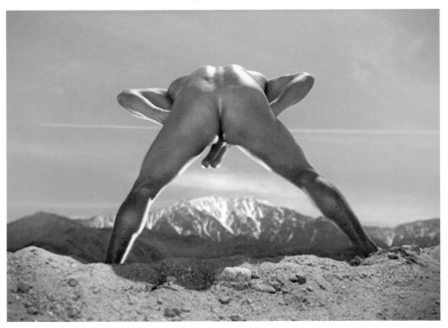

4

PATRICK HILL
A STEADY VOICE. A DETERMINED LEADER.

PATRICIA HILL
FOR PRESIDENT

MAKE AMERICA STRONG

PAID FOR BY PATRICIA HILL FOR PRESIDENT, INC.

Kara Walker

1969 born in Stockton (CA), lives and works in New York (NY), USA

With her black-paper silhouettes, ochre gouaches, magic-lantern projections and video animations, Kara Walker has been exposing the heart of darkness of American culture, revealing its passion for violence and its inherent racism. 2007 saw Walker's first full-scale museum survey that toured internationally for nearly two years. The exhibition brought together recent works with seminal older pieces, such as *Gone: An Historical Romance of a Civil War as It Occurred between the Dusky Thighs of One Young Negress and Her Heart* (1994), the installation with which Walker polarized the New York art world on her debut at the Drawing Art Center. In her cut-out installations, Walker reinterprets a technique that echoes the genteel 18th-century art of paper silhouettes up to Lotte Reiniger's silhouette films, but forces it into a completely different direction, to tell stories of slavery and subjugation. Her large-scale tableaux, glued to the wall like dioramas, often start from references to the antebellum American South, with its cotton plantations, decadent landowners and mortified slaves. The representation of racial oppression is one of the central themes in Walker's work, but it is accompanied by a complex reflection on the seductive power of desire. Recently, Walker has been experimenting with film and shadow-puppets animation, as in the video installation *...calling to me from the angry surface of some grey and threatening sea. I was transported* (2007). This new body of works expands her research on racial stereotypes, while introducing more complex narrative structures that ark back to the tradition of the minstrel show and to the transmission of oral culture.

Mit ihren schwarzen Papiersilhouetten, ockergelben Gouachen, Laterna-Magica-Projektionen und Videoanimationen hat Kara Walker das Herz der Finsternis der amerikanischen Kultur freigelegt und ihre Gewalttätigkeit sowie den ihr innewohnenden Rassismus offenbart. 2007 wurde Walkers erste große Museumsretrospektive eröffnet, die fast zwei Jahre lang international zu sehen war. Neben neueren Arbeiten zeigte die Ausstellung auch wichtige ältere Werke wie *Gone: An Historical Romance of a Civil War as It Occurred between the Dusky Thighs of One Young Negress and Her Heart* (1994), jene Installation, mit der Walker die New Yorker Kunstwelt bei ihrem Debüt im Drawing Art Center polarisiert hatte. In ihren Scherenschnitten übernimmt Walker eine Technik, deren Tradition von der vornehmen Kunst des 18. Jahrhunderts bis hin zu Lotte Reinigers Silhouettenfilmen reicht, doch anstatt sie einfach nachzuahmen, gibt sie ihr eine völlig andere Richtung, um Geschichten von Sklaverei und Unterjochung zu erzählen. Ihre großformatigen Tableaus, die wie Dioramen auf die Wände geklebt werden, beginnen oft mit Szenen aus den amerikanischen Südstaaten vor dem Bürgerkrieg mit Baumwollplantagen, dekadenten Gutsherren und gedemütigten Sklaven. Die Darstellung von Rassenunterdrückung ist eins der zentralen Themen in Walkers Œuvre, doch es geht einher mit einer komplexen Reflexion über die verführerische Macht der Begierde. Seit Kurzem experimentiert Walker mit dem Medium Film und mit Schattenspielanimationen, etwa in der Videoinstallation *... calling to me from the angry surface of some grey and threatening sea. I was transported* (2007). Auch in diesen neueren Arbeiten werden rassische Stereotypen thematisiert, allerdings anhand komplexerer Erzählstrukturen, die auf die Tradition der Minstrelshows und die Überlieferung oraler Kultur zurückgehen.

Kara Walker expose avec ses silhouettes en papier noir, ses projections de lanternes magiques et ses animations vidéo le côté obscur de la culture américaine, en insistant sur sa passion de la violence et son racisme. En 2007, une première exposition d'envergure consacrée à Walker a été organisée, qui circula dans différents musées du monde pendant près de deux ans. L'exposition rassemblait des travaux récents et des pièces plus anciennes, comme *Gone* (sous-titrée « une romance en temps de guerre civile telle qu'elle se déroula entre les cuisses mates et le cœur d'une jeune négresse », 1994), installation qui polarisa le milieu artistique new-yorkais lorsqu'elle fut montrée pour la première fois au Drawing Art Center. Avec ses installations, Walker réinterprète une technique en vogue au XVIIIe siècle et utilisée jusque dans les films d'animation de Lotte Reiniger, mais en la poussant dans une direction nouvelle, pour raconter l'esclavage et l'assujettissement. Ses tableaux à grande échelle, collés au mur comme des dioramas, partent souvent de références au Sud américain d'avant la guerre de Sécession, avec ses plantations de coton, ses propriétaires terriens décadents et ses esclaves humiliés. La représentation de l'oppression raciale est un des thèmes centraux de l'œuvre de Walker, mais elle s'accompagne d'une réflexion complexe sur le pouvoir du désir. Walker expérimente depuis peu avec le film et l'animation en ombre chinoise, comme dans l'installation vidéo *...calling to me from the angry surface of some grey and threatening sea. I was transported* (2007). Ce nouvel ensemble d'œuvres est une prolongation de sa recherche sur les stéréotypes raciaux. Il lui permet d'introduire des structures narratives plus complexes qui font écho à la tradition de la chanson de geste et à la transmission de la culture orale.

C. A.

SELECTED EXHIBITIONS →
2008 *Kara Walker: The Black Road*, Centro de Arte Contemporáneo de Málaga. *Kara Walker*, Art Gallery of Ontario, Toronto **2007** *Kara Walker: My Complement, My Enemy, My Oppressor, My Love*, The Walker Art Center, Minneapolis; Musée d'Art moderne de la Ville de Paris; Hammer Museum, Los Angeles. *Kara Walker: Harper's Pictorial History of the Civil War (Annotated)*, Addison Gallery of American Art, Andover **2006** *Kara Walker at the Met: After the Deluge*, The Metropolitan Museum of Art, New York

SELECTED PUBLICATIONS →
2008 *Kara Walker: Bureau of Refugees*, Charta, Milan. *Waiting in New Orleans: A Reader by Paul Chan*, Creative Time, New York **2007** *Kara Walker: After the Deluge*, Rizzoli, New York. *Kara Walker: My Complement, My Enemy, My Oppressor, My Love*, Walker Art Center, Minneapolis; Hatje Cantz, Ostfildern. *Walker: Narratives of a Negress*, Rizzoli, New York **2004** Gwendolyn DuBois Shaw: *Seeing the Unspeakable: The Art of Kara Walker*, Duke University Press, Durham

ULYSSES S. GRANT.

THE LAST DELEGATION FROM MISSISSIPPI IN THE CONGRESS OF THE UNITED STATES.

Voices are lowered and Rage is suppressed. It is as though Negritude, politicised, upbeat, vengeful and Mean (and imperative) were a form of Addiction in need of 12 step counselling. A recovery program was put into place in lieu of War.

1 **Untitled**, 2001–05, set of 9 collages on paper, 1 part 27.9 x 22.9 cm, 8 parts 40.6 x 28.6 cm (each)

2/3 **...calling to me from the angry surface of some grey and threatening sea. I was transported**, 2007, 5-channel video installation, colour, sound, 11 min, loop

4 **Hysteria! Savagery! Passions!**, 2006, gouache, paper collage on panels, 1 from a group of 11 parts, ca 45.7 x 50.8 cm (each)

5 **Authenticating the Artifact**, 2007, mixed media, cut paper, acrylic on gessoed panel, 152.7 x 213.4 x 5.1 cm

„Frühe amerikanische Spielarten von Scherenschnitten zu sehen, war für mich wie ein kathartisches Erlebnis. Was ich da erkannte – außer Erzählung, Historizität und Rassismus –, war dieser ganz physische Akt des Verlagerns: das Paradox, dass durch die Entfernung einer Form von einer leeren Fläche ein schwarzes Loch entsteht."

« J'ai vécu une catharsis en découvrant la grande variété d'anciennes silhouettes américaines en papier découpé. Ce que j'ai reconnu, au-delà des récits, du caractère historique et du racisme, c'est ce décalage très physique : le paradoxe résidant dans le geste de découper une forme dans une surface blanche pour créer un trou noir. »

"I had a catharsis looking at early American varieties of silhouette cuttings. What I recognized, besides narrative and historicity and racism, was this very physical displacement: the paradox of removing a form from a blank surface that in turn creates a black hole."

2

3

4

Jeff Wall

1946 born in Vancouver, lives and works in Vancouver, Canada

Jeff Wall is famous for his large light boxes, which combine photography with the format of painting and the brilliance of the film screen, but he also works in black-and-white, more closely related to traditional photography. The artist takes two different approaches in creating his works. One involves staging pictorial motifs on a cinematographic scale: *Men Waiting* (2006), for example, shows unemployed people on the street, while in *War Game* (2007) children play at soldiers on a run-down piece of wasteland. These apparently chance scenes of grim urban reality are actually elaborate compositions involving amateur actors, and their black-and-white aesthetic recalls neo-realistic cinema. But Wall also adopts a documentary approach to capture motifs such as – in *Cold Storage* (2007) – an abandoned industrial cold store and thus, meta-phorically, the frozen moment that is photography. Usually Wall does not photograph the motifs he finds immediately; instead he reconstructs and stages them like history paintings, but using filmic means – a method he refers to as "near documentary". Many of his works are of everyday scenes on the edges of society, presented in a socially critical, realistic way that traces back to the tradition of Manet as the "painter of modern life". *An Eviction* (1988/2004), for example, shows a man's desperate struggle against eviction, but this event is only a tiny detail of a suburban panorama. The image was digitally processed from unused production stills. Wall's "cinematographic" photographs play around with a key issue of photographic theory by meticulously arranging the decisive moment rather than spontaneously capturing it.

Jeff Wall wurde bekannt durch großformatige Leuchtkästen, welche die Fotografie mit dem Format der Malerei und der Brillanz der Filmleinwand verbinden, aber er arbeitet auch in Schwarz-Weiß, was der traditionellen Fotografie näher steht. Seine Arbeiten verfolgen zwei unterschiedliche Ansätze. Er inszeniert mit kinematografischem Aufwand Bildmotive, *Men Waiting* (2006) etwa zeigt Arbeitslose wartend auf der Straße, *War Game* (2007) Kinder auf einem verwahrlosten Stück Brachland beim Kriegspielen. Diese scheinbar zufälligen Szenen trostloser urbaner Realität sind komplexe Kompositionen mit Laiendarstellern, deren Schwarz-Weiß-Ästhetik an den neorealistischen Film erinnert. Aber Wall hält Motive auch dokumentarisch fest, etwa bei *Cold Storage* (2007) einen verlassenen industriellen Kühlraum und mit ihm sozusagen metaphorisch den „gefrorenen Moment", der Fotografie bedeutet. Wall hält die Motive, die er findet, meist nicht unmittelbar fotografisch fest, sondern (re-)konstruiert und inszeniert sie, gleich einer Historienmalerei mit filmischen Mitteln – eine Arbeitsweise, die er als „near documen-tary" bezeichnet. Viele Arbeiten zeigen alltägliche Szenen am Rande der Gesellschaft mit einem sozialkritischen Realismus, der auf die Tradition von Manet als „Maler des modernen Lebens" zurückgeht. *An Eviction* (1988/2004) etwa zeigt den verzweifelten Kampf eines Mannes gegen eine Zwangsräumung, wobei sich das Geschehen winzig in einem vorstädtischen Panorama abspielt. Das Bild wurde mittels ungenutzter Produkti-onsstills digital neu arrangiert. Walls „kinematografische" Fotografien spielen zudem mit einer fototheoretischen Frage, da sie den „entscheidenden Augenblick" eben gerade nicht spontan erfassen, sondern minutiös vorbereiten.

Jeff Wall s'est fait connaître par ses grandes boîtes lumineuses qui associent photographie, format pictural et brillance de l'écran cinéma-tographique. Mais il travaille aussi en noir et blanc, ce qui le rapproche de la photographie traditionnelle. Ses œuvres suivent deux démarches distinctes. L'une est cinématographique : dans *Men Waiting* (2006), Wall met en scène des chômeurs attendant dans la rue ; dans *War Game* (2007), des enfants qui jouent à la guerre dans un terrain vague. Ces scènes de désolation urbaine apparemment fortuites, dont l'esthétique en noir et blanc rappelle le néo-réalisme italien, sont des compositions complexes réalisées avec des figurants amateurs. L'autre démarche est plus documentaire : *Cold Storage* (2007) fixe le motif d'une glacière industrielle désaffectée et donc métaphoriquement l'« instant gelé » qui définit la photographie. Wall ne photographie en principe pas ses motifs directement, mais les construit ou les reconstitue comme une peinture d'histoire mise en scène avec des moyens filmiques, une démarche que l'artiste décrit aussi comme du « near documentary ». Nombre d'œuvres montrent des scènes quotidiennes, marginales, sous le signe d'un réalisme sociocritique qui s'inscrit dans la tradition de Manet, qui se voulait le « peintre de la vie moderne ». C'est ainsi que *An Eviction* (1988/2004) montre la lutte désespérée d'un homme pour éviter l'expulsion, événe-ment minuscule noyé dans un immense panorama de banlieue. L'image a été retravaillée sur ordinateur à l'aide de photographies de plateau inutilisées. Les photographies « cinématographiques » de Wall jouent aussi sur un aspect théorique de la photographie en ceci qu'elles ne fixent pas l'« instant décisif » de manière spontanée, mais qu'elles le préparent de toutes pièces.

E. S.

SELECTED EXHIBITIONS →
2008 *Street & Studio: An Urban History of Photography*, Tate Modern, London; Museum Folkwang, Essen. *Jeff Wall: Belichtung*, Deutsche Guggenheim, Berlin **2007** *Jeff Wall*, MoMA, New York; The Art Institute of Chicago; SFMOMA, San Francisco. The 2nd Moscow Biennale of Contemporary Art, Moscow **2006** *The 80's: A Topology*. Museo Serralves, Porto. *Super Vision*, ICA, Boston **2005** *Jeff Wall: Photo-graphs 1978–2004*, Schaulager, Münchenstein/Basle

SELECTED PUBLICATIONS →
2008 *Jeff Wall*, Editorial RM, Barcelona. *Street & Studio: An Urban History of Photography*, Tate Modern, London; Museum Folkwang, Essen. *Jeff Wall: Exposure*, Guggenheim Museum, New York **2007** *Jeff Wall, Selected Essays and Writings*, MoMA, New York. *Jeff Wall: Works and Collected Writings*, Poligrafa, Barcelona **2006** *The 80's: A Topology*. Museo Serralves, Porto. *Super Vision*, ICA; MIT Press, Boston. *Jeff Wall: catalogue raisonné 1978–2004*, Schaulager, Münchenstein/Basle; Steidl, Göttingen

1 **Shop Window, Rome**, 2006, transparency in light-box, 70 x 51 x 14 cm
2 **War Game**, 2007, silver gelatine print, 247 x 302.6 cm

3 **Tenants**, 2007, silver gelatine print, 255.4 x 335.3 cm
4 **Cold Storage**, 2007, silver gelatine print, 258.5 x 319 cm

„Ich beginne damit, etwas nicht zu fotografieren."

« Je commence par ne pas photographier le sujet. »

"I begin with not photographing."

2

3

4

Rebecca Warren

1965 born in London, lives and works in London, United Kingdom

Appropriating, reinventing and otherwise exploiting the works of Degas, Rodin, Picasso, Boccioni and Fontana, Rebecca Warren is something of a bull in the china shop that is the Western sculptural tradition. She is best known for her anarchic unfired, untreated clay sculptures that query themes of gender and self-expression, and which are almost lovingly flecked with passages of muted colours and elsewhere marked by impressions left behind from her fingers modelling the pliant material. Breasts and buttocks, dancers and portrait busts that might suspiciously recall heads of cabbage, are often set atop white bases, although Warren has recently begun – à la Brancusi – to incorporate pedestals into her artworks. The wonderfully quirky *MS 1* (2007) flaunts a base (and what rests upon it) further enclosed within a casket-like Plexiglas box, while other works employ the format of a wall-mounted vitrine, a receptacle for a canny array of quotidian detritus. This interest in installation follows upon Warren's earlier conceit of placing sculptures on studio trolleys – they cannot help but look like skateboards upon which the cumbersome figures ride, held safely in place by their leaden, oversized feet. The artist also works in with bronze – another venue for the exploration of form's disintegration in her practice. She models clay, sends it to the foundry, receives the broken clay original back and then revises it before sending it to the foundry – again – for recasting in a protracted back and forth that increasingly reveals mutations as the exigencies of process, an alchemy in which Warren translates raw matter into motion.

Die ungenierte Art, wie sich Rebecca Warren Werke von Degas, Rodin, Picasso, Boccioni oder Fontana aneignet, sie umdeutet oder anderweitig verwertet, macht sie gewissermaßen zum Elefanten im Porzellanladen der westlichen Bildhauertradition. Am bekanntesten ist sie für ihre anarchischen Skulpturen aus ungebranntem, unbehandeltem Ton, die Themen wie Geschlecht und Selbstdarstellung kritisch behandeln und die fast liebevoll mit gedämpften Farbtupfern besprenkelt oder durch Abdrücke ihrer modellierenden Finger anderweitig markiert sind. Brüste und Gesäßteile, Tänzer und Porträtbüsten, die verdächtig an Kohlköpfe erinnern, werden oft auf weiße Sockel gesetzt, obwohl Warren seit Kurzem auch Postamente – à la Brancusi – in ihre Kunstwerke integriert. Das wunderbar schrullige *MS 1* (2007) prangt auf einem (Rest-)Sockel, der zusätzlich von einer schatullenartigen Plexiglas-Box umschlossen ist, während sich andere Werke im Format einer Wandvitrine präsentieren, eines Behälters für ein raffiniertes Aufgebot an alltäglichem Müll. Dieses Interesse für Installationen ergibt sich aus Warrens früherem Konzept, Skulpturen auf Rollwagen zu stellen, wie man sie im Atelier benutzt – sie sehen wie Skateboards aus, auf denen die klobigen Figuren fahren, die von ihren bleiernen, überdimensionierten Füßen im Gleichgewicht gehalten werden. Die Künstlerin verwendet auch Bronze – eine weitere Gelegenheit, in ihrer Praxis die Auflösung der Form zu erkunden. Sie modelliert Ton, schickt ihn zur Gießerei und bekommt das zerbrochene Original aus Ton zurück, das sie dann überarbeitet, bevor sie es erneut zur Gießerei schickt, um es in einem langwierigen Hin und Her umzugestalten: Mutationen erweisen sich immer mehr als Erfordernisse eines alchemistischen Prozesses, durch den Warren Rohmaterial in Bewegung umsetzt.

En s'appropriant, réinventant, ou du moins en exploitant les œuvres de Degas, Rodin, Picasso, Boccioni et Fontana, Rebecca Warren se conduit comme un éléphant dans le magasin de porcelaine qu'est la tradition de la sculpture européenne. Warren est principalement connue pour ses sculptures anarchiques en terre non cuite et non traitée qui touchent aux thèmes du genre et de l'expression personnelle, et sont presque amoureusement tachetées de couleurs pâles, ou marquées à d'autres endroits par la pression de ses doigts sur la terre encore meuble. Seins et fesses, danseurs et portraits en buste à têtes de chou, sont souvent placés sur des socles blancs, même si Warren commence depuis peu – à la manière de Brancusi – à incorporer les piédestaux à ses créations. Son *MS 1* (2007) délicieusement excentrique exhibe ainsi un socle (et ce qui est posé dessus) lui-même inséré dans une sorte de boîte en Plexiglas aux allures de cercueil. D'autres œuvres prennent la forme de vitrines murales, qui servent de réceptacle à toute une collection de détritus quotidiens. Ce goût pour l'installation intervient après une période où Warren se contentait de présenter ses sculptures sur des chariots d'atelier – qui prenaient alors des allures de skateboards montés par ses encombrants personnages, fermement campés sur leurs pieds lestés et surdimensionnés. L'artiste travaille aussi le bronze – une nouvelle occasion d'explorer la désintégration de la forme dans sa pratique. Elle modèle l'argile, envoie le modelage à la fonderie, récupère l'original en terre brisé et le retravaille avant de le retourner à la fonderie. Ce long procédé de va-et-vient révèle les transformations de l'œuvre et l'importance du processus, l'alchimie par laquelle Warren traduit la matière brute en mouvement.

S. H.

SELECTED EXHIBITIONS →
2008 *The Vincent Award 2008*, Stedelijk Museum, Amsterdam. *Martian Museum of Terrestrial Art*, Barbican Centre, London **2007** *The Third Mind*, Palais de Tokyo, Paris. *Unmonumental: The Object in the 21st Century*, New Museum, New York. *No Room for the Groom*, Herald St, London **2006** *The Turner Prize*, Tate Britain, London, *Tate Triennial*, Tate Britain, London.

SELECTED PUBLICATIONS →
2007 *Ernesto Neto, Olaf Nicolai, Rebecca Warren, Parkett 78*, Zürich
2006 *Rebecca Warren*, JRP Ringier, Zürich

1 **Regine**, 2007, bronze, 125 x 35 x 40 cm, pedestal 57 x 28 x 28 cm
2 **The Living II**, 2007, mixed media wall mounted vitrine, 70 x 138 x 32 cm

3 Installation view, Turner Prize, Tate Britain, London, 2006

„Ich arbeite soweit es geht gegen die Vorschriften. Ton ist ein glitschiges Material und mein Umgang damit ist absichtlich voller Risiko. Das nötige Handwerkszeug ist auch Teil dieses Prozesses, nicht als Ziel, sondern als Mittel."

« J'évite de travailler de manière prédéfinie. La glaise est glissante et ma position à son égard est délibérément précaire. Les valeurs du savoir-faire et du métier sont soumises à ce processus, pas comme but mais comme moyen. »

"I try not to work in a prescribed way. Clay is slippery and my position within it is deliberately precarious. Skills and craft values are subsumed into this process, not as ends but as means."

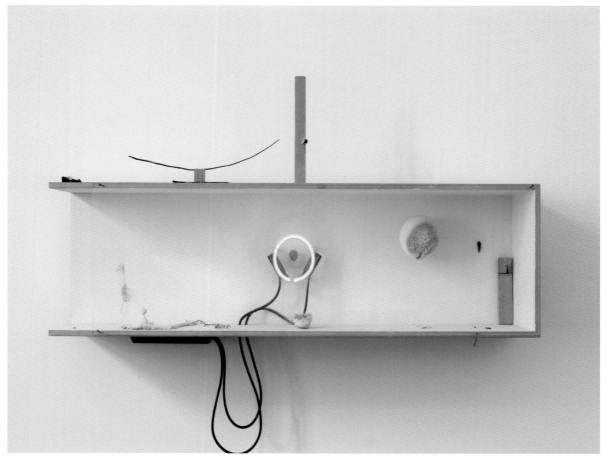

2

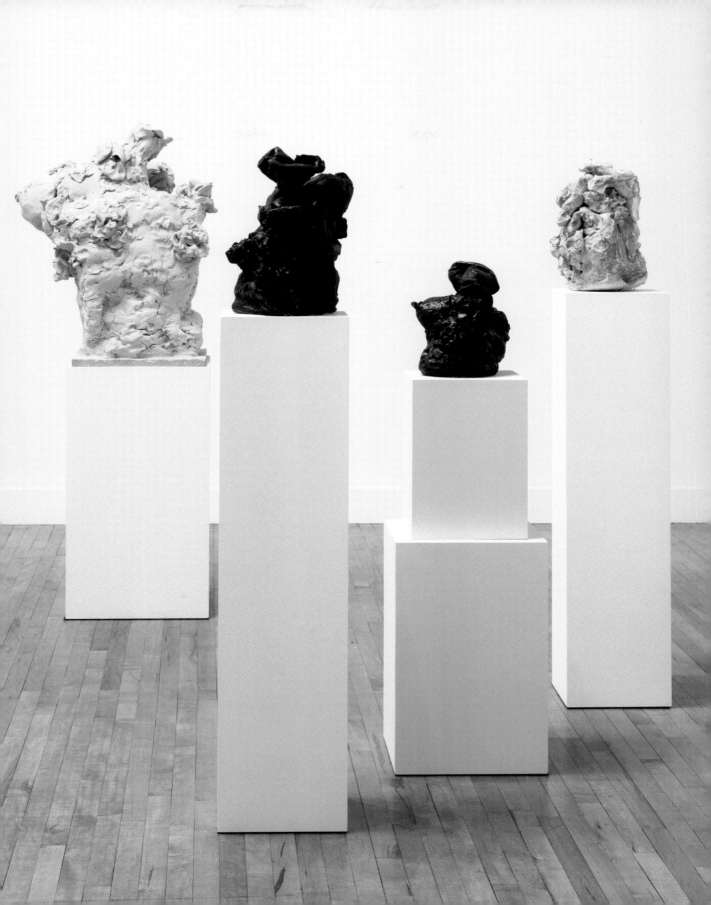

Marnie Weber

1959 born in Bridgeport (CT), lives and works in Los Angeles (CA), USA

Marnie Weber's exhibition *Sing Me a Western Song* (2007) in Los Angeles presented an overview of her artistic, musical and performance activities to date. The multimedia artist showed *A Western Song*, a film in which she also appears at the head of the Spirit Girls, Weber's vehicle for her musical performances, where she composes, plays synthesizer and sings. In the film, the Spirit Girls are ghostly beings on a journey through a Wild West terrain, complete with a travelling circus and saloons. Weber's works are based among other things on 19th-century spiritualist photographs and legends such as the Fox sisters, who used to enchant people with their erotically charged spiritualist shows. The collages, costumes, sculptures and installations on display in Los Angeles were imbued with an exoticism of time and space, an old-fashioned air. Weber's works are full of masked or disguised figures and hybrid combinations of men and beasts, like a mixture of carnival and surrealist opera. And it is above all surrealist artists such as Meret Oppenheim and Lee Miller who have significantly influenced her artistic practice. No less important, however, are the staged photographs of artists such as Pierre et Gilles, Cindy Sherman and Jeff Koons. Weber alludes to this sort of staged photography in her exploration of foreground/background relations, her use of colour and to a certain extent her subject matter. In fact she pushes the envelope even further, adding a large helping of *Alice in Wonderland* and *The Wizard of Oz* before whirling the whole lot through Wild West films. The outcome can perhaps best be described as a surrealist operetta on speed.

Mit der Ausstellung *Sing Me a Western Song* (2007) in Los Angeles zog Marnie Weber eine Summe ihrer bisherigen künstlerischen und musikalisch-performerischen Aktivitäten. Die Multimedia-Künstlerin zeigte dabei den Film *A Western Song*, in welchem die Spirit Girls auftauchen, von Weber selbst angeführt. Die Spirit Girls bilden zugleich ihre Formation für musikalische Performances, bei denen sie die Stücke komponiert, Synthesizer spielt und singt. Innerhalb des Films sind die Spirit Girls geisterhafte Wesen auf einer Reise durch eine Western-Welt mit Wanderzirkus und Saloons. Eine Grundlage für Webers Arbeiten sind spiritistische Fotografien aus dem 19. Jahrhundert sowie Legenden wie jene von den Fox-Schwestern, die mit erotisch aufgeladenen spiritistischen Shows die Menschen in ihren Bann zogen. Ein zeitlicher und räumlicher Exotismus, ein Flair des *old fashioned* durchzieht die in Los Angeles ausgestellten Collagen, Kostüme, Skulpturen und Installationen. Immer wieder tummeln sich Wesen mit Masken und Verkleidungen sowie Mensch-Tier-Kombinationen in Webers Werken, die dadurch wie eine Mischung aus Karneval und surrealistischer Oper wirken. Und tatsächlich sind vor allem surrealistische Künstlerinnen wie Meret Oppenheim und Lee Miller für ihren Ansatz von Bedeutung. Nicht minder wichtig sind jedoch inszenierte Fotografien, etwa von Pierre et Gilles, Cindy Sherman, aber auch Jeff Koons. Weber bezieht sich in ihrer Arbeit mit Hintergrund-Vordergrund-Beziehungen, ihrer Farbigkeit und teilweise auch ihrer Motivik auf solche inszenierten Fotografien. Allerdings dreht sie das Rad noch weiter. Sie packt eine gute Portion *Alice in Wonderland* und *Wizard of Oz* dazu und wirbelt das Ganze durch Wild-West-Filme. Was auf diese Weise entsteht, ist vielleicht am ehesten mit einer surrealistischen Operette auf Speed zu vergleichen.

Avec l'exposition *Sing Me a Western Song* (Los Angeles 2007), l'artiste multimédia Marnie Weber livrait une somme de ses activités artistiques et musico-performatives. Elle y présentait le film *A Western Song*, dans lequel apparaissent sous sa direction les Spirit Girls. Les Spirit Girls sont aussi les membres du groupe qui joue dans ses performances musicales, pour lesquelles elle compose les morceaux, chante et joue du synthétiseur. Dans le film, les Spirit Girls sont apparentées à des esprits qui sillonnent le monde du western avec saloons et cirque itinérant. Les œuvres de Weber s'inspirent notamment des photographies spirites du XIX\u1D49 siècle et de légendes comme celle des sœurs Fox, qui fascinèrent les gens avec leurs shows spirites chargés d'érotisme. Un exotisme temporel et spatial, un parfum *old fashioned* parcourent les collages, costumes, sculptures et installations de l'exposition de Los Angeles. On voit caracoler un peu partout des êtres masqués et déguisés ainsi que des combinaisons homme-animal dans les œuvres de Weber, ce qui leur confère une ambiance de carnaval mêlé d'opéra surréaliste. De fait, des artistes surréalistes comme Meret Oppenheim et Lee Miller sont une source d'inspiration privilégiée pour sa démarche. Ne sont toutefois pas moins importantes les mises en scènes photographiques de Pierre et Gilles, de Cindy Sherman, mais aussi de Jeff Koons. Dans son travail, Weber se réfère à ce genre de mises en scènes photographiques par le rapport arrière-plan/premier plan, le chromatisme, mais aussi, en partie, l'iconographie. Il est vrai que Weber pousse la chose encore plus loin en ajoutant une bonne dose d'*Alice au pays des merveilles* et de *Magicien d'Oz* qu'elle fait virevolter dans des westerns. La création qui en résulte se compare peut-être le mieux avec une opérette surréaliste sous acide.

H. L.

SELECTED EXHIBITIONS →
2008 *Good Dolls Bad Dolls*, The Armory, Pasadena. *Expenditure*, Busan Biennale, Busan Museum of Modern Art, Busan. *Sonic Youth – Sensational Fix*, LIFE, Saint-Nazaire; Museion, Bolzano; Kunsthalle Düsseldorf. *Spirit Girls Performance*, High Desert Test Sites, Joshua Tree **2007** *Marnie Weber: A Western Song*, Utställningar 07, Vita Kuben, Umea. *Sympathy for the Devil: Art and Rock and Roll Since 1967*, Museum of Contemporary Art of Chicago

SELECTED PUBLICATIONS →
2005 *LA Artland: Contemporary Art from Los Angeles*. Black Dog Publishing, London. *The Greatest Album Covers of All Time*, Collins and Brown, London. *Hans Christian Anderson, Illustrated by Artists from Around the World*, SolArc Publishing, Hertfordshire.

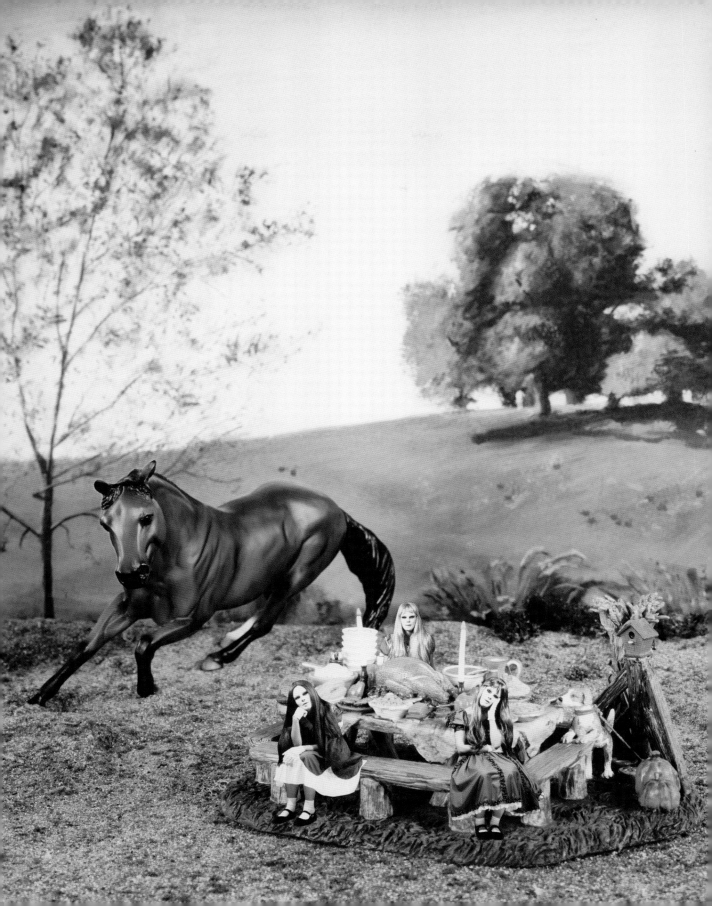

1 **Fun at the Picnic**, 2007, collage on light jet print, 152.4 x 121.9 cm
2 Installation view, *Marnie Weber: Sing Me a Western Song*, mixed media installation with film, Patrick Painter Inc., Los Angeles, 2007

3 **The Spirit Bear**, 2007, mixed media, 305 x 142 x 127 cm

„Indem ich meinen Charakteren und Tieren absichtlich eine gewisse Theatralik mitgebe, durch die Kostüme, Illusionen, Miniaturen, Requisiten und meine eigene Musik, die ich verwende, versuche ich, Geschichten von Leidenschaft, Kampf und Verwandlung zu erzählen."

« En utilisant une "théâtralité" délibérée avec tous les personnages et les animaux, et par l'emploi de costumes, d'artifices, de miniatures, d'accessoires et de ma propre musique, je cherche à créer des histoires de passion, de lutte et de transformation. »

"By using a purposeful 'staginess' with all the characters and animals, and through the use of costumes, illusions, miniatures, props and my own music, I attempt to create stories of passion, struggle and transformation."

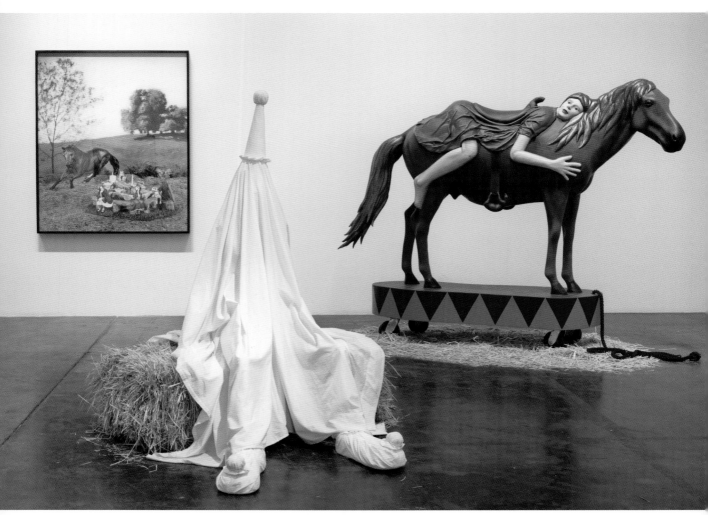

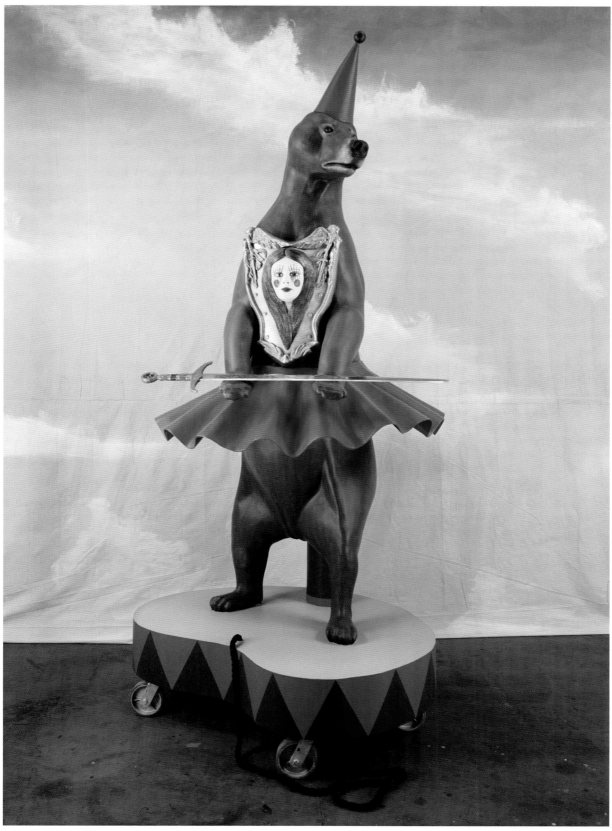

Franz West

1947 born in Vienna, lives and works in Vienna, Austria

"I believe that if neuroses were visible, they would look like this." When Franz West talks about his sculptures in this way, he means what he says: they embody something and, due to their very size and stature, represent a counterpart with whom we have to engage. It is no surprise that West has his roots in Vienna, the city of Freud and Nitsch. Originally influenced by Vienna actionism, and to this day characterized by a preference for archaic cultures, West's art addresses the relationship between object and body. This can be seen in his outdoor sculptures that hang around in parks or urban space, as well as in the *Passstücke* (adapters): the often bizarre appearance of these objects made of papier-mâché, plaster and polyester is disturbing to the gaze, which generally focuses on the body. Their meaning emerges through use; they are provocative prostheses of aesthetic experience which turn viewers into performers and force them to adopt an unusual stance. By the same logic, West is also interested in transitions between sculptures and utility objects: his tubular steel chairs covered in African batik fabrics, for example, are basically just furniture, but by putting them in performative situations he makes their use, however casual, sculpturally active. But West also creates autonomous sculptures that do not require use for their completion: the group of works around *Rachel Was Here* (2007), for example, not only upset the sculpture-plinth relationship with charming clumsiness, their atavism also expresses an obstinacy that is never merely illustrative, nor is it just formal; instead, with pointed recalcitrance, they confront the viewer with irony, ungainliness and high spirits: an abstract garden of brightly burgeoning neuroses.

„Ich behaupte, wenn man Neurosen sehen könnte, dann sähen sie so aus." Wenn Franz West so über seine Skulpturen spricht, ist das direkt gemeint: Sie verkörpern etwas, stellen schon der Statur nach ein Gegenüber dar, mit dem man es erstmal aufzunehmen hat. Nicht von ungefähr ist West in Wien, der Stadt von Freud und Nitsch verwurzelt. In seiner Kunst, ursprünglich geprägt vom Wiener Aktionismus und bis heute von der Vorliebe für archaische Kulturen getragen, ist die Beziehung von Objekt und Körper durchgängiges Thema. Das erweist sich an Wests lässig in Park oder Stadtraum herumlungernden Plastiken ebenso wie an den *Passstücken*: Das oft skurrile Erscheinungsbild dieser aus Pappmaché, Gips und Polyester geformten Objekte irritiert das Auge – weil es eigentlich in erster Linie auf den Körper zielt. Sie erschließen sich durch Verwendung, sind provozierende Prothesen ästhetischer Erfahrung, die Betrachter zu Performern machen und sie in ungewohnte Haltungen zwingen. In gleicher Logik interessieren West auch Übergänge zwischen Skulptur und Gebrauchsobjekt: Seine mit afrikanischen Wachsbatikstoffen behängten Stühle aus Stahlrohr etwa sind an sich bloß Mobiliar, doch indem er sie in performative Situationen stellt, macht er ihre, sei es noch so beiläufige, Verwendung skulptural aktiv. Daneben entwickelt er aber auch Skulpturen, die autonom und nicht erst qua Gebrauch komplett sind: Die Werkgruppe um *Rachel Was Here* (2007) zum Beispiel stellt in charmanter Grobklotzigkeit nicht bloß das Skulptur-Sockel-Verhältnis auf den Kopf. Ihr Atavismus prägt zudem Eigensinn aus, der nie illustrativ, aber eben auch nie bloß formal ist, sondern in pointierter Sprödigkeit die Betrachter ironisch, ungeschlacht und fröhlich konfrontiert: ein abstrakter Garten grell blühender Neurosen.

« Je prétends que si on pouvait voir les névroses, voilà à quoi elles ressembleraient. » Cette déclaration de Franz West à propos de ses sculptures est à prendre au pied de la lettre : elles incarnent quelque chose et leur seule stature en fait un vis-à-vis auquel le spectateur doit d'abord se mesurer. Ce n'est pas par hasard que West est installé à Vienne, la ville de Freud et de Nitsch. Dans son œuvre, qui fut d'abord influencé par l'actionnisme viennois et qui est aujourd'hui encore empreint d'une prédilection pour l'archaïque, le rapport entre l'objet et le corps est un thème constant. Ses objets « pour s'asseoir », ses immenses sculptures qui traînent négligemment dans l'espace public, ou encore ses *Passstücke* (pièces ajustées), objets souvent grotesques en papier mâché, en plâtre et en polyester, tous irritent le regard parce qu'ils s'adressent d'abord au corps. Ils s'apprivoisent par leur utilisation et sont des prothèses provocatrices d'expérience esthétique qui transforment le spectateur en performeur, l'obligeant à des attitudes inhabituelles. Dans la même logique, West s'intéresse aussi aux transitions entre sculpture et objet utilitaire : ses chaises en acier recouvertes de batiks africains cirés ne sont que du mobilier, mais dans des situations performatives, leur utilisation – même incidente – active leur caractère de sculpture. Mais West développe aussi des sculptures autonomes dont la raison d'être ne résulte pas de l'utilisation : avec leur charmante balourdise, les œuvres regroupées autour de *Rachel Was Here* (2007) ne se contentent pas d'inverser le rapport sculpture/socle. Leur atavisme dénote aussi un sens de l'entêtement qui n'est jamais seulement illustratif ou formel, mais dont la rudesse ciblée houspille le spectateur de manière ironique, grossière et joyeuse : un jardin abstrait où fleurissent des névroses hautes en couleurs.

J. A.

SELECTED EXHIBITIONS →
2008 *Franz West, To Build a House You Start with the Roof: Work, 1972–2008*, Baltimore Museum of Art, Baltimore. *Franz West: Sit on My Chair, Lay on My Bed*, Museum für angewandte Kunst, Vienna. *Leben? Biomorphe Formen in der Skulptur*, Kunsthaus Graz. *Games*, Kunsthalle Wien, Vienna. *Vertrautes Terrain – Aktuelle Kunst in und über Deutschland*, ZKM, Karlsruhe. *The Hamsterwheel*, Malmö Konsthall, Malmö **2007** *Strange Events Permit Themselves the Luxury of Occuring*, Camden Arts Center, London

SELECTED PUBLICATIONS →
2008 *Franz West, To Build a House You Start with the Roof: Work, 1972–2008*, Baltimore Museum of Art, Baltimore; The MIT Press, Cambridge. *Passstücke*, Gagosian Gallery, New York **2007** *Pop Art Is*, Gagosian Gallery, London **2006** *Franz West*, Friedrich Christian Flick Collection, Berlin; DuMont, Cologne **2004** *Franz West: Gesammelte Gespräche und Interviews*, Verlag der Buchhandlung Walther König, Cologne

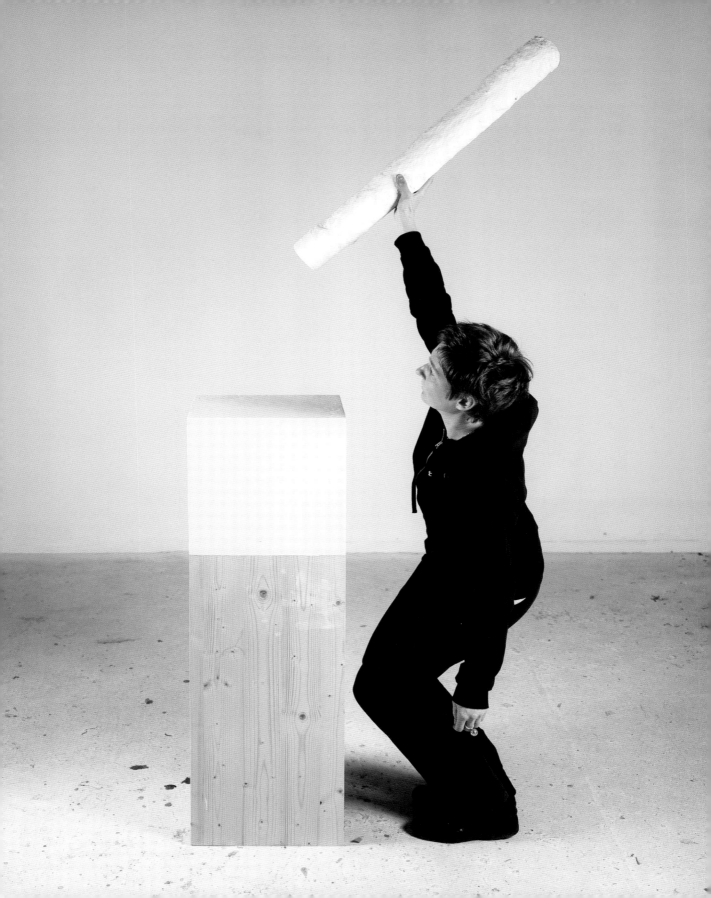

1 **Passstück**, 2007, papier-mâché, gauze, paint, plastic, 84 x 10 x 10 cm, pedestal (wood, paint) 111 x 37 x 33 cm
2 **Liege**, 2007, metal, air mattress, 90 x 150 x 73 cm
3 **Nullen / Zeros**, 2006, plaster, dispersion, foam, pedestal (wood, paint)

4 **Studienobjekt**, 2007, epoxy resin, metal, 320 x 420 x 200 cm
5 **Postexpression / Nachempfindung**, 2007, epoxy resin, ca 250 x 260 x 180 cm

„Ich habe gedacht, ja gehofft, meine Kunst wäre wie ein Schrei, aber im Gegenteil, sie war wie eine Blüte."

« J'avais pensé et même espéré que mon art était comme un cri, mais au contraire, il a été comme une floraison. »

"I had thought – and even hoped – that my art would be like a scream, but on the contrary, it was like a flower."

2

3

4

Pae White

1963 born in Pasadena (CA), lives and works in Los Angeles (CA), USA

Pae White relishes making artworks that shift before your eyes and play between arts, architecture, craft and design. Her delicate mobiles, made from humdrum materials, cut colour-aid paper and thread, take on multiple identities, each paper disc representing a splash of light, whether sparks from a Roman candle firework, the refraction of a waterfall or the glint of a peacock's feathers. The vertical stacks can take on more concrete form looking like the night-lighted windows of high-rise buildings or a city viewed from altitude. White is from Los Angeles, and for Skulptur Projekte Münster 07 she worked with the Kleimann Pastry Shop, situated in the heart of Münster, to make a selection of marzipan interpretations of East LA-style "taco trucks" (my-fi, 2007). The sweet mix of traditional confectionary and Californian fastfood culture was then displayed alongside more traditional candied souvenirs in the shop window. Also part of the project was a sound installation for the city centre, where carrillons played pop songs about love and bells stood in the parks, created after models by the side of roads that link the former Spanish missions in California. One of Pae's most recent works, the stage curtain for the newly inaugurated Norwegian National Opera in Oslo (2008), appears to be a massive sheet of crumpled tin foil (contrasting the clean lines of Snøhetta's design of the building). In reality, however, the curtain consists of digital images of aluminium foil which reflect and adopt the colours of the auditorium. As it lifts, it is revealed as computer woven curtaining — the first magic of the night.

Pae White produziert mit Vorliebe Kunstwerke, die sich vor unseren Augen verändern und sich zwischen Kunst, Architektur, Handwerk und Design bewegen. Ihre filigranen Mobiles aus einfachsten Materialien – farbiges Papier und Fäden – haben vielfältige Eigenschaften. Jede Papierscheibe ist wie ein Lichtreflex, es könnten Funken von einem Goldregen sein, die Brechung eines Wasserfalls oder das Schimmern von Pfauenfedern. Die vertikalen Elemente nehmen manchmal konkretere Formen an und sehen wie nächtlich beleuchtete Fenster von Hochhäusern oder wie eine Stadt aus der Vogelperspektive aus. White stammt aus Los Angeles – für die Skulptur Projekte Münster 07 arbeitete sie mit der im Stadtzentrum gelegenen Konditorei Kleimann zusammen und schuf Marzipanskulpturen von den für East L.A. typischen „Taco Trucks" (my-fi, 2007). Die süße Mischung aus traditionellem Konfekt und kalifornischer Fastfood-Kultur wurde dann neben eher herkömmlichen Süßigkeiten im Schaufenster der Konditorei gezeigt. Darüber hinaus entwickelte sie für die Münsteraner Innenstadt eine Klanginstallation, in der Glockenspiele Popsongs über das Thema Liebe spielten und Glocken, wie sie den Weg zwischen alten spanischen Missionen in Kalifornien säumen, in den Parks standen. Eines von Paes neuesten Werken, der Bühnenvorhang für die gerade eingeweihte Norwegische Nationaloper in Oslo (2008), wirkt wie ein riesiges Blatt aus zerknittertem Stanniol (im Kontrast zu den klaren Linien des von Snøhetta entworfenen Baus). In Wirklichkeit besteht der Vorhang jedoch aus digitalen Bildern von Alufolie, die sich den Farben des Auditoriums reflektierend anverwandelt. Beim Aufgehen offenbart sich dann der computergewirkte Vorhangstoff — der erste magische Moment des Abends.

Pae White éprouve un plaisir évident à produire des œuvres qui se balancent devant nos yeux et jouent avec l'art, l'architecture, l'artisanat et le design. Ses mobiles délicats réalisés à partir de matériaux ordinaires, nuanciers en papier et fils de couleur, revêtent des identités multiples, chaque disque de papier représentant une éclaboussure de lumière différente : une étincelle de feu d'artifice, la réfraction d'une cascade, ou encore le chatoiement du panache d'un paon. Ses empilements verticaux prennent parfois des formes plus concrètes pour rappeler la vision nocturne des fenêtres éclairées d'un immeuble ou une ville vue du ciel. White vient de Los Angeles et pour Skulptur Projekte Münster 07, elle a travaillé avec la pâtisserie Kleimann située au cœur de Münster, pour produire une sélection de figurines en pâte d'amande représentant des « camionnettes à tacos » typiques des quartiers Est de Los Angeles (my-fi, 2007). Ce doux mélange de confection traditionnelle et de culture américaine du fast-food a ensuite été présenté au milieu d'autres friandises plus traditionnelles dans la vitrine de la boutique. White a également réalisé une installation sonore pour le centre-ville de Münster : des carillons jouaient des chansons d'amour pop et des cloches bordaient les chemins des parcs à la manière des anciennes routes des missions espagnoles en Californie. Une de ses créations les plus récentes, un rideau de scène pour le nouvel Opéra national de Norvège à Oslo (2008), apparaît comme une lourde feuille d'étain froissé (contrastant avec les lignes pures du bâtiment conçu par Snøhetta). En réalité, le rideau est constitué d'images numérisées de feuilles d'aluminium qui réfléchissent et s'approprient les couleurs de l'auditorium. Lorsque le rideau se lève, sa nature informatique est dévoilée – la première touche de magie de la soirée.

S. R.

SELECTED EXHIBITIONS →
2008 *Pae White: Lisa, Bright & Dark*, Scottsdale Museum of Contemporary Art, Scottsdale; Taubman Museum of Art, Roanoke. *Re-Reading the Future*, International Triennale of Contemporary Art, Prague. *Martian Museum of Terrestrial Art*, Barbican Centre, London. **2007** *If Everybody had an Ocean. Brian Wilson, An Art Exhibition*, Tate St Ives; CAPC Musée d'art contemporain, Bordeaux. *Skulptur Projekte Münster 07*, Münster. **2006** *Pae White: in no particular order*, Manchester Art Gallery, Manchester

SELECTED PUBLICATIONS →
2008 *Pae White: Lisa, Bright & Dark*, Scottsdale Museum of Contemporary Art, Scottsdale **2007** *Skulptur Projekte Münster 07*, Verlag der Buchhandlung Walther König, Cologne. *Idylle: Traum und Trugschluss*, Hatje Cantz, Ostfildern **2005** *Pae White: Ohms and Amps*, Centre d'art contemporain la Synagogue de Delme; Les presses du réel, Paris. *Brian Wilson: an Art Book*, Four Corners Books, London

1 **Scrap Tapestry 1**, 2006, collage, coloured cotton, weaved, 300 x 205 cm
2 **Ship o' Fools**, 2008, silver colour coated clay, bulbs, steel, cable, 120 x 75 cm
3 **my-fi**, 2007, Majolica, steel pedestal, hanging, 3 parts, bell 80 x ø 90 cm (each). Installation view, Skulptur Projekte Münster 07

4 Installation view, *Pae White: In No Particular Order*, Milton Keynes Gallery, Milton Keynes, 2005
5 **Stage Curtain**, 2008. Installation view, Opera House, Oslo

„Mir gefällt die Idee, dass alles in der Welt das Potenzial hat, zum Kunstwerk zu werden, selbst wenn es nur ein Motiv ist."

« J'aime l'idée que tout dans le monde a les qualités pour être transformé en objet d'art, même si ce n'est qu'un motif. »

"I like the idea that everything in the world has the potential to be reintroduced as an art piece, even if it's just a motif."

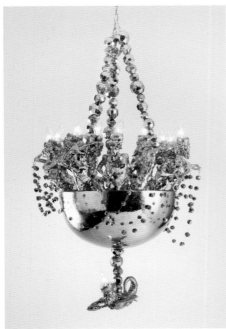

2

3

Kehinde Wiley

1977 born in Los Angeles (CA), lives and works in Brooklyn (NY), USA

In 2008, The Studio Museum in Harlem hosted Kehinde Wiley's one-man show *The World Stage: Africa, Lagos – Dakar*. In this exhibition Wiley took his passion for portraiture to a global scale by temporarily setting up studios in Lagos, Dakar and many other African cities. The show included paintings like *Three Wise Men Greeting Entry into Lagos* (2008), where three black males are posing as a traditional sculpture of post-colonial African art, and a group of more straightforward portraits such as *Mame Ngagne* (2007) in which young black men are depicted against a background of brightly coloured fabrics. Part of a wider project that had previously taken Wiley to China and will soon extend to India and Poland, *The World Stage* is an artistic enterprise that allows the artist to confront himself and his African roots with different cultures and traditions. Inspired by 19th century European portraiture, Wiley reinterprets the genre by weaving references to popular culture into it. His large-scale canvases, usually set in opulent frames, portray young urban black males proudly standing in front of highly decorated backgrounds. While the iconography might be reminiscent of a long gone aristocracy, the subjects are often connected to hip hop culture and its fascination with masculinity and power. In *Napoleon Leading the Army over the Alps* (2005), for example, Wiley reinterprets a Jacques-Louis David masterpiece by restaging it with a contemporary black rider dressed in camouflage and bandanna. Wiley investigates the perception of blackness and creates a contemporary hybrid Olympus in which tradition is invested with a new street credibility.

2008 präsentierte das Harlemer Studio Museum Kehinde Wiley mit *The World Stage: Africa, Lagos – Dakar*. In dieser Einzelausstellung globalisierte Wiley seine Leidenschaft fürs Porträt, indem er zeitweilig Ateliers in Lagos, Dakar und vielen anderen afrikanischen Städten einrichtete. Zu den Exponaten gehörten Gemälde wie *Three Wise Men Greeting Entry into Lagos* (2008), in dem drei farbige Männer als traditionelle Skulptur der postkolonialen Kunst Afrikas posieren, sowie eine Gruppe geradlinigerer Porträts wie *Mame Ngagne* (2007), in dem junge Schwarze vor einer hellfarbigen Textur dargestellt sind. *The World Stage* – Teil eines größeren Projekts, mit dem Wiley schon in China war und das demnächst auf Indien und Polen ausgedehnt werden soll – ist ein Unternehmen, das dem Künstler ermöglicht, sich selbst und seine afrikanischen Wurzeln mit anderen Kulturen und Traditionen zu konfrontieren. Angeregt von der europäischen Porträtmalerei des 19. Jahrhunderts interpretiert Wiley die Genre auf neue Weise, indem er es durch Bezüge zur Popkultur anreichert. Seine großformatigen, normalerweise opulent gerahmten Gemälde porträtieren junge farbige Städter, die stolz vor einem stark ornamentalen Hintergrund posieren. Die Ikonografie mag an eine längst untergegangene Aristokratie erinnern, doch die dargestellten Figuren haben oft einen Bezug zur Hip-Hop-Kultur mit ihrer Vorliebe für Maskulinität und Power. In *Napoleon Leading the Army over the Alps* (2005) deutet Wiley beispielsweise ein Meisterwerk von Jacques-Louis David um: Der Reiter ist hier ein Schwarzer unserer Tage, angetan mit Tarnkleidung und Stirnband. Wiley thematisiert die Wahrnehmung des Schwarzseins und schafft einen hybriden Olymp, in dem die Tradition eine neue aktuelle Glaubwürdigkeit erhält – die der Straßenszene.

En 2008, le Studio Museum de Harlem a accueilli l'exposition monographique de Kehinde Wiley, *The World Stage : Africa, Lagos – Dakar*. Il y déployait à une échelle mondiale sa passion pour le portrait, allant jusqu'à installer son studio tour à tour à Lagos, Dakar et dans de nombreuses autres villes africaines. L'exposition comprenait des tableaux comme *Three Wise Men Greeting Entry into Lagos* (2008), où trois hommes noirs posent à la manière d'une sculpture classique de l'art africain post-colonial, ou encore une série de portraits plus directs comme *Mame Ngagne* (2007), où de jeunes Noirs sont représentés devant des tissus aux couleurs vives. Nouvel épisode d'un projet de grande ampleur qui a déjà conduit Wiley en Chine et l'emmènera bientôt en Inde et en Pologne. *The World Stage* est une entreprise artistique qui permet à Wiley de se confronter, avec ses racines africaines, à différentes cultures et traditions. Inspiré par les portraitistes européens du XIXᵉ siècle, Wiley réinterprète le genre en y insérant des références à la culture populaire. Ses grandes toiles, généralement serties dans des cadres imposants, montrent de jeunes Noirs urbains qui posent fièrement devant des arrière-plans exagérément décoratifs. Si cette iconographie n'est pas sans évoquer une aristocratie depuis longtemps éteinte, les sujets sont souvent liés à la culture hip-hop et à sa fascination pour la virilité et le pouvoir. Dans *Napoleon Leading the Army over the Alps* (2005), Wiley réinterprète le chef-d'œuvre de Jacques-Louis David en remplaçant le personnage par un chevalier noir contemporain vêtu d'une tenue de camouflage et d'un bandeau. Wiley explore la perception de la négritude et crée un Olympe contemporain et hybride où la tradition est investie d'une nouvelle crédibilité venant de la rue.

C. A.

SELECTED EXHIBITIONS →
2008 *Kehinde Wiley, The World Stage: Africa Lagos – Dakar*, The Studio Museum in Harlem, New York. *Focus: Kehinde Wiley*, The Modern Art Museum of Fort Worth **2007** *Kehinde Wiley*, Portland Art Museum, Portland. *New York States of Mind*, Queens Museum of Art, New York; Haus der Kulturen der Welt, Berlin **2006** *Kehinde Wiley: Infinite Mobility*, Columbus Museum of Art, Columbus. *Black Alphabet – Contexts Of Contemporary African-American Art*, Zacheta National Gallery of Art, Warsaw

SELECTED PUBLICATIONS →
2008 *Kehinde Wiley, The World Stage: Africa Lagos – Dakar*, The Studio Museum in Harlem, New York **2007** *Kehinde Wiley: Columbus*, Roberts and Tilton, Los Angeles; The Columbus Museum of Art, Columbus. *The World Stage: China*, John Michael Kohler Arts Center, Sheboygen; Roberts and Tilton, Los Angeles **2006** *Neo Baroque!*, Byblos Art Gallery, Verona; Charta, Milan **2005** *Kehinde Wiley: Passing/Posing Paintings & Faux Chapel*, Brooklyn Museum of Art, Brooklyn; Earth Enterprise, New York

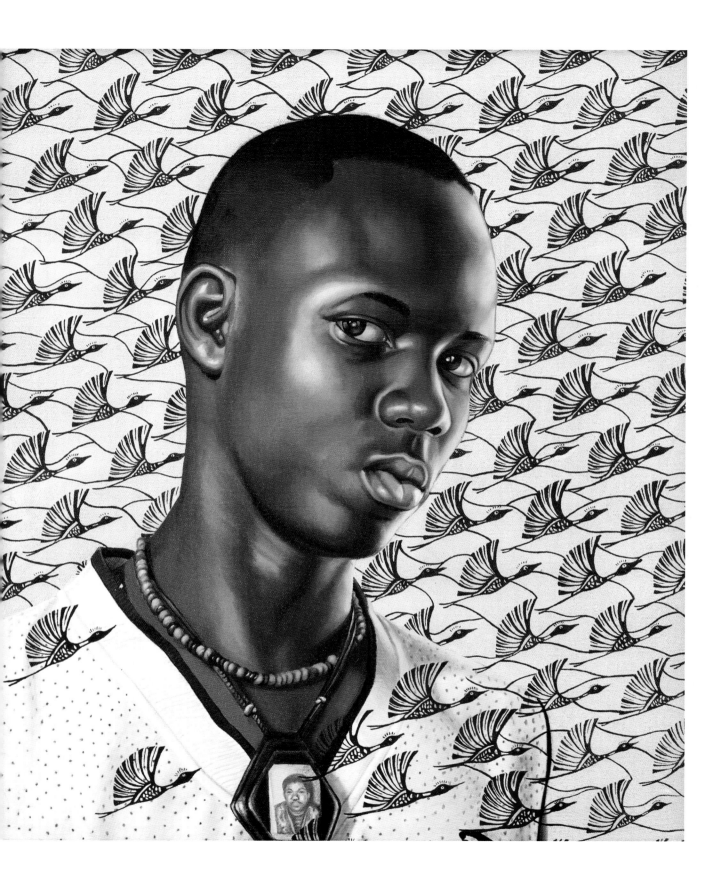

1 **Mame Ngagne**, 2008, oil on canvas, 66 x 55.9 cm
2 **Three Wise Men Greeting Entry into Lagos**, 2008, oil on canvas, 182.9 x 243.8 cm

3 **Napoleon Leading the Army over the Alps**, 2005, oil on canvas, 274.3 x 274.3 cm
4 **Louis Philippe Joseph, Duke of Orleans**, 2006, oil on canvas, 213.4 x 243.8 cm

„Das Wichtigste in meinem Werk ist für mich selbst folgende Tatsache: Die Geschichte der westeuropäischen Malerei ist die Geschichte westeuropäischer weißer Männer in Machtpositionen."

« Ce qui compte le plus dans mon travail, à mon avis, c'est que l'histoire de la peinture européenne occidentale est l'histoire de la domination des hommes blancs d'Europe occidentale. »

"What's most important in my work, to my own mind, is that the history of Western European painting is the history of Western European white men in positions of dominance."

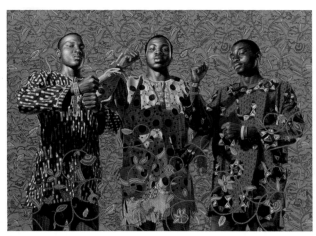

2

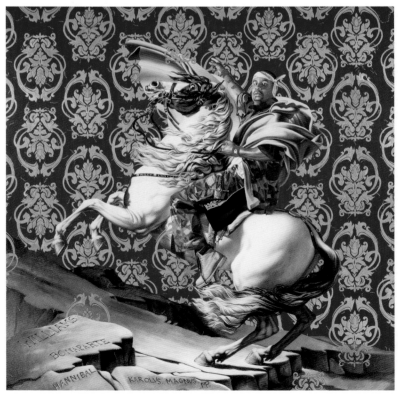

3

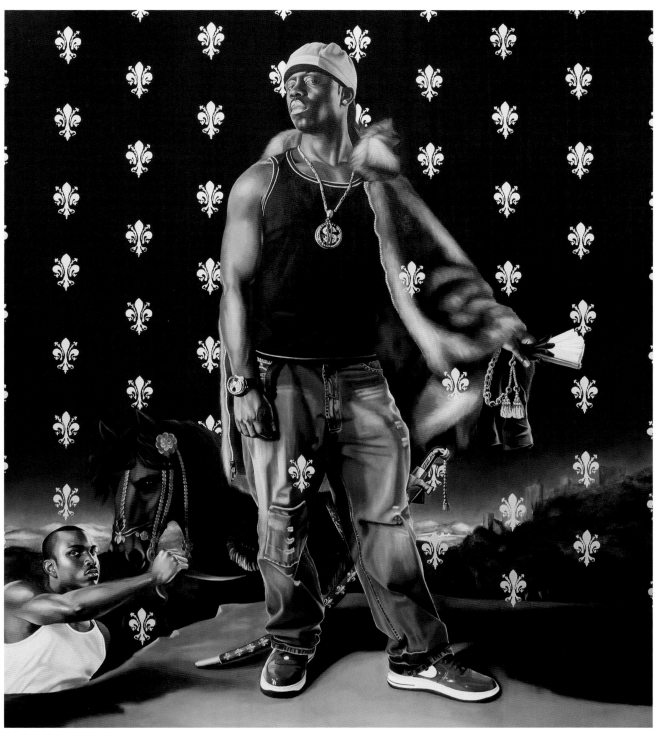

Jonas Wood

1977 born in Boston (MA), lives and works in Los Angeles (CA), USA

Jonas Wood approaches painting as a classical medium, focusing on traditional genres such as portraiture, still life and domestic scenes, but also experimenting with unusual subjects, in particular with sport. In *Bullets* (2007) Wood reproduces a famous image of two basketball players from the Bullets team – one extremely tall next to a short one – caught in an awkward pose, as they hold three basketballs, one on top of the other. While the resemblance to the original photograph is evident, Wood's rendering of anatomic features with thick layers of paint turns the two players into strangely deformed creatures, like giant insects flattened out on the canvas. Wood's interest in the representation of sport has also resulted in a series of paintings and drawings inspired by ancient Greek pottery depicting athletes, such as in *Untitled (Runners)* (2008). Along with the sport canvases, Wood has been painting details of his parents' home. In *Guest Room* (2007), he portrays a room with the walls filled by photographed and painted portraits and the floor covered by a red, heavily ornamented carpet that rises vertically as an intricate mosaic. The artist usually adopts hand-made photo-collages as preliminary studies for his paintings, which thus acquire a peculiar flatness. This patchwork effect connects Wood's practice to both the tradition of folk embroidery and to the quirky, natural elegance of painters like David Hockney and Alex Katz. Wood's idiosyncratic brand of realism can be extremely modest in its subjects and yet incredibly complex and refined in their treatment, often verging onto a nearly cubist distortion of the world.

Jonas Wood behandelt Malerei insofern als klassisches Medium, als er sich auf traditionelle Genres wie Porträt, Stillleben und häusliche Szenen konzentriert, allerdings experimentiert er auch mit ungewöhnlichen Sujets, insbesondere mit solchen aus dem Sport. In *Bullets* (2007) reproduziert er ein berühmtes Foto zweier Basketballspieler aus dem Bullets-Team – ein extrem langer neben einem kleinen –, die in einer unbeholfenen Pose drei Basketbälle übereinander halten. Die Ähnlichkeit mit der Originalaufnahme ist offensichtlich, doch indem Wood die anatomischen Merkmale mit dicken Farbschichten wiedergibt, verwandelt er beide Spieler in merkwürdig deformierte Kreaturen, die wie gigantische, auf der Leinwand platt gedrückte Insekten wirken. Sein Interesse für sportliche Motive dokumentiert sich auch in einer Reihe von Gemälden und Zeichnungen, die von antiken griechischen Athletendarstellungen auf Vasen inspiriert sind, etwa *Untitled (Runners)* (2008). Neben den Sportbildern hat Wood auch Details aus seinem Elternhaus gemalt. In *Guest Room* (2007) zeigt er ein Zimmer, dessen Wände mit fotografierten und gemalten Porträts zugepflastert sind und auf dessen Fußboden ein roter, reich verzierter Teppich liegt, der im Bild als verschlungenes Mosaik vertikal aufragt. Normalerweise benutzt der Künstler handgemachte Fotocollagen für die Vorstudien zu seinen Gemälden, was ihnen eine eigentümliche Flachheit verleiht. Dieser Patchwork-Effekt verweist einerseits auf traditionelle Stickereiarbeiten, andererseits aber auch auf die natürliche Eleganz von Malern wie David Hockney und Alex Katz. Wood pflegt eine ganz eigene Art von Realismus, der von den Sujets her äußerst anspruchslos sein mag, in ihrer Umsetzung jedoch unglaublich komplex und subtil sein kann und sich oft einer nahezu kubistischen Verzerrung der Welt annähert.

Jonas Wood aborde la peinture comme un médium classique en se concentrant sur des genres traditionnels tels que le portrait, les natures mortes et les scènes domestiques, mais il expérimente en abordant des sujets inhabituels, en particulier le sport. Dans *Bullets* (2007), Wood reproduit une image célèbre de deux joueurs de basket de l'équipe des Bullets – l'un extrêmement grand, l'autre lui arrivant à la taille – saisis dans une pose insolite, puisqu'ils portent trois ballons de basket empilés les uns sur les autres. La ressemblance avec la photo d'origine est évidente, mais la manière dont Wood traite l'anatomie des deux sportifs, avec d'épaisses couches de peinture, fait d'eux des créatures étrangement difformes, comme des insectes géants écrasés sur la toile. La curiosité de Wood pour la représentation du sport a également débouché sur une série de peintures et de dessins inspirés des poteries grecques antiques où figurent des athlètes, comme *Untitled (Runners)* (2008). Parallèlement à ses peintures « sportives », Wood a peint des détails de la maison de ses parents. Dans *Guest Room* (2007), il présente une pièce dont les murs sont tapissés de portraits peints ou photographiques, tandis que le sol est recouvert d'un épais tapis rouge aux motifs très chargés qui s'élève à la verticale comme une mosaïque compliquée. L'artiste travaille à partir de collages de photos pour les études préliminaires à ses peintures, ce qui explique pourquoi elles possèdent cette planéité très spéciale. Cet effet patchwork relie la pratique de Wood à la fois à la tradition de la broderie populaire et à l'élégance naturelle, excentrique, de peintres comme David Hockney et Alex Katz. Le style réaliste très particulier de Wood peut être extrêmement simple si l'on s'en tient aux sujets de ses tableaux, mais il est incroyablement complexe et raffiné dans leur traitement, et tend souvent vers une distorsion presque cubiste du monde. C. A.

518

1 **Bullets**, 2007, oil on canvas, 182.9 x 132.1 cm
2 **Untitled (Black 4)**, 2008, ink, coloured pencil on paper, 58.4 x 46.4 cm
3 **Untitled (Blue Crate)**, 2008, oil on canvas, 121.9 x 91.4 cm
4 **Untitled (Black 2)**, 2008, ink, coloured pencil on paper, 58.4 x 46.4 cm
5 **Untitled (Runners)**, 2008, oil on canvas, 182.9 x 132.1 cm

2

4

3

5

Christopher Wool

1955 born in Boston (MA), lives and works in New York (NY) and Marfa (TX), USA

The swooping lines and intermittent drips in Christopher Wool's recent large canvases and silkscreens might at first sight recall the imagery of a Jackson Pollock or Brice Marden, but more fundamentally they refer to the long history of the painterly gesture in general – the constant urge toward mark-making and a conflicting compulsion toward erasure. In his predominantly grey untitled paintings from recent years, Wool draws thin lines of black enamel paint with a spray gun, then he literally wipes them out with rags dipped in paint thinner until the complete surface is covered with the most subtly varied shades of grey. Wool doesn't attempt to make this eradicating gesture appear spontaneous or expressionistic, but rather deliberate in every aspect. In the horizontal and vertical swaths of paint and the upside-down drips you can tell that his canvas has been worked on, rotated, then re-worked. For his works on paper, Wool takes photographs of his paintings and collages them on the computer before making these new images into silkscreens, in which the grain of the reproduction process is patently visible. While Wool became known in the late 1980s for paintings he made with pattern rollers and his trademark word paintings, today his art influences a younger generation of abstractionists and mark-makers such as Kelley Walker, Seth Price, Josh Smith and Wade Guyton. Using every possible tool not usually associated with painting (rollers, rags, spray guns and the computer), Wool still manages to bring all the potentialities of the medium to the canvas, always stretching the limits while continuing to refine his painterly chops.

Wenn die geschwungenen Linien und unregelmäßigen Drips in Christopher Wools neuen Siebdrucken und großformatigen Leinwänden auf den ersten Blick an die Motivwelt eines Jackson Pollock oder Brice Marden denken lassen, verweisen sie doch viel grundsätzlicher auf die malerische Geste und ihre lange Tradition – das stete Verlangen, Zeichen zu setzen, und den entgegengesetzten Trieb zur Auslöschung. Für seine zumeist grauen, unbetitelten Gemälde der letzten Jahre zeichnet Wool mit einer Farbspritzpistole dünne Linien in Enamelfarbe, die er dann mit einem Lappen, den er mit Lösungsmittel getränkt hat, buchstäblich auswischt, bis die komplette Bildoberfläche mit fein abgestuften Grautönen bedeckt ist. Diese Geste des Auslöschens soll keineswegs spontan oder expressionistisch erscheinen, sie ist in jeder Hinsicht bewusst gesetzt. Die horizontalen und vertikalen Farbstreifen und die nach oben verlaufenden Tropfen verraten, wie an dieser Leinwand gearbeitet wurde, wie sie gedreht und wieder überarbeitet wurde. Für seine Papierarbeiten verarbeitet Wool Fotografien seiner Gemälde, die er am Computer collagiert, bevor er das neu entstandene Bild dann als Siebdruck produziert, in betont körniger Reproduktion. Wool wurde in den späten 1980er Jahren mit Gemälden, die er mit Musterwalzen machte, und seinen typischen Word Paintings bekannt, heute beeinflusst seine Kunst eine jüngere Generation abstrakter Künstler wie Kelley Walker, Seth Price, Josh Smith und Wade Guyton. Während er alle möglichen Werkzeuge benützt, die man normalerweise nicht mit Malerei in Verbindung bringt (Walzen, Lappen, Spritzpistolen und Computer), bringt Wool dennoch das ganze Potenzial des Mediums auf die Leinwand, immer auf dem Schritt über die Grenze, des Mediums Malerei an sich und der eigenen malerischen Möglichkeiten.

Si les lignes plongeantes et les coulures discontinues des dernières toiles et sérigraphies grand format de Christopher Wool peuvent, à première vue, rappeler la construction picturale d'un Jackson Pollock ou d'un Brice Marden, elles renvoient plus radicalement à la longue histoire du geste pictural – le perpétuel besoin de faire des marques et une compulsion contradictoire à l'effacement. Dans les peintures sans titre à prédominance grise de ces dernières années, Wool dessine au pistolet de minces arabesques noires qu'il efface ensuite avec des chiffons imbibés de diluant jusqu'à ce que la surface entière soit recouverte des plus subtiles nuances de gris. Wool n'essaie pas de faire apparaître ce geste de gommage comme spontané ou expressionniste, mais plutôt comme mûrement réfléchi. Ces gerbes de peinture horizontales et verticales, ces coulures signalent que la toile a été travaillée, tournée puis retravaillée. Pour ses œuvres sur papier, Wool prend des photos de ses peintures et en fait des collages sur ordinateur, avant de réaliser, à partir de ces nouvelles images, des sérigraphies sur lesquelles le grain du procédé de reproduction est nettement visible. Alors que Wool s'est fait connaître à la fin des années 1980 par des peintures réalisées avec des rouleaux tampons à motifs ou des peintures de mots, son art influence aujourd'hui une nouvelle génération d'abstractionnistes et de « faiseurs de marque » comme Kelley Walker, Seth Price, Josh Smith ou Wade Guyton. Se servant de tous les outils à disposition (rouleaux tampons, chiffons, pistolets et ordinateur), Wool arrive encore à porter sur la toile toutes les potentialités du moyen d'expression, à repousser les limites tout en continuant à affiner sa marque.

CH. L.

SELECTED EXHIBITIONS →
2008 *Christopher Wool*, Museo Serralves, Porto. *Oranges and Sardines: Conversations on Abstract Painting with Mark Grotjahn, Wade Guyton, Mary Heilmann, Amy Sillman, Charline von Heyl, and Christopher Wool*, Hammer Museum, Los Angeles. *Psychopts* (with Richard Hell), John McWhinnie@Glenn Horowitz Bookseller, New York **2007** *Camouflage*, Portland Art Museum, Portland. *Lines, Grids, Stains, Words.* MoMA, New York **2006** *Christopher Wool*, IVAM, Valencia; Musee d'art moderne et contemporain, Strasbourg

SELECTED PUBLICATIONS →
2008 *Christopher Wool*, Taschen, Cologne. Richard Hell, *Christopher Wool: Psychopts*, JMc & GHB Editions, New York **2007** *Christopher Wool*, Galerie Max Hetzler; Holzwarth Publications, Berlin. *Christopher Wool: Pattern Paintings 1987–2000*, Skarstedt Gallery; Luhring Augustine, New York **2006** *Christopher Wool*, IVAM, Valencia; Editions des Musées de Strasbourg, Strasbourg. *Christopher Wool*, Simon Lee Gallery, London. *Christopher Wool*, Gagosian Gallery, Los Angeles

1 **Untitled**, 2007, enamel on linen, 320 x 243.8 cm
2 **Untitled**, 2007, silkscreen ink on paper, 182,9 x 140,3 cm

3 **Untitled**, 2007, enamel on linen, 320 x 243.8 cm

„Malerei ist wie ein Kampf zwischen Planung und Überraschung für mich. Die besten Gemälde kann man sich gar nicht vorstellen, bevor man damit begonnen hat … Das trifft natürlich auch auf die schlechtesten zu."

« Je conçois la peinture comme une lutte entre le programmé et l'imprévu. Les meilleures peintures sont celles que vous ne pouviez imaginer avant de commencer… Bien sûr, les pires se produisent aussi de la même façon. »

"Painting, for me, is often a struggle between the planned and the unforeseen. The best paintings are the ones that you could not have imagined before you began… Of course the worst paintings are created in this way as well."

Erwin Wurm

1954 born in Bruck-an-der-Mur, lives and works in Vienna, Austria, and New York (NY), USA

If physical, corporeal and social realms are integral aspects of the sculptural processes Erwin Wurm has been investigating for over two decades, these are absolutely bound to his creative expansion of sculptural forms. His *Mind Bubbles* (2008) are oversized potato shapes covered in knitwear that – like the speech bubbles in a comic strip – can be filled with different contents. Some of them are placed on matching wooden plinths raising the age-old, thorny question of sculpture's relationship to the pedestal. One might see Wurm's "potato" series as commenting on readymades or the gravitas of minimalism. But that sounds so profound, and the works are quite funny. Wurm walks a tightrope between humour and critique, bridging sculpture and performance. The instructions and interactions that lead to his popular *One Minute Sculptures* (1988–), which are recorded in photographs, become laden with symbolic weight in the *Instructions on How to Be Politically Incorrect* (2003), which include dipping one's arm up to the shoulder in the fly of someone else's pants to look for a bomb or spitting in someone's soup. Wurm casts a good-natured, but sharp eye on the peculiar place that is the art world by staging its social hierarchies (*Kissing the Museum Director/Be Nice to Your Curators*, 2006), casting models of iconic buildings as they melt into puddles (*Guggenheim Melting*, 2005) and anthropomorphizing heavy-weight institutions caught in compromising positions (*Art Basel Fucks Documenta*, 2006). Critique is implicit, not strident, and nothing is sacred or spared – especially not status symbols such as cars, houses and boats that Wurm submits to strange deformations.

Physische, materielle und soziale Welten sind integrale Aspekte der skulpturalen Prozesse, mit denen sich Erwin Wurm seit über zwei Jahrzehnten beschäftigt, und dabei unmittelbar ausschlaggebend für seine kreative Erweiterung skulpturaler Formen. Seine *Mind Bubbles* (2008) sind überdimensionierte Kartoffelformen in Strickwaren, die sich – wie die Sprechblasen in einem Comic – mit unterschiedlichen Inhalten füllen lassen. Manche von ihnen ruhen auf einem passenden Holzsockel, was die schwierige, Jahrhunderte alte Frage nach der Beziehung zwischen Skulptur und Sockel aufwirft. Man könnte diese „Kartoffel"-Serie als einen Kommentar zu Readymades oder zum Minimalismus betrachten, was angesichts der Witzigkeit dieser Arbeiten aber viel zu bedeutungsschwer klingt. Wurm vollführt einen Drahtseilakt zwischen Humor und Kritik, schlägt eine Brücke zwischen Skulptur und Performance. Die Anweisungen und Interaktionen, die zu seinen populären, fotografisch dokumentierten *One Minute Sculptures* (1988–) führten, bekommen in *Instructions on How to Be Politically Incorrect* (2003) ein symbolisches Gewicht: Im Hosenschlitz eines anderen nach einer Bombe zu suchen, gehört genauso dazu, wie jemandem in die Suppe zu spucken. Mit einem freundlichen, aber scharfen Blick betrachtet Wurm die Eigenheiten der Kunstwelt, wenn er ihre sozialen Hierarchien inszeniert (*Kissing the Museum Director/Be Nice to Your Curators*, 2006), Modelle ikonischer Bauten im Schmelzprozess zeigt (*Guggenheim Melting*, 2005) oder prominente Institutionen in Menschenform, die in kompromittierenden Stellungen zu sehen sind (*Art Basel Fucks Documenta*, 2006). Die Kritik ist implizit, nicht schrill, nichts ist heilig oder wird ausgespart – schon gar nicht Statussymbole wie Autos, Häuser und Boote, die Wurm seltsamen Deformationen unterwirft.

Si les questions physiques, corporelles et sociales font partie intégrante des processus que Wurm explore depuis plus de deux décennies, c'est parce qu'elles sont inséparables de son travail d'élargissement des formes de la sculpture. Ses *Mind Bubbles* (2008) sont en forme de pommes de terre géantes, revêtues d'un tricot et, comme les bulles d'une bande dessinée, peuvent être remplies de différents contenus. Certaines sont disposées sur un socle en bois de même couleur, soulevant l'épineuse question de la relation entre la sculpture et son piédestal. On pourrait voir cette série de « patates » comme un commentaire sur le ready-made ou le sérieux du minimalisme, mais cette interprétation semble trop profonde pour une œuvre plutôt comique. Wurm navigue entre humour et critique et fait se rejoindre sculpture et performance. Les instructions et interactions qui ont débouché sur ses célèbres *One Minute Sculptures* (1988–), documentées à travers des photographies, deviennent lourdes de symbolisme dans ses *Instructions on How to Be Politically Incorrect* (2003), où il est proposé notamment de passer son bras entier à travers la braguette de pantalon d'une personne à la recherche d'une bombe ou de cracher dans la soupe de quelqu'un. Wurm jette aussi un regard débonnaire mais aiguisé sur ce milieu particulier qu'est le monde de l'art en mettant en scène sa hiérarchie sociale (*Kissing the Museum Director/Be Nice to Your Curators*, 2006), transformant en flaques des maquettes d'architectures emblématiques (*Guggenheim Melting*, 2005), ou représentent des institutions majeures sous la forme de personnages placés dans des situations compromettantes (*Art Basel Fucks Documenta*, 2006). Sa critique n'est pas stridente mais implicite, rien n'est sacré ni épargné – pas même les signes de statuts sociaux tels que les voitures, les maisons ou les bateaux, auxquels Wurm fait subir d'étranges déformations. V. R.

SELECTED EXHIBITIONS →
2008 *Erwin Wurm: Phantom Projekt*, Kunstverein Arnsberg. *Erwin Wurm: The Artist Who Swallowed the World*, Kunstmuseum St. Gallen **2007** *Erwin Wurm: Spit in Someone's Soup*, Malmö Konstmuseum, Malmö. *Erwin Wurm, Retrospective*, Musée d'art contemporain de Lyon. *Erwin Wurm. Das lächerliche Leben eines ernsten Mannes...*, Deichtorhallen, Hamburg. *Erwin Wurm – Hamlet*, Kunsthaus Zürich. **2006** *Erwin Wurm. Keep a Cool Head*, MUMOK, Vienna

SELECTED PUBLICATIONS →
2008 Kunstwerkstatt Erwin Wurm, Prestel, Munich. Interviews Volume 2, Kunsthalle Wien, Vienna; Verlag der Buchhandlung Walther König, Cologne **2007** Erwin Wurm. Von Konfektionsgröße 50 zu 54 in acht Tagen, Edizioni Periferia, Lucerne **2006** Erwin Wurm: The artist who swallowed the world, MUMOK, Vienna; Hatje Cantz, Ostfildern. Erwin Wurm. The ridiculous life of a serious..., Kunstraum Innsbruck; Verlag der Buchhandlung Walther König, Cologne

1 **House Attack (from the series** *On the Roof of the Museum of Modern Art***)**, 2006, mixed media. Installation view, MUMOK, Vienna
2 **Art Basel Fucks Documenta**, 2006, resin, acrylic, 62 x 124 x 85 cm
3 **Herr Krause kommt nach Hause nach der grossen Sause**, 2007, mixed media sculpture. Installation view, Deichtorhallen, Hamburg

4 **Mind Bubbles**, 2007, styrofoam, acrylic, wool, dimensions variable. Installation view, Villa Manin, Codroipo
5 Left: **Envy Bumps**, 2007, bronze, nickelplated, 167 x 66 x 54 cm, right: **Anger Bump**, 2007, acrylic clothes, 155 x 80 x 47 cm

„Ich versuche, Werke zu schaffen, die – zumindest auf den ersten Blick – allgemein verständlich sind. Ich verwende oft Zitate und arbeite mit Anspielungen auf Comicstrips, Science Fiction, Filme und so weiter. Sie stellen die globale Umgangssprache unserer Zeit dar."

« J'essaie de créer une œuvre accessible au plus grand nombre, du moins au premier coup d'œil. J'utilise souvent des références à la bande dessinée, à la science-fiction, au cinéma, etc., ce qui constitue la langue vernaculaire internationale de notre époque. »

"I try to create work that is generally accessible, at least on the primary level. I often use quotes and include references to comic strips, science fiction, movies and so on. They constitute the global vernacular of our age."

2

3

4

Xu Zhen

1977 born in Shanghai, lives and works in Shanghai, China

Xu Zhen is a playful but nonetheless highly critical observer of and commentator upon his surroundings – which include his home country but also and above all his professional environment: the art scene. In *Wet Paint* (2008), for example, he applied a coat of white paint to a partition wall in a gallery space, thus paying homage to the idea of the White Cube perfectly prepared for the presentation of art. Except that here the coat of paint itself is the work of art. By using paint that does not dry, Xu takes Yves Klein's scrutiny of the White Cube in *Le Vide* (1958) – his legendary exhibition of a white-painted gallery space – a step further. In Xu's case, the viewers can only move around the space with caution and a certain unease, given that this simple intervention has transformed it from a neutral space for viewing art into something almost organic that drips and sweats. The installation *Dinosaurs* (2007), on the other hand, makes direct reference to the contemporary art scene or, more precisely, to the preserved animals in Damien Hirst's *Natural History* series. Xu gives a new twist to the concept of working with dead animals: his brontosaurus, consisting of cow carcasses and presented in a large glass display case, transforms a truly historical animal into an impressive sculpture and takes a sideswipe at contemporary conceptual art in the process, banishing it to the realm of extinct giant lizards. *ShanghART Supermarket* (2007) is an open criticism of the art market: the boxes of wares on offer in the replica discount store are all empty – this is an economy where there is nothing in circulation except emptiness and superficial beauty.

Xu Zhen ist ein schelmischer, jedoch deswegen nicht weniger kritischer Beobachter und Kommentator seiner Umwelt, womit sein Heimatland, vor allem aber sein berufliches Terrain, die Kunstszene, gemeint wären. In *Wet Paint* (2008) etwa hat er eine in den Galerieraum eingezogene Wand mit einem weißen Anstrich versehen, der den Vorstellungen vom perfekt für eine Präsentation vorbereiteten White Cube alle Ehre macht. Doch der Anstrich selbst ist das Werk. Indem Xu eine Farbe verwendet, die nicht trocknet, spitzt er Yves Kleins Auseinandersetzung mit dem White Cube bei dessen legendärer Ausstellung eines weiß gestrichenen Galerieraums, *Le Vide* (1958), weiter zu. Denn bei Xu können sich die Besucher nur mit Vorsicht und einem gewissen Unbehagen durch den Raum bewegen, der durch diesen simplen Eingriff von einem „neutralen" Ort der Kunstbetrachtung fast schon zu etwas Organischem geworden ist, das tropft und schwitzt. Die Installation *Dinosaurs* (2007) hingegen birgt eine direkte Anspielung auf die zeitgenössische Kunstszene, genauer auf Damien Hirsts *Natural History*-Serie mit ihren Tierpräparaten. Doch Xu gibt der Arbeit mit dem toten Tier eine andere Wendung, denn mit seinem aus Rinderkadavern geformten Brontosaurier, der in großen gläsernen Schaukästen präsentiert wird, hat Xu ein wahrhaft historisches Tier in eine eindrucksvolle Skulptur verwandelt und so mit einem Seitenhieb auch gleich die zeitgenössische Konzeptkunst in das Reich der ausgestorbenen Riesenechsen verbannt. Mit *ShanghART Supermarket* (2007) übt Xu unverhohlene Kritik am Kunstmarkt: Im nachgebauten Discounter sind die Schachteln aller feilgebotenen Waren leer – es ist eine Wirtschaft, in der nichts als Inhaltslosigkeit und schöner Schein zirkulieren.

Xu Zhen est un observateur et commentateur espiègle mais non moins critique de son environnement, c'est-à-dire de son pays natal, mais surtout de son domaine professionnel, la scène artistique. Pour *Wet Paint* (2008), il recouvrait d'une couche de peinture blanche un mur monté dans une galerie qui fait honneur aux conceptions du *white cube* méticuleusement préparé pour une présentation artistique. Mais l'œuvre est la couche de peinture elle-même. Avec l'emploi d'une peinture qui ne sèche pas, Xu Zhen pousse encore plus loin la confrontation avec le *white cube* qu'Yves Klein avait présentée lors de sa légendaire exposition d'une galerie peinte en blanc – *Le Vide* (1958). Chez Xu Zhen, les spectateurs ne peuvent en effet se mouvoir qu'avec prudence et une certaine gêne dans la salle, que cette simple intervention transforme d'un lieu « neutre » dédié à la contemplation de l'art, en quelque chose de déjà organique qui suinte et qui goutte. L'installation *Dinosaurs* (2007) contient en revanche une référence à la scène artistique contemporaine, plus précisément à la série *Natural History* de Damien Hirst avec ses animaux conservés dans du formol. Mais Xu imprime une autre direction à son travail sur les animaux morts : avec le brontosaure constitué de cadavres de bœufs et présenté dans d'immenses vitrines, Xu a transformé un animal effectivement historique en une impressionnante sculpture, reléguant du même coup l'art conceptuel contemporain au royaume des grands reptiliens défunts. Avec *ShanghART Supermarket* (2007), Xu émet désormais une critique ouverte du marché de l'art : dans ce magasin de discount, les boîtes de toutes les marchandises proposées à la vente sont vides – il s'agit d'une économie dans laquelle ne circulent plus qu'un manque de contenu et une belle apparence. A. M.

SELECTED EXHIBITIONS →
2008 *Avant-Garde China: Twenty Years of Chinese Contemporary Art*, The National Art Center, Tokyo; The National Museum of Art, Osaka; Aichi Prefectural Museum of Art, Nagoya. *Farewell to Post-Colonialism*, The Third Guangzhou Triennial, Guangzhou **2007** *PERFORMA 07 – The Second Visual Art Performance Biennial*, New York. *China – Facing Reality*, MUMOK, Vienna **2006** *China Power Station I–III*, Serpentine Gallery, London; Astrup Fearnley Museet for Moderne Kunst, Oslo; MUDAM, Luxemburg

SELECTED PUBLICATIONS →
2008 *Avatars and Antiheroes: A Guide to Contemporary Chinese Artists*, Kodansha International Ltd., Tokyo. *China–Facing Reality*, MUMOK, Vienna; NAMOC – National Art Museum of China, Beijing; Verlag für moderne Kunst, Nuremberg **2007** *China Art Book*, DuMont, Cologne. *Ice Cream*, Phaidon Press, London. *ShanghART*, Shanghart Gallery, Shanghai; Verlag der Buchhandlung Walther König, Cologne

香格纳

ShanghAI
SUPERMARK

1 **ShanghART Supermarket**, 2007, cash register, counter, shelves, refrigerator, multiple consumer products, 350 x 550 x 600 cm

2 **Flower-de-luce (Irises)**, 2008, never drying paint, 71 x 93 cm
3/4 **Dinosaurs**, 2007, glass container, meat, formaldehyde, 300 x 900 cm

„Es interessiert mich sehr, was zwischen Menschen und ihrer Umwelt ‚passiert'. Ich hoffe immer, dass ich einen ‚Unfall' auslösen kann. Die Wirklichkeit, in der wir uns bewegen ist häufig einfallsreicher als unsere Fantasie. Deswegen hoffe ich, eine ‚falsche' Realität schaffen zu können, die die Einbildungskraft anregt."

« Je suis très intéressé par ce qui se "passe" entre les gens et leur environnement. J'espère toujours réussir à faire que se produise un "accident". La réalité qui nous entoure est souvent plus imaginative que nos propres imaginations. J'espère donc que mon œuvre puisse créer une "fausse" réalité qui soit à même de susciter l'imagination. »

"I am quite interested in what 'happens' between people and their environment. I always hope to make some 'accident' occur. The reality that surrounds us is often more imaginative than our own imaginations. Thus, I hope my work can create a 'false' reality that can provoke imagination."

2

Yang Fudong

1971 born in Beijing, lives and works in Shanghai, China

Yang Fudong has emerged as the chronicler of a lost generation that is wandering through modern China without direction, cultural anchoring or existential foundations. His five-part video series *Seven Intellectuals in Bamboo Forest I–V* (2003–07) is based on an old folk legend where seven poets seek refuge in a forest and, far from all social conventions, devote themselves to a life of creative freedom. Yang's work provides a contemporary interpretation and features a group of seven young people in today's China. Whether they are in an urban or a rural setting, they are shown to be permanently dislocated, with no connection to their environment or each other. They travel like foreign visitors through a homeland that is alien to them. Yang emphasizes the sense of detachment through his choice of formal means. Many of his films are shot in black-and-white, giving them a curiously timeless feel, and there is no linear, self-contained plot or dialogue. This also applies to the comparatively short video *No Snow on the Broken Bridge* (2006). Seven young men and women, whose sense of being out of time is suggested by their historicized clothing, have gathered for an elegiac reflection on Nature. Here, Yang splits the piece into eight parallel projections, transferring the disorientation of his protagonists onto the viewing situation itself. *East of Que Village* (2007), also shot in black-and-white and conceived as a six-channel projection, is without doubt Yang's most existential film. Here he contrasts the fight for survival of a group of stray dogs with the daily struggles of a group of human beings and shows creatural hunger in its truest sense.

Yang Fudong tritt als Chronist einer verlorenen Generation auf, die ohne Richtung, kulturelle Verankerung oder existentielle Grundlage durch das zeitgenössische China irrt. Seine fünfteilige Videoserie *Seven Intellectuals in Bamboo Forest I–V* (2003–07) basiert auf einer volkstümlichen Legende, wonach einst eine Gruppe von sieben Dichtern Zuflucht in den Wäldern gesucht und sich dort fern aller gesellschaftlicher Konventionen einem Leben in kreativer Freiheit hingegeben hat. Yang liefert eine zeitgenössische Interpretation und versetzt eine Gruppe von sieben jungen Menschen in das gegenwärtige China. Ob sie sich in urbanen oder ländlichen Kontexten befinden, stets bleiben sie unverortet, ohne Bezug zu ihrer Umgebung oder zueinander. Sie reisen als Fremde durch die ihnen fremde Heimat. Yang betont das Gefühl der Bindungslosigkeit durch die Wahl der formalen Mittel. Viele seiner Filme sind in Schwarz-Weiß gedreht, was sie seltsam zeitlos macht, zudem gibt es weder eine lineare, in sich geschlossene Handlung noch Dialoge. Dies gilt auch für das vergleichsweise kurze Video *No Snow on the Broken Bridge* (2006). Sieben junge Männer und Frauen, deren zeitliche Ortlosigkeit durch historisierende Kleidung angedeutet wird, haben sich zu einer elegischen Naturbetrachtung versammelt. Yang hat hierbei die Projektion in acht parallel laufende Projektionen aufgefächert, so dass sich die Orientierungslosigkeit seiner Protagonisten auf die Betrachtungssituation überträgt. *East of Que Village* (2007), ebenfalls in Schwarz-Weiß und als Sechskanal-Projektion angelegt, ist der wohl existentiellste Film Yangs. Er stellt dem Überlebenskampf einer Gruppe streunender Hunde den Kampf um das tägliche Überleben einer Gruppe von Menschen gegenüber und zeigt den kreatürlichen Hunger im ureigenen Sinne.

Yang Fudong se présente comme le chroniqueur d'une génération perdue errant dans la Chine d'aujourd'hui – sans but et sans ancrage culturel ni fondement existentiel. Sa série de vidéos en cinq parties *Seven Intellectuals in Bamboo Forest I–V* (2003–07) s'inspire d'une légende populaire selon laquelle un groupe de sept poètes aurait jadis cherché refuge dans les bois pour s'y adonner à une vie de liberté créatrice à l'écart de toute convention sociale. Yang en livre une interprétation contemporaine et transplante un groupe de sept jeunes dans la Chine d'aujourd'hui. Que le contexte soit urbain ou rural, ils restent toujours désorientés, sans lien avec leur environnement ni les uns avec les autres, voyageant en étrangers dans une patrie qui leur est étrangère. Yang renforce encore le sentiment de manque d'attaches par le choix des moyens formels. Nombre de ses films sont tournés en noir et blanc, ce qui les rend étrangement intemporels. De plus, ils ne contiennent aucun dialogue et ne présentent aucune action linéaire ou cohérente. Ceci vaut aussi pour la vidéo relativement courte *No Snow on the Broken Bridge* (2006). Sept jeunes hommes et femmes, dont la désorientation temporelle est indiquée par des vêtements historisants, se sont réunis pour une contemplation élégiaque de la nature. Yang a fragmenté sa projection en huit projections parallèles, de sorte que la désorientation des protagonistes se retrouve dans la situation de la contemplation. *East of Que Village* (2007), également réalisé en noir et blanc et en projection à six canaux, est sans doute le film le plus existentiel de Yang : la lutte pour la survie d'une meute de chiens errants y est mise en regard de la lutte quotidienne d'un groupe de gens pour sa propre survie, la faim des créatures étant ainsi ramenée à son sens le plus fondamental. A. M.

SELECTED EXHIBITIONS →
2008 *Farewell to Post-Colonialism*, The Third Guangzhou Triennial, Guangzhou. *Yang Fudong – China in Transition*, Kunstforeningen GL Strand, Copenhagen **2007** *Think with the Senses – Feel with the Mind*, 52nd Venice Biennale, Venice **2006** *Yang Fudong: No Snow on the Broken Bridge*, Parasol Unit, London **2005** *Yang Fudong*, Castello di Rivoli, Turin. *Yang Fudong: Don't worry, it will be better...*, Kunsthalle Wien, Vienna.

SELECTED PUBLICATIONS →
2007 *China Art Book*, DuMont, Cologne. **2006** *No Snow on the Broken Bridge. Film and Installations by Yang Fudong*, Parasol Unit, London; Verlag der Buchhandlung Walther König, Cologne. *Yang Fudong*, Castello di Rivoli, Turin; Verlag der Buchhandlung Walther König, Cologne. *Yang Fudong, Lucy McKenzie, Julie Mehretu, Parkett 76*, Zurich **2005** *Yang Fudong*, Kunsthalle Wien, Vienna; Verlag der Buchhandlung Walther König, Cologne

„Manchmal finde ich, dass Landschaft ein sehr emotionaler Zustand ist, wie mit dem Herzen zu denken. Wenn du dein Herz verloren hast, siehst du die Landschaft nicht, auch wenn sie schön ist."

« Parfois je sens que le paysage est un peu comme une manière de penser avec le cœur, ou une sorte d'état émotionnel. Quand on perd son cœur, on ne voit plus le paysage, même s'il est beau. »

"Sometimes I feel landscape is kind of thinking by your heart, or a kind of emotional state. When you lost your heart, you shall not see the landscape even if it is beautiful."

3

4

5

6

7

8

Toby Ziegler

1972 born in London, lives and works in London, United Kingdom

Does the computer alter traditional genres such as painting, sculpture or drawing? Few artists ask themselves this question, but Toby Ziegler is one who does. His specific aesthetic references Vasarely's op art, hard edge and early computer art such as that of Manfred Mohr. But the crucial aspect for Ziegler is the combination of digital design and analogue execution in painting or sculpture. He thus shatters the perfection of mathematical calculation and creates a hybrid construct, paying particular attention not only to manual work but also to reflective supports. These further emphasize the multi-perspective aspect of his works: any movement by the viewer leads to shifts in the perception of the geometrical structures. To grasp the essence of things artistically is one of Ziegler's primary concerns. The realization that objects displayed on a computer screen coagulate into abstract information led him to work with collage techniques in some of his latest works. Ziegler adds organic elements to his characteristic digital geometric structures, constituting a break within the picture in a material, technical, perspectival and mathematical sense. Since 2006, Ziegler has been incorporating clouds into his landscape pictures, and since 2007, he has been doing so with the aid of this collage technique which combines two pictorial systems: a calculated, geometric system and an organic one – the elusiveness of organic cloud formations making them hard to capture precisely within geometric parameters. Interestingly, Ziegler's new pictures bring him into contact with a pictorial tradition which already knew how to combine rigorous geometry, perspective and organic forms: the wooden inlays of the Renaissance.

Verändert der Computer die traditionellen Gattungen wie Malerei, Skulptur und Zeichnung? Nicht allzu viele Künstler stellen sich diese Frage, zu ihnen gehört Toby Ziegler. Er entwickelte eine spezifische Ästhetik mit Bezügen zu Vasarelys Op Art, zu Hard Edge und früher Computerkunst, wie sie etwa Manfred Mohr realisierte. Doch entscheidend für Ziegler ist die Kombination von digitalem Entwurf und analoger, malerischer oder skulpturaler Ausführung. Auf diese Weise bricht er die rechnerische Perfektion und schafft eine Hybridkonstruktion. Besonderen Wert legt er dabei nicht nur auf die Manualität, sondern auch auf reflektierende Bildträger, welche die oft vorhandene Multiperspektivik in seinen Werken nochmals verstärkt, da die Bewegungen des Betrachters zu Verschiebungen der geometrischen Strukturen bei der Wahrnehmung führen. Die Essenz von Dingen künstlerisch zu erfassen, ist eine zentrale Bestrebung Zieglers. Dabei führte ihn die Erkenntnis, dass Objekte im Computer zu abstrakter Information gerinnen, zu dem Ansatz, bei seinen neueren Werken mit der Collagetechnik zu arbeiten. So fügt er die für ihn typischen digitalen geometrischen Strukturen zusammen, bringt aber mit organischen Elementen einen Bruch ins Bild: materiell, technisch, perspektivisch und vor allem rechnerisch. Seit 2006 setzt Ziegler Wolken in seinen Landschaftsbildern ein, seit 2007 geschieht dies mit der Collagetechnik, wodurch zwei piktorale Systeme, das gerechnete, geometrische und das organische, sich vermischen – denn organische Wolkenformen lassen sich ob ihrer Flüchtigkeit nicht präzise geometrisch fassen. Interessanterweise gelangen seine neuen Bilder dadurch mit einer Bildtradition in Berührung, die strenge Geometrie, Perspektivik und organische Formen bereits zu vereinen wusste: die Holzintarsien der Renaissance.

Le numérique modifie-t-il les genres traditionnels comme la peinture, la sculpture et le dessin ? Les artistes qui se posent cette question ne sont pas légion, Toby Ziegler en fait partie. Il a développé une esthétique spécifique avec des références à l'Op Art de Vasarely, au Hard Edge et aux débuts de l'art numérique, auxquels a notamment contribué Manfred Mohr. Mais chez Ziegler, l'aspect décisif est la combinaison entre projet numérique et exécution analogique – picturale ou sculpturale. Ziegler rompt ainsi la perfection mathématique et crée une construction hybride. Il accorde pour cela une valeur particulière au travail manuel, mais aussi aux supports réfléchissants, qui soulignent encore la multiperspective, car les déplacements du spectateur conduisent à des décalages dans la perception des structures géométriques. Capter l'essence des choses sur un mode artistique est le moteur central de Ziegler. Dans ses œuvres récentes, la conscience que les réalisations numériques finissent figées en une information abstraite l'a donc conduit à travailler avec le collage. Ziegler introduit des éléments organiques dans ses structures géométriques numériques créant une rupture de matière, de technique, de perspective et de calcul. Depuis 2006, il introduit des nuages dans ses tableaux paysagers et depuis 2007, il les incorpore sous forme de collages, combinant deux systèmes plastiques : l'un calculé et géométrique, l'autre organique – la fugacité de leurs formes organiques ne permet pas d'appréhender les nuages en termes géométriques précis. Fait intéressant, ses tableaux récents se rattachent ainsi à une tradition qui a su concilier rigueur géométrique, perspective et formes organiques : la marqueterie de la Renaissance.

H. L.

SELECTED EXHIBITIONS →
2008 *Parkhaus*, Kunsthalle Düsseldorf. *The Hamsterwheel*, Malmö Konsthall, Malmö **2007** *Franz West, Soufflé – eine Massenausstellung*, Kunstraum Innsbruck. *How to Improve the World*, Birmingham Museum and Art Gallery, Birmingham. *Size Matters: XXL – recent large-scale paintings*, HVCCA – The Hudson Valley Center for Contemporary Art, Peekskill **2006** *Archipeinture: Painters build Architecture*, Camden Arts Centre, London; Le Plateau/FRAC Île-de-France, Paris

SELECTED PUBLICATIONS →
2008 *Franz West, Soufflé – eine Massenausstellung*, Kunstraum Innsbruck; Verlag der Buchhandlung Walther König, Cologne **2005** *Supernova*, British Council, London

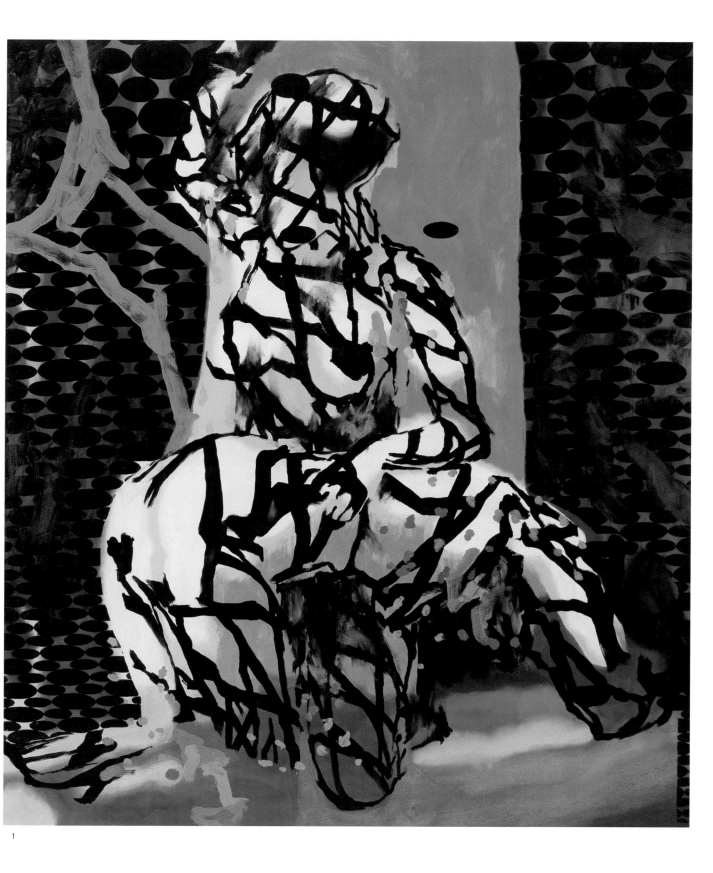

1 **Victorian Water Mains (2nd Version)**, 2008, oil on canvas, 147 x 173 cm
2 **Symbolic Impasse**, 2008, oil, gold leaf on canvas, bonsai, 115 x 267 x 85 cm
3 **The Subtle Power of Spiritual Abuse (Study)**, 2007, inkjet on paper, oil paint, gesso, pins, 128 x 155 cm

4 **Sad Cowboy**, 2007, oil on canvas, 242 x 210 cm
5 **Pathetic Fallacy (2nd Version)**, 2007, cardboard, glue, gesso, horse hair, 125 x 210 x 90 cm

„Wenn man den einfachsten aller Gegenstände anschaut, sagen wir eine Kartoffel, ist es erschreckend, wie viele Informationen man braucht, um den Kern des ‚Kartoffel-seins' zu kommunizieren."

« Quand on regarde le plus simple des objets, par exemple une pomme de terre, il est effrayant de penser quelle somme d'information est nécessaire pour communiquer l'essence de sa "pomme-de-terre-itude". »

"Looking at the most basic of objects, such as a potato, it is terrifying to think how much information is needed to communicate the essence of its 'potato-ness'."

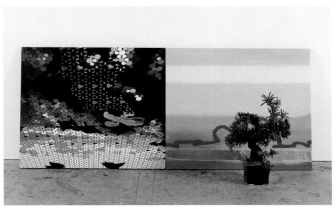

2

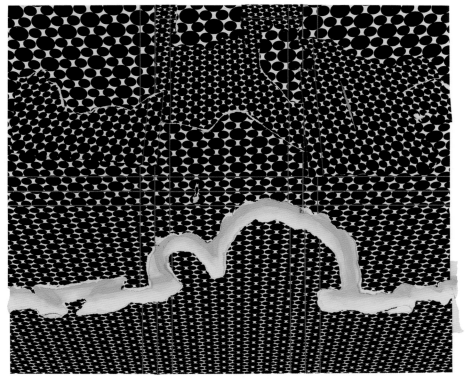

3

4

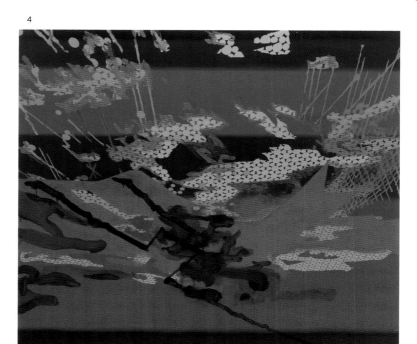

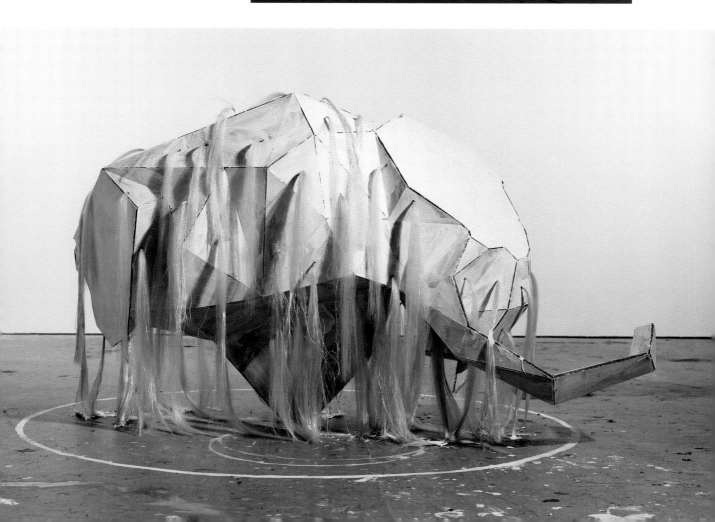

Thomas Zipp

1966 born in Heppenheim, lives and works in Berlin, Germany

For *Dwarf Nose* (2008) – one of Thomas Zipp's most recent installations – the artist turned the gallery into a deposit of gigantic missiles: Zipp took a number of decommissioned Patriot Missile warheads and reassembled them into an image of extraordinary power that evokes cold war nightmares of destruction but also childish memories of war games. A similar attraction to the rhetoric of power and the paranoia of history is evident in *Planet Caravan? Is There Life after Death? A Futuristic World Fair* (2007), a complex installation combining free-standing panels with paintings, collages and sculptures. With its evocative imagery populated by pictures of renowned astronomers, philosophers and scientists, the work merges religion, history, science and politics to exemplify the various systems of thoughts through which humanity has attempted to understand the world. Besides these large-scale installations, Zipp adopts a variety of media such as painting, drawing and photography. His work is often embedded with references to futurism and the avant-garde of the early 20th century. Unlike his predecessors though, Zipp sketches the future with a dark palette and tints it with bleak, apocalyptic overtones: in the painting *Black August* (2007), or in *A.B. Pusteblume* (2006), for example, Zipp depicts imaginary catastrophes and a mutant form of vegetation sprouted from some ecological disaster. Often Zipp combines different media in the same work, such as in *Uranlicht* (2006), a small portrait that is hung next to a large checkered painting. The two are connected by eight white lines that extend from the drawing into the canvas, sketching a desperate landscape of loneliness.

Für *Dwarf Nose* (2008) – eine von Thomas Zipps neuesten Installationen – verwandelte der Künstler die Galerie in ein Depot mit riesigen Raketen: Er nahm eine Reihe ausgemusterter Patriot-Missile-Sprengköpfe und fügte sie zu einem ungeheuer aussagekräftigen Bild zusammen, das die Zerstörungsalpträume des Kalten Kriegs heraufbeschwört, aber auch kindliche Erinnerungen an Kriegsspiele. Auf ähnliche Weise zeigen sich die Rhetorik der Macht und die Paranoia der Geschichte in *Planet Caravan? Is There Life after Death? A Futuristic World Fair* (2007), einer komplexen Installation aus frei stehenden Tafeln, Gemälden, Collagen und Skulpturen. In einer sinnträchtigen Bildwelt voller Porträts berühmter Astronomen, Philosophen und Wissenschaftler verschmelzen hier Religion, Geschichte, Wissenschaft und Politik miteinander und veranschaulichen die verschiedenen Denksysteme, durch die die Menschheit versucht hat, sich die Welt zu erklären. Neben diesen Rauminstallationen arbeitet Zipp auch mit einer Vielzahl an Medien wie Malerei, Zeichnung und Fotografie. Sein Œuvre enthält oft Verweise auf den Futurismus und die Avantgarde des frühen 20. Jahrhunderts. Doch anders als seine Vorgänger skizziert Zipp die Zukunft in dunkler Palette und färbt sie mit trostlosen, apokalyptischen Untertönen ein: In Gemälden wie *Black August* (2007) oder *A.B. Pusteblume* (2006) beschreibt er imaginäre Katastrophen und eine mutierende Form von Vegetation als Resultat eines ökologischen Desasters. Oft kombiniert Zipp verschiedene Medien in ein und demselben Werk, etwa in *Uranlicht* (2006), einem kleinen Porträt, das neben einem großen karierten Gemälde hängt. Beide sind durch acht weiße Linien miteinander verbunden, die sich von der Zeichnung bis in die Leinwand hinein erstrecken und eine trostlose Landschaft der Einsamkeit entstehen lassen.

Pour *Dwarf Nose* (2008) – une des installations les plus récentes de Thomas Zipp – l'artiste a transformé la galerie en dépôt pour missiles géants : il a assemblé un grand nombre de têtes de missiles Patriot désamorcés pour former une image d'une puissance extraordinaire, évoquant les cauchemars de destruction de la guerre froide ou des souvenirs de jeux d'enfants. Cette attirance pour la rhétorique du pouvoir et la paranoïa dans l'histoire se manifeste aussi dans *Planet Caravan ? Is There Life after Death ? A Futuristic World Fair* (2007), une installation complexe associant sculptures, collages et peintures accrochées sur panneaux. Avec une iconographie évocatrice peuplée de célèbres astronomes, philosophes et scientifiques, son travail intègre religion, histoire, science et politique pour illustrer les divers systèmes de pensée à travers lesquels l'humanité a tenté de comprendre le monde. Parallèlement à ce travail de grandes installations, Zipp utilise une grande diversité de médiums (peinture, dessin, photographie). Son travail s'inscrit dans l'héritage du futurisme et des avant-gardes du début du XXᵉ siècle, mais contrairement à ses prédécesseurs, Zipp brosse l'avenir avec une palette sombre teintée de connotations sinistres et apocalyptiques. Ainsi les peintures *Black August* (2007) ou *A.B. Pusteblume* (2006) dépeignent une catastrophe imaginaire et une forme de végétation mutante qui serait née d'un désastre écologique. Zipp combine souvent différentes disciplines dans une même œuvre : dans *Uranlicht* (2006), un petit portrait est accroché à côté d'une grande peinture en damiers. Les deux cadres sont reliés par huit lignes blanches qui filent du dessin à la toile, esquissant un paysage solitaire et mélancolique.

C. A.

SELECTED EXHIBITIONS →
2008 *Thomas Zipp: Planet Caravan? Is There Life after Death? A Futuristic World Fair*, Museum Dhondt Daehnens, Deurle **2007** *Planet Caravan? Is there Life after Death? – A Futuristic World Fair*, Kunsthalle Mannheim, Museum in der Alten Post, Mülheim. *Kunstpreis der Böttcherstraße in Bremen 2007*, Kunsthalle Bremen **2006** *Rings of Saturn*, Tate Modern, London. *Of Mice and Men*, 4th Berlin Biennial for Contemporary Art, Berlin **2005** *Thomas Zipp: The Return of the Subreals*, Oldenburger Kunstverein, Oldenburg.

SELECTED PUBLICATIONS →
2008 *Thomas Zipp: Black Pattex 78*, Galeria Heinrich Ehrhardt, Madrid **2007** *Thomas Zipp: Planet Caravan? Is There Life after Death? A Futuristic World Fair*, Kunsthalle Mannheim; Kerber Verlag, Bielefeld. *Thomas Zipp: Papers*, Galerie Guido W. Baudach, Berlin; Galerie Krinzinger, Vienna. *Kommando Friedrich Hölderlin Berlin*, Galerie Max Hetzler, Berlin **2005** *Thomas Zipp. Achtung! Vision: Samoa, The Family of Pills & The Return of the Subreals*, Oldenburger Kunstverein, Oldenburg; Hatje Cantz, Ostfildern

1 **Psychonaut A**, 2008, diabase, silver, wood, 191 x 38 x 55 cm
2 **Crystal Meth**, 2007, mixed media, 3 parts, dimensions variable
3 Installation view, *Thomas Zipp: Planet Caravan? Is There Life after Death? A Futuristic World Fair*, Kunstmuseum Mannheim, 2007
4 **O.4**, 2006, mixed media, 6 parts, dimensions variable

5 **Achtung! Luther**, 2006, mixed media, 17 parts, dimensions variable
6 **Black August**, 2007, acryl, oil on canvas, 250 x 200 cm
7 **Loos**, 2006, mixed media on paper, 39 x 30 cm (framed)
8 Installation view, *Thomas Zipp: Dwarf Nose*, Harris Lieberman Gallery, New York, 2008

2

3

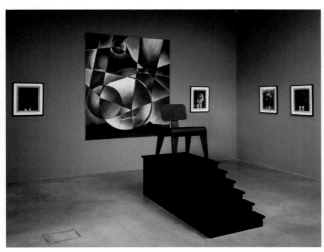

4

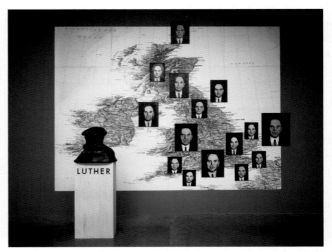

5

6

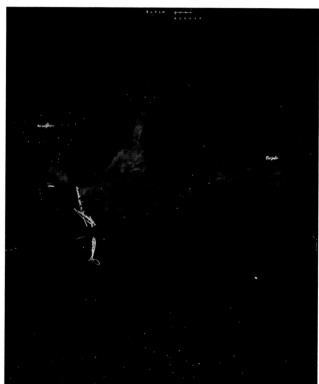

7

8

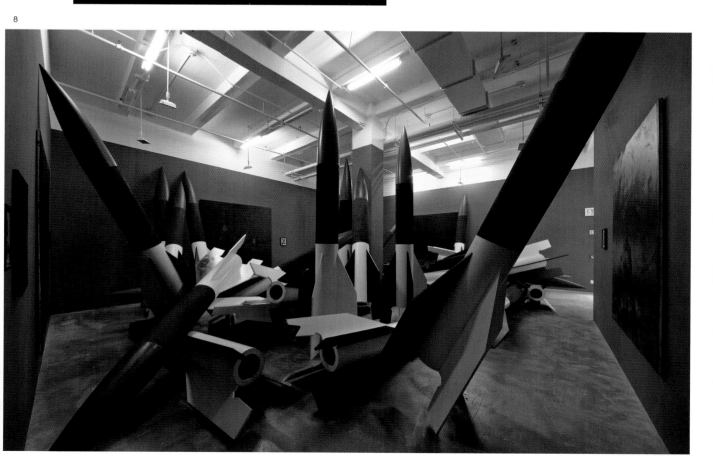

Acknowledgements — Dank — Remerciements

303 Gallery, Simon Greenberg — Alexander and Bonin, Oliver Newton, Ariel Phillips — Allora & Calzadilla Studio — Darren Almond Studio, Connor Linskey, Kathleen Madden — Galería Helga de Alvear, James Steele — The Approach, Katy Partridge — Arndt & Partner, Julie Herbe, Katrin Kramer, Natalija Martinovic — Galerie Guido W. Baudach, Jasmin Scheckenbach, Heike Tosun — Blum & Poe, Heather Rasmussen, John Steele — Monica Bonvicini Studio, Magdalena Magiera — Mary Boone Gallery, Ron Warren — Bortolami, Meghan Hoyt, Nicole Will — Gavin Brown's enterprise, Alex Zachary — Glenn Brown Studio, Edgar Laguinia — Galerie Daniel Buchholz, Katharina Forero de Mund, Michael Kerkmann — Cai Guo-Qiang Studio, Bonnie Huie, Alicia Lu — Galerie Gisela Capitain, Wiebke Kayser, Sarah Moog, Dorothee Sorge — Galleria Massimo De Carlo, Anna Cappozzo — China Art Archives and Warehouse, Bonnie Huie — China Art Objects Galleries, Maeghan Reid — Christie's, Leonie Ashfield, Stella Calvert-Smith, Stephanie Manstein, Barbara Pusca, Milena Sales — James Cohan Gallery, Ginger Cofield, Jessica Lin Cox, Christopher Rawson — Sadie Coles HQ, Rebecca Heald, Karimah Shofuneh, Chelsea Zaharczuk — Contemporary Fine Arts, Verena Hollank, Julia Rüther, Imke Wagener — Martin Creed Studio, Rob Eagle, David Southard — Galerie Chantal Crousel — Thomas Dane Gallery, Georgia Ciancimino — Deitch Projects, Jasmine Levett — Thomas Demand Studio, Miriam Böhm, Ariane Pauls — Design and Artists Copyright Society (DACS), Cassandra King, Joy Stanley — EIGEN + ART, Corinna Wolfien — Elmgreen & Dragset Studio, Sandra Stemmer, Elmar Vestner — Zach Feuer Gallery, Grace Evans — Galleria Emi Fontana, Alessio delli Castelli — Galeria Fortes Vilaça, Alexandre Gabriel, Marcia de Moraes — Stephen Friedman Gallery, Bethany Pappalardo, Alice Walters — Frith Street Gallery, Dale McFarland — Gagosian Gallery, Ian Cooke, James McKee — Ellen Gallagher Studio — Barbara Gladstone Gallery, Jessie Greene, Eric Nylund — Marian Goodman Gallery — Douglas Gordon Studio, Martina Aschbacher, Bert Ross — Galerie Bärbel Grässlin, Philipp Dieterich, Susanne Hofmann, Klaus Webelholz — Greene Naftali, Sam Pulitzer, Jay Sanders, Alexandra Tuttle — greengrassi, Lindsay Jarvis — Andreas Grimm Gallery, Martina Tauber — Mark Grotjahn Studio, Daniel Cummings, Laurel Lozzi — Andreas Gursky Studio, Annette Völker — Galerie Hammelehle und Ahrens, Sabrina Biegel — Mona Hatoum Studio — Galerie Reinhard Hauff — Haunch of Venison, Claudia Stockhausen — Hauser & Wirth, Nicole Keller, Julia Lenz, Sabina Sarwa, Karin Seinsoth, Michael Stark — Arturo Herrera Studio — Galerie Max Hetzler, Wolfram Aue, Olivia Franke, Evke Rulffes, Tanja Wagner — Rhona Hoffman Gallery, Charlotte Marra — Xavier Hufkens, Ann Hoste — Pierre Huyghe Studio, Michaël Pierson — Jablonka Galerie, Christian Schmidt — Galerie Michael Janssen, Katrin Wohlt — Johnen + Schöttle, Markus Mascher, Tan Morben — Jay Jopling/White Cube, Rowan Aust, Alex Bradley, Sophie Greig, Amy Houmoller, Susannah Hyman, Sara McDonald — Kaikai Kiki New York LLC, Marika Shishido — Paul Kasmin Gallery, Rebecca Siegel, Mark Markin — Mike Kelley Studio, Mary Clare Stevens — Anton Kern Gallery, Bridget Finn — Jeff Koons Studio, Lauran Rothstein — David Kordansky Gallery, Natascha Garcia-Lomas, Dwyer Kilcollin, Melissa Tolar — Galerie Krinzinger — kurimanzutto, Amelia Hinojosa — Ulrich Lamsfuß Studio — Simon Lee, Lindsay Ramsay — Galerie Gebr. Lehmann, Jörg Goedecke, Karola Matschke, Max Meyer-Abich — Lehmann Maupin Gallery, Stephanie Smith — Luhring Augustine, Caroline Burghardt, Tiffany Edwards — Vera Lutter Studio, Hajarah Abdus-Sabur, Susan Feldman — Giò Marconi, Ylinka Barotto — Matthew Marks Gallery, Stephanie Dorsey, Caroline Gabrielli, Senem Oezdogan, Ben Thornborough — Josephine Meckseper Studio, Arianna Petrich, Zachary Zahringer — Urs Meile, Karin Seiz, René Stettler — Metro Pictures, Alexander J. Pall, James Woodward — Beatriz Milhazes Studio, Tereza Lyrio — Robert Miller Gallery — Victoria Miro, Bryony McLennan, Anna Mustonen, Kathy Stephenson — Christian Nagel, Florian Baron, Andrea Zech — Galerie Neu, Sasha Rossmann — neugerriemschneider, Emilie Breyer, Valerie Chartrain, Claire Rose — Frank Nitsche Studio — Tim Noble & Sue Webster Studio, Andrew McLachlan — Galerie Giti Nourbakhsch — Albert Oehlen Studio — Anthony d'Offay, Hannah Barry — Patrick Painter Inc., Jacquelyn De Longe, Heather Harmon, Luis Zavala — Maureen Paley, Susanna Chisholm, Katie Guggenheim, Patrick Shier— Parallax, Julia Dault — Peres Projects, Nick Koenigsknecht, Victoria Sounthavong, Blair Taylor — Galerie Emmanuel Perrotin, Nathalie Brambilla — Pest Control Office, Holly Cushing — Friedrich Petzel Gallery, Colby Bird, Jason Murison, Andrea Teschke — Phillips de Pury & Company, Johanna Frydman, Cynthia Leung — Richard Phillips Studio — Fondazione Prada, Mario Mainetti — Galerie Eva Presenhuber, Gregor Staiger, Kerstin Weiss, Silja Wiederkehr — Richard Prince Studio, Betsy Biscone — Regen Projects, Tanya Brodsky, Brad Hudson — Anselm Reyle Studio, Alexander Fischer von Mollard — Andrea Rosen Gallery, Jeremy Lawson — Thomas Scheibitz Studio, Andrea Niederbuchner — Esther Schipper, Kathrin Heimburger, Nina Köller — Gregor Schneider Studio, Andreas Gerads — Jack Shainman Gallery, Sabrina Vanderputt — ShanghART Gallery — Sikkema Jenkins & Co., Ellie Bronson — Sotheby's, Roxy Pennie, Lauren Pirrung — Monika Sprüth Philomene Magers, Franziska von Hasselbach — Galeria Luisa Strina, Camila Leme — Thomas Struth Studio, Sonja Ameglio — Tate Modern, Anna Ridley, Lucie Strnadova — Mickalene Thomas Studio, Jordan Buschur — Janaina Tschäpe Studio, Joann Kim — Piotr Uklański Studio, Arianna Petrich, Malgorzata Bakalarz — Francesco Vezzoli Studio, Luca Corbetta — Susanne Vielmetter Los Angeles Projects, Gosia Wojas — Walker Art Center, Barbara Economon — Galerie Michael Werner, Jason Duval — Archiv Franz West, Michaela Obermaier, Andrea Überbacher — Kehinde Wiley Studio, Anthony Lanzilote, Carrie Mackin — Christopher Wool Studio — Erwin Wurm Studio, Claudia Salzer — Zeno X Gallery, Roxane Baeyens, Koen van den Brande, Jelle Breynaert — Toby Ziegler Studio — Thomas Zipp Studio, Kai Erdmann — David Zwirner, Jessica Witkin

Practical guide — Serviceteil — Guide pratique

In this practical guide, you will find all information of interest to art lovers, gallery goers and collectors. **REPRESENTATION** lists the galleries representing the artists within their region. Additional, up-to-date information on artists and exhibitions can always be found at the Internet addresses also given here. **PRIMARY MARKET PRICES** are the prices for which the galleries sell the works. Big variations are possible, depending on the medium and dimensions of the work. Where the gallery chooses not to publicize these prices, you can contact it directly if you are interested. The **AUCTION SALES** list the five best results for those artists whose works have already been sold at auction. The relevant data were supplied by artnet.com.

Following this guide, you will find a short glossary by Ariane Beyne and Raimar Stange that gives a brief explanation of the most important artistic terms, genres and techniques.

Im Serviceteil dieses Anhangs finden Sie alle Angaben, die für Kunstliebhaber, Galeriengänger und Sammler interessant sind. Unter **REPRESENTATION** werden die Galerien aufgelistet, die den jeweiligen Künstler in ihrer Region vertreten. Auf den angegebenen Internetseiten können Sie zudem immer aktuelle Informationen über Künstler und Ausstellungen bekommen. Die **PRIMARY MARKET PRICES** nennen die Preise, zu denen die Werke direkt von den Galerien verkauft werden. Je nach Medium und Umfang der Arbeiten sind hier große Schwankungen möglich. Teilweise werden diese Daten nicht veröffentlicht, bei Interesse können Sie sich dann direkt an die Galerie wenden. Unter **AUCTION SALES** sind die fünf besten Ergebnisse für diejenigen Künstler gelistet, deren Arbeiten bereits auf Auktionen gehandelt wurden. Die Daten hierfür wurden uns von artnet.com zur Verfügung gestellt.

Im Anschluss finden Sie ein Glossar von Ariane Beyne und Raimar Stange, das kurz die wichtigsten Fachbegriffe, Kunstgattungen und Techniken erklärt.

Dans les pages suivantes, on trouvera toutes les informations utiles aux amateurs d'art, aux visiteurs de galeries et aux collectionneurs. Dans la rubrique **REPRESENTATION** figurent les galeries qui représentent les artistes dans leur région respective. Les adresses de pages Internet permettent aussi de trouver des informations récentes sur les artistes et les expositions. Les **PRIMARY MARKET PRICES** sont les prix auxquels les œuvres sont vendues directement par les galeries. De forts écarts de prix sont possibles en fonction du médium utilisé et de la taille des œuvres. Quand ces informations ne sont pas publiées, les personnes intéressées peuvent s'adresser directement aux galeries. La rubrique **AUCTION SALES** donne les cinq meilleurs résultats de ventes pour les artistes dont les œuvres ont déjà été adjugées en maisons de ventes. Ces données ont été gracieusement mises à notre disposition par artnet.com.

Dans le glossaire établi par Ariane Beyne et Raimar Stange, on trouvera une brève explication des principaux termes professionnels, genres et techniques artistiques.

TOMMA ABTS

REPRESENTATION →
Galerie Daniel Buchholz
Neven-DuMont-Straße 17
D – 50667 Köln
Tel: +49 (0)221 257 49 46
www.galeriebuchholz.de

greengrassi
1a Kempsford Road
GB – London SE11 4NU
Tel: +44 (0)20 78 40 91 01
www.greengrassi.com

Galerie Giti Nourbakhsch
Kurfürstenstraße 12
D – 10785 Berlin
Tel: +49 (0)30 44 04 67 81
www.nourbakhsch.de

David Zwirner
525 West 19th Street
US – New York, NY 10011
Tel: +1 212 727 20 70
www.davidzwirner.com

PRIMARY MARKET PRICES →
Upon request

Franz Ackermann, Mental Map:
Evasion IV, 1996/97

FRANZ ACKERMANN

REPRESENTATION →
neugerriemschneider
Linienstraße 155
D – 10115 Berlin
Tel: +49 (0)30 28 87 72 77
www.neugerriemschneider.com

Gavin Brown's enterprise
620 Greenwich Street
US – New York, NY 10014
Tel: +1 212 627 52 58
www.gavinbrown.biz

Giò Marconi
Via Tadino, 15
I – 20124 Milano
Tel: +39 02 29 40 43 73
www.giomarconi.com

Mai 36 Galerie
Rämistrasse 37
CH – 8001 Zürich
Tel: +41 (0)44 261 68 80
www.mai36.com

PRIMARY MARKET PRICES →
$21.500 – $470.000

AUCTION SALES →
Price: $586.677
Mental Map: Evasion IV, 1996/97
Acrylic on canvas,
259.7 x 289.5 cm
Date sold: 13-Oct-07
Auction house: Phillips de Pury &
Company, London

Price: $520.347
B2 Barbeque with the Duke, 1999
Oil on canvas, 280 x 400 cm
Date sold: 08-Feb-06
Auction house: Christie's, London

Price: $420.000
Evasion VI, 1996
Acrylic on canvas, 195 x 210 cm
Date sold: 15-May-07
Auction house: Sotheby's,
New York

Price: $408.888
New Building, 1999
Oil on canvas, 260.5 x 200 cm
Date sold: 22-Jun-06
Auction house: Christie's, London

Price: $408.000
Untitled (Waterfall No. 2), 2002
Oil on canvas, 280 x 350 cm
Date sold: 16-Nov-06
Auction house: Christie's,
New York

AI WEIWEI

REPRESENTATION →
China Art Archives and
Warehouse
P.O. Box 100102-43
CN – 100102 Beijing, China
Tel: +86 10 84 56 51 52
www.archivesandwarehouse.com

Galerie Urs Meile
Rosenberghöhe 4
CH – 6004 Luzern
Tel: +41 (0)41 420 33 18
www.galerieursmeile.com

Mary Boone Gallery
745 Fifth Avenue
US – New York, NY 10151

Ai Weiwei, Divina Proportion, 2007

Tel: +1 212 752 29 29
www.maryboonegallery.com

PRIMARY MARKET PRICES →
Upon request

AUCTION SALES →
Price: $657.000
Chandelier, 2002
Crystal, light bulbs, metal,
548.6 x ø 403.9 cm
Date sold: 20-Sep-07
Auction house: Sotheby's,
New York

Price: $241.000
Divina Proportione, 2007
Huanghuali wood, dimensions
variable
Date sold: 17-Mar-08
Auction house: Sotheby's,
New York

Price: $228.000
Map of China, 2004
Wood from destroyed Qing
Dynasty temples,
51 x 200 x 160 cm
Date sold: 31-Mar-06
Auction house: Sotheby's,
New York

Price: $150.000
Coloured Vases, 2006
Painted neolithic vessels, 24
parts, dimensions variable
Date sold: 20-Sep-06
Auction house: Sotheby's,
New York

Price: $145.000
6.3-4, 2006
C-prints, set of 24, 100 x 142 cm
Date sold: 17-Mar-08
Auction house: Sotheby's,
New York

DOUG AITKEN

REPRESENTATION →
303 Gallery
525 West 22nd Street
US – New York, NY 10011
Tel: +1 212 255 11 21
www.303gallery.com

Victoria Miro Gallery
16 Wharf Road
GB – London N1 7RW
Tel: +44 (0)20 73 36 81 09
www.victoria-miro.com

Galerie Eva Presenhuber
Limmatstrasse 270
CH – 8005 Zürich
Tel: +41 (0)43 444 70 50
www.presenhuber.com

Regen Projects
633 North Almont Drive

US – Los Angeles, CA 90069
Tel: +1 310 276 54 24
www.regenprojects.com

Taka Ishii Gallery
1-3-2 5F, Kiyosumi Koto-ku
JP – Tokyo 135-0024
Tel: +81 (0)3 56 46 60 50
www.takaishiigallery.com

PRIMARY MARKET PRICES →
Upon request

AUCTION SALES →
Price: $114.000
electric earth (linear version),
1999
Video laserdisc, sound, 18 min
Date sold: 13-May-04
Auction house:
Phillips de Pury & Company,
New York

Price: $54.000
turbulence (triptych), 1999
C-print mounted on Plexiglas,
85.1 x 108.6 cm
Date sold: 08-Nov-04
Auction house:
Phillips de Pury & Company,
New York

Price: $45.000
here to go (ice cave), 2002
C-print mounted on Perspex,
182 x 182 cm
Date sold: 11-May-06
Auction house: Sotheby's,
New York

Price: $45.000
two second separation, 2000
C-print mounted on Plexiglas,
2 parts, 48.2 x 237.2 cm
Date sold: 13-Nov-03
Auction house: Sotheby's,
New York

Price: $35.850
the mirror #1–11, 1998
Cibachrome print, 11 parts,
50.6 x 63.3 cm
Date sold: 12-Nov-03
Auction house: Christie's,
New York

HALUK AKAKÇE

REPRESENTATION →
Bernier/Eliades Gallery
11 Eptachalkou
GR – 11851 Athens
Tel: +30 210 34 13 93 35
www.bernier-eliades.gr

Nogueras Blanchard
Xuclà 7
E – 08001 Barcelona
Tel: +34 (0)93 342 57 21
www.noguerasblanchard.com

Deitch Projects
76 Grand Street
US – New York, NY 10013
Tel: +1 212 343 73 00
www.deitch.com

Galerie Max Hetzler
Zimmerstraße 90/91
D – 10117 Berlin
Tel: +49 (0)30 229 24 37
www.maxhetzler.com

Gallery Bob van Orsouw
Limmatstrasse 270
CH – 8005 Zürich
Tel: +41 (0)44 273 11
www.bobvanorsouw.ch

PRIMARY MARKET PRICES →
$14.500–$43.500

ALLORA & CALZADILLA

REPRESENTATION →
Barbara Gladstone Gallery
515 West 24th Street
US – New York, NY 10011
Tel: +1 212 206 93 00
www.gladstonegallery.com

Galerie Chantal Crousel
10, rue Charlot
F – 75003 Paris
Tel: +33 (0)1 42 77 38 87
www.crousel.com

Leon Tovar Gallery
16 East 71 Street
US – New York, NY 10021
Tel: +1 212 585 24 00
www.leontovargallery.com

Lisson Gallery
52–54 Bell Street
GB – London NW1 5DA
Tel: +44 (0)20 77 24 27 39
www.lissongallery.com

PRIMARY MARKET PRICES →
Upon request

DARREN ALMOND

REPRESENTATION →
Galerie Max Hetzler
Zimmerstraße 90/91
D – 10117 Berlin
Tel: +49 (0)30 229 24 37
www.maxhetzler.com

Matthew Marks Gallery
523 West 24th Street
US – New York, NY 10011
Tel: +1 212 243 02 00
www.matthewmarks.com

White Cube
48 Hoxton Square
GB – London N1 6PB

Darren Almond, Six Months Later (detail), 1999

Tel: +44 (0)20 79 30 53 73
www.whitecube.com

PRIMARY MARKET PRICES →
$20.000–$40.000 (photographs)
$90.000–$200.000 (films)
$200.000–$300.000 (large
sculptures)

AUCTION SALES →
Price: $100.418
Six Months Later, 1999
Colour photographs, 24 images
per frame, 24 frames total,
64.5 x 53.9 cm
Date sold: 22-Jun-07
Auction house:
Phillips de Pury & Company,
London

Price: $63.396
Time and Time Again, 1998
Video, clock, sound, speaker,
dimensions variable
Date sold: 14-Oct-06
Auction house:
Phillips de Pury & Company,
New York

Price: $61.417
Oświęcim, March, 1997
2-channel, 8mm films, b/w,
parallel films transferred to
video, with Arvo Pärt's Litany:
Trisagion, 8 min
Date sold: 06-Feb-07

Auction house:
Phillips de Pury & Company,
London

Price: $29.875
Diary, 2000
Steel, aluminium, vinyl, glass,
electro mechanics,
28.3 x 77.5 x 29.9 cm
Date sold: 16-May-02
Auction house: Sotheby's,
New York

Price: $20.400
Alfred, 1999
Cast aluminium, paint,
114.5 x 22.3 x 1.2 cm
Date sold: 13-Nov-03
Auction house: Sotheby's,
New York

PAWEŁ ALTHAMER

REPRESENTATION →
neugerriemschneider
Linienstraße 155
D – 10115 Berlin
Tel: +49 (0)30 28 87 72 77
www.neugerriemschneider.com

Fundacja Galerii Foksal
Górskiego 1A
PL – 00-033 Warszawa
Tel: +48 (0)22 826 50 81
www.fgf.com.pl

PRIMARY MARKET PRICES →
$4.500–$270.000

DAVID ALTMEJD

REPRESENTATION →
Andrea Rosen Gallery
525 West 24th Street
US – New York, NY 10011
Tel: +1 212 627 60 00
www.andrearosengallery.com

Xavier Hufkens
Rue Saint-Georges 6–8
B – 1050 Bruxelles
Tel: +32 (0)2 639 67 30
www.xavierhufkens.com

PRIMARY MARKET PRICES →
Upon request

HOPE ATHERTON

REPRESENTATION →
Bortolami
510 West 25th Street
US – New York,
NY 10001
Tel: +1 212 727 20 50
www.bortolamigallery.com

PRIMARY MARKET PRICES →
$10.000–$30.000 (paintings)

AUCTION SALES →
Price: $6.600
Virgin, 2003
Charcoal, ink, acrylic,
102.9 x 153.7 cm
Date sold: 12-May-06
Auction house:
Phillips de Pury & Company,
New York

Hope Atherton, Virgin, 2003

Price: $3.600
Calling My Children Home, 2001
Wood, rock putty, epoxy clay,
animal skin, wool, hair, moss,
chain, 180.3 x 58.4 x 19.1 cm
Date sold: 12-Sep-06
Auction house:
Phillips de Pury & Company,
New York

Price: $2.880
Ash Bird, 2006
Ink, acrylic, charcoal,
41.9 x 31.8 cm
Date sold: 27-Feb-07

Auction house:
Phillips de Pury & Company,
New York

Price: $2.640
The Egg Harvester, 2003
Wood, vine, chicken feathers,
felt, hot glue, chain,
58.4 x 96.5 x 61 cm
Date sold: 27-Feb-07
Auction house:
Phillips de Pury & Company,
New York

Price: $1.020
Untitled (Two Unicorns from
Tree), 2001
Pastel, watercolour, 76.2 x 57.2 cm
Date sold: 17-Nov-07
Auction house: Rago Auctions,
Lambertville

Banksy, Keep It Spotless, 2007

BANKSY

REPRESENTATION →
Pest Control
info@pestcontroloffice.com

Lazarides
8 Greek Street
GB – London W1D 4DG
Tel: +44 (0)20 32 14 00 55
www.lazinc.com

PRIMARY MARKET PRICES →
Upon request

AUCTION SALES →
Price: $1.870.000
Keep It Spotless, 2007
Household gloss, spray paint on
canvas, 214 x 305 cm
Date sold: 14-Feb-08
Auction house: Sotheby's,
New York

Price: $1.260.396
Simple Intelligence Testing, 2000
Oil on canvas laid on board,
in 5 parts, 91.5 x 91.5 cm
Date sold: 28-Feb-08
Auction house:
Sotheby's, London

Price: $660.327
The Rude Lord, 2006
Oil on canvas, 88.6 x 76.8 cm
Date sold: 12-Oct-07
Auction house:
Sotheby's, London

Price: $605.000
Vandalised Phone Box, 2005
Telephone box, pickaxe
Date sold: 14-Feb-08
Auction house: Sotheby's,
New York

Price: $576.461
Space Girl and Bird
Spray paint on steel, 133 x 54 cm
Date sold: 25-Apr-07
Auction house: Bonhams,
London

MATTHEW BARNEY

REPRESENTATION →
Barbara Gladstone Gallery
515 West 24th Street
US – New York, NY 10011
Tel: +1 212 206 93 00
www.gladstonegallery.com

Regen Projects
633 North Almont Drive
US – Los Angeles, CA 90069
Tel: +1 310 276 54 24
www.regenprojects.com

Sadie Coles HQ
35 Heddon Street
GB – London W1B 4BP
Tel: +44 (0)20 74 34 22 27
www.sadiecoles.com

PRIMARY MARKET PRICES →
Upon request

AUCTION SALES →
Price: $571.000
Cremaster 2, 1999
Silkscreen, digital video disc,
nylon, tooled saddle leather,
sterling silver, polycarbonate,
honeycomb, beeswax, acrylic,
nutmeg, 97.2 x 119.4 x 102.2 cm
Date sold: 14-Nov-07
Auction house: Sotheby's,
New York

Price: $457.000
Cremaster Suite, 1994–2002
C-prints, 5 parts, 111.8 x 86.4 cm
Date sold: 14-May-08
Auction house: Sotheby's,
New York

Matthew Barney, Cremaster 2, 1999

Price: $400.000
Cremaster 5: A Dance for the
Queen's Menagerie, 1997
C-prints, 7 parts, 137.2 x 110.5 cm
Date sold: 09-Nov-04
Auction house: Sotheby's,
New York

Price: $387.500
Cremaster 4, 1994/95
Multiple with plastic, satin, tartan,
laser disc, Plexiglas,
120 x 120 x 90 cm
Date sold: 19-May-99
Auction house: Christie's,
New York

Price: $348.000
Cremaster 5: Her Giant, 1997
C-print, 96.8 x 69.2 cm
Date sold: 17-May-07
Auction house: Christie's,
New York

TIM BERRESHEIM

REPRESENTATION →
Galerie Hammelehle und Ahrens
An der Schanz 1a
D – 50735 Köln
Tel: +49 (0)221 287 08 00
www.haah.de

Patrick Painter Inc.
2525 Michigan Avenue
US – Santa Monica, CA 90404
Tel: +1 310 264 59 88
www.patrickpainter.com

Marc Jancou Contemporary
Great Jones Alley
US – New York, NY 10012
Tel: +1 212 473 21 00
www.marcjancou.com

PRIMARY MARKET PRICES →
$7.000–$52.000

COSIMA VON BONIN

REPRESENTATION →
Friedrich Petzel Gallery
535 West 22nd Street
US – New York, NY 10011
Tel: +1 212 680 94 67
www.petzel.com

Galerie Daniel Buchholz
Neven-DuMont-Straße 17
D – 50667 Köln
Tel: +49 (0)221 257 49 46
www.galeriebuchholz.de

PRIMARY MARKET PRICES →
Upon request

AUCTION SALES →
Price: $33.000
Men Suddenly in Black, 2003

Felt, cotton, printed fabric, loden,
cowhide, 360.7 x 392.4 cm
Date sold: 26-Feb-07
Auction house: Sotheby's,
New York

Price: $5.400
Untitled
Steel, stone, wood, photograph,
50.5 x 60 x 19.4 cm
Date sold: 13-Dec-04
Auction house: Phillips de Pury &
Company, New York

Price: $4.560
Gouvenor, 2002
C-print, 130.8 x 156.2 cm
Date sold: 14-Mar-06
Auction house: Phillips de Pury &
Company, New York

MONICA BONVICINI

REPRESENTATION →
Galleria Emi Fontana
Viale Bligny, 42
I – 20136 Milano
Tel: +39 02 58 32 22 37
www.galleriaemifontana.com

West of Rome
380 South Lake Avenue, Suite 210
US – Pasadena, CA 91101
Tel: +1 626 793 15 04
www.westofromeinc.com

Metro Pictures
519 West 24th Street
US – New York, NY 10011
Tel: +1 212 206 71 00
www.metropicturesgallery.com

PRIMARY MARKET PRICES →
$10.000–$65.000 (drawings and
collages)
$15.000–$250.000 (sculptures
and installations)

CECILY BROWN

REPRESENTATION →
Contemporary Fine Arts
Am Kupfergraben 10
D – 10117 Berlin
Tel: +49 (0)30 288 78 70
www.cfa-berlin.com

Gagosian Gallery
555 West 24th Street
US – New York, NY 10011
Tel: +1 212 741 11 11
www.gagosian.com

PRIMARY MARKET PRICES →
Upon request

AUCTION SALES →
Price: $1.608.000
The Pyjama Game, 1997/98

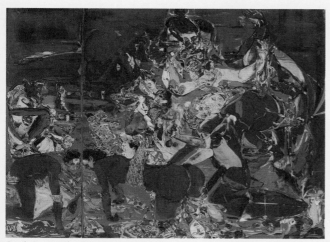

Cecily Brown, The Pyjama Game, 1997/98

Oil on canvas, 183 x 249 cm
Date sold: 16-May-07
Auction house: Christie's,
New York

Price: $1.260.396
Teenage Wildlife, 2003
Oil on canvas, 203.2 x 228.6 cm
Date sold: 28-Feb-08
Auction house: Phillips de Pury &
Company, London

Price: $1.105.000
The Girl Who Had Everything, 1998
Oil on canvas, 252.7 x 279.4 cm
Date sold: 15-Nov-07
Auction house: Phillips de Pury &
Company, New York

Price: $1.104.000
Guys and Dolls, 1997/98
Oil on canvas, 193 x 249 cm
Date sold: 15-May-07
Auction house: Sotheby's,
New York

Price: $992.000
Black Painting No. 6, 2003
Oil on canvas, 121.9 x 127 cm
Date sold: 17-May-07
Auction house:
Phillips de Pury & Company,
New York

GLENN BROWN

REPRESENTATION →
Gagosian Gallery
555 West 24th Street
US – New York, NY 10011
Tel: +1 212 741 11 11
www.gagosian.com

Galerie Max Hetzler
Zimmerstraße 90/91
D – 10117 Berlin
Tel: +49 (0)30 229 24 37
www.maxhetzler.com

Patrick Painter Inc.
2525 Michigan Avenue
US – Santa Monica,
CA 90404
Tel: +1 310 264 59 88
www.patrickpainter.com

PRIMARY MARKET PRICES →
Upon request

AUCTION SALES →
Price: $969.169
The Rebel, 2001
Oil on panel, 84.5 x 70 cm
Date sold: 21-Jun-07
Auction house:
Sotheby's, London

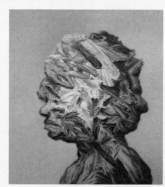

Glenn Brown, The Rebel, 2001

Price: $734.400
The Marquess of Breadlabane,
2000
Oil on panel, 96.5 x 78.7 cm
Date sold: 15-May-07
Auction house: Sotheby's,
New York

Price: $688.000
Bertrand Russell at the BBC, 1999
Oil on panel, 71.7 x 63.5 cm
Date sold: 14-Nov-06
Auction house: Sotheby's,
New York

Price: $656.000
I Do Not Feel Embarrassed at
Attempting to Express Sadness
and Loneliness, 2001
Oil on panel, 61 x 47 cm
Date sold: 17-May-07
Auction house: Phillips de Pury &
Company, New York

Price: $577.000
The Living Dead, 1995
Oil on panel, 54 x 46.4 cm
Date sold: 14-Nov-07
Auction house: Sotheby's,
New York

ANDRÉ BUTZER

REPRESENTATION →
Galerie Guido W. Baudach
Oudenarder Straße 16–20
D – 13347 Berlin
Tel: +49 (0)30 28 04 77 27
www.guidowbaudach.com

Galerie Max Hetzler
Zimmerstraße 90/91
D – 10117 Berlin
Tel: +49 (0)30 229 24 37
www.maxhetzler.com

Metro Pictures
519 West 24th Street
US – New York, NY 10011
Tel: +1 212 206 71 00
www.metropictures.com

Patrick Painter Inc.
2525 Michigan Avenue
US – Santa Monica, CA 90404
Tel: +1 310 264 59 88
www.patrickpainter.com

Gary Tatintsian Gallery
Iljinka Street 3/8 bld. 5
RUS – 109012 Moscow
Tel: +7 495 921 21 02
www.tatintsian.com

PRIMARY MARKET PRICES →
$7.200–$108.000

CAI GUO-QIANG

REPRESENTATION →
Cai Studio
40 East First Street #1B
US – New York, NY 10003
Tel: +212 995 09 08
www.caiguoqiang.com

PRIMARY MARKET PRICES →
Upon request

AUCTION SALES →
Price: $9.538.966
Set of 14 Drawings for Asia-Pacific
Economic Cooperation, 2002
Gunpowder on paper,
various dimensions
Date sold: 25-Nov-07
Auction house: Christie's,
Hong Kong

Price: $2.640.856
Project for Extraterrestrials No. 10:
Project to Extend the Great Wall
of China by 10,000 Metres, 2000
Gunpowder on paper,
300 x 2000 cm
Date sold: 07-Oct-07
Auction house: Sotheby's,
Hong Kong

Price: $1.273.000
Man, Eagle and Eye in the Sky:
Eyes, 2004
Gunpowder on paper, panel,
230 x 465 cm
Date sold: 20-Sep-07
Auction house: Sotheby's,
New York

Cai Guo-Qiang, Set of 14 Drawings for
Asia-Pacific Economic Cooperation
(No. 11), 2002

Price: $977.024
Two Tigers Turning Heads, 2005
Gunpowder on paper,
200 x 300 cm
Date sold: 09-Apr-08
Auction house: Sotheby's,
Hong Kong

Price: $895.876
Man, Eagle and Eye in the Sky:
Eagles Watching Man-Kite, 2004
Gunpowder on paper, mounted
on wood as 6-panel screen,
230 x 465 cm
Date sold: 28-May-06
Auction house: Christie's,
Hong Kong

MAURIZIO CATTELAN

REPRESENTATION →
Galleria Massimo De Carlo
Via Giovanni Ventura, 5

I – 20134 Milano
Tel: +39 02 70 00 39 87
www.massimodecarlo.it

Marian Goodman Gallery
24 West 57th Street
US – New York, NY 10019
Tel: +1 212 977 71 60
www.mariangoodman.com

Galerie Emmanuel Perrotin
76, rue de Turenne
F – 75003 Paris
Tel: +33 (0)1 42 16 79 79
www.galerieperrotin.com

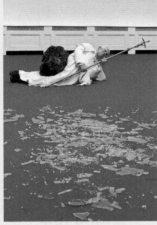

Maurizio Cattelan, La Nona Ora, 1999

PRIMARY MARKET PRICES →
$1.000.000–$2.000.000

AUCTION SALES →
Price: $3.032.000
La Nona Ora, 1999
Wax, clothing, polyester
resin, metallic powder,
volcanic rock, carpet, glass,
dimensions variable
Date sold: 11-Nov-04
Auction house:
Phillips de Pury & Company,
New York

Price: $2.751.500
Not Afraid of Love, 2000
Polyester styrene, resin, paint,
fabric, 205.7 x 312.4 x 137.2 cm
Date sold: 10-Nov-04
Auction house: Christie's,
New York

Price: $2.080.000
The Ballad of Trotsky, 1996
Mixed media sculpture,
taxidermic horse, leather
saddlery, rope, pulley,
75 x 270 x 200 cm
Date sold: 12-May-04
Auction house: Sotheby's,
New York

Price: $2.023.500
Untitled, 2001
Painted wax, hair, fabric,
60 x 40 cm
Date sold: 10-Nov-04
Auction house: Christie's,
New York

Price: $1.261.595
Charlie Don't Surf, 1997
School desk, chair, mannequin,
clothing, pencils, 112 x 71 x 70 cm
Date sold: 10-Feb-05
Auction house: Sotheby's,
London

MAT COLLISHAW

REPRESENTATION →
Cosmic Galerie
7–9, rue de l'Équerre
F – 75019 Paris
Tel: +33 (0)1 42 71 72 73
www.cosmicgalerie.com

Tanya Bonakdar Gallery
521 West 21st Street
US – New York, NY 10011
Tel: +1 212 414 41 44
www.tanyabonakdargallery.com

Analix Forever
Rue de l'Arquebuse 25
CH – 1204 Genève
Tel: +41 (0)22 329 17 09
www.analix-forever.com

Haunch of Venison
6 Haunch of Venison Yard
GB – London W1K 5ES
Tel: +44 (0)20 74 95 50 50
www.haunchofvenison.com

PRIMARY MARKET PRICES →
$2.700 (daguerreotypes)–
$240.000 (installations)

AUCTION SALES →
Price: $11.697
Little Miss Chief by the Pool, 2003
Colour photographic print in
gilded wood frame, 25.5 x 20.5 cm
Date sold: 08-Apr-08
Auction house: Sotheby's, Milan

Price: $8.921
Paco, 1997
Colour photographic print
mounted on aluminium,
200 x 149 cm
Date sold: 22-May-07
Auction house: Sotheby's, Milan

Price: $8.596
Catching Fairies, 1995
Handcoloured photograph,
19 x 27.3 cm
Date sold: 08-Dec-99
Auction house: Christie's,
London

Price: $8.409
John Luca & Paco, 1997
Colour photograph in lightbox,
61 x 55 x 9 cm
Date sold: 08-Dec-99
Auction house: Christie's,
London

Price: $7.433
Self Portrait, 1997
Colour photograph in lightbox,
49 x 41 x 7.5 cm
Date sold: 22-Oct-02
Auction house: Sotheby's,
London

GEORGE CONDO

REPRESENTATION →
Luhring Augustine
531 West 24th Street
US – New York, NY 10011
Tel: +1 212 206 91 00
www.luhringaugustine.com

Galerie Andrea Caratsch
Waldmannstrasse 8
CH – 8001 Zürich
Tel: +41 (0)44 272 50 00
www.galeriecaratsch.com

Simon Lee
12 Berkeley Street
GB – London W1J 8DT
Tel: +44 (0)20 74 91 01 00
www.simonleegallery.com

PRIMARY MARKET PRICES →
Upon request

AUCTION SALES →
Price: $1.049.000
Tumbling Heads, 2006
Oil on canvas,
203.5 x 165.7 cm
Date sold: 15-May-08
Auction house:
Phillips de Pury & Company,
New York

Price: $713.000
The Birdman, 1995

George Condo, Tumbling Heads, 2006

Oil on canvas, 182.8 x 193 cm
Date sold: 15-Nov-07
Auction house: Sotheby's,
New York

Price: $565.439
Visions of Mexico, 1995
Oil on canvas,
198 x 305 cm
Date sold: 12-Oct-07
Auction house: Sotheby's,
London

Price: $465.471
The Insane Psychiatrist, 2002
Oil, varnish on canvas,
152.3 x 121.8 cm
Date sold: 14-Oct-07
Auction house: Christie's,
London

Price: $442.740
Internal Constellation, 2001
Acrylic, pencil, graphite on
canvas, 275.9 x 275.9 cm
Date sold: 12-Oct-07
Auction house: Sotheby's,
London

MARTIN CREED

REPRESENTATION →
Gavin Brown's enterprise
620 Greenwich Street
US – New York, NY 10014
Tel: +1 212 627 52 58
www.gavinbrown.biz

Hauser & Wirth
Limmatstrasse 270
CH – 8005 Zürich
Tel: +41 (0)44 446 80 50
www.hauserwirth.com

Johnen + Schöttle
Maria-Hilf-Straße 17
D – 50677 Köln
Tel: +49 (0)221 31 02 70
www.johnen-schoettle.de

PRIMARY MARKET PRICES →
Upon request

AUCTION SALES →
Price: $90.000
Work No. 200: Half the Air
in a Given Space, 1998
Balloons, 30 cm each,
dimensions variable
Dates sold: 26-Feb-07
Auction house: Christie's,
New York

Price: $78.000
Work No. 275: Small Things,
2001
Neon lights, 170 x 1870 cm
Date sold: 26-Feb-07
Auction house: Christie's,
New York

Price: \$51.070
Thirty-Nine Metronomes
Beating Time, One at Each
Speed, 1995
Yamaha metronomes, 39 parts,
dimensions variable
Date sold: 26-Jun-08
Auction house: Bloomsbury
Auctions, London

Price: \$39.400
Work No. 221: Things, 2002
Neon light, 15.2 x 76.2 x 2.5 cm
Date sold: 16-Nov-07
Auction house: Phillips de Pury &
Company, New York

Price: \$39.000
30 Seconds On, 30 Seconds Off,
1996
Lights, timer, dimensions variable
Date sold: 18-Nov-06
Auction house: Rago Auctions,
Lambertville

JOHN CURRIN

REPRESENTATION →
Gagosian Gallery
555 West 24th Street
US – New York, NY 10011
Tel: +1 212 741 11 11
www.gagosian.com

Regen Projects
633 North Almont Drive
US – Los Angeles, CA 90069
Tel: +1 310 276 54 24
www.regenprojects.com

Sadie Coles HQ
35 Heddon Street
GB – London W1B 4BP
Tel: +44 (0)20 74 34 22 27
www.sadiecoles.com

PRIMARY MARKET PRICES →
Upon request

AUCTION SALES →
Price: \$847.500
Homemade Pasta, 1999
Oil on canvas, 127 x 106.7 cm
Date sold: 10-Nov-04
Auction house: Christie's,
New York

Price: \$601.000
Couple in Bed, 1993
Oil on canvas, 101.6 x 81.9 cm
Date sold: 15-May-08
Auction sold: Phillips de Pury &
Company, New York

Price: \$486.400
The Kennedy's, 1996
Oil on canvas, 91.4 x 81.2 cm
Date sold: 12-May-05
Auction house: Phillips de Pury &
Company, New York

John Currin, Homemade Pasta, 1999

Price: \$444.800
Standing Nude, 1993
Oil on canvas, 122 x 91 cm
Date sold: 11-Nov-04
Auction house:
Phillips de Pury & Company,
New York

Price: \$433.600
The Optimist, 1996
Oil on canvas,
81.3 x 66 cm
Date sold: 12-May-04
Auction house: Sotheby's,
New York

AARON CURRY

REPRESENTATION →
Galerie Daniel Buchholz
Neven-DuMont-Straße 17
D – 50667 Köln
Tel: +49 (0)221 257 49 46
www.galeriebuchholz.de

David Kordansky Gallery
510 Bernard Street
US – Los Angeles,
CA 90012
Tel: +1 323 222 14 82
www.davidkordanskygallery.com

Michael Werner Gallery
4 East 77th Street
US – New York, NY 10075
Tel: +1 212 988 16 23
www.michaelwerner.com

PRIMARY MARKET PRICES →
Upon request

ENRICO DAVID

REPRESENTATION →
Galerie Daniel Buchholz
Neven-DuMont-Straße 17
D – 50667 Köln
Tel: +49 (0)221 257 49 46
www.galeriebuchholz.de

Cabinet
20A Northburgh Street

GB – London EC1V 0EA
Tel: +44 (0)207 253 53 77

PRIMARY MARKET PRICES →
Upon request

TACITA DEAN

REPRESENTATION →
Frith Street Gallery
17–18 Golden Square
GB – London W1F 9JJ
Tel: +44 (0)20 74 94 15 50
www.frithstreetgallery.com

Marian Goodman Gallery
24 West 57th Street
US – New York, NY 10019
Tel: +1 212 977 71 60
www.mariangoodman.com

PRIMARY MARKET PRICES →
\$9.000–\$180.000

THOMAS DEMAND

REPRESENTATION →
303 Gallery
525 West 22nd Street
US – New York, NY 10011
Tel: +1 212 255 11 21
www.303gallery.com

Taka Ishii Gallery
1-3-2 5F, Kiyosumi Koto-ku
JP – Tokyo 135-0024
Tel: +81 (0)3 56 46 60 50
www.takaishiigallery.com

Regen Projects
633 North Almont Drive
US – Los Angeles, CA 90069
Tel: +1 310 276 54 24
www.regenprojects.com

Esther Schipper
Linienstraße 85
D – 10119 Berlin
Tel: +49 (0)30 28 39 01 39
www.estherschipper.com

Monika Sprüth
Philomene Magers
Wormser Straße 23
D – 50677 Köln
Tel: +49 (0)221 38 04 15
www.spruethmagers.com

PRIMARY MARKET PRICES →
Upon request

AUCTION SALES →
Price: \$298.198
Raum, 1994
C-print mounted on Diasec,
183 x 270 cm
Date sold: 30-May-08
Auction house:
Villa Grisebach, Berlin

Price: \$262.400
Collection, 2002
C-print mounted on Plexiglas,
149.8 x 200 cm
Date sold: 05-May-06
Auction house: Christie's,
New York

Price: \$218.107
Ghost, 2003
C-print mounted on Diasec,
121.9 x 160 cm
Date sold: 29-Jun-08
Auction house:
Phillips de Pury & Company,
London

Price: \$204.000
Collection, 2002
C-print mounted on Plexiglas,
149.8 x 200 cm
Date sold: 26-Feb-07
Auction house: Christie's,
New York

Price: \$200.787
Zeichensaal, 1996
C-print mounted on Diasec,
183 x 285 cm
Date sold: 08-Feb-07
Auction house: Christie's,
London

RINEKE DIJKSTRA

REPRESENTATION →
Marian Goodman Gallery
24 West 57th Street
US – New York, NY 10019
Tel: +1 212 977 71 60
www.mariangoodman.com

Galerie Max Hetzler
Zimmerstraße 90/91
D – 10117 Berlin
Tel: +49 (0)30 229 24 37
www.maxhetzler.com

Sommer Contemporary Art
13, Rothschild Boulevard
IL – Tel Aviv 66881
Tel: +972 (0)3 516 64 00
www.sommercontemporaryart.com

PRIMARY MARKET PRICES →
Upon request

AUCTION SALES →
Price: \$405.500
Hilton Head Island, S.C.,
USA, June 24, 1992, 1992–96
C-prints, set of 6,
190 x 156 cm
Date sold: 14-May-02
Auction house: Christie's,
New York

Price: \$185.500
Odessa, Ukraine, August 4, 1993
C-print, 124.5 x 104.1 cm

Date sold: 13-Nov-03
Auction house:
Phillips de Pury & Luxembourg,
New York

Price: $105.000
Julie, Den Haag, Netherlands,
February 29, 1994
C-print, set of 3, 154 x 130 cm
Date sold: 15-Nov-01
Auction house: Christie's,
New York

Price: $102.800
Selfportrait, Marnixbad,
Amsterdam, 1991
C-print, 152.4 x 129 cm
Date sold: 17-Nov-00
Auction house: Christie's,
New York

Price: $95.600
Selfportrait, Marnixbad,
Amsterdam, 1991
C-print, 152.4 x 129 cm
Date sold: 11-Nov-02
Auction house:
Phillips de Pury & Luxembourg,
New York

NATHALIE DJURBERG

REPRESENTATION →
Giò Marconi
Via Tadino, 15
I – 20124 Milano
Tel: +39 02 29 40 43 73
www.giomarconi.com

Zach Feuer Gallery
530 West 24th Street
US – New York, NY 10011
Tel: +1 212 989 77 00
www.zachfeuer.com

PRIMARY MARKET PRICES →
$20.300

PETER DOIG

REPRESENTATION →
Gavin Brown's enterprise
620 Greenwich Street
US – New York,
NY 10014
Tel: +1 212 627 52 58
www.gavinbrown.biz

Contemporary Fine Arts
Am Kupfergraben 10
D – 10117 Berlin
Tel: +49 (0)30 288 78 70
www.cfa-berlin.com

Victoria Miro Gallery
16 Wharf Road
GB – London N1 7RW
Tel: +44 (0)20 73 36 81 09
www.victoria-miro.com

Peter Doig, White Canoe, 1990/91

Michael Werner Gallery
4 East 77th Street
US – New York, NY 10075
Tel: +1 212 988 16 23
www.michaelwerner.com

PRIMARY MARKET PRICES →
Upon request

AUCTION SALES →
Price: $11.283.464
White Canoe, 1990/91
Oil on canvas, 200 x 241 cm
Date sold: 07-Feb-07
Auction house:
Sotheby's London

Price: $3.624.000
The Architect's Home in the
Ravine, 1991
Oil on canvas, 200 x 275 cm
Date sold: 15-May-07
Auction house: Sotheby's,
New York

Price: $3.581.027
Orange Sunshine, 1995/96
Oil on canvas,
274.3 x 200 cm
Date sold: 21-Jun-07
Auction house:
Sotheby's, London

Price: $2.729.000
Untitled (Silver Pond
Painting), 2001
Oil on canvas, 185.7 x 198.8 cm
Date sold: 14-Nov-07
Auction house: Sotheby's,
New York

Price: $2.650.029
White Creep, 1995/96
Oil on canvas, 290 x 200 cm
Date sold: 27-Feb-08
Auction house:
Sotheby's, London

MARLENE DUMAS

REPRESENTATION →
Galerie Paul Andriesse
Gebouw Detroit,
Withoedenveem 8
NL – 1019 HE Amsterdam
Tel: +31 (0)20 623 62 37
www.galeries.nl/andriesse

Frith Street Gallery
17–18 Golden Square
GB – London W1F 9JJ
Tel: +44 (0)20 74 94 15 50
www.frithstreetgallery.com

Gallery Koyanagi
1-7-5 Ginza Chuo-ku
JP – Tokyo 104-0061
Tel: +81 (0)3 35 61 18 96
www.gallerykoyanagi.com

Zeno X Gallery
Leopold De Waelplaats 16
B – 2000 Antwerpen
Tel: +32 (0)3 216 16 26
www.zeno-x.com

David Zwirner
525 West 19th Street
US – New York, NY 10011
Tel: +1 212 727 20 70
www.davidzwirner.com

PRIMARY MARKET PRICES →
$280.000 (oil on canvas
50 x 50 cm)

AUCTION SALES →
Price: $6.343.082
The Visitor, 1995
Oil on canvas, 180 x 300 cm
Date sold: 01-Jul-08
Auction house: Sotheby's, London

Price: $3.339.517
The Teacher (Sub A), 1987

Oil on canvas, 160 x 200 cm
Date sold: 09-Feb-05
Auction house: Christie's, London

Price: $1.920.000
Die Baba (The Baby), 1985
Oil on canvas, 130 x 110.3 cm
Date sold: 15-Nov-06
Auction house: Christie's,
New York

Price: $1.898.814
The Dance, 1992
Oil on canvas, 90 x 180.8 cm
Date sold: 20-Jun-07
Auction house: Christie's, London

Price: $1.608.000
In the Beginning, 1991
Oil on canvas, 145 x 200 cm
Date sold: 15-May-07
Auction house: Sotheby's,
New York

MARCEL DZAMA

REPRESENTATION →
David Zwirner
525 West 19th Street
US – New York, NY 10011
Tel: +1 212 727 20 70
www.davidzwirner.com

PRIMARY MARKET PRICES →
$4.000 – $150.000

AUCTION SALES →
Price: $43.988
After the Flood, Before the Fire,
2005
Watercolour, ink, 20 parts,
151.1 x 149.2 cm
Date sold: 03-Apr-08
Auction house: Phillips de Pury &
Company, London

Price: $37.685
Heroes and Villains, 2004
Acrylic and paper collage on
canvas, 2 parts, 61.6 x 94.5 cm
Date sold: 15-Oct-07
Auction house: Sotheby's, London

Price: $36.000
Untitled, 1997-2001
Pen, ink, watercolour, set of 22,
31.1 x 25.1 cm
Date sold: 11-Nov-05
Auction house:
Phillips de Pury & Company,
New York

Price: $25.882
No More Waiting to Get Older,
2003
Oil, varnish, paper collage on
board,
30.7 x 32.4 cm
Date sold: 09-Feb-07
Auction house: Christie's, London

Marcel Dzama, After the Flood, Before the Fire, 2005

Price: $26.394
Beck Video, 2006
Ink, watercolour, paper, 10 works,
35.6 x 27.9 cm
Date sold: 06-Sep-08
Auction house:
Phillips de Pury & Company,
London

MARTIN EDER

REPRESENTATION →
Galerie EIGEN + ART
Auguststraße 26
D – 10117 Berlin
Tel: +49 (0)30 280 66 05
www.eigen-art.com

PRIMARY MARKET PRICES →
$60.000–$140.000

AUCTION SALES →
Price: $520.000
Bonjour Tristesse, 2003
Oil on canvas mounted on panel,
169.5 x 150 cm
Date sold: 14-Nov-06
Auction house: Sotheby's,
New York

Price: $198.000
From a New World towards the
Next, 2004
Oil on canvas, 209 x 155 cm
Date sold: 13-Sep-06
Auction house: Christie's,
New York

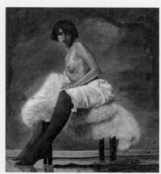

Martin Eder, Bonjour Tristesse, 2003

Price: $192.000
Gedanken beim Verlassen
meines Kopfes, 2004
Oil on canvas, 198.1 x 238.8 cm
Date sold: 16-Nov-06
Auction house: Christie's,
New York

Price: $181.132
Das Klopfen auf Holz, 2004
Oil on canvas, 180 x 240 cm
Date sold: 15-Oct-06
Auction house: Christie's,
London

Price: $180.000
Mascara (Dream Endlessly), 2004
Oil on canvas, 200 x 150 cm
Date sold: 11-May-06
Auction house: Sotheby's,
New York

OLAFUR ELIASSON

REPRESENTATION →
neugerriemschneider
Linienstraße 155
D – 10115 Berlin
Tel: +49 (0)30 28 87 72 77
www.neugerriemschneider.com

Tanya Bonakdar Gallery
521 West 21st Street
US – New York, NY 10011
Tel: +1 212 414 41 44
www.tanyabonakdargallery.com

PRIMARY MARKET PRICES →
$10.900–$1.250.000

AUCTION SALES →
Price: $1.524.750
Fivefold Eye, 2000
Highgrade steel, mirror,
157.5 x 157.5 x 74.9 cm
Date sold: 14-Oct-07
Auction house: Christie's, London

Price: $334.728
The Fault Series, 2001
C-prints, set of 32, mounted on
foamcore, each 60.9 x 40.6 cm,
overall 243.8 x 325.1 cm
Date sold: 22-Jun-07
Auction house: Phillips de Pury &
Company, London

Price: $268.679
The Glacier Series, 1999
C-prints, set of 42,
each 34 x 50 cm, overall
244 x 404 cm
Date sold: 31-Oct-06
Auction house: Christie's,
London

Price: $240.000
River Raft, 2000
C-prints mounted on board,
set of 42, each 30.5 x 40 cm,

overall 209.5 x 320 cm
Date sold: 05-May-06
Auction house: Christie's,
New York

Price: $228.000
The Cave Series, Looking In, 1998
C-prints, set of 49, mounted on
board, each 24.1 x 36.1 cm, overall
219 x 306 cm
Date sold: 16-Nov-06
Auction house: Christie's,
New York

ELMGREEN & DRAGSET

REPRESENTATION →
Galleria Massimo De Carlo
Via Giovanni Ventura, 5
I – 20134 Milano
Tel: +39 02 70 00 39 87
www.massimodecarlo.it

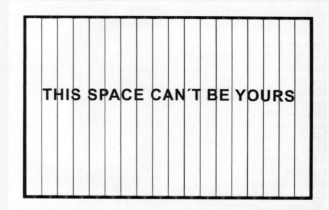

Elmgreen & Dragset, This Space Can't Be Yours, 2006

Victoria Miro Gallery
16 Wharf Road
GB – London N1 7RW
Tel: +44 (0)20 73 36 81 09
www.victoria-miro.com

Galerie Emmanuel Perrotin
76, rue de Turenne
F – 75003 Paris
Tel: +33 (0)1 42 16 79 79
www.galerieperrotin.com

Galleri Nicolai Wallner
Njalsgade 21
DK – 2300 Copenhagen
Tel: +45 32 57 09 70
www.nicolaiwallner.com

PRIMARY MARKET PRICES →
$29.000–$290.000

AUCTION SALES →
Price: $110.301
This Space Can't Be Yours, 2006
Tri-vision billboard with electrical
wiring, 144 x 209 x 10 cm

Date sold: 29-Jun-08
Auction house:
Phillips de Pury & Company,
London

Price: $89.763
Go Go Go, 2005
Aluminium, Plexiglas, light bulbs,
bucket, mop, plastic sign, gloves,
488 x 178 x 178 cm
Date sold: 06-Feb-07
Auction house: Phillips de Pury &
Company, London

Price: $61.000
Powerless Structures, Fig. 122,
2000
Wood, paint, steel chain, door
handles, hinges,
217.2 x 104.1 x 10.2 cm
Date sold: 31-Mar-08
Auction house: Phillips de Pury &
Company, New York

Price: $21.250
Powerless Structures, Fig. 132,
2001
Acrylic on wood panel, metal
door handle, hinges, envelope,
paper sheets,
224.9 x 104.7 x 23.4 cm
Date sold: 10-Sep-07
Auction house: Christie's,
New York

Price: $13.200
Powerless Structures,
Fig. 170 – Paint buckets, 2001
Aluminium, polyester,
609.6 x 88.9 x 88.9 cm
Date sold: 18-Nov-06
Auction house: Rago Auctions,
Lambertville

TRACEY EMIN

REPRESENTATION →
Gagosian Gallery
555 West 24th Street

US – New York, NY 10011
Tel: +1 212 741 11 11
www.gagosian.com

Lehmann Maupin Gallery
540 West 26th Street
US – New York, NY 10001
Tel: +1 212 255 29 23
www.lehmannmaupin.com

White Cube
48 Hoxton Square
GB – London N1 6PB
Tel: +44 (0)20 79 30 53 73
www.whitecube.com

PRIMARY MARKET PRICES →
Upon request

AUCTION SALES →
Price: $220.000
I Promise to Love You, 2007
Clear red neon, 145.8 x 143 cm
Date sold: 14-Feb-08
Auction house: Sotheby's,
New York

Price: $157.936
Exorcism of the Last Painting I
Ever Made, 1996
14 paintings, 78 drawings,
5 body prints, other items,
dimensions variable
Date sold: 08-Feb-01
Auction house:
Christie's, London

Price: $152.727
My Coffin, 1996/97
Casket, mattress, ink on paper,
4 sheets, 42 x 183 x 59 cm
Date sold: 23-Jun-04 w
Auction house: Sotheby's, London

Price: $147.687
My Heart Is with You, 2006
Pink neon, 34.9 x 159.9 cm
Date sold: 16-Oct-07
Auction house: Christie's, London

Price: $118.577
Keep Me Safe, 2006
Clear red neon, 32.2 x 89.5 cm
Date sold: 21-Jun-07
Auction house: Sotheby's, London

URS FISCHER

REPRESENTATION →
Gavin Brown's enterprise
620 Greenwich Street
US – New York, NY 10014
Tel: +1 212 6 27 52 58
www.gavinbrown.biz

Galleria Massimo De Carlo
Via Giovanni Ventura, 5
I – 20134 Milano
Tel: +39 02 70 00 39 87
www.massimodecarlo.it

Sadie Coles HQ
35 Heddon Street
GB – London W1B 4BP
Tel: +44 (0)20 74 34 22 27
www.sadiecoles.com

Galerie Eva Presenhuber
Limmatstrasse 270
CH – 8005 Zürich
Tel: +41 (0)43 444 70 50
www.presenhuber.com

Regen Projects
633 North Almont Drive
US – Los Angeles, CA 90069
Tel: +1 310 276 54 24
www.regenprojects.com

The Modern Institute
73 Robertson Street
GB – Glasgow G2 8QD
Tel: +44 (0)141 24 83 71 12 48
www.themoderninstitute.com

PRIMARY MARKET PRICES →
Upon request

Urs Fischer, Warum wächst ein
Baum – Kann man zuviel fragen, 2001

AUCTION SALES →
Price: $64.783
Warum wächst ein Baum – Kann
man zuviel fragen, 2001
Polyurethane, lacquer, acrylic,
styrofoam, 100 x 93 x 13 cm
Date sold: 01-Jul-08
Auction house: Christie's,
London

Price: $12.000
Sigh, Sigh, Sherlock!, 2004
Fibreglass gypsum, ceramic,
91.4 x 33.7 x 33.7 cm
Date sold: 27-Feb-07
Auction house:
Phillips de Pury & Company,
New York

GÜNTHER FÖRG

REPRESENTATION →
Galerie Gisela Capitain
St.-Apern-Straße 20–26
D – 50667 Köln
Tel: +49 (0)221 35 57 01 00
www.galeriecapitain.de

Galerie Bärbel Grässlin
Schäfergasse 46 B
D – 60313 Frankfurt am Main
Tel: +49 (0)69 29 92 46 70
www.galerie-graesslin.de

Galerie Max Hetzler
Zimmerstraße 90/91
D – 10117 Berlin
Tel: +49 (0)30 229 24 37
www.maxhetzler.com

Galerie Vera Munro
Heilwigstraße 64
D – 20249 Hamburg
Tel: +49 (0)40 47 47 46
www.veramunro.de

PRIMARY MARKET PRICES →
$45.000 – $350.000

AUCTION SALES →
Price: $321.500
Lead Paintings, 1987
Acrylic on panel, 32 parts,
sketch, 61 x 40.6 cm
Date sold: 18-Nov-99
Auction house: Sotheby's,
New York

Price: $124.667
Untitled, 2000
Acrylic on canvas, 490 x 290 cm
Date sold: 28-May-08
Auction house: Dorotheum, Vienna

Price: $124.528
Untitled, 1990
Acrylic on lead on wood,
280 x 160 cm
Date sold: 14-Oct-06
Auction house: Phillips de Pury &
Company, New York

Price: $122.279
Untitled (in 10 parts), 1986
Acrylic on lead on panel,
57.2 x 37.5 cm
Date sold: 01-Jul-08
Auction house: Christie's, London

Price: $97.000
Untitled, 1988
Acrylic on lead on panel,
240 x 160 cm
Date sold: 10-Sep-07
Auction house: Christie's,
New York

WALTON FORD

REPRESENTATION →
Paul Kasmin Gallery
293 Tenth Avenue
US – New York, NY 10001
Tel: +1 212 563 44 74
www.paulkasmingallery.com

PRIMARY MARKET PRICES →
Upon request

AUCTION SALES →
Price: $10.200
Benjamin's Emblem, 2000
Etching, aquatint, 112.5 x 77 cm,
edition number 46 of 50
Date sold: 16-Nov-06
Auction house: Sotheby's,
New York

Price: $2.000
Please Forgive Me, 1986
Oil on board, 86.4 x 91.4 cm
Date sold: 01-Jun-03
Auction house: Wright, Chicago

TOM FRIEDMAN

REPRESENTATION →
Gagosian Gallery
555 West 24th Street
US – New York, NY 10011
Tel: +1 212 741 11 11
www.gagosian.com

PRIMARY MARKET PRICES →
Upon request

AUCTION SALES →
$856.000
Untitled, 2000
Construction paper,
30.5 x 289.6 x 304.8 cm
Date sold: 16-Nov-06
Auction house:
Phillips de Pury & Company,
New York

Price: $505.000
Garbage Can, 2003
Paper, glue, plastic garbage can,
152.4 x 99.1 x 57.2 cm
Date sold: 15-May-08
Auction house:
Phillips de Pury & Company,
New York

Price: $352.000
Untitled, 2001
Clay, wire, fuzz, hair, plastic, paint,
94 parts, dimensions variable
Date sold: 10-May-05
Auction house: Sotheby's,
New York

Price: $318.400
Untitled, 1995
Ink, coloured pencil,
106.7 x 106.7 cm
Date sold: 10-Nov-05
Auction house:
Phillips de Pury & Company,
New York

Price: $310.400
Untitled, 2001
Wooden sticks,
185.4 x 86.4 x 53.3 cm
Date sold: 11-Nov-04
Auction house: Phillips de Pury &
Company, New York

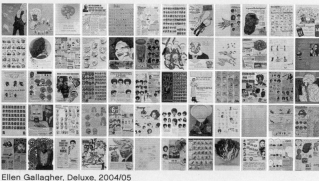

Ellen Gallagher, Deluxe, 2004/05

ELLEN GALLAGHER

REPRESENTATION →
Gagosian Gallery
555 West 24th Street
US – New York, NY 10011
Tel: +1 212 741 11 11
www.gagosian.com

Hauser & Wirth
Limmatstrasse 270
CH – 8005 Zürich
Tel: +41 (0)44 446 80 50
www.hauserwirth.com

PRIMARY MARKET PRICES →
Upon request

AUCTION SALES →
Price: $668.200
Deluxe, 2004/05
Aquatint, dry-point,
photogravure, spite-bite,
lithography, silkscreen,
embossing, tattoo machine
engraving (portfolio of 60),
33 x 26.7 cm
Date sold: 15-May-08
Auction house: Sotheby's,
New York

Price: $144.000
Nightlamp, 1999
Enamel and canvas collage on
canvas, 304.7 x 243.7 cm
Date sold: 10-May-06
Auction house: Christie's,
New York

Price: $115.750
Soma, 1998
Oil, pencil and paper on canvas,
243.8 x 213.4 cm
Date sold: 15-May-01
Auction house: Sotheby's,
New York

Price: $113.525
Wild Kingdom, 1995
Oil, graphite and paper on
canvas, 213.5 x 183 cm
Date sold: 14-May-02
Auction house: Christie's,
New York

Price: $101.575
Untitled, 1999
Oil, ink and paper on canvas,
304.8 x 243.8 cm
Date sold: 13-Nov-02
Auction house: Sotheby's,
New York

ISA GENZKEN

REPRESENTATION →
Galerie Daniel Buchholz
Neven-DuMont-Straße 17
D – 50667 Köln
Tel: +49 (0)221 257 49 46
www.galeriebuchholz.de

neugerriemschneider
Linienstraße 155
D – 10115 Berlin
Tel: +49 (0)30 28 87 72 77
www.neugerriemschneider.com

Hauser & Wirth
Limmatstrasse 270
CH – 8005 Zürich
Tel: +41 (0)44 446 80 50
www.hauserwirth.com

David Zwirner
525 West 19th Street
US – New York, NY 10011
Tel: +1 212 727 20 70
www.davidzwirner.com

PRIMARY MARKET PRICES →
$10.900–$1.090.000

AUCTION SALES →
Price: $67.524
Untitled (from the series of
Flugzeugfenster), 2007
Spraypaint on plastic, lacquer,
metal, 129 x 105 x 10 cm
Date sold: 28-Feb-08
Auction house: Sotheby's, London

Price: $44.919
Untitled, 2007
Plastic, fabric, mirror foil, wood,
metal, lacquer, 194 x 60 x 100 cm
Date sold: 01-Jul-08
Auction house: Christie's, London

Price: $37.432
Untitled, 1990
Glass, metal in wire casing,
126 x 28.5 cm
Date sold: 02-Jul-08
Auction house: Sotheby's,
London

Price: $31.089
Basic Research, 1989
Oil on canvas, 92 x 88 cm
Date sold: 01-Jun-07
Auction house: Kunsthaus
Lempertz, Cologne

Price: $28.800
Saal, 1987
Mixed media construction with
concrete, steel, wire,
203.2 x 87 x 83.8 cm
Date sold: 14-May-03
Auction house: Sotheby's,
New York

LUIS GISPERT

REPRESENTATION →
Mary Boone Gallery
745 Fifth Avenue
US – New York, NY 10151
Tel: +1 212 752 29 29
www.maryboonegallery.com

Zach Feuer Gallery
530 West 24th Street
US – New York, NY 10011
Tel: +1 212 989 77 00
www.zachfeuer.com

Fredric Snitzer Gallery
2247 NW 1st Place
US – Miami, FL 33127
Tel: +1 305 448 89 76
www.snitzer.com

PRIMARY MARKET PRICES →
$5.000–$100.000

ROBERT GOBER

REPRESENTATION →
Matthew Marks Gallery
523 West 24th Street
US – New York, NY 10011
Tel: +1 212 243 02 00
www.matthewmarks.com

PRIMARY MARKET PRICES →
Upon request

Robert Gober, Untitled, 1990

AUCTION SALES →
Price: $3.625.000
Untitled, 1990
Beeswax, cotton, wood, leather,
human hair, 31.1 x 14 x 52.1 cm
Date sold: 15-May-08
Auction house: Phillips de Pury &
Company, New York

Price: $912.856
Untitled, Lightbulb, 1990, in
collaboration with Sherrie Levine
Enamel, beeswax,
20 x 7.5 x 7.5 cm
Date sold: 30-Jun-08
Auction house: Christie's, London

Price: $912.000
Untitled, 1990
Beeswax, cotton, wood, leather,
human hair, 31.8 x 12.7 x 50.8 cm
Date sold: 10-May-05
Auction house: Sotheby's,
New York

Price: $830.750
Deep Basin Sink, 1984
Plaster, wire lath, wood, semi-
gloss enamel paint,
66 x 73.7 x 61 cm
Date sold: 14-Nov-00
Auction house: Sotheby's,
New York

Price: $794.500
Untitled, 1991
Wood, beeswax, leather, cotton,
human hair, 34 x 18 x 96.5 cm
Date sold: 19-May-99
Auction house: Christie's,
New York

DOUGLAS GORDON

REPRESENTATION →
Gagosian Gallery
555 West 24th Street
US – New York, NY 10011
Tel: +1 212 741 11 11
www.gagosian.com

Galerie Eva Presenhuber
Limmatstrasse 270
CH – 8005 Zürich
Tel: +41 (0)43 444 70 50
www.presenhuber.com

PRIMARY MARKET PRICES →
Upon request

AUCTION SALES →
Price: $96.000
Predictable Incident in
Unfamiliar Surroundings
(Nos. 1, 2, 3, 4, 5), 1995
Video with projector, player,
cassette tape, beer,
party-pack edition, dimensions/
duration variable
Date sold: 13-May-02

Auction house:
Phillips de Pury & Luxembourg,
New York

Price: $88.000
Self-Portrait of You and Me
(Most Wanted Men), 2007
Smoke, mirror, 73 x 93.4 cm
Date sold: 14-Feb-08
Auction house: Sotheby's,
New York

Price: $86.344
Self-Portrait of You and Me
(Bette Davis), 2006
C-print, mirror, 88 x 78 cm
Date sold: 30-Jun-08
Auction house: Phillips de Pury &
Company, London

Price: $74.366
Monster, 1996/97
C-print mounted on Diasec,
70.5 x 113 cm
Date sold: 29-Jun-08
Auction house: Phillips de Pury &
Company, London

Price: $65.725
The End (Bird Man of Alcatraz),
1995–2000
Photograph with solvent-based
inks on canvas, 180.4 x 238.8 cm
Date sold: 14-Nov-02
Auction house: Christie's,
New York

MARK GROTJAHN

REPRESENTATION →
Gagosian Gallery London
4–24 Britannia Street
GB – London, WC1X 9JD
Tel: +44 (0)20 78 41 99 60
www.gagosian.com

Blum & Poe
2754 South La Cienega Boulevard
US – Los Angeles, CA 90034
Tel: +1 310 836 20 62
www.blumandpoe.com

Mark Grotjahn, Untitled (Blue Face
Grotjahn), 2005

Anton Kern Gallery
532 West 20th Street
US – New York, NY 10011
Tel: +1 212 367 96 63
www.antonkerngallery.com

PRIMARY MARKET PRICES →
$50.000–$250.000 (drawings)
$250.000–$750.000 (paintings)

AUCTION SALES →
Price: $1.217.000
Untitled (Blue Face Grotjahn),
2005
Oil on canvas, 154.9 x 124.8 cm
Date sold: 15-May-08
Auction house: Phillips de Pury &
Company, New York

Price: $937.000
Untitled (Orange Butterfly M02G),
2002
Oil on canvas, 121.9 x 86.4 cm
Date sold: 15-Nov-07
Auction house: Phillips de Pury &
Company, New York

Price: $757.800
Untitled (Pink Butterfly Green
MG03), 2003
Oil on canvas, 91.4 x 71.1 cm
Date sold: 15-May-08
Auction house: Phillips de Pury &
Company, New York

Price: $573.786
Untitled (Black Butterfly M02G),
2002
Oil on canvas, 121.9 x 86.4 cm
Date sold: 06-Feb-08
Auction house: Christie's, London

Price: $537.787
Untitled (White Butterfly), 2001
Oil on canvas, 122 x 102 cm
Date sold: 13-Oct-07
Auction house:
Phillips de Pury & Company,
London

SUBODH GUPTA

REPRESENTATION →
Hauser & Wirth
Limmatstrasse 270
CH – 8005 Zürich
Tel: +41 (0)44 446 80 50
www.hauserwirth.com

In Situ – Fabienne Leclerc
6, rue du Pont de Lodi
F – 75006 Paris
Tel: +33 (0)1 53 79 06 12
www.insituparis.fr

Nature Morte
A-1 Neeti Bagh
IN – New Delhi 110049
Tel: +91 11 41 74 02 15
www.naturemorte.com

Subodh Gupta, Untitled, 2005

PRIMARY MARKET PRICES →
$217.500–$942.500 (paintings)
up to $1.450.000 (sculptures)

AUCTION SALES →
Price: $1.427.500
Untitled, 2006
Oil on canvas, 166.4 x 228.6 cm
Date sold: 19-Jun-08
Auction house: Saffronart,
Mumbai

Price: $1.200.339
Untitled, 2005
Oil on canvas, 167 x 229.2 cm
Date sold: 01-Jul-08
Auction house:
Sotheby's, London

Price: $1.192.019
Saat Samundar Paar, 10, 2003
Oil on canvas, 158 x 229 cm
Date sold: 24-May-08
Auction house: Christie's,
Hong Kong

Price: $1.181.005
Untitled, 2007
Stainless steel, stainless steel
utensils, 243.8 x 243.8 x 91.4 cm
Date sold: 11-Jun-08
Auction house: Christie's, South
Kensington

Price: $825.000
Saat Samunder Paar VII, 2003
Oil on canvas, 167.4 x 228.6 cm
Date sold: 14-May-08
Auction house: Sotheby's,
New York

ANDREAS GURSKY

REPRESENTATION →
Matthew Marks Gallery
523 West 24th Street
US – New York, NY 10011
Tel: +1 212 243 02 00
www.matthewmarks.com

Monika Sprüth Philomene Magers
Wormser Straße 23
D – 50677 Köln
Tel: +49 (0)221 38 04 15
www.spruethmagers.com

PRIMARY MARKET PRICES →
$29.500–$1.090.000

AUCTION SALES →
Price: $3.346.456
99 Cent II, Diptych, 2001
C-prints mounted on Plexiglas,
206 x 341 cm
Date sold: 07-Feb-07
Auction house: Sotheby's, London

Price: $2.867.547
Los Angeles, 1998
C-print, 157.5 x 316.7 cm
Date sold: 27-Feb-08
Auction house: Sotheby's, London

Price: $2.480.000
99 Cent II, Diptych, 2001
C-prints mounted on Plexiglas,
205.7 x 341 cm
Date sold: 16-Nov-06
Auction house: Phillips de Pury &
Company, New York

Price: $2.256.000
99 Cent, 2001
C-print, 207 x 336 cm
Date sold: 10-May-06
Auction house: Sotheby's,
New York

Price: $1.375.000
Pyongyang IV, 2007
C-print, 304.5 x 207 cm
Date sold: 14-Feb-08
Auction house: Sotheby's,
New York

WADE GUYTON

REPRESENTATION →
Friedrich Petzel Gallery

535 West 22nd Street
US – New York, NY 10011
Tel: +1 212 680 94 67
www.petzel.com

Galerie Gisela Capitain
St.-Apern-Straße 20–26
D – 50667 Köln
Tel: +49 (0)221 35 57 01 00
www.galeriecapitain.de

PRIMARY MARKET PRICES →
Upon request

AUCTION SALES →
Price: $73.337
Untitled, 2005
Inkjet on canvas, 110.2 x 90.2 cm
Date sold: 02-Apr-08
Auction house: Christie's, South Kensington

Price: $41.600
ICF 10, 2004
Xerox and spraypaint on paper, 4 works, 77.5 x 58.4 cm
Date sold: 03-Apr-08
Auction house: Phillips de Pury & Company, London

DANIEL GUZMÁN

REPRESENTATION →
Harris Lieberman Gallery
89 Vandam Street
US – New York, NY 10013
Tel: +1 212 206 12 90
www.harrislieberman.com

kurimanzutto
Mazatlán 5, Depto. T-6, Colonia Condesa
MX – 06140 México D.F.
Tel: +52 55 52 86 30 59
www.kurimanzutto.com

PRIMARY MARKET PRICES →
Upon request

RACHEL HARRISON

REPRESENTATION →
Greene Naftali Gallery
508 West 26th Street
US – New York, NY 10001
Tel: +1 212 463 77 70
www.greenenaftaligallery.com

Galerie Meyer Kainer
Eschenbachgasse 9
A – 1010 Wien
Tel: +43 (0)1 585 72 77
www.meyerkainer.com

Galerie Christian Nagel
Richard-Wagner-Straße 28
D – 50674 Köln
Tel: +44 (0)221 257 05 91
www.galerie-nagel.de

PRIMARY MARKET PRICES →
$9.000–$100.000

AUCTION SALES →
Price: $19.200
Untitled (from Posh Floored as Ali G Tackles Becks), 2003
Air freshener, wood, stucco, acrylics, 59.7 x 64.8 x 29.8 cm
Date sold: 18-May-07
Auction house: Phillips de Pury & Company, New York

Price: $9.000
Perth Amboy, 2001
C-prints, 2 works, 38.1 x 50.8 cm
Date sold: 12-May-06
Auction house: Phillips de Pury & Company, New York

Price: $5.040
Perth Amboy (2 Hands Man), 2001
C-print, 50.8 x 40.4 cm
Date sold: 15-Mar-05
Auction house: Christie's, New York

MONA HATOUM

REPRESENTATION →
Alexander and Bonin
132 Tenth Avenue
US – New York, NY 10011
Tel: +1 212 367 74 74
www.alexanderandbonin.com

Galerie Chantal Crousel
10, rue Charlot
F – 75003 Paris
Tel: +33 (0)1 42 77 38 87
www.crousel.com

Galleria Continua
Via del Castello, 11
I – 53037 San Gimignano
Tel: +39 0577 94 31 34
www.galleriacontinua.com

Galerie Max Hetzler
Zimmerstraße 90/91
D – 10117 Berlin
Tel: +49 (0)30 229 24 37
www.maxhetzler.com

White Cube
48 Hoxton Square
GB – London N1 6PB
Tel: +44 (0)20 79 30 53 73
www.whitecube.com

PRIMARY MARKET PRICES →
$14.500–$362.500

AUCTION SALES →
Price: $217.000
Entrails Carpet, 1995
Silicone rubber,
4.4 x 198.1 x 297.1 cm
Date sold: 14-Nov-07

Auction house: Christie's, New York

Price: $149.000
Silence, 1994
Glass, 127 x 92.7 x 59.1 cm
Date sold: 16-Nov-00
Auction house: Christie's, New York

Price: $129.000
Pin Carpet, 1995
Stainless steel pins, canvas, glue, 2.7 x 124.5 x 246.5 cm
Date sold: 14-May-01
Auction house: Phillips de Pury & Luxembourg, New York

Price: $119.500
Pin Carpet, 1999
Stainless steel pins, canvas, glue, 3 x 124.5 x 188 cm
Date sold: 11-May-04
Auction house: Christie's, New York

Price: $114.782
Deep Throat, 1996
Wood, masonite, cloth, glass, metal, paint, disc player, monitor, laser disc, 75.5 x 85 x 85 cm
Date sold: 08-Feb-06
Auction house: Christie's, London

EBERHARD HAVEKOST

REPRESENTATION →
Galerie Gebr. Lehmann
Görlitzer Straße 16
D – 01099 Dresden
Tel: +49 (0)35 18 01 17 83
www.galerie-gebr-lehmann.de

Anton Kern Gallery
532 West 20th Street
US – New York, NY 10011
Tel: +1 212 367 96 63
www.antonkerngallery.com

PRIMARY MARKET PRICES →
Upon request

AUCTION SALES →
Price: $318.250
Beziehung 2, 2002
Oil on canvas, 130 x 170 cm

Date sold: 09-Jun-07
Auction house: Villa Grisebach, Berlin

Price: $251.046
Intro 1, 2001
Oil on canvas, 80 x 180.4 cm
Date sold: 21-Jun-07
Auction house: Christie's, London

Price: $228.173
Team, 2001
Oil on canvas, 74 x 115 cm
Date sold: 08-Feb-06
Auction house: Christie's, London

Price: $202.970
Bowling 2, 2002
Oil on canvas, 169.5 x 260 cm
Date sold: 28-Feb-08
Auction house: Phillips de Pury & Company, London

Eberhard Havekost, Intro 1, 2001

Price: $192.000
Dimmer 4, DD 01, 2001
Oil on canvas, 70 x 150 cm
Date sold: 10-May-06
Auction house: Christie's, New York

RICHARD HAWKINS

REPRESENTATION →
Galerie Daniel Buchholz
Neven-DuMont-Straße 17
D – 50667 Köln
Tel: +49 (0)221 257 49 46
www.galeriebuchholz.de

Greene Naftali Gallery
508 West 26th Street
US – New York, NY 10001
Tel: +1 212 463 77 70
www.greenenaftaligallery.com

Praz-Delavallade
28, rue Louise-Weiss
F – 75013 Paris
Tel: +33 (0)1 45 86 20 00
www.praz-delavallade.com

PRIMARY MARKET PRICES →
Upon request

JONATHAN HERNÁNDEZ

REPRESENTATION →
kurimanzutto
Mazatlán 5, Depto. T-6, Colonia
Condesa
MX – 06140 México D.F.
Tel: +52 55 52 86 30 59
www.kurimanzutto.com

PRIMARY MARKET PRICES →
Upon request

ARTURO HERRERA

REPRESENTATION →
Sikkema Jenkins & Co
530 West 22nd Street
US – New York, NY 10011
Tel: +1 212 929 22 62
www.sikkemajenkinsco.com

Galerie Max Hetzler
Zimmerstraße 90/91
D – 10117 Berlin
Tel: +49 (0)30 229 24 37
www.maxhetzler.com

PRIMARY MARKET PRICES →
$7.300–145.000

AUCTION SALES →
Price: $57.600
I Am Yours, 2000
Fabric with cut felt wall pieces,
161 x 456.6 cm
Date sold: 13-May-04
Auction house: Phillips de Pury &
Company, New York

Price: $38.400
Arm in Arm, 2001
Cut wool felt, 251.5 x 84.1 cm
Date sold: 13-May-05
Auction house: Phillips de Pury &
Company, New York

Price: $33.460
Behind The House I, 1999
Painting with coloured felt,
2 parts, 257.8 x 178.8 cm
Date sold: 18-Nov-03
Auction house: Christie's,
New York

Price: $31.200
From the Road, 2001
Acrylic on paper with paper
collage, 216.5 x 192.1 cm
Date sold: 14-May-04
Auction house: Phillips de Pury &
Company, New York

Price: $18.000
Study for When Alone Again –
Hammer Museum, 2001
Colour pencil, 119.4 x 207 cm
Date sold: 14-May-04
Auction house: Phillips de Pury &
Company, New York

CHARLINE VON HEYL

REPRESENTATION →
Friedrich Petzel Gallery
535 West 22nd Street
US – New York, NY 10011
Tel: +1 212 680 94 67
www.petzel.com

Galerie Gisela Capitain
St.-Apern-Straße 20–26
D – 50667 Köln
Tel: +49 (0)221 35 57 01 00
www.galeriecapitain.de

PRIMARY MARKET PRICES →
Upon request

THOMAS HIRSCHHORN

REPRESENTATION →
Arndt & Partner
Zimmerstraße 90/91
D – 10117 Berlin
Tel: +49 (0)30 280 81 23
www.arndt-partner.com

Galerie Chantal Crousel
10, rue Charlot
F – 75003 Paris
Tel: +33 (0)1 42 77 38 87
www.crousel.com

Stephen Friedman Gallery
25–28 Old Burlington Street
GB – London W1S 3AN
Tel: +44 (0)20 74 94 14 34
www.stephenfriedman.com

Barbara Gladstone Gallery
515 West 24th Street
US – New York, NY 10011
Tel: +1 212 206 93 00
www.gladstonegallery.com

PRIMARY MARKET PRICES →
$20.000–$370.000

AUCTION SALES →
Price: $158.490
Relief Abstrait No. 548
(Nietzsche), 1999
Aluminium foil, plastic, paper
collage, 226.1 x 172.7 x 12.7 cm
Date sold: 14-Oct-06
Auction house: Phillips de Pury &
Company, New York

Price: $119.545
Relief Abstrait No. 825, 1999
Plastic, foil, cling film, cardboard,
printed paper on board,
aluminium collage,
173.5 x 226 x 10.2 cm
Date sold: 22-Jun-07
Auction house: Sotheby's, London

Price: $95.094
Relief Abstrait (Gold), 1999
Cellophane, aluminium foil,

cardboard on painted wood,
173 x 226 x 17 cm
Date sold: 15-Oct-06
Auction house: Christie's, London

Price: $91.970
Die fünf Kontinente
(Ozeanien), 1999
Relief, wood, cardboard,
aluminium foil, tape, photocopies,
203 x 221.5 x 14 cm
Date sold: 23-Jun-05
Auction house: Christie's, London

Price: $74.353
Relief Abstrait No. 747
(Nietzsche), 1999
Cellophane, aluminium foil,
cardboard on painted wood,
180 x 220 x 15 cm
Date sold: 14-Oct-07
Auction house:
Christie's, London

DAMIEN HIRST

REPRESENTATION →
Gagosian Gallery
555 West 24th Street
US – New York, NY 10011
Tel: +1 212 741 11 11
www.gagosian.com

Damien Hirst, Lullaby Spring, 2002

White Cube
48 Hoxton Square
GB – London N1 6PB
Tel: +44 (0)20 79 30 53 73
www.whitecube.com

PRIMARY MARKET PRICES →
Upon request

AUCTION SALES →
Price: $19.075.098
Lullaby Spring, 2002
Stainless steel, glass cabinet
with painted cast pills,
182.9 x 274.3 x 10.2 cm
Date sold: 21-Jun-07
Auction house: Sotheby's, London

Price: $9.623.141
Eternity, 2002–04
Butterflies, paint on canvas,
213.4 x 533.4 cm
Date sold: 13-Oct-07
Auction house: Phillips de Pury &
Company, London

Price: $7.432.000
Lullaby Winter, 2002
Glass, stainless steel, painted
cast pills, 182.9 x 274.3 x 10.2 cm
Date sold: 16-May-07
Auction house: Christie's,
New York

Price: $7.150.000
Where There's a Will, There's
a Way, 2007
Stainless steel and glass
cabinet with painted resin,
plaster and cast metal pills,
182.9 x 274.3 x 10.2 cm
Date sold: 14-Feb-08
Auction house: Sotheby's,
New York

Price: $3.478.217
3-(5-Chloro-2-Hydroxphenylazo)-4,
5-Dihydroxy-2, 7-Naphthalene-
disulfonic Acid, 1998
Paint on canvas, 213.4 x 518 cm
Date sold: 28-Feb-08

Auction house:
Phillips de Pury & Company,
London

ANDREAS HOFER

REPRESENTATION →
Galerie Guido W. Baudach
Oudenarder Straße 16–20
D – 13347 Berlin
Tel: +49 (0)30 28 04 77 27
www.guidowbaudach.com

Galerie Christine Mayer
Liebigstraße 39
D – 80538 München

Tel: +49 (0)89 24 24 38 32
www.galeriechristinemayer.com

Hauser & Wirth
Limmatstrasse 270
CH – 8005 Zürich
Tel: +41 (0)44 446 80 50
www.hauserwirth.com

Metro Pictures
519 West 24th Street
US – New York, NY 10011
Tel: +1 212 20 67 1 00
www.metropictures.com

PRIMARY MARKET PRICES →
from $5.800 (drawings)
$14.500–$72.500 (paintings)
$43.500–$290.000 (sculptures)

THOMAS HOUSEAGO

REPRESENTATION →
Xavier Hufkens
Rue Saint-Georges 6–8
B – 1050 Bruxelles
Tel: +32 (0)2 639 67 30
www.xavierhufkens.com

David Kordansky Gallery
510 Bernard Street
US – Los Angeles, CA 90012
Tel: +1 323 222 14 82
www.davidkordanskygallery.com

The Modern Institute
73 Robertson Street
GB – Glasgow G2 8QD
Tel: +44 (0)141 24 83 71 12 48
www.themoderninstitute.com

PRIMARY MARKET PRICES →
$10.000–$300.000

HUANG YONG PING

REPRESENTATION →
Barbara Gladstone Gallery
515 West 24th Street
US – New York, NY 10011
Tel: +1 212 206 93 00
www.gladstonegallery.com

Goedhuis Contemporary
42 East 76th Street
US – New York, NY 10021
Tel: +1 212 535 69 54
www.goedhuiscontemporary.com

PRIMARY MARKET PRICES →
Upon request

AUCTION SALES →
Price: $432.640
Le carte du Monde, 2000
Mixed media, 1100 x 400 x 400 cm
Date sold: 25-Nov-07
Auction house: Christie's,
Hong Kong

Price: $348.000
Da Xian – The Doomsday, 1997
Mixed media with bowls,
fibreglass, oil paint, expired food
products, ink drawings, photos
Date sold: 20-Sep-07
Auction house: Sotheby's,
New York

Price: $216.724
Memorandum Bat Project I, II and
III, 2004
Mixed media, height 470 cm
Date sold: 09-Apr-08
Auction house: Sotheby's,
Hong Kong

Price: $168.000
Da Xian – The Doomsday, 1997
Mixed media with bowls,
fibreglass, oil paint, expired food
products, ink drawings, photos
Date sold: 11-May-06
Auction house:
Phillips de Pury & Company,
New York

Price: $113.207
Le jugement dernier, 1997
Oil on fibreglass with expired
food products, 78.1 x 141 x 141 cm
Date sold: 14-Oct-06
Auction house: Phillips de Pury &
Company, New York

PIERRE HUYGHE

REPRESENTATION →
Marian Goodman Gallery
24 West 57th Street
US – New York, NY 10019
Tel: +1 212 977 71 60
www.mariangoodman.com

Xavier Hufkens
Rue Saint-Georges 6–8
B – 1050 Bruxelles
Tel: +32 (0)2 639 67 30
www.xavierhufkens.com

Esther Schipper
Linienstraße 85
D – 10119 Berlin
Tel: +49 (0)30 28 39 01 39
www.estherschipper.com

PRIMARY MARKET PRICES →
Upon request

AUCTION SALES →
Price: $47.407
Rue Longvic, Dijon, 1995
Offset print mounted on
cardboard, 66.5 x 86.5 cm
Date sold: 26-Apr-06
Auction house: Christie's, Paris

Price: $40.000
Chantier Barbès-Rochechouart,
Paris, 1994

Offset print mounted on
cardboard, 80 x 120 cm
Date sold: 26-Apr-06
Auction house: Christie's, Paris

Price: $19.964
Géant Casino, Montpellier, 1999
Offset print mounted on
cardboard, 88.3 x 66 cm
Date sold: 29-Jun-08
Auction house: Phillips de Pury &
Company, London

Price: $16.296
Trajet, Paris, 1992
Offset print mounted on
cardboard, 67 x 94.5 cm
Date sold: 26-Apr-06
Auction house: Christie's, Paris

Price: $12.148
La Toison d'Or, Dijon, 1993
Offset print mounted on
cardboard, 67 x 100.5 cm
Date sold: 26-Apr-06
Auction house: Christie's, Paris

EMILY JACIR

REPRESENTATION →
Alexander and Bonin
132 Tenth Avenue
US – New York, NY 10011
Tel: +1 212 367 74 74
www.alexanderandbonin.com

Galleria Alberto Peola
Via della Rocca, 29
I – 10123, Torino
Tel: +39 011 812 44 60
www.albertopeola.com

Anthony Reynolds Gallery
60 Great Marlborough Street
GB – London W1F 7BG
Tel: +44 (0)20 74 39 22 01
www.anthonyreynolds.com

PRIMARY MARKET PRICES →
Upon request

AUCTION SALES →
Price: $16.220
Rizek (from the series Where We
Come From), 2002/03
Printed text, mounted C-prints,
4 works, 13 x 18.4 cm
Date sold: 29-Jun-08
Auction house: Phillips de Pury &
Company, London

Price: $5.760
Jihad (from the series Where We
Come From), 2002/03
Printed text, C-print,
25.4 x 25.4 cm
Date sold: 14-Mar-06
Auction house:
Phillips de Pury & Company,
New York

Price: $5.520
George/Fayez (from the series
Where We Come From), 2002/03
Printed text, c-prints, 2 works,
20 x 30.2 cm
Date sold: 12-Sep-06
Auction house: Phillips de Pury &
Company, New York

Mike Kelley, Deodorized Central Mass
with Satellites, 1991/99 (detail)

MIKE KELLEY

REPRESENTATION →
Gagosian Gallery
555 West 24th Street
US – New York, NY 10011
Tel: +1 212 741 11 11
www.gagosian.com

Jablonka Galerie
Lindenstraße 19
D – 50674 Köln
Tel: +49 (0)221 240 34 26
www.jablonkagalerie.com

Galleria Emi Fontana /
West of Rome
380 South Lake Avenue, Suite 210
US – Pasadena, CA 91101
Tel: +1 626 793 15 04
www.westofromeinc.com
www.galleriaemifontana.com

Patrick Painter Inc.
2525 Michigan Avenue
US – Santa Monica, CA 90404
Tel: +1 310 264 59 88
www.patrickpainter.com

Metro Pictures
519 West 24th Street
US – New York, NY 10011
Tel: +1 212 20 67 1 00
www.metropictures.com

Galerie Hussenot
5 bis, rue des Haudriettes
F – 75003 Paris
Tel: +33 (0)1 48 87 60 81
www.galeriehussenot.com

PRIMARY MARKET PRICES →
Upon request

AUCTION SALES →
Price: $2.704.000
Deodorized Central Mass with
Satellites, 1991/99
1 central mass and 12 satellites:
found stuffed animals sewn over
wood and wire mesh frames
with Styrofoam packing material,
metal hardware, nylon rope,
and pulleys; 10 deodorizers:
fibreglass, car lacquer, electronic
device with disinfectant mixture
Installation dimensions variable.
Central mass: 137.2 x 386.1 x
160 cm, Satellite dimensions vary
from 48.3 x 45.7 x 45.7 to 94 x
101.6 x 101.6 cm, Deodorizers:
213.4 x 58.4 x 44.5 cm
Date sold: 16-Nov-06
Auction house:
Phillips de Pury & Company,
New York

Price: $1.104.000
Test Room Containing Multiple
Stimuli Known to Elicit
Curiosity and Manipulatory
Responses, 1999
Mixed media installation,
350.5 x 1800.7 x 729 cm
Date sold: 26-Feb-07
Auction house: Christie's,
New York

Price: $713.000
Memory Ware Flat #2, 2000
Paper, pulp, tile grout, acrylic,
miscellaneous beads, buttons,
jewellery on wooden panel,
179.1 x 118.1 cm
Date sold: 14-May-08
Auction house: Sotheby's,
New York

Price: $688.000
Ahh… Youth!, 1991
Set of 8 Cibachrome
photographs, 7 at 61 x 50.8 cm
each, 1 at 61 x 45.7 cm
Date sold: 11-May-06
Auction house: Phillips de Pury &
Company, New York

Price: $688.000
Ahh… Youth!, 1991
Set of 8 Cibachrome
photographs, 7 at 61 x 50.8 cm
each, 1 at 61 x 45.7 cm
Date sold: 09-May-06
Auction house: Christie's,
New York

TERENCE KOH

REPRESENTATION →
Peres Projects
969 Chung King Road
US – Los Angeles, CA 90012
Tel: +1 213 617 11 00
www.peresprojects.com

Terence Koh, Untitled (Man/Animal),
2006

PRIMARY MARKET PRICES →
Upon request

AUCTION SALES →
Price: $157.000
Untitled (Man/Animal), 2006
Plaster, gold glitter, gold leaf,
baboon head, bees, wood,
2 mirrors, 2 plinths,
47 x 19 x 20.3 cm
Date sold: 15-May-08
Auction house: Sotheby's,
New York

Price: $143.564
The Camel Was God, the
Camel Was Shot, 2007
Bronze with white patina,
22 x 179 x 55 cm
Date sold: 28-Feb-08
Auction house: Phillips de Pury &
Company, London

Price: $67.000
Coke Head, 2006
Plaster cast with diamond dust,
sugar, paint, 60.1 x 34.9 x 34.9 cm
Date sold: 16-May-08
Auction house: Phillips de Pury &
Company, New York

Price: $60.000
My Swahili Years, 2007
Bronze, paint, oil, wax, wire,
28 x 28 x 16.5 cm
Date sold: 15-May-08
Auction house: Phillips de Pury &
Company New York

Price: $45.600
Untitled 12 (3 Stacks of Towels
and a White Horse), 2003
Towels, plastic horse, fake hair,
acrylic, glue adhesive, household
paint on wood shelf,
27.9 x 109.9 x 26 cm
Date sold: 18-May-07
Auction house: Phillips de Pury &
Company, New York

JEFF KOONS

REPRESENTATION →
Sonnabend Gallery
536 West 22nd Street
US – New York, NY 10011
Tel: +1 212 627 10 18
www.sonnabend.com

Gagosian Gallery
555 West 24th Street
US – New York, NY 10011
Tel: +1 212 741 11 11
www.gagosian.com

Galerie Max Hetzler
Zimmerstraße 90/91
D – 10117 Berlin
Tel: +49 (0)30 229 24 37
www.maxhetzler.com

Galerie Jérôme de Noirmont
36–38, avenue Matignon
F – 75008 Paris
Tel: +33 (0)1 42 89 89 00
www.denoirmont.com

PRIMARY MARKET PRICES →
Upon request

AUCTION SALES →
Price: $25.796.067
Balloon Flower (Magenta),
1995–2000
High chromium stainless steel
with transparent colour coating,
340 x 285 x 260 cm
Date sold: 30-Jun-08
Auction house: Christie's, London

Price: $23.561.000
Hanging Heart (Red/Gold),
1994–2006
Stainless steel with transparent
color coating, yellow brass,
296.2 x 215.9 x 101.6 cm
Date sold: 14-Nov-07
Auction house: Sotheby's,
New York

Jeff Koons, Balloon Flower (Magenta),
1995–2000

Price: $11.801.000
New Hoover Convertibles,
New Shelton Wet/Drys 5-Gallon,
Double Decker, 1981–86
Vacuum cleaners, acrylic and
fluorescent lights,
251.5 x 104.1 x 71.1 cm
Date sold: 13-May-08
Auction house: Christie's,
New York

Price: $11.801.000
Diamond (Blue/Gold), 1994–2005
Stainless steel, transparent colour
coating, 198.1 x 220.1 x 220.1 cm
Date sold: 13-Nov-07
Auction house: Christie's,
New York

Price: $9.001.000
Naked, 1988
Porcelain, 115.6 x 68.6 x 68.6 cm
Date sold: 14-May-08
Auction house: Sotheby's,
New York

DR. LAKRA

REPRESENTATION →
Kate MacGarry
7a Vyner Street
GB – London E2 9DG
Tel: +44 (0)20 89 81 91 00
www.katemacgarry.com

kurimanzutto
Mazatlán 5, Depto. T-6, Colonia
Condesa
MX – 06140 México D.F.
Tel: +52 55 52 86 30 59
www.kurimanzutto.com

PRIMARY MARKET PRICES →
Upon request

AUCTION SALES →
Price: $49.908
Untitled (Pomada), 2004
Ink on vintage magazine,
30.5 x 23 cm
Date sold: 16-Oct-07
Auction house: Christie's, London

Price: $23.636
Untitled (Retrato Mujer), 2007
Ink, varnish on vintage colour
photograph mounted on canvas,
50.2 x 40.6 cm
Date sold: 03-Apr-08
Auction house:
Phillips de Pury & Company,
London

Price: $22.800
Untitled (Business), 2005
Coloured inks, acrylic,
149.9 x 111.8 cm
Date sold: 28-Feb-07
Auction house: Christie's,
New York

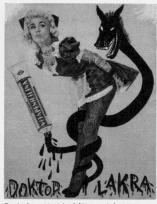

Dr. Lakra, Untitled (Pomada), 2004

Price: $21.148
Untitled (Bulova Watch), 2006
Ink on vintage magazine paper,
34.9 x 25.4 cm
Date sold: 03-Apr-08
Auction house: Phillips de Pury &
Company, London

Price: $21.148
Untitled (Homenaje a Ensor), 2006
Graphite on paper, 80 x 104.1 cm
Date sold: 03-Apr-08
Auction house: Phillips de Pury &
Company, London

ULRICH LAMSFUSS

REPRESENTATION →
Galerie Max Hetzler
Zimmerstraße 90/91
D – 10117 Berlin
Tel: +49 (0)30 229 24 37
www.maxhetzler.com

Galerie Daniel Templon
30, rue Beaubourg
F – 75003 Paris
Tel: +33 (0)1 42 72 14 10
www.danieltemplon.com

PRIMARY MARKET PRICES →
$14.500–$58.000

WON JU LIM

REPRESENTATION →
Galerie Max Hetzler
Zimmerstraße 90/91
D – 10117 Berlin
Tel: +49 (0)30 229 24 37
www.maxhetzler.com

Patrick Painter Inc.
2525 Michigan Avenue
US – Santa Monica, CA 90404
Tel: +1 310 264 59 88
www.patrickpainter.com

Pilar Para & Romero Galería
de Arte

Conde de Aranda 2
E – 28001 Madrid
Tel: +34 (0)91 576 28 13
www.pilarparra.com

PRIMARY MARKET PRICES →
Upon request

VERA LUTTER

REPRESENTATION →
Gagosian Gallery
555 West 24th Street
US – New York, NY 10011
Tel: +1 212 741 11 11
www.gagosian.com

Galerie Max Hetzler
Zimmerstraße 90/91
D – 10117 Berlin
Tel: +49 (0)30 229 24 37
www.maxhetzler.com

PRIMARY MARKET PRICES →
$55.000–$85.000

AUCTION SALES →
Price: $84.955
Brooklyn Bridge, 1996
Gelatin silver prints, mounted on
2 canvases, 223.8 x 284.8 cm
Date sold: 23-Oct-05
Auction house: Christie's, London

Price: $83.650
The Tower, Fire Boat House,
Fulton Ferry Landing, New York,
July 7, 1996
Gelatin silver print, 279.5 x 132 cm
Date sold: 11-Nov-04
Auction house: Christie's,
New York

Price: $81.600
135 La Salle Street, Chicago II:
November 7, 2001
Gelatin silver print,
195.6 x 142.3 cm
Date sold: 11-Nov-05
Auction house:
Phillips de Pury & Company,
New York

Price: $71.700
Frankfurt Airport IV: April 13, 2001
Gelatin silver print,
204.8 x 424.7 cm
Date sold: 12-May-04
Auction house: Christie's,
New York

MAREPE

REPRESENTATION →
Galerie Max Hetzler
Zimmerstraße 90/91
D – 10117 Berlin
Tel: +49 (0)30 229 24 37
www.maxhetzler.com

Anton Kern Gallery
532 West 20th Street
US – New York, NY 10011
Tel: +1 212 367 96 63
www.antonkerngallery.com

Galeria Luisa Strina
Rua Oscar Freire 502
BR – São Paulo 01426-000
Tel: +55 11 30 88 24 71
www.galerialuisastrina.com.br

PRIMARY MARKET PRICES →
$7.300–$217.500

PAUL MCCARTHY

REPRESENTATION →
Hauser & Wirth
Limmatstrasse 270
CH – 8005 Zürich
Tel: +41 (0)44 446 80 50
www.hauserwirth.com

PRIMARY MARKET PRICES →
$100.000–$1.800.000

AUCTION SALES →
Price: $1.496.000
Bear and Rabbit on a Rock, 1992
Mascot heads, acrylic fur, metal
armature, foam rubber,
270 x 190 x 130 cm
Date sold: 26-Feb-07
Auction house: Christie's,
New York

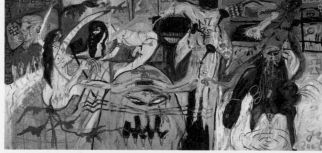

Jonathan Meese, Agamemnon's Hähnchenbesteck, 2003

Price: $856.000
Santa Long Neck, 2004
Painted bronze, 270 x 114 x 97 cm
Date sold: 07-Nov-05
Auction house: Phillips de Pury &
Company, New York

Price: $559.304
Red Plug, 1995
Resin on fibreglass, height:
335 cm
Date sold: 09-Feb-06
Auction house: Sotheby's, London

Price: $553.600
Hammer Head, 2003/04
Cast silicon rubber,
100.3 x 58.4 x 86.4 cm

Date sold: 16-Nov-06
Auction house:
Phillips de Pury & Company,
New York

Price: $505.000
Pot Head, 2002
Pink silicon rubber, steel,
83.8 x 106.7 x 121.9 cm
Date sold: 15-May-08
Auction house: Sotheby's,
New York

JOSEPHINE MECKSEPER

REPRESENTATION →
Arndt & Partner
Zimmerstraße 90/91
D – 10117 Berlin
Tel: +49 (0)30 280 81 23
www.arndt-partner.com

Elizabeth Dee Gallery
545 West 20th Street
US – New York, NY 10011
Tel: +1 212 924 75 45
www.elizabethdeegallery.com

Galerie Reinhard Hauff
Paulinenstraße 47
D – 70178 Stuttgart
Tel: +49 (0)711 60 97 70
www.reinhardhauff.de

PRIMARY MARKET PRICES →
$14.500–$217.500

JONATHAN MEESE

REPRESENTATION →
Contemporary Fine Arts
Am Kupfergraben 10
D – 10117 Berlin
Tel: +49 (0)30 288 78 70
www.cfa-berlin.com

Bortolami
510 West 25th Street
US – New York, NY 10001
Tel: +1 212 727 2050
www.bortolamigallery.com

Galerie Krinzinger
Seilerstätte 16
A – 1010 Wien

Tel: +43 (0)15 13 30 06
www.galerie-krinzinger.at

Galerie Daniel Templon
30, rue Beaubourg
F – 75003 Paris
Tel: +33 (0)1 42 72 14 10
www.danieltemplon.com

PRIMARY MARKET PRICES →
Upon request

AUCTION SALES →
Price: $269.912
Agamemnon's Hähnchen-
besteck, 2003
Oil on canvas, triptych,
209.5 x 418.5 cm
Date sold: 14-Oct-07
Auction house:
Christie's, London

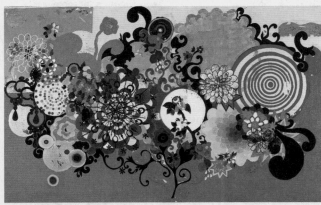
Beatriz Milhazes, O Mágico, 2001

Price: $251.200
Alex De Large in seinem
geliebten Mädchenzimmer,
2001
Oil on canvas, triptych,
209.6 x 139.7 cm
Date sold: 14-Nov-06
Auction house: Sotheby's,
New York

Price: $240.000
Der Werwolfmeese de Mees,
2004
Oil and colour photograph
collage on canvas, 2 parts,
210 x 280.5 cm
Date sold: 16-May-07
Auction house: Sotheby's,
New York

Price: $191.273
Der Inkazardoz, 2001
Oil on canvas, 3 parts,
209.5 x 140 cm
Date sold: 22-Jun-07
Auction house:
Sotheby's, London

Price: $171.114
Dr. Mabusen's, 2002

Oil on canvas, 3 parts,
209 x 421.5 cm
Date sold: 13-Oct-07
Auction house: Phillips de Pury &
Company, London

BEATRIZ MILHAZES

REPRESENTATION →
Galeria Fortes Vilaça
Rua Fradique Coutinho 1500
BR – São Paulo 05416-001
Tel: +55 11 30 32 70 66
www.fortesvilaca.com.br

James Cohan Gallery
533 West 26th Street,
US – New York, NY 10001
Tel: +1 212 714 95 00
www.jamescohan.com

Stephen Friedman Gallery
25–28 Old Burlington Street
GB – London W1S 3AN
Tel: +44 (0)20 74 94 14 34
www.stephenfriedman.com

Galerie Max Hetzler
Zimmerstraße 90/91
D – 10117 Berlin
Tel: +49 (0)30 229 24 37
www.maxhetzler.com

PRIMARY MARKET PRICES →
$250.000–$300.000 (paintings)

AUCTION SALES →
Price: $1.049.000
O Mágico, 2001
Oil, acrylic, gold leaf on canvas,
188 x 298 cm
Date sold: 15-May-08
Auction house: Sotheby's,
New York

Price: $465.471
Laranjeiras, 2002/03
Acrylic on canvas, 59 x 160 cm
Date sold: 14-Oct-07
Auction house:
Christie's, London

Price: $409.762
A Chuva, 1996
Oil, acrylic, enamel, gold leaf,
metallic paints on canvas,
151 x 141.2 cm
Date sold: 01-Jul-08
Auction house: Christie's, London

Price: $293.338
O Periquito, 1998
Acrylic on canvas,
199.4 x 251.5 cm
Date sold: 13-Oct-07
Auction house: Phillips de Pury &
Company, London

Price: $281.769
O Peixe, 1996/97
Oil, acrylic, gold leaf on canvas,
181 x 255 cm
Date sold: 25-Oct-05
Auction house: Sotheby's,
London

SARAH MORRIS

REPRESENTATION →
Air de Paris
32, rue Louise Weiss
F – 75013 Paris
Tel: +33 (0)1 44 23 02 77
www.airdeparis.com

Galerie Max Hetzler
Zimmerstraße 90/91
D – 10117 Berlin
Tel: +49 (0)30 229 24 37
www.maxhetzler.com

Friedrich Petzel Gallery
535 West 22nd Street
US – New York, NY 10011
Tel: +1 212 680 94 67
www.petzel.com

White Cube
48 Hoxton Square
GB – London N1 6PB
Tel: +44 (0)20 79 30 53 73
www.whitecube.com

PRIMARY MARKET PRICES →
$10.000–$40.000 (drawings)
$75.000–$450.000 (paintings
and films)

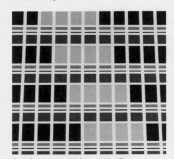
Sarah Morris, Midtown Madison
Square Garden (Stairwell), 1998

AUCTION SALES →
Price: $162.000
Midtown Madison Square
Garden (Stairwell), 1998
Household gloss paint on canvas,
182.9 x 182.9 cm
Date sold: 18-May-07
Auction house: Phillips de Pury &
Company, New York

Price: $145.000
Caesar's (Las Vegas), 2000
Acrylic on canvas, 214.6 x 214 cm
Date sold: 15-Nov-07
Auction house: Sotheby's,
New York

Price: $145.000
Midtown, 1211, Rockefeller Plaza,
1998
Household gloss paint on canvas,
213.3 x 213.3 cm
Date sold: 14-Nov-07
Auction house: Christie's,
New York

Price: $143.564
Rock Greek (Capital), 2002
Household gloss paint on canvas,
214 x 214 cm
Date sold: 29-Feb-08
Auction house: Phillips de Pury &
Company, London

Price: $102.000
Department of Energy (Capital),
2001
Household gloss paint on canvas,
214.6 x 214.6 cm
Date sold: 27-Feb-07
Auction house: Phillips de Pury &
Company, New York

RON MUECK

REPRESENTATION →
Anthony d'Offay Gallery
Dering Street
GB – London W1
Tel: +44 (0)20 74 99 41 00
www.doffay.com

PRIMARY MARKET PRICES →
Upon request

AUCTION SALES →
Price: $531.200
Pinocchio, 1996
Fibreglass, hair, pigment,
83.8 x 20 x 20 cm
Date sold: 12-May-05
Auction house: Phillips de Pury &
Company, New York

Price: $69.600
Untitled (Mask Maquette), 2000
Plaster mask, 19.1 x 12.7 x 11.4 cm
Date sold: 12-May-06
Auction house: Phillips de Pury &
Company, New York

Price: $67.978
Big Baby 2, 1996/97
Mixed media with polyester resin,
85 x 71 x 70 cm
Date sold: 08-Dec-98
Auction house: Christie's, London

Ron Mueck, Pinocchio, 1996

TAKASHI MURAKAMI

REPRESENTATION →
Blum & Poe
2754 South La Cienega Boulevard
US – Los Angeles, CA 90034
Tel: +1 310 83 62 06 2
www.blumandpoe.com

Galerie Emmanuel Perrotin
76, rue de Turenne
F – 75003 Paris
Tel: +33 (0)1 42 16 79 79
www.galerieperrotin.com

Scai – The Bathhouse
Kashiwayu-Ato, 6-1-23 Yanaka,
Taito-ku
JP – Tokyo 110-0001
Tel: +81 (0)3 38 21 11 44
www.scaithebathhouse.com

PRIMARY MARKET PRICES →
Upon request

AUCTION SALES →
Price: $15.161.000
My Lonesome Cowboy, 1998
Oil, acrylic, fibreglass, iron, 254 x
116.8 x 91.4 cm
Date sold: 14-May-08
Auction house: Sotheby's,
New York

Price: $2.711.807
Panda, 2003
Fibreglass, antique Louis Vuitton
trunk, wooden pedestal,
255.3 x 165.1 x 109.2 cm
Date sold: 03-Apr-08
Auction house: Phillips de Pury &
Company, London

Price: $2.393.000
Vapor Trail, 2004

Acrylic on canvas laid on panel,
100.3 x 100.3 x 5.1 cm
Date sold: 15-Nov-07
Auction house: Sotheby's,
New York

Price: $1.650.000
Red Flower Ball, 2007
Painting, acrylic, platinum leaf on
canvas laid on panel, Ø 150 cm
Date sold: 14-Feb-08
Auction house: Sotheby's,
New York

Price: $1.640.102
Dob Flower, 2000
Acrylic on canvas laid on panel,
122 x 122 cm
Date sold: 01-Jul-08
Auction house: Sotheby's, London

WANGECHI MUTU

REPRESENTATION →
Susanne Vielmetter
Los Angeles Projects
5795 West Washington Boulevard
US – Culver City, CA 90232
Tel: +1 323 933 21 17
www.vielmetter.com

Sikkema Jenkins & Co
530 West 22nd Street
US – New York, NY 10011
Tel: +1 212 92 9 22 62
www.sikkemajenkinsco.com

Victoria Miro Gallery
16 Wharf Road
GB – London N1 7RW
Tel: +44 (0)20 73 36 81 09
www.victoria-miro.com

PRIMARY MARKET PRICES →
$180.000

AUCTION SALES →
Price: $406.722
A Little Thought for All Ya'll Who're
Thinking of Beating Around the
Bush 2004!, 2004
Ink, acrylic, sequins, paper
collage on Mylar, 106.6 x 129.5 cm
Date sold: 07-Feb-08
Auction house: Christie's, London

Price: $385.000
Untitled, 2004
Ink, acrylic, sequins, collage on
Mylar, 190.5 x 104.1 cm
Date sold: 14-Nov-07
Auction house: Christie's,
New York

Price: $193.000
Soul on a Peg Leg, 2001
Ink, watercolour, gouache,
sequins, paper, felt collage,
150 x 110.5 cm
Date sold: 15-May-08

Auction house: Phillips de Pury &
Company, New York

Price: $156.000
You'll Always Try to Get Me, 2004
Ink, acrylic, and printed paper
collage on Mylar, 53.3 x 73.7 cm
Date sold: 17-May-07
Auction house: Christie's,
New York

Price: $105.600
The Royal Slipper Dipper (Fungus
Series), 2003
Airbrush paint, watercolour, paper
collage on Mylar, 82.6 x 52.1 cm
Date sold: 17-Nov-06
Auction house: Phillips de Pury &
Company, New York

ERNESTO NETO

REPRESENTATION →
Tanya Bonakdar Gallery
521 West 21st Street
US – New York, NY 10011
Tel: +1 212 414 41 44
www.tanyabonakdargallery.com

Galeria Fortes Vilaça
Rua Fradique Coutinho 1500
BR – São Paulo 05416-001
Tel: +55 11 30 32 70 66
www.fortesvilaca.com.br

Galerie Max Hetzler
Zimmerstraße 90/91
D – 10117 Berlin
Tel: +49 (0)30 229 24 37
www.maxhetzler.com

Tomio Koyama Gallery
1-3-2-7F, Kiyosumi, Koto-ku
JP – Tokyo 135-0024
Tel: +81 (0)3 36 42 40 90
www.tomiokoyamagallery.com

PRIMARY MARKET PRICES →
$15.000–$250.000

AUCTION SALES →
Price: $53.267
Cosmovo, 2001
Nylon fabric, styrofoam pellets,
380 x 100 x 116 cm
Date sold: 29-Feb-08
Auction house: Phillips de Pury &
Company, London

Price: $53.267
PAFF, Turmeric, 1997
Polyamide fabric, turmeric,
356.9 x 66 x 66 cm
Date sold: 29-Feb-08
Auction house: Phillips de Pury &
Company, London

Price: $52.500
It Happens in the Frictions of the
Bodies, 1999

Spices in polymade fabric,
1000.1 x 499.8 cm
Date sold: 14-Nov-01
Auction house: Sotheby's,
New York

Price: $39.000
O a Vesso de Mundo, 1999
Lycra, polystyrene pellets,
65.4 x 76.2 x 76.2 cm
Date sold: 15-Nov-06
Auction house: Sotheby's,
New York

Price: $35.250
Apolo 3, 1997
Aluminium, polyamide, cotton,
rubber, steel,
335.3 x 335.3 x 274.3 cm
Date sold: 22-Nov-00
Auction house: Christie's,
New York

Ernesto Neto, Cosmovo, 2001

FRANK NITSCHE

REPRESENTATION →
Galerie Gebr. Lehmann
Görlitzer Straße 16
D – 01099 Dresden
Tel: +49 (0)35 18 01 17 83
www.galerie-gebr-lehmann.de

Galerie Max Hetzler
Zimmerstraße 90/91
D – 10117 Berlin
Tel: +49 (0)30 229 24 37
www.maxhetzler.com

Galerie Nathalie Obadia
3, rue du Cloître Saint-Merri
F – 75004 Paris
Tel: +33 (0)1 42 74 67 68
www.galerie-obadia.com

PRIMARY MARKET PRICES →
Upon request

AUCTION SALES →
Price: $72.000
VFL-14-2002, 2002
Oil on canvas, 195 x 209.5 cm
Date sold: 11-May-06
Auction house: Sotheby's,
New York

Price: $54.339
OGY-12-2004, 2004
Oil on canvas, 159.9 x 200.3 cm
Date sold: 17-Oct-06
Auction house: Christie's, London

Price: $48.889
Untitled (RAH-5), 2003
Oil on canvas, 200 x 180.3 cm
Date sold: 13-Oct-07
Auction house:
Phillips de Pury & Company,
London

Price: $40.353
Untitled, 1999
Oil on canvas, 135 x 130 cm
Date sold: 25-Oct-05
Auction house: Sotheby's,
London

Price: $38.240
Lay 8, 1999
Oil on canvas, 155 x 140 cm
Date sold: 11-Nov-04
Auction house: Christie's,
New York

Frank Nitsche, VFL-14-2002, 2002

TIM NOBLE AND
SUE WEBSTER

REPRESENTATION →
Deitch Projects
76 Grand Street
US – New York, NY 10013
Tel: +1 212 343 73 00
www.deitch.com

Gagosian Gallery
555 West 24th Street
US – New York, NY 10011
Tel: +1 212 741 11 11
www.gagosian.com

PRIMARY MARKET PRICES →
$80.000–$1.320.000

AUCTION SALES →
Price: $700.787
Toxic Schizophrenia, 1997
516 coloured UFO reflector caps,
lamps and holders, foamex,
PVC film, aerosol paint, electric
light sequencser (51-channel
multi-functional),
200 x 7 x 260 cm
Date sold: 07-Feb-07
Auction house: Sotheby's, London

Price: $541.000
YE$, 2001
335 ice white turbo reflector
caps, lamps, holders and daisy
washers, lacquered brass,
enamelled paint, electric light,
sequencer (3-channel shimmer
effect), 148.6 x 294.6 x 25.4 cm
Date sold: 15-Nov-07
Auction house: Phillips de Pury &
Company, New York

Price: $491.820
$, 2001
204 ice white turbo reflector
caps, lamps, holders and daisy
washers, lacquered brass,
enamelled paint, electric light,
sequencer (3-channel shimmer
effect), 183 x 122 x 25.4 cm
Date sold: 12-Oct-07
Auction house: Sotheby's, London

Price: $454.273
Fuckingbeautiful (hot pink
version), 2000
8 neon sections, transformers,
148 x 6.5 x 168 cm
Date sold: 22-Jun-07
Auction house: Phillips de Pury &
Company, London

Price: $452.800
Toxic Schizophrenia, 1997
516 coloured UFO reflector caps,
lamps and holders, foamex,
PVC film, aerosol paint, electric
light sequencser (51-channel
multi-functional),
200 x 7 x 260 cm
Date sold: 12-May-05
Auction house: Phillips de Pury &
Company, New York

ALBERT OEHLEN

REPRESENTATION →
Galerie Max Hetzler
Zimmerstraße 90/91
D – 10117 Berlin
Tel: +49 (0)30 229 24 37
www.maxhetzler.com

Luhring Augustine
531 West 24th Street
US – New York, NY 10011
Tel: +1 212 206 91 00
www.luhringaugustine.com

Albert Oehlen, Born To Be Late, 2001

Galerie Nathalie Obadia
3, rue du Cloître Saint-Merri
F – 75004 Paris
Tel: +33 (0)1 42 74 67 68
www.galerie-obadia.com

Galería Juana de Aizpuru
Calle Barquillo, 44
E – 28004 Madrid
Tel: +34 (0)91 310 55 61
www.juanadeaizpuru.com

Thomas Dane Gallery
11 Duke Street
GB – London SW1Y 6BN
Tel: +44 (0)20 79 25 25 05
www.thomasdane.com

Skarstedt Gallery
20 East 79th Street
US – New York, NY 10075
Tel: +1 212 737 20 60
www.skarstedt.com

PRIMARY MARKET PRICES →
$42.000–$490.000

AUCTION SALES →
Price: $552.000
Born To Be Late, 2001
Inkjet ink with oil and enamel
on canvas, 330 x 340 cm
Date sold: 26-Feb-07
Auction house: Christie's, New York

Price: $519.685
Ohne Titel (Gelbes Kreuz), 1988
Oil on canvas, 195 x 195 cm
Date sold: 07-Feb-07
Auction house: Sotheby's, London

Price: $478.182
Schuhe, Kleidung, Tonbehälter
1993–99
Oil on printed fabric, 146 x 114 cm
Date sold: 22-Jun-07
Auction house: Sotheby's,
London

Price: $458.867
Peon, 1986–96
Oil on canvas, 191,5 x 191,5 cm
Date sold: 14-Oct-06
Auction house: Sotheby's,
London

Price: $456.000
Spitzer Spion, 2000
Oil on canvas, 243,2 x 243,2 cm
Date sold: 17-May-07
Auction house:
Phillips de Pury & Company,
New York

CHRIS OFILI

REPRESENTATION →
Contemporary Fine Arts
Am Kupfergraben 10
D – 10117 Berlin
Tel: +49 (0)30 288 78 70
www.cfa-berlin.com

Victoria Miro Gallery
16 Wharf Road
GB – London N1 7RW
Tel: +44 (0)20 73 36 81 09
www.victoria-miro.com

David Zwirner
525 West 19th Street
US – New York, NY 10011
Tel: +1 212 727 20 70
www.davidzwirner.com

PRIMARY MARKET PRICES →
Upon request

AUCTION SALES →
Price: $1.001.600
Afrodizzia, 1996
Paper collage, oil paint, glitter,
polyester resin, map pins,
elephant dung on canvas,
243.8 x 182.9 cm
Date sold: 12-May-05
Auction house: Phillips de Pury &
Company, New York

Price: $656.692
Strange Eyes, 2001
Oil paint, polyester resin,
elephant dung, map pins, glitter
on canvas, 194.9 x 121.9 x 26 cm
Date sold: 07-Feb-07
Auction house: Sotheby's, London

Price: $649.056
Rarra Azizah Dilberta, 1994
Acrylic, oil resin, plastic beads,
elephant dung on canvas,
191.3 x 122.6 cm
Date sold: 14-Oct-06
Auction house: Phillips de Pury &
Company, New York

Price: $608.849
Nooca, 1999
Oil, acrylic, paper collage, resin,
elephant dung, glitter, beads on
canvas, 189.2 x 121.9 x 16.5 cm
Date sold: 23-Oct-05
Auction house: Christie's, London

Price: $385.805
Rara and Mala, 1994
Acrylic, oil, resin, elephant dung
on canvas, 193 x 121.2 x 16 cm
Date sold: 01-Jul-08
Auction house: Sotheby's, London

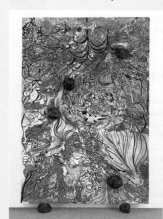
Chris Ofili, Afrodizzia, 1996

PAULINA OLOWSKA

REPRESENTATION →
Galerie Daniel Buchholz
Neven-DuMont-Straße 17
D – 50667 Köln
Tel: +49 (0)221 257 49 46
www.galeriebuchholz.de

Metro Pictures
519 West 24th Street
US – New York, NY 10011
Tel: +1 212 206 71 00
www.metropictures.com

PRIMARY MARKET PRICES →
Upon request

GABRIEL OROZCO

REPRESENTATION →
Galerie Chantal Crousel
10, rue Charlot
F – 75003 Paris
Tel: +33 (0)1 42 77 38 87
www.crousel.com

Marian Goodman Gallery
24 West 57th Street
US – New York, NY 10019
Tel: +1 212 977 71 60
www.mariangoodman.com

kurimanzutto
Mazatlán 5, Depto. T-6, Colonia
Condesa
MX – 06140 México D.F.
Tel: +52 55 52 86 30 59
www.kurimanzutto.com

White Cube
48 Hoxton Square
GB – London N1 6PB
Tel: +44 (0)20 79 30 53 73
www.whitecube.com

PRIMARY MARKET PRICES →
Upon request

AUCTION SALES →
Price: $308.000
Samurai Tree 1Q, 2007
Tempura, burnished gold leaf
on canvas, 75 x 75 cm
Date sold: 14-Feb-08
Auction house: Sotheby's,
New York

Price: $208.029
Horses running endlessly, 1995
Wood, 65 parts, 2 x 88 x 88 cm
Date sold: 23-Jun-05
Auction house: Christie's,
London

Price: $180.135
Samurai Tree 3L, 2006
Egg tempera and gold leaf on
wooden panel, 55 x 55 cm
Date sold: 03-Apr-08
Auction house: Phillips de Pury &
Company, London

Price: $162.000
Atomists: Making Strides, 1996
Computer generated plastic-
coated print, 2 parts,
199.5 x 198 cm
Date sold: 05-May-06

Auction house: Christie's,
New York

Price: $117.600
Pelotas y Platanos, 1990–94
Cibachrome print, 7 works,
various sizes
Date sold: 09-Nov-04
Auction house: Phillips de Pury &
Company, New York

Jorge Pardo, Untitled (3), 2000

JORGE PARDO

REPRESENTATION →
neugerriemschneider
Linienstraße 155
D – 10115 Berlin
Tel: +49 (0)30 28 87 72 77
www.neugerriemschneider.com

Friedrich Petzel Gallery
535 West 22nd Street
US – New York, NY 10011
Tel: +1 212 680 94 67
www.petzel.com

PRIMARY MARKET PRICES →
$5.000–$250.000

AUCTION SALES →
Price: $156.000
Untitled (1–5), 2000
Silkscreen on canvas,
250 x 400 cm
Date sold: 12-May-05
Auction house: Phillips de Pury &
Company, New York

Price: $119.500
Untitled, 1999
Acrylic on canvas, 250 x 400 cm
Date sold: 13-Nov-03
Auction house: Phillips de Pury &
Luxembourg, New York

Price: $72.000
Untitled, 2002
Inkjet print on canvas, 10 panels,
210 x 370 cm
Date sold: 10-May-06
Auction house: Christie's,
New York

Price: $51.400
Untitled (8 Lamps), 1998
Glass and metal, 8 works,
each 28.5 cm, overall
325.1 x 299.7 cm
Date sold: 10-Sep-07
Auction house: Christie's,
New York

Price: $28.800
Tubular, 2004
Hand woven tapestry,
245.1 x 316.2 cm
Date sold: 14-Mar-06
Auction house:
Phillips de Pury & Company,
New York

MANFRED PERNICE

REPRESENTATION →
Anton Kern Gallery
532 West 20th Street
US – New York, NY 10011
Tel: +1 212 367 96 63
www.antonkerngallery.com

Stella Lohaus Gallery
Vlaamse Kaai 47
B – 2000 Antwerpen
Tel: +32 (0)3 248 08 71
www.stellalohausgallery.com

Mai 36 Galerie
Rämistrasse 37
CH – 8001 Zürich
Tel: +41 (0)44 261 68 80
www.mai36.com

The Modern Institute
73 Robertson Street
GB – Glasgow G2 8QD
Tel: +44 (0)141 24 83 71 12 48
www.themoderninstitute.com

Galerie Neu
Philippstraße 13
D – 10115 Berlin
Tel: +49 (0)30 285 75 50
www.galerieneu.com

Regen Projects
633 North Almont Drive
US – Los Angeles, CA 90069
Tel: +1 310 276 54 24
www.regenprojects.com

PRIMARY MARKET PRICES →
Upon request

RAYMOND PETTIBON

REPRESENTATION →
Contemporary Fine Arts
Am Kupfergraben 10
D – 10117 Berlin
Tel: +49 (0)30 288 78 70
www.cfa-berlin.com

Xavier Hufkens
Rue Saint-Georges 6–8
B – 1050 Bruxelles
Tel: +32 (0)2 639 67 30
www.xavierhufkens.com

Regen Projects
633 North Almont Drive
US – Los Angeles, CA 90069

Tel: +1 310 276 54 24
www.regenprojects.com

David Zwirner
525 West 19th Street
US – New York, NY 10011
Tel: +1 212 727 20 70
www.davidzwirner.com

PRIMARY MARKET PRICES →
Upon request

AUCTION SALES →
Price: $744.000
Self-Portrait as Goofy-Foot, 2000
Acrylic on paper, 203.2 x 200.7 cm
Date sold: 11-May-06
Auction house: Sotheby's,
New York

Price: $144.000
Untitled (Asea... My Secret Spot),
2003
Acrylic, watercolour, gouache, ink,
76.2 x 56.8 cm
Date sold: 16-May-07
Auction house: Sotheby's,
New York

Price: $119.801
Untitled (Nature Has Given), 2007
Acrylic, ink, gouache, 171 x 80 cm
Date sold: 28-Feb-08
Auction house: Sotheby's, London

Price: $79.000
Untitled (The Perspective Had
Never Seemed So Steep), 1988
Oil on canvas, 122 x 152.5 cm
Date sold: 12-Sep-07
Auction house: Sotheby's,
New York

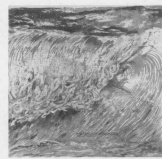

Raymond Pettibon, Self-Portrait as
Goofy-Foot, 2000

Price: $69.818
Untitled (A Big Wave Came), 1991
Ink, watercolour, 11 works, 7 dated
1989/99, 76 x 57 cm
Date sold: 24-Jun-04
Auction house: Sotheby's, London

ELIZABETH PEYTON

REPRESENTATION →
neugerriemschneider

Linienstraße 155
D – 10115 Berlin
Tel: +49 (0)30 28 87 72 77
www.neugerriemschneider.com

Gavin Brown's enterprise
620 Greenwich Street
US – New York, NY 10014
Tel: +1 212 627 52 58
www.gavinbrown.biz

Sadie Coles HQ
35 Heddon Street
GB – London W1B 4BP
Tel: +44 (0)20 74 34 22 27
www.sadiecoles.com

Regen Projects
633 North Almont Drive
US – Los Angeles, CA 90069
Tel: +1 310 276 54 24
www.regenprojects.com

PRIMARY MARKET PRICES →
$4.000 – $300.000

AUCTION SALES →
Price: $856.000
Colin De Land, 1994
Oil on canvas, 152.4 x 101.6 cm
Date sold: 08-Nov-05
Auction house: Christie's,
New York

Price: $818.113
Princes William and Harry, 1999
Oil on linen, 101.6 x 76.2 cm
Date sold: 14-Oct-06
Auction house: Phillips de Pury &
Company, New York

Price: $800.000
John Lennon 1964, 1996
Oil on masonite, 61.2 x 48.5 cm
Date sold: 11-May-05
Auction house: Christie's,
New York

Price: $769.000
Kurt Cobain, 1995
Acrylic on canvas, 40.6 x 30.5 cm
Date sold: 13-May-08
Auction house: Christie's,
New York

Price: $741.000
Jarvis (Dancing), 1996
Oil on canvas, 61.5 x 45.7 cm
Date sold: 15-May-08
Auction house: Sotheby's,
New York

RICHARD PHILLIPS

REPRESENTATION →
Gagosian Gallery
555 West 24th Street
US – New York, NY 10011
Tel: +1 212 741 11 11
www.gagosian.com

Galerie Max Hetzler
Zimmerstraße 90/91
D – 10117 Berlin
Tel: +49 (0)30 229 24 37
www.maxhetzler.com

White Cube
48 Hoxton Square
GB – London N1 6PB
Tel: +44 (0)20 79 30 53 73
www.whitecube.com

PRIMARY MARKET PRICES →
$25.000 – $375.000

AUCTION SALES →
Price: $384.000
Lippen Beisser, 1999
Oil on canvas, 121.9 x 110.5 cm
Date sold: 17-May-07
Auction house:
Phillips de Pury & Company,
New York

Price: $300.000
Blessed Mother, 2000
Oil on canvas, 213.4 x 182.9 cm
Date sold: 16-May-07
Auction house: Sotheby's,
New York

Price: $217.000
Strawberry Eater, 1999
Oil on canvas, 198.1 x 160 cm
Date sold: 15-May-08
Auction house: Sotheby's,
New York

Price: $142.400
President of the United States
of America, 2001
Oil on canvas, 262.9 x 396.2 cm
Date sold: 09-Nov-04
Sotheby's, New York

Price: $132.055
Double, 1996/97
Oil on canvas, 213.4 x 157.5 cm
Date sold: 06-Feb-07
Auction house:
Phillips de Pury & Company,
London

RICHARD PRINCE

REPRESENTATION →
Sadie Coles HQ
35 Heddon Street
GB – London W1B 4BP
Tel: +44 (0)20 74 34 22 27
www.sadiecoles.com

Barbara Gladstone Gallery
515 West 24th Street
US – New York, NY 10011
Tel: +1 212 206 93 00
www.gladstonegallery.com

Regen Projects
633 North Almont Drive

US – Los Angeles, CA 90069
Tel: +1 310 276 54 24
www.regenprojects.com

PRIMARY MARKET PRICES →
Upon request

AUCTION SALES →
Price: $8.467.258
Overseas Nurse, 2002
Ink-jet print, acrylic on canvas,
236.2 x 142.2 cm
Date sold: 01-Jul-08
Auction house: Sotheby's,
London

Price: $7.433.000
Man-Crazy Nurse No. 2, 2002
Ink-jet print, acrylic on canvas,
198.1 x 147.3 cm
Date sold: 13-May-08
Auction house: Christie's,
New York

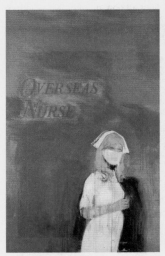

Richard Prince, Overseas Nurse, 2002

Price: $6.089.000
Piney Woods Nurse, 2002
Ink-jet print, acrylic on canvas,
203.2 x 132.1 cm
Date sold: 13-Nov-07
Auction house: Christie's,
New York

Price: $4.745.000
Millionaire Nurse, 2002
Ink-jet print, acrylic on canvas,
147.3 x 91.4 cm
Date sold: 14-May-08
Auction house: Sotheby's,
New York

Price: $4.297.000
Registered Nurse, 2002
Ink-jet print, acrylic on canvas,
162.6 x 106.7 cm
Date sold: 15-Nov-07
Auction house:
Phillips de Pury & Company,
New York

NEO RAUCH

REPRESENTATION →
Galerie EIGEN + ART
Auguststraße 26
D–10117 Berlin
Tel: +49 (0)30 280 66 05
www.eigen-art.com

David Zwirner
525 West 19th Street
US–New York, NY 10011
Tel: +1 212 727 20 70
www.davidzwirner.com

PRIMARY MARKET PRICES →
$140.000–$600.000

AUCTION SALES →
Price: $844.444
Losung, 1998
Oil on canvas, 300 x 200 cm
Date sold: 21-Jun-06
Auction house: Sotheby's, London

Price: $768.000
Tal, 1999
Oil on canvas, 200 x 250.2 cm
Date sold: 17-May-07
Auction house: Christie's,
New York

Price: $729.038
Erwerb, 1998
Oil on canvas, 100 x 70 cm
Date sold: 12-Oct-07
Auction house: Sotheby's, London

Price: $726.217
Süd, 2002
Oil on canvas, 160 x 140 cm
Date sold: 14-Oct-07
Auction house: Christie's, London

Price: $712.000
Kamin, 2000
Oil on canvas, 100 x 70 cm
Date sold: 17-May-07
Auction house:
Phillips de Pury & Company,
New York

TOBIAS REHBERGER

REPRESENTATION →
neugerriemschneider
Linienstraße 155
D–10115 Berlin
Tel: +49 (0)30 28 87 72 77
www.neugerriemschneider.com

Friedrich Petzel Gallery
535 West 22nd Street
US–New York, NY 10011
Tel: +1 212 680 94 67
www.petzel.com

Giò Marconi
Via Tadino, 15
I–20124 Milano

Tel: +39 02 29 40 43 73
www.giomarconi.com

Galerie Micheline Szwajcer
Verlatstraat 14
B–2000 Antwerpen
Tel: +32 (0)3 237 11 27
www.gms.be

PRIMARY MARKET PRICES →
$6.500–$268.000

AUCTION SALES →
Price: $31.698
Cutting Library, 2000
MDF, laminate, television,
316.2 x 100 x 40 cm
Date sold: 14-Oct-06
Auction house: Phillips de Pury &
Company, New York

Price: $26.400
Suck. Watch. Sucked. Watched,
1999
Two monitors, speakers,
styrofoam, cables, fleece, foam,
wood, 160 x 160 x 90.5 cm
Date sold: 12-Nov-04
Auction house: Phillips de Pury &
Company, New York

Price: $24.528
Untitled, 2003
Velcro tape, metal ring, cable
socket, bulb, 3 works, dimensions
variable, 50 x 35 x 19 cm
Date sold: 13-Oct-06
Auction house: Sotheby's,
London

Price: $19.200
Arroyo grande 30.04.02–18.08.02
–#20 (+ 4 others; 5 works), 2002
Velcro tape, cable socket, bulb,
61.6 x 23.5 x 24.8 cm
Date sold: 27-Feb-07
Auction house:
Phillips de Pury & Company,
New York

Tobias Rehberger, Cutting Library,
2000

Price: $3.600
Starship Trooper, 1998
Velcro tape, cable socket, bulb,
173.4 x 123.2 cm
Date sold: 14-Mar-06
Auction house: Phillips de Pury &
Company, New York

ANSELM REYLE

REPRESENTATION →
Gagosian Gallery
555 West 24th Street
US–New York, NY 10011
Tel: +1 212 741 11 11
www.gagosian.com

Galerie Almine Rech
Avenue Victoria 11
B–1000 Bruxelles
Tel: +32 (0)2 648 56 84
www.galeriealminerech.com

The Modern Institute
73 Robertson Street
GB–Glasgow G2 8QD
Tel: +44 (0)141 24 83 71 12 48
www.themoderninstitute.com

Andersen S Contemporary
Klubiensvej 22
DK–2100 Copenhagen
Tel: +45 4697 84 37
www.andersen-s.dk

PRIMARY MARKET PRICES →
$58.000–$272.000 (paintings)
$94.000–$2.900.000 (sculptures)

AUCTION SALES →
Price: $634.956
Untitled, 2004
Acrylic, aluminium foil on canvas,
390 x 265 cm
Date sold: 14-Oct-07
Auction house: Christie's, London

Price: $621.312
Untitled, 2006
Acrylic, PVC foil on canvas in
acrylic glass box,
234.5 x 200 x 26.2 cm
Date sold: 27-Feb-08
Auction house: Sotheby's, London

Price: $489.916
Untitled, 2006
Oil, PVC foil, Perspex on canvas,
230 x 190 cm
Date sold: 15-Oct-07
Auction house: Sotheby's,
London

Price: $409.762
Untitled, 2005
Oil, PVC foil, acrylic glass on
canvas, 227 x 332 cm
Date sold: 01-Jul-08
Auction house: Sotheby's,
London

Anselm Reyle, Untitled, 2004

Price: $397.783
Untitled, 2005
Oil, PVC foil, mirrored Plexiglas on
canvas, 227.4 x 332 cm
Date sold: 01-Jul-08
Auction house: Christie's, London

DANIEL RICHTER

REPRESENTATION →
Contemporary Fine Arts
Am Kupfergraben 10
D–10117 Berlin
Tel: +49 (0)30 288 78 70
www.cfa-berlin.com

Regen Projects
633 North Almont Drive
US–Los Angeles, CA 90069
Tel: +1 310 276 54 24
www.regenprojects.com

David Zwirner
525 West 19th Street
US–New York, NY 10011
Tel: +1 212 727 20 70
www.davidzwirner.com

PRIMARY MARKET PRICES →
$14.500–$362.500

AUCTION SALES →
Price: $824.000
Die wieder da sind, 2002
Oil, lacquer on canvas,
259 x 339 cm
Date sold: 15-May-07
Auction house: Christie's,
New York

Price: $770.829
Trevelfast, 2004
Oil on canvas, 282.9 x 232.1 cm
Date sold: 13-Oct-07
Auction house: Phillips de Pury &
Company, London

Price: $543.396
Süden, 2002

Daniel Richter, Die wieder da sind, 2002

Oil on canvas, 289 x 300 cm
Date sold: 15-Oct-06
Auction house: Christie's, London

Price: $481.000
Grünspan (fertig ist die Möhre), 2002
Oil, lacquer on canvas, 288.3 x 294.6 cm
Date sold: 15-Nov-07
Auction house: Phillips de Pury & Company, New York

Price: $450.370
Über die Toten nichts Schlechtes, 2001
Oil, lacquer on canvas, 224.7 x 146.7 cm
Date sold: 21-Jun-06
Auction house: Sotheby's, London

THOMAS RUFF

REPRESENTATION →
Johnen Galerie
Schillingstraße 31
D – 10179 Berlin
Tel: +49 (0)30 27 58 30 30
www.johnengalerie.de

Johnen + Schöttle
Maria-Hilf-Straße 17
D – 50677 Köln
Tel: +49 (0)221 31 02 70
www.johnen-schoettle.de

Mai 36 Galerie
Rämistrasse 37
CH – 8001 Zürich
Tel: +41 (0)44 261 68 80
www.mai36.com

Galerie Rüdiger Schöttle
Amalienstraße 41
D – 80799 München

Tel: +49 (0)89 33 36 86
www.galerie-ruediger-schoettle.de

David Zwirner
525 West 19th Street
US – New York, NY 10011
Tel: +1 212 727 20 70
www.davidzwirner.com

PRIMARY MARKET PRICES →
$29.000–$181.000

AUCTION SALES →
Price: $203.227
Substrat 10 III, 2003
Inkjet print face mounted on Diasec, 325.1 x 184.5 cm
Date sold: 21-Jun-07
Auction house: Christie's, London

Price: $169.000
nudes br16, 2004
C-print mounted on Diasec, 110.2 x 153.7 cm
Date sold: 16-May-08
Auction house: Phillips de Pury & Company, New York

Price: $167.326
gr 20, 2003
C-print mounted on Diasec, 109.9 x 165.1 cm
Date sold: 29-Feb-08
Auction house: Phillips de Pury & Company, London

Price: $165.354
nudes KY 02, 2003
Laserchrome print mounted on Diasec, 153 x 119.3 cm
Date sold: 08-Feb-07
Auction house: Sotheby's, London

Price: $156.000
nudes Pea 10, 1999
C-print mounted on Diasec,

101.6 x 129.5 cm
Date sold: 11-May-06
Auction house: Sotheby's, New York

ANRI SALA

REPRESENTATION →
Galerie Chantal Crousel
10, rue Charlot
F – 75003 Paris
Tel: +33 (0)1 42 77 38 87
www.crousel.com

Marian Goodman Gallery
24 West 57th Street
US – New York, NY 10019
Tel: +1 212 977 71 60
www.mariangoodman.com

Hauser & Wirth
Limmatstrasse 270
CH – 8005 Zürich
Tel: +41 (0)44 446 80 50
www.hauserwirth.com

Johnen + Schöttle
Maria-Hilf-Straße 17
D – 50677 Köln
Tel: +49 (0)221 31 02 70
www.johnen-schoettle.de

PRIMARY MARKET PRICES →
Upon request

AUCTION SALES →
Price: $7.425
A Place for Sheep and Games, 2004
C-print flush, mounted on aluminium, 102 x 152 cm
Date sold: 29-Feb-08
Auction house: Phillips de Pury & Company, London

Price: $7.420
31°-131, 2003
Photograph, 120.5 x 160 cm
Date sold: 04-Apr-07
Auction house: Artcurial Briest Le Fur Poulain F. Tajan, Paris

Price: $7.383
Casa Zoo III, 2001
Colour photograph mounted on aluminium, 110 x 165 cm
Date sold: 08-Jun-04
Auction house: Artcurial Briest Le Fur Poulain F. Tajan, Paris

WILHELM SASNAL

REPRESENTATION →
Anton Kern Gallery
532 West 20th Street
US – New York, NY 10011
Tel: +1 212 367 96 63
www.antonkerngallery.com

Hauser & Wirth
Limmatstrasse 270
CH – 8005 Zürich
Tel: +41 (0)44 446 80 50
www.hauserwirth.com

Sadie Coles HQ
35 Heddon Street
GB – London W1B 4BP
Tel: +44 (0)20 74 34 22 27
www.sadiecoles.com

Johnen + Schöttle
Maria-Hilf-Straße 17
D – 50677 Köln
Tel: +49 (0)221 31 02 70
www.johnen-schoettle.de

Fundacja Galerii Foksal
Górskiego 1A
PL – 00-033 Warsaw
Tel: +48 (0)22 826 50 81
www.fgf.com.pl

PRIMARY MARKET PRICES →
Upon request

AUCTION SALES →
Price: $457.676
Girls Smoking, Anka, Dominika, Peaches, 2001
Oil on canvas, set of 3, Anka: 33 x 33 cm; Dominika: 33 x 33 cm; Peaches: 33 x 33 cm
Date sold: 29-Jun-08
Auction house: Phillips de Pury & Company, London

Price: $396.000
Airplanes, 1999
Oil on canvas, diptych, 150 x 299.7 cm
Date sold: 16-May-07
Auction house: Christie's, New York

Price: $217.000
Factory, 2000
Oil on canvas, 101 x 101 cm
Date sold: 15-May-08
Auction house: Phillips de Pury & Company, New York

Wilhelm Sasnal, Girls Smoking, Peaches, 2001

Price: $216.000
UFO, 2002
Oil on canvas, 149.9 x 149.9 cm
Date sold: 16-Nov-06
Auction house: Phillips de Pury &
Company, New York

Price: $204.000
Untitled (Plane and Bombs), 2001
Oil on canvas, 139.7 x 180.3 cm
Date sold: 11-May-06
Auction house: Phillips de Pury &
Company, New York

MATTHIAS SCHAUFLER

REPRESENTATION →
Galerie Hammelehle und Ahrens
An der Schanz 1a
D – 50735 Köln
Tel: +49 (0)221 287 08 00
www.haah.de

Patrick Painter Inc.
2525 Michigan Avenue
US – Santa Monica, CA 90404
Tel: +1 310 264 59 88
www.patrickpainter.com

PRIMARY MARKET PRICES →
$7.000–$30.000

THOMAS SCHEIBITZ

REPRESENTATION →
Tanya Bonakdar Gallery
521 West 21st Street
US – New York, NY 10011
Tel: +1 212 414 41 44
www.tanyabonakdargallery.com

Monika Sprüth Philomene Magers
Wormser Straße 23
D – 50677 Köln
Tel: +49 (0)221 38 04 15
www.spruethmagers.com

Produzentengalerie Hamburg
Admiralitätstraße 71
D – 20459 Hamburg
Tel: +49 (0)40 37 82 32
www.produzentengalerie.com

PRIMARY MARKET PRICES →
$6.000–$200.000

AUCTION SALES →
Price: $307.200
Douglas, 1999
Oil on canvas, 228.5 x 150 cm
Date sold: 16-Mar-06
Auction house: Christie's,
New York

Price: $283.464
Anlage, 2000
Oil on canvas, 200.4 x 270.5 cm
Date sold: 08-Feb-07
Auction house: Christie's, London

Thomas Scheibitz, Douglas, 1999

Price: $262.376
Familienbild, 2000
Oil on canvas, 199.5 x 280.5 cm
Date sold: 28-Feb-08
Auction house: Phillips de Pury &
Company, London

Price: $226.415
Brillux, 1999
Oil on canvas, 200 x 150 cm
Date sold: 15-Oct-06
Auction house: Christie's, London

Price: $186.131
Vogel, 2000
Oil on canvas, 230 x 150 cm
Date sold: 23-Jun-05
Auction house: Christie's, London

GREGOR SCHNEIDER

REPRESENTATION →
Sadie Coles HQ
35 Heddon Street
GB – London W1B 4BP
Tel: +44 (0)20 74 34 22 27
www.sadiecoles.com

Konrad Fischer Galerie
Platanenstraße 7
D – 40233 Düsseldorf
Tel: +49 (0)211 68 59 08
www.konradfischergalerie.de

Barbara Gladstone Gallery
515 West 24th Street
US – New York, NY 10011
Tel: +1 212 206 93 00
www.gladstonegallery.com

Galleria Massimo De Carlo
Via Giovanni Ventura, 5
I – 20134 Milano
Tel: +39 02 70 00 39 87
www.massimodecarlo.it

Wako Works of Art
3-18-2-101/103, Nishi-Shinjuku,

Shinjuku-ku
JP – Tokyo 160-0023
Tel: +81 (0)3 33 73 28 60
www.wako-art.jp

PRIMARY MARKET PRICES →
Upon request

AUCTION SALES →
Price: $117.735
Nacht, Totes Haus Ur, 2001
Wood, glass, paint on wooden
support, 134.6 x 108 x 3.5 cm
Date sold: 14-Oct-06
Auction house: Phillips de Pury &
Company, New York

Price: $98.323
Man with Cock, 2004
Cast rubber, expanding foam,
garbage bag, clothing,
30 x 62 x 190 cm
Date sold: 29-Jun-08
Auction house: Phillips de Pury &
Company, London

Raqib Shaw, Garden of Earthly Delights III, 2003

Price: $82.677
Blutrotes Fenster, 2001
Wood, glass, enamel on wood,
133 x 108 x 6 cm
Date sold: 06-Feb-07
Auction house:
Phillips de Pury & Company,
London

Price: $66.384
Kellerfenster, 1985–2001
Installation with wood, plaster,
cement metal grill, brackets,
237 x 135 x 47.5 cm
Date sold: 06-Feb-02
Auction house: Christie's,
London

Price: $35.897
Totes Haus Ur Rheydt, 1999
Gelatin silver prints, 34 works,
17.9 x 12.8 cm
Date sold: 02-Jun-06
Auction house: Christie's,
London

RAQIB SHAW

REPRESENTATION →
White Cube
48 Hoxton Square
GB – London N1 6PB
Tel: +44 (0)20 79 30 53 73
www.whitecube.com

PRIMARY MARKET PRICES →
Upon request

AUCTION SALES →
Price: $5.538.854
Garden of Earthly Delights III, 2003
Acrylic, glitter, enamel,
rhinestones, mixed media on
board, 3 parts, 305 x 152.5 cm
Date sold: 12-Oct-07
Auction house: Sotheby's, London

Price: $357.425
Untitled (Garden of Earthly
Delights), 2004
Acrylic, glitter, enamel, mixed

media on board, 42 x 59.5 cm
Date sold: 28-Feb-08
Auction house: Sotheby's, London

Price: $ 206.128
Chrysanthemum and Bee (after
Katsushika Hokusai), 2001
Metallic paint, enamel, glitter on
panel, 61 x 91.4 cm
Date sold: 02-Jul-08
Auction house: Sotheby's, London

Price: $144.000
Hanga Irises and Grasshopper
(after Katsushika Hokusai), 2001
Acrylic, metallic paint, glitter,
rhinestone on panel,
45,7 x 60.8 cm
Date sold: 16-May-07
Auction house: Sotheby's,
New York

Price: $91.000
Untitled, 2004
Acrylic, metallic paint, graphite,

glitter rhinestones, 43,2 x 61 cm
Date sold: 15-May-08
Auction house: Sotheby's,
New York

CINDY SHERMAN

REPRESENTATION →
Metro Pictures
519 West 24th Street
US – New York, NY 10011
Tel: +1 212 20 67 1 00
www.metropictures.com

Monika Sprüth Philomene Magers
Wormser Straße 23
D – 50677 Köln
Tel: +49 (0)221 38 04 15
www.spruethmagers.com

PRIMARY MARKET PRICES →
Upon request

Cindy Sherman, Untitled (#92), 1981

AUCTION SALES →
Price: $2.112.000
Untitled (#92), 1981
C-print, 58.9 x 120.1 cm
Date sold: 16-May-07
Auction house: Christie's,
New York

Price: $1.217.000
Untitled Film Still (#48), 1979
Gelatin silver print, 40.6 x 50.8 cm
Date sold: 13-Nov-07
Auction house: Christie's,
New York

Price: $1.008.684
Untitled (#209), 1989
C-print, 147.4 x 106 cm
Date sold: 29-Jun-08
Auction house: Phillips de Pury &
Company, London

Price: $665.600
Untitled (#209), 1989
C-print, 147.4 x 106.7 cm
Date sold: 16-Nov-06
Auction house: Christie's,
New York

Price: $553.000
Untitled (#204), 1989
C-print, 136.5 x 135.3 cm

Date sold: 14-May-08
Auction house: Christie's,
New York

SANTIAGO SIERRA

REPRESENTATION →
Galería Helga de Alvear
Doctor Fourquet 12
E – 28012 Madrid
Tel: +34 (0)91 468 05 06
www.helgadealvear.com

Lisson Gallery
52–54 Bell Street
GB – London, NW1 5DA
Tel: + 44 (0)20 77 24 27 39
www.lissongallery.com

Prometeogallery
Via Giovanni Ventura, 3
I – 20134 Lambrate, Milano

Tel: +39 02 26 92 44 50
www.prometeogallery.com

PRIMARY MARKET PRICES →
$29.000–$87.000

DASH SNOW

REPRESENTATION →
Contemporary Fine Arts
Am Kupfergraben 10
D – 10117 Berlin
Tel: +49 (0)30 288 78 70
www.cfa-berlin.com

Peres Projects
969 Chung King Road
US – Los Angeles, CA 90012
Tel: +1 213 617 11 00
www.peresprojects.com

PRIMARY MARKET PRICES →
Upon request

AUCTION SALES →
Price: $8.750
Incest the Game the Whole
Family Can Play, 2006
Photograph, record player, hand
painted cinderblocks,
121.9 x 76.2 cm

Date sold: 16-May-08
Auction house: Phillips de Pury &
Company, New York

RUDOLF STINGEL

REPRESENTATION →
Galleria Massimo De Carlo
Via Giovanni Ventura, 5
I – 20134 Milano
Tel: +39 02 70 00 39 87
www.massimodecarlo.it

Sadie Coles HQ
35 Heddon Street
GB – London W1B 4BP
Tel: +44 (0)20 74 34 22 27
www.sadiecoles.com

Paula Cooper Gallery
534 West 21st Street
US – New York, NY 10011
Tel: +1 212 255 11 05
www.paulacoopergallery.com

PRIMARY MARKET PRICES →
$100.000–$700.000

AUCTION SALES →
Price: $1.945.000
Untitled, 2000
Styrofoam, 4 parts,
242.6 x 485.1 cm
Date sold: 15-Nov-07
Auction house: Phillips de Pury &
Company, New York

Price: $1.217.000
Untitled, 1989
Oil on canvas, 254 x 170.2 cm
Date sold: 13-Nov-07
Auction house: Christie's,
New York

Price: $972.079
Untitled, 2002
Insulation board, wood,
aluminium, 2 parts, 240 x 235 cm
Date sold: 28-Feb-08
Auction house:
Phillips de Pury & Company,
London

Price: $931.400
Untitled, 2004
Oil, enamel on canvas, 2 parts,
200.7 x 149.9 cm
Date sold: 16-Nov-07
Auction house:
Phillips de Pury & Company,
New York

Price: $883.366
Untitled (Silver Mesh), 1989
Oil, enamel on canvas,
250.1 x 180.3 cm
Date sold: 28-Feb-08
Auction house:
Phillips de Pury & Company,
London

THOMAS STRUTH

REPRESENTATION →
Marian Goodman Gallery
24 West 57th Street
US – New York, NY 10019
Tel: +1 212 977 71 60
www.mariangoodman.com

Galerie Max Hetzler
Zimmerstraße 90/91
D – 10117 Berlin
Tel: +49 (0)30 229 24 37
www.maxhetzler.com

Galerie Rüdiger Schöttle
Amalienstraße 41
D – 80799 München
Tel: +49 (0)89 33 36 86
www.galerie-ruediger-schoettle.de

Galerie Paul Andriesse
Gebouw Detroit,
Withoedenveem 8
NL – 1019 HE Amsterdam
Tel: +31 (0)20 623 62 37
www.galeries.nl/andriesse

Monica De Cardenas
Via Francesco Viganò, 4
I – 20124 Milano
Tel: +39 02 29 01 00 68

Galerie Greta Meert
Rue du Canal 13
B – 1000 Bruxelles
Tel: +32 (0)2 219 14 22
www.galeriegretameert.com

PRIMARY MARKET PRICES →
$9.400–$822.000

AUCTION SALES →
Price: $1.049.000
Pantheon, Rome, 1990
Cibachrome print, 184.2 x
238.2 cm
Date sold: 13-Nov-07
Auction house: Christie's, New York

Price: $902.766
National Museum of Art, Tokyo,
1999
Cibachrome print, 179.5 x 277 cm
Date sold: 21-Jun-07
Auction house: Sotheby's, London

Price: $892.200
Pantheon, Rome, 1990
Cibachrome print,

Thomas Struth, Pantheon, Rome, 1990

184.2 x 238.2 cm
Date sold: 15-May-08
Auction house: Sotheby's,
New York

Price: $840.293
Mailänder Dom, Fassade, 1998
C-print mounted on Plexiglas,
189.2 x 235 cm
Date sold: 14-Oct-07
Auction house: Christie's, London

Price: $816.831
Self-Portrait, Alte Pinakothek, 2000
C-print, 158.4 x 187 cm
Date sold: 28-Feb-08
Auction house: Phillips de Pury &
Company, London

Wolfgang Tillmans, Installation (10 works of 17), 1999

Mirrors, birch plywood, stove,
wok, gas canister,
27.9 x 71.8 x 54.6 cm
Date sold: 16-Nov-07
Auction house: Phillips de Pury &
Company, New York

Price: $18.000
Atlas, 1995
Silkscreen inks on tent, tent
cover, tent bag, tent poles, tent
pole bag, metal stakes,
149.8 x 259 x 124.4 cm
Date sold: 13-Sep-06
Auction house: Christie's,
New York

Price: $16.730
Untitled, 1995
C-print, 20.3 x 25.4 cm
Date sold: 15-May-03
Auction house: Christie's,
New York

MICKALENE THOMAS

REPRESENTATION →
Rhona Hoffman Gallery
118 North Peoria Street
US – Chicago, IL 60607
Tel: +1 312 455 19 90
www.rhoffmangallery.com

Lehmann Maupin Gallery
540 West 26 Street
US – New York, NY 10001
Tel: +1 212 255 29 23
www.lehmannmaupin.com

Susanne Vielmetter
Los Angeles Projects
5795 West Washington Boulevard
US – Culver City, CA 90232
Tel: +1 323 933 21 17
www.vielmetter.com

PRIMARY MARKET PRICES →
$20.000–$80.000

AUCTION SALES →
Price: $36.000
Looking Up (She Works Hard for
the Money Pin-up Series), 2004
Rhinestones, acrylic paint, oil
enamel on woodpanel,
121.9 x 91.4 x 4.4 cm
Date sold: 18-May-07
Auction house: Phillips de Pury &
Company, New York

WOLFGANG TILLMANS

REPRESENTATION →
Galerie Daniel Buchholz
Neven-DuMont-Straße 17
D – 50667 Köln
Tel: +49 (0)221 257 49 46
www.galeriebuchholz.de

Andrea Rosen Gallery
525 West 24th Street
US – New York, NY 10011
Tel: +1 21 26 27 60 00
www.andrearosengallery.com

Maureen Paley
21 Herald Street
GB – London E2 6JT
Tel: +44 (0)20 77 29 41 12
www.maureenpaley.com

PRIMARY MARKET PRICES →
$8.000–$80.000

AUCTION SALES →
Price: $96.000
Installation, 1999
C-prints, 17 works, dimensions
variable
Date sold: 18-Oct-06
Auction house: Phillips, de Pury &
Company, New York

Price: $61.000
White Jeans on White, 1991
Cibachrome print, 148.5 x 214.6 cm
Date sold: 14-May-08
Auction house: Christie's,
New York

Price: $50.190
After Midnight, 1999
C-print, 132 x 157.5 cm
Date sold: 12-Nov-02
Auction house: Phillips de Pury &
Luxembourg, New York

Price: $49.000
Window, New Inn Yard, 1997
C-print, 15 works, 40.6 x 30.5 cm
Date sold: 12-Nov-02
Auction house: Christie's,
New York

Price: $48.000
Last Still Life, New York, 1995
Colour photograph, 196 x 135 cm
Date sold: 07-Nov-05
Auction house: Phillips de Pury &
Company, New York

RIRKRIT TIRAVANIJA

REPRESENTATION →
neugerriemschneider

Linienstraße 155
D – 10115 Berlin
Tel: +49 (0)30 28 87 72 77
www.neugerriemschneider.com

Gavin Brown's enterprise
620 Greenwich Street
US – New York, NY 10014
Tel: +1 212 627 52 58
www.gavinbrown.biz

Galleria Emi Fontana /
West of Rome
380 South Lake Avenue, Suite 210
US – Pasadena, CA 91101
Tel: +1 626 793 15 04
www.westofromeinc.com
www.galleriaemifontana.com

kurimanzutto
Mazatlán 5, Depto. T-6,
Colonia Condesa
MX – 06140 México D.F.
Tel: +52 55 52 86 30 59
www.kurimanzutto.com

PRIMARY MARKET PRICES →
$2.500–$250.000

AUCTION SALES →
Price: $48.000
Untitled, 2003
Neon tubes, electrical cables,
power supply, control unit,
50.2 x 400.1 cm
Date sold: 11-May-06
Auction house: Phillips de Pury &
Company, New York

Price: $44.572
Untitled (Cure), 1993
Cloth tent, table, stools, tea
kettles, hotplate, tea pots
and cups, metal shelf, tea, water,
350 x 350 x 350 cm
Date sold: 08-Feb-01
Auction house: Christie's, London

Price: $34.600
Untitled (Flaming Morning Glory
No. 103), 2005

GERT UND UWE TOBIAS

REPRESENTATION →
Galerie Michael Janssen
Kochstraße 60
D – 10969 Berlin
Tel: +49 (0)30 25 80 08 50
www.galeriemichaeljanssen.de

Galerie Rodolphe Janssen
Rue de Livourne 35
B – 1050 Bruxelles
Tel: +32 (0)2 538 08 18
www.galerierodolphejanssen.com

Team Gallery
83 Grand Street
US – New York, NY 10013
Tel: +1 212 279 92 19
www.teamgal.com

Tomio Koyama Gallery
1-3-2-7F, Kiyosumi, Koto-ku
JP – Tokyo 135-0024
Tel: +81 (0)3 36 42 40 90
www.tomiokoyamagallery.com

PRIMARY MARKET PRICES →
$3.500–$45.000

AUCTION SALES →
Price: $44.404
Untitled (Carry on
Screaming), 2005
Colour woodcut,
205.1 x 170.5 cm
Date sold: 02-Apr-08
Auction house: Christie's,
South Kensington

FRED TOMASELLI

REPRESENTATION →
carlier I gebauer
Markgrafenstraße 67

Fred Tomaselli, Gravity in Four Directions, 2001

D – 10969 Berlin
Tel: +49 (0)30 24 00 86 30
www.carliergebauer.com

James Cohan Gallery
533 West 26th Street,
US – New York, NY 10001
Tel: +1 212 714 95 00
www.jamescohan.com

White Cube
48 Hoxton Square
GB – London N1 6PB
Tel: +44 (0)20 79 30 53 73
www.whitecube.com

PRIMARY MARKET PRICES →
Upon request

AUCTION SALES →
Price: $937.000
Gravity in Four Directions, 2001
Leaves, pills, printed paper,
acrylic, resin on wood,
182.9 x 182.9 cm
Date sold: 13-Nov-07
Auction house: Christie's,
New York

Price: $912.856
Big Bird, 2004
Acrylic, leaves, resin, printed
paper collage on panel,
121.9 x 121.9 cm
Date sold: 30-Jun-08
Auction house: Christie's,
London

Price: $336.000
Butterfly Effect, 1999
Acrylic, aspirin tablets, paper
collage, resin on woodpanel,

152.4 x 213.4 x 3 cm
Date sold: 17-May-07
Auction house:
Phillips de Pury & Company,
New York

Price: $289.000
49 Palms Oasis, 1995
Pills, acrylic, resin on panel,
121.9 x 121.9 cm
Date sold: 14-May-08
Auction house: Christie's,
New York

Price: $288.000
Torso (Large), 1999
Acrylic, hemp leaves,
pills, printed paper,
resin on wood,
137.2 x 182.9 cm
Date sold: 16-May-07
Auction house: Sotheby's,
New York

JANAINA TSCHÄPE

REPRESENTATION →
Galeria Fortes Vilaça
Rua Fradique Coutinho 1500
BR – São Paulo 05416-001
Tel: +55 11 30 32 70 66
www.fortesvilaca.com.br

Galerie Xippas
108, rue Vieille du Temple
F – 75003 Paris
Tel: + 33 (0)1 40 27 05 55
www.xippas.com

Nichido Contemporary Art
Da Vinci Kyobashi B1

4-3-3 Hatchobori, Chuo-ku
JP – Tokyo 104-0032
Tel: +81 (0)3 35 55 21 40
www.nca-g.com

Sikkema Jenkins & Co
530 West 22nd Street
US – New York, NY 10011
Tel: +1 212 929 22 62
www.sikkemajenkinsco.com

carlier l gebauer
Markgrafenstraße 67
D – 10969 Berlin
Tel: +49 (0)30 24 00 86 30
www.carliergebauer.com

PRIMARY MARKET PRICES →
$11.000 (photographs)
$30.000 (drawings)
$55.000 (paintings)

LUC TUYMANS

REPRESENTATION →
Wako Works of Art
3-18-2-101/103, Nishi-Shinjuku,
Shinjuku-ku
JP – Tokyo 160-0023
Tel: +81 (0)3 33 73 28 60
www.wako-art.jp

Zeno X Gallery
Leopold De Waelplaats 16
B – 2000 Antwerpen
Tel: +32 (0)3 216 16 26
www.zeno-x.com

Luc Tuymans, Sculpture, 2000

David Zwirner
525 West 19th Street
US – New York, NY 10011
Tel: +1 212 727 20 70
www.davidzwirner.com

PRIMARY MARKET PRICES →
$200.000 (painting 50 x 50 cm)

AUCTION SALES →
Price: $1.472.000
Sculpture, 2000
Oil on canvas, 154.9 x 63.7 cm
Date sold: 11-May-05
Auction house: Christie's,
New York

Price: $1.080.000
Mrs., 1999
Oil on canvas, 217.2 x 133.3 cm
Date sold: 15-Nov-06
Auction house: Christie's,
New York

Price: $750.297
Evidence, 2005
Oil on canvas, 106.8 x 89 cm
Date sold: 28-Feb-08
Auction house: Phillips de Pury &
Company, London

Price: $721.201
Eyes (Set of 3), 2001
Oil on canvas, 3 parts,
58.4 x 64.3 cm
Date sold: 29-Jun-08
Auction house: Phillips de Pury &
Company, London

Price: $576.000
Fish, 1999
Oil on canvas, 67.6 x 62.2 cm
Date sold: 12-May-05
Auction house:
Phillips de Pury & Company,
New York

PIOTR UKLAŃSKI

REPRESENTATION →
Galerie Emmanuel Perrotin
76, rue de Turenne
F – 75003 Paris
Tel: +33 (0)1 42 16 79 79
www.galerieperrotin.com

Gagosian Gallery
555 West 24th Street
US – New York, NY 10011
Tel: +1 212 741 11 11
www.gagosian.com

Galleria Massimo De Carlo
Via Giovanni Ventura, 5
I – 20134 Milano
Tel: +39 02 70 00 39 87
www.massimodecarlo.it

PRIMARY MARKET PRICES →
Upon request

AUCTION SALES →
Price: $1.071.698
The Nazis, 1998
Black and white and colour
photographs, 34.9 x 25.4 cm
Date sold: 14-Oct-06
Auction house: Phillips de Pury &
Company, New York

Price: $408.000
Untitled (Skull), 1999
Blueboard ink print (site specific
commission)
Date sold: 11-May-06
Auction house: Phillips de Pury &
Company, New York

Price: $240.000
Untitled (Monsieur François
Pinault, Président du Groupe
Artemis), 2003
C-print, 112 x 146 cm
Date sold: 16-May-07
Auction house: Sotheby's,
New York

Piotr Uklański, The Nazis, 1998 (detail)

Price: $228.000
Untitled (Skull), 2000
Blueboard ink print
Date sold: 16-Nov-06
Auction house: Phillips de Pury &
Company, New York

Price: $228.000
Untitled, 2002
Colour pencil shavings with
adhesive, Plexiglas,
153 x 280 x 10.2 cm
Date sold: 10-Nov-05
Auction house: Phillips de Pury &
Company, New York

FRANCESCO VEZZOLI

REPRESENTATION →
Gagosian Gallery
555 West 24th Street
US – New York, NY 10011
Tel: +1 212 741 11 11
www.gagosian.com

Francesco Vezzoli, Is Veruschka in
Paris?, 2001

Galerie Yvon Lambert
108, rue Vieille-du-Temple
F – 75003 Paris
Tel: +33 (0)1 42 71 09 33
www.yvon-lambert.com

Giò Marconi
Via Tadino, 15
I – 20124 Milano
Tel: +39 02 29 40 43 73
www.giomarconi.com

Galerie Neu
Philippstraße 13
D – 10115 Berlin
Tel: +49 (0)30 285 75 50
www.galerieneu.com

Galleria Franco Noero
Via Giulia di Barolo, 16 D
I – 10124 Torino
Tel: +39 011 88 22 08
www.franconoero.com

PRIMARY MARKET PRICES →
Upon request

AUCTION SALES →
Price: $318.802
Is Veruschka in Paris?, 2001
Laserprint on canvas with metallic
embroidery, 52 x 42 cm
Date sold: 15-Oct-07
Auction house: Christie's, London

Price: $300.000
Crying Divas from The Screen-
plays of an Embroiderer I, 1999
Laserprint on canvas with metallic
embroidery, 30 parts,
99.1 x 494.9 cm
Date sold: 17-May-07
Auction house: Phillips de Pury &
Company, New York

Price: $191.925
Vaghe stelle dell'Orsa, 1999
Laserprint on canvas with metallic
embroidery, triptych, 42 x 30 cm
Date sold: 07-Feb-08
Auction house: Christie's, London

Price: $181.132
Vincente Minnelli Was an
Embroiderer, 2000
Laserprint on canvas with metallic
embroidery, 8 parts, 33 x 43.5 cm
Date sold: 16-Oct-06
Auction house: Christie's, London

Price: $133.000
La diosa arrodillada (The kneeling
goddess), 2002
Laserprint on canvas with metallic
embroidery, 41.9 x 29.8 cm
Date sold: 16-Oct-06
Auction house: Sotheby's,
New York

KARA WALKER

REPRESENTATION →
Sikkema Jenkins & Co
530 West 22nd Street
US – New York, NY 10011
Tel: +1 212 929 22 62
www.sikkemajenkinsco.com

PRIMARY MARKET PRICES →
Upon request

AUCTION SALES →
Price: $355.731
Untitled (Girl with Bucket), 1998
Paper cutouts, 2 parts,
203.2 x 139.7 cm
Date sold: 20-Jun-07
Auction house: Christie's, London

Price: $329.600
The Battle of Atlanta: Being the
Narrative of a Negress in the
Flames of Desire – A
Reconstruction, 1995
Paper cutouts with adhesive
backing, dimensions variable
Date sold: 10-May-05
Auction house: Sotheby's,
New York

Price: $216.000
From the Series: Negress Notes,
Set 5, 1996
Watercolour and ink, 26 elements,
1–9, 17–21, 26 25.3 x 17.7 cm, 10–16,
22, 23 22.8 x 15.2 cm, 24
17.8 x 12.7 cm, 25 30.4 x 22.8 cm
Date sold: 10-May-06
Auction house: Christie's,
New York

Price: $216.000
Mastah's Done Gone, 1998
Paper cutouts, 17 parts,
170 x 594 cm
Date sold: 20-Jun-07
Auction house: Christie's, London

Price: $145.000
Untitled, 1993/94
Paper cutouts, 127 x 95.3 cm
Date sold: 14-Jan-08

Auction house: Christie's,
New York

JEFF WALL

REPRESENTATION →
Marian Goodman Gallery
24 West 57th Street
US – New York, NY 10019
Tel: +1 212 977 71 60
www.mariangoodman.com

Johnen Galerie
Schillingstraße 31
D – 10179 Berlin
Tel: +49 (0)30 27 58 30 30
www.johnengalerie.de

Johnen + Schöttle
Maria-Hilf-Straße 17
D – 50677 Köln
Tel: +49 (0)221 31 02 70
www.johnen-schoettle.de

Galerie Rüdiger Schöttle
Amalienstraße 41
D – 80799 München
Tel: +49 (0)89 33 36 86
www.galerie-ruediger-schoettle.de

Jeff Wall, The Well, 1989

White Cube
48 Hoxton Square
GB – London N1 6PB
Tel: +44 (0)20 79 30 53 73
www.whitecube.com

PRIMARY MARKET PRICES →
$150.000–$750.000

AUCTION SALES →
Price: $1.245.058
The Well, 1989
Cibachrome transparency in
lightbox, 229 x 179 cm
Date sold: 01-Jul-08
Auction house: Sotheby's, London

Price: $993.000
The Forest, 2001
Silver gelatin print,
239.1 x 302.9 cm
Date sold: 14-May-08

Auction house: Sotheby's,
New York

Price: $351.150
The Crooked Path, 1991
Cibachrome transparency in
lightbox, 135.2 x 165.1 x 25.4 cm
Date sold: 23-Okt-05
Auction house: Christie's, London

Price: $277.500
The Well, 1989
Cibachrome transparency in
lightbox, 229 x 179 cm
Date sold: 13-Nov-00
Auction house: Phillips de Pury &
Company, New York

Price: $265.600
An Octopus, 1990
Cibachrome transparency in
lightbox, 210.6 x 248.9 x 22.2 cm
Date sold: 08-Nov-04
Auction house: Phillips de Pury &
Company, New York

REBECCA WARREN

REPRESENTATION →
Maureen Paley
21 Herald Street
GB – London E2 6JT
Tel: +44 (0)20 77 29 41 12
www.maureenpaley.com

Galerie Max Hetzler
Zimmerstraße 90/91
D – 10117 Berlin
Tel: +49 (0)30 229 24 37
www.maxhetzler.com

Matthew Marks Gallery
523 West 24th Street
US – New York, NY 10011
Tel: +1 212 243 02 00
www.matthewmarks.com

Donald Young Gallery
933 West Washington Boulevard
US – Chicago, IL 60607
Tel: +1 312 455 01 00
www.donaldyoung.com

PRIMARY MARKET PRICES →
Upon request

AUCTION SALES →
Price: $43.000
Totem (A), 2003
Painted Clay, 68.6 x 17.8 x 20.3 cm
Date sold: 15-Nov-07
Auction house: Sotheby's,
New York

MARNIE WEBER

REPRESENTATION →
Bernier/Eliades Gallery
11 Eptachalkou

GR – 11851 Athens
Tel: +30 210 34 13 93 35
www.bernier-eliades.gr

Patrick Painter Inc.
2525 Michigan Avenue
US – Santa Monica, CA 90404
Tel: +1 310 264 59 88
www.patrickpainter.com

Praz-Delavallade
28, rue Louise-Weiss
F – 75013 Paris
Tel: +33 (0)1 45 86 20 00
www.praz-delavallade.com

Simon Lee
12 Berkeley Street
GB – London W1J8DT
Tel: +44 (0)20 74 91 01 00
www.simonleegallery.com

PRIMARY MARKET PRICES →
Upon request

Franz West, Larvae, 2004

FRANZ WEST

REPRESENTATION →
Gagosian Gallery
555 West 24th Street
US – New York, NY 10011
Tel: +1 212 741 11 11
www.gagosian.com

Galerie Meyer Kainer
Eschenbachgasse 9
A – 1010 Wien
Tel: +43 (0)1 585 72 77
www.meyerkainer.com

Galerie Eva Presenhuber
Limmatstrasse 270
CH – 8005 Zürich
Tel: +41 (0)43 444 70 50
www.presenhuber.com

PRIMARY MARKET PRICES →
$6.000 – $400.000

AUCTION SALES →
Price: $721.201

Larvae, 2004
Lacquered aluminium, 2 works,
229.9 x 160 x 160 cm
Date sold: 29-Jun-08
Auction house: Phillips de Pury &
Company, London

Price: $207.781
Untitled (Bench), 1993
Steel with foam upholstery, white
sheet, 110 x 634 x 80 cm
Date sold: 13-Oct-07
Auction house:
Phillips de Pury & Company,
London

Price: $206.128
Element of the Environment –
Alpenglühn, 2001
Papier-maché, plaster, gauze,
paint, metal, 147 x 118.5 x 90.5 cm
Date sold: 30-Jun-08
Auction house: Phillips de Pury &
Company, London

Price: $162.000
Mohrenländle, 1992/93
Aluminium, gauze, cardboard,
lacquer, 80 x 200 x 5.1 cm
Date sold: 27-Feb-07
Auction house: Phillips de Pury &
Company, New York

Price: $156.000
Drei Sitzwürste, 2000
Varnished aluminium, yellow:
53.3 x 452.1 x 68.8 cm, orange:
53.3 x 457.2 x 50.8 cm, pink:
50.8 x 434.3 x 66 cm
Date sold: 14-Oct-06
Auction house:
Phillips de Pury & Company,
New York

PAE WHITE

REPRESENTATION →
neugerriemschneider
Linienstraße 155
D – 10115 Berlin

Tel: +49 (0)30 28 87 72 77
www.neugerriemschneider.com

greengrassi
1a Kempsford Road
GB – London SE11 4NU
Tel: +44 (0)20 78 40 91 01
www.greengrassi.com

1301 PE
6150 Wilshire Boulevard
US – Los Angeles, CA 90048
Tel: +1 323 938 58 22
www.1301pe.com

PRIMARY MARKET PRICES →
$3.500 – $95.000

AUCTION SALES →
Price: $18.000
Fish to Snake... A Dirty Joke – You
Don't Need to Know, 1999
Fish skin, snake skin, cardboard,
thread, metal fasteners,
dimensions variable
Date sold: 17-Nov-06
Auction house: Phillips de Pury &
Company, New York

Price: $4.375
Untitled (Contents of My
Handbag), 2001
Paper, string, 53.3 x 21 x 22.9 cm
Date sold: 16-Nov-07
Auction house: Phillips de Pury &
Company, New York

Price: $4.200
Aries, 2000
Paper, clock chime,
62.9 x 45.1 x 22.9 cm
Date sold: 18-Nov-06
Auction house: Rago Auctions,
Lambertville

Price: $355
Hornet
Hairnets, acrylic on pillow,
eyelash, pins, 26.5 x 28 x 6 cm
Date sold: 05-Apr-07
Auction house: Christie's, South
Kensington

KEHINDE WILEY

REPRESENTATION →
Deitch Projects
76 Grand Street
US – New York, NY 10013
Tel: +1 212 343 73 00
www.deitch.com

Rhona Hoffman Gallery
118 North Peoria Street
US – Chicago, IL 60607
Tel: +1 312 455 19 90
www.rhoffmangallery.com

Roberts & Tilton
5801 Washington Boulevard

Kehinde Wiley, Passing, Posing (from
Coronation of the Virgin), 2005

US – Culver City, CA 90232
Tel: +1 323 549 02 23
www.robertsandtilton.com

PRIMARY MARKET PRICES →
Upon request

AUCTION SALES →
Price: $97.000
Passing, Posing (from Coronation
of the Virgin), 2005
Oil, enamel on canvas,
207 x 175.2 cm
Date sold: 14-May-08
Auction house: Christie's,
New York

Price: $61.000
WIP Mrs. Hale as "Euphrosyne" III,
2005
Oil, enamel on canvas,
210.8 x 177.8 cm
Date sold: 14-Nov-07
Auction house: Christie's, New York

Price: $58.000
Thomas Armory I, 2006
Oil on canvas, 66 x 55.9 cm
Date sold: 15-May-08
Auction house: Sotheby's,
New York

Price: $55.000
Female Prophet Anne,
Samuel's Mother, 2003
Oil on canvas, 208.2 x 177.8 cm
Date sold: 15-May-08
Auction house: Sotheby's,
New York

Price: $45.600
Easter Realness #6, 2004
Oil on canvas, 304.8 x 304.8 cm
Date sold: 12-May-06
Auction house: Phillips de Pury &
Company, New York

JONAS WOOD

REPRESENTATION →
Anton Kern Gallery
532 West 20th Street

US – New York, NY 10011
Tel: +1 212 367 96 63
www.antonkerngallery.com

PRIMARY MARKET PRICES →
Upon request

CHRISTOPHER WOOL

REPRESENTATION →
Luhring Augustine
531 West 24th Street
US – New York, NY 10011
Tel: +1 212 206 91 00
www.luhringaugustine.com

Galerie Max Hetzler
Zimmerstraße 90/91
D – 10117 Berlin
Tel: +49 (0)30 229 24 37
www.maxhetzler.com

Galerie Gisela Capitain
St.-Apern-Straße 20–26
D – 50667 Köln
Tel: +49 (0)221 35 57 01 00
www.galeriecapitain.de

Simon Lee
12 Berkeley Street
GB – London W1J8DT
Tel: +44 (0)20 74 91 01 00
www.simonleegallery.com

PRIMARY MARKET PRICES →
Upon request

AUCTION SALES →
Price: $1.810.276
Untitled, 1991 (P137)
Alkyd on aluminium,
228.5 x 152.5 cm
Date sold: 20-Jun-07
Auction house: Christie's, London

Price: $1.810.276
Untitled, 1996 (P252)
Enamel on aluminium,

Christopher Wool, Untitled, 1996
(P252)

228.5 x 152.7 cm
Date sold: 20-Jun-07
Auction house: Christie's, London

Price: $1.696.000
Hole In Your Fuckin Head,
1992 (W31)
Enamel on aluminium,
274.3 x 182.9 cm
Date sold: 16-Nov-06
Auction house: Phillips de Pury &
Company, New York

Price: $1.416.000
Untitled, 1988 (P80)
Alkyd, flashe on aluminium,
198.1 x 121.9 cm
Date sold: 10-May-06
Auction house: Sotheby's,
New York

Price: $1.248.000
Untitled, 1990 (W17)
Alkyd, enamel on aluminium,
274 x 183 cm
Date sold: 10-May-06
Auction house: Christie's,
New York

ERWIN WURM

REPRESENTATION →
Xavier Hufkens
Rue Saint-Georges 6–8
B – 1050 Bruxelles
Tel: +32 (0)2 639 67 30
www.xavierhufkens.com

Galerie Krinzinger
Seilerstätte 16
A – 1010 Wien
Tel: +43 (0)15 13 30 06
www.galerie-krinzinger.at

Tomio Koyama Gallery
1-3-2-7F, Kiyosumi, Koto-ku
JP – Tokyo 135-0024
Tel: +81 (0)3 36 42 40 90
www.tomiokoyamagallery.com

Galerie Thaddaeus Ropac
Mirabellplatz 2
A – 5020 Salzburg
Tel: +43 (0)662 88 13 93 10
www.ropac.net

PRIMARY MARKET PRICES →
$8.000–$500.000

AUCTION SALES →
Price: $37.432
Looking for a Bomb 3, 2003
C-print mounted on Diasec,
125.7 x 184.2 cm
Date sold: 29-Jun-08
Auction house: Phillips de Pury &
Company, London

Price: $19.449
Ohne Titel, 1982

Wood, painted, height 97 cm
Date sold: 17-Jun-08
Auction house: Kinsky, Vienna

Price: $14.973
Untitled (One Minute Sculpture),
1997
C-print, 44.7 x 30.1 cm
Date sold: 29-Jun-08
Auction house: Phillips de Pury &
Company, London

Price: $12.873
Schreitender
Wood, painted, 240 x 120 x 150 cm
Date sold: 29-Nov-95
Auction house: Wiener Kunst
Auktionen, Vienna

Price: $12.048
Untitled, 1997
Mixed media on canvas,
140 x 100 cm
Date sold: 29-Nov-95
Auction house: Kinsky, Vienna

Erwin Wurm, Looking for a Bomb 3,
2003

XU ZHEN

REPRESENTATION →
James Cohan Gallery
533 West 26th Street,
US – New York, NY 10001
Tel: +1 212 714 95 00
www.jamescohan.com

Esther Schipper
Linienstraße 85
D – 10119 Berlin
Tel: +49 (0)30 28 39 01 39
www.estherschipper.com

ShanghART Gallery
50 Moganshan Road, Building 16
CN – 200060 Shanghai
Tel: +86 21 63 59 39 23
www.shanghartgallery.com

PRIMARY MARKET PRICES →
Upon request

YANG FUDONG

REPRESENTATION →
Marian Goodman Gallery
24 West 57th Street
US – New York, NY 10019
Tel: +1 212 977 71 60
www.mariangoodman.com

ShanghART Gallery
50 Moganshan Road, Building 16
CN – 200060 Shanghai
Tel: +86 21 63 59 39 23
www.shanghartgallery.com

PRIMARY MARKET PRICES →
Upon request

AUCTION SALES →
Price: $25.200
After All I Didn't Force You, 1998
VHS cassette tape, mini cassette
tape, 2 min 50 sec
Date sold: 17-Nov-06
Auction house: Phillips de Pury &
Company, New York

Price: $20.400
The First Intellectual, 2000
C-print, 185.4 x 124.5 cm
Date sold: 20-Sep-06
Auction house: Sotheby's,
New York

Price: $20.377
Shenjia Alley, Fairy 7, 2000
Cibachrome print, 2 works, with
Shenjia Alley, Fairy 9,
62.5 x 150 cm
Date sold: 16-Oct-06
Auction house: Sotheby's, London

Price: $12.376
Don't Worry It Will Be Better, 2000
Digitally manipulated C-print,
mounted on aluminium,
76 x 118 cm
Date sold: 29-Feb-08

Auction house: Phillips de Pury &
Company, London

Price: $12.000
Breeze, 2000
C-print, 80 x 152.4 cm
Date sold: 12-May-06
Auction house:
Phillips de Pury & Company,
New York

TOBY ZIEGLER

REPRESENTATION →
Simon Lee
12 Berkeley Street
GB – London W1J8DT
Tel: +44 (0)20 74 91 01 00
www.simonleegallery.com

Patrick Painter Inc.
2525 Michigan Avenue
US – Santa Monica, CA 90404
Tel: +1 310 264 59 88
www.patrickpainter.com

PRIMARY MARKET PRICES →
Upon request

THOMAS ZIPP

REPRESENTATION →
Galerie Guido W. Baudach
Oudenarder Straße 16–20
D – 13347 Berlin
Tel: +49 (0)30 28 04 77 27
www.guidowbaudach.com

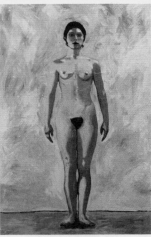
Thomas Zipp, Lydia, 2003

Galería Heinrich Ehrhardt
San Lorenzo 11
E – 28004 Madrid
Tel: +34 (0)91 310 44 15
www.heinrichehrhardt.com

Alison Jacques Gallery
16–18 Berners Street
GB – London W1T 3LN
Tel: +44 (0)20 76 31 47 20
www.alisonjacquesgallery.com

Galerie Krinzinger
Seilerstätte 16
A – 1010 Wien
Tel: +43 (0)15 13 30 06
www.galerie-krinzinger.at

Harris Lieberman Gallery
89 Vandam Street
US – New York, NY 10013
Tel: +1 212 206 12 90
www.harrislieberman.com

PRIMARY MARKET PRICES →
$14–$1.400.000

AUCTION SALES →
Price: $28.800
Lydia, 2003
Oil on canvas, 110.2 x 69.5 cm
Date sold: 17-Nov-06
Auction house: Phillips de Pury &
Company, New York

Price: $18.361
Tutu, 2006
Oil on canvas, 80 x 70 cm
Date sold: 20-May-08
Auction house: Subastas Segre,
Madrid

Price: $2.037
Sandman, 2007
Pencil on paper, 40 x 30 cm
Date sold: 16-Oct-07
Auction house: Christie's, London

AUCTION RESULTS BY artnet°

Images of Cecily Brown, Cai Guo-Qiang, John Currin, Urs Fischer, Eberhard Havekost, Jeff Koons, Dr. Lakra, Jonathan Meese, Albert Oehlen, Anselm Reyle, Thomas Scheibitz, Cindy Sherman, Thomas Struth, Fred Tomaselli, Luc Tuymans, Francesco Vezzoli, Kehinde Wiley and Christopher Wool: courtesy Christie's Images Ltd.

Images of Tomma Abts, Darren Almond, Hope Atherton, Maurizio Cattelan, George Condo, Marcel Dzama, Elmgreen & Dragset, Robert Gober, Mark Grotjahn, Mike Kelley, Sarah Morris, Ron Mueck, Ernesto Neto, Chris Ofili, Jorge Pardo, Tobias Rehberger, Wilhelm Sasnal, Wolfgang Tillmans, Piotr Uklański, Franz West, Erwin Wurm, Yang Fudong and Thomas Zipp: courtesy Phillips de Pury & Company.

Images of Ai Weiwei, Banksy, Matthew Barney, Glenn Brown, Peter Doig, Marlene Dumas, Martin Eder, Ellen Gallagher, Subodh Gupta, Damien Hirst, Terence Koh, Beatriz Milhazes, Frank Nitsche, Raymond Pettibon, Richard Prince, Daniel Richter, Raqib Shaw and Jeff Wall: courtesy Sotheby's.

artnet®

Is it on artnet?

61 Broadway, 23rd Floor _ New York, NY 10006 _ info@artnet.com _ www.artnet.com
Mauerstraße 83 / 84 _ D-10117 Berlin _ info@artnet.de _ www.artnet.de

Glossary

ANIME → Japanese cartoon films, whose simply drawn figures and straightforward plots are based on Japanese manga comics. In the 1990s, anime and their extravagant soundtracks became famous outside Japan.

APPROPRIATION ART → In Appropriation Art, objects, images and texts are lifted from their cultural context and placed unchanged in a new one. They thus become charged with a new significance.

ARTE POVERA → Art movement which began in Italy in the 1960s. Artists used "humble" materials and the simplest design principles to reduce artworks to their barest essentials.

ASSEMBLAGE → A three-dimensional picture made of different materials, usually of everyday use.

BODY ART → Art that takes the body for its subject and makes it the object of performances, sculptures or videos.

CIBACHROME → A colour print (usually large format) made from a slide.

CODE → Sign system providing the basis for communication and conveying information.

COLLAGE → Work of art made up of a variety of unconnected objects or fragments that were not created by the artist.

COMPUTER ANIMATION → Apparently three-dimensional models produced on a computer which can be "walked through" or seen from different perspectives by the user; or virtual figures which move on the screen.

CONCEPTUAL ART → Conceptual Art emerged in the 1960s. It gives primacy to the basic idea of a work's content. This is often revealed in language alone, i. e. texts or notes. The actual execution of the work is considered secondary and may be totally lacking.

CONSTRUCTIVISM → Early 20th-century art movement that coined a mostly abstract formal language and sought to put modern art to everyday use.

C-PRINT → A colour print from a photographic negative.

CROSSOVER → Crossover refers to crossing the boundaries between art and popular culture and between different cultures; also to the inclusion of music, design and folklore etc in artistic work.

CURATOR → A curator decides what exhibitions are about, and selects the participating artists.

DADA → Revolutionary art movement at its peak in the 1920s, whose collages, performances and public readings of nonsense poetry called all existing cultural values into question.

DECONSTRUCTION → A means of interpretation that regards a work not as a closed entity but as an open and many-layered network of the most varied elements in form and content. These elements, their functions and contradictions, are revealed by deconstruction.

DIGITAL ART → Art that makes use of new digital media such as computers and the Internet.

DOCUMENTARY ART → This type of art concentrates on giving a more or less factual, uninterpreted account of social reality.

ECLECTICISM → A common resort of postmodernism, characterised by extensive quotation from largely historical styles and other artists' works.

ENTROPY → A concept derived from thermodynamics signifying the degree of disorder in closed systems. Total entropy would be reached when a system collapsed in chaos. By analogy, entropy indicates the informational value of news. The ultimate here would be a meaningless rushing noise.

ENVIRONMENT → An interior or exterior space entirely put together by the artist which integrates the viewer in the aesthetic experience.

FICTION → A picture or a story is a fiction when it is based on free invention.

FLUXUS → Radical experimental art movement embracing a variety of forms, including happenings, poetry, music and the plastic arts, whose ephemeral nature removed art from its accepted museum context.

FOLK ART → Traditional arts and crafts connected to particular regions – especially rural areas – or ways of life, which remain relatively unaffected by changes of style.

FUTURISM → Founded in Italy around 1910 by a group of writers and artists, the Futurist movement made a radical break with the past. It promoted a type of art reflecting life in the modern age, characterised by simultaneity, dynamism and speed.

GENDER SURFING → The confusing game with sexual roles whose point is to mix them up, to humorous effect.

GLOBALISATION → Globalisation means that economic or cultural processes increasingly have worldwide implications.

HAPPENING → An artistic action in front of a public that normally becomes involved in what happens.

HIGH AND LOW CULTURE → A complex of themes concerning the influence of trivial culture (low art) on modern art (high art). The concept derives from an exhibition assembled by Kirk Varnedoe in 1990 at the New York Museum of Modern Art.

HYBRID → Of many forms, mixed, incapable of single classification.

ICON → Image or person venerated by a cult.
ICONOGRAPHY → The language of images or forms that is typical of a particular cultural context; for example, the iconography of advertising, Western, postmodern architecture etc.
ICONOLOGY → The interpretation of the content of a work of art, based on its iconography.
INSTALLATION → A work of art that integrates the exhibition space as an aesthetic component.
INTERACTIVE ART → Works of art intended for the viewer's direct participation. Normally this participation is made possible by computer technology.

LOCATION → Site of an event or exhibition etc.

MAINSTREAM → Predominant style reflecting the taste of the general public.
MANGA → Comics and cartoon films, the most popular type of reading matter in Japan, where manga is produced and consumed in large quantities.
MEMENTO MORI → An event or object reminding one of death.
MINIMAL ART → Art trend of the 1960s that traces sculptures and pictures back to clear basic geometric forms and places them in a concrete relation to the space and the viewer.
MIXED MEDIA → Combination of different media, materials and techniques in the production of a work of art.
MONTAGE → Joining together pictorial elements or sequences in photography, film and video.
MULTIPLE → In the 1960s, the classical concept of a work of art came under fire. Instead of a single original, works of art were produced in longer runs, i. e. as "multiples". The idea was to take art out of museums and galleries and make it more available.

NARRATION → Telling a story in art, film or literature.

OBJECT ART → All works of art that contain already existing objects or materials, or are entirely composed of them. (cf. readymade)
OP ART → A type of 1960s Abstract Art that played with optical, rather than visual, effects on the eye.

PERFORMANCE → Artistic work performed in public as a (quasi-theatrical) action. The first performances took place during the 1960s in the context of the Fluxus movement, which tried to widen the concept of art.
PHOTOREALISM → Hyper-realistic painting and sculpture using exaggerated photographic sharpness to take a critical look at the details of reality.
POLITICAL CORRECTNESS → A socio-political attitude particularly influential in the USA. The purpose of Political Correctness is to change public language. The principal requirement is to refer to social "minorities" in a non-judgmental way.
POP ART → Artistic strategy of the 1960s which transformed the popular iconography of film, music and commerce into art.
POP CULTURE → Pop culture finds its expression in the mass circulation of items from areas such as fashion, music, sport and film. The world of pop culture entered art in the early 60s, through Pop Art.
POSTMODERNISM → Unlike modernism, Postmodernism starts from the assumption that grand utopias are impossible. It accepts that reality is fragmented and that personal identity is an unstable quantity transmitted by a variety of cultural factors. Postmodernism advocates an irreverent, playful treatment of one's own identity, and a liberal society.
POST-PRODUCTION → This term taken from the field of film describes, among other things, the post-processing of visual material.
PRODUCTION STILL → Photo of a scene from a film or of an actor in a film, taken on the set by a specialist photographer and used for publicity or documentary purposes.

READYMADE → A readymade is an everyday article which the artist declares to be an artwork and exhibits without major alterations. The idea derives from French artist Marcel Duchamp, who displayed the first readymades in New York in 1913, e. g. an ordinary urinal (Fountain) or a bottle drier.

SAMPLING → Arrangement of existing visual or audio material with the main intention of playing with the material's formal characteristics. Rather than quoting from the material, whose sources are often unclear, sampling aims to reformulate it.

SELF-REFERENTIAL ART → Art that refers exclusively to its own formal qualities and so rejects any idea of portrayal.

SEMANTICS → The study of the significance of linguistic signs, i. e. the meaning of words.

SETTING → An existing or specially created environment surrounding a work of art.

SITUATIONISM → The International Situationists are a group of artists who introduced the concept of "situation" in art in the mid-20th century. According to its practitioners, situationism means constructing temporary situations and transforming them to produce a higher level of passionate intensity.

STEREOTYPE → A standardised, non-individual image that has become generally accepted.

STRUCTURAL FILM → Expression commonly used since the 1960s in the USA to describe experimental films that reveal the material composition and the physical processes of film making.

STRUCTURALISM → Structuralism systematically examines the meaning of signs. The purpose of structuralism is to explore the rules of different sign systems. Languages and even cultural connections are seen and interpreted by structuralism as sign systems.

SURREALISM → Art movement formed in the 1920s around the writer André Breton and his followers, whose main interest was Automatism, or the suspension of conscious control in creating art.

TERROR → This artistic subject gained increasing popularity after "9/11".

TRANSCENDENCE → In philosophy and religion, transcendence is what is beyond normal human perception. In the extraordinary experience of transcendence, therefore, the boundaries of consciousness are crossed.

TRASH → The US word for "rubbish" aims at a level below accepted aesthetic and qualitative norms, with ironic intent.

URBANISM → City-planning and city-living considered as a concept.

VIDEO STILL → Still image taken by stopping a running videotape on screen or scanning a videotape.

VIENNESE ACTIONISM → Artform based around happenings of a ritualistic, bloodthirsty and apparently painful nature. Actionists often used sadomasochism and orgies for their systematic attack on the apparent moral and religious hypocrisy of Austrian society in the early 1960s.

VIRTUAL REALITY → An artificial world created on computer. (cf. computer animation)

WHITE CUBE → The neutral white exhibition room which in modern times has succeeded older forms of presenting art, e. g. hanging of pictures close to each other on coloured wallpaper. The white cube is supposed to facilitate the concentrated and undisturbed perception of the work of art.

WORK-IN-PROGRESS → Work which the artist does not attempt to complete, focusing instead on the actual creative process.

YOUNG BRITISH ARTISTS (YBA) → Group of British artists who since the beginning of the 1990s have created a furore with object and video art inspired by pop culture.

Ariane Beyn and Raimar Stange

Glossar

ANIME → Japanische Zeichentrickfilme, deren einfach gezeichnete Figuren und schlichte Handlungen auf den japanischen Manga-Comics basieren. In den neunziger Jahren wurden diese Filme und ihre aufwendigen Soundtracks auch über Japan hinaus bekannt.

APPROPRIATION ART → Bei der Appropriation Art werden Objekte, Bilder und Texte aus ihrem kulturellen Zusammenhang genommen und unverändert in einen neuen gestellt. Dadurch laden sie sich mit neuer Bedeutung auf.

ARTE POVERA → In den sechziger Jahren in Italien entstandene Kunstrichtung, die vor allem „ärmliche" Materialien und einfachste Gestaltungsprinzipien nutzte, um die Werke auf ihre ureigensten Qualitäten zu reduzieren.

ASSEMBLAGE → Dreidimensionales Bild aus verschiedenen, meist dem Alltag entnommenen Materialien.

BODY ART → Kunst, die den Körper thematisiert und zum Gegenstand von Performances, Skulpturen oder Videoarbeiten macht.

CIBACHROME → Ein meist großformatiger Farbpapierabzug von einem Dia.

COLLAGE → Ein künstlerisches Werk, das aus aneinandergefügten, vom Künstler nicht selbst angefertigten zusammenhanglosen Objekten beziehungsweise Objektteilen besteht.

COMPUTERANIMATION → Im Computer erzeugte, scheinbar dreidimensionale Modelle, die vom Benutzer „durchwandert" beziehungsweise von verschiedenen Perspektiven aus gesehen werden können; virtuelle Figuren, die sich auf dem Bildschirm bewegen.

C-PRINT → Ein „colour-print", der Farbpapierabzug eines Fotonegativs.

CROSSOVER → Beim Crossover werden die Grenzen zwischen Kunst und Populärkultur sowie zwischen verschiedenen Kulturen überschritten und Musik, Design, Folklore etc. in die künstlerische Arbeit einbezogen.

DADA → Revolutionäre Künstlerbewegung, die in den zwanziger Jahren des 20. Jahrhunderts vor allem mit ihren Collagen, Lautdichtungen und Performances sämtliche kulturellen Werte in Frage stellte.

DEKONSTRUKTION → Eine Interpretationsweise, die ein Werk nicht als geschlossene Einheit betrachtet, sondern als offenes und vielschichtiges Geflecht aus unterschiedlichsten formalen und inhaltlichen Elementen. Diese Elemente, ihre Funktionen und Widersprüche werden in der Dekonstruktion aufgedeckt.

DIGITALE KUNST → Kunst, die mit neuen Medien wie Computer oder Internet arbeitet.

DOKUMENTARISCHE KUNST → Diese Kunst konzentriert sich auf die mehr oder weniger sachliche, uninterpretierte Wiedergabe von gesellschaftlicher Wirklichkeit.

EKLEKTIZISMUS → In der Postmoderne übliches Verfahren, das durch das ausgiebige Zitieren von (historischen) Stilen und Werken anderer Künstler charakterisiert ist.

ENTROPIE → Der aus der Wärmelehre stammende Begriff benennt dort den Grad der Unordnung in geschlossenen Systemen. Vollständige Entropie wäre dann erreicht, wenn ein System sich im Chaos auflöst. Analog dazu zeigt die Entropie die Größe des Informationswertes einer Nachricht an. Der Endpunkt hier: ein bedeutungsloses Rauschen.

ENVIRONMENT → Komplett durchgestalteter Innen- oder Außenraum, der den Betrachter in das ästhetische Geschehen integriert.

FIKTION → Ein Bild oder eine Geschichte ist dann eine Fiktion, wenn sie auf freier Erfindung beruht.

FLUXUS → Radikal experimentelle Kunstströmung, die unterschiedliche Formen wie Happening, Poesie, Musik und bildende Kunst zusammenbringt. Das Flüchtige dieser Aktionen tritt an die Stelle von auratischer Musealität.

FOLK ART → Kunsthandwerkliche und volkstümliche Ästhetik, die an bestimmte Regionen oder Berufsstände, zum Beispiel das bäuerliche Milieu, gebunden ist und von Stilwandlungen relativ unberührt bleibt.

FOTOREALISMUS → Hyperrealistische Malerei und Skulptur, die mit überzogener fotografischer Schärfe Ausschnitte der Realität kritisch beleuchtet.

FUTURISMUS → Die um 1910 von Dichtern und bildenden Künstlern in Italien ausgerufene futuristische Bewegung vollzog einen radikalen Bruch mit der Vergangenheit. Sie forderte stattdessen eine den Lebensbedingungen der Moderne angemessene Kunst der Simultaneität, Dynamik und Geschwindigkeit.

GENDER SURFING → Das verwirrende Spiel mit den Geschlechterrollen, das auf die lustvolle Überschreitung ihrer Grenzen abzielt.

GLOBALISIERUNG → Globalisierung bedeutet, dass wirtschaftliche oder kulturelle Prozesse zunehmend weltweite Auswirkungen haben.

HAPPENING → Künstlerische Aktion in Anwesenheit des Publikums, das zumeist in das Geschehen einbezogen wird.

HIGH AND LOW CULTURE → Themenkomplex, der den Einfluss der Trivialkultur (Low Art) auf die moderne Kunst (High Art) beleuchtet. Der Begriff geht zurück auf eine von Kirk Varnedoe 1990 im New Yorker Museum of Modern Art konzipierte Ausstellung.
HYBRID → Vielgestaltig, gemischt, nicht eindeutig zuzuordnen.

IKONE → Bilder oder Personen, die kultisch verehrt werden.
IKONOGRAFIE → Bild- oder Formensprache, die für einen bestimmten kulturellen Zusammenhang typisch ist, zum Beispiel die Ikonografie der Werbung, des Westerns, der postmodernen Architektur etc.
IKONOLOGIE → Wissenschaft von der inhaltlichen Interpretation eines Kunstwerks, die auf seiner Ikonografie basiert.
INSTALLATION → Ein Kunstwerk, das den Ausstellungsraum als ästhetische Komponente mit einbezieht.
INTERAKTIVE KUNST → Kunstwerke, die die direkte Einflussnahme des Betrachters – meist durch computergestützte Technik – vorsehen.

KODE → Zeichensystem als Grundlage für Kommunikation und Informationsübermittlung.
KONSTRUKTIVISMUS → Künstlerische Richtung zu Beginn des 20. Jahrhunderts, die in Anlehnung an die moderne Technik eine zumeist abstrakte Formensprache und die alltägliche Anwendung moderner Kunst suchte.
KONZEPTKUNST → Die Konzeptkunst entstand in den sechziger Jahren und stellt die inhaltliche Konzeption eines Werkes in den Vordergrund. Diese wird oft nur durch Texte oder Notizen präsentiert, die tatsächliche Umsetzung eines Werkes wird für zweitrangig erklärt und bleibt manchmal auch aus.
KURATOR → Ein Kurator legt die inhaltlichen Schwerpunkte einer Ausstellung fest und trifft die Auswahl der beteiligten Künstler.

LOCATION → Ort einer Veranstaltung, Ausstellung etc.

MAINSTREAM → Bereits etablierte, dem Geschmack der breiten Masse entsprechende Stilrichtung.
MANGA → Comics und Zeichentrickfilme, die bevorzugte Populärliteratur Japans, die dort in großen Mengen produziert und konsumiert wird.
MEMENTO MORI → Ereignis oder Objekt, das an den Tod erinnert.
MINIMAL ART → Kunstströmung der sechziger Jahre, die Skulpturen und Bilder auf klare geometrische Grundformen zurückführte und in eine konkrete Beziehung zu Raum und Betrachter setzte.
MIXED MEDIA → Verbindung verschiedener Medien, Materialien und Techniken bei der Produktion eines Kunstwerks.
MONTAGE → Zusammenfügen von Bildelementen oder Bildfolgen in Fotografie, Film und Video.
MULTIPLE → In den sechziger Jahren entwickelte sich eine kritische Haltung gegenüber dem klassischen Werkbegriff: Anstelle eines einzelnen Originals wurden Kunstwerke in höherer Auflage, das heißt als Multiples, produziert. Kunst sollte auf diese Weise die Museen und Galerien verlassen können und mehr Menschen zugänglich gemacht werden.

NARRATION → Erzählung in Kunst, Film und Literatur.

OBJEKTKUNST → Kunstwerke, die bereits existierende Gegenstände oder Materialien beinhalten oder ganz aus ihnen bestehen. (vgl. Readymade)
OP ART → Kunstströmung der sechziger Jahre, deren Vertreter mit der visuellen Wirkung von Linien, Flächen und Farben experimentieren.

PERFORMANCE → Künstlerische Arbeit, die in Form einer (theatralischen) Aktion einem Publikum vorgeführt wird. Erste Performances fanden während der sechziger Jahre im Rahmen der Fluxus-Bewegung statt, die auf die Erweiterung des Kunstbegriffs abzielte.
POLITICAL CORRECTNESS → Eine engagierte Haltung, die besonders einflussreich in den USA vertreten wird. Ziel der Political Correctness ist es, die moralischen Standards des öffentlichen Lebens zu erhöhen. Gefordert wird vor allem ein gerechter Umgang mit sozialen Minderheiten.
POP ART → Eine künstlerische Strategie der sechziger Jahre, die populäre Ikonografien aus Film, Musik und Kommerz in die Kunst überführte.
POPKULTUR → Die Popkultur findet ihren Ausdruck in massenhaft verbreiteten Kulturgütern aus Bereichen wie Mode, Musik, Sport oder Film. Anfang der sechziger Jahre fand die Welt der Popkultur durch die Pop-Art Eingang in die Kunst.
POSTMODERNE → Die Postmoderne geht, im Gegensatz zur Moderne, von der Unmöglichkeit großer Utopien aus. Sie akzeptiert die Wirklichkeit als eine zersplitterte und die persönliche Identität als eine unstabile Größe, die durch eine Vielzahl kultureller Faktoren vermittelt wird. Die Postmoderne plädiert für einen ironisch-spielerischen Umgang mit der eigenen Identität sowie für eine liberale Gesellschaft.
POSTPRODUKTION → Ein aus dem Filmbereich übernommener Begriff, der die Nachbearbeitung von Bildmaterial u. ä. beschreibt.

PRODUCTION STILL → Foto von einer Filmszene oder von den Protagonisten eines Films, das am Filmset von einem speziellen Fotografen für die Werbung oder zu dokumentarischen Zwecken aufgenommen wird.

READYMADE → Ein Alltagsgegenstand, der ohne größere Veränderung durch den Künstler von diesem zum Kunstwerk erklärt und ausgestellt wird. Der Begriff geht auf den französischen Künstler Marcel Duchamp zurück, der 1913 in New York die ersten Readymades, zum Beispiel ein handelsübliches Pissoir (Fountain) oder einen Flaschentrockner, präsentierte.

SAMPLING → Arrangement von vorhandenem Bild- oder Tonmaterial, das vor allem mit den formalen Eigenschaften des verarbeiteten Materials spielt. Anders als das Zitieren zielt das Sampling dabei auf neue Formulierungen ab und lässt seine Quellen häufig im Unklaren.
SELBSTREFERENZIELLE KUNST → Kunst, die sich ausschließlich auf ihre eigenen formalen Eigenschaften bezieht und jeden Abbildcharakter zurückweist.
SEMANTIK → Lehre von der Bedeutung sprachlicher Zeichen.
SETTING → Eine vorgefundene oder inszenierte Umgebung, in die ein Werk kompositorisch eingebettet ist.
SITUATIONISMUS → Die Künstlergruppe der Internationalen Situationisten führte Mitte des 20. Jahrhunderts den Begriff der „Situation" in die Kunst ein. Die Situation ist demnach eine Konstruktion temporärer Lebensumgebungen und ihre Umgestaltung in eine höhere Qualität der Leidenschaft.
STEREOTYP → Klischeehafte Vorstellung, die sich allgemein eingebürgert hat.
STRUKTURALISMUS → Der Strukturalismus untersucht systematisch die Bedeutung von Zeichen. Ziel des Strukturalismus ist es, die Regeln verschiedener Zeichensysteme zu erforschen. Sprachen und auch kulturelle Zusammenhänge werden vom Strukturalismus als Zeichensysteme verstanden und interpretiert.
STRUKTURELLER FILM → In den USA geläufige Bezeichnung für Experimentalfilme seit den sechziger Jahren, die die materielle Beschaffenheit und die Wahrnehmungsbedingungen des Films offen legen.
SURREALISMUS → Kunstbewegung, die sich Mitte der zwanziger Jahren des 20. Jahrhunderts um den Literaten André Breton und seine Anhänger formierte und psychische Automatismen in den Mittelpunkt ihres Interesses stellte.

TERROR → Sujet, das nach „9/11" mehr und mehr an Attraktivität gewinnt.
TRANSZENDENZ → In Philosophie und Religion der Begriff für das, was außerhalb der normalen menschlichen Wahrnehmung liegt. In der Erfahrung der Transzendenz werden also die Grenzen des Bewusstseins überschritten.
TRASH → Trash – ursprünglich: „Abfall" – ist die ironische Unterbietung ästhetischer und qualitativer Normen.

URBANISMUS → Reflexionen über Städtebau und das Zusammenleben in Städten.

VIDEO STILL → Durch Anhalten des laufenden Videobandes auf dem Bildschirm erscheinendes oder aus den Zeilen eines Videobandes herausgerechnetes (Stand-)Bild.
VIRTUAL REALITY → Im Computer erzeugte künstliche Welt. (vgl. Computeranimation)

WHITE CUBE → Begriff für den neutralen weißen Ausstellungsraum, der in der Moderne ältere Formen der Präsentation von Kunst, zum Beispiel die dichte Hängung von Bildern auf farbigen Tapeten, ablöste. Der White Cube soll die konzentrierte und ungestörte Wahrnehmung eines Kunstwerks ermöglichen.
WIENER AKTIONISMUS → Blutig und schmerzhaft erscheinende Happening-Kunst rituellen Charakters, die mit oftmals sadomasochistischen Handlungen und Orgien systematisch die moralisch-religiöse Scheinheiligkeit der österreichischen Gesellschaft der frühen sechziger Jahre angreift.
WORK-IN-PROGRESS → Werk, das keine Abgeschlossenheit anstrebt, sondern seinen prozessualen Charakter betont.

YOUNG BRITISH ARTISTS (YBA) → Gruppe englischer Künstler, die seit Anfang der neunziger Jahre mit ihrer von der Popkultur inspirierten Objekt- und Videokunst Furore macht.

Ariane Beyn und Raimar Stange

Glossaire

ACTIONNISME VIENNOIS → Happening à caractère rituel, dont les manifestations sanglantes et douloureuses s'attaquent à la bigoterie morale et religieuse de la société autrichienne du début des années soixante, dans des actions et des orgies à caractère sadomasochiste.

ANIMATION → Module d'apparence tridimensionelle produit par ordinateur et pouvant être « parcouru » par le spectateur – en fait : pouvant être vu sous des points de vue changeants ; figures virtuelles qui se meuvent sur un écran.

ANIME → Dessins animés japonais dans lesquels le graphisme simple des figures et l'action sobre sont issus des mangas, les bandes dessinées japonaises. Depuis les années 90, ces films et leurs bandes-son très élaborées se sont aussi fait connaître au-delà des frontières japonaises.

APPROPRIATION ART → Des objets, des images, des textes sont extraits de leur contexte culturel pour être transplantés tels quels dans un nouveau contexte, où ils se chargent d'une nouvelle signification.

ART CONCEPTUEL → L'art conceptuel, qui a vu le jour dans les années 60, met au premier plan le contenu de l'œuvre, dont la conception n'est souvent présentée que par des textes ou des notes, la réalisation concrète étant déclarée secondaire, voire éludée.

ART DE L'OBJET → On peut y classer toutes les œuvres d'art entièrement composées ou comportant des objets ou des matériaux préexistants. (cf. Ready-made).

ART DIGITAL → Art s'appuyant sur les moyens offerts par les nouveaux médias tels que l'informatique ou l'internet.

ART DOCUMENTAIRE → Forme d'art qui se concentre sur la représentation plus ou moins objective de la réalité sociale sans ajout d'aucune interprétation.

ART INTERACTIF → Art qui prévoit une intervention directe du spectateur dans l'œuvre. Le plus souvent, cette intervention est rendue possible par des techniques s'appuyant sur l'informatique.

ARTE POVERA → Mouvement artistique né en Italie dans les années 1960, qui se servit surtout de matériaux et de principes de création « pauvres », en vue de réduire les œuvres à leurs qualités intrinsèques.

ASSEMBLAGE → Image en trois dimensions composée de matériaux divers issus le plus souvent de la vie courante.

AUTO-REFERENCE → Se dit d'un art qui renvoie exclusivement wà ses propres propriétés formelles et rejette ainsi tout caractère représentatif.

BODY ART → Art qui prend le corps pour thème et qui en fait l'objet central de performances, de sculptures ou d'œuvres vidéo.

CIBACHROME → Tirage papier d'une diapositive, le plus souvent en grand format.

CODE → Système de signes qui sous-tend la communication et la transmission d'informations.

COLLAGE → Œuvre d'art constituée d'objets ou de parties d'objets juxtaposés qui ne sont pas des productions personnelles de l'artiste.

COMMISSAIRE → Le commissaire d'une exposition fixe le contenu d'une présentation et procède au choix des artistes participants.

CONSTRUCTIVISME → Courant artistique du début du siècle dernier dont la recherche formelle, le plus souvent abstraite, s'appuie sur la technique moderne et vise à l'application de l'art dans la vie quotidienne.

C-PRINT → « Colour-print », tirage papier en couleurs à partir d'un négatif.

CROSSOVER → Dans le Crossover, les limites entre l'art et la culture populaire, ainsi qu'entre les différentes cultures, sont rendues perméables. La musique, le design, le folklore etc. sont intégrés dans le travail artistique.

CULTURE POP → La culture pop trouve son expression dans des biens culturels répandus en masse et issus de domaines tels que la mode, la musique, le sport ou le cinéma. Au début des années 1960, le monde de la culture pop devait entrer dans l'art par le biais du Pop Art.

DADA → Mouvement artistique révolutionnaire des années 1920 qui remit en question l'ensemble des valeurs culturelles, surtout dans des collages, des poèmes phonétiques et des performances.

DECONSTRUCTION → Mode d'interprétation qui ne considère pas l'œuvre comme une unité finie, mais comme un ensemble d'éléments formels et signifiants les plus divers, et qui met en évidence leurs fonctions et leurs contradictions.

ECLECTISME → Procédé courant dans l'art postmoderne qui se caractérise par la citation généreuse d'œuvres et de styles d'autres artistes.

ENTROPIE → Concept issu de la thermodynamique, où il désigne l'état de désordre dans les systèmes clos. L'entropie totale serait ainsi atteinte lorsqu'un système se dissout en chaos. Par analogie, l'entropie indique la valeur informative d'une nouvelle. L'entropie totale serait atteinte par un bruit de fond vide de sens.

ENVIRONNEMENT → Espace intérieur ou extérieur entièrement formé par l'artiste et intégrant le spectateur dans l'événement esthétique.

FICTION → Une image ou une histoire est une fiction lorsqu'elle repose sur l'invention libre.

FLUXUS → Courant artistique expérimental et radical qui réunit différentes formes d'art comme le happening, la poésie, la musique et les arts plastiques. Le caractère fugace de ces actions y remplace l'aura de la muséalité.
FOLK ART → Esthétique artisanale et folklorique liée à certaines régions ou à certains métiers – par exemple le monde rural –, et qui reste relativement à l'écart des évolutions stylistiques.
FUTURISME → Le mouvement futuriste, proclamé vers 1910 par des poètes et des plasticiens italiens, accomplit une rupture radicale avec le passé, dont il exigeait le remplacement par un art rendant compte des conditions de vie modernes, avec des moyens nouveaux comme la simultanéité, la dynamique et la vitesse.

GENDER SURFING → Jeu troublant sur les rôles des sexes, et qui vise à la voluptueuse transgression de leurs limites.
GLOBALISATION → La globalisation renvoie au fait que certains processus économiques ou culturels ont de plus en plus fréquemment des répercussions au niveau mondial.

HAPPENING → Action artistique menée en présence du public, qui est le plus souvent intégré à l'évènement.
HIGH AND LOW CULTURE → Complexe thématique dans lequel l'influence de la culture triviale (Low Art) éclaire l'art moderne (High Art). Ce concept remonte à une exposition organisée par Kirk Varnedoe en 1990 au Museum of Modern Art de New York.
HYBRIDE → Multiforme, mixte, qui ne peut être classé clairement.

ICONE → Image ou personne faisant l'objet d'une vénération ou d'un culte.
ICONOGRAPHIE → Vocabulaire d'images ou de formes caractéristiques d'un contexte culturel déterminé. Ex. : l'iconographie de la publicité, du western, de l'architecture postmoderne…
ICONOLOGIE → Science de l'interprétation du contenu d'une œuvre sur la base de son iconographie.
INSTALLATION → Œuvre d'art qui intègre l'espace d'exposition comme une composante esthétique.

LOCATION → Endroit où a lieu un évènement, une exposition etc.

MAINSTREAM → Tendance stylistique qui s'est imposée et qui correspond au goût de la masse.
MANGA → Bandes dessinées et dessins animés, littérature populaire du Japon, où elle est produite et consommée en grande quantité.
MEMENTO MORI → Evènement ou objet qui rappelle la mort.
MINIMAL ART → Courant artistique des années 1960 qui réduit les sculptures et les tableaux à des formes géométriques clairement définies et qui les place dans un rapport concret avec l'espace et le spectateur.
MIXED MEDIA → Mélange de différents médias, matériaux et techniques dans la production d'une œuvre d'art.
MONTAGE → Agencement d'éléments visuels ou de séquences d'images dans la photographie, le cinéma et la vidéo.
MULTIPLE → Au cours des années 1960 est apparue une attitude critique à l'égard de la notion classique d'œuvre : au lieu d'un original unique, les œuvres furent produites en tirages plus élevés (comme «multiples» précisément), ce qui devait permettre à l'art de quitter les musées et les galeries et d'être accessible à un plus grand nombre.

NARRATION → Récit dans l'art, le cinéma et la littérature.

OP ART → Courant artistique des années 1960 dont les représentants travaillent sur le jeu visuel des lignes, des surfaces et des couleurs. Ces artistes composent des motifs déterminés visant à produire des effets d'optique.

PERFORMANCE → Travail artistique présenté à un public sous la forme d'une action (théâtrale). Les premières performances furent présentées pendant les années 1960 dans le cadre du mouvement Fluxus, qui visait à l'élargissement du concept d'art.
PHOTO DE PLATEAU → Photo d'une scène de cinéma ou de protagonistes d'un film, prise pendant le tournage, à des fins publicitaires, par un photographe spécialisé. Les photos d'une documentation prises durant le tournage sont également appelées stills.
PHOTOREALISME → Peinture et sculpture hyperréaliste qui porte un regard critique sur des morceaux de réalité à travers une amplification extrême de la vision photographique.
POLITICAL CORRECTNESS → Attitude engagée particulièrement influente aux Etats-Unis, et qui se fixe pour but de relever les standards moraux de la vie publique. Une revendication majeure en est le traitement plus juste des minorités sociales.
POP ART → Stratégie artistique des années 1960 qui fit entrer dans l'art l'iconographie populaire du cinéma, de la musique et du commerce.

POSTMODERNISME → Par opposition à l'art moderne, le postmodernisme postule l'impossibilité des grandes utopies. Il accepte la réalité comme étant éclatée et l'identité personnelle comme une valeur instable fondée par un grand nombre de facteurs culturels. Le postmodernisme plaide en faveur d'un maniement ironique et ludique de l'identité personnelle et pour une société libérale.
POSTPRODUCTION → Terme emprunté à l'industrie du cinéma et qui désigne le traitement a posteriori d'un matériau visuel ou autre.

READY-MADE → Un objet quotidien déclaré œuvre d'art par l'artiste et exposé comme tel sans changement notoire. Le terme remonte à l'artiste français Marcel Duchamp, qui présente les premiers ready-mades – par exemple un urinoir du commerce (Fountain) ou un porte-bouteilles – en 1913 à New York.
REALITE VIRTUELLE → Monde artificiel généré par ordinateur. (cf. Animation)

SAMPLING → Arrangement de matériaux visuels ou sonores jouant essentiellement des caractéristiques formelles du matériau utilisé. Contrairement à la citation, le sampling vise à des formulations nouvelles et ne cite généralement pas ses sources.
SEMANTIQUE → Etude de la signification des signes linguistiques.
SETTING → Environnement existant ou mis en scène qui vient s'insérer dans la composition d'une œuvre.
SITUATIONNISME → Au milieu du siècle dernier, le groupe d'artistes de l'Internationale situationniste a introduit dans l'art le concept de situation, construction temporaire d'environnements de la vie et leur transformation en une intensité de passion.
STEREOTYPE → Idée qui a acquis droit de cité sous forme de cliché.
STRUCTURAL FILM → Depuis les années 1960, terme couramment employé aux Etats-Unis pour désigner des films d'art et d'essai qui mettent en évidence la conformation matérielle et les conditions de perception du cinéma.
STRUCTURALISME → Le structuralisme étudie systématiquement la signification des signes. Il a pour but d'étudier les facteurs qui régissent différents systèmes de signes. Les langues, mais aussi les contextes sociaux y sont compris et interprétés comme des systèmes de signes.
SURREALISME → Mouvement artistique formé au milieu des années 1920 autour du poète André Breton et de ses partisans, et qui plaça l'automatisme psychique au centre de ses préoccupations.

TERRORISME → Sujet qui gagne de plus en plus en attractivité depuis les attentats du 11 septembre 2001.
TRANSCENDANCE → En philosophie et en religion, terme employé pour désigner l'au-delà de la perception humaine ordinaire. Dans l'expérience inhabituelle de la transcendance, les limites de la conscience sont donc transgressées.
TRASH → Trash – à l'origine : «ordure, déchet» – est l'abaissement ironique des normes esthétiques et qualitatives.

URBANISME → Réflexions sur la construction des villes et la vie urbaine.

VIDEO STILL → Image (fixe) obtenue à l'écran par arrêt d'une bande vidéo ou calculée à partir des lignes d'une bande vidéo.

WHITE CUBE → Terme désignant la salle d'exposition blanche, neutre, qui dans l'art moderne remplace des formes plus anciennes de présentation, par exemple l'accrochage dense de tableaux sur des papiers peints de couleur. Le White Cube propose une perception concentrée et non troublée de l'œuvre d'art.
WORK-IN-PROGRESS → Œuvre qui ne recherche pas son achèvement, mais qui souligne au contraire son caractère processuel.

YOUNG BRITISH ARTISTS (YBA) → Groupe de artistes anglais qui, depuis les années 1990, fait parler de lui avec son art de l'objet et ses vidéos inspirés du Pop Art.

Ariane Beyn et Raimar Stange

Biographical notes on the authors — Kurzbiografien der Autoren — Les auteurs en bref

C. A. – CECILIA ALEMANI
Independent curator and art critic, frequently contributes to artforum.com, *Mousse Magazine* and *Domus*. Currently working on the exhibition *Italics: Italian Art between Tradition and Revolution, 1968–2008*, curated by Francesco Bonami.
Freischaffende Kuratorin und Kritikerin, regelmäßige Beiträge für *artforum.com, Mousse Magazine* und *Domus*. Arbeitet derzeit mit Kurator Francesco Bonami an der Ausstellung *Italics: Italian Art between Tradition and Revolution, 1968–2008*.
Critique et commissaire indépendante ; contributions fréquentes à *artforum.com, Mousse Magazine* et *Domus*. Travaille actuellement sur l'exposition *Italics: Italian Art between Tradition and Revolution, 1968–2008* organisée par Francesco Bonami.

J. A. – JENS ASTHOFF
Works as a freelance author and critic from Hamburg. Contributions to *Kunst-Bulletin, Kunstforum, Camera Austria* and *Kultur & Gespenster*, a.o. Recent essays for catalogues on Anselm Reyle, Janis Avotins and Annette Kelm.
Lebt als freier Autor und Kritiker in Hamburg. Schreibt u.a. für *Kunst-Bulletin, Kunstforum, Camera Austria* und *Kultur & Gespenster*. Zahlreiche Katalogbeiträge, zuletzt über Anselm Reyle, Janis Avotins und Annette Kelm.
Auteur et critique indépendant installé à Hambourg. Contribue entre autre à *Kunst-Bulletin, Kunstforum, Camera Austria* et *Kultur & Gespenster*. Essais récents pour les catalogues d'Anselm Reyle, Janis Avotins et Annette Kelm.

A. B. – ANDREW BONACINA
Studied at the Courtauld Institute and the Royal College of Art in London where he is based as a writer and curator. A Contributing Editor of *UOVO* magazine, he regularly writes for *Frieze* and *Untitled* and is a director of the independent imprint *Almanac*.
Studierte am Courtauld Institute und am Royal College of Art in London, wo er als Autor und Kurator lebt. Er ist Contributing Editor des *UOVO* Magazins, schreibt für *Frieze* und *Untitled* und ist Direktor des unabhängigen Verlags *Almanac*.
Études au Courtauld Institute et au Royal College of Art à Londres, où il vit et travaille comme auteur et commissaire. Co-rédacteur du magazine *UOVO*, écrit régulièrement pour *frieze* et *Untitled*, directeur de l'édition indépendante *Almanac*.

S. H. – SUZANNE HUDSON
New York-based critic and Assistant Professor of Modern Art at the University of Illinois. A regular contributor to *Artforum*, her writing has appeared in publications including *October, Art Journal* and *Parkett*.
In New York lebende Kritikerin und Assistant Professor of Modern Art an der University of Illinois. Neben regelmäßigen Beiträgen für *Artforum* schreibt sie außerdem für Publikationen wie *October, Art Journal* und *Parkett*.
Critique d'art installée à New York ; maître de conférences sur l'art moderne à l'Université d'Illinois. Collaborations régulières à *Artforum*, ses textes ont notamment été publiés dans *October, Art Journal* et *Parkett*.

CH. L. – CHRISTY LANGE
Berlin-based writer and Assistant Editor of *frieze*. She has written for *Afterall, Foam, frieze, Modern Painters, The Observer, Parkett* and *Tate Etc*. She is also a contributor to the recent monograph on Stephen Shore.
In Berlin lebende Autorin und Assistant Editor bei *frieze*. Sie schreibt für *Afterall, Foam, frieze, Modern Painters, The Observer, Parkett* und *Tate Etc*. Zuletzt hat sie zur aktuellen Monografie von Stephen Shore beigetragen.
Auteur et assistante éditoriale de *frieze* installée à Berlin. Écrit pour *Afterall, Foam, frieze, Modern Painters, The Observer, Parkett* et *Tate Etc*. A également contribué à la monographie publiée récemment sur Stephen Shore.

H. L. – HOLGER LUND
Art historian and curator. Since 2004, he is co-director of fluctuating images, a non-commercial media art space in Stuttgart. Regularly invited as a visiting lecturer to various institutes in Germany.
Kunsthistoriker und Kurator. Seit 2004 Kodirektor von fluctuating images, einem nicht-kommerziellen Medienkunstraum in Stuttgart. Unterrichtet regelmäßig an verschiedenen deutschen Hochschulen.
Historien de l'art et commissaire d'expositions. Depuis 2004, co-directeur de fluctuating images, espace d'art multimédia à but non lucratif basé à Stuttgart. Intervenant régulier dans différentes universités allemandes.

A. M. – ASTRID MANIA
Berlin-based independent writer and curator with a PhD in art history. She regularly contributes to *artnet.com*, *Art Review* and *Flash Art*, amongst others, and is the editor of the artist's book *David Hatcher: I Don't Must*.
Astrid Mania ist promovierte Kunsthistorikerin und lebt als freie Autorin und Kuratorin in Berlin. Sie schreibt u.a. für *artnet.com*, *Art Review* und *Flash Art* und ist Herausgeberin des Künstlerbuchs *David Hatcher: I Don't Must*.
Docteur en histoire de l'art, auteur et commissaire indépendante. Contribue régulièrement entre autre à *artnet.com*, *Art Review* et *Flash Art* ; directrice de publication du livre d'artiste *David Hatcher: I Don't Must*.

R. M. – RODRIGO MOURA
Curator, editor and art critic. Since 2004 he has held a position as curator at Inhotim Centro de Arte Contemporânea. He is a former curator of Museu de Arte da Pampulha (2003–06) in Belo Horizonte, the city where he lives.
Kurator, Herausgeber und Kunstkritiker. Seit 2004 ist er Kurator am Inhotim Centro de Arte Contemporânea. Außerdem war er 2003–06 Kurator am Museu de Arte da Pampulha in Belo Horizonte, seinem derzeitigen Wohnsitz.
Commissaire, éditeur et critique d'art. Occupe le poste de conservateur du Inhotim Centro de Arte Contemporânea depuis 2004. Ancien conservateur du Museu de Arte da Pampulha (2003–06) à Belo Horizonte, sa ville de résidence actuelle.

S. R. – SIMON REES
Curator at the Contemporary Art Centre (CAC) in Vilnius who writes regularly for international press and publications.
Kurator am Contemporary Art Centre (CAC) in Vilnius mit zahlreichen Veröffentlichungen in der internationalen Presse und in Katalogen.
Conservateur au Contemporary Art Centre (CAC) à Vilnius ; écrit régulièrement pour la presse internationale et d'autres publications d'art.

V. R. – VIVIAN REHBERG
Chair of Critical Studies and lecturer in art history at Parsons Paris School of Art & Design, and a founding editor of the *Journal of Visual Culture*. She is a frequent contributor to *frieze*, *Modern Painters* and other art publications.
Professorin für Critical Studies und Dozentin für Kunstgeschichte an der Parsons Paris School of Art & Design, sowie Gründungsherausgeberin des *Journal of Visual Culture*. Regelmäßige Beiträge u.a. zu *frieze* und *Modern Painters*.
Chaire d'études critiques et maître de conférences en histoire de l'art à la Parsons Paris School of Art & Design ; fondatrice et éditrice du *Journal of Visual Culture*. Contributions régulières à *frieze*, *Modern Painters* et d'autres publications d'art.

E. S. – EVA SCHARRER
Independent curator and critic, currently based in Basle. She has written various catalogue essays and is a regular contributor to *Artforum International*, *artforum.com*, *Modern Painters*, *Kunst-Bulletin*, *Spike Art*, and others.
Freischaffende Kuratorin und Kritikerin, lebt derzeit in Basel. Hat zahlreiche Katalogessays verfasst und schreibt regelmäßig Beiträge u.a. für *Artforum International*, *artforum.com*, *Modern Painters*, *Kunst-Bulletin* und *Spike Art*.
Commissaire et critique d'art indépendante installée à Bâle. A écrit plusieurs essais pour différents catalogues et contribue régulièrement à *Artforum International*, *artforum.com*, *Modern Painters*, *Kunst-Bulletin*, *Spike Art* et d'autres publications.

Photo credits — Fotonachweis — Crédits photographiques

We would like to thank all the individuals, galleries and institutions who placed photographs and information at our disposal for ART NOW 3.
Unser Dank gilt allen Personen, Galerien und Institutionen, die großzügig Bildmaterial und Informationen für ART NOW 3 zur Verfügung gestellt haben.
Nous remercions toutes les personnes, galeries et institutions qui ont mis gracieusement à la disposition de ART NOW 3 leurs documentations, images et informations.

Abts, Tomma → © Tomma Abts 1–4 Courtesy Galerie Daniel Buchholz, Cologne/Berlin / greengrassi, London / Galerie Giti Nourbakhsch, Berlin **Ackermann, Franz** → © Franz Ackermann 1–3 Courtesy neugerriemschneider, Berlin **Ai Weiwei** → © Ai Weiwei 1 Courtesy Galerie Urs Meile, Beijing/Lucerne 2, 3 Courtesy Leister Foundation, Switzerland / Erlenmeyer Stiftung, Switzerland / Galerie Urs Meile, Beijing/Lucerne 4, 5 Courtesy Mary Boone Gallery, New York Portrait Frank Schinski **Aitken, Doug** → © Doug Aitken 1–6 Courtesy 303 Gallery, New York **Akakçe, Haluk** → © Haluk Akaçe 1, 3, 4 Courtesy Galerie Max Hetzler, Berlin / Photo 3 Holger Niehaus / Photo 4 Jörg von Bruchhausen 2 Courtesy The Approach, London **Allora & Calzadilla** → © Allora & Calzadilla 1 Courtesy San Francisco Art Intitute / the artists / Gladstone Gallery, New York / Photo Seza Bali 2, 3 Courtesy the artists / Gladstone Gallery, New York 4 Courtesy Haus der Kunst, Munich / the artists / Gladstone Gallery, New York / Photo Marino Solokov 5 Courtesy Kunsthalle Zürich / the artists / Gladstone Gallery, New York / Photo A. Burger **Almond, Darren** → © Darren Almond 3 Courtesy Galerie Max Hetzler, Berlin / Photo Jörg von Bruchhausen 4 Courtesy Parasol Unit Foundation for Contemporary Art, London / Photo Hugo Glendinning Portrait Richard Dawson **Althamer, Paweł** → © Paweł Althamer 1, 2 Courtesy neugerriemschneider, Berlin / Photo 1 Roman Mensing 3, 4 Courtesy neugerriemschneider, Berlin / Foksal Gallery Foundation, Warsaw / Photo 3 Marco de Scalzi / Photo 4 Jens Ziehe **Altmejd, David** → © David Altmejd 1–4 Courtesy Andrea Rosen Gallery, New York / Photo 1 Tom Powel / Photos 2–4 Ellen Page Wilson Portrait Ellen Page Wilson **Atherton, Hope** → © Hope Atherton 1–5 Courtesy Bortolami Gallery, New York **Banksy** → © Banksy 1, 2 Courtesy Pest Control Office, London **Barney, Matthew** → © Matthew Barney 1–4 Courtesy Gladstone Gallery, New York / Photo 1 Hugo Glendinning / Photos 2–4 Chris Winget **Berresheim, Tim** → © Tim Berresheim 1–5 Courtesy Galerie Hammelehle und Ahrens, Cologne **Bonin, Cosima von** → © Cosima von Bonin 1–5 Courtesy Friedrich Petzel Gallery, New York **Bonvicini, Monica** → © Monica Bonvicini / VG Bild-Kunst, Bonn 2008 1–5 Courtesy Galleria Emi Fontana, Milan / West of Rome, Pasadena / Photos 1, 2 Johannes Linders / Monica Bonvicini / Photo 3 Fredrik Nilsen / Photo 4 Monica Bonvicini / Photo 5 Mattias Givell Portrait Monica Bonvicini **Brown, Cecily** → © Cecily Brown 1, 2 Courtesy Gagosian Gallery, New York 3 Courtesy Contemporary Fine Arts, Berlin / Photo Jochen Littkemann Portrait Sidney B. Felsen **Brown, Glenn** → © Glenn Brown 1, 3, 4 Courtesy Galerie Max Hetzler, Berlin / Photos Jörg von Bruchhausen 2 Courtesy the artist Portrait Sex, 2003, oil on panel, 126 x 85 cm Courtesy Gagosian Gallery, New York **Butzer, André** → © André Butzer 1–4 Courtesy Galerie Max Hetzler, Berlin Portrait Thomas Biber **Cai Guo-Qiang** → © Cai Guo-Qiang 1–4 Courtesy Cai Studio / Photos 1, 3 Hiro Ihara / Photo 2 Tatsumi Masatoshi / Photo 4 Chen Shizhen Portrait Courtesy Cai Studio / Photo Ma Da **Cattelan, Maurizio** → © Maurizio Cattelan 1–3 Courtesy Galerie Emmanuel Perrotin, Paris/Miami / Photo 1 Axel Schneider / Photo 2 Wonge Bergmann / Photo 3 Zeno Zotti **Collishaw, Mat** → © Mat Collishaw 1–3 Courtesy the artist / Haunch of Venison 2008 4–6 Courtesy the artist / Spring Projects, London / Haunch of Venison 2008 **Condo, George** → © George Condo / VG Bild-Kunst, Bonn 2008 1–7 Courtesy Luhring Augustine, New York Portrait Sara Fuller **Creed, Martin** → © Martin Creed 1, 5 Courtesy the artist / Gavin Brown's enterprise, New York 2, 3 Courtesy the artist / Hauser & Wirth, Zürich London / Gavin Brown's enterprise, New York 4, 6 Courtesy the artist / Hauser & Wirth, Zürich London / Photo 4 Hugo Glendinning / Photo 6 A. Burger **Currin, John** → © John Currin 1–4 Courtesy Gagosian Gallery, New York **Curry, Aaron** → © Aaron Curry 1–5 Courtesy Galerie Daniel Buchholz, Cologne/Berlin / David Kordansky Gallery, Los Angeles Portrait Amy Bessone **David, Enrico** → © Enrico David 1–4 Courtesy Galerie Daniel Buchholz, Cologne/Berlin 5, 6 Courtesy Cabinet, London / Galerie Daniel Buchholz, Cologne/Berlin **Dean, Tacita** → © Tacita Dean 1–5 Courtesy the artist / Frith Street Gallery, London / Marian Goodman Gallery, New York/Paris / Photo 5 Alex Delfanne Portrait Nick MacRae **Demand, Thomas** → © Thomas Demand / VG Bild-Kunst, Bonn 2008 1–4 Courtesy the artist Portrait Oliver Mark, Berlin **Dijkstra, Rineke** → © Rineke Dijkstra 1–6 Courtesy Galerie Max Hetzler, Berlin / Marian Goodman Gallery, New York/Paris **Djurberg, Natalie** → © Natalie Djurberg 1, 3 Courtesy the artist / Giò Marconi, Milan / Zach Feuer Gallery, New York 2, 4 Courtesy the artist / Fondazione Prada, Milan **Doig, Peter** → © Peter Doig 1–3 Courtesy Michael Werner Gallery, New York and Berlin / Photos Marcella Leith / David Clark: Tate Portrait Alex Smailes **Dumas, Marlene** → © Marlene Dumas 1–4 Courtesy Zeno X Gallery, Antwerp / Photos Peter Cox Portrait Andre Vannoord **Dzama, Marcel** → © Marcel Dzama 1–5 Courtesy the artist / David Zwirner, New York Portrait Courtesy the artist / David Zwirner, New York / Photo Spike Jonze 2008 **Eder, Martin** → © Martin Eder / VG Bild-Kunst, Bonn 2008 1–4 Courtesy Galerie EIGEN + ART, Leipzig/Berlin / Photos 1, 4 Uwe Walter, Berlin Portrait © Martin Eder / VG Bild-Kunst, Bonn 2008 **Eliasson, Olafur** → © Olafur Eliasson 1–5 Courtesy neugerriemschneider, Berlin Portrait Jacob Jorgensen **Elmgreen & Dragset** → © Elmgreen & Dragset 1, 2, 5, 6, pages 10/11 Courtesy the artists / Photo 1, pages 11/12 Thorsten Arendt/artdoc.de / Photo 2 Elmar Vestner / Photo 5 James Evans / Photo 6 Elmgreen & Dragset 3, 4 Courtesy Galerie Emmanuel Perrotin, Paris/Miami / Photo 3 Mariano Peuser / Photo 4 Anders Sune Berg **Emin, Tracey** → © Tracey Emin 1 Courtesy Gagosian Gallery, New York 2, 3 Courtesy the artist / Lehmann Maupin Gallery, New York 4 Courtesy Jay Jopling/White Cube, London / Photo Prudence Cummings Associates Ltd **Fischer, Urs** → © Urs Fischer 1, 3 Courtesy Galerie Eva Presenhuber, Zürich / Sadie Coles HQ, London 2, 4 Courtesy Galerie Eva Presenhuber, Zürich / Photos Stefan Altenburger Photography, Zürich **Förg, Günther** → © Günther Förg 1, 3 Courtesy Galerie Gisela Capitain, Cologne / Photos Lothar Schnepf 2 Courtesy Galerie Bärbel Grässlin, Frankfurt am Main / Photo Wolfgang Günzel Portrait Andrea Stappert **Ford, Walton** → © Walton Ford 1–5 Courtesy Paul Kasmin Gallery, New York / Photos 2, 3 Christopher Burke Studio **Friedman, Tom** → © Tom Friedman 1–3 Courtesy Gagosian Gallery, New York Portrait Justin Kemp **Gallagher, Ellen** → © Ellen Gallagher 1, 4 Courtesy the artist / Hauser & Wirth, Zürich London / Photos Studio Ellen Gallagher 2 Courtesy the artist / Hauser & Wirth, Zürich London / Tate, London / Photo Mike Bruce Portrait Edgar Cleijne **Genzken, Isa** → © Isa Genzken Photo 1 Roman Mensing 2, 3 Courtesy neugerriemschneider, Berlin 4–6 Courtesy Galerie Daniel Buchholz, Cologne/Berlin / neugerriemschneider, Berlin Portrait Wolfgang Tillmans **Gispert, Luis** → © Luis Gispert 1, 2 Courtesy Zach Feuer Gallery, New York / Mary Boone Gallery, New York 3–6 Courtesy Mary Boone Gallery, New York / Courtesy Zach Feuer Gallery, New York **Gober, Robert** → © Robert Gober 1–3 Courtesy Matthew Marks Gallery, New York Portrait Catherine Opie 2001 **Gordon, Douglas** → © Douglas Gordon 1 Courtesy the artist 2 Courtesy Inverleith House, Edinburgh 3 Courtesy Kunstmuseum Wolfsburg / Photo Matthias Langer 4 Courtesy Gagosian Gallery, New York / Photo Courtesy the artist **Grotjahn, Mark** → © Mark Grotjahn 1–4, front cover, endpapers Courtesy Gagosian Gallery, New York / Blum & Poe, Los Angeles / Anton Kern Gallery, New York / Shane Campbell Gallery, Chicago / Photo front cover, endpapers Joshua White **Gupta, Subodh** → © Subodh Gupta 1 Courtesy Galleria Continua, San Gimignano / Photo Aurélien Mole 2, 3 Courtesy Jack Shainman Gallery, New York / Photo 3 Shalendra Kumar **Gursky, Andreas** → © Andreas Gursky / VG Bild-Kunst, Bonn 2008 1–3 Courtesy Monika Sprüth Philomene Magers, Cologne/Munich/London Portrait Tom Lemke **Guyton, Wade** → © Wade Guyton 1–5 Courtesy Friedrich Petzel Gallery, New York **Guzmán, Daniel** → © Daniel Guzmán 1–4 Courtesy the artist / kurimanzutto, Mexico City / Photos Michel Zabé / Enrique Macías Portrait Rodolfo Díaz Cervantes

To stay informed about upcoming TASCHEN titles, please request our magazine at www.taschen.com/magazine or write to TASCHEN, Hohenzollernring 53, D-50672 Cologne, Germany; contact@taschen.com; Fax: +49-221-254919. We will be happy to send you a free copy of our magazine, which is filled with information about all of our books.

© 2008 TASCHEN GmbH
Hohenzollernring 53, D-50672 Köln
www.taschen.com

ART NOW Vol 3

Edited by Hans Werner Holzwarth

Chief editors: Cornelia Lund, Lutz Eitel

Texts: Cecilia Alemani, Jens Asthoff, Andrew Bonacina, Suzanne Hudson, Christy Lange, Holger Lund, Astrid Mania, Rodrigo Moura, Simon Rees, Vivian Rehberg, Eva Scharrer

English translation: Pauline Cumbers, Emily Speers Mears
German translation: Stefan Knödler, Gisela Sturm, Matthias Wolf
French translation: Wolf Fruhtrunk, Anthony Allen, Geneviève Bégou, Marie Gravey, Patrick Hersant, Blandine Pélissier, Alice Petillot

Editorial team: Kirsty Bell, Thomas Boutoux, Lucie Kostmann, Holger Lund, Jacqueline Todd, Miriam Wiesel
Coordination: Anna Stüler
Design: Hans Werner Holzwarth and Jan Blatt, based on the *ART NOW* design by Sense/Net, Andy Disl and Birgit Reber

Printed in Italy
ISBN 978–3–8365–0511–6